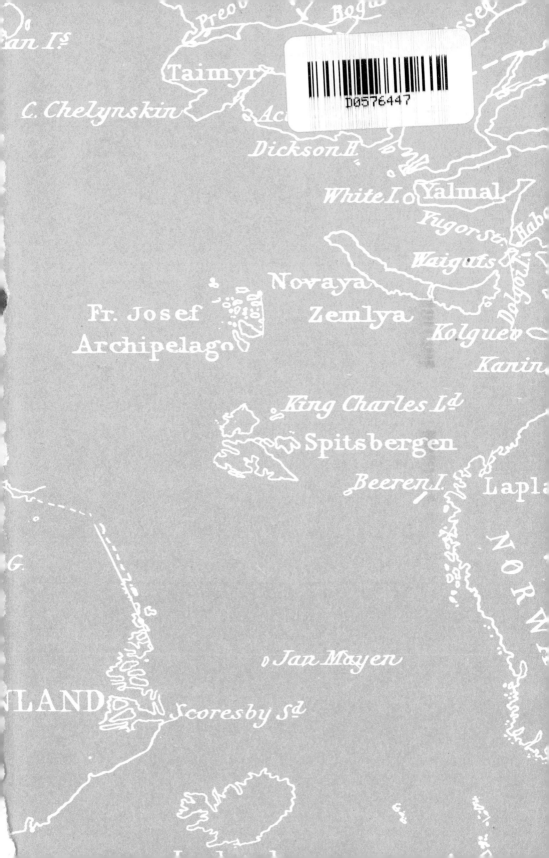

arctic voices

voices

resistance at the tipping point

Edited by

Subhankar Banerjee

SEVEN STORIES PRESS
New York

A SEVEN STORIES PRESS FIRST EDITION

Arctic Voices is being made possible by a generous grant from the
Alaska Wilderness League.

SEVEN STORIES PRESS
140 Watts Street
New York, NY 10013
sevenstories.com

College professors may order examination copies of Seven Stories Press titles for a free
six-month trial period. To order, visit http://www.sevenstories.com/textbook
or send a fax on school letterhead to (212) 226-1411.

LIBRARY OF CONGRESS CATALOGING-IN-PUBLICATION DATA

Arctic voices : resistance at the tipping point / edited by Subhankar Banerjee.
p. cm.
Includes bibliographical references.
ISBN-13: 978-1-60980-385-8 (hardback)
ISBN-10: 1-60980-385-X (hardback)
1. Arctic peoples—Social conditions.
2. Indigenous peoples—Ecology—Arctic regions.
3. Traditional ecological knowledge—Arctic regions.
4. Environmental degradation—Arctic regions.
5. Environmental responsibility—Arctic regions.
6. Arctic regions—Environmental conditions.
I. Banerjee, Subhankar.
GN473.A76 2012
577.0911'3—dc23
2012011126

PHOTOGRAPHY THROUGHOUT BY SUBHANKAR BANERJEE
(*unless otherwise indicated*)

DESIGN BY POLLEN, NEW YORK

PRINTED IN THE UNITED STATES

9 8 7 6 5 4 3 2 1

CONTENTS

From Kolkata To Kaktovik
En Route To Arctic Voices

Something Like An Introduction

SUBHANKAR BANERJEE

"I learned by living out in the wilderness."

—Sarah James[1]

"When we think of wars in our times, our minds turn to Iraq and Afghanistan. But the bigger war is the war against the planet. This war has its roots in an economy that fails to respect ecological and ethical limits—limits to inequality, limits to injustice, limits to greed and economic concentration."

—Vandana Shiva[2]

1.

How do we talk about the Arctic?

How do we think about the Arctic?

How do we relate to the Arctic?

And, why talk about the Arctic, now? These are some questions we explore, through stories, in this volume.

Along the way, we talk about big animals, big migrations, big hunting, big

land, big rivers, big ocean, and big sky; and also about big coal, big oil, big warming, big spills, big pollution, big legislations, and big lawsuits.

And we talk about small things, too—small animals, small migrations, small hunting, small rivers, small warming, small spills, small pollution, small legislations, and small lawsuits.

<div align="center">2.</div>

In the Arctic, impacts of climate change can be seen and/or experienced everywhere.[3] Indeed, the Arctic is warming at a rate double that of the rest of the planet. When I was in the Arctic National Wildlife Refuge in 2001–02, there was much talk in the communities about oil development, but very little about climate change. But when I returned north to Alaska/Siberia/Yukon in 2005, 2006, and 2007, almost everyone was talking about the effects of climate change on animals and on the communities. I had witnessed things that I had not seen before—an exposed coffin from melting of permafrost (plate 15); a drunken forest in Siberia, trees leaning at odd angles from softening of the permafrost; and the skeleton of caribou that had died from starvation due to winter icing on the tundra. I also had heard stories of communities that needed to relocate because of coastal erosion (see Christine Shearer's essay in this volume); the drying up of lakes that is affecting subsistence fishing; and deeper snow or taller and bushier willows making the migration much harder for the caribou, for examples. We tell many stories of climate change in *Arctic Voices*.

At the same time, I am realizing that there is an Arctic paradox: that oil, coal, and gas, the burning of which has caused unprecedented Arctic warming, are the same nonrenewable resources whose extraction projects are expanding rapidly in the Arctic—terrestrial and offshore.

These days there is talk about ecological restoration, including ecological corridors—to connect up landscapes that we fragmented all through the nineteenth and twentieth centuries—from Yellowstone to Yukon; from Baja to Bering. In the Arctic, however, we are going in reverse—severely fragmenting the ecocultural space with great speed. There are resource wars[4]—for oil, gas, coal, and minerals—everywhere in the Arctic—from Alaska to Siberia, with Nunavut and Greenland along the way. In Arctic Alaska, these wars have intensified since I first arrived there more than a decade ago. I'd also note here that Arctic Alaska resides in the most biologically diverse quadrant of

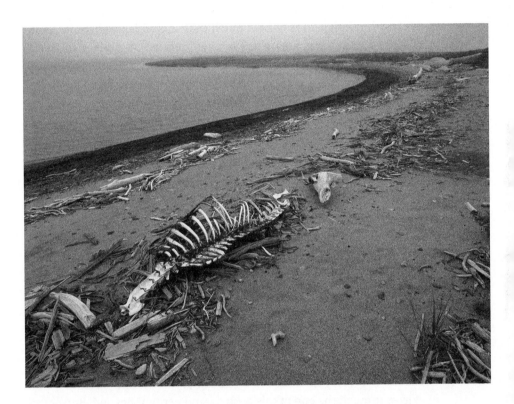

In the winter of 2006 about a thousand caribou from the Teshekpuk Lake herd came over to the Arctic National Wildlife Refuge, a 240-mile journey. Kaktovik resident Robert Thompson said that this never happened before. He speculated that the tundra froze, and the caribou came looking for food. The tundra also froze in the Arctic Refuge, resulting in the deaths of several hundred animals that winter. The skeleton shown is one those dead caribou that was photographed the following summer. Due to unprecedented Arctic warming there is thawing of snow and rain during the autumn and winter months, followed by freezing that produces solid ice on the tundra. Hoofed animals, including caribou/ reindeer and musk ox are able to dig through snow to find food, but are not able to break through ice— they are starving and dying. In many parts of the arctic these freeze-thaw cycles have contributed to significant population decline for these animals. *(Photograph by Subhankar Banerjee, August 2006.)*

the circumpolar north. There is a great irony in the fact that oil sits underneath caribou calving grounds in the Arctic National Wildlife Refuge; oil sits underneath bird nesting and molting grounds in the Teshekpuk Lake Wetland; coal sits underneath caribou calving grounds in the Utukok River Upland; oil sits underneath the migration route of bowhead whales in the Beaufort and Chukchi seas.

It's worth taking a look at how much coal and oil is up there in Arctic Alaska. By current estimates, there is some 30 billion barrels of oil in the Beaufort and Chukchi seas. Let's put that number in perspective. In the US, each year we consume a little over 7.5 billion barrels of oil—30 billion barrels only amounts to four years of US consumption. Not that long, right? But that's not how it works—with oil coming from elsewhere and also coal and gas contributing to the energy needs, we could drill in the Arctic Ocean for the next thirty years. And, oil in the Arctic National Wildlife Refuge? Best estimates go from about 7 billion to 16 billion barrels, meaning one to two and a half years of US annual oil consumption. Again, with help from other energy sources, oil companies could potentially drill in the Arctic Refuge for several decades. Then, there is oil in the Teshekpuk Lake Wetland.... Now, consider coal. Nick Jans points out in his essay that there is a possible maximum of 4 trillion tons of bituminous coal in the Western Arctic of Alaska, which is nearly 9 percent of world's known coal reserves. The annual coal consumption in the US is about 1 billion tons, which means at the current rate of consumption we could potentially burn the Arctic coal for the next four thousand years. No, that's not a typo—four thousand years of coal!

If we take the approach of business as usual, we will continue to extract fossil fuels—from the Arctic and elsewhere in North America—and then burn it, at least through the end of this century, and perhaps beyond. Burning of fossil fuels has brought us to the Anthropocene! Now we must stand up and stop any maniacal plan that would set us on a path to another one hundred years of fossil fuel culture. A counterargument to this would be: China and India will continue to burn coal and oil, so why should we stop burning fossil fuels in the US? While this ping-pong argument-counterargument is beyond the scope of this anthology, we must imagine a planet where our primary sources of energy are not coal-oil-gas, but clean sustainable energies that are healthy for all life on earth, including humans.

The first color plate in this volumes includes photographs that I took in the Arctic—Alaska, Siberia, and Yukon in Canada, during 2000–07. I use photography to raise awareness about the Arctic, [5,6] but I never would have

imagined that my photographs would be used on the US Senate floor to argue against oil drilling in the Arctic National Wildlife Refuge—yet that is exactly what Senator Barbara Boxer did and won a crucial vote on March 19, 2003. Nor did I imagine that my exhibition at the Smithsonian Institution would be censored[7] and become the topic of a Senate hearing at which Senator Richard Durbin would support my work, or that later a Senate investigation would follow. But when then-Senator Ted Stevens during a May 2003 Senate debate said that President Jimmy Carter and I were giving "misinformation to the American public"—effectively calling us liars—then I did fear possible deportation, and realized that if I were to have a voice in conservation in the US, I must become a US citizen. So I did.

3.

The British poet Tom Lowenstein has spent much time, since 1973, in Tikigaq (aka Point Hope), in Arctic Alaska, to learn about Iñupiat spirituality of a bygone era. He writes in his remarkable poetry prose book, *Ancient Land, Sacred Whale: Inuit Hunt and Its Rituals*, what old Tikigaq people said: "Never tell one story. Always add a second. That way, the first one won't fall over."[8] In *Arctic Voices* we tell nearly forty stories in all, so that these voices will stand tall, together—as resistance against destruction.

You might wonder how someone with an Indian-sounding name like mine, someone from the south, comes to concern himself with all things northern. Here is how it all began. In 2000 I left my career as a scientist and was wandering aimlessly from Florida to British Columbia looking for inspiration for a photography project; I had found none when, in late October, I arrived with two friends in Churchill in sub-Arctic Canada—a popular tourist destination. There, polar bears gather along the Hudson Bay and wait on land for the bay to freeze over. Once on ice, they hunt and eat. I took a photo of one bear eating another—not normal, I was told, but no one in town said the Arctic was getting warmer (plate 1). I now read that the bears of Hudson Bay will disappear within a few decades at best, or within a decade at worst, because these days ice is forming later in autumn and melting sooner in spring, leaving the bears longer on land, where they must wait and starve.[9] This gruesome photograph of death produced in me a desire to live in the wild, with the polar bears.

After nearly five months of research, and discussions with biologists, and with

Iñupiat hunter and conservationist Robert Thompson, I arrived on March 19, 2001, in Robert's village, Kaktovik, along the Beaufort Sea coast, in Arctic Alaska. It was 40 below zero. Robert said, "Let's take a walk on the Arctic Ocean." We did. I was dressed properly and felt fine. Later that evening we traveled by snowmobiles to Arey Island—a thin stretch of Barrier Island that sits in between the Beaufort Sea and the Hulahula-Okpilak Delta. The wind picked up and started blowing at fifty, sixty miles per hour; wind chill dropped to minus 90 degrees Fahrenheit; my camera froze; I panicked and began to wonder, *What the heck am I doing here? I grew up in Kolkata, India. I have gotten myself in over my head. I won't survive this land. Forget about photography. I must return to Seattle.* I barely made it back to Kaktovik—the hardest six-mile journey I ever took. Robert and his wife, Jane, reassured me, "Things will get much worse, but you'll survive." Things did get much worse, indeed. The following year, Robert and I experienced a blizzard during March and April while camping in the Canning River Delta on the western edge of the Arctic National Wildlife Refuge. We had four calm days out of the twenty-nine that we camped there. Other times, a blizzard blew steady at sixty-five miles per hour with temperatures around minus 40 degrees that brought the windchill down to around minus 110 degrees (plate 2). There, we observed a polar bear mother with two cubs play outside the den (plate 3). This isn't an adventure story, as you might think, but instead, as you'll see later in this volume, we ask such questions as, "Can you imagine the oil companies cleaning up a BP-like spill in the frozen Arctic Ocean in such a blizzard?"

During 2001–02, I ended up spending fourteen months in the Arctic Refuge, in all seasons, with Robert Thompson or with Charlie Swaney and Jimmy John from Arctic Village—a Gwich'in community of about 150 residents on the south side of the Brooks Range. Much of that time was during winter, which up there is nearly nine months of the year. I witnessed musk oxen with new-born calf migrating over snow-covered tundra; an American dipper finding food in 40 below zero in the open water of a creek along the Hulahula River; a few caribou digging through snow for food; moose chomping on willow; porcupine chomping on willow, too; wolves and wolverines coming and going leaving their tracks behind; ptarmigans flocking and their talk that sounded like "go back, go back" outside our tent when I was trying to sleep—a sample of life, during the harsh winter months.

Now consider how politicians talk about all this. In March 2002, then-Senator Frank Murkowski held up a flat white poster board on the US Senate floor and said of the Arctic National Wildlife Refuge, "This is a picture of ANWR as it exists for about nine months of the year. This is what it looks

like. It's flat, it's unattractive; don't be misinformed." Secretary of the Interior Gail A. Norton, during a March 12, 2003, congressional testimony, famously described the Arctic Refuge coastal plain as an object of conceptual art—"a flat white nothingness." In an October 2, 2005, front-page story in the *Chicago Tribune*, then-Senator Ted Stevens was quoted saying, "And they're [the American public] not susceptible anymore to misrepresentations that ANWR is some kind of pristine wilderness. It's empty. It's ugly." Then, on November 5, 2005, Senator Stevens said on *PBS News Hour with Jim Lehrer*, "This is the area in wintertime. And I defy anyone to say that that is a beautiful place that has to be preserved for the future. It is a barren wasteland, frozen wasteland."

Arctic Voices paints a very different picture—we present the Arctic neither as a frozen wasteland nor as a pristine wilderness, but, instead, simply as *home* for numerous species—animal and human—who either visit for a while or live there year-round.

Over the past decade, many people have asked me, "Why should I care about the Arctic?" While I still may not have the whole answer, I've been putting together bits and pieces in response to that question. It's terra incognita; it's the "far north" that we may never get to see, only imagine; it's a place of *snow and ice* and *ice and snow* where icebergs crash and polar bears roam—where we would get hypothermia; it's where Santa Claus and Rudolph the Red-Nosed Reindeer fly around—something only a Siberian shaman used to be able to do. . . . These are the things that dreams are made of.

Indeed, around the world, the Arctic is thought to be a remote place disconnected from our daily lives. On the contrary, hundreds of millions of birds migrate to the Arctic each spring from every corner of the earth—including Yellow Wagtail from Kolkata—for nesting and rearing their young, and resting—a planetary celebration of global interconnectedness. On the other hand, caribou, whale, and fish migrate hundreds and sometimes thousands of miles, connecting numerous indigenous communities through subsistence food harvests—local and regional interconnectedness. However, deadly industrial toxins migrate to the Arctic from every part of our planet, making animals and humans of the Arctic among the most contaminated inhabitants of the earth. The breast milk of high Arctic women in some parts of Greenland and northern Canada is scientifically regarded as being as toxic as hazardous waste—a planetary tragedy of global interconnectedness. Marla Cone tells this tragic story in this volume—she calls it "Arctic Paradox." And Rosemary Ahtuangaruak tells a story of declining public

health in her community caused by pollution from the nearby oil fields of Prudhoe Bay.

There is another kind of Arctic pollution that a photo helped me to understand. Upon seeing one of my photographs people have asked, "Are these colors real or manipulated?" The photograph in question is of a group of musk oxen on the Canning River Delta that I had taken in early May 2001, in the Arctic National Wildlife Refuge (plate 4). The temperature was about minus 35 degrees Fahrenheit; deep haze severely restricted visibility, as I lay flat on my belly with the lens touching snow to make the animals visible, barely. Indeed, I began to wonder how could there be such vibrant colors in an environment that is supposed to be free of pollution? I remember from my childhood many colorful sunrises and sunsets in Kolkata, where pollution in the air was all around us; it still is. There had to be particulates in the air to create those deep red-orange colors in the musk oxen photo, and I surmised that the source of the pollution was perhaps the nearby oil fields of Prudhoe Bay (plate 36), but on probing further I also came to know about the Arctic haze that a handful of scientists have been studying. I don't know if what you see in the photo is indeed Arctic haze or pollution from Prudhoe Bay, but, nevertheless, a fact sheet states:

> Arctic haze is a thin, persistent, brown haze that causes limited visibility on the horizons of what had been previously very clear Arctic skies. It is most visible in the early spring and can be seen from northern Greenland, the Arctic coasts of Canada and Alaska and occasionally in eastern Siberia. . . . The Arctic haze that accumulates by late winter, trapped under the dome of cold air, is as large as the continent of Africa! . . . Arctic haze is made up of a complex mix of microscopic particles and acidifying pollutants such as soot, hydrocarbons, and sulfates. Up to 90% of Arctic haze consists of sulfates. . . . We can find out where Arctic haze comes from because the chemicals that make up Arctic haze are like a footprint that can lead us back to their sources. The main sources of the sulfates found in Arctic haze are things like power plants, pulp and paper mills and oil and gas activities. The other pollutants found in Arctic haze can be traced to industries such as vehicles, shipping and agriculture. The places in which these industries occur and where these pollutants thus originate are in the heavily populated and industrialized areas of Europe, North America and Asia.[10]

The question is: What is the long-term stress acidification from Arctic haze might put on the fragile Arctic ecology? While we don't know *this* yet, the haze might also be contributing to the rapid polar melt:

Industry, transportation, and biomass burning in North America, Europe, and Asia are emitting trace gases and tiny airborne particles that are polluting the polar region, forming an "Arctic Haze" every winter and spring. Scientists suspect these pollutants are speeding up the polar melt.[11]

As you can see, the Arctic is far from being a remote place disconnected from our daily lives. Instead, we're all connected to the northern landscape. In this volume, we tell many stories of local, regional, and global interconnectedness—both celebratory and tragic.

During 2001–02, I visited Washington, DC several times for various activist campaigns that were made possible by Alaska Wilderness League. During one of those visits, upon seeing one of my photographs, one young environmental activist asked me, with honest bewilderment, "How could there be a hunting camp in a pristine wilderness?" The "wilderness" in question was the Arctic National Wildlife Refuge, and the "hunting camp" was Charlie Swaney's hunting camp along the East Fork of the Chandalar River, in the Arctic Refuge, near Arctic Village. That day, I didn't have an answer, but it is that question, more than anything else that prompted me to learn about the history of American conservation.

The reason the young environmentalist asked that question, I think, was because American environmental writing has always glorified, and continues to glorify, the formative years of the conservation movement, when the ideal that was expressed was one that separated man from nature—the second half of the nineteenth century; it celebrates the movement's founders as prophets and does not take a critical look at what actually happened. The massive 2008 Library of America anthology, *American Earth: Environmental Writing Since Thoreau*, which environmental journalist and climate change activist Bill McKibben edited (and to which I contributed my Arctic photographs), unfortunately perpetuates that point of view. Fortunately though, recent scholarship is changing American environmental history by shedding light on the dark side of conservation, which I will share with you as crucial backdrop for the stories presented in this volume. In his groundbreaking book, *Crimes Against Nature: Squatters, Poachers, Thieves and the Hidden History of American Conservation*, historian Karl Jacoby points out that, in the nineteenth century, when the conservation movement began to take shape, in short order, subsistence hunters—Native Americans and rural whites—were labeled "poachers," inhabitants as "squatters," and subsistence gatherers as "thieves," and those who would set fires for ecocultural reasons

as "arsonists," if their homelands were deemed worthy of conservation, effectively criminalizing the traditional activities of the inhabitants.[12] One of the case studies in the book illuminates the conflict of conservation and indigenous habitation during the formation of the Yellowstone National Park—the first National Park that was established in 1872. Jacoby points out that five tribes—the Crow, Bannock, Shoshone, Blackfeet, and Nez Perce—actively used the Yellowstone Plateau for subsistence hunting and gathering, and that "Indian trails . . . were everywhere." Yet,

> . . . park backers nonetheless persisted in describing the region as existing in "primeval solitude," filled with countless locations that "have never been trodden by human footsteps." . . . Drawing upon a familiar vocabulary of discovery and exploration, the authors of the early accounts of the Yellowstone region literally wrote Indians out of the landscape, erasing Indian claims by reclassifying inhabited territory as empty wilderness. . . . Neither the Bannock, the Shoshone, the Crow, nor the Blackfeet practiced agriculture, and seeing no landscapes in the Yellowstone region that had been "improved" through farming, many Euro-Americans conveniently concluded that the area's Indian's were rootless beings, with no ties to the lands they roamed across. What this ideology of dispossession overlooked was that Indian migratory patterns were not a series of random wanderings but rather a complex set of annual cycles, closely tied to seasonal variations in game and other wild foodstuffs.

Jacoby continues:

> The vision of nature that the park's backers sought to enact—nature as pre-human wilderness—was predicated on eliminating any Indian presence from the Yellowstone landscape. By 1895, a congressional report on Yellowstone could speak of the park as serving three central functions:
>> First. As a region containing some of the chief natural wonders of the world.
>> Second. As the largest of the forest reserves.
>> Third. As the greatest existing game preserve.

You might be surprised to know that the success of conservation with those clearly articulated central functions was made possible by militarization—the US military ran Yellowstone National Park for thirty-two years—to protect the land and tourists from the people of the land. Jacoby writes that militarization of public lands was met with great enthusiasm:

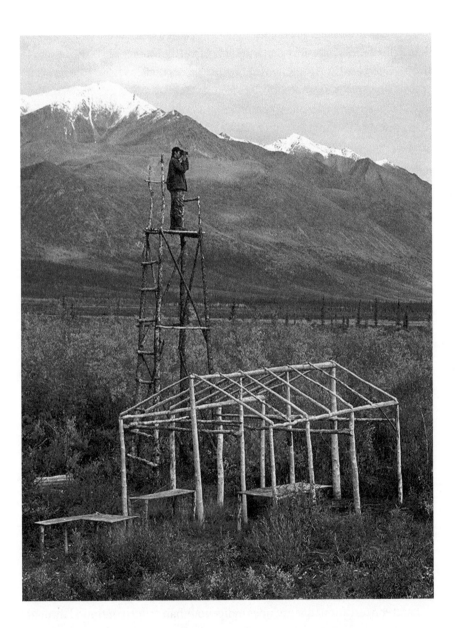

Charlie Swaney is scanning for animals from his camp along the East Fork of Chandalar River, Arctic National Wildlife Refuge, near Arctic Village. *(Photograph by Subhankar Banerjee, August 2002.)*

John Muir for instance rejoiced at seeing Yellowstone "efficiently managed and guarded by small troops of United States cavalry." "Uncle Sam's soldiers," the Sierra Club president enthused, are "the most effective forest police." "I will not say that this Rocky Mountain region is the only part of the country where this lesson of obedience to law is badly needed," agreed Charles Dudley Warner in *Harper's* magazine, "but it is one of them." ... Sharing Muir's and Warner's enthusiasm for "military discipline," many conservationists soon suggested that much of rest of the federal government's conservation program be delegated to the military.

George Parkins Marsh had published his influential conservation manifesto *Man and Nature* in 1864; Yosemite was protected by a land grant signed by President Abraham Lincoln in 1864 (later to be named National Park in 1890) that laid the foundation for Yellowstone National Park to be established in 1872, and the idea to remove Native Americans and rural whites from conservation-worthy land took shape. But what environmental historians perhaps have overlooked is that during the same decade American artists had imagined, or at a minimum presented, wilderness differently than how conservationists had envisioned it. In particular, I'd point to two paintings, both by Hudson River School painter Sanford Robinson Gifford: *In the Wilderness*, circa 1860, in which we see a Native American family inhabiting a lakeshore in the foreground and (presumably) Mount Katahdin in the background; and *A Home in the Wilderness*, circa 1866, in which we see a small home in a wooded land along a lakeshore with Mount Hayes in the background. The idea to put small human figures in large landscapes with the intent to show human habitation and labor preceded Gifford—John Constable in England and Barbizon School painter and conservationist Théodore Rousseau in France. While rooted in the tradition of the sublime, I'd suggest that Gifford's two paintings—*In the Wilderness* and *A Home in the Wilderness*—are also works of moral ecology.

As you can see, there were two roads for American wilderness in the 1860s—only one of them was taken and "that has made all the difference," and that is why it is difficult for a young American environmentalist today to imagine a hunting camp in a wilderness.

Land conservation that excludes indigenous habitation continued through the rest of the nineteenth and all through the first half of the twentieth century and culminated successfully with the passage of the 1964 Wilderness Act—considered a monumental achievement in conservation. Howard

Zahniser, one of the chief architects of the Act, proclaimed, "Man himself is a visitor who does not remain [in a wilderness]." *This* philosophy of exclusion is coming to a halt now, and is being reimagined—with critiques from scholars and resistance from indigenous inhabitants throughout the world. In his influential essay, "The Trouble with Wilderness; or, Getting Back to the Wrong Nature," historian William Cronon writes:

> This, then, is the central paradox: wilderness embodies a dualistic vision in which the human is entirely outside the natural. If we allow ourselves to believe that nature, to be true, must also be wild, then our very presence in nature represents its fall. The place where we are is the place where nature is not. If this is so—if by definition wilderness leaves no place for human beings, save perhaps as contemplative sojourners enjoying their leisurely reverie in God's natural cathedral—then also by definition it can offer no solution to the environmental and other problems that confront us. To the extent that we celebrate wilderness as the measure with which we judge civilization, we reproduce the dualism that sets humanity and nature at opposite poles. We thereby leave ourselves little hope of discovering what an ethical, sustainable, *honorable* human place in nature might actually look like.[13]

What relevance does all this wilderness history have to the Arctic landscape today? If we ask a simple question, "What do you think of the Arctic National Wildlife Refuge?" we might potentially get the following answers. "It's home. To us, it's home," says Robert Thompson. "It's a beautiful landscape," says the tourist. "It's a pristine wilderness, untouched by man," says the conservationist. "It's a frozen wasteland," says the politician. "It's a nursery. This is where I was born," would say a bear or a bird, or a caribou if it had a voice. They are all talking about the same piece of land. Additionally, from early ideas of terra incognita—as Romans once imagined the Arctic—to male white explorers' fantasies discussed by Lisa Bloom in her book *Gender on Ice: American Ideologies of Polar Expeditions*,[14] and to a present political landscape in which Native philosophies of habitation are more important than ever[15,16]—the Arctic today contains all of these histories, including that of the wilderness.

In 2004, I did a joint event with Gwich'in Elder, cultural activist, and *Arctic Voices* contributor Sarah James at Harvard University (in conjunction with my exhibition *Seasons of Life and Land: Arctic National Wildlife Refuge* at the Harvard Museum of Natural History).[17] It was June and the dogwoods

were in full bloom; we walked around campus. She told me stories and said, "I learned by living out in the wilderness." (She had said this before in other talks and testimonies.) I was intrigued by her use of the word *wilderness*, as how we talk about something is almost everything. She was referring to her childhood growing up on the land, with her family, along the Salmon River (also known as the Sheenjek River). Her father had a copy of Henry David Thoreau's *Walden* that she had read. Several years later, in 2007, during a cold January morning, when I visited her home in Arctic Village, she showed me a hand-drawn map of the Sheenjek River Valley with various Gwich'in family camps marked, and lamented the fact that that particular history of Gwich'in habitation along the Sheenjek was wiped clean when the Arctic National Wildlife Range was established. On December 6, 1960, US Secretary of Interior Fred A. Seaton signed the Public Land Order 2214, establishing the Arctic National Wildlife Range for "the purpose of preserving unique wildlife, wilderness and recreational values."[18]

Nowhere in this Public Land Order do we find names of the Gwich'in and Iñupiat communities inhabiting this northern region, having done so already for many millennia. Neither do we find names of the Crow, Bannock, Shoshone, Blackfeet, and Nez Perce—in the 1895 congressional report that articulated the central functions of the Yellowstone National Park.

I think Sarah's statement, "I learned by living out in the wilderness," simultaneously performs two remarkable things—complicates the wilderness discourse by injecting *justice* into the American wilderness philosophy; and points toward "what an ethical, sustainable, *honorable* human place in nature might actually look like" in the twenty-first century.

However, habitation in the Arctic is now under great threat from rapid industrialization. To discuss a key topic of cultural survival, I'll return to the late nineteenth century. Philosopher Jonathan Lear opens his fascinating book, *Radical Hope: Ethics in the Face of Cultural Devastation*, with what Plenty Coups, the last great chief of the Crow Nation, said shortly before he died to Frank B. Linderman—a white man who "had come to Montana in 1885 as a teenager, and . . . became a trapper, hunter, and cowboy." Linderman writes at the end of his book:

Plenty Coups refused to speak of his life after the passing of the buffalo, so that his story seems to have been broken off, leaving many years unaccounted for. "I have not told you half of what happened when I was young," he said, when urged to go on. "I can think back and tell you much more of war and

horse-stealing. But when the buffalo went away the hearts of my people fell to the ground, and they could not lift them up again. After this nothing happened. There was little singing anywhere. Besides," he added sorrowfully, "you know that part of my life as well as I do. You saw what happened to us when the buffalo went away."[19]

Lear goes on to make philosophical inquiries into the statement, "After this nothing happened"—not about what Plenty Coups had meant (which none of us would know anyway), but about what he could have meant.

The people of the Gwich'in Nation fear that oil development in the calving ground of the Porcupine River caribou herd on the coastal plain of the Arctic National Wildlife Refuge would destroy the herd and, subsequently, the Gwich'in culture. Through a poster that reads "Will the caribou go the way of the buffalo? Or will you save our Arctic way of life?" the Gwich'in Nation explicitly connected the fate of the buffalo and the plains Indians with the possible fate of the caribou and the Gwich'in. Sarah James writes in this volume, "We are the caribou people. Caribou are not just what we eat; they are who we are. They are in our stories and songs and the whole way we see the world. Caribou are our life. Without caribou we wouldn't exist." Her statement expresses similar concerns as Plenty Coups's. Also, there is a key common ground in their strategies for survival—collaboration. Plenty Coups collaborated with the US government—an unlikely ally, for the survival of his people, even as their way of life was being destroyed and they had to accept a new way of life on the reservation. Lear calls this "Radical Hope." Similarly, the Gwich'in collaborate with conservation groups—traditionally an unlikely ally, to help them fight for cultural survival. While Plenty Coups lamented the destruction of the way of life of the Crow people that he had witnessed, Sarah James, by contrast, is staking a claim on the future survival—"Without caribou we wouldn't exist"—of the Gwich'in way of life as they know it now.

Today, indigenous communities of the Arctic have a voice and participate directly in the political process through their own indigenous human rights organizations—Gwich'in Steering Committee, REDOIL, and others—something that would have been unthinkable, say, five decades ago. And these organizations are working in close partnership with conservation organizations such as the Alaska Wilderness League, Northern Alaska Environmental Center, and others. Perhaps of greatest importance, *Arctic Voices* attempts to bridge the gap between the two expressions: "How could there be a hunting

camp in a pristine wilderness?" and "I learned by living out in the wilderness," as conservation and indigenous human rights organizations come together to find common ground and build resistance movements against a common foe—industrial destruction of the Arctic land, life, and culture. The 1980 Alaska National Interest Land Conservation Act signed by President Jimmy Carter protected more than 100 million acres of land and water in Alaska—the largest conservation act ever, anywhere, but it also protected subsistence hunting and fishing rights in those lands. It has been a long road since Yosemite and Yellowstone to get *here*, but questions continue to linger as we move toward conservation that includes habitation, for our time, in this century. In an earlier essay I wrote:

> While both conservation and indigenous human rights organizations are imagining preservation of land for future generations, there is an inherent conflict in these two views. The Gwich'in want to insure that a hunter and his family would still be able to go out to the land to hunt caribou to bring back meat for the family, while the conservationist's view would be that a future generation of tourists would still be able to meet the caribou in the most primordial state. But, what if the tourist meets the hunter? What would they say to each other? The encounter between Native and tourist versions of conservation may be trumped should the political will of the US government prevail in developing the entire American Arctic for fossil fuel.[20]

On seeing my photos of hunting/butchering during lectures and in exhibitions in the US and in Europe, audiences have expressed a feeling of unease. In fact, during the 2009 UN Climate Conference in Copenhagen, a United Nations Environment Programme (UNEP) representative told me, "I wish you had not shown these hunting photographs here in Copenhagen." She was referring to Gwich'in caribou hunting photos that I had taken near Arctic Village, in January 2007 (plates 7 & 8). I wanted to understand the source of such anxiety and realized that I've lived in three different societies—*domestic* (India, for twenty-two years); *post-domestic* (continental US, for twenty-two years); and *pre-domestic* (Arctic, over the past decade)—that historian Richard Bulliet defined in his book, *Hunters, Herders, and Hamburgers: The Past and Future of Human-Animal Relationships.*[21]

I used to be horrified when the chicken would be butchered right in front of me during my childhood in Kolkata. "Break the neck first; the rest is easy," I was told. Looking at a skinned goat hanging, I thought, *blood in my meat*. I

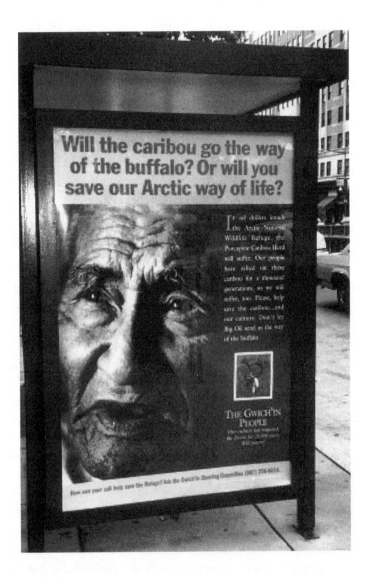

Gwich'in Nation poster: "Will the caribou go the way of the buffalo? Or will you save our Arctic way of life?" (*Courtesy Gwich'in Steering Committee, www.gwichinsteeringcommittee.org.*)

came to the US and felt relieved that for the first time I could buy my chicken or beef or lamb neatly packaged in Styrofoam covered with plastic—no blood—and I never had to know where it came from. Years later, I went to the Arctic where I experienced killing and butchering, and then I ate caribou, moose, sheep, and whale that came from the land and the sea. I saw where the food came from and I again saw blood in my meat.

Arctic Voices is deeply rooted in *land-as-home*—"land" that provides "home" and "food" to our species and to all the other species with whom we share this earth.

However, species are disappearing like autumn leaves off the trees. There is now an overwhelming realization that the health of our planet is in crisis. Scientists have suggested that the Holocene era in which human civilization flourished has come to an end, and that we are now living in the Anthropocene—a consequence of global climate change from massive accumulation of greenhouse gases in the atmosphere from burning first coal, then oil and gas, since the beginning of the Industrial Age. Historian Dipesh Chakrabarty writes in his influential essay, "The Climate of History: Four Theses":

> Scholars writing on the current climate-change crisis are indeed saying something significantly different from what environmental historians have said so far. In unwittingly destroying the artificial but time-honored distinction between natural and human histories, climate scientists posit that the human being has become something much larger than the simple biological agent that he or she always has been. Humans now wield a geological force. As Oreskes puts it:
>> For centuries, scientists thought that earth processes were so large and powerful that nothing we could do could change them. This was a basic tenet of geological science: that human chronologies were insignificant compared with the vastness of geological time; that human activities were insignificant compared with the force of geological processes. And once they were. But no more. There are now so many of us cutting down so many trees and burning so many billions of tons of fuels that we have indeed become geological agents. We have changed the chemistry of our atmosphere, causing the sea level to rise, ice to melt, and climate to change. There is no reason to think otherwise.[22]
> Biological agents, geological agents—two different names with very different consequences.[23]

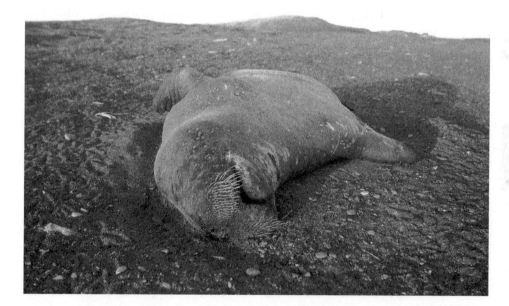

Dead baby walrus on barrier island, along the Kasegaluk Lagoon and Chukchi Sea, near Point Lay.
(Photograph by Steven Kazlowski, 2011.)

"Tens of thousands of walruses have come ashore in northwest Alaska because the sea ice they normally rest on has melted. Scientists with two federal agencies are most concerned about the one-ton female walruses stampeding and crushing each other and their smaller calves near Point Lay, Alaska, on the Chukchi Sea. The federal government is in a year-long process to determine if walruses should be put on the endangered species list." —Seth Borenstein, "Melting Sea Ice Forces Walruses Ashore in Alaska," *Associated Press*, September 13, 2010.

4.

Each of these experiences over the years contributed to me becoming increasingly engaged with the Arctic—in the field and in the communities—and along the way I befriended writers, scientists, conservationists, and indigenous activists. I have also had the good fortune to accompany writer Peter Matthiessen on three separate trips to Arctic Alaska, in 2002, 2006, and 2007. I feel immense gratitude for all of the friendships that have contributed to this volume. And that is the story I wanted to share with you—why someone who grew up reading novelist-activist Mahasweta Devi in Kolkata keeps talking about all things northern.

As I was writing this introduction and completing the final draft of this book, the Occupy Movement was born and quickly went global—more than nine hundred cities total. Each morning I considered taking the train from Princeton, where I was a Director's Visitor at the Institute for Advanced Study, to Penn Station to join Occupy Wall Street. Instead, I had no choice but to work long hours to complete *Arctic Voices*. It seemed at the time that I was doing the lesser thing while the world was bursting out with infectious resistance: First came the Arab Spring—and dictators fell; then came Wisconsin—pizza got ordered from Cairo for Madison, a good story you might like to tell; then young climate justice activist Tim DeChristopher was put in jail for two years for disrupting a fast-track Bush-era oil lease sale; then came the Keystone XL pipeline protest, outside the White House—more than a thousand arrests; and finally came Occupy. All in just one year. I remained a spectator working on a book.

Then again, putting together *Arctic Voices* made a certain kind of sense, inspired by all these big acts of resistance. The Arctic, after all, is big—it is the top of our earth, the ice cap, some call it, but it is so much more, and it's that so-much-more that this book is about.

The Arctic has become our planet's tipping point—climate change is wreaking havoc up there. Resource wars continue to spread. Industrial toxins continue to accumulate widely. But also, the voices of resistance are gathering, are getting louder and louder—and that is the story this volume presents. It is the noise and the music of all our voices bundled together.

Arctic Voices doesn't have a linear structure; it isn't arranged chronologically or even geographically, but rather as a web of interconnections with loosely defined themes that you may read in any order you wish. I have found plenty of things in common between essays—for example, the spectacled eiders

that winter in the frozen Bering Sea written about by Nancy Lord, also nest in the Teshekpuk Lake Wetland that Jeff Fair writes about; both writer Velma Wallis and artist Annie Pootoogook use stories and art as an outlet for healing as they both address alcoholism in their unique ways; and common words take on new meaning, for example, Seth Kantner and Matthew Gilbert put the word subsistence on its head, while Andri Snær Magnason tells us how Alcoa hijacked the word sustainability in Iceland and Greenland. I'm sure you will find more such interconnectedness, and I surmise that you will begin to think and talk about the Arctic differently than you did before. And perhaps you'll find an answer to the question, "Why should I care about the Arctic?"

—SB

PRINCETON, KOLKATA (INDIA),
AND NEW YORK CITY
DECEMBER 2011–FEBRUARY 2012

NOTES

1. Sarah James, "We Are the Ones Who Have Everything to Lose," in *Arctic Voices: Resistance at the Tipping Point*, ed. Subhankar Banerjee (New York: Seven Stories Press, 2012).

2. Vandana Shiva, "Time to End War Against Earth" (Sydney Peace Prize acceptance speech, Sydney Opera House, Sydney, Australia, November 30, 2010)

3. Yates McKee, "Of Survival: Climate Change and Uncanny Landscape in the Photography of Subhankar Banerjee," in *Impasses of the Post-Global: Theory in the Era of Climate Change*, Vol.2, ed. Henry Sussman (Ann Arbor, Michigan: Open Humanities Press, 2012).

4. I first came across the term "resource wars" from national resource expert Michael Klare's book *Resource Wars: The New Landscape of Global Conflict* (New York: Metropolitan Books, 2001). Also see art historia Kelley E. Wilder's essay "Resource Wars" in the exhibition catalog *Subhankar Banerjee: Resource Wars* (New York: Sundaram Tagore Gallery, 2008).

5. Subhankar Banerjee, "Photography's Silence of (Non)Human Communities," in All Our Relations, eds. Catherine de Zegher and Gerald McMaster (Sydney: 18th Biennale of Sydney, June 2012).

6. Subhankar Banerjee, "Photography Changes Our Awareness of Global Issues and Responsibilities," in *Photography Changes Everything*, ed. Marvin Heiferman (New York: Aperture and Washington: Smithsonian Institution, 2012).

7. Finis Dunaway, "Reframing the Last Frontier: Subhankar Banerjee and the Visual Politics of the Arctic National Wildlife Refuge," in *A Keener Perception: Ecocritical Studies in American Art History*, eds. Alan Braddock and Christoph Irmscher (Tuscaloosa: University of Alabama Press, 2009).

8. Tom Lowenstein, *Ancient Land, Sacred Whale: Inuit Hunt and Its Rituals* (New York: North Point Press, 1993).

9. Subhankar Banerjee, "Ought Not We Establish Access to Food a Species Right?" in *Third Text* special issue: *Contemporary Art and Politics of Ecology*, eds. T. J. Demos and Yates McKee (London: Routledge, forthcoming).

10. "Arctic Haze Fact Sheet," Safe Drinking Water Foundation, accessed on January 12, 2012, http://www.safewater.org/PDFS/resourcesknowthefacts/Arctic_Haze_Fact_Sheet_07.pdf.

11. "Why Is Arctic Sea Ice Melting Faster Than Predicted? NOAA Probing Arctic Pollution," *Science Daily*, April 7, 2008, http://www.sciencedaily.com/releases/2008/04/080407132120.htm.

12. Karl Jacoby, *Crimes Against Nature: Squatters, Poachers, Thieves and the Hidden History of American Conservation* (Berkeley: University of California Press, 2001).

13. William Cronon, "The Trouble with Wilderness; or, Getting Back to the Wrong Nature," in *Uncommon Ground: Rethinking the Human Place in Nature* (New York: W. W. Norton & Company, 1996).

14. Lisa Bloom, *Gender on Ice: American Ideologies of Polar Expeditions* (Minneapolis: University of Minnesota Press, 1993).

15. Manuela Picq, "Indigenous resistance is the new 'terrorism'," Al Jazeera, July 10, 2011, http://www.aljazeera.com/indepth/opinion/2011/06/201162995115833636.html.

16. Fred Pearce, "Busting the Forest Myths: People as Part of the Solution," *Yale Environment 360*, February 16, 2012, http://e360.yale.edu/feature/busting_the_forest_myths_people_as_part_of_the_solution/2495/.

17. Beth Potier, "Art and Activism Meet in Photo Exhibit," *Harvard University Gazette*, June 10, 2004, http://www.news.harvard.edu/gazette/2004/06.10/11-banerjee.html.

18. Full text of the Public Land Order 2214 can be found here: http://arctic.fws.gov/plo2214.htm.

19. Jonathan Lear, *Radical Hope: Ethics in the Face of Cultural Devastation* (Cambridge: Harvard University Press, 2006).

20. Subhankar Banerjee, "Land-as-Home Versus Environmental and Political Imperialism in the American North," The Scholar & Feminist 7, no. 1 (2008), http://barnard.edu/sfonline/ice/gallery/banerjee.htm.

21. Richard W. Bulliet, *Hunters, Herders, and Hamburgers: The Past and Future of Human-Animal Relationships*, (New York: Columbia University Press, 2005).

22. Naomi Oreskes, "The Scientific Consensus on Climate Change: How Do we Know We're Not Wrong?" in *Climate Change: What It Means for Us, Our Children, and Our Grandchildren*, eds. Joseph F. C. Dimento and Pamela Doughman (Cambridge: The MIT Press, 2007) p. 93.

23. Dipesh Chakraborty, "The Climate of History: Four Theses," *Critical Inquiry* 35, (2009).

Here's What You Can Do
To Keep *Wild* Alive

EMILIE KARRICK SURRUSCO *and* CINDY SHOGAN

❖

My first visit to the Alaska Wilderness League (AWL) office in Washington, DC was in 2001. I was there to show my winter photos from the Arctic National Wildlife Refuge to members of the US Congress. There, I met Cindy Shogan, executive director of AWL—a down-to-earth, dedicated conservationist. I had just returned from the Arctic Refuge and had not yet adjusted to the hustle and bustle of modern life, and definitely not to the AWL atmosphere I experienced, which reminded me of a bazaar in India. Activists had come from all over the country: everyone was on the phone talking to some staff member of a senator or member of the House, to set up a meeting; everyone could hear what everyone else was saying—a large common area with some partitions. There, I began to learn "US Lobbying 101." Since then I've returned to that office many times. The AWL is the only national grassroots organization entirely dedicated to conservation of Alaska's wild lands. I asked Cindy and her colleague, writer Emilie Karrick Surrusco, to identify the key areas in Arctic Alaska that we must protect now. Here is what they have to say and how you can get engaged.

❖

THE SUN sits high in the sky in Washington, DC as we write this. It's a long way from Arctic Alaska, where the sun is just awakening from a long winter's

slumber. The birds are returning, the polar bear mothers and cubs are emerging from their dens, and the fields and fields and fields of wildflowers—dotting endless tundra—are just bursting forth. People surround us here; life is dominated by our hectic human connections. There, humans exist on the edge of another kind of life—a life that can only be summed up in one tiny little word, a word that does so little to encompass the sheer potential of existence without limits, beginnings, and endings that are dictated by the forces of raw survival, the beauty of life untended by human hand. That word is *wild*.

The people of Arctic Alaska know the limits of this little word. To them, *wild* isn't a state of being; it is *the* state of being. To those of us who know Arctic Alaska from the outside, this wild is a novel concept. It's been a long time since our lives were filled with the noises of life outside of ourselves. For those of us who have been lucky enough to experience it, we understand the need to protect it, to fight to keep it alive and intact for our children and their children. For those of us who will never set foot in Arctic Alaska, the need is even more pressing. As one Alaska Wilderness League member put it, "I am a lawyer in New Jersey. I have never visited Alaska and likely will never do so. But there is a certain psychic pleasure in knowing that somewhere there is a pristine wilderness untouched by commercial exploitation."

Most of all, we understand that this wild, kinetic, breathing, boundless place is embedded deep down in the sinew of the people of Arctic Alaska. Without it, they cease to exist. You'll hear their voices on these pages. You'll learn about their fight against massive corporations with billion-dollar budgets and the political system at their fingertips. You'll know, year after year, they've kept these forces at bay. Alongside them, the icons of wilderness conservation—Mardy and Olaus Murie, Dr. Edgar, and Peggy Wayburn, and countless others—have walked the halls of Congress, talked to people in Kansas, Maine, and Mississippi, and told them about this faraway place where wild reigns. Now it's your turn to carry these voices far and wide. It's time to join the fight for a world that fills our souls with something that is only deeply known, and will disappear forever if we let it go. Without it, a vital part of us will cease to exist. We can't let that happen. Here's what you can do to keep *wild* alive.

ARCTIC NATIONAL WILDLIFE REFUGE

Long known as the wilderness icon of our nation, the Arctic National Wildlife Refuge remains under relentless attack. Big Oil and its cronies in Congress continue to push to open the Arctic Refuge's coastal plain to drilling. The coastal plain is the biological heart of the 19-million-acre Arctic Refuge and is the sacred calving grounds for the Porcupine River caribou herd that, for thousands of years, has been the foundation of the Gwich'in culture.

The coastal plain also contains the most important land denning habitat for polar bears in Alaskan Arctic, and is a key habitat for wolves, grizzly bears, and brown bears as well as a year-round home to musk oxen, foxes, and wolverines. Millions of migratory birds rely on the coastline, lakes, and rivers of the coastal plain for nesting, feeding, and breeding. In fact, birds that migrate through all fifty US states and across six continents begin their lives in the Arctic Refuge each year.

The Gwich'in people regard the Arctic Refuge's coastal plain as a place so sacred that they will never set foot there themselves. The oil companies, meanwhile, hope to crisscross the coastal plain's 1.5 million acres of ecologically rich tundra with eight hundred oil wells, roads, airports, gravel mines, and more. The power to protect this place ultimately lies in our elected officials in Washington, because although it is located in the northeastern corner of Arctic Alaska, it belongs to you and me. You can join this fight by demanding that your members of Congress keep Big Oil out of a place that is vital to the future survival of the people of the Gwich'in Nation, to the wildlife species that thrive there, and to our nation's wilderness legacy. You can also tell the president that you believe the Arctic Refuge should be designated as one of our nation's national monuments. For more than fifty years, we've held them off. Now is the time to protect the Arctic Refuge for good.

BEAUFORT AND CHUKCHI SEAS

The Arctic Ocean's Beaufort and Chukchi seas are known as "the garden" to the Iñupiat people. For thousands of years, they have lived off the bounty of these waters. The entire US population of polar bears, beluga whales, bowhead whales, walrus, and ice seals, plus many species of fish, waterfowl, and much more rely on the Arctic Ocean's sea ice environment. Today, the Arctic Ocean

OIL & GAS LEASING ON ALASKA'S NORTH SLOPE

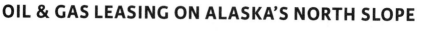

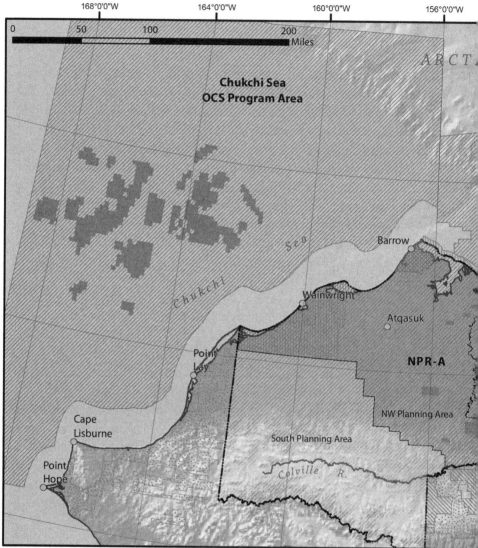

*Map composed by Alaska Center for the Environment, The Wilderness Society, Northern Alaska Environmental Center, and Audubon Alaska, Map last updated December 16, 2011.

Map Features

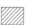

Sold Federal and State Leases

Active Federal Lease Area

Potential Federal Lease Area

Active State Lease Area

Arctic Slope Regional Corporation
(Surface &/or Subsurface Rights)

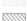

Deferred Federal Lease Area
(Temporary, Length of Time Varies)

Arctic Ocean BOEMRE (formerly MMS)

Beaufort Sea Program Area 2007 - 2012
 1.1 million acres leased
 33.2 million acres
 Lease Sale 202 - 97% offered for lease in 2007

Chukchi Sea Program Area 2007 - 2012
 2.7 million acres leased
 39.3 million acres
 Lease Sale 193 - 75% offered in 2008

State (Annual Area-Wide Lease Sales)

North Slope Areawide, Foothills, and Beaufort Sea
 14.0 million acres in active lease areas

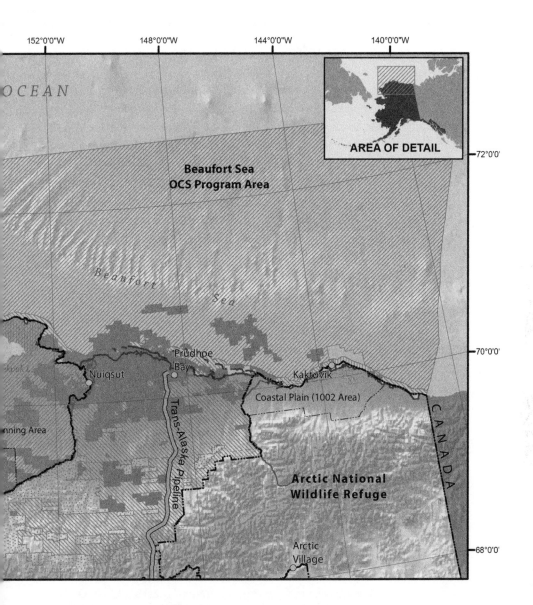

152°0'0"W 148°0'0"W 144°0'0"W 140°0'0"W

OCEAN

AREA OF DETAIL

Beaufort Sea
OCS Program Area

72°0'0'

Beaufort Sea

70°0'0'

Prudhoe Bay
Nuiqsut

Kaktovik

Coastal Plain (1002 Area)

...nning Area

Trans-Alaska Pipeline

CANADA

Arctic National
Wildlife Refuge

68°0'0'

Arctic
Village

National Petroleum Reserve - Alaska (Federal BLM)
Plan for entire NPR-A began in 2010

Northeast Planning Area
~900,000 acres leased
4.6 million acres - 95% opened to lease
430,000 acres deferred from leasing until 2018

Northwest Planning Area
~500,000 acres leased
8.8 million acres - 100% opened to lease
1.5 million acres deferred from leasing until 2014

South Planning Area
9.2 million acres

(Courtesy Northern Alaska Environmental Center.)

is warming at twice the rate of the rest of the world from climate change—and the Arctic sea ice is melting at an alarming rate.

This already-stressed environment is now a prime target for Big Oil. Companies such as Shell Oil are pushing to drill there despite the fact that there is no proven way to clean up an oil spill in the Arctic's extreme, ice-choked conditions. In addition, there is such a paucity of data on the Arctic Ocean's marine environment and its inhabitants that no one knows how industrial development will really affect the delicate balance of life. Already, several Arctic marine wildlife species have been declared threatened or endangered. The Arctic Ocean is facing a double jeopardy—from climate change, and oil and gas drilling—and the people of the Arctic coast are fighting for their survival.

The federal government's Department of the Interior decides where and when offshore drilling can happen in our nation's waters. The fate of America's Arctic Ocean lies in its hands. You can join this fight by demanding that this federal agency make decisions based on sound science rather than politics. We must heed the lessons learned from disasters such as the *Exxon Valdez* tanker accident in Prince William Sound, Alaska, that spilled 11 million gallons of oil, which is still found on beaches more than twenty years later, and the *Deepwater Horizon* disaster, which caused 205 million gallons of oil to spew into Gulf of Mexico waters.

THE OIL FIELDS

Oil drilling in Arctic Alaska is a dangerous and dirty business. From Rosemary Ahtuangaruak's hometown of Nuiqsut, which has seen a 600 percent increase in respiratory illnesses since the Alpine oil field was built next door, to the Prudhoe Bay oil fields, which average more than a spill a day, oil drilling in the Alaskan Arctic has had far-reaching impacts—many of which are still unknown. Yet despite this track record, the state of Alaska and Big Oil hold themselves up as models of environmental sensitivity. It is time for this glaring incongruity to come to light. You can join this fight by helping community activists like Rosemary Ahtuangaruak get her stories out, and demanding that the children of Nuiqsut and other Arctic communities have a basic human right to grow up with clean air and clean water. Not only must the oil companies be held accountable for the human health and environmental impacts, only now becoming known, but they also must be kept from the further damage they could inflict on future generations.

TESHEKPUK LAKE WETLAND

Teshekpuk Lake is one of the most well-known places in the unfortunately named National Petroleum Reserve–Alaska (NPR–A), which, at 23.5 million acres, is the largest single unit of public lands in the nation. Teshekpuk Lake sits in the northernmost part of the reserve, in the western portion of Arctic Alaska. The lake and its surrounding wetlands are ecologically unique and one of the most important wildlife habitats in the circumpolar Arctic. Known as an Important Bird Area of global significance, Teshekpuk Lake is home to large numbers of shore and water birds, such as the Pacific black brant and greater white-fronted goose. Many of the birds that nest in Teshekpuk Lake during the summer migrate throughout all fifty US states. It also is the largest goose molting area in the Arctic. Gray wolves, grizzly bears, polar bears, and the sixty-seven-thousand-strong Teshekpuk Lake caribou herd all thrive in this area. The Iñupiat people of the surrounding Arctic communities have relied on the caribou and other wildlife of the Teshekpuk Lake area for their survival for thousands of years.

In the past, Teshekpuk Lake and its surrounding wetlands have been under dire threat from oil and gas drilling. However, in July 2008, the federal government's Bureau of Land Management (BLM) announced that it would defer all oil and gas leasing in the Teshekpuk wetlands for at least ten years. The next step is to ensure that this temporary protection becomes permanent. You can join this fight by ensuring that the federal government understands the importance of this area to the people of Arctic Alaska and its biological importance to many of the bird species of our nation and the world.

COLVILLE RIVER CORRIDOR AND DELTA

Alaska's largest Arctic river, the Colville River drains through much of the renowned Brooks Range mountains. The Colville River corridor and delta sit in the southern portion of the reserve and has long been known as one of the most significant regions for raptors in North America. The area provides nest sites and hunting habitat for Arctic peregrine falcons, gyrfalcons, and rough-legged hawks. The Colville's rich streamside also provides habitat for songbirds, moose, wolves, grizzly bears, and more than twenty species of fish. Included in the Colville watershed are several proposed national natural landmarks and a host of important archaeological sites. Archaeologists have

found thirteen species of dinosaur fossils in the Colville River area, which boasts fossils from the late Cretaceous period—some 68 million to 73 million years ago.

Although the BLM completed a management plan for the Colville River Special Area in July 2008, they instituted only a one-mile buffer from development along the river. You can join this fight by spreading the word about this ecologically vital place and by asking the federal government to do more to protect nesting raptors from oil and gas drilling.

WESTERN ARCTIC AND UTUKOK RIVER UPLANDS

Spanning 4 million acres in the western corner of the reserve, the Utukok Uplands are the main calving grounds for the Western Arctic caribou herd, which, at nearly four hundred thousand caribou, is the nation's largest caribou herd. Calf survival is higher in these traditional calving grounds, and females nursing their young need unrestricted movement to reach and use the calving areas. Insect relief habitats are essential to the health of the herd, because here the caribou gather in huge clusters and quickly move long distances to respond to insect harassment—conditions that make them more vulnerable to disruption from oil and gas drilling. Forty Western Arctic villages rely on these caribou as a food source for their subsistence culture. The Utukok Uplands area also is prime habitat for brown bears, wolverine, and wolves, and boasts concentrations of cultural and archaeological sites.

The Utukok Uplands have been designated as a special area by the federal government in recognition of the area's significant biological resources. However, this special area should be expanded south to encompass the Brooks Range continental divide in order to better protect vital wildlife habitats from oil and gas development. You can join this fight by asking the federal government to ensure that the people of Arctic Alaska can continue to depend on this area and the nation's largest caribou herd for generations to come.

YUKON FLATS NATIONAL WILDLIFE REFUGE

Not as well known as the Arctic National Wildlife Refuge to its north, the Yukon Flats National Wildlife Refuge also has been under threat from oil and gas development. At 9 million acres, the Yukon Flats Refuge is the third-largest

conservation area in the national wildlife refuge system. Characterized by mixed forests of spruce, birch, and aspen, the Yukon Flats Refuge supports the highest density of breeding ducks in Alaska and is known as one of the greatest waterfowl breeding areas in North America. Yukon Flats also is a key habitat for moose, beaver, lynx, marten, mink, muskrat, and river otter, as well as grizzly bears, black bears, wolves, and Dall sheep. The people who live both within and around the borders of the Yukon Flats Refuge depend on its substantial wildlife resources to survive.

The Yukon Flats Refuge is one of the places in Alaska where scientists are documenting the earliest evidence of climate change, including warmer temperatures, shrinking lakes, and more wildfires. Already, some species are showing signs of stress, including salmon, which is a staple food source for local people.

In 2009, Yukon Flats was under dire threat from development when the US Fish and Wildlife Service decided not to move forward with a land exchange that would have traded lands in refuge protection for lands owned by the Doyon Corporation. The government would have allowed oil and gas development on more than two hundred thousand acres adjacent to a designated Wild River and National Recreation Area.

You can join this fight by ensuring that the voices of the people of the Yukon Flats Refuge continue to be heard, and that no further threats from oil and gas development compromise their way of life.

In size, Arctic Alaska stretches beyond the confines of our imaginations. The people are sprinkled across vast expanses of tundra, mountains, lakes, rivers, and valleys in small spurts of civilization. There are no roads to link them. Extreme weather conditions keep air travel sporadic. For much of the time, people exist separate from one another. Yet, one day not long ago, in a conference room in Washington, DC, we witnessed an amazing sight. Brought together by Alaska Wilderness League's environmental justice team, Iñupiat women from communities in the west and Gwich'in women from villages in the east embraced one another and listened tearfully to the trials of their faraway neighbors. For a few hours, they were together. During that brief time, they forged a unity that launched a new kind of Arctic activism. They laughed, they commiserated, they told stories about their children and their spouses. They shopped for gifts for grandchildren and goods like hot sauce (which is an essential accompaniment to pickled *muktuk*) that can only be

found in the cities of the continental US. At the end of it all, the space between them had disappeared. They had a common foe—Big Oil. From then on, they were committed to fighting that foe together.

The Alaska Wilderness League (AWL) is committed to leading the effort to shape a new way of fighting for Arctic Alaska, one that brings together diverse voices in a common effort, from those who live and breathe in the place, to people across the United States and throughout the world who know it as a dream, an image, a flight of fantasy. What is intrinsic in the fight for Arctic Alaska is that it is a corner of our world that belongs to all of us.

Since our inception in 1993, AWL has harnessed the skills, energy, and passion of our staff—headquartered in Washington, DC—to fight, day in and day out, to keep our Arctic Alaska wild. Our first priority is to ensure that the growing, divergent group of wild Alaska voices is mobilized at the right time and in the right place.

Each year, AWL brings a select group of activists to Washington for Wilderness Week. Flown in from Alaska and throughout the lower forty-eight states, these activists take their message to Congress to ensure that the people making decisions about Arctic Alaska understand that this is a place that is important to the Iowa grandmother in her eighties, who is planning yet another trek through the Arctic Refuge this year, and the two teenagers from New Jersey, who convinced their mom to bring them to Washington because it is their future she is protecting.

On March 20, 2007, twenty-five hundred activists in red shirts came to Washington, DC for AWL's Climate Crisis Action Day—Cool the Planet, Save the Arctic. Many elected leaders (local, state, and federal) were joined by youth, faith, and Native speakers, on stage in front of the US capitol. These activists then fanned out across Capitol Hill to lobby their representatives and senators, and urge them to protect Arctic Alaska and combat climate change.

Such mobilizations are carried out on a smaller scale by AWL field staff strategically placed in New England, the mid-Atlantic, and the Midwest. From civic club slideshows and classroom presentations to rallies outside congressional district offices and polar bears on roller skates, our field staff brings the message of Arctic Alaska home. And while our work is serious, we always make sure to have fun. We celebrated the fiftieth anniversary of the Arctic Refuge by flying Arctic bird kites, inspiring one activist to take his kite on a migration from Minnesota to Alaska and back again. Our polar bear mascot, Ice-P, roams the US, even making an appearance at a Department of the Interior staff meeting, and cyberspace. Ice-P's following on

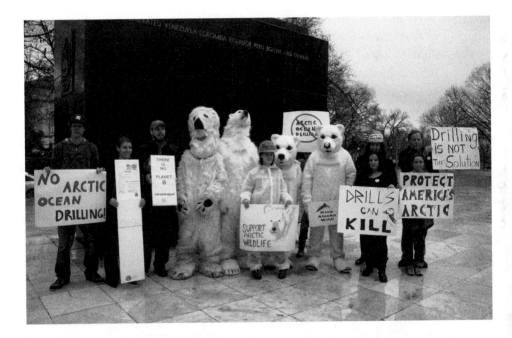

Animal mascots and activists gather in Washington, DC for a Department of Interior Arctic hearing and rally against Arctic Ocean drilling, December 2011. *(Courtesy Alaska Wilderness League.)*

Facebook continues to grow exponentially. Oftentimes, Ice-P is joined by a grizzly bear, a salmon, a brant, a sandpiper, and recently, an Arctic tern with a fifteen-foot wingspan.

The AWL also mobilizes the people who live in Arctic Alaska. The League's Alaska-based environmental justice team logs many miles criss-crossing the Arctic coast, nurturing, listening, and leading. From Earl Kingik, a proud Iñupiaq Elder from Point Hope on the Chukchi Sea, to Betsy Beardsley, a born and raised Alaskan, and Darcie Warden, an accomplished Fairbanks-based caribou hunter, this team works tirelessly to amplify the voices of the Arctic coast.

As we did in that historic meeting of Iñupiat and Gwich'in women, the League brings the people of Arctic Alaska to Washington. The League has enabled Arctic Alaska activists to testify before Congress, to sit down with top administration officials at the White House, and to stand with members of Congress in the shadow of the capitol to speak out before the national press corps.

In the wake of the *Deepwater Horizon* disaster in the Gulf of Mexico, we brought these Arctic Alaska voices to Louisiana and Mississippi. Rosemary Ahtuangaruak left her subzero perch on Arctic ice, where she had been participating in a bowhead whale count, to emerge in 90-degree humidity on another coast, where the smell of oil had completely replaced the natural smell of the ocean. There, she and others, including Verner Wilson—whose grandfather had just received his check for less than $100 from Exxon to compensate for the loss of his livelihood from the *Exxon Valdez* spill more than twenty years prior—listened to the stories of what was being lost to the still seeping oil. They then took their eyewitness account to Washington and told administration officials and members of Congress that they would not stand by and let the same thing happen in their Arctic waters.

Why is it that massive corporations with billion-dollar budgets and the political system at their fingertips have so far failed to have their way in Arctic Alaska? Because they are up against the likes of Mae Hank and Sarah James, Rosemary Ahtuangaruak and Earl Kingik, Robert Thompson and Jonathon Solomon, and the many others we've neglected to name—people who, generation after generation, have thrived in an environment that so many describe as "harsh" or "inhospitable" or "barren" or "cold." They have a connection to this place that goes back before the United States or Alaska or North America even existed. It is a human connection

to place that has been severed in modern human society. These people are our teachers. They are not afraid to stare down a big, bad oil company and speak truth to power. They know that the threat they face goes by one name: greed. We, too, cannot be afraid. The stakes are too high for us to let fear get in the way.

We must heed the voices of Arctic Alaska and demand that this place not be destroyed by the greed of a few. The time is now. Before another child in Nuiqsut struggles to breathe, another polar bear cub drowns for lack of sea ice in the Chukchi Sea, or another newborn caribou loses its instinctive birthplace in the Arctic Refuge, we must fight for Arctic Alaska.

snapshot of now

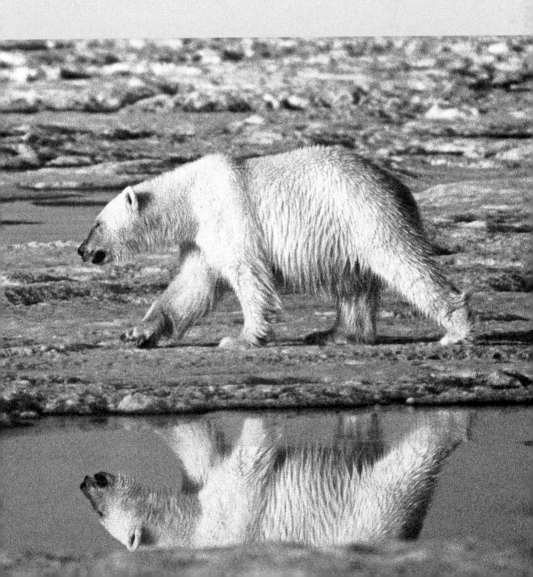

On the eighteenth memorial of the spill, when Exxon was still fighting us in court, Alaska Native carver Mike Webber created a Shame Pole, a type of totem pole, to ridicule Exxon into paying its public debt. The hardest part to carve, he told me, was the words pouring from the mouth of Exxon's CEO, "We will make you whole." The CEO had a long nose, like Pinocchio when he lied, and no ears. "Exxon never listened to us," Mike said.

—RIKI OTT

A polar bear approaches a whale bone left from previous year's hunt by the Iñupiat community of Kaktovik, Bernard Harbor, along the Beaufort Sea coast, Arctic National Wildlife Refuge (detail). This image has been distributed by the Associated Press (without Subhankar's permission) widely and has become one of the most published photographs in the history of the medium of photography. (*Photograph by Subhankar Banerjee, June 2001.*)

From Early Warming

Crisis and Response in the
Climate-Changed North

NANCY LORD

❖

In Early Warming: Crisis and Response in the Climate-Changed North, *Alaskan writer Laureate Nancy Lord takes us on a journey that spans several Arctic and subarctic habitats and communities in Alaska and the Northwest Territories in Canada. In the last chapter of the book, "The Oceanic Realm: Bering Sea," Nancy writes about a gathering of Yup'ik Elders in Bethel, Alaska, where they discuss their struggle to preserve the Bering Sea they call* Imarpik— *"big container"—from destruction by the commercial fishing industry. This book is about a gathering of voices, so it makes sense to open with a story about an actual gathering of voices. Much of* Arctic Voices *is also about finding interconnections across many voices—Barry Lopez tells the story of his first sighting of narwhal in the Bering Sea; and Earl Kingik points out the importance of a continuous marine habitat—subarctic Bering, and Arctic Chukchi and Beaufort seas. Here is Nancy's story from the Bethel gathering.*

❖

Early Warming: Crisis and Response in the Climate-Changed North *was published by Counterpoint in 2011.*

THE OCEANIC REALM: BERING SEA

In a conference room in Bethel, Alaska, twenty-some Yup'ik Elders from sur-rounding Bering Sea villages bent their heads over three tables spread with maps. The maps were the result of earlier interviews with these Elders and many others, about their subsistence uses and the habitats important to the fish and animals—walrus, seals, ducks, and beluga whales—on which their families and cultures relied. The Elders, members of the Bering Sea Elders Advisory Group, were checking the maps to see if they agreed with the lines that were drawn, and they were marking more detailed information about the times animals were in particular places, the conditions in which they hunted in different places, and the numbers of animals they had seen in different years.

The Elders were from small-dot places like Kwigillingok, Quinhagak, Mekoryuk, Toksook Bay, and Kipnuk, and they talked together about changes they had seen. Most had long histories of hunting and fishing in the Bering Sea, going back to the time of kayaks and harpoons and knowing how to navigate by reading the ocean currents. They had been told how things were by their own Elders.

At the table with the seal map, the men talked about ice thickness and the danger of hunting on ice that's too thin. In an area they marked for a lot of bearded seals, they noted that, in their experience over many years, the ice is usually thick enough by the end of November. "We stay home when it's not safe," a white-haired man said. Someone else said, "We used to tell the weather by the ice. Now we can't."

The table's scribe asked, "How do you tell the weather now?"

"TV," someone said, and they all laughed.

At another table, David Bill, chairman of the group, tapped his finger on a portion of the fish map. The Elders there were talking about their subsistence catches of salmon and whitefish—anadromous species that live in the Bering Sea and travel up the Yukon and Kuskokwim Rivers.

A couple of important lines were drawn on all the maps. One cutting through the Bering Sea was the International Date Line, dividing US waters from those of Russia. The other, extending from the south end of Kuskokwim Bay in jagged steps around Nunivak Island and then west around St. Matthew Island before straightening north to intercept the date line, the Elders referred to as "the northern boundary." Above the line, put into effect in 2007 as a precautionary interim measure, bottom trawlers shall not go. Even as the Bering Sea warms and fish and ice coverage both move northward, the trawlers—those boats

Bearded seal with pup on pack ice of the Bering Sea. *(Photograph by Steven Kazlowski, April 2002.)*

that drag big nets weighted with chains and tires across the ocean floor—may not, for now, follow them.

The line up to which trawling was allowed was already as close as fourteen miles to some of the communities from which the men and women in the room had come, and places they'd marked for their fishing and hunting were in some of those same waters.

The ice is different now, the men with the walrus map were saying. Sometimes the winds blow it farther south, but then it goes out faster in the spring. It's thinner. The ice edge—that's where everything feeds, where they hunt—is different; it's hard to know where it will be and how it will move. They have to travel farther to get to the walrus. That takes more fuel, and they don't know the area as well. It's more dangerous.

In 2011, the North Pacific Fisheries Management Council, responsible for most fisheries in Alaska's federal waters, was to reconsider the northern boundary, and bottom trawlers might be allowed to follow the fish northward, into waters they haven't previously fished. Those same waters are home to ice-dependent sea mammals like walrus and seals, crabs, threatened species like the spectacled eider, and the Yup'ik, Iñupiaq, and Siberian Yup'ik people who depend in profound ways upon the health and bounty of the northern Bering Sea.

First, though, a large area above the line—called the Northern Bering Sea Research Area—is supposed to have a "research plan." The plan is primarily meant for research into the potential impacts of trawling on bottom habitat, but it is also meant to provide some protection for vulnerable species along with the subsistence needs of the people.

Over at the first table, the woman acting as a facilitator rolled up the maps the group was finished with and laid out another one. "This is a *science* map," Dorothy Childers explained, making clear the difference between the maps generated from local and traditional knowledge and this new one, which had come from scientific data. "The science maps show where the animals are when you're not hunting them." The particular map was of Alaska's four species of eiders, sea ducks that nest on land but winter at sea. The men studied the map with interest, locating uninhabited St. Matthew Island far to the northwest and placing their hands on the circular shape marking the winter habitat of spectacled eiders. That part of the ocean was far from anywhere they knew and in winter well beyond the travels of any Native people.

Who would have thought that frozen place would also be home to such life? It wasn't until 1995 that researchers tracked a transmitter implanted in

a spectacled eider to discover the wintering ground of that species. A flyover and subsequent research confirmed that the entire world's population—some 360,000 spectacled eiders—winter in open-water leads in the otherwise frozen Bering Sea, and in those leads dive to the bottom to feed on clams. Childers set a photo of one of these *polynya* (Russian for "little field") areas beside the map; the thousands of birds squeezed into it looked like grains of brown sand filling a crack in an otherwise vast expanse of white.

"This needs to be protected," the Elders told Childers. "Let the fish and the rest grow out there."

Childers wrote that down.

"We rely on the sea for subsistence," someone said. "All the sea. We need to take care of it."

It is true that the Bering Sea, that semi-enclosed part of the Pacific Ocean that extends from Alaska to Russia and the Aleutian Islands to the strait also named for explorer Vitus Bering, can be a ferocious place in winter, when the crab fisheries take place, and that boats go down and men die on a regular basis there. It is also true that the Bering Sea, because of physical properties including its broad continental shelf and general shallowness, the movements of currents and ice, and upwellings, is a prodigiously rich biological basin, one of the most productive environments in the world. Its biodiversity is profound: more than 450 species of fish, crustaceans, and mollusks; 50 species of birds including 20 million individual seabirds; and 25 species of marine mammals including the world's rarest whale, the North Pacific right whale.

The Bering Sea's great bounty has supported people who've lived on and around it for a very long time—"from time immemorial," as the Natives say. On the American side lie sixty-five communities, home to 27,500 people. Although this human population is small, the villages that line the coast—on the Russian side as well as the American—today remain intricately connected to all aspects of Bering Sea weather, seasons, and nourishment in all its forms. This part of Alaska was late to be influenced by the trappers, traders, and outside interests of all kinds, and it maintains more cultural intactness—including language and traditional foods—than much of the rest of Alaska, where cultural change came earlier and hard.

For those in the Bethel conference room, the Bering Sea is home, the center of their universe, their gardens and breadbaskets, the place of their ancestors, back to the beginning. One Elder said to me, "It's not the Bering Sea. That's the name from a newcomer. It's Imarpik." *Imarpik* translates literally to "big container," identifying the sea as a big bowl, full of resources. Less literally

it refers to the one ocean that means everything. The Elders spoke of their own Elders, and what they had instructed. "My grandmother told me, 'you will protect the Bering Sea.' When you talk about the Bering Sea, you're talking about me."

Today, though, the Bering Sea also feeds the world. The fish and shellfish catches on its American side make up almost half (by weight) of all fisheries production in US waters. Dutch Harbor on its southern edge has ranked number one among US fishing ports nearly every year since 1981. In the beginning, king crab was king. Now the largest catches belong to the trawl fleets. The midwater trawl fleet fishes over deep water to catch enormous schools of pollock, and the separate bottom trawl fleet sweeps up groundfish on the continental shelf. In both cases huge cone-shaped nets sweep up everything in their paths, and in both cases there are environmental consequences. The midwater trawls catch tons of "nontarget" species, including salmon intended for subsistence and commercial fisheries elsewhere. The bottom trawls tear up the sea bottom—toppling corals, overturning rocks, busting apart crabs, scraping up the sediments that are home to the clams and worms that other creatures eat.

In the regional center of Bethel, forty miles up the Kuskokwim River from the Bering Sea, the Elders who gathered to document their resource use knew about trawling, and they didn't like it. Many had been involved in efforts to "cap" the pollock fleet's bycatch—to make them stop fishing when they've caught too many salmon. They don't want the bottom trawlers to go any farther north; in fact, they would like to see them confined to a smaller area than they already fish. They want them to leave the bottom of the Bering Sea alone, in the wholeness that provides the habitat and food for so much else.

These men might have lived subsistence lives, more familiar with hunting gear and judging ice and weather than with the teachings of Western education, but they were no slouches when it came to organizing and participating in modern governance systems. They knew the laws that affect how they live, and they knew the strength they bring, through tribal rights and their own citizenship, to influencing regulations and the decisions of government agencies. In addition to chairing the advisory group, David Bill, who lives in the village of Toksook Bay, served on a subsistence halibut board created by the National Marine Fisheries Service, the board of the nonprofit Bering Sea Fishermen's Association, and his local school board. Interpreter Fred Phillip was a leader in his own right; the natural resources director for the Native village of Kwigillingok, he has also served on many organizational boards and

traveled dozens of times to Washington, DC to represent the interests of his people before Congress.

Outside, the temperature was at zero, and the November sun skidded low across a pale blue sky. Snow machines zipped along the frozen Kuskokwim River, and taxis (five dollars to anywhere in town) plied the icy roads. A thin snow cover was just enough to brighten the landscape: no trees but the wooden buildings squatting on pilings. Smoke drifted sideways from a few stovepipes, evidence of shifts away from expensive heating oil to the burning of wood pallets and cardboard. There was talk of importing firewood from the forests of southeast Alaska.

The Elders understood why they had come to Bethel, and each of the three days they were seated at the tables, ready to work, well in advance of starting times. They stayed in those seats for hours, more attentive than any meeting-goers I've seen in my life. Now and then a cell phone rang and one reached into a pocket to hold a brief and muffled conversation.

The participants knew that they had until 2011 to influence where the bottom trawlers go and to make their case for protecting the subsistence use that lies at the heart of their lives and culture. They knew that they couldn't just say, "We want to protect as much as possible of the sea that provides for us" and expect the rightness of that principle to prevail over the tremendous economic value of all those fish that might be caught if bottom trawling was allowed to follow the climate shift north. They would need to identify, in a way that resource managers and policy makers could understand and quantify, exactly what areas they and the animals depended upon for their lives. They would have to present a concrete proposal—data—that said, this is the value here and here and here, and this is the reason this area—this exact piece of Imarpik—should be protected. What was once a wholeness already had lines drawn across it; they had to participate in the system that would further divide up the big container. The scientists knew science, but only they—the Elders—held the wealth of generational knowledge about the animals and what they ate, the seasonal cycles, the way water and ice moved, and how things changed over time, all those interwoven aspects scientists called an ecosystem. And only they were looking out for the needs of their people and the future generations.

For years they'd been speaking out about the changes they've seen in and around the Bering Sea. They'd watched sea ice form later and retreat earlier and faster. They'd witnessed surprising storm patterns, different movements of fish and marine mammals, new species showing up, sudden die-offs of

seabirds, unusual plankton blooms, and other environmental oddities beyond their usual experience or what they had learned from their parents and grandparents to expect as "normal." They're well aware that, as rich as the Bering Sea is, its productivity is less than it used to be. They've seen steep declines in species of marine mammals, birds, and fish. They've caught smaller salmon and mammals with thinner fat layers.

In my own travels through the Bering Sea, in the four years I worked on adventure cruise ships and stopped in villages all the way to Russia, I heard repeated concerns about the difficulty in predicting weather or anticipating storms, about decreasing numbers of fur seals at the Pribilof Islands and evidence that the young animals were starving on the rookeries, about kittiwakes failing to lay eggs, and watched thousands of walrus hauled out on a single rocky beach. I also heard about the hunting party—with children—that drowned when their boat overturned in a storm. Scientists now were documenting the same changes local people had been reporting for years. They spoke of ecosystem stress and nutritional stress, of "regime change." They studied ice and the relationship of ice to productivity. Regular surveys had shown that forty-five fish species had shifted their ranges northward. Research into predator species like seals, whales, and some species of seabirds showed they were altering their diets and sometimes traveling greater distances to find food. "Grabs" of the sea floor from research vessels were finding fewer clams and other benthic species.

Due to its remoteness, size, and often fierce weather, it has always been a challenge to conduct scientific research in the Bering Sea. If the science had lagged what local people observed, mounting data supported the need for a new approach to fisheries management. The old method had centered on single species; survey the "biomass" (how much of the species was out there) and then allow for a percentage take each year, based on what was guessed to be a "maximum sustainable yield." In other words, fish those commercial species as hard as possible without depleting them. Conservation organizations had begun hammering on the need to consider the entire ecosystem and be precautionary. They argued that fishery managers should look beyond the population numbers of commercial species and calculations of sustainable catches. In this new world, managers need to be able to predict population trends in a rapidly changing environment and factor in a new degree of environmental variability. In light of so much uncertainty, they need to manage conservatively, to carefully track trends, and to identify and protect ecologically important areas under

stress from climate change. They need to do all this against the pressure of a high-stakes fishing industry that wants to catch as much "product" as can be justified.

And thus it was that tribes from the Bering Sea region, with a number of conservation organizations, in 2007 won that rare victory at the industry-dominated North Pacific Fisheries Management Council. The Council unanimously agreed that as-yet-unexploited portions of the northern Bering Sea should be at least temporarily protected from an expansion of industrial fishing. The managers noted specifically that rising temperatures could result in a redistribution of fishery resources into and within northern waters and that they bore a responsibility for making sure that, before fisheries were allowed to expand, adequate protections would be in place for marine mammals, crabs, animals listed under the Endangered Species Act, and subsistence resources depended upon by local people.

In the Bering Sea, it's all about the ice. That puts it too simply, of course, but Native people and scientists know that ice plays an essential role in the life of the Bering Sea, just as it does in the Arctic Ocean. Sea ice is, of course, the habitat of species like seals and walrus. Algae grow upon it, in turn feeding species that live under the ice and at the ice edge. The formation, movement, and melting of ice affect not just the sea's biological productivity but ocean currents and the exchange of heat between ocean and atmosphere, in an enormously complex system.

From temperature-related research, we now know this: since 1950, the ice cover in the Bering Sea has decreased. We also know that, since 1980, water temperatures in the Bering Sea have increased by about 1.8 degrees Fahrenheit. A poster I studied in the basement of the Alaska Fisheries Science Center in Kodiak showed the relationship between ice cover and the catch of opilio (*Chionoecetes opilio*) crab; the more ice, the more crab. It also showed the southern Bering Sea "cold pool"—an area of cold bottom water on the continental shelf, formed under ice—contracting and moving northward by 143 miles since 1982. The text read, "As cold bottom water moves north, Arctic species (like opilio crab) are lost from the southern Bering Sea."

The evidence—experiential and scientific—of a rich Bering Sea becoming less rich is backed by some decades-long data. One study of chum salmon weights since the 1960s showed a steady decline in size, indicating they were getting less to eat. In 2000 an analysis of carbon isotopes in historic samples of whale baleen suggested a 30–40 percent decline in average seasonal primary production since 1970. "Primary production" is, essentially, phytoplankton

(those microscopic, free-floating, photosynthesizing organisms at the base of the food chain), which feed everything above it.

This is what we know about phytoplankton production: It is generally controlled by sunlight and available nutrients, but in the Bering Sea it has also depended on seasonal sea ice. When the ice melts in spring, the influx of water with lower salinity encourages a "bloom" of phytoplankton. And, the ice itself supports the bloom with the sea algae that grow on it. Change the ice coverage and the timing of the melt and you change the size, timing, and the species makeup of the phytoplankton bloom.

The Bering Sea has changed, in my lifetime, from a primarily cold Arctic ecosystem dominated by sea ice to sub-Arctic conditions. There are winners and losers as the result of this change. When there was more sea ice and it melted in the spring, the resulting bloom occurred before there were many zooplankton (mostly microscopic animals) to feed on it, and it tended to fall to the sea bottom and feed species that live there. The lack of sea ice results in a later (and smaller) bloom, which gets eaten by the zooplankton and other species in the higher parts of the water column before it can fall to the bottom. Thus, to mention just two commercial fish species, the biomass of pollock has in recent years increased dramatically (despite heavy fishing) and the flatfish known as Greenland turbot, which lives close to the bottom and likes cold water, has declined in equally dramatic measure. The very rich benthic (bottom dwelling) communities of worms, clams, and crustaceans—upon which gray whales, walrus, diving birds, and other bottom feeders depend—are less rich than they so recently were.

Scientists also worry about the mismatch of prey availability and predator needs. A later phytoplankton bloom prolongs the winter hunger period of fish and shellfish; many won't survive their juvenile stages. Meanwhile, warmer ocean temperatures may cause some species to reproduce earlier, before foods they need are available. Studies of phenology (the interactions between the yearly life cycle of a species and the yearly climate cycle) have shown that most species, around the globe, are advancing their breeding, hatching, budding, and migrating times. In a California study the common murre (a diving bird that eats mostly small fish and zooplankton) was found to be breeding a remarkable two months earlier in 2000 than in 1975.

The loss of ice in the Bering Sea is likely to have additional effects. More open water in winter may add to the severity of rough seas and increase the mortality of birds at sea. Warmer water requires cold-blooded fish to increase

their metabolism, which requires more food; this is a particular problem for young fish, which rely on fat reserves to get through their first winter.

On the first day at the Bering Sea Elders' gathering, the group listened (via its translator) to a presentation by Tom Van Pelt, the program manager for the North Pacific Research Board (NPRB), about the science that organization funds. One of the NPRB's primary programs is specific to the Bering Sea—an integrated ecosystem research program to look at, among other things, changing ice and currents, food availability, and how those changes cascade through the whole system. The idea, Van Pelt said, is for the one hundred scientists working on specific projects to think beyond their particular projects and disciplines and try to gain a larger understanding of how all things relate and interact. After three years of field seasons, two years (2011–12) would be given to synthesizing the results.

I thought I detected in the room a certain amount of puzzlement: Were the scientists only coming to realize, at this late date, that all things were connected?

There were questions following the science presentation, and they were all about the effects of bottom trawling on the ocean floor and the bycatch caught in trawlers' nets. These were not parts of the NPRB's program, and Van Pelt could only say that he wasn't the right person to ask about those specifics. The science currently being conducted is more basic to the workings of the Bering Sea, though I knew the scientists would agree that maximum sharing of information—science, traditional knowledge, the effects of fishing and other activities—would be a good thing, something to work toward for the holistic understanding they sought.

The Elders' immediate concern about trawling was whether areas for bottom trawling would be expanded in the Bering Sea, but they also expressed alarm about the amount of pollock fishing taking place in deeper waters—and the bycatch from that fishery.

The most valuable fish (considering volume) in Alaska and the world's most abundant food fish is one that most Americans wouldn't recognize and may never have even heard of. Alaska pollock or walleye pollock (*Theragra chalcogramma*), a North Pacific member of the cod family, is a modest-looking, one- or two-pound, speckled fish with a lot of fin area, top and bottom. Landings of pollock from the Bering Sea are the largest of any single fish species in the United States, some 2.5 billion pounds a year, valued at hundreds of millions of dollars. On an individual basis, pollock is a low-value fish; with its

white flesh and mild taste, it ends up not in fish markets or fancy restaurants but made into fish sticks, fast-food fish fillets, and artificial crabmeat. Since the late 1970s, as a result of changes in the Bering Sea, pollock have done very well; only recently have their numbers begun to drop and catches been reduced.

What both fishermen and scientists have found is that pollock are indeed moving northward. Generally, pollock spawn each winter in the southern Bering Sea, near the Aleutian Islands, then follow their food (plankton and small fish) north as waters warm in the spring. The bulk of them, following the outer contour of the continental shelf, now migrate to and beyond the international border with Russia. In effect, Alaska's pollock are becoming Russian pollock.

Andrew Rosenberg, a former deputy director of the National Marine Fisheries Service, was quoted in the *Los Angeles Times* in 2008: "It [the northward pollock movement] will be a food security issue and has an enormous potential for political upheaval." He expected that pollock would be a test case in a growing pattern of fish driven by climate change across jurisdictional borders.

Once in Russian waters, the pollock are caught by Russian fishermen in a poorly managed, probably overexploited fishery that's known to be plagued by lax enforcement and poaching. Catches there have been increasing as the Alaskan catches have been throttled back to stay at sustainable levels.

Pollock is just one of the species moving north in the Bering Sea, but because of its enormous economic value, it has gotten serious attention. Twenty-five years of scientific surveys have shown that dozens of other fish species are also shifting to the north. The range shift—thirty miles for pollock, thirty-four for halibut, fifty-five for opilio crab—is occurring two or three times faster than that of terrestrial species. According to the scientists, these species appear to be shifting in response to the extent of seasonal ice, itself moving northward and correlated to climate change.

As vital as the Bering Sea is for the men and women meeting in Bethel, the climate-change-induced threats we see there extend far beyond Alaska's shores. It's not just the Bering Sea's rich ecosystem that's at stake; it's the life support systems that the Bering Sea influences and the entire world needs.

If we know little about the effects of global warming on the Bering Sea, we know barely more about those effects on any of the oceans—which cover three-quarters of our earth and house 90 percent of the planet's biomass. Compared to land, oceans have been inadequately studied; everywhere,

ocean research is difficult, resource-intensive, and expensive. The Intergovernmental Panel on Climate Change (IPCC), for example, gave little attention to the marine system.

Consider: ocean temperatures may be a better indicator of global warming than air temperatures, because the ocean stores more heat (90 percent of the heat in the earth's climate system) and responds more slowly to change. Recent studies suggest the ocean is warming 50 percent faster than the IPCC reported in 2007 (and that thermal expansion rates and sea level rise were thus also underestimated by a similar amount). The next IPCC report is expected to give greater attention to ocean science, including the uncertainties in understanding and modeling climate change because of deficiencies in the knowledge base.

What we do know at this point is "big picture"—global warming affects ocean temperatures, the supply of nutrients that enter the ocean from the land, ocean chemistry, marine food webs, wind systems, ocean currents, the volume of ocean water, and extreme events such as hurricanes. The ecological responses to these are already playing out in processes ranging from primary production (where all the eating begins) to biogeography (where organisms live) to evolution.

Considerable attention has been given to the effect of warming on thermohaline (*thermo* as in temperature and *haline* as in salt content) circulation (also known as the ocean conveyor belt), which is what moves both energy and material around the world and thus has a huge influence on climate. Most of that attention has gone to the possibility of the slowing, or even shutdown, of the North Atlantic "conveyor." In the North Atlantic, pools of cold, dense water sink, pulling warm surface waters north from the tropics. With warming and the addition of freshwater from the melt of glaciers and the Greenland ice cap, the sinking of cold water has lessened in recent years. A map of the path of the thermohaline circulation looks somewhat like a picture of the human body's blood circulation; blue lines mark the deepwater currents, red the surface currents, and they all tie in and keep moving. The oldest waters, with a transit time of some sixteen hundred years, end up in the North Pacific, finally in the Bering Sea. Clearly, if that first deepwater formation in the North Atlantic quits on us, the entire ocean circulation will be altered—kind of like your heart stopping.

There are many other implications of climate change for our oceans, poorly understood at present. A warmer ocean will hold less oxygen, for one thing. A warmer ocean will increase stratification, potentially locking nutrients away from those who need them. A warmer ocean with less ice appears to be freeing up mercury and other pollutants, raising contaminant levels throughout the

food web and accumulating at the top, in marine mammals and those who eat them. A warmer ocean already appears, in the Arctic, to be releasing methane clathrate (hydrate) compounds—large frozen methane deposits that lie mostly under sediments on the ocean floor, though some also underlie permafrost on land. Methane is roughly twenty times more potent as a greenhouse gas than carbon dioxide. The carbon in these frozen deposits is thought to exceed that in all other fossil fuels on earth combined. There is strong evidence that runaway methane clathrate release may have caused major alterations of the ocean environment and earth's atmosphere on a number of occasions in the past, most notably in connection with the Permian-Triassic extinction event (the Great Dying) 251 million years ago. At that time 70 percent of terrestrial vertebrate species went extinct.

In June 2011 the North Pacific Fisheries Management Council asked that the research plan being developed for the northern Bering Sea be expanded to include additional information about the ecosystem and effects of trawling, to identify species and habitats that might be of interest to the commercial fishing industry, and to give additional consideration to input from the affected coastal communities. The Bering Sea Elders Advisory Group continues its participation in the process.

They Have No Ears

RIKI OTT

❖

I first met Riki Ott in 2005 during an activist campaign in Washington, DC. She generously gave me a copy of her book, Sound Truth and Corporate Myths: The Legacy of the Exxon Valdez Oil Spill. *I also learned that Riki would visit several Iñupiat villages on the North Slope organized by REDOIL to share her experience about oil toxicity. She is a scientist by training—a marine toxicologist—and an activist at heart. The 1989* Exxon Valdez *spill changed her life. In the essay that follows, she writes:*

> *After earning a master's and doctorate in marine toxicology (pollution), I had gone to Alaska, became a commercial fisherman, and made Cordova my home. After Exxon's spill, I had dedicated my life to exposing, understanding, and fixing the problems that led to the spill. Over time, this work led me beyond the lingering spill-related socioeconomic and environmental problems to the much more systemic problems of America's addiction to oil and coal, corporate power, and the illusion of democracy.*

*In 2010, after BP's Deepwater Horizon spill, she spent nearly six months
in the Gulf of Mexico. I asked her if she would tell us about her experience on
Exxon Valdez, Deepwater Horizon, and her trips to the North Slope villages.
She did, and along the way she exposed the culture of Big Oil in America.*

❖

POLITICS AND oil have linked the lives of whalers and caribou hunters in
the Arctic with the lives of fishermen and Alaska Native people in Prince
William Sound. People who depend on food from the land and sea know to
take care of that which supports them. People who want oil know how to get
the oil—from the ground and from the political system.

The threat from oil and this clash of values emerged relatively quickly, over
one generation. America's thirst for oil sent oilmen exploring and probing to
the edges of the continent and beyond into shallow seas. In 1968, the largest
oil field in North America was discovered at Prudhoe Bay. Ten years later,
Alaska North Slope crude oil was moving to market by pipeline and tankers.

In 1989, the *Exxon Valdez* oil spill catastrophe shut down commercial fishing
and traditional Alaska Native subsistence harvests in Prince William Sound
and, temporarily, another debate in Congress to open the Arctic National
Wildlife Refuge to oil and gas leasing. Oilmen took another tack—offshore.
Earlier, during the Reagan presidency, Interior Secretary James Watt had done
away with the conservative three-square-mile block leasing program in favor
of area-wide leasing. This opened entire oceans to onetime sales. Further, oil
companies were relieved of onerous environmental protection requirements
and allowed to manipulate the marine environment to suit their needs by
building artificial man-made islands for drilling platforms.

By 2006, under George W. Bush's "expedited" energy program, the entire
Arctic Ocean—all 73 million acres—had been opened to offshore oil and gas
leasing, and large tracts had been sold; the Prudhoe Bay oil field complex
had expanded dramatically; and oil activities in the NPR-A had considerably
ramped up. The future of the coastline in the Arctic Refuge was again being
debated in Congress, despite disquieting stories from fishermen and Alaska
Native people in Prince William Sound that the ecosystem was still stained
with Exxon's oil, fisheries had not recovered, and people were still fighting
the oil giant in court.

Louisiana residents in Grand Isle express their outrage about the disaster from BP's *Deepwater Horizon* spill in the Gulf of Mexico. This image was first published in "The BP oil disaster: A year in photography" by Erika Blumenfeld, in *Al Jazeera*, April 23, 2011. *(Photograph by Erika Blumenfeld, 2010.)*

In response to the growing threats to their ancestral lands and culture, a group of Iñupiat, Gwich'in, and others visited Prince William Sound and my hometown of Cordova to see and hear the stories of struggle to recover from Exxon's spill. These stories swept north on the "tundra telegraph" (word of mouth), and in 2006 I was invited to carry these stories to North Slope villages in person by REDOIL—Resisting Environmental Destruction on Indigenous Lands, a group that had formed during the Cordova visit.

Robert Thompson, an Iñupiaq hunter and conservationist from Kaktovik, was a founding member of REDOIL. He was eager for Kaktovik's schoolchildren to hear Cordova's stories. But the schools were built, heated, and staffed by oil money, and the schoolmaster was wary of stories that might bite the hand that fed his kingdom.

Rebuffed by Kaktovik's schools, I shared stories with visitors to the Thompson's home, passing around a jar of oiled rocks from Prince William Sound—a fresh collection taken *seventeen years* after Exxon's spill. The "talking rocks" spoke volumes. People could see, smell, and touch the oil. It was understood even before I explained that wildlife could not thrive on oiled beaches—and neither could cash-based communities or subsistence cultures that depended on a healthy ecosystem.

Exxon's spill changed my life path, or, perhaps more accurately, *aligned* me with it. Up to the spill, my career path seemed random. After earning a master's and doctorate in marine toxicology (pollution), I had gone to Alaska, became a commercial fisherman, and made Cordova my home. After Exxon's spill, I had dedicated my life to exposing, understanding, and fixing the problems that led to the spill. Over time, this work led me beyond the lingering spill-related socioeconomic and environmental problems to the much more systemic problems of America's addiction to oil and coal, corporate power, and the illusion of democracy.

The *Exxon Valdez* disaster was not an accident. It was the predictable result of the oil industry's culture of gaming with laws and regulations to shave operating costs and increase profits.[1] Promises traded for public trust and operating permits were not codified into law. Much of the promised safety, spill prevention, and spill-response measures vanished over time, along with the promised vigilance by oversight agencies. Industrial self-regulation is an abrogation of public trust, but oil money flooded into Alaska's coffers every year, deafening state politicians' ears to criticisms of their golden goose. It was a high-stakes game of Russian roulette. Every time a tanker left the dock

in Valdez, it was like firing one round from the chamber. Exxon's turn had the bullet.

Just past midnight on March 24, 1989, the *Exxon Valdez* gutted itself on Bligh Reef, ripping open eight of eleven cargo holds and spilling somewhere between 11 million and 38 million gallons of Alaska North Slope crude oil into the sea. The captain, a known alcoholic, didn't even have a driver's license at the time because of drunk driving charges.

Four days after the spill, an Exxon public relations man stood in our high school gym and promised, "We will make you whole. We will pay all reasonable claims." Instead, Exxon began a desperate bid to minimize its liability for damages. Exxon began to spill lies and deception into the news. Penalties are based on spill volume: report less, pay less. Fines are based on damages: fewer carcasses mean lower fines. Public relations are based on a good story: if you don't have one, make one up.

Alaskans weren't prepared for a cover-up: we had expected a cleanup. That's what the oil industry had promised in thick, wordy contingency plans that had been read and approved by state and federal officials. But words are cheap and cleanup equipment is not, so the oil industry had invested heavily in toxic chemical dispersants that conveniently sink oil—out of sight, out of mind—and it had scrimped and bought only the cheapest brands of booms, skimmers, and absorbent material, and in nowhere near the quantity needed for a large spill. Training people to operate this equipment is also costly; so is providing workers with adequate protective gear. Exxon scrimped on these costs as well, convincing federal agencies to approve four hours of hazardous waste safety training and hard hats instead of the required forty hours of training and respirators.

Three years later, in 1992, the US Coast Guard gave a cursory sign-off of Exxon's cleanup. A few months later, pink salmon stocks collapsed in Prince William Sound. The following year, Pacific herring and pink salmon stocks crashed, along with the rest of the ecosystem. Exxon declared this had nothing to do with its spill, but when federal scientists dug pits on the beaches in response to concerns raised by Alaska Native people, the scientists found Exxon's oil—relatively fresh, liquid, and toxic.

Legions of scientists launched studies. A decade later, the findings split cleanly into two camps.[2] Studies by federal and state researchers and others *not* funded by Exxon found that oil killed eggs and young life forms of herring and salmon; stunted growth and reduced survival of baby fish and birds; damaged reproduction in adult fish, birds, sea otters, and orcas; and

weakened and sickened healthy wildlife, reducing survival. Independent scientists measured oil impacts over multiple generations, through the food web, and from the oiled beaches. They concluded that the delayed ecosystem collapse and long-term harm to wildlife was linked to Exxon's oil. In the second camp, studies funded by Exxon found no conclusive link between its oil spill and harm to wildlife.

Pink salmon and herring are the mainstay of Cordova's cash economy and the Prince William Sound ecosystem. Pink salmon recovered after five or so generations (ten years), but the herring have failed to recover from the 1993 collapse. Once-lucrative herring fisheries are closed indefinitely. Altogether, fifteen of twenty-four species that were studied were still listed optimistically as "recovering" twenty years after the spill. Scientists estimate about fifty-six tons of Exxon's oil is still on the beaches of Prince William Sound—and they say it will be there for another fifty years. Exxon has refused to pay the $92 million requested by the state and federal governments for additional cleanup efforts, as a condition of the original settlement.[3]

Exxon also refused to honor its promise to pay claims and instead fought everyone in court. The stress from economic hardship and prolonged litigation tore our community apart. Individual and social dysfunction manifested as spikes in domestic violence, substance abuse, divorces, and suicides—all documented by a team of sociologists studying disaster trauma. Compensatory damages did not include long-term losses; subsistence claims amounted to "a-buck-a-duck," or the equivalent price for grocery store food. *Nineteen years after the spill,* the Supreme Court ruled in ExxonMobil's favor, reducing the punitive damage award to ten cents on the dollar—four days of net profit for the oil giant. People with claims that had survived the brutal process recovered about 10 percent of their economic losses—and not one cent of the losses to quality of life or culture.

Meanwhile, literally thousands of *Exxon Valdez* cleanup workers became sick with what Exxon medical doctors diagnosed as the "Valdez Crud"—simple colds and flu, headaches, burning eyes, sore throats, and skin rashes. After the cleanup, many suffered rapidly declining health to the point of disability and even death. Researching medical and court records, I discovered Exxon's clinical data and air quality monitoring data supported evidence of a chemical illness epidemic from overexposure to oil and dispersants. Exxon had simply covered it up—and the federal government had looked away.[4]

On the eighteenth memorial of the spill, when Exxon was still fighting us in court, Alaska Native carver Mike Webber created a Shame Pole, a type of

totem pole, to ridicule Exxon into paying its public debt. The hardest parts to carve, he told me, were the words pouring from the mouth of Exxon's CEO, "We will make you whole." The CEO had a long nose, like Pinocchio when he lied, and no ears. "Exxon never listened to us," Mike said.

Our story resonated with Alaska Native people on the North Slope.

Flying into the village of Nuiqsut in the dark, I was surprised to see bright lights from oil field activities in every direction. It felt like the village was at the center of a candelabra.

My host, Rosemary Ahtuangaruak, is a former community health aide practitioner and mayor. She was the first to speak out about the skyrocketing cases of asthma as the oil wells marched ever closer to Nuiqsut. The closest wells, with their flaring gases and air pollution, are now within four miles of the village. In spite of her public health advocacy, or perhaps because of it, we were also banned from speaking at the village schools in Nuiqsut.

The villages to the west—the ones farthest away from the Prudhoe Bay oil fields—greeted us warmly and openly. We shared our stories with the students, and the youths' excitement brought curious parents to public events in the evening.

In Barrow, 330 miles above the Arctic Circle, the fourth grade class pulled desks together to make a table so Rosemary and I could model the oil fields around Nuiqsut. We used paper cups and pencils for oil wells and pipeline. The lattice almost surrounded the village. Rosemary asked, "Can the caribou migrate through that?" Students in the circle shook their heads silently—*No!* When Rosemary mimicked the noise from the seismic testing—BOOM! BOOM!—the children all jumped. They knew noise would scare away caribou and whales.

The tundra telegraph spread our stories faster than the small planes that carried us west. People began to share some of their concerns with us. In Point Lay, on the shores of the Chukchi Sea, the high school students listened intently to Rosemary, following her voice and body language closely.

Watching the class, it struck me that I was witnessing an oral tradition of sharing knowledge and processing new information. My culture learns from books; the Iñupiat youth learns from listening to stories. Survival of the individual, community, and culture depended on sharing stories about hunting, fishing, ice conditions, weather patterns, and more. In a real way, the stories we shared were about a different threat to their culture unlike any other. The bright side of the oil economy had brought heated homes, flush toilets, modern schools, and an all-American lifestyle to these remote villages. We brought warnings of the dark side—the threats to destroy their culture

by eliminating their wild foods, creating illnesses and community dysfunction, and altering the land and sea through oil activities and climate change.

One of the boys directed a question at me. Pointing to a nautical chart on the wall, he said, "We gather wood on the beach. Why do they tell us the oil will not come ashore?"

Unlike in my culture, in the Native tradition pauses between speakers are acceptable and even expected. I studied the map, which showed a fraction of coastline with Point Lay and a lot of ocean. There are no trees in Point Lay—no trees anywhere on the windswept Arctic coast. Some wood drifts down rivers from the Brooks Range; more comes from the taiga forest far to the east in Canada and carried by long shore currents. To have driftwood collect on the beach means that the lagoon in front of the village is a depositional zone—anything caught in the long shore current, like oil, would wind up on the beach like the driftwood. "They" referred to the oilmen who also visited the villages to share their promise of risk-free oil development. This boy, maybe sixteen, was already a seasoned and skilled hunter who knew his environment.

I drew a deep breath. "'They' lie," I said softly, knowing this concept is foreign in a culture that depends on truth for survival. Subtle frowns crossed the faces of the students.

I held up the jar of oiled talking rocks. "They told us not one drop of oil would spill in Prince William Sound. They told us they could clean up if there was a spill. They couldn't clean up oil in the Sound; there is no way they can clean up an oil spill in the Arctic, and they know it. So they say oil will not come ashore. They don't listen to our concerns."

Rosemary chimed in. "'They' lied to us, too," she said firmly. The faces softened. The talking rocks and Rosemary carried a truth that could not be denied.

We struck a chord when we mentioned lies and not listening. The towns of Atqasuk and Wainwright are within the National Petroleum Reserve–Alaska (NPR-A); Point Lay is just to the west. At public meetings, people in all three villages expressed frustration with the lack of cultural understanding on the part of oilmen and federal government officials. People had selected allotments to record and set aside private inholdings within the NPR-A. Allotments almost always have cultural value such as traditional hunting or fishing areas, or sacred places where ancestors are laid to rest. But the oilmen often ignored allotment boundaries, especially during exploration, and the federal government ignored the people's complaints.

"They are not *listening* to us." The local knowledge about currents and

migratory paths of land and marine animals was ignored in the environmental impact statements. "We don't want to happen here what happened in Nuiqsut." The pleas for flight restrictions during caribou hunting season were ignored. Allotment boundaries were ignored. "It makes you cry when they run over the graves," people said. "They have no ears," we were told. "BLM has no ears." (The Bureau of Land Management manages the NPR-A for the Department of Interior.) When the risk of oil spills shrunk from 94 percent to less than 10 percent—with no change in technology and glib assurances of clean up[5]: "They're *lying* to us." This callous disrespect of the Iñupiats' concerns is unthinkable in a culture that values and teaches respect.

Even worse, the oilmen had figured out how to twist the core cultural value of conflict avoidance against the people. Cooperation is critical for survival in an unforgiving land. Many activities are shared. Youths depend on Elders for sharing stories that teach responsibility, skills, and what is expected of them in society. The young and old, sick and infirm, depend on healthy members for food, shelter, and companionship. Conflicts are avoided because broken relationships create social and community dysfunction that, in turn, threatens survival.

Early on, oilmen had presented Conflict Avoidance Agreements to community leaders, the whaling captains, to sign. Many did, not seeing a problem as this value is so deeply rooted in their culture. But the agreements contained clauses that restrict people from speaking in public against the oil industry. As the oil industry's "spiderweb effect"—the sweeping plans to industrialize the North Slope—became more evident, the agreements presented a cultural dilemma: people needed to respect their captains and avoid conflict, but the captains did not represent the whole community, and some people were seeing the larger threat to whales, the Arctic ecosystem, and their culture. After hearing our stories, people realized conflict was unavoidable, and they had to speak their truth to power.

In 2006, Point Hope was the most outspoken community against oil development, especially offshore. The village sits on a large natural gravel strip that juts out like a wishbone into the Chukchi Sea. Sea mammals such as bowhead whales, beluga, seals, and walrus pass close to shore during spring and fall migrations. Residents identify strongly with their whaling culture and were preparing to face—and resolve—the conflicts.

Three years later, in January 2009, a whaling captain from Point Hope, Earl Kingik, joined Rosemary and I as we repeated our trip across the North Slope. REDOIL and Point Hope had emerged as early leaders in filing legal challenges against the Bush administration's decisions to allow oil drilling in

the Beaufort and Chukchi seas—the entire Arctic Ocean. This time we were warmly welcomed in all the villages, including Nuiqsut and Kaktovik, as many in the Iñupiat community had come to realize they were caught in a high-stakes game where they had the most to lose. Schoolmasters called assemblies so we could present to all the students; many students remembered us.

When we finally arrived in Point Hope, the tundra telegraph—and even some official radio stations—had carried our stories far and wide. In response, Arctic Slope Regional Corporation (ASRC), an oil field service contractor and one of twelve regional corporations created in 1971 under the Alaska Native Claims Settlement Act to extract "resources" for profit, invited us to present at its hastily called public meeting. Since we didn't want to divide the community's attention, we agreed, but instead of having us go first, as originally promised, ASRC asked us to go last.

Three hours later, just before ten o'clock in the evening, ASRC announced that it was late, and out of respect for the Elders, our presentation was canceled! Trembling and with her black eyes snapping, Rosemary stood to directly challenge the corporate leaders. She calmly announced we would present a short talk to whoever wanted to stay, even if it was only one person. The Elders all stayed, while parents with young children left. The entire ASRC board had to stay because we were using their projector. Stunned Elders thanked us afterward. ASRC had not told them of the dangers posed by oil development or of other opportunities for future generations, like the wind generator project that Robert Thompson was promoting for Kaktovik.

On April 20, 2010, a deep-water oil well owned by British Petroleum blew out in the Gulf of Mexico and began spewing a low-end, *Exxon Valdez*–size oil spill every three and a half days into the sea. Hoping to help Gulf residents avoid some of the mistakes we had made in Alaska, I flew down to Louisiana in early May and stayed into October.

It was déjà vu. British Petroleum was unprepared to contain and control a blowout of this size, despite voluminous contingency plans that had been approved on paper—yet didn't work in practice. The liability game began: BP underestimated spill volume; covered up carcasses; overstated effectiveness of its dispersants while understating human health and ecosystem impacts; downplayed health risks to frontline workers, especially those at the source and near the in situ burn operations; trained workers for four hours and gave them hard hats instead of respirators; and ignored public health risks. The BP blowout also was not an accident, but rather the predictable result

of the oil industry's gaming with laws and regulations. This time, BP's turn had the bullet.

British Petroleum played off Exxon's song sheet almost to the note. In Orange Beach, Alabama, I was sitting in a high school gym with fifteen hundred residents when a BP spokesperson promised, "We will make you whole. We will pay all legitimate claims." If it weren't for the heat, I would have thought I had stepped twenty-one years backward in time and was reliving Exxon's nightmare.

There were three huge differences: the coastal population, the science, and what I call "the illusion." The Gulf of Alaska is mostly populated with sea life, while the Gulf of Mexico is home to 4 million to 5 million humans who live, play, and work right along the coast. After traveling this coast from Louisiana to Florida all summer, collecting stories and working with people, I am convinced that I witnessed an emerging public health epidemic of chemical illness from exposure to dangerous levels of BP's oil and toxic chemicals.

The science supports this. Since the *Exxon Valdez* spill, scientists understand that oil is more toxic than thought to wildlife and people;[6] environmental medicine has emerged to diagnose and treat intermediate and low-level oil and chemical exposures in the general population.[7]

But the oil industry and political leaders cannot admit that the Gulf blowout created a public health epidemic[8] and people should have been evacuated, because this admission *undermines the illusion*—the false assumption and fatally flawed belief—that the economic benefits of our oil addiction outweigh the costs in lives, health, the environment, and the life-supporting climate. The real Gulf story threatens to rip the veil off that illusion.

During our 2009 trip to the Arctic villages, Earl Kingik had asked schoolchildren to write letters to President Obama, explaining their culture and what they learned from Rosemary and I about the need to protect the ocean and wildlife from oil development and oil spills. "Will the president listen to us?" many students asked doubtfully. Earl told them that Obama supported tribal sovereignty and he would listen. The youth produced a thick stack of letters that were personally delivered to Obama a few months later.

But given the ongoing coverup in the Gulf of Mexico, it seems that Obama "has no ears" either.

In the past five years, the Iñupiat community has filed at least nine lawsuits challenging lease sales and environmental plans, with Point Hope and other REDOIL members as the lead plaintiffs in most of the cases. Questions

concerning collective and cumulative social, cultural, and environmental impacts of an oil spill in Arctic waters remain unanswered.

Alaska holds the largest offshore oil reserves in the nation—an estimated 27 billion barrels, more than double the Atlantic and Pacific Coasts combined. But the United States now has less than 2 percent of the world's proven oil resources. Only biologic and geologic forces, and time, can *produce* oil. The United States now *extracts*—it doesn't "produce"—7 percent of the world's oil, and the rate of extraction in the United States has declined since the 1970s. From Reagan forward, the United States has become increasingly dependent upon foreign oil, despite generous tax breaks to the oil industry and one of the lowest royalty rates in the world.[9] The United States cannot drill its way out of this mess. Energy independence *with* oil is impossible; energy independence *from* oil is not.

In July 2010, the community of Port Sulfur, Louisiana, hosted a talking circle to share stories with Iñupiats from Alaska and a couple from the Niger Delta, where there is *one oil spill a day*. Sitting in the circle with our African American, Cajun, and American Indian hosts, I listened as the talk swung from the immediate social, environmental, and economic impacts of the Gulf disaster to the future.

Kindra Arneson of Venice, Louisiana, asked, "Why can't we have jobs that don't kill us or destroy our land? We need to do something different for our children."

Nimmo Bassey from Nigeria responded, "One of our prime ministers said, 'The Stone Age did not end because of lack of stones.'"

Climate scientists have made it clear that if people wish to have a livable planet for their children, the Oil Age must end soon, regardless of how much oil is left to extract. Yet politicians have no ears. Change must come from communities, from parents and grandparents who insist on lifestyle changes and energy options for children like the Iñupiat and other Alaska Native people have done with solar and wind power.

We not only need to explore new energy systems, we must examine the consciousness that created these problems in the first place so that we do not compound the problems with unconscious solutions. At its core, living sustainably is about relationships and respect—how we treat each other, other living beings, and the earth. To have "no ears" to the cries of future generations is to be complicit in a process that is pushing earth's life support systems over the edge.

Riki Ott wishes to acknowledge and thank Alaska Native leader Ilarion "Larry" Merculieff for his insights and critical review of this essay. His willingness to share his similar observations and experiences in North Slope communities created space to share her truth.

NOTES

1. Riki Ott, *Not One Drop: Betrayal and Courage in the Wake of the* Exxon Valdez *Oil Spill* (White River Junction, VT: Chelsea Green Publishing, 2008).

2. Riki Ott, *Sound Truth and Corporate Myths: The Legacy of the* Exxon Valdez *Oil Spill* (Cordova, AK: Dragonfly Sisters Press, 2004).

3. Patti Epler, "Unfunded *Exxon Valdez* Cleanup Efforts under Judicial Consideration," *Alaska Dispatch*, January 19, 2011, http://www.alaskadispatch.com/dispatches/news/8349-unfunded-exxon-valdez-cleanup-efforts-under-judicial-consideration

4. Ott, *Sound Truth and Corporate Myths*, 2004.

5. Mark Jaffe and David Olinger, "Gulf Oil Spill Fuels Alaska 'Village's Fears over Offshore Drilling," *Denver Post*, August 29, 2010, http://www.denverpost.com/news/ci_15928501?source=rss.

6. Charles Peterson et al., "Long-Term Ecosystem Response to the *Exxon Valdez* Oil Spill," *Science* 302: 2082–6, December 19, 2003; Jan-Paul Zock et al., "Prolonged Respiratory Symptoms in Cleanup Workers of the Prestige Oil Spill," *American Journal of Respiratory and Critical Care Medicine* 176: 610–6, 2007; Terry Tamminen, *Lives per Gallon: The True Cost of Our Oil Addiction* (Washington, DC: Shearwater/Island Press, 2008); Adam Voiland, "The Smallest of Pollutants Are Linked to Outsize Health Risks," *US News & World Report*, February 27, 2008, http://health.usnews.com/articles/health/2008/02/27/the-smallest-of-pollutants-are-linked-to-outsize-health-risks.html.

7. Nicholas Ashford and Claudia Miller, *Chemical Exposures: Low Levels and High Stakes*, 2nd ed. (Hoboken, NJ: Wiley, 2008).

8. Riki Ott, see *Huffington Post* series from May 17, 2010, to January 21, 2011; Dahr Jamail, "Illnesses linked to BP oil disaster," *Al Jazeera English*, January 5, 2011, http://english.aljazeera.net/indepth/features/2010/12/20101230105158700342.html; Jeff Young, "Toxic Tide: Discovering the Health Effects of the Deepwater Disaster," *Living on Earth*, NPR, February 15, 2011, and February 22, 2011, http://www.loe.org/shows/segments.htm?programID=11-P13–00006&segmentID=3.

9. William Freudenburg and Robert Gramling, *Blowout in the Gulf: The BP Oil Spill Disaster and the Future of Energy in America* (Cambridge: MIT Press, 2011).

BPing the Arctic?

SUBHANKAR BANERJEE

❧

In 2010, the Obama administration was considering giving Shell a permit to drill exploratory wells in the Beaufort and Chukchi seas of Arctic Alaska. BP's tragic Deepwater Horizon *spill brought dangers of offshore drilling to the public's attention, and Shell's Arctic Ocean drilling was suspended for 2010. But Shell continued to pressure the Obama administration to grant them the permit. I wrote a blog piece in May 2010 for TomDispatch.com about Shell's proposed Arctic drilling. Many thanks to Tom Engelhardt, the piece was widely distributed, and was translated in French and German. In August 2010, I founded ClimateStoryTellers.org to write on this subject, and presented stories on the Arctic, desert, forest, ocean, and more by storytellers from Arctic to Australia, including* Arctic Voices *contributors Rosemary Ahtuangaruak and Christine Shearer. In September 2010, ClimateStoryTellers. org joined the coalition United for America's Arctic (ourarcticocean.org) to fight Shell's proposed drilling in the Beaufort and Chukchi seas. The story that follows is adapted from a series of blog pieces I wrote beginning in May 2010 on Shell's proposed drilling in the Beaufort and Chukchi seas.*

❧

MAY 25, 2010. Bear with me. I'll get to the oil. But first you have to understand where I've been and where you undoubtedly won't go, but Shell's drilling rigs surely will—unless someone stops them.

Millions of Americans have come to know the Arctic National Wildlife Refuge, even if at a distance, thanks to the massive media attention it got when the Bush administration indicated that one of its top energy priorities was to open it up to oil and gas development. Thanks to the efforts of environmental organizations, the Gwich'in Steering Committee, and activists from around the country, George W. Bush fortunately failed in his attempt to turn the refuge into an industrial wasteland.

While significant numbers of Americans have indeed come to care for the Arctic Refuge, they know very little about the Alaskan Arctic Ocean regions—the Chukchi Sea and the Beaufort Sea—which the refuge abuts.

I came to know these near-shore coastal areas over the past decade and realized what the local Iñupiat had known for millennia: these two Arctic seas are verdant ecological habitats for remarkable numbers of marine species. They're home to an estimated ten thousand endangered bowhead whales, thirty-six hundred to forty-six hundred threatened polar bears, more than sixty thousand beluga whales, Pacific walrus, three species of seals, and numerous species of fish and birds, not to mention the vast range of "non-charismatic" marine creatures we can't see, right down to the krill—tiny shrimp-like marine invertebrates—that provide the food that makes much of this life possible.

The Iñupiat communities across the Arctic coast of both seas—Kaktovik, Nuiqsut, Barrow, Wainright, Point Lay, Point Hope, and Kivalina—depend on the rich bounty of the Arctic Ocean for subsistence foods. And their cultural and spiritual identities are inextricably linked to the seas and its creatures.

Unfortunately, as you've already guessed, I'm not here just to tell you about the glories of the Alaskan Arctic, which happens to be the most biologically diverse quadrant of the entire circumpolar north. I'm writing this because of the oil. Because under all that life in the Arctic seas, there's something our industrial civilization wants, something oil companies have had their eyes on for a long time now.

If you've been following the increasing ecological devastation unfolding before our collective eyes in the Gulf of Mexico since BP's rented *Deepwater Horizon* exploratory drilling rig went up in flames (and then under the waves), then you should know about—and protest—Shell Oil's plan to begin exploratory oil drilling in the Beaufort and Chukchi seas this summer.

On March 31, standing in front of an F-18 Green Hornet fighter jet and a large American flag at Andrews Air Force Base, President Obama announced a new

energy proposal, which would open up vast expanses of America's coastlines, including the Beaufort and Chukchi seas, to oil and gas development. Then, on May 13, the United States Ninth Circuit Court of Appeals handed a victory to Shell Oil. It rejected the claims of a group of environmental organizations and Native Iñupiat communities that had sued Shell and the Interior Department's Minerals Management Service (MMS) to stop exploratory oil drilling in the Arctic seas.

On May 14, I called Robert Thompson in Kaktovik, an Iñupiat community along the Beaufort Sea coast. "I'm very stressed right now," he told me. "We've been watching the development of BP's oil spill in the Gulf on television. We're praying for the animals and people there. We don't want Shell to be drilling in our Arctic waters this summer."

As it happened, I was there when, in August 2006, Shell's first small ship arrived in the Beaufort Sea. Robert's wife Jane caught it in her binoculars from her living room window, and I photographed it as it was scoping out the sea bottom in a near-shore area just outside Kaktovik. Its job was to prepare the way for a larger seismic ship due later that month.

Since then, Robert has been asking one simple question: If there were a Gulf-like disaster, could spilled oil in the Arctic Ocean actually be cleaned up?

He's asked it in numerous venues—at Shell's Annual General Meeting in The Hague, Netherlands, in 2008, and at the Arctic Frontiers Conference in Tromsø, Norway, that same year. At Tromsø, Larry Persily—then associate director of the Washington office of Alaska Governor Sarah Palin, and since December 2009, the federal natural gas pipeline coordinator in the Obama administration—gave a twenty-minute talk on the role oil revenue plays in Alaska's economy.

During the question-and-answer period afterward, Robert, typically, asked: "Can oil be cleaned up in the Arctic Ocean? And if you can't answer yes, or if it can't be cleaned up, why are you involved in leasing this land? And I'd also like to know if there are any studies on oil toxicity in the Arctic Ocean, and how long will it take for oil there to break down to where it's not harmful to our marine environment?"

Persily responded: "I think everyone agrees that there is no good way to clean up oil from a spill in broken sea ice. I have not read anyone disagreeing with that statement, so you're correct on that. As far as why the federal government and the state government want to lease offshore, I'm not prepared to answer that. They're not my leases, to be real honest with everyone."

A month after that conference, Shell paid an unprecedented $2.1 billion to the MMS for oil leases in the Chukchi Sea. In October and December 2009,

A polar bear hunts a bearded seal resting on sea ice in Beaufort Sea. *(Photograph by Steven Kazlowski, August 2007.)*

the MMS approved Shell's plan to drill five exploratory wells—three in the Chukchi Sea and two in the Beaufort Sea.

It would be an irony of sorts if the only thing that stood between the Obama administration and an Arctic disaster-in-the-making was BP's present catastrophe in the Gulf of Mexico.

This isn't the first time that America's Arctic seas have been exploited for oil. Throughout the latter part of the nineteenth century, commercial whalers regularly ventured into those seas to kill bowhead whales for whale oil, used as an illuminant in lamps and as candle wax. It was also the finest lubricating oil then available for watches, clocks, chronometers, and other machinery. Later, after petroleum became more widely used, whale baleen became a useful material for making women's corsets.

In 1848, when the first New England whaling ship arrived in Alaska, an estimated thirty thousand bowhead whales lived in those Arctic seas. Just two years later, there were two hundred American whaling vessels plying those waters, and they had already harvested seventeen hundred bowheads.

Within fifty years, an estimated twenty thousand bowhead whales had been slaughtered. By 1921, commercial whaling of bowheads had ended, as whale oil was no longer needed and the worldwide population of bowheads had, in any case, declined to about three thousand—with the very survival of the species in question.

Afterward, the bowhead population began to bounce back. Today, more than ten thousand bowheads and more than sixty thousand beluga whales migrate through the Chukchi and Beaufort seas. The bowhead is believed to be perhaps the longest-lived mammal. It is now categorized as "endangered" under the Endangered Species Act of 1973 and received additional protection under the Marine Mammal Protection Act of 1972.

It would, of course, be unforgivably ironic if, having barely outlived the first Arctic oil rush, the species were to fall victim to the second.

Iñupiat communities have been hunting bowheads for more than two millennia for subsistence food. In recent decades, the International Whaling Commission has approved an annual quota of sixty-seven whales for nine Iñupiat villages in Alaska. This subsistence harvest is deemed ecologically sustainable and not detrimental to the recovery of the population.

My first experience of a bowhead hunt in Kaktovik was in September 2001. After the whale was brought ashore, everyone—from infants to Elders— gathered around the creature to offer a prayer to the creator, and to thank the

King eider ducks migrate over frozen Chukchi Sea, Point Barrow. *(Photograph by Steven Kazlowski, May 2009.)*

whale for giving itself up to, and providing needed food for, the community. The *maktak* (whale skin and blubber) was then shared among community members in three formal celebrations over the year to come—Thanksgiving, Christmas, and Naluqatuk (a June whaling feast), two of which I attended.

And it's not just whales and the communities that live off them that are at stake. Oil drilling, even at a distance, has already taken a toll in the Arctic. After all, the survival of several Arctic species, including polar bears, walruses, seals, and sea birds, is seriously threatened by the widespread melting of sea ice, the result of climate change (caused, of course, by the burning of fossil fuels).

In addition, millions of birds use the near-shore Arctic waters, barrier islands, coastal lagoons, and river deltas for nesting and rearing their young in spring, and for feeding in summer before they start migrating to their southern wintering grounds. When the Arctic wind blows in one direction, nutrient-rich freshwater from the rivers is pushed out into the ocean; when it blows in the other direction, saltwater from the sea enters the lagoon. This mixing of freshwater and saltwater creates a nutrient-rich near-shore ecological habitat for birds, many species of fish, and several species of seals. If oil drilling begins in the Arctic seas and anything goes wrong, the nature of the disaster in the calving, nesting, and spawning grounds of so many creatures would be hard to grasp.

With the *Deepwater Horizon* crisis in the Gulf of Mexico ongoing, scientists are beginning to worry about hurricane season. It officially begins on June 1 and doesn't officially end until November 30. Any significant storm entering the Gulf would, of course, only exacerbate the disaster, moving oil all over the place, while hindering cleanup operations. Now, think about the Arctic Ocean, where blizzards and storms aren't seasonal events, but year-round realities and—thanks (many scientists believe) to the effects of climate change—their intensity is actually on the rise. Even in summer, they can blow in at eighty miles per hour, bringing any oil spill on the high seas very quickly into ecologically rich coastal areas.

The Native village of Point Hope and REDOIL (Resisting Environmental Destruction on Indigenous Lands) joined fourteen environmental organizations in sending a letter to Interior Secretary Ken Salazar. In light of the oil spill in the Gulf of Mexico, it urged him to reconsider his decision to allow Shell to proceed with its drilling plan. That same week, Secretary Salazar finally ordered a halt to all new offshore drilling projects and asked Shell to explain how it could improve its ability to prevent a spill—and, if one happens, how it would effectively respond to it in the Arctic.

Shell responded publicly that it would employ a pre-made dome to contain any leaking well and deploy chemical dispersants underwater at the source of any oil leak. From what I understand, both methods have been attempted by BP in the Gulf of Mexico. The dome has so far failed, developing hydrates and becoming unusable before ever being placed over the leak. Scientists now believe that those toxic chemical dispersants have resulted in significant ecological devastation to coral reefs and could be dangerous to other sea life. None of this bodes well for the Arctic.

There is, I'm beginning to realize, another crisis we have to face in the Gulf, the Arctic, and elsewhere: How do we talk about—and show—what we can't see? Yes, via video, we can see the gushing oil at the source of BP's well a mile below the surface of the water, and thanks to TV and newspapers we can sometimes see (or read about) oil-slicked dead birds, dead sea turtles, and dead dolphins washing up on coastlines. But what about all the other aspects of life under water that we can't see, that won't simply wash up on some beach, that in terms of our daily lives might as well be on Mars? What's happening to the incredible diversity of marine life inhabiting that mile-deep water, and what cumulative impact will all that oil have on it, on the ecology of the Gulf of Mexico, and possibly—in ways we may not yet be able to imagine—on our lives?

These are questions that desperately need to be asked and answered before we allow oil ships to head north and drilling to spread to America's Arctic Ocean. Keep in mind that there, unlike in the temperate and tropical oceans where things grow relatively fast, everything grows very slowly. On the other hand, toxins left behind from oil spills will take far longer to break down in the frigid climate. As bad as the Gulf may be, a damaged Arctic will take far more time to heal.

President Obama and Secretary Salazar should stop this folly now. It's important for them to listen to those who really know what's at stake—the environmental groups and human rights organizations of the indigenous Iñupiat communities. It's time to put a stop to Shell's drilling plan in America's Arctic Ocean for this summer—and all the summers to come.

[*On May 27, President Obama suspended Shell's Arctic drilling plan for 2010. But that was only the beginning of a long story that has no end in sight—like all good stories, it became more like a large onion with many layers to peel.*]

September 16, 2010. I noticed on *HuffPost Green*, the environmental page of *Huffington Post*, a Shell Oil ad placed conveniently above one of my earlier

blog posts, titled, "Letter to Young Americans." Here is a quick read: The ad says, "Let's Go," asking all of us to join in. My story asks all young people to join in. The ad says, "Go Further," telling us to progress into the future. My story says, "Start the climate revolution now," for the purpose of a brighter future. The ad and the story outwardly appear to be saying the same thing and peacefully cohabiting in the *HuffPost* Greenscape.

Then I thought further. The ad says, "Let's Make What We've Got." Let's split this into two parts. I'd say, because Shell likes to "take" more than they "make," we could replace one with the other. And "What We've Got?" Oil is what we've got. So to get at the essence of the story, the line should read, "Let's Take the Oil We've Got." My story, on the other hand, talks about getting off of fossil fuels—oil and coal—and starting a clean energy revolution. So you see, in spite of the superficial similarities, the ad and the story are actually heading down two different roads.

About the oil that we've got—resource expert Michael Klare has stated that there is no easy oil anymore, only "extreme energy" in faraway places like the Arctic or in deep oceans, and it comes to us with great devastation.

That's why Shell wants to "Go Further," literally—in distance, not in time. Actually, Shell wants to go quite far, all the way to the Beaufort and Chukchi seas of Arctic Alaska to get the oil that is there. And they want you to support them in their journey, which is why they say, "Let's Go."

I also saw that two columns to the right and about an inch down, there was a news story, titled, "Alaska Sues Feds to Lift Arctic Drilling Suspension." Here is how that story came to life. Interior Secretary Ken Salazar visited Arctic Alaska, and his itinerary included a town hall meeting in Barrow (the northernmost Iñupiat community in Alaska), a stop at the National Petroleum Reserve–Alaska, and a flight over the Beaufort and Chukchi seas. Then a few days later, there appeared a story in the *Los Angeles Times* with one of my much-published polar bear reflection photos along Beaufort Sea with the headline, "Salazar: Arctic Oil Drilling Must Wait."

But the story couldn't end there, either.

There is a lot of money at stake for Shell. They have already spent more than $2 billion in lease sales and probably several hundred million already in other operations and public relations in the Arctic communities, and outside. Did Shell arm-twist the Alaska state government? From my decade-long experience working on Arctic Alaska issues, all I can say is—most likely. So there you have it. The State of Alaska is so willing to allow Shell to go drill in the Beaufort and Chukchi seas that it sues the Feds to lift the Arctic offshore drilling ban.

Back to the ad: Shell wants to "Go Further." As it happens, Shell has actually gone very far—all the way to the Sakhalin Island, on the Sea of Okhotsk in Far Eastern Siberia, to drill for oil.

On December 2, 2005, Claude Martin reported about Shell's Sakhalin operation in the *New York Times,* "The oil pipeline will cross over 1,000 wild rivers and tributaries, many of them important to salmon spawning. In addition, despite public protests, a million tons of dredging waste has already been dumped into Aniva Bay—an area crucial to the livelihood of the island's indigenous community—and has led to the destruction of the local fishery. To make matters worse, an oil platform is being built at the very spot off Sakhalin where the last 100 critically endangered Western Pacific gray whales feed. By Shell's own estimates, there is a 24 percent chance that there will be a major oil spill during the life of the 40-year project."

Things actually got really bad for Shell in Sakhalin. When Shell bought the Sakhalin leases in 1996, the price of oil was $22 a barrel and little attention was paid. But five or six years ago, as the price of oil went through the roof, everyone began paying attention, including Vladimir Putin. Moscow sided with the Sakhalin Island environmentalists, and there was even a threat of a $50 billion lawsuit against Shell. In 2007, Shell was forced to give up half of its control of the Sakhalin operation to the Russian energy giant Gazprom. In a CNN story, a Sakhalin local commented about Shell, "The company did everything that was good for them and not good for us."

Shell's "Let's Go" ad was not only occupying the space above my earlier post but also placed in multiple places all over the *HuffPost Green,* including the banner, and it was all over progressive and conservative media outlets. Shell spent a lot of money on this ad.

No matter how many "Let's Go" ads we see on *HuffPost Green* and elsewhere, we must decipher the intent and stop Shell's plan to drill in the Beaufort and Chukchi seas of America's Arctic.

November 26, 2010. On November 24, the Obama administration designated 187,157 square miles (approximately 120 million acres) in Arctic Alaska as a "critical habitat" for polar bears threatened by disappearing sea ice due to climate change.

During the Bush administration, three environmental groups—Center for Biological Diversity, Natural Resources Defense Council, and Greenpeace—filed a lawsuit against the US Department of Interior to protect polar bears and their habitats. On May 15, 2008, the US Fish and Wildlife Service (FWS), a division of the Department of Interior, listed polar bears as a "threatened species" under

the Endangered Species Act. Then, on October 29, 2009, the FWS proposed 200,541 square miles in Arctic Alaska to be designated as "critical habitat" for polar bears. Subsequently, existing US Air Force structures, communities of Barrow and Kaktovik, and some territorial waters that were incorrectly estimated were excluded, resulting in 187,157 square miles for the final designation. This was a hard-won victory for the environmental community.

The designated habitat includes three ecozones—sea ice, barrier islands, and onshore denning habitat. Polar bears use these areas for feeding, finding mates, denning, and raising cubs. It is their homeland where they live and survive. Nearly 95 percent of this designated habitat is in the sea ice of the Beaufort and Chukchi seas of Arctic Alaska.

In March and April 2002, Robert Thompson and I camped on the Canning River Delta along the Beaufort Sea coast in the Arctic National Wildlife Refuge for twenty-nine days to observe a polar bear den. We saw the mother bear and her two cubs play near the den once. But during that whole time, we had only four calm days. The rest of the time, a blizzard blew steady, with a peak speed of 65 miles per hour, and the temperature hovered around minus 45 degrees Fahrenheit with the windchill dropping it to minus 120 degrees Fahrenheit.

Can you imagine, in such a climate, anyone doing a cleanup operation after a major oil spill like the one we had earlier this year in the Gulf of Mexico?

The Arctic Refuge coastal plain along the Beaufort Sea coast is the only land conservation area in the US for denning polar bears. Unlike grizzly or black bears that require a real den on a hillside, polar bears build their dens in temporary snow banks onshore, or on the sea ice offshore. Pregnant females go in these temporary dens in October to November, give birth during December to January, and nurse their cubs inside the den until March or April, at which point they emerge from the dens with usually one or two cubs. At that time, the mother has not eaten for five to seven months, and they critically require good spring ice for seal hunting to feed themselves and to nurse their cubs.

About sixteen hundred polar bears roam the Beaufort Sea of the US and Canada, and about two thousand to three thousand polar bears roam the Chukchi Sea of the US and Russia.

Arctic warming has changed everything for these bears. They're stressed about their home on the melting sea ice, and their food—the seals that critically depend on sea ice as well.

If Shell is given the permit to drill in the Beaufort and Chukchi seas, there is no doubt they'll affect the bears during their denning time. If disturbed, a

pregnant female bear will abandon a den. But more importantly, think about their food—bearded and ringed seals that are in abundance in those seas. Those seals eat fish, and the fish eat smaller creatures, going all the way down to the nearly invisible plankton. A major spill from Shell's drilling operation would cause havoc on the food chain from the very bottom to the very top predator—the polar bears. A major oil spill from an offshore drilling operation in the harsh Arctic environment is not just a possibility, it's inevitable.

Between the time Shell's drilling plan was suspended in late May and now, the only things that have changed are: Shell has spent a lot of money on ad campaigns; Alaska Congressional delegations have revved up their rhetoric of job-and-economy; and the Arctic has gotten perhaps a tad bit warmer. But the fact remains, as Robert Thompson always says, "No one knows how to clean up an oil spill underneath the Arctic ice."

The question remains: Will the President deny or grant Shell the permit to go drill—and destroy—the critical habitat of polar bears that he just designated? Let us hope he will do the right thing.

December 8, 2010. Shell placed another ad, "We have the technology—Let's go," conveniently under one of my blog posts on the *HuffPost Green* page.

So, what are we supposed to do with what the ad says? To search for answers, I looked at a recent post by Ralph Nader titled, "Institutional Insanity." In it, Nader writes about how Republican lawmakers would make outrageous statements that journalists do not question. Nader asserts, "Mute Democrats and mindless reporters make insane Republicans possible." But most importantly, he writes, "The American people deserve to have reporters ask one question again and again: 'Senator, Representative, Governor, President, would you be specific, give examples and cite your sources for your general assertions?'"

Since the Obama administration is currently considering permitting Shell to drill in the harsh environment of the Beaufort and Chukchi seas of Arctic Alaska, I'd urge all journalists to raise Nader's question verbatim as it relates to the "technology" that Shell is talking about.

In his book, *After the Ice: Life, Death and Geopolitics in the New Arctic,* Alun Anderson, former editor-in-chief of *New Scientist,* quotes directly from a 339-page report that was published in 2008 by the Mineral Management Service (MMS) of the George W. Bush administration, "Floating production systems for the Beaufort Sea, Chukchi Sea, and North Bering Sea are not considered to be technically feasible, even with continuous ice management. No floating

production structures could be economically designed to stay on station with multiyear ice loads found in the Beaufort and Chukchi seas."

Anderson also quotes Michael Paulin, lead author of the MMS report, "What happens if you are under ice for nine months of the year? And what do you do to work over your wells or correct something or repair something? That's a challenge. In the Gulf of Mexico . . . those things all can be done using remote vehicles. If you are covered with ice, how are you going to do that? You'd better think about it because you need to prove that you could do that in the Arctic."

This was the conclusion of a major report produced by a pro-oil administration just two years ago.

Is any journalist asking either the Obama administration or Shell the details of a possibly secret technology that Shell might have developed since the MMS report was published? The administration must ask Shell all of the questions addressed in Anderson's book and ask the company "to be specific, give examples, and cite sources for their general assertions."

In his book, Anderson does not advocate one way or the other whether we should or shouldn't drill in the harsh environment of the Arctic seas. In fact, he seems ambivalent about the subject. In some cases he shows excitement about all these futuristic technologies that Russia is employing for Arctic resource explorations, while in other parts of the book he writes about ecological and cultural devastations that these extreme energy projects might bring.

We all know that Arctic sea ice is melting rapidly due to climate change. But here is the crucial point we must address: the Arctic Ocean continues to be covered in solid ice for eight to nine months of the year. While that still remains the case, Arctic sea drilling will always be very destructive, no matter what technology Shell or any other company proclaims that they have.

Shell doesn't have any technology to address the concerns raised in Anderson's book. No such technology exists. What they do have is a multi-million-dollar ad campaign and a well-funded public relations team.

[*In response to a lawsuit brought by Iñupiat and environmental organizations, on December 30, 2012, the Environmental Appeals Board of the Environmental Protection Agency revoked part of Shell's major source air quality permit. Subsequently Shell abandoned their 2011 drilling plan. But the story couldn't end there, either.*]

August 15, 2011. One of the riskiest and most destructive extreme energy oil exploration projects on the planet is moving toward implementation without

scientific understanding or technical preparedness—Shell's oil drilling in the Arctic Ocean of Alaska.

On August 4, the US Bureau of Ocean Energy Management, Regulation, and Enforcement (BOEMRE), which replaced the MMS in 2012, conditionally approved Shell's plan to drill up to four exploratory wells in the Beaufort Sea of Arctic Alaska starting July 2012. A *Los Angeles Times* editorial correctly opined, "Shell Oil's conditional permit to drill exploratory wells off Alaska should not have been granted. The hazards of drilling in such waters are in some ways worse than operating thousands of feet underwater. . . . It's too early for any approval, conditional or otherwise." Shell still needs several more permits including an air quality permit from the Environmental Protection Agency before they can do any drilling in the Arctic seabed. We must stop it.

I'll tell you how BOEMRE is ignoring science to fast track Shell's dangerous drilling plan.

On May 4, 2011, Shell submitted their revised Beaufort Sea Exploration Plan (EP) with BOEMRE—two exploratory wells in 2012, and two in 2013. Then on May 12, they submitted their Chukchi Sea plan—three exploratory wells in 2012, and three in 2013. They've upped the ante; instead of the five wells that they had asked for in the past, now they're asking for ten. On July 5, BOEMRE deemed Shell's Beaufort application "submitted" and on August 4 conditionally approved it.

The BOEMRE press release about the permit begins with the announcement that Shell's Beaufort exploratory wells would be in "shallow water." This is a key argument you'll hear from Shell and BOEMRE and it goes like this: BP's *Deepwater Horizon* was operating at a depth of 5,000 feet while Shell's Arctic wells would operate in shallow water with depth of about 120 feet. The pressure is lower at shallower depth, sure, but don't buy this argument. I'll explain below that drilling in the harsh ice covered environment of the Arctic Ocean is actually worse than drilling in the subtropical Gulf of Mexico.

BOEMRE director Michael Bromwich wrote in the press release, "We base our decisions regarding energy exploration and development in the Arctic on the best scientific information available."

Here is how I'd reinterpret Bromwich's comment: "We *know* that we have too many gaps in our scientific understanding of the Arctic Ocean. If Shell kills the ocean out there, we can always say our knowledge was limited—honestly, we didn't know. But if we do an appropriate and thorough scientific study of the Beaufort and Chukchi seas we might find out that Shell shouldn't really

go there to drill. So we based our permit on the best *scientific information available*."

The press release also states, "BOEMRE found no evidence that the proposed action would significantly affect the quality of the human environment. Therefore, BOEMRE determined that an Environmental Impact Statement (EIS) was not required, and issued a Finding of No Significant Impact (FONSI), a key step in the approval of the EP."

What BOEMRE has done instead is an Environmental Assessment (EA).

I spoke with Erik Grafe, an attorney with the Earthjustice office in Anchorage to understand the EA versus EIS process. "EA is a small internal report that a federal agency produces, whereas, an EIS is a thorough process: an extensive draft report is produced and the public is invited to comment on it. This process also offers alternatives—if the proposed action is deemed environmentally destructive then other options are explored. Through full public participation and a rigorous process a final EIS is produced," Erik told me.

The National Environmental Policy Act (NEPA) states, "an Environmental Impact Statement must be prepared if substantial questions are raised as to whether a project . . . may cause significant degradation of some human environmental factor."

On July 15, 2011, fourteen environmental organizations and Resisting Environmental Destruction on Indigenous Lands (REDOIL) sent a letter to James Kendall, regional director of BOEMRE, Alaska. The letter demands that BOEMRE "must prepare a full EIS to analyze and disclose the effects of the proposed drilling." To substantiate their demand the letter states, "The proposed activity threatens a number of significant effects, including effects to endangered bowhead whales from drilling and ice–breaking noise, effects from a very large oil spill, and cumulative effects, and has the potential to harm subsistence activities that are of central cultural significance to Arctic coastal communities. NEPA requires these effects to be analyzed in an EIS."

The letter also points out, "The recommendations of National Commission on the BP *Deepwater Horizon* Oil Spill also strongly support preparation of an EIS for Shell's exploration plan."

BOEMRE rubber-stamped Shell's plan a fortnight later, without doing an EIS.

In 2009, when the MMS granted Shell five exploratory drilling permits in the Beaufort and Chukchi seas, the agency concluded that a large spill was "too remote and speculative an occurrence" to warrant analysis, even though

it acknowledged that such a spill could have devastating consequences in the Arctic Ocean's icy waters and could be difficult to clean up.

Last year *Rolling Stone* reported on what BP had put in their exploration plan application for *Deepwater Horizon* that the MMS had rubber-stamped. The article reads, "BP claims that a spill is 'unlikely' and states that it anticipates 'no adverse impacts' to endangered wildlife or fisheries. Should a spill occur, it says, 'no significant adverse impacts are expected' for the region's beaches, wetlands and coastal nesting birds."

The government and corporations are making the United States into the town of Punxsutawney, where in each new drilling cycle we would awake to the same set of cruel lies that lead to the destruction of our environment.

In 2010, the National Marine Fisheries Service completed a biological opinion recognizing the importance of Camden Bay and its surrounding areas in the Beaufort Sea as a feeding and resting area for endangered bowhead whales. Shell's wells would be near Flaxman Island and Brownlow Point, west of Camden Bay—mere miles away from the feeding and resting area. Shell would drill there from July 10 through October 31, while bowhead whales would migrate through there from beginning of September through mid-October—an unfortunate crossing of paths.

A joint press release, dated August 4, 2011, by twelve environmental organizations and REDOIL states, "Shell estimates close to 5,600 migrating bowhead whales, almost half the population of the species, could be exposed to sound and disturbance from the drilling and icebreaking that could cause them to change their behavior and avoid the feeding area. This could harm the population, particularly mothers and young calves, and could affect Alaska Native communities that rely on the bowhead whale and other species to sustain their subsistence way of life." This is one example where oil, ecology, and human rights will collide with Shell's drilling plan.

Now consider the larger gap in our knowledge of the Arctic Ocean ecology. In March 2010, Secretary Salazar had asked the US Geological Survey (USGS) to conduct a special review of information to better understand the marine environment of the Beaufort and Chukchi seas, and specifically asked to examine the "effects of exploration activities on marine mammals; determine what research is needed for an effective and reliable oil spill response in ice-covered regions; evaluate what is known about the cumulative effects of energy extraction on ecosystems; and review how future changes in climate conditions may either mitigate or compound the impacts from Arctic energy

development." After a thorough yearlong process in late June 2011 the USGS released a comprehensive assessment.

I learned from the August 4 press release that the USGS report reinforces the fact, "we need a basic understanding of the Arctic Ocean ecosystem before we can drill there."

Leah Donahey, Western Arctic and oceans program director at the Alaska Wilderness League told me, "With hundreds of pieces of key information missing, inadequate synthesis of existing scientific data and a need to gather additional types of information such as traditional knowledge from Alaska Natives, the USGS report argues that now is the time to be conducting rigorous scientific analysis on the impacts of drilling in the Arctic Ocean."

BOEMRE is ignoring the basic fact that scientific knowledge is necessary before any drilling is approved, while the USGS report states that without detailed scientific knowledge "it is difficult, if not impossible" to make informed decisions about oil and gas development in America's Arctic Ocean.

This is what I'd call fast tracking—the MMS did that for BP, and now BOEMRE is doing it for Shell.

During George W. Bush's presidency Arctic science was suppressed and manipulated to promote Arctic drilling. The Obama administration is now walking on the trail that was blazed by his predecessor.

First, here is a story from the Bush era. Opening up the coastal plain of the Arctic National Wildlife Refuge to oil drilling was a top priority of President Bush. During 2001–02, I spent a lot of time in the Arctic Refuge and had many conversations with Fran Mauer, then the lead wildlife biologist with the refuge office in Fairbanks.

In 2001, a US Senate Committee asked then-Secretary of Interior Gale Norton detailed information about the Porcupine River Caribou Herd (PCH) that calve in the Arctic Refuge coastal plain where drilling was proposed. Norton asked the Fish and Wildlife Service to prepare a report on the caribou—Fran Mauer was assigned the task.

Fran prepared the caribou report and sent it to Norton. After a few months he was sent a faxed copy of the report that Norton had sent to the US Senate. Fran was horrified—Norton had replaced his report with something else entirely. Fran went to the Public Employees for Environmental Responsibility (PEER), who then started an investigation. On October 21, 2001, in a front-page story in the *Washington Post*, Michael Gurnwald exposed Norton's mischief: "[W]hen Norton formally replied to the committee, she left out the agency's scientific data that suggested caribou could be affected by oil drilling, while

including its data that supported her case for exploration in the refuge, documents show. Norton also added data that was just wrong."

Norton's letter to Senator Fran Murkowski dated July 11, 2001, states, "Figure 2 shows the extent of [caribou] calving during 1983–2000. Concentrated calving occurred primarily *outside* of the 1002 Area [where drilling was proposed] in 11 of the last 18 years." Whereas, Fran Mauer's original report states, "Figure 2 shows the extent of calving during 1983–2000. . . . There have been PCH calving concentrations *within* the 1002 Area for 27 of 30 years." "This went way beyond spin," said PEER national field director Eric Wingerter. "They manipulated the data in an attempt to manipulate Congress. Norton's big mistake here was getting caught." Wingerter also called for Norton's resignation. In 2006, Norton resigned following an ethics scandal—no relation to oil drilling; and then a few months later joined Shell—to promote oil drilling.

Fast forward to right now. Dr. Charles Monnett, a wildlife biologist with BOEMRE and one of the country's top Arctic scientists, was suddenly suspended on July 18. Ten days later PEER filed a scientific misconduct complaint on behalf of Dr. Monnett.

In 2006, Dr. Monnett and a colleague published a seven-page article in the peer-reviewed journal *Polar Biology*. The article reported sightings of four drowned polar bears in the Beaufort Sea in 2004. With Arctic warming sea ice is melting at an unprecedented rate creating large expanses of open water. At times polar bears are swimming much longer distances, but after finding no sea ice to rest or feed, they are dying of exhaustion. Dr. Monnet brought all these to the world's attention.

The Interior Inspector General is apparently investigating that five-year-old paper.

"Ever since this paper was published, Dr. Monnett has been subjected to escalating official harassment, culminating in his recent virtual house arrest," said PEER Executive Director Jeff Ruch. "This is a cautionary tale with a deeply chilling message for any federal scientist who dares to publish groundbreaking research on conditions in the Arctic. . . . Despite bold rhetoric about respecting science, this case illustrates that federal scientists working in controversial areas today are at greater risk than during the Bush administration."

On July 28, Suzanne Goldenberg wrote (published with my polar bear photo taken along the Beaufort Sea coast) in the *Guardian*, "The Obama administration has been accused of hounding the scientist so it can open up the fragile region to drilling by Shell and other big oil companies." Exactly a week later the administration did grant Shell the permit.

Caribou is a signature species of the Arctic National Wildlife Refuge, while polar bear is a signature species of the Arctic Ocean. Unsurprisingly, Mauer and Monnet are silenced by successive administrations to promote destructive oil drilling in the Arctic.

Leah Donahey walked me through a few facts about Shell's spill response plan. Shell claims that they'll be able to recover 95 percent of oil spilled in Arctic water using mechanical containment and recovery efforts. However, the June 2011 USGS report states that in broken ice conditions, the amount of oil that could be cleaned up using mechanical recovery techniques is estimated at a mere 1–20 percent. Recovery rates for the *Deepwater Horizon* spill was 3 percent, and for the *Exxon Valdez* spill it was 8–9 percent.

Did Shell lie? Heck, yes!

Oil companies put whatever in their exploration and spill response plans and if all goes well the federal agency will rubber stamp it. Consider this: In their *Deepwater Horizon* exploration plan that the MMS had approved, BP pledged that they would protect sensitive species including walrus, sea otters, and sea lions—all coldwater species not found in the Gulf of Mexico. They did a cut-and-paste from some Arctic document—this we found out, after the spill.

Shell's worst-case oil spill discharge is based on conditions in the Arctic on August 1, when the ocean is mostly free of sea ice, temperatures are above freezing, there is nearly twenty-four-hours of daylight and storms are few and less severe. But they plan to drill from July 10 through October 31. By early to mid-October the Arctic Ocean freezes over and it's mostly dark with extremely cold temperatures and severe blizzards. I spent an enormous amount of time up there in all seasons and I can tell you that the difference between August 1 and October 15 is like this: you'll feel like you're on two different planets.

BP had stated in their exploration plan for *Deepwater Horizon* that they would be able to handle a worst-case scenario of a spill that discharges 162,000 barrels a day, nearly three times more than the highest spill per day that actually happened in the Gulf blowout.

If you thought the clean up effort of the *Deepwater Horizon* spill was a nightmare, think again. For Shell's Arctic operation, the nearest Coast Guard station is more than one thousand miles away. "It'd take a week to eighteen days for response vessels to arrive on site, and thirty-nine to seventy-four days to drill a relief well. This means any spill occurring well before October

could mean cleanup would be pushed into the nine months when the Arctic Ocean is completely covered with ice," Leah told me. "In fact, Shell admits that it cannot safely or effectively respond to any spill that would occur more than twenty-one days into the Arctic drilling season."

How would Shell deal with this problem? "Shell plans to leave the spilled oil until spring comes and the ice thaws. This 'leave in place' plan is no plan at all," Leah explained.

So far, I've only mentioned oil in the water, and oil underneath ice, but what about methane?

BP's *Deepwater Horizon* disaster released an enormous amount of methane that created massive dead zones. Methane sucks oxygen from water and chokes all life to death. Methane concentrations in areas of the Gulf had reached one hundred thousand times more than normal with hotspots that reached a million times more than normal—no life could ever survive that.

Both the Beaufort and Chukchi seas have large but unknown quantities of methane underneath their sea floors. Already large quantities of methane have been escaping rapidly in the East Siberian Arctic Shelf due to warming of subsea permafrost there. Also know that methane is twenty times more potent as a greenhouse gas than CO_2. Scientists are very worried about a potentially massive amount of methane escaping from both terrestrial and subsea permafrost due to Arctic warming. If that happens it'd be catastrophic for the planet.

Now imagine Shell's operation causes a spill on October 1 that begins spewing oil and methane. According to Shell's brilliant "leave in place" plan, the spilled oil will float all over, in the ocean, underneath the ice. And, unlike in the Gulf of Mexico where part of the methane could move up the water column and then escape into the air, in the Arctic Ocean in mid-October there is no chance of escape as the water is covered over with ice, except for a few patches of *polynyas*—open water between sea ice. Trapped methane would certainly accelerate the creation of huge dead zones. Come summer, after the ice thaws, when Shell finally gets ready to deal with the spill, instead of finding an Arctic Ocean bursting with new life—seal pups, fish, birds, polar bears—we would find an Arctic that is dead, totally dead.

Marine scientist Samantha Joye visited the Gulf seafloor nearly eight months after BP's blowout. We saw her inside a tiny submarine and she exclaimed, "Yeah, it looks like everything is dead."

Also know that everything grows very slowly in the Arctic Ocean compared to temperate and tropical oceans. A dead Arctic sea will take much longer to heal.

Did BOEMRE do a methane study in the Beaufort and Chukchi seas? Heck, no!

The July 15 letter to James Kendall that I mentioned earlier states, "NEPA requires an analysis of the incremental effects of Shell's proposed Beaufort Sea drilling when added to other past, present, and reasonably foreseeable future actions."

So, what else is Shell planning beyond their Beaufort Sea drilling? As I mentioned above Shell also submitted an exploration plan on May 12 to drill six exploratory wells in the Chukchi Sea of Arctic Alaska—three in 2012 and three in 2013.

The Beaufort and Chukchi are two adjacent seas, one north and the other west and northwest of the terrestrial landmass in Arctic Alaska. For animals like endangered bowhead whales and threatened polar bears there is no border—they migrate freely through both seas.

One of the crucial things the July 15 letter points out is the "cumulative effects" that Shell's multi-sea, multiyear drilling plans will have on the Arctic Ocean ecology and on the Iñupiat communities. The letter continues on to say, "If Shell drills its wells in both the Beaufort and Chukchi seas in 2012 and 2013, as it intends, bowheads may encounter Shell's exploration activities in both seas over two consecutive years. Thousands of bowheads will be potentially affected by the drilling, ice management, borehole seismic surveying, and vessel traffic, and the danger of a biologically significant impact will be especially high if cows and calves are exposed to the multiple disturbances."

The Chukchi Sea Lease Sale 193, however, is caught up in a lawsuit brought by four Iñupiat and eleven environmental organizations in the 9th Circuit US District Court for the District of Alaska—the Native Village of Point Hope, City of Point Hope, Iñupiat Community of the Arctic Slope, REDOIL, Alaska Wilderness League, Center for Biological Diversity, Defenders of Wildlife, National Audubon Society, Natural Resources Defense Council, Northern Alaska Environmental Center, Oceana, Pacific Environment, Sierra Club, The Wilderness Society, and the World Wildlife Fund. I wrote a fourteen-page standing declaration in support of that lawsuit.

Leah Donahey explained to me that after the court makes their decision, first the Lease Sale 193 has to be approved, and then BOEMRE has to deem the exploration plan "submitted" before any permit is considered or issued.

One of the crucial permits Shell still needs for both their Beaufort and Chukchi operations are air quality permits for their drill ships *Frontier Discoverer* and *Kulluk* that they intend to use. Sarah Saunders of Earthjustice gave me a

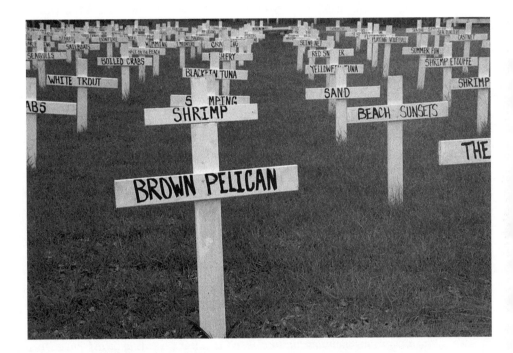

Residents of Grand Isle, Louisiana, mourn the loss of their lifestyle and wildlife that has been dramat-
ically impacted by BP's oil disaster. This image was first published in "The BP Oil Disaster: A Year in
Photography" by Erika Blumenfeld, in *Al Jazeera*, April 23, 2011. *(Photograph by Erika Blumenfeld, 2010.)*

timeline of where that process is: On March 31, 2010, the EPA issued the final air quality permit for the Chukchi Sea, and on April 9, the one for the Beaufort Sea. Then on May 3, a group of Iñupiat and environmental organizations filed a petition for review of both permits with the Environmental Appeals Board (EAB) of the EPA. Separately the Alaska Eskimo Whaling Commission and Iñupiat Community of the Arctic Slope filed petitions for review of the permits—on May 3, for the Chukchi permit and on May 12, for the Beaufort permit. On December 30, 2010, the EAB issued its order denying in part the petitions for review and remanding the permits back to the EPA. On July 1, 2011, the EPA released the revised draft permits for public comments, which were due August 5.

But why all the fuss about air quality permits?

"The fleet of large vessels Shell plans to use for its Beaufort Sea operations will emit large amounts of air pollution that could harm human health and the environment, and significantly degrade the Arctic's clean air. Shell will emit these pollutants into a rapidly changing Arctic environment and in relatively close proximity to Alaska Native villages. . . . Shell may emit up to 336 tons per year of NO_x and up to 28 tons per year of $PM_{2.5}$ (fine particles). Both of these pollutants are harmful to human health. . . . NEPA requires BOEMRE to analyze the effects of these emissions," I learned from the July 15 letter.

You see, slowly, incrementally, and cumulatively, Shell might kill the Arctic Ocean. The government would be a partner in that crime if they give Shell the permit to do so. Iñupiat and environmental organizations are determined to fight Shell and the government—legally and by taking their protest to the streets.

On September 10, 2008, the New York Times *reported a wide-ranging ethics scandal in the Mineral Management Service of the Department of the Interior. The allegations included "financial self-dealing, accepting gifts from energy companies, cocaine use and sexual misconduct." The investigation concluded that several MMS officials "frequently consumed alcohol at industry functions, had used cocaine and marijuana, and had sexual relationships with oil and gas company representatives." Following BP's* Deepwater Horizon *spill, President Obama replaced the MMS with BOEMRE.*

A press release from PEER, dated August 28, 2011, states, "A top federal Arctic scientist [Dr. Charles Monnett] is returning to work today after six weeks on administrative leave without any charges being leveled against him. . . . Meanwhile, the agency which suspended the scientist is itself under investigation for mishandling the matter. . . . The leave was ordered by BOEMRE Director

Michael Bromwich who reversed himself after the agency was informed that its top officials, including Bromwich, are now under investigation by Interior's Scientific Integrity Officer for breaking new departmental scientific integrity rules designed to protect researchers from political interference as alleged in a PEER complaint filed on Dr. Monnett's behalf."

On September 19, 2011, the EPA approved air-quality permits for both Discoverer and the Kulluk *drill ships that Shell plans to use.*

On October 3, 2011, the Obama administration moved another step closer to granting Shell the permit to drill in the Arctic Ocean—BOEMRE deemed Shell's Chukchi Sea lease sale complete, and the exploration plan complete. The exploration plan was pending final approval. The agency accepted public comments through end of November to prepare an Environmental Assessment, and refused to do a full Environmental Impact Statement.

During September 2011, a new coalition was formed—United for America's Arctic (ourarcticocean.org) to fight Shell's drilling in the Beaufort and Chukchi seas. As of this writing, seventy-one organizations have joined the coalition, including ClimateStoryTellers.org, which I founded in 2010.

On December 16, 2011, United for America's Arctic distributed a press release titled, "Obama administration rubber stamps Shell's drilling plans for the Arctic's Chukchi Sea" that began with these words, "In the latest in a series of reckless decisions about America's Arctic Ocean, the Obama administration today gave Royal Dutch Shell the green light to drill in the Arctic's Chukchi Sea beginning next summer."

On February 17, 2012, the Obama administration approved Shell's spill response plan for the Chukchi Sea.

On February 17, 2012, REDOIL and eight environmental groups—Alaska Wilderness League, Center for Biological Diversity, Natural Resources Defense Council, Northern Alaska Environmental Center, Oceana, Pacific Environment, Sierra Club, and The Wilderness Society filed a legal suit in the 9th Circuit Court of Appeals asking the judges to send the air quality permit that was granted to the Shell drilling ship Noble Discoverer back to the EPA for reconsideration.

On February 29, 2012, Shell filed a preemptive legal suit in the US District Court for the District of Alaska against REDOIL and 12 environmental organizations—Alaska Wilderness League, Center for Biological Diversity, Defenders of Wildlife, Greenpeace, National Audubon Society, Natural Resources Defense Council, Northern Alaska Environmental Center, Ocean Conservancy, Oceana, Pacific Environment, Sierra Club, and The Wilderness Society. On March 4, the New York Times *reported that Shell employed "a rare—and rarely*

successful—legal gambit in an effort to preempt anticipated legal challenges to its plans to begin exploration in the Arctic Ocean this summer." Most likely REDOIL and the environmental groups will challenge Shell's spill response plan that the Obama administration had approved.

On March 6, 2012, the United for America's Arctic sent out an email announcement to it's partner organizations that states, "We have set the lofty goal of sending President Obama one million comments between the anniversary of the Exxon Valdez oil spill (March 24) and the Deepwater Horizon disaster (April 20). In addition, we will be organizing a nationwide day of action on April 14. We still have time to stop Shell from drilling this summer. But we must act now—and we must act together."

On March 28, 2012, the Obama administration approved Shell's spill response plan for the Beaufort Sea.

Shell still needs more permits, including approval on application to drill, and the Marine Mammal Protection Act permits for both the Beaufort and Chukchi seas.

For the latest on this issue visit ClimateStoryTellers's special series on Shell's Arctic Drilling: http://www.climatestorytellers.org/stories/climatestorytellers-series-shell-arctic-drilling. This story has no end in sight, and will go on.

Teshekpuk in the Arctic's Biggest Wetland

STEVE ZACK *and* JOE LIEBEZEIT

❖

*In 2006, I was able to return to Arctic Alaska because of the generous finan-cial support from Tom Campion, chairman of the board of Alaska Wilderness League. I spent nearly four months, mostly in the Western Arctic, including Utukok River Upland, Teshekpuk Lake Wetland, Kasegaluk Lagoon, and the Iñupiat community of Point Lay. That year, the George W. Bush Administra-tion tried very hard to sell off the entire Teshekpuk Lake Wetland to Big Oil. The conservation community put together a unified voice and presented a website of the campaign—Save Tesehkpuk Lake (savetlake.org). After return-ing home, I scanned some of my photos and twelve of them became the photo gallery of the site. One of those photos—*Known and Unknown Tracks (*plate 18)—created a minor controversy: no exploration company should have had permits to cause those 3D seismic tracks. The homepage stated: "The Bush administration tried to sell the area as part of an oil and gas lease sale held on September 27, 2006. The federal courts, however, ruled that the plan was illegal, and the critical wildlife habitat around Teshekpuk Lake was removed*

from the sale. Prior to the court ruling, over 300,000 Americans asked the administration to protect the Teshekpuk Lake Wetlands. And during the summer, a bipartisan group of representatives and senators likewise argued for restored protections." The Bush plan was defeated. That same year, wildlife biologists Steve Zack, Joe Liebezeit, and their colleagues at the Wildlife Conservation Society had completed their second consecutive season of bird study in the Teshekpuk Lake Wetland. The team returned there every year since to continue their research. During summer 2011, Steve wrote four blog pieces as Field Notes for Yale Environment 360. What follows is an essay they wrote for this volume that includes some excerpts from those blog pieces. As you'll see, they experienced many joyous moments, but also real danger.

❖

"WE HAVE the Japan bird over here, and the China bird is nearby," Wildlife Conservation Society (WCS) field assistant Lizzie Goodrick states confidently into the walkie-talkie. She is reporting to our other field assistants monitoring birds near our remote field camp on the Ikpikpuk River on Alaska's North Slope. The birds in question—small, long-billed shorebirds, called dunlin—have indeed been photographed in those countries last winter and have returned to breed again where we captured, banded, and applied geolocators to them, here in our Ikpikpuk site, a year ago.

During summer 2011, we returned to the western Alaskan Arctic, for the seventh consecutive year. The Ikpikpuk camp is located on the far western edge of the Teshekpuk Lake Special Area in the National Petroleum Reserve–Alaska (NPR–A), and is a 1½-hour flight by bush plane from near the Prudhoe Bay oil fields to the east, and seventy miles from Barrow to the west. *Teshekpuk* is Iñupiaq for "large body of water." Teshekpuk Lake is the largest lake in the largest contiguous wetland complex in the circumpolar Arctic. Arctic coastal wetlands draw migratory waterbirds—shorebirds, waterfowl, and loons—and songbirds, by the millions, from all over the world to breed in the brief summer of the Arctic. With new technologies like geolocators, and international collaborations, we are tearing apart the geographic details of these birds' remarkable migratory lives.

Geolocators are a computer chip, a battery, and a light diode, bound together in a very small package—about 0.5 grams. They record time of sunrise and duration of day, daily, thus recording the detailed geographic movements of migrants over a year.

Brant geese on Teshekpuk Lake wetland. *(Photograph by Florian Schulz, 2009.)*

In 2010, at Ikpikpuk, we applied several geolocators to breeding dunlins after capturing them with a bow trap sprung over incubating birds on their tundra nests. For dunlins, it is glued to a band around the leg. We also adorn these birds with color "flags" (a band with a stiff flange that sticks out from the leg), and these flags are color-coded to indicate the country where banded (in this case, green indicates United States). This way, bird photographers around the world can see a flagged bird, photograph it, and identify where it nests. The green flag on our dunlin also had alphanumeric coding indicating the individual identification; thus, "EEK" was photographed in Japan. With the assistance of the US Fish and Wildlife Service (USFWS), we saw the picture of our bird in its winter home. Another photograph of an Ikpikpuk dunlin came to us from China.

Lizzie and her partner, John Diener, captured EEK for the second time in two years at Ikpikpuk and retrieved the geolocator, which we take back and send to our colleagues at the USFWS. They download the data from the computer chip, as part of a collective, continent-wide effort to determine where the different subspecies of dunlin, a species of conservation concern because of a declining population trend, are wintering, and learn of their migratory pathways to and from the Arctic.

We also flagged and color-banded several semipalmated sandpipers at Ikpikpuk to begin to understand adult survivorship patterns. As expected, most of those banded birds returned this summer to Ikpikpuk to breed, affording us the opportunity to monitor who is back, and who is new to our plots. Semipalmated sandpipers winter on shorelines of South America, quite a journey for a bird that weighs less than an ounce.

We sighted a female bar-tailed godwit with an orange flag, indicating that it had been banded in Australia. Remote is a relative term: Ikpikpuk is a veritable gathering ground of birds with fancy jewelry—color bands and flags—from all over the globe. We were surrounded by birds that had arrived from Japan, China, South America, and Australia.

And, there was the champion migrant, the Arctic tern, which defended its nest by swooping down and striking our head when we got too close. These birds make an annual round-trip from the Arctic to the Antarctic, covering more than forty thousand kilometers. It experiences more twenty-four-hour days than any other vertebrate.

The stunning yellow-billed loon that was nesting just across the river likely flew in from the Yellow Sea. The lone Smith's longspur, singing nonstop because it had no partner to court, winters in the American Midwest. The

pomarine jaegers stopped to breed at Ikpikpuk this year, as we had abundant brown lemmings. These birds winter in tropical oceans worldwide, stealing food from albatross and petrels. The male pectoral sandpipers, all puffed up with their chesty flight displays, will soon leave the chick rearing to females and return to their wintering grounds in southern South America. Finally, graceful tundra swans at Ikpikpuk may be among the swans we see in winter, near our office, in Portland, Oregon.

For many years ornithologists knew that spectacled eiders bred in Western Arctic Alaska, but did not know where they spent the winter. Only in the past twenty years have they recognized that this species spends the entire winter in the frozen Bering Sea. Well, not a completely frozen sea, as this species crowds in sea ice openings—*polynyas*—above shallow beds filled with clams.

Over the years, we've seen many other species of shorebirds, songbirds, and water birds—in the nesting habitat here in the Western Arctic, as well as a few species in the winter habitat in far away places. We can add red phalaropes, an aquatic shorebird that winters in open-ocean upwellings as far south as southern South America, returning here to nest. And, Africa is represented by the Northern Wheatear, a songbird breeding in shrubby Arctic settings amid caribou and musk oxen, and returns south to be among elephant and wildebeest in the winter. On a trip to Argentina in 2009, we saw buff-breasted sandpipers and American golden plovers in pampas grasslands near the coast. These species, too, are Arctic Alaska breeders.

Most of our migratory Arctic shorebirds are thought to be declining, some such as the semipalmated sandpipers, dramatically so. We are only beginning to understand where in their expansive migratory worlds they are facing threats, such as deforestation and development, causing their declines. New technologies like geolocators, as well as satellite transmitters for larger birds, are revealing the details of migratory movements of these and other birds, for the first time. With that information, we can look at their migratory geographies and learn of the threats and challenges these birds are facing. Their conservation is truly a global challenge.

In 2008, the two of us traveled to South Korea. We caught dunlin and bar-tailed godwits (and other species), during spring passage migration on wetlands of the Yellow Sea, to assess whether some of these Arctic breeders were infected by avian flu amid a huge outbreak of millions of poultry. Asian wintering dunlin make up the majority of Arctic Alaska–breeding dunlin, while dunlin that winter along the Pacific states nest primarily south of the Brooks Range. While there, we saw, up close, one of the major threats to migratory

birds in the Asian flyway: the new forty-miles-long Saemangeum Sea Wall that has shut off tidal flow and has dramatically affected the migratory habitat in these most important wetland, Saemangeum and the adjacent Geum, in all of Asia and the Asian flyway. The bar-tailed godwit that we captured and released, return south from Arctic Alaska in the early fall—fattens up in southwestern shorelines of Alaska and then undertakes a *nonstop* flight from Alaska to either Australia or New Zealand. As we worked with Koreans to gain research permission, we joked that we wanted to work with "our" birds while they were studying "their" birds. They nodded in amusement. If we could recognize that these and other migratory birds are indeed our collective responsibility, perhaps we could help make migration less perilous for birds in our changing world.

The Teshekpuk Lake Wetland should be among our national treasures, yet few outside of Alaska are aware of it, or how its future—the balance of wildlife protection and of development—is being shaped now. Indeed, when we first started our Arctic science and conservation activities for the Wildlife Conservation Society in 2001, we knew little of it and our focus was on the besieged Arctic National Wildlife Refuge, and the threat to drilling in the coastal plain there. Our institution, then the New York Zoological Society, had supported wildlife surveys by Olaus and Mardy Murie and a young graduate student, George Schaller, in the 1950s, which helped establish the interest and need for the refuge. The coastal plain of the refuge, the so-called 1002 Area, was again under serious threat of development and we felt that there was more heat than light on understanding what the oil "footprint" effect was on Arctic wildlife, and thus what the risks were of drilling for oil on the coastal plain. As a science-based conservation organization with deep roots in Alaska's Arctic, we wanted to understand how best to bring science to the issue, and to find ways where new wildlife information could assist in wildlife conservation. Little did we know then that we were creating a path toward Teshekpuk.

We brought together oil company scientists, federal scientists, and others to engage in an ambitious study of nesting birds near and distant from the existing Prudhoe Bay oil fields. We did so on the knowledge that in the oil fields, native nest predators—Arctic fox, common raven, and glaucous gulls—had increased in number because of the food (edible garbage) and diverse structures (buildings, gravel pads, culverts, etc.) that provided means to nest and raise young for these predators that were previously absent on the flat coastal plain.

Our study sites, as part of the larger study, were in the Prudhoe Bay and the western Kuparuk oil fields. As we began to learn more of Alaska's Arctic, we

became intrigued with the immense Western Arctic, including Teshekpuk. Western Arctic Alaska is virtually encompassed by the largest piece of federal (public) land in the United States: the National Petroleum Reserve–Alaska (NPR–A). At 23.5 million acres, it is about the size of Indiana, but at that time virtually off the public radar. Yet, development plans were also afoot for the NPR–A, and the Teshekpuk Lake region was slated to be the first to be developed as it was thought to have oil and was situated near the westernmost extension of the Prudhoe Bay oil fields, Alpine, on the Colville River Delta. We recognized that there was little understanding of how productive this region was for Arctic wildlife, and that our studies of nesting birds could help bring such information to light for the first time.

Western Arctic Alaska contains the world's biggest Arctic wetland—thousands of small shallow ponds, numerous large and deep lakes, all interspersed with predominantly wet sedge tundra. This is the most productive of Arctic habitats, providing strong pulses of insects during the shorebird and songbird breeding season, and providing ample grazing for caribou and their young. In this immense Arctic wetland the highest density of birds are found, and it is here these birds nest and rear their young.

Walking across the tundra near Teshekpuk Lake in the midst of the birds' breeding season is a wondrous thing. We have walked countless miles in our research there, finding and monitoring nests at the core of our conservation studies. The Teshekpuk region is mostly flat, but small-scale relief in the geography create major variations in habitat that facilitate the nesting and feeding of the tremendous migratory bird assemblage. The countless small ponds attract both red and red-necked phalaropes for feeding. Their nests are most often on pond edges, with tall sedges draped over the incubating males (females, the showier sex, may lay clutches of eggs for two or more males and play no role in incubation or rearing of the young). Tundra polygons are the predominant features of the landscape. They are variably wet or dry within them, and the polygon edges are foot-wide borders of slightly higher and drier habitat. On these edges we often find nests. Lapland longspur nests are most often found on the south-facing sides of such polygon ridges, as this most abundant passerine commences nests early in the spring and benefit from the solar radiation that is most prevalent to the south amid the twenty-four-hour days. If the tundra polygons are mostly dry within, then that is where we find the majority of bird nests. Greater white-fronted geese nest in loose neighborhoods, with failed nesting pairs constantly flying overhead the remaining active nesting pairs. Semipalmated and pectoral sandpipers,

our most common nesting shorebirds are the most easily found nests, simple scrapes on the ground with few to many sedge leaves providing cover. Less common shorebirds, like dunlin and stilt sandpiper, also nest in dry patches among wet tundra. Nesting anonymously in an "ocean" of tundra seems to be the nesting strategy of shorebirds in the far north.

Larger lakes, particularly those deep enough to hold fish, attract loons—yellow-billed, pacific, and red-throated. Their nests are on the lake edge, as loons cannot really walk on land but rather waddle on their chest. Lakes that have small "islands" (often patches of tundra that simply emerge near the shore) are the nesting habitat as well, of loons, Arctic terns, and cackling geese. In drier sites where the tundra is slightly elevated are the nesting territories of both black-bellied and American golden plovers. Their nests are exposed, but their eggs are remarkably cryptic against the lichens and small stones. On some of these dry, elevated tundra settings are the lekking grounds of buff-breasted sandpipers. Males display by holding one, then two wings up in a way that invites females to come in and examine their display up close. Females seem very choosy, visiting several males across several days before making a choice. Males play no role in rearing the young.

Small streams that wind through the tundra frequently have patches of taller willow, and so attract ptarmigan (willow and rock), and redpolls (common and hoary). Everywhere, the skies are filled with foraging jaegers (particularly long-tailed and parasitic, with the larger pomarine present only in years of brown lemming abundance).

We conducted our work first out of a remote field camp near Teshekpuk Lake, at the Olak site for four years before moving further west to Ikpikpuk. Our shorebird nesting studies at Olak were part of the larger effort to understand if "subsidized" predators—the Arctic fox, raven, and gulls that had increased in the oil fields—had a measurable effect on nesting bird populations. Identifying and quantifying such an oil "footprint" effect (here, an indirect effect) would be informative in understanding the potential consequences of growing development into the Arctic coastal plain—to the east in the Arctic National Wildlife Refuge, and westward into the NPR–A.

The results of our multi-partner, four-year study across many sites in the Alaskan Arctic revealed that there were some measureable effects. For example, songbirds nesting closer to development had lower nesting success in comparison to more distant nests. However, we could not detect any

overarching effect on shorebird populations. In retrospect, we realized that the natural variation, year to year, and site to site, of nest predation swamped our ability to detect the effect of "subsidized" predators in the oil fields.

Yet, because we had gone to the Olak site, we obtained novel information on nesting birds there that highlighted the importance of the Teshekpuk Lake region to migratory birds. We found higher nesting densities of birds near Teshekpuk, and for some species, higher nest productivity, compared to studies by us in the oil fields, and by our partners elsewhere in Arctic Alaska. Thus, our study added one more distinction about wildlife in the Teshekpuk Lake region, further indicating its importance to wildlife and the need for protection from development.

The two other key issues pertaining to wildlife in the Teshekpuk Lake have long been known. Northeast of Teshekpuk Lake is the gathering ground of several species of geese that come from Siberia, Canada, and Arctic Alaska to undergo their flightless molt. All waterfowl molt their flight feathers after the breeding season and become flightless for a few weeks while the new flight (primary and secondary) feathers grow. It is at this time that these geese are the most vulnerable and susceptible to disturbance. Tens of thousands of Pacific brant, snow, greater white-fronted, cackling, and Canada geese congregate near Teshekpuk in the fall, and there have been long concerns over how industrial development in this once-remote region would negatively affect, and physiologically stress, these species at their most vulnerable time. Teshekpuk Lake is also the center of the range of the Teshekpuk Lake caribou herd, numbering around seventy thousand animals, is unique among the four caribou herds in Arctic Alaska in not retreating to the mountains in the winter, but rather migrating around Teshekpuk Lake throughout the year. This herd is the most important subsistence herd to the Iñupiat people of Barrow and nearby villages. The concern of encroaching energy development is that it would disrupt the calving of caribou and affect where the herd moves throughout the year.

The NPR–A started out as a Naval Petroleum Reserve in the 1920s, as surface oil was thought to be an important reserve of oil for the navy as it converted from coal to oil in its ships. In the 1970s it was renamed, and authority of management went from the Navy to the Department of Interior. The Bureau of Land Management (BLM), as part of Interior, oversees the NPR–A today and is in charge of proposing a balance of development (through lease sales) and protection of resources in this immense landscape rich in resources, including wildlife.

In the late 1970s, the BLM designated four large areas as "special areas" in the NPR–A for their wildlife attributes. The Teshekpuk Lake Special Area (1.75

million acres overall) surrounds the lake and encompasses the main migratory geography of the Teshekpuk Lake Caribou Herd and the goose molting rounds. Also designated as special areas were the calving region of the largest Arctic Alaska Caribou Herd, the Utukok River Uplands Special Area in the southwestern NPR–A, and the Colville River Special Area containing the largest populations of breeding birds of prey south of Teshekpuk Lake, and the Kasegaluk Lagoon, important for marine mammals as well as migratory birds. All together, these special areas comprise some 33 percent of the NPR–A, and so for us and other conservation groups, comprise the most important conservation opportunities in Western Arctic Alaska requiring protection prior to development.

Special areas are meant to confer "maximal protection for wildlife . . . consistent with exploration issues." How exploration (i.e., development) can afford wildlife protection, and whether any development near important wildlife values can be consistent is open to interpretation. Our interpretation of this unclear phraseology is to argue for protection of key areas in the NPR–A for wildlife, and keep development, and affects of development away. We feel there is room for balanced development and wildlife protection in this biggest piece of public land in the United States, but protection of Teshekpuk and the other special areas is a minimal standard of such balance for wildlife protection.

In 1998 the BLM decided to open up 87 percent across the northern part of the NPR–A to leasing, including areas within the Teshekpuk Lake Special Area, yet, none of those leased areas have been developed. That Record of Decision did protect the goose molting areas and some other places around Teshekpuk. Yet in 2005, the Bush administration rescinded those protections and pressed for full development in the northeast portion of the NPR–A, including Teshekpuk. That decision was challenged by lawsuits (WCS is not a litigious organization, and was not part of the lawsuits). The lawsuits offset those development plans, such that the drive for complete development of the region resulted in none. Subsequent planning by the BLM has led to minor leasing in tracks south of the Teshekpuk Lake Special Area in 2010. Protection from leasing throughout most of the Teshekpuk Lake Special Area has been proffered by the BLM since, as they have recognized the importance of studies like ours in indicating the wildlife importance of this region.

The most important conservation study in the NPR–A involved no wildlife data. Rather, in the fall of 2010, the USGS released the results of intensive investigations of the distribution of oil and gas in the NPR–A. Astonishingly, in contrast to previous estimates, the USGS study indicated that only 10

During the George W. Bush administration, in anticipation of the opening up of the Teshekpuk Lake Special Area for oil development, oil exploration companies had built a staging area in the northwest section of the wetland. Through legal suits the conservation community prevailed in protecting this important Arctic wetland. *(Photograph by Subhankar Banerjee, July 2006.)*

percent of the oil originally estimated lie underneath the NPR–A. Instead of a continuous oil deposit in the so-called Barrow Shield that runs through the Teshekpuk Lake region, there is a sudden shift from oil to gas deposits at longitude 153° west. This surprising result helps explain the prevalent pattern of lease *relinquishment* west of Teshekpuk Lake that has happened since the 1998 purchases.

The quest for protection of the Teshekpuk Lake Special Area, and of the remaining wetlands, and of the other special areas remains uncertain. The BLM is currently engaged in developing a comprehensive plan for the entire NPR–A. How much wildlife protection will be afforded by that effort, and whether such protection is permanent, is unclear. Recent planning by the BLM suggests that protection in the Teshekpuk Lake Special Area seems likely, but it is not clear whether such protection is simply the absence of leasing or, instead, the establishment of real protection.

An even larger threat to wildlife is looming in the Arctic now. The Inter-governmental Panel on Climate Change estimated that the Arctic has warmed at an alarming rate, twice the global average over the past hundred years. The rapid decline of summer sea ice is well documented and is dramatically affecting polar bears and many marine species. Less appreciated are the accumulating effects on Arctic landscapes, which include dramatic changes in topography due to melting of permafrost, and a tendency toward the drying of landscapes, which has led to the desiccation of lakes, and transition from wet to dry tundra, in some regions.

Permafrost—the perennially frozen soil, just below the thin topsoil is warming and melting. Permafrost melting could hasten annual drainage of water in the wetlands, as tundra polygons and other permafrost structures that normally help hold water like small dams, would be "breached" and more water would flow out by streams and rivers to the Beaufort Sea. Alaska's Arctic shorelines are disintegrating and eroding, as stronger storms hammer a more exposed (because the ice has receded) and softened (because of the melting permafrost) coast. Such storms change the near-shore habitats to more salt-tolerant sedges.

The main concern as the Arctic warms is that this region—a desert by annual precipitation measures—risks drying up in many areas. Evaporation is expected to exceed even the projected greater precipitation in the region's rapidly changing climate. As the wet tundra is the most important wildlife habitat, drawing in millions of nesting migratory birds and calving caribou on the coastal plain, the risk of desiccation of shallow ponds and meadows is a

tremendous concern. Large lakes are not expected to be dramatically affected, but drying of small ponds would likely affect phalaropes and perhaps much of the insect productivity that arises from such ponds. Reduction in lake volume could affect fish populations, and thus the birds that feed on them: loons, terns, and sabine gulls.

One major long-term risk in the wetlands due to the warming climate is "paludification"—the transition to more peat bog–like habitat replacing wet tundra. Such a transition would dramatically affect insect populations, as bogs are comparatively sterile water bodies, while the existing wet sedge tundra produces abundant aquatic insects with aerial adults so important to shorebirds and songbirds.

Arctic shorebirds that breed in the tundra leave with fledged young to Beaufort and Chukchi Sea shorelines to feed again as "shore" birds and gain fat reserves necessary for molt and migration southward. Eroding shorelines are a conspicuous feature of the changing climate. With sea ice receding, storms increasing in strength, and permafrost melting softening the shore, erosion is increasing. Environs north of Teshekpuk Lake have eroded more than a kilometer inland over the past fifty years, and in one year eroded fully one hundred meters inland. If and how this is affecting shorebird feeding is unknown.

The seasons are also changing dramatically. Winters are milder, springs come sooner, and falls linger longer. As we have seen with our own eyes, the seasons of flowering, and of animal movements are being reshaped. Our studies of nesting birds, coupled with previous data from the 1980s, show a significant advance in nesting, with shorebirds and songbirds breeding more than ten days earlier, on average, than three decades ago. The pattern of earlier nesting would seem to alter these birds' complicated annual cycle of migratory movements and their need to solve energetically stressful activities around the calendar year. Arctic breeders arrive here after long journeys, hungry, then gain energy by voracious feeding to meet the energy needs for incubating eggs, raising their young, replacing body feathers, adding fat for migration, and then fly south again. There, they replace more body feathers, build up fat reserves, again, and begin migrating north—all in a calendar year with little room for temporal adjustment, as each phase involves a precise choreography, timed with food availability. Shorebird migratory movements north and south also typically involve stopping over at wetlands when those wetlands are most productive.

Yet the earlier Arctic springs are altering that calendar, advancing the peak of insect abundance. As these birds hatch their young to coincide with such

peaks, we believe that earlier nesting is an attempt to match hatching of their chicks with peak insect activity. For the past two years, we have added insect sampling in the tundra and in tundra ponds to understand when that peak is, and we hope, through time, to see if it, too, is advancing.

To test this idea, our field crews sweep our sampling ponds with a small net meant to capture aquatic stages of insects that will soon metamorphose into flying adults and potential prey of shorebirds. We also employ "pit fall" traps, where terrestrial insects stumble into long trays with a layer of weak antifreeze that preserves such insects for subsequent sorting. This sampling is part of a larger, coordinated effort across many research sites in the North American Arctic as we try to assemble basic data on the impacts of warming in the region. Will these changes soon lead to a so-called "phenological mismatch," where these migrants can no longer arrive in the Arctic in time for the earlier spring flush of insects?

And how will migratory birds deal with the "double whammy" of climate change? They are facing the warming Arctic in the north, yet many species are also facing predicted rising seas flooding their wetlands in the south. Rather than escaping the effects of the changing climate with their ample capacity as world travelers, they are being affected by different climate effects in their different ports of call, thousands of miles apart.

The Arctic is also changing with an invasion from the south. The low, flat world of tundra is getting woodier, and there are clear signs of shrubs and small trees creeping northward. We saw a large forest of tall alders well north of the Brooks Range last year on a raft trip down the Utukok River. This forest was filled with American robins, a species more typical of lower latitudes.

Boreal animals from the south are becoming more common in the Arctic, and, in effect, moving northward with the vegetation and climate changes. Numerous waterfowl species, like greater scaup and American wigeon, have been arriving here outside their supposed breeding range. The red fox is encountering and supplanting the Arctic fox. A few years ago, we encountered Arctic fox regularly and red fox rarely. Now our encounter pattern has reversed. We have monitored nests with cameras in order to understand which species are the most prevalent nest predators, and this year we have detected more red fox preying on shorebird nests than ever before. (We also recorded a few Arctic fox predations of nests this year; they are down, but not out.)

In the late summer of 2008, we set out to initiate a new study on the Arctic Ocean coastline north of Teshekpuk Lake. Our goal was to investigate how "post-breeding" shorebirds that flock to the shoreline may be impacted by

the intrusion of saltwater into their foraging habitats. To do this, in late July, we chartered a bush plane and began the logistically challenging and costly endeavor of establishing a new field camp on the shores of the Arctic Ocean near Pitt Point, Alaska.

We learned quickly that the Beaufort Sea coastline is a completely new environment compared to our previous inland camp location. A fog belt was always present, either sitting ominously a few miles off the coast or blanketing our camp in a thick pea-soup mist. At times, visibility would be cut to less than one hundred yards. As we scouted out the surrounding terrain to select transect locations where we planned to survey shorebirds, we quickly came to discern the salt-killed tundra patches. These denuded areas didn't seem to offer much in the way of food or cover for foraging birds. From the air, we noticed this dead tundra to be tinged a sickly red color in large patches along parts of the coastline.

The ocean itself was dramatically eroding away the adjacent tundra. Up and down the water's edge, large chunks of tundra the size of houses were toppled over and leaning into the surf. We could see that the white bands of ice within the exposed permafrost were quickly melting, now that they were exposed to the elements.

On our fifth day since arriving at the new site, we were finally ready to start our shorebird surveys. The weather was uncharacteristically sunny, although the fog band lurked menacingly off the coastline as usual. As we were preparing to get to work, we noticed something white on the horizon moving toward us. After only a few moments of concerned staring, it became clear: a polar bear was heading our way. We grabbed our shotguns and cans of pepper spray in case we needed to fire some warning shots to scare the bear away from our camp. A few hundred feet away from us, the bear approached and slowly sauntered around our camp. Every once in a while the bear would rear up on its hind legs and check us out with its head tilted to the side. It didn't appear to be too concerned about our presence and seemed to be looking at us as a curiosity. Eventually, after some time the bear laid down on the beach not too far from our camp and appeared to fall asleep to the sound of the crashing surf.

Back at camp, we weighed our options. Although we've taken precautions to protect ourselves from curious bears, the camp would still be vulnerable while we are out in the field during the daytime, and while asleep at night. The prospect of keeping a round-the-clock vigil while trying to conduct our fieldwork was not a viable one with such a small crew. We eventually came

to the difficult decision to evacuate the camp. Just as fast as we arrived, we had to break down camp, pack up, and leave.

As the Arctic ice cap continues to shrink in size, polar bears lose their icy hunting grounds and, just as importantly, they lose their mobility. Although they are adept swimmers and can go long distances in the water, they do have limits, especially young and old bears. That same year, polar bear biologists working in Alaska reported more polar bear sightings on the Arctic Ocean shoreline than in many previous years. This appears to be a growing trend. Landlocked polar bears have limited options. They either have a long, potentially treacherous swim to the distant ice pack where their best hunting opportunities await, or they must try to eke out a living in the terrestrial environment to which they are less suited. The bear that visited our camp may have been one of these landlocked bears.

The true irony is that the reason we went to this remote section of coastline was to study the very thing that may have resulted in us and the bear crossing paths—climate change.

The best available conservation "tool" in the toolbox dealing with the changing climate is in the protection of large areas to help systems "buffer" against the manifold changes. Here, again, the importance of the Teshekpuk Lake Special Area as a critically large area of habitat for wildlife is evident.

We have been among the very few to experience the rhythm of the summer in this remote region, with the multitude of bird nests, caribou passage, and wonder of this immense landscape under the twenty-four-hour sun. It is worth protecting for its international assemblage of wildlife and its distinctive and essential wetlands. We hope all Americans can become aware of this international treasure on our public land, and help conserve it now, and into the future.

Protecting the Apples
but Chopping the Trees

ANDRI SNÆR MAGNASON

❖

Initially I had imagined only including essays about Arctic Alaska for this volume. But when Anna Lui, then an editor at Seven Stories Press, suggested that I contact Andri Snær Magnason, a young celebrated novelist from Iceland, to write a piece for Arctic Voices, *I thought it'd indeed be good to expand the scope a bit and ask him to share a few stories from other parts of the Arctic and subarctic. In one e-mail, I wrote to Andri, "What I'm doing with the anthology is not a top-down approach. I have loosely set the vision and scope, but it's titled 'Voices,' so it's your voice." I urged him to "tell us a beautiful story." He did. With his masterful narrative he takes us on a whirlwind journey: In Iceland, just one corporation, Alcoa, has caused havoc for the entire nation; and in Greenland, the story is only beginning. As I was wrapping up the contracts for this book, Andri e-mailed me on November 2, 2011: "Just came from Greenland a few weeks ago—extremely interesting to be in Greenland. They are sixty thousand; 30 percent have more than elementary education; and they have*

projects on their table that sum up to 1,000 percent of the GDP. In Iceland, we crashed because of a bubble in a project that was 25 percent of the GDP." The essay that follows was written by the author for this anthology in Icelandic. It was translated into English by Salka Gudmundsdóttir.

✤

I WAS looking at my grandfather's collection of negatives the other day. My grandpa lost his father when he was eleven years old. He left school and started supporting the family by becoming a delivery boy. He still did well. He was lucky because the workers' union had recently built apartment buildings for the poorest people in Reykjavík. The ambition was such that these were practically the best flats in the town around that time, featuring a flush toilet and an electric cooker. In the cellar there was a small room, which he used as a darkroom. Now he sits by his computer, scanning in those photographs, and what a treasure they are.

He became an accomplished athlete, and, later on, a skier and mountaineering enthusiast. His was the first generation to climb mountains just for fun; his parents' generation would never have thought of scaling a mountain only to ski back down again. He met my grandmother in 1955. They got married in 1956 and went on a honeymoon up to Vatnajökull, Europe's biggest glacier, the next day. It wasn't an actual honeymoon but a three-week research trip to measure the annual precipitation on the glacier. At the time, it was the equivalent of a polar expedition, with inferior maps, limited telecommunications, and completely unexplored terrain. The group built a lodge by the edge of the glacier. It was to be the future site for a glacial research lodge.

My grandpa's photographs clearly show the incredible changes that have taken place in the past fifty years. The lodge is now located around five kilometers from the edge of the glacier. Glacial terrain currently covers approximately 10 percent of the country. According to predictions, Iceland's glaciers will mostly disappear in the twenty-first century if the present trend continues. It is a strange sensation to stand on top of a glacier, with a two-hundred-meter–thick ice mass underneath your feet and with nothing but glacier spanning the entire horizon, and imagining that over the course of one lifetime—my own lifetime, even—all of this will disappear. Something that was considered almost eternal, something like the ocean, a mountain, or the sky, has gone from living on a geological scale and moved toward the scale on which we humans live.

Icebergs in Iceland's Jökulsárlón Lagoon, which is growing as the Vatnajökull Glacier—Europe's larg-est—melts. *(Photograph by Olaf Otto Becker, 1999; from his book* Under the Nordic Light: A Journey through Time, Iceland 1999–2011, *published by Hatje Cantz, 2011.)*

This reminded me of a documentary about a Native tribe in Indonesia that had sold its land to a woodcutting company. When the forest had been chopped down and the land was left behind, scorched and bare, they were, of course, completely devastated; all their lives they had lived in a dense forest, and even though they had sold the forest, they couldn't imagine what they were doing when they sold it. The forest had been so dense, so alive—so strong. The idea of "not forest" was unthinkable. They didn't even have a word for that condition.

Even though I pretend to understand what scientists say—that the glaciers will disappear; even though I read research papers, shut my eyes, and try to picture it all; and even though I see computerized images of the country as it might look like when the glaciers recede—I still don't understand it. I've read up on what will happen in other parts of the world if this occurs. Areas where several hundred million people live will possibly become uninhabitable because of water shortage. It hasn't happened yet, and I don't think I really understand it. It hasn't changed any major aspects of my behavior. I go with the flow. I fly overseas more than ten times a year—something that began after I got involved with environmental issues. I have a carbon footprint the size of a *Tyrannosaurus rex*.

The consequences of the warming have started to show. The temperature of the ocean around Iceland has gone up, and regional species are moving farther north while southern species can be seen in Icelandic fishing territories. Mackerel swam into all of the country's harbors last summer. My friends caught several while angling and had great trouble: nobody knew how to cook this fish. Cliffs that have always been teeming with birds living off capelin and other fish were left half empty; puffin burrows were full of chicks that died of starvation because the sand eels were a no-show. We own an abandoned farmhouse in the northernmost part of Iceland, almost on the Arctic Circle. Some of the Arctic terns that fly there every summer to lay their eggs come from the Antarctic. No animal in the world migrates as far a distance as the Arctic tern. If you go too close to the nesting grounds, they usually attack you like a swarm of bees, scream at you from all directions. But last year they hovered in the air, silent and alone. The chicks were all dead or dying of starvation and the terns tried to catch flies, even butterflies, to feed those still alive. The nourishment you get from a fly comes nowhere near the protein of a sand eel. The silent terns had an apocalyptic air to them.

But the discourse on these issues is generally positive in Iceland, and a large part of the nation is skeptical. We're familiar with rapid changes in nature.

We know that underneath Vatnajökull there are remnants of farms from the Viking Age. People ask, "What made the glaciers grow so small back then?" People long for better weather. The rise in temperature has already enabled us to grow more corn, more fruit, more kinds of trees. But the changes are more rapid than they've ever been before. When the weight of the glaciers disappears, geologists expect more volcanic activity, when the crust of the earth will rise from beneath the burden. I don't think I've ever thought of it this way before: Man treads so heavily on earth that even the volcanoes start erupting.

Icelanders are hoping to find oil. North of the country there lies the so-called Dragon Area, which reaches into Norwegian territorial waters. We want to find oil, but we don't actually know anything about oil. We know our glaciers are melting because of oil, but we still want to join the party. Norway is our great role model in matters of oil, and we would love to become like them. We want to be rich; we want to live the good life. I can hardly remember any negative news being presented to us about oil drilling in Norway, not a single negative article about the negative environmental impacts of their drilling. All reports are positive. The Norwegian oil fund is a shining example when it comes to ethical investment. Finding oil means finding security and happiness.

All hell broke loose in Iceland during the parliamentary election campaign in 2009, when a left-wing MP said in a television interview that maybe we shouldn't be looking for oil. That oil was destroying the earth's atmosphere and that if there was oil on the continental shelf, we should just leave it alone. It's hard to shock people nowadays. But she provoked a wave of anger and ultimately lost her seat in parliament, and her allies from that greenie party had to retract her words. This was before the BP accident. The accident has helped give us a slight understanding that drilling comes with a risk, that a black hole might possibly open up north of the country like in the Gulf of Mexico. In cold water, an accident like that would be even worse. But somehow it seems as if people's experiences in one place don't transfer very easily elsewhere. Even though catastrophes happen—*Exxon Valdez*, the BP spill—it still doesn't have an effect. Although people see the glaciers melting and know that the world's oil supplies may run out, it's as if we don't understand things until we see them appear on the horizon, don't understand words until we go through the real meaning of them ourselves. We want companies to drill not far from one of our best fishing grounds. People hope the search will begin as soon as possible and that they'll find as much oil as they can. As much as possible.

There is a small town in Northern Iceland called Thórshöfn. It's the most remote village in Iceland. It has 480 inhabitants, and they mainly live off of fishing. They've

had a new site plan made, making provisions for two runways for jets, as well as a gigantic harbor for an oil tanker and freighters. They are living in the hope that soon oil will be found in the sea about three hundred kilometers north and that you will be able to sail to Asia through the North Pole. They've had the Chinese ambassador over for a visit and are very excited. In the fjord where Alcoa has just opened the biggest aluminum plant in Europe, they're planning for an oil depot measuring 450,000 cubic meters. That is five times bigger than the oil depots in the capital, for the same reason: to ensure business, in case oil is discovered north of Iceland. In the West Fjords, a town council has conducted discussions with an unknown Russian oil company that wants to build an oil refinery by Arnarfjordur, one of the most beautiful and vulnerable fjords in the country. If someone were hoping for resistance from the northern noble savages—saving the last frontiers of earth—he might become quite disappointed.

When Icelanders became Christians a thousand years ago, in the year 1000 CE, Icelandic poets went through a bit of a struggle. Icelanders had believed in the heathen gods since time immemorial, and there was an extremely strong poetic tradition in the country at the time: poets would sail to Norway and compose poems of praise about kings, according to strict Nordic meter. As a reward, they would receive ships or rings of gold, and great honor, of course. But the language of poetry was different from the language of the everyday. The poetic language was based on Nordic mythology. In a poem, the hero did not sail across the ocean; he was "riding his sea horse." They didn't say "earth" in a poem; they said "the bride of Odin." And people wouldn't say "sky," but "helmet of the dwarves," in accordance with the polytheistic view of the world. How could a Christian poet write about God—the creator of heaven and earth—when the poetic tradition would force him to call God the creator of Odin's bride and the helmet of the dwarves? The first poets who wrote about God really struggled. The worlds collided. You couldn't say Jesus, without saying Odin and referring to the world of the Norse gods. It took decades—if not centuries—for the new way of thinking to sink in. It took time to adopt new legends, new metaphors, new phrases. That sort of thing doesn't happen overnight. It's hard for us today to understand that once, ideas such as sin, grace, and mercy were new to the language. Concepts like Jesus and crucifixes didn't have any symbolic reference beyond Jack or Y.

And so you can forever find areas where we underestimate language, where our possibilities for expression are limited—often without our knowing. I don't necessarily mean the Icelandic language, but languages in general.

Freedom and independence are ideas we take for granted. It's even considered natural to send bombs off into the world in order to bring people freedom and

independence. Iceland was under Norwegian and later Danish royal rule up until the year 1944, when we gained independence. In primary school I was taught that the Icelandic people had spent six hundred years yearning for freedom, but that the nation had been oppressed and held down by greedy kings. They forbade people to do business with anyone apart from Danish monopolistic merchants who exploited the people. In the summer of 1809, a bizarre revolution took place in Iceland. A British soap merchant wanted to conduct trade with Icelanders, but the Danish governor forbade it. The British merchant reacted by arresting the Danish officials. This proved easy since there were no armed forces in Iceland. The British soap merchant appointed his interpreter, Jörgen Jörgensen, as governor. That man took his role very seriously. He was inspired by the French revolution and sent out a declaration claiming Iceland was free and independent, and that all men were equal and would be able to vote for parliament the next summer. Then he went even further than the French revolutionaries: everyone would be allowed to vote, not only those possessing land or property. The Icelandic people responded unenthusiastically, since nobody had ever talked of, or asked for, independence. The idea had never been mentioned. Jörgen was disappointed when nobody joined up with him, praised him, or took advantage of this freedom, even though 90 percent of the nation were land tenants. For sure, people were unhappy and oppressed, but they had no idea that wasn't how the world was supposed to be. The main leader of the Icelandic nation at the time said, "Independency cannot be the wish of any good Icelander." Ultimately, this short revolution came to nothing. The Danes took over again and everything went back to the way it had been. The idea was so exotic that people didn't even understand what was being talked about. People turned down the idea of voting for your own government as if it was merely some sort of a joke, and they mocked Jörgen, calling him King of the Dog Days, when his aim was, on the contrary, to bring people power and freedom from kings. Iceland's independence hero, Jón Sigurdsson, wasn't born until 1811—and it took more than a hundred years of poems, speeches, declarations, and essays for the people to really understand what this Jörgen Jörgensen guy had been talking about back in 1809.

In Iceland, and maybe in the world in general, the word *sustainability* is a fairly recent addition to public discourse. It is often used—I hear it almost on a daily basis—but I don't think we fully understand it. People use it for different purposes. Sometimes I wonder whether it will take us a hundred years to understand the concept, or whether we won't understand it until we've actually reduced the rights of future generations, or our own rights, to a decent life and environment. The word in English and Icelandic (*sjálfbærni*)

exists as two domains in Iceland: www.sjalfbaerni.is and www.sustainability. is. Both are owned by the aluminum company Alcoa.

Iceland is a fairly large island with regard to the size of the nation. Three hundred thousand people live on a hundred thousand square kilometers, but almost all live by the coast. The highlands feature an incredible landscape with hot springs and waterfalls, black deserts with lush oases in between, trackless terrain and glaciers, volcanoes, craters, unbridged rivers, mossy mountains, and unnamed places. In a handful of hours you can experience many types of landscapes. The nation is small; in order to provide renewable hydroelectric power for the entire nation, it only takes a few small dams. The nation needs around two hundred megawatts, and if it wanted to power its fleet of cars and ships, it would take about as much more. Because of the location of the country, the relative overabundance of hydroelectric energy, and the small population, the country is automatically preserved and pristine. There is no economical way of disturbing it—but thanks to aluminum, one energy-intensive metal, it has become possible to ruin many of the most beautiful and vulnerable places in the country. Places that should be on UNESCO's World Heritage list have become the main political conflict in Iceland.

The fact that Alcoa owns the domain sjalfbaerni.is—sustainability.is—is perhaps a sign that we still need to say Odin in order to say Jesus. To say nature, we need to say "Bride of Alcoa."

In Iceland, the environmental struggle revolves around "clean energy," or the dark side of clean energy. Iceland escaped mostly unscathed from the industrial revolution by developing our energy slowly and gradually. The capital Reykjavík is geothermally heated, a practice we began in the midst of the great depression of the 1930s, and in Reykjavík, the last coal-powered energy plant has been empty and abandoned for more than thirty years. Just after 1990, we had reached a place that you might call the End of History. We had built up a pure and renewable energy system, and we were heating our houses with sustainable geothermal energy and our companies with hydroelectric power. We only needed a method to power our ships and cars with these same energy sources. We had started to solve problems relating to overfishing and tried to stop erosion on land from centuries of overgrazing. A nation that obtains all of its energy from domestic and renewable sources, catches 1 percent of all the fish in the world, and is able to do so without reducing the fish stocks should be in a good place.

But this achievement wasn't defined as freedom; rather, our engineers and contractors defined it as a problem and a crisis. The nation didn't need more

energy. We had glacial rivers running freely into the sea—but this was called running for nothing, running to waste, throwing the gold into the sea. An unspoiled country wasn't something to be happy about. Engineers calculated how much we were losing every day by letting a waterfall flow unharnessed. They constructed an expansive market system praising Iceland as the dream destination for heavy industry. But the problem was that hardly any companies in the world need two hundred to six hundred megawatts at one go. Practically the only companies in the world that require that much energy are aluminum corporations, which are not only the most energy-intensive in the world but also the most intensive by a mile: one factory uses up energy on par with the energy consumption of a city of a million people. They built a two-hundred-megawatt dam in the 1990s, but there was no interest in the energy. It stood unused for ten years. But then energy options in Europe and the Americas started to abate, and at the same time there was a boom in demand from China. The aluminum industry fled from urban areas and sought out places with "stranded energy" and "still untapped resources," names used by the industry to describe unspoiled nature. And thus a tsunami began, the end of which is not yet in sight. In the name of clean energy, we are going to increase the emission of greenhouse gases in Iceland by as much as the emission of a million cars.

In East Iceland there were two mighty glacial rivers. One of them flowed from beneath a glacier at an altitude of six hundred meters, first forming a kind of herbaceous wetland before tumbling off the edge of the highland ridge and running across ledges for six hundred meters, thus creating many of the most beautiful cascades in Iceland. From there on it flowed into Lagarfljót, a remarkable greenish lake thought to be the home of our very own Loch Ness monster.

The other river was called Jökla, and it flowed a rusty brown from beneath the glacier, through a grassy, untouched valley full of Ice Age remnants before streaming through two-hundred-meter-deep canyons, from where it wandered across black sands that from the air resemble silken threads. This river was unique because seals would swim up to ten kilometers upriver where they gave birth by its banks. Farmers used to catch hundreds of them in nets every year.

Both rivers were upset for Alcoa's sake. One river was dammed and the cascading waterfalls dried up. They drilled a seventy-kilometer-long tunnel to divert water into a reservoir behind the biggest dam in Europe. The great muddy river with the seals became a stretch of dust as it was diverted into the greenish lake. Put together, the area reached by Alcoa's influence measures around three thousand square kilometers. Almost all of the waters of East Iceland were turned

around and rearranged and altered for the sake of one aluminum company. The raw material comes from Jamaica and Brazil, where they plow down the jungle to obtain bauxite through open strip mines, which is then processed with lye, which is then sent by ships across half the globe as white powder known as alumina. We've become addicted to this white powder. This whole process is considered sustainable according to Alcoa's website. It sustains *humans,* they say; it's for the good of four hundred workers and the local community.

I once read a book to my son, a watered-down Disney version of *Winnie the Pooh.* Winnie meant to catch a fish. But when Winnie had caught the fish, the fish looked at him sadly and said, "Don't eat me, Winnie!" So Winnie let the fish go and the storybook had a happy ending with Winnie sitting down to roast a hot dog. Because a hot dog obviously isn't an animal. (They didn't say where Piglet was, though.)

While the sale of sealskins is prohibited in Europe, you can still spoil their habitat and sell the products created in the process. Aluminum isn't furry. It's not a seal, nor a jungle, nor a nesting ground. We've actually created the same ridiculous nonsense you could see in that Winnie the Pooh storybook. The sale of animal products is prohibited, but you can sell the products of a factory that ruins their habitat. You're not allowed to pick the apples but you can chop down the tree.

There should be a label on soda cans that shows what was sacrificed for the packaging, just like cigarette packets that say "smoking kills." In the US alone, around eight hundred thousand tons of aluminum cans get dumped every year without being recycled. This amount of aluminum would suffice to renew the commercial air fleet of the US four times a year. If all were as it should be, there would be a cradle-to-cradle system for these cans. You shouldn't need a gram of new aluminum to serve this market. If things were as they should be, people would be drinking water from a faucet.

People wax lyrical about the New North, areas that until now have been marginal and on the defensive. Technological advances have taken over from manpower-intensive agriculture and fishing industries. Villages have gone into decline. Middle-aged and older men are at the helm, and they can still remember the time when men would move from the countryside into town with a wife and four children to do proper hard work. Those villages have declined and many of them have been unable to renew themselves, to find a new industry or other opportunities for other kinds of education. A bitterness and anger over years of decay makes people greet big corporations with open arms. There seems to be

no antidote for men with shiny PowerPoint presentations. There doesn't seem to be much will to expose the PR language surrounding "state-of-the-art" factories.

If I tell someone he's probably not the best man to beat Kasparov at chess, he won't be insulted. If I tell the same man he has no business conducting negotiations with a global corporation, he will, however, feel slighted. More often than not, grandmasters of negotiation are dealing with mayors who have previously run one kindergarten school and taken care of maintenance on a couple of streets and sidewalks, and given four teenagers summer jobs.

After years of decay, people envision a new life and a new context, and even hope for a better life. In Eastern Iceland, the majority was prepared to sacrifice their nature for the hope of a better future, for the hope of security, for the hope of independence, even on Alcoa's terms. The corporation gave them four hundred jobs and a million dollars to build a sports center, but in exchange, Alcoa got six hundred megawatts for forty years, energy prices that save Alcoa $200 million a year. The CEO of Alcoa, Alain Belda, got a $20 million bonus the year he landed the deal.

A factory the size of the Alcoa plant and six hundred megawatts ought to be enough for a nation of three hundred thousand, but when you strike a lousy deal, it hardly leaves enough behind to maintain the town where it's located. A community of five thousand people in Eastern Iceland now catches 0.2 percent of all the fish caught by mankind and smelts 1 percent of all the aluminum in the world—but people are still moving away. Two hundred empty apartments bear testament to the shattered expectations. Alcoa will pay a minimum price for the energy for the next forty years so that Landsvirkjun, the state energy company, delivers the nation no profit. We were told we were sacrificing nature for the sake of the economy, but like in a fable by Aesop, we sacrificed both nature and the economy. Real estate prices tripled, the banks poured foreign loans into society, and the price of stocks multiplied until it all collapsed.

An investment of this kind is like a trap. A $3 billion investment causes great economic activity. It creates around five thousand jobs during construction, filling people up with enthusiasm and optimism, and making them invest in equipment and take bets on future growth. But as soon as the factory opens, as soon as it starts running, four hundred people get jobs at the factory—but thousands lose theirs. Contractors are left without projects, and mortgaged equipment stands unused. Engineering companies lay off highly educated people. Society's turnover plummets tax revenues and consumption slumps. Instead of the age of prosperity beginning once the factory opens, you might call it the beginning of the recession. An investment of this kind is like a shot of heroin for the economy—not a shot

of vitamins. The downturn begins as soon as the fun is over. And then what's the solution to the recession? To build a new factory and more power plants. The solution isn't having already built a dam and an aluminum plant, but to keep building dams. And because people always negotiate in times of recession, their only thought is to obtain a deal as soon as possible. Contractors, labor unions, politicians, and not least of all locals—all longing for a new era, a new industry, the hope for a better future—come together to procure the most conveniently priced resources for the big corporation, even subsidized by the state, creating special laws and exemptions regarding taxes and pollution.

And so this way of thinking has spread all over Iceland, raising hopes in the hearts of town councils in charge of small villages on the defensive, with majestic nature in their backyard—also called untapped energy sources. Suddenly the primal energy need of a town of two thousand people becomes no less than six hundred megawatts, and the basic industry for survival becomes no less than a 350,000-ton aluminum plant. Can you imagine a more fabulous situation for corporations? In Iceland there are two villages at this exact stage right now. Locals say that areas that were once meant to become national parks are actually quite ugly.

In this way, a multitude of areas in Iceland have become endangered concurrently. Thjórsá River, in South Iceland, is home to the largest salmon stock in Iceland, and it's in danger because there are plans to dam the river in three places. By the source of the river there lies Thjórsárver, a unique wetland located six hundred kilometers above sea level. Altogether the area spans around two hundred square kilometers. It's on the Ramsar wetland list, unsurprisingly, since it's the largest nesting ground in the world for pink-footed geese. The pink-footed goose is the only species of bird that almost completely relies on Iceland. There has been an ongoing struggle for the future of this area for almost forty years. The energy company keeps bringing new ideas about power plants in this place whenever the last one gets turned down. Originally the idea was to sink the area in its entirety. In 2002, the idea was to put a reservoir measuring forty square kilometers in the middle of the area. Much was at stake back then. Since Century Aluminum wanted to enlarge its plant, contractors wanted to start work as soon as possible. The council in the town that's closest to the plant said only dreamers wanted to protect the area, that it wasn't anything special, and that when there is a choice between people or geese, people should choose people. Century is owned by Glencore, the notorious commodity trading conglomerate.

In Husavik, in North Iceland, Alcoa has been trying to get at three geothermal areas—all on a Yellowstone scale in terms of natural beauty—to power a new 350,000-ton aluminum plant. Then we would have earmarked nearly all the

energy in the north and all the energy in the east for Alcoa. Also, all energy in the south would be earmarked to Century Aluminum and Rio Tinto. The production of aluminum has doubled, and the industry is fighting to get to double again, up to almost 1.5 million tons. We can see the PR machine becoming stronger every year.

All of this is happening in the twinkling of an eye. Over a period of ten years, people have kicked off an industrial revolution, the end of which is not in sight, letting us grow toward becoming reliant on specific industries that will require growth in the future—industries where company interests don't match the public's best interests. We see headlines such as "a billion in export earnings," but in reality, only a small fraction of that amount ends up in the Icelandic economy. People have been sympathetic toward the needs of a dying village. If the locals want something, they must be right. They must know what they're doing. But you might make the claim that people who haven't been hurt by pollution don't actually know what pollution is. The Icelandic government not only promised low energy prices but also Minimum Environmental Red Tape, to attract corporations.

The aluminum industrial complex in Iceland has shown it is prepared to destroy the habitat of birds and seals, drown hundreds of square kilometers of vegetation, and spoil 5 percent of the salmon stock. When glacial rivers are blocked, over time—it might take twenty to a hundred years—the reservoirs fill up with mud. After that, you can no longer produce electricity. When you balance out the fluctuations of fluvio-glacial waters, it affects the marine life. The largest rearing habitat of cod is based around the fluvio-glacial waters on the south coast of Iceland, and the fry hatch to the rhythm of the spring floods. The glacial water is full of dissolved chemicals, which nourish the flora and fauna of the sea.

Century Aluminum has a factory in Hvalfjördur, just outside Reykjavík, and has started to build another factory close to Keflavík. In order to power the factory, three to five geothermal power plants must be built around Reykjavík. Geothermal energy is clean and renewable up to a certain point—you open up a hole in the ground and it blows steam—but the steam is accompanied by an enormous amount of SO_2 and H_2S. Already, pollution from SO_2 and H_2S has become so high in Reykjavík that silver—silver jewelry, silver spoons of grandmothers, silver in computers and other fragile technology—grows black in a matter of days, and moss has started dying in a fairly large area surrounding the factories. The energy isn't renewable except up to a certain point. If you act too fast, it's like letting air out of a balloon: the areas become useless for electricity production in only a few decades.

Now, levels of fluorine pollution near Century Aluminum's factory have been measured at nearly dangerous levels in sheep. Horses living close to the factory have caught strange diseases, their hooves have become deformed,

and they have died. Suddenly, pollution has become something other than the nagging of officials, something other than European regulations, guidelines, levels, negative talk, and a threat to the economy. Suddenly it's a question of animals dying, and people have started to wonder: What is the long-term effect on people? They keep drilling and opening up new holes. You need more energy to power the aluminum plants. Will we need to truly experience it for ourselves to understand? But all of this wouldn't be possible if there wasn't one metal in the world that requires thirty times more energy than steel. Without aluminum, Iceland would practically be automatically preserved, due to its isolation. All of this is sustainable. Having fulfilled our needs with pure energy, we define the situation as a recession and seek all possible ways to turn our nature and the country's vascular network into a dead product.

<p style="text-align:center">* * *</p>

Iceland has the energy and the fish, but not much else that anyone might be interested in. But just across the sea lies Greenland, and Alcoa has arrived in Greenland to repeat their shenanigans from Iceland in a slightly different context. In Manitsoq, the population has shrunk from 3,200 down to 2,800 over twenty years. The young people go abroad to study and don't come back, or get no further education at all. Manitsoq is a gorgeous place, an island—in fact, Greenland's land transportation is actually so bad that every single town is practically an island.

I met a group from Manitsoq that had come to Iceland to have a look at conditions in East Iceland. An older man in the group said something in Greenlandic. The man next to him translated for him. "Is nature more important than man? Why can't you sacrifice nature in order to have a good life?" And another old man said: "We shouldn't let the waters run to waste."

But nature aside, I thought: If a three-billion-dollar investment is enough to capsize the Icelandic economy, how much will it take to overheat Greenland's economy of sixty thousand people and put it into meltdown? The effect is in some ways predictable. In a small town, rent gets out of control once engineering companies and construction workers begin to settle in. Small local businesses can't compete and close down. The poorest are pushed into the margin of society. Contractors show up and take out loans to construct buildings that are big, cheap, and ugly. Something happens to the aesthetic sense and people lose control, tearing down historic buildings to make way for more money and ruining the beach or the small-boat harbor. There's always something in all of this hullabaloo that destroys something sacred and unquantifiable. It always happens.

I asked whether this wasn't too big for a small society. But the man told me there were a few dozen so-called lone rangers in town, men who go out and fish when there's fish to be had but do no work in between. These men need to change, he told me. Whether people who have adapted to this lifestyle will want to change is another matter. Whether they will be willing to exchange fishing for monotonous shifts is another matter altogether. Whether Alcoa will actually want to hire them is an even bigger question. This reminds me of the story about this man sitting in his boat, angling for fish. A businessman shows up and says, "If you take out a loan with me, buy a bigger boat and build a factory, you can become rich and retire in about twenty years." The man asks, "What will I do then?" And the businessman replies, "You can buy a small boat and angle for fish."

There is a deep hatred of environmental organizations in Iceland and Greenland, not least among sailors and people in rural areas. In Iceland, Paul Watson sank whaling boats in Reykjavík Harbor back in 1986. A love of whales became the symbol for the stupidity and naivety of foreigners, and whaling became a touchstone for not giving in to "foreign oppression." *Greenpeace* became a mock term in Iceland, a synonym for terrorists. In Greenland, the situation is somewhat worse, understandably, because real economic and social harm occurred over there when the sale of seal products was prohibited in Europe. People actually lost their livelihoods. While reindeer, moose, and wild boar are still being hunted all over Europe, the seal became something you shouldn't use or sell. I remember one of my first political debates, when I was seventeen years old. We ran into a Greek girl who was wearing a T-shirt condemning seal hunting. "What are they supposed to eat over in Greenland?" I asked. "Why can't they eat vegetables?" she said. "Like what, Iceberg salad?"

And this is yet another problem facing the New North. Alcoa isn't the only one to have Greenland in their sights. They've found oil. There are rare earth minerals over there. People want to open up a uranium mine. There are diamonds and gold in Greenland. There are ten to a hundred Klondikes over there, waiting to be opened up. The word for sustainability in Greenlandic, *atajuarsinnaasoq*, has already been hijacked by Alcoa. To open the factory in Greenland is the best thing they can do for the planet, and the humans that will get jobs say the rhetoric. There are probably few places in the world that have more need than Greenland for knowledge and experience of environmental matters, that have as much need for strong supervision and regulations. But when Greenpeacers chain themselves to the oil drilling platform, whose side will the locals be on? Who will be "us" and who will be "them"?

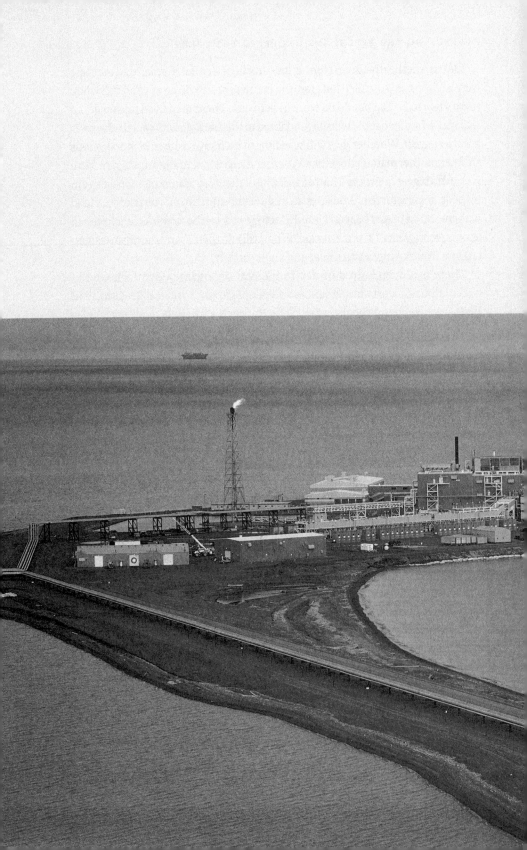

pain and joy
of being connected

Guardians of one of Earth's last and largest wildernesses, the people and animals of the Arctic are hundreds of miles from any significant source of pollution, living in one of the most desolate spots on the planet, yet paradoxically, they are among the planet's most contaminated living organisms. What was once pristine has become a deep-freeze archive that stores memories of the industrial world's pollution. This is the Arctic Paradox, arguably the most severe case of environmental injustice on earth.

—MARLA CONE

Gas flaring at Endicott—an offshore facility operated by BP in the Prudhoe Bay oil fields. It is situated on two man-made gravel islands, connected to the mainland by a 1.5-mile man-made gravel causeway (detail). (*Photograph by Subhankar Banerjee, 2002.*)

from **Silent Snow**

The Slow Poisoning of the Arctic

MARLA CONE

❖

*By 2005, I was mentally exhausted from giving so many talks across the US,
about the Arctic National Wildlife Refuge, since 2001. I was looking to read
again and learn about new things. That year, I read Marla Cone's book* Silent
Snow: The Slow Poisoning of the Arctic, *which had just been published. I
was shocked and angry after I turned the last page. The book's jacket states:
"Traditionally thought of as the last great unspoiled territory on earth, the
Arctic is in reality home to some of the most contaminated people and animals
on the planet. . . . Inuit women who eat seal and whale meat have far higher
concentrations of PCBs and mercury in their breast milk than women who live
in the most industrialized areas of the world, and they pass these poisons to
their infants, leaving them susceptible to disease." The book is composed of
three parts: Part I, "The Arctic Paradox," has six chapters; Part II, "Scientists
Seeking Order out of Chaos," has five chapters; and Part III, "Solutions and
Predictions" has three chapters. On August 30, 2011, I wrote to Marla urging
her to excerpt an essay from the book for* Arctic Voices. *She responded the*

same day, "I would love to have a piece included in your anthology. Would you prefer an Alaska one? I would take that from the Barrow chapter. Or would the Greenland chapter work?" Indeed the book has a chapter titled "A Fish Can't Feed a Village: Alaska's Communal Hunts," but instead, I urged her to excerpt an essay that would introduce the concept of what she calls "Arctic Paradox" and two separate stories from the high Arctic—one from Greenland, and another from Svalbard, Norway. She generously agreed. On July 24, 2011, The Guardian published an article, "Melting Arctic Ice Releasing Banned Toxins, Warn Scientists." The writer refers to Rachel's Carson's famous book Silent Spring, but not Silent Snow. Why? I wonder. Silent Snow ought to be required reading for anyone who cares about the health of our planet, in the same way Silent Spring has since become.

❖

Silent Snow: The Slow Poisoning of the Arctic was published by Grove Press in 2005.

IT IS early evening in late April, nine days since the return of the midnight sun, and a 450-pound polar bear and her two cubs walk on the finger of a frozen fjord. Spring has arrived on Svalbard, about six hundred miles from the North Pole. The mother bear lumbers along, hunting ringed seals, leaving a zigzagged path of twelve-inch-wide craters followed by the smaller paw prints of her two four-month-old sons.

A few miles away, from the front seat of a helicopter, scientist Andy Derocher has spotted the family's fresh trail. The chopper's pilot skillfully loops, spins and straddles the tracks, following their erratic path for several miles. "She's running here," Derocher tells the pilot, pointing to a row of tracks at the edge of a craggy glacier. "I think she's ahead of us here somewhere." One of the world's leading bear experts, Derocher is responsible for monitoring the health of the species.

Etched by harsh winds and ancient glaciers, Norway's Svalbard archipelago is a brutal place, unforgiving of weaknesses. From the moment of birth—even conception—animals here struggle against the odds. Most newborn polar bears die even under the best natural conditions. Yet it is an unnatural threat—a man-made one—that is intruding upon this polar bear nursery and

imperiling the High Arctic. Before they even leave the safety of their dens, Svalbard's polar bear cubs already harbor more industrial pollutants in their bodies than most other creatures on earth.

Born at Christmastime, cradled in pure white snow, polar bears are born blind, toothless, a pound apiece, as feeble as kittens. For four months the cubs nestle in a den carved by their mother on the bleak, snowy banks of a frozen sea, gorging themselves on her rich, fatty milk. Mother bears store a lifetime of chemicals in their fat—peaking in concentration during the winter fast when they give birth—and then they bequeath it, via their milk, to their cubs. After just a few weeks of drinking the milk, which is one-third fat, the cubs carry higher concentrations of industrial chemicals and pesticides than their mothers.

Guardians of one of earth's last and largest wildernesses, the people and animals of the Arctic are hundreds of miles from any significant source of pollution, living in one of the most desolate spots on the planet, yet paradoxically, they are among the planet's most contaminated living organisms. What was once pristine has become a deep-freeze archive that stores memories of the industrial world's pollution. This is the Arctic Paradox, arguably the most severe case of environmental injustice on earth. Exposed to extreme levels of the same contaminants found in virtually everyone on the planet, the inhabitants of the Arctic have become the industrialized world's lab rats, the involuntary subjects of an unintentional human experiment that reveals what happens when a boundless brew of chemicals builds up in the environment. The Inuit living in northern Greenland, near the North Pole, contain the highest concentrations of chemical contaminants found in humans anywhere on earth.

There are no pesticides or factories or coal-burning power plants in the Arctic but, because of prevailing winds and ocean currents, pollution generated in the planet's mid-latitudes inevitably migrates north. When chemicals are spilled in urban centers, sprayed on farm fields, or synthesized in factories, they become hitchhikers embarking on a global voyage. Carried by winds, waves, and rivers, they move drop by drop, migrating from cities in the US, Europe, and Russia into the bodies of Arctic animals and people a world away. Chemicals such as polychlorinated biphenyls (PCBs) condense in the winter cold and evaporate come spring. Looking for a cold place to settle, they hop around the world, always headed north with prevailing winds and currents, and the Arctic becomes their final resting place. When the snow and ice melts in springtime, the chemicals are released into the ecosystem—right at the most vulnerable time for wildlife. They endure in the Arctic for decades, perhaps

centuries, and are consumed by marine animals, accumulating in their fat. As a result, the Arctic's most voracious predators—the polar bears, foxes, birds of prey and toothed whales—have among the highest body burdens of contaminants on the planet. About two hundred toxic pesticides and industrial compounds have been detected in the bodies of the Arctic's indigenous people and animals, including the long-lasting "Dirty Dozen" persistent organic pollutants banned decades ago, including PCBs and organochlorine pesticides such as DDT, mirex, and chlordane. They are joined by heavy metals like mercury, a potent neurotoxicant released by coal-burning power plants, and some relative newcomers, including flame retardants found in furnishings and electronics, and a chemical used to manufacture Teflon.

Scientific studies suggest that these extraordinary loads of chemicals are weakening the Arctic's polar bears and other top predators, jeopardizing their survival at the same time they are struggling to cope with the melting of their hunting grounds caused by global warming. These chemicals are capable of harming people and animals in ways that are hidden from the naked eye, and the impacts on living organisms are often unpredictable. They can mutate or activate genes and damage cells, which can trigger cancer or other diseases, and scramble hormones to render an animal's offspring feminized or infertile. They can thin a bird's eggshells, killing its chicks, enter the brain of a human fetus and jumble its architecture, and suppress immune cells and antibodies, weakening the body's ability to fight off disease and infections.

Polar bears' immune cells and antibodies, needed to fight off disease, have been suppressed, and their sex hormones—testosterone and progesterone—as well as their thyroid hormones and even their bone structure have been altered by PCBs. Scientists suspect that these chemicals are culling Svalbard's older bears and perhaps weakening or killing cubs. They also might have left a missing generation of mother bears. And perhaps most curious of all, small numbers of strange, pseudo-hermaphroditic bears, have been discovered. Of every hundred Svalbard bears captured, three or four have female as well as partial male genitalia. Imitating hormones, PCBs, DDT, and other chemicals are thought to be capable of gender-bending, leaving some animals half-male, half-female. "Everything indicates that the polar bears are being affected by these contaminants," said Geir Gabrielsen, the Norwegian Polar Institute's director of ecotoxicology. "There are so many indications that there are population effects."

Making matters worse, contaminants aren't the only environmental threat to the Arctic. It faces a triple whammy of human influences—contaminants, climate change, and commercial development—that the United Nations

Environment Programme says is likely to inflict drastic changes on its natural resources and way of life this century. Wildlife scientists from all five nations—Canada, Denmark, Norway, Russia, and the US—with polar bears have adopted a resolution saying that the bears are "susceptible to the effects of pollutants" and those effects could be exacerbated by the stresses of global warming. Some scientists predict that the most vulnerable populations of the world's twenty thousand to twenty-five thousand polar bears could be extinct in a few decades.

When Derocher took a research job at the Norwegian Polar Institute in 1996, he thought he had found polar paradise. But it wasn't long before he knew something was wrong. "Things just don't appear right," Derocher told his colleagues. Why weren't there more bears? Where were the older ones? Why were so few females over the age of fifteen bearing cubs? Were they dying? Were they infertile? "Within the first year, it became pretty darned clear that I wasn't working with an unperturbed population," he says. Derocher immediately suspected chemicals were to blame. "Could you realistically put two hundred to five hundred foreign compounds into an organism and expect them to have absolutely no effect?" asks Derocher, who is now a professor of biological sciences with University of Alberta and is studying Canada's bears. "Polar bears carry a huge variety of pollutants. Try and convince me that they have no impact on the animal's physiology. I would be happier if I could find no evidence of pollution affecting polar bears, but so far, the data suggest otherwise."

In the northern reaches of Spitsbergen, Svalbard's largest island, it's hard to tell where ice ends and clouds begin. As the scientists' helicopter flies above the frozen sea, shades of white blend seamlessly, and the horizon is lost. Only about a dozen people on earth know how to find and catch a polar bear, and Derocher is one of the best, tracking down thousands of them in two decades. Because their fur is pigment free, translucent as ice, and the hollow cores of the shafts reflect light, it is easier to spot their tracks than to spot the bears themselves.

Their helicopter hovers three hundred feet above the surface—close enough for Derocher to distinguish a bear from a fox but high enough for his eyes to sweep miles of ice at a time. Even from that distance, he can tell that these tracks were made by a mother and two cubs. Derocher has picked up their trail, and they are now walking right below the chopper.

In the backseat, Magnus Andersen, Derocher's Norwegian colleague, fills a syringe with colorless liquid, the same tranquilizer that veterinarians use

to anesthetize dogs and cats for surgery. He injects the drug into a dart and screws it onto a modified shotgun equipped with a .22-caliber blank. The pilot, Oddvar Instanes, dips to about six feet over the mother's head, so close they can see the coarse hair on her back blowing in the wind as she runs. Silently, Andersen kneels on one leg and opens the door. A freezing blast of air slaps him in the face. The blades whip up a frenetic whirlwind of snow, masking his view. The mother bear starts to run, and the helicopter, its engine roaring, follows her, spinning in 360-degree circles perilously close to the ground and turning sideways to give Andersen a good, clear shot. He leans out the open door, attached by a thin green cord. He takes aim and fires. A muffled, dull thud. The smell of gunpowder wafts through the door. "OK," Andersen says. A dart sticks out of the bear's rump; he is pleased. Precision is important. If he had hit her in the chest, it would have killed her, as sure as a bullet. Within minutes, the mother starts to wobble, but she isn't going down. Andersen readies another syringe and fires, hitting her in the rump again. She lies down on her stomach, eyes open, one giant paw splayed back. The cubs nuzzle her, trying to waken her, and then curl up beside her.

Peering out over their sleeping mother's back, they are wide-eyed and curious as the helicopter lands and Derocher and Andersen cautiously approach on foot, their boots crunching in the crusty snow. The two men circle slowly around the bears. Gloveless, Derocher strokes a cub's creamy white fur and Andersen holds out a finger for the other to sniff and lick. At fifty pounds apiece, these four-month-old cubs are as cuddly as their mother is deadly. These are the first humans these cubs have seen, and perhaps the last. Andersen gently loops ropes around their necks and tethers them to their mother. Without her, they would die.

Derocher sets down his black toolbox, removes some dental pliers and opens the bear's jaw. Leaning inside her gaping mouth, he deftly extracts a tooth, a useless pre-molar the size of a cribbage peg that will be used to confirm her age. She is around fifteen years old, and Derocher wonders if this will be her last set of cubs. Older females like her are rarely seen denning in Svalbard, even though polar bears live as long as twenty-eight years in the wild. Andersen is working on her other end, using a biopsy tool to slice a quarter-inch diameter plug of blubber from her rump. Then he quickly siphons a tube of blood. Derocher kneels beside the mother and milks her to sample the creamy liquid she is feeding her sons. The milk, fat, and blood will be analyzed at a lab for a suite of chemicals. Then he lifts her giant head and puts her lolling tongue back in her mouth. They tranquilize the cubs, which

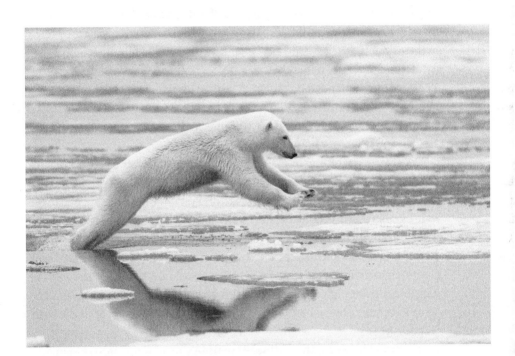

A polar bear sow hunts for seals on sea ice off the coast of Svalbard. *(Photograph by Steven Kazlowski, August 2009.)*

are left snoring, all eight paws splayed out on the snow. The threesome will sleep for two hours, then shake off the drowsiness and continue on their way. Andersen and Derocher pack up their toolbox and silently walk back to the helicopter to search for more bears.

Capturing polar bears is dangerous, for both man and bear. On a spring day in 2000, two of their colleagues were on their way back to base camp when they were caught in a whiteout and their chopper crashed into a glacier, killing everyone aboard. Now, when caught in whiteouts, Derocher and his crew throw black garbage bags filled with rocks out the window. Sometimes it's the only way to know which way is up in Svalbard. This perilous work is critical for understanding how wild animals are faring, and what chemicals they carry in their bodies. "Otherwise," Derocher says, "we would blindly stumble into extinction. My job is to make sure polar bears are around for the long term. The Arctic without polar bears would be like the plains without buffalo." The helicopter glides north between snow-draped peaks and Derocher spots more tracks—this time, a mother and two plump yearlings. Andersen fills another syringe and rests the shotgun on his leg.

Hours later, at the end of their day, Derocher peers out the helicopter window. Bad weather is closing in on them. Clouds to the north are threatening a whiteout but, miraculously, a perfect path of crystalline skies has opened to the south, guiding them back to their research station. Derocher snaps a photograph, allowing himself to relax enough to enjoy the view for the first time since they started the season's work a month earlier. Derocher and his colleagues seek clarity, cherishing spring's eternal light. But they know that soon enough, the long, black polar night will descend, plunging them into darkness again, and come December, somewhere out there in the dark, another ice bear will be born.

East of Svalbard, along the northwestern tip of Greenland, brothers Mamarut and Gedion Kristiansen have pitched a makeshift tent on the sea ice, where the Arctic Ocean meets the North Atlantic. From their home in Qaanaaq, a village in Greenland's Thule region, the northernmost civilization on earth, the Kristiansens traveled here, to the edge of the world, by dog sledge. It took six hours to journey the thirty-five miles across a rugged glacier to this sapphire-hued fjord, where every summer they camp on the precarious ice for weeks at a time, patiently awaiting their prey. Nearby lies the carcass of a narwhal, a reclusive unicorn-like whale with a spiraling ivory tusk. Mamarut slices off a piece of *mattak*, the whale's raw pink blubber and mottled gray skin, as a snack. "*Peqqinnartoq*," he says in Greenlandic. *Healthy food.* Mamarut's wife,

Tukummeq Perry, a descendant of Robert E. Peary, who led the first white man's expedition to the North Pole, is boiling their favorite entrée on a camp stove. They dip hunting knives into the kettle, pulling out steaming ribs of freshly killed ringed seal, and devour the hearty meat with some hot black tea.

About 850 miles from the North Pole, the people of Qaanaaq are the closest on earth to the archetype of traditional polar life. They are the world's top predators, the human version of polar bears, and their fate—like the fate of Svalbard's bears—illustrates how contaminants have upset the Arctic's fragile balance. Greenland's Inuit eat much like a polar bear does—seal is the national favorite—and ironically, this close connection to the environment has left them as vulnerable to the byproducts of modern society. The bodies of the women in Qaanaaq contain the highest human concentrations of chemical contaminants found anywhere.

Two centuries ago, colonizers brought smallpox and other lethal diseases to the far North, wiping out entire communities of native people. Today the outside world is imposing a more subtle, insidious, and intractable scourge on the Arctic. Inuit in remote areas of Greenland carry more mercury and PCBs in their bodies than anyone on earth, and the Canadian Inuit aren't far behind. Nearly everyone tested in Greenland and more than half of the Inuit tested in Canada exceed the concentrations of PCBs and mercury considered safe under international health guidelines. "There may be only 155,000 Inuit in the entire world," says Sheila Watt-Cloutier, former chair of the Inuit Circumpolar Council, an organization that represents the Inuit of Greenland, Alaska, Canada and Chukotka, "but the Arctic is the barometer of the health of the planet, and if the Arctic is poisoned, so are we all."

PCBs, DDT, and similar contaminants accumulate in animal tissues and move up the oceanic food chain (which is actually a vast web, not a chain) from algae or plankton to crustaceans, to fish, to seals, and—at the top of the food web—polar bears and people. Arctic people are especially vulnerable because of their place at the very top of the natural world's dietary hierarchy. They eat 194 different species of wild animals. On a daily basis, they consume the meat or blubber of fish-eating whales, seals, and walrus. In the remote villages such as Qaanaaq, people dine on marine mammals and seabirds thirty-six times per month on average, consuming about a pound of seal and whale each week.

In Greenland in the 1980s and 1990s, some Inuit women probably had such high levels of chemicals in their bodies that their breast milk technically could have been declared "hazardous waste," says Eric Dewailly, director of

the Public Health Research Unit at Laval University and a leading authority on Inuit health and contamination. Men tested in Greenland in the early to mid-1990s had average concentrations of 15.7 parts per million of PCBs in their fat. In comparison, industrial waste that contains 50 parts per million requires special disposal procedures because of its toxicity, and it is likely that in remote areas of Greenland, some people—including pregnant women—exceed that level for PCBs alone, Dewailly says.

For mercury, 97 percent of women tested in Qaanaaq exceed the US guideline designed to protect fetuses from neurological effects, according to a 2009 report by the Arctic Monitoring Assessment Programme (AMAP), an international research endeavor. And in Nunavut, Canada, 59 percent of children surveyed exceeded the level considered acceptable, mostly from eating narwhal and beluga. PCBs in Arctic women also exceed the amounts considered hazardous to fetuses. More than 90 percent of women tested in Qaanaaq and 52 percent in Nunavik, Canada, exceed Canada's "level of concern" for PCBs, according to AMAP's 2009 report. Although their PCB levels have been dropping for the past decade, they remain inordinately high. In Arctic Russia, meanwhile, contaminant levels appear to be rising. Data from Russia released in 2004 show that some of its Arctic people rank with Greenlanders as the most toxic human beings on the planet.

Traditionally, their marine diet has made the Inuit among the world's healthiest people. Minus the contaminants, this diet is arguably the most nutritious in the world—loaded with vitamins, minerals, antioxidants, protein and fatty acids. Dewailly says eating marine mammals and fish is "like getting a huge vaccine in your food." The polar diet keeps hearts healthy and protects from many cancers. When scientists dissected the prostate glands of Greenlandic men, "not a single cancer cell was found," Dewailly says. Heart disease is rare there, and the diet rich in fatty acids also may reduce neuro-degenerative diseases. Public health officials are torn between encouraging the Inuit to keep eating their traditional foods and advising them to reduce their consumption. "The level of contamination is very high in Greenland but there's a lot of Western food that is worse than the poisons," says Dr. Gert Mulvad of Greenland's Primary Health Care Clinic. But scientists have discovered that the extraordinary loads of chemicals in Arctic people might be causing subtle injuries that jeopardize their health. Mothers and babies are the most vulnerable of all because the chemicals permeate the womb, moving from a mother's tissues to her fetus right at the time when her baby is growing and most susceptible to damage to its brain, reproductive organs and

immune system. Studies of infants in Greenland and Arctic Canada, exposed prenatally and through breast milk, suggest that the PCBs and other chemicals are harming children. "Subtle health effects are occurring in certain areas of the Arctic due to exposure to contaminants in traditional food, particularly for mercury and PCBs," says an AMAP report.

There are no dead bodies, no smoking guns. But scientists have amassed compelling evidence that Arctic inhabitants are not escaping these compounds unscathed. Children in the Arctic suffer extraordinarily high rates of infectious diseases such as ear infections that recur so often they cause permanent hearing loss. Scientists say immune suppression caused by chemical exposure could be responsible, at least in part. PCBs babies are also born with lower birth weight and the contaminants appear to inflict neurological damage on newborns comparable in scope to that which would result if their mothers drank moderate amounts of alcohol while pregnant. Tests on Arctic and North Atlantic children show that prenatal exposure to mercury and PCBs alters their brain development, slightly reducing their intelligence and memory skills.

Anthropologists say the contamination jeopardizes more than health; it threatens sweeping societal changes in the Arctic akin to cultural genocide. Efforts to alter Inuit diets can unwittingly trigger permanent cultural changes. Hunting embodies everything in the Inuit's 4,500-year-old society: their language, their art, their clothing, their legends, their celebrations, their community ties, their economy, their spirituality. "It's not just food on a plate," Watt-Cloutier says. "It's a way of life."

In late spring, noon looks the same as midnight and temperatures still dip below freezing. Yet the retreat of the polar night and return of the midnight sun means that the Arctic's treasures, long locked in the ice, are within reach again. Narwhal hunting season has begun. Every year in northern Greenland, hunters kill hundreds of the shy, almost mystical beasts.

Mamarut and other hunters are gathering on the edge of town to load up their sledges. He wears khaki pants, rubber boots and a long-sleeved T-shirt emblazoned with Polo Club. His wife loads the sledge with a plastic bag full of food—Ritz crackers, soup mix, bread, tea—along with some toilet paper, rope, an ax, a kayak, sealskin jackets, and a rifle. The blubber of the narwhal caught two days earlier will sustain them as they camp on the ice for days. Their favorite way of eating it is raw, fresh from a kill.

A sealskin whip arches perfectly over Mamarut's dogs, as artfully executed as the line of a fly fisherman. His younger brother, Gedion, trails behind,

guiding his own dog team across the glacier, dodging skyscraper-sized icebergs that rise inexplicably from the flat terrain like giant sandcastles on a beach. The ice ahead of them undulates, like waves on a frozen sea. The Kristiansens' twenty-six dogs—strong enough to pull two three-thousand-pound narwhals—race toward a sliver of brilliant blue in the distance. The waters off Qaanaaq are known to navigators as the North Water, thawed year-round in an otherwise frozen sea, where an upwelling of nutrients draws an array of marine creatures. The black and cream-colored dogs sprint across snow so bright it burns the eyes. They pant as they run, their tongues hanging so low they could almost lick the ice. Cracking the whip over their heads, Mamarut grunts to them, words that sound like *huva, huva, huva*: left, left, left. As the wind picks up, he adds two layers of clothes, including a parka crafted from the tan and gray hide of a ringed seal. His wooden sledge, a work of art perfect in its simplicity, rumbles and bumps as it carves a path in the snow, bending and flexing with the ice. The only tracks visible in the snow are from the sledge and the dogs, and the only smells emanate from their rear ends, fumes so potent they seem toxic. Part wolf, the dogs snarl at each other, eating fistfuls of raw seal meat that Mamarut and Gedion toss to them, and they are treated harshly: as slaves, not friends. This is a matter of life and death for Qaanaaq's hunters. A good dog team means life. A bad one could mean death. The hunters need senses as keen as their dogs', even keener.

The Kristiansens live as their forefathers did thousands of years ago, relying on foods culled from the bounty of the sea and skills honed by generations. One man—a lone hunter sitting silently in a kayak armed with a harpoon—is pitted against a one-ton whale. Such simplicity isn't quaint; it is a necessity in this hostile and isolated expanse of glacier-carved bedrock. Survival here means people live as marine mammals live, hunting like they do, wearing their skins. No factory-engineered fleece compares with the warmth of a sealskin parka or bearskin trousers. No motorboat sneaks up on a whale as well as a handmade kayak latched together with strips of hide. No snowmobile flexes with the ice like a dog-pulled sledge crafted of driftwood. And, most important of all, no imported food nourishes their bodies, warms their spirit and strengthens their hearts like the flesh they slice from flanks of a whale or seal.

In remote villages like Qaanaaq, Greenland's hunting traditions are the strongest of all. An isolated village of about six hundred people, separated from Canada by Baffin Bay and nestled on the slope of a granite mountain, Qaanaaq faces a great sea of ice. There, the Inuit hunt seal, beluga, walrus, narwhal, even polar bear. Qaanaaq's polar night—twenty-four hours of

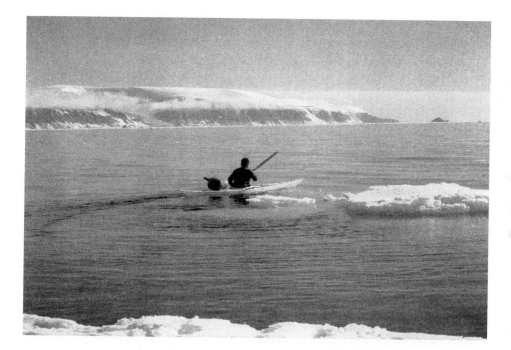

Gedion Kristiansen on his kayak, Qaanaq, Greenland. Inuit in Greenland hunt narwhal the traditional way—one man in a sealskin kayak, armed with a harpoon, pitted against a one-ton whale. *(Photograph by Marla Cone, 2001.)*

darkness—endures from November through mid-February. During those long winters, their native food warms them from within like a fire glowing inside a lantern. When they eat anything else, instead of fire inside, they feel ice.

Six hours after their journey began with the flick of a whip, the Kristiansens arrive at their ancestral hunting grounds. Joined within minutes by several other hunters, they gather on the edge of the ice, waiting to spot a whale's breath. "If only we could see one, we'd be happy," Mamarut whispers, lifting binoculars and eyeing the mirror-like fjord for the pale gray back of the *qilalugaq*, or narwhal. "Sometimes they arrive at a certain hour of the day and then the next day, same hour, they come back. Other times they disappear for two days." The best Inuit hunters, more than anything else, are patient. "Maybe the mother of the seas has called them back," Mamarut says with a laugh. Mamarut is big, bawdy and beefy, the Elder brother and joker of the family. He celebrated his forty-second birthday on this hunting trip with some packaged chicken broth and a bit of *mattak*. Gedion is ten years younger, lanky, quiet, the expert kayaker, wearing a National Geographic cap. The Kristiansen brothers are among the best hunters in a nation of hunters, able to sustain their families on the income from their hunts without them or their wives taking side jobs, which is unusual in Greenland. In a good year, the Kristiansens can eat their fill of *mattak* and earn more than fifteen thousand US dollars per year selling the rest to markets, and in winter, they sell sealskins to a Greenlandic company marketing them in Europe. About one-third of the food the Kristiansens consume is the meat of wild mammals and birds.

Their hair is the blackest of black, thick and straight, cut short. Their skin is darkened by the sun, but they have no wrinkles. One night, after setting up camp, they joke that when the sun hits their campsite, it will be as warm as Los Angeles and they will get a suntan. Mamarut and Gedion say they would someday like to see women on a beach wearing bikinis. Today, on a June morning, the windchill makes the temperature hover around zero, and their only shelter on the ice is a plastic tarp strapped to the sledge, creating a makeshift tents for five adults to sleep in, so cramped they can't bend a knee or flex an elbow without disturbing their neighbors. A noxious oil-burning lamp is their only source of heat. A camp stove, used for melting ice for tea and boiling seal meat, is set up on a wood box outside.

Along the edge of the Arctic Ocean, Gedion and Mamarut are waiting for a narwhal. Then they smoke cigarettes and wait. Once they waited almost a month on the ice before catching one. During their vigil, the hunters remain

alert for cracks or other signs that the ice beneath them is shifting. In an instant, it can break off and carry them to sea. No wonder that Greenlanders have several dozen phrases for ice, but only one for tree. Ice is everything to them—it's danger, it's dinner, it's the water they drink. There's the jagged ice they encountered along the way that slices like knives into the paws of their dogs, leaving a trail of bloody paw prints. There's the unpredictable ice that breaks into floes, sometimes taking a hunter or two along with it. There's the craggy ice along the edge where narwhals hide, in search of halibut or shrimp. A good hunter, more than anything else, knows the ice. He knows where it will shift and shatter, leaving shards like a broken dish. Mamarut jabs a sharp metal pole into the ice to check its stability. He leaves a mark on the ice, and if he sees that it has moved, he knows it is time to pack up and set up a new camp. The next morning, he announces that it is time to move onto a rocky outcropping on the ice edge. "Not safe here," Mamarut says.

That night, the brothers spot a pod of belugas, about ten of them, their white backs glistening in the dark water, their misty breath spraying out from their blowholes. But the belugas were there before they were, and they know there is no way to sneak up on them now. Hunters must arrive at the fjord before the whales do, then wait, like a polar bear stalking a seal at a breathing hole. Just in case, Gedion readies his sleek, eighteen-foot kayak, or *qajaq*, a wood frame stitched with sailcloth and sealskin. Although the Canadian Inuit invented kayaks, Greenlanders perfected them. Gedion inflates the bladder of a seal until it looks like a seal-shaped balloon and then fastens it to a metal harpoon head with a long nylon line. When the harpoon is fired, it will float in the water like a buoy, marking the spot of a harpooned whale and preventing its head from sinking. Then he attaches a waterproof sealskin liner to the hole in the kayak that will keep him dry. A wooden harpoon, or *unaaq*, with a metal blade is laid on top. When Gedion hears or sees the whales coming, he quietly climbs into his kayak with his harpoon and seal buoy. He must instantaneously judge the ice conditions, the current, the wind, and the speed and direction of the whales. If a kayaker makes the slightest noise, a narwhal will hear it. Gedion must first strike with a harpoon—in the whale's back, usually from behind so he can't be seen—and then he can finish the job with a rifle. The whale must be directly in front of his kayak, about thirty feet away, close but not too close—or its powerful dive will submerge him and he will drown. Once, when Mamarut harpooned a narwhal, another one kicked him with its tail. His kayak flipped over and broke, but he managed to stay inside it and get to shore. Like most

Greenlanders, he can't swim—there's not much need to master swimming when no one can survive the frigid water for more than a few moments. After a whale is harpooned, buoys are attached to its back, and its carcass is hauled back to shore, where it is butchered immediately. The big ones weigh a ton and stretch fifteen feet long. The hunters taste some of the blubber right away, and bury the rest in the ice.

It's this traditional diet of narwhal, beluga and other creatures that leaves Greenland's Inuit so highly contaminated. But Tukummeq, Mamarut and Gedion, like most of the people of Qaanaaq, don't travel outside the fjords surrounding their village and they remain oblivious to the scientists and political leaders fretting about how many parts per billion of toxic chemicals are safe. They simply don't have the luxury to worry about threats so imperceptible, so intangible. Instead, they worry about things they can hear and see: thinning ice conditions from climate change, the whereabouts of whales, where their next meal will come from. Anxiety about chemicals is left to those who live in faraway lands, those whose bodies contain far less of the substances. The Kristiansens learned about the contaminants—the *akuutissat minguttitsisut*—from listening to the radio. But they have not changed their diet, and no one has advised them to. Seal, narwhal, beluga are what they hunt, so it is what they eat. Virtually every day, they eat the meat and *mattak*, and with every bite, mercury, PCBs, and other dangerous chemicals amass in their bodies, moving from mother to child just like they do with polar bears. "We can't avoid them. It's our food," Gedion says with a shrug.

On this five-day hunting trip, a short one for the Kristiansens, they reap little reward for their patience—a few seals, two auks, and two eider ducks. Mamarut, his wife Tukummeq, and Gedion pack up their sledges and drive the dogs back toward Qaanaaq. 'Sometimes you have to just go back empty-handed and feed the dogs," Mamarut says. Upon returning to their village, Inuit hunters share their experiences so that everyone may learn from them. The Kristiansen brothers learned to hunt narwhal from their father. Now Gedion's son, Rasmus, four at the time of this journey, often joins their hunts, amusing his father by pretending to drive the dogs and harpoon a narwhal. It won't be long before Rasmus will paddle a kayak beside his father. Since around 2400 BCE this Inuit legacy has been passed on to generations of boys by generations of men. Their ancestors' memories, as vivid as a dream, as old as the sea ice, mingle with their own, inseparable.

"*Qaatuppunga piniartarlunga,*" Mamarut says. "As far back as I can remember, I hunted."

Frozen in time, slow to heal, the Arctic will be haunted by its toxic legacy for countless generations to come.

The Fall of the Yukon Kings

DAN O'NEILL

❖

I first met Dan O'Neill in 2006 over lunch in a Thai restaurant in Fairbanks with a few friends, including Peter Matthiessen; Fran Mauer, a retired wildlife biologist of the Arctic National Wildlife Refuge; and Luci Beach, a former executive director of the Gwich'in Steering Committee. I had read and talked about in my lectures Dan's book The Firecracker Boys—*an Alaska classic, and a classic of American history. The 1994 St. Martin's Griffin edition of the book's front cover reads:*

> *On July 14, 1958, "Father of the H-Bomb" Edward Teller arrived in Alaska to unveil Project Chariot, a plan to carve a new harbor out of the Alaskan coast by detonating up to six thermonuclear bombs.*

The back cover continues with:

> *Thanks only to a tiny handful of Eskimos and biologists, who recognized the*

grave environmental implications of this plan, was the United States govern-
ment finally prevented from inflicting a catastrophe worse than Chernobyl on
its own land and people.

In this volume, Caroline Cannon refers to The Firecracker Boys, *and*
Maria Williams writes about Project Chariot. In another book, A Land Gone
Lonesome: An Inland Voyage Along the Yukon River, *Dan wrote about the*
majestic Yukon River and the inhabitants of the region. In 2010, I urged him
to write an essay for Arctic Voices. *I was lucky. He was just getting ready*
to write about the king salmon—like the polar bear and the caribou, the
king salmon is a signature species of Alaska, yet we know so little about the
politics that revolves around its use and survival. Dan's first draft came in
at over twenty thousand words—you can say that he threw a curveball at
me. Fortunately, I had crucial help from editor Christine Clifton-Thornton in
selecting, in consultation with Dan, a little less than half of those words for
the essay that follows. He is now working on a book on the subject.

❖

IN SEATTLE, New York, London, and Tokyo, seafood marketers, restaura-
teurs, and retailers speak of sockeye, coho, pink, chum, and Chinook. But an
Alaskan first learns the names of the state's five species of salmon in colloquial
form. They say "reds" for sockeyes, "silvers" for cohos, "humpies" for pinks,
"dogs" for chum, and—not without homage—they call the Chinook "kings."

Kings or Chinooks, they are the rarest and most highly prized salmon in
Alaska, the most sought after by sports fishermen, the most commercially
valuable. And they are enormous fish. In 1949, a commercial fisherman work-
ing near Petersburg, Alaska, hauled in a king salmon measuring more than five
feet in length and weighing 126 pounds. That is just about exactly the size of an
average twenty-year-old American woman—5'4½", 127 pounds. In May of 1985,
a local man named Les Anderson, fishing in Alaska's Kenai River, landed what
is said to be the largest king salmon ever taken on a rod and reel: 97 pounds,
four ounces. In a snapshot, Anderson takes a knee holding the shining slab
horizontally, like he's poised to fit a chrome bumper onto a tractor-trailer.

In evolutionary terms it is tautological to say it, but kings are big for good
reason. Big fish have the power to hold their position in swift currents, to feed

and breed and otherwise occupy places that would tax lesser fish. They can push aside the cobble-sized gravel found in faster water and deposit their eggs deeper, better protecting them. A single large female can deposit more than seventeen thousand eggs. And eggs from a large king are themselves large. They are loaded with more nutrients in the yolk sacks, improving the survival chances of the emergent alevins (a kind of half fish, half egg).

Like all the Pacific salmon, Chinook migrate from the sea back into their natal freshwater streams to breed. They breed only once in their life and then die. From California to western Alaska, there are probably well over a thousand spawning populations of Chinook. But the largest runs tend to be in the big rivers. The immense Columbia River hosts a notable run of Chinooks. But greater still is the Yukon River, which draws into its mouth the largest migrating Chinook, chum, and coho salmon stocks in the world.

From its delta on the Bering Sea coast in western Alaska, the Yukon bisects a subcontinental landmass comprised of Alaska and Canada's Yukon Territory. The Chinook that ascend the Yukon all the way to its headwater streams, like the Teslin River that arises in British Columbia, will travel more than two thousand miles from the ocean, climbing twenty-two hundred feet above sea level. It is one of the longest fish migrations in the world. Because the kings will not feed once they enter the river, they must build up beforehand tremendous reserves of oil. Consequently, the Yukon kings are the richest salmon in the world, containing as much as 24 percent oil. Many epicures who know Yukon kings say they have no equal.

Archeologists think that ancient hunter-gatherers had begun pulling the monster fish out of the Yukon River by eight thousand years ago. No doubt the people marveled at so providential a miracle: all these behemoths, each one a banquet of succulent food, torpedoing upriver, delivering themselves right to the people's camps, every year, like a gift from the far-off ocean.

An archival photograph from 1913 shows a fishing operation on the Yukon and a gate-mouthed lunker hanging from a fish rack. The photographer's annotation notes that the fish camp had caught some seventy-five-pounders. Another old photo from 1924 shows a nattily dressed man posing beside a hook-nosed king hanging in front of a shop in Dawson City, Yukon Territory. This fish is said to weigh eighty-five pounds.

The long history of local people fishing for kings along the Yukon River continues today. One woman told a National Park Service interviewer recently about the big kings her father used to catch below the village of Eagle: "I remember one time my dad and I checked the net across from our old fish

Stan Zuray by fishcamp shack at Rampart Rapids, along the Yukon River. *(Photograph by Stan Zuray, 2011.)*

camp down there . . . the fish was giant, and it wasn't dead . . . and it almost flipped us!"

Stan Zuray, who has fished for kings near the mostly Native village of Tanana for thirty-eight years, has similar stories. "It was always like a game each year. When would we catch the first fifty-pounder, you know? You'd catch that first fifty-one-pounder, that first fifty-four-pounder! And that would happen every year. I don't ever remember not catching a fifty-pound king salmon in those years, say, prior to Ninety-six or something like that," he says. "And then of course that changed."

Indeed it did. In 2010, the average weight of a king salmon caught in fish wheels at the Rapids where Zuray fishes was 10.8 pounds. That year, a scant 14 percent of the kings were females. To a fisheries biologist, these are classic signs of a fish stock in peril. Except, apparently, if the biologist happens to be managing this fishery for the Alaska Department of Fish and Game or the US Fish and Wildlife Service. In any case, the slender thread connecting the people along the Yukon to eight thousand years of traditional fishing appears ready to snap.

Stanley Zuray has been a dog musher, trapper, and salmon fisherman since he came into the upper Yukon area in 1973. He was twenty-three then; he's in his sixties now. His ponytail and his stubble have turned gray. He's got a few laugh lines, a few worry lines, and a few creases the country chipped in. He would remind you of Russell Crowe, if you could extrapolate Crow forward fifteen years and dial up a Boston accent. The accent seems unattenuated, maybe because he and his girlfriend moved so abruptly from Boston straight into the bush that he didn't have much contact with others until the neural ruts had worn too deep. Nine days after they arrived in Alaska, as soon as the car sold, they chartered a bush plane in Fairbanks and that afternoon tossed their gear out on the banks of the Tozitna River, forty roadless miles north of the village of Tanana, two hundred mostly roadless miles west of Fairbanks. "We fished the chum and king run that first year and kept the dogs barely alive—at least the ones we didn't eat," he says, laughing at the crazy truth of it. He is easygoing, congenial, affirming in conversation, and as resolute as the current of the Yukon River.

Like probably every fisherman who ever scratched his beard, Stanley will analyze all the angles and aspects of fish, fishing gear, catches, runs, and trends over the years. But perhaps more than most, he is circumspect—he thinks before he talks. He thinks *while* he talks, actually, editing himself as he goes, sometimes half out loud in his Boston brogue: "Fawty years, maybe? Er, fawty-one? Yeeeah. Yup. Fawty-one." Listening to him is like watching a

driver hunting for an address in an unfamiliar city—he keeps hitting the breaks mid-block, backing up, and trying another street. But it is an indication of his care with facts: strange as it may seem, he is a fisherman allergic to exaggeration. "I've been writing it down," he says. "Some of this stuff I've been writing down for, God, maybe twenty years now. Because I know that as the years go on my perception is going to change."

In hindsight, Zuray was pretty well suited for the strange direction his life would take. But it was pure accident that had him sliding smack into the middle of the politics and science of fish sampling. It started when a US Fish and Wildlife Service man named Monty Millard came upriver one summer in the mid-1990s looking for a wheel fisherman who would catch chum salmon for the government as part of a salmon population study. None of the fishermen in Tanana were available. Ditto all the way upriver to the Rampart Rapids, a fishing hotspot forty miles above Tanana, until finally Zuray was about the last person he could ask. Stan said he could probably help Millard out. He would have his own dog fish caught by September first or so. Staying on at the Rapids until the run petered out could mean he was there into October. But he could do it—stay in camp a little longer, run his wheel for the biologists, make a little money. He guessed so anyway. Monty Millard was a "big boss," Zuray says, the first federal manager of subsistence fisheries for the Yukon River. But Stan liked him, thought of him as "a friend, and good guy, old school, who said what he thought (unless the bigger guys were there). He's gone now." Before his premature death in 2002, Millard helped to stir into motion a dust devil that became a williwaw, that became if not a storm system visible from space, at least a regional disturbance—Stanley.

Some of the upper Yukon people fish with gillnets tied to shore. These are called set nets. A salmon pokes its head in through the mesh, past its gills, and can't back out again. Other people use fish wheels, which have been catching salmon on the Yukon River for a hundred years. A fish wheel is a big gangling contraption something like a paddle wheel with four arms. It's perhaps twenty-five feet in diameter, mounted on a log raft, and turned by the current. Log spars and heavy cables keep the wheel positioned just off shore. Two opposed baskets project from the axle, and as the current sweeps them downstream, they strain the water intercepting fish migrating upstream. At right angles to the baskets, two paddles keep the wheel rotating during the moment when neither basket is submerged. As a basket rises in its rotation, it drops any fish onto a slide that sends it into a box alongside. It may seem like an artifact from some prehistoric stick culture, but when made the old-time

way, with the sweeping curves of peeled and bent tamarack and spruce poles, it is a thing of beauty, graceful in motion, ingeniously practical.

At grayed plywood tables along the gray stony beaches of the Yukon, the people cut the fish in different ways depending on the intended use. Most people will head and gut and fillet the fish, taking out the backbone and ribs. But they will leave a connection at the tail so that both fillets can be flipped flesh side out and hung over a pole to dry. Sometimes the meat is carefully slashed crosswise to facilitate drying. The guts go into the river, and the head and backbones go into the dog pot, which is half an oil drum set over a drift-wood fire. A stinky stew is cooked every other day, enough for two days. At feeding time, up to thirty dogs will spin in orbits at the ends of their chains, stirring up the silent country with manic barking.

One way the people like to handle the kings is to make what they call "strips," a kind of jerky, redolent of smoke and fish oil, eaten like candy by people all over Alaska, especially Alaska Natives. Strips are so highly prized, they are treated like money. Since antiquity, they have been a traditional medium of barter. What strips aren't eaten by fall are put up in canning jars or frozen. Banked, you might say.

Generally, the smokehouse is a tall structure built of spruce poles. The roofs and siding show a patchwork of corrugated roofing panels differentially rusted. When you open the door, the light reveals thousands of strips dangling from racks rising far up to the ceiling, red-orange ribbons glistening against the smoke-blackened ceiling.

The creeping signs that the kings were in trouble first showed up in smoke-houses. Stan had built his tiers of racks too close together, and that was a nuisance because the strips above were always touching the ones below. Then one year they weren't. Every year, the gaps between the fish grew.

Actually, Zuray credits fishermen farther upriver in Canada with first pointing out the shrinking size of the kings. "Long before we experienced a decline in size and amount of fish and female rates, the Canadians noticed it. They talked about little fish, but it didn't hit home. Then the problem moved down to the US side, into the Eagle area, and then the Fort Yukon area, and then it started hitting us. Because as the runs get smaller and smaller and smaller, the problem just moves closer to the source."

The shrinking fish problem, as Zuray and his fellow upriver fishermen saw it, was abetted by the managers of the two agencies—the Alaska Department of Fish and Game (ADF&G) and the US Fish and Wildlife Service—that have jurisdiction over the Yukon River salmon runs. There were some excellent

field biologists working on the river, but their superiors, the fishery managers, seemed oblivious to all the warning signs of a fish stock in serious decline—perhaps on the brink of collapse—while obstinately accommodating the downriver commercial fishing interests. Reciprocally, managers' policies that favored the commercial industry necessarily short-change the upriver subsistence users. And that is to say nothing of the hapless Canadians, who are generally content to watch politely as the Yanks eat their lunch.

For example, Stan and other upriver fishermen had for years pointed out that a particular downriver method of fishing called drift netting was hammering the king salmon stocks. Fred Andersen, a retired fisheries biologist who worked in the Yukon fishery for more than twenty years, explains: "Traditionally, people along the lower river deployed set nets in eddies, and there are a limited number of eddies. So, the lower river fishery was pretty low key and slow paced." Then people discovered drift netting, where a net was stretched out from a boat drifting down the middle of the river. "And it was highly successful," says Andersen. "That gear was able to catch fish—*is* able to catch fish—that were completely out of reach of those shore-based nets," he says. "Now, 80 or 90 percent of the fishing in the lower river is by drift net. All of a sudden, the people are drifting fifty-fathom nets through these channels—fifty fathoms is three hundred feet—that's a standard piece of gear down there."

The result was a dramatic increase in catch compared with the time spent fishing, or the "catch per unit effort" (CPUE) in the parlance of fishery management. While the department looked at test nets, sonar counts, and the catch rates of subsistence fishermen, it was also managing the fishery partly on the basis of CPUE. "Then, all of a sudden—with drift nets—the gear was more efficient, and the CPUE went sky high." To any objective observer, the instantaneous rise in CPUE was because of the introduction of the new, more efficient fishing method. But to ADF&G, the harvest was higher because suddenly and inexplicably there were more fish in the river. And the miraculous multiplication of the fishes just happened to coincide with the appearance of drift netting. "They weren't stupid. They knew that drift nets were more effective. But it seemed to me that they never fully compensated for that increase in efficiency. It was crazy."

Crazy as in reckless, but not crazy as in incomprehensible. "It frequently seemed to me," says Andersen, "that there was and is a tendency to favor whichever data source was indicating greatest run strength, hence justifying lower river commercial fishing openings, and to downplay the other indicators that might be suggesting a run of lesser size."

One thing the department did accomplish over the years, says Andersen, was to substantially reduce the amount of allowable fishing time. But they also increased the allowable harvest. In 1980 a genuine bumper run occurred, with the Alaska commercial harvest topping 150,000 kings, a record that still stands today. In response, ADF&G proposed that the allowable commercial harvest for the lower river districts be increased from a fixed quota of 90,000 kings to a "range," the upper end of which was 120,000.

"When you raise the quota, you raise the expectations of the fishermen— and the staff too, I suppose," says Andersen. "So in the minds of a lot of lower river fishermen, that became the goal: 120,000. And they were relentless in their pressure on the managers to take as many fish in a given season as possible." The lower river fishing districts have, since statehood, been managed from an office in Emmonak, near the mouth of the Yukon, and they still are. "So the managers were there. They were accessible. They were there to be beat on by the local guys who wanted more fishing time, longer fishing periods and more of them. Just a lot of pressure on these guys to capitulate and allow more harvest than they might have done absent that pressure."

The larger harvests might not have been a problem while the runs were strong during the 1980s and through most of the 1990s. But then, starting in 1998, the runs plummeted. And people like Stan Zuray began to press the Alaska Board of Fisheries to do something to control overfishing in light of poor returns. In this, Stan wasn't the lone campaigner, nor even the first. Virgil Unphenour, a highly knowledgeable fish processor from Fairbanks, had been paying attention and speaking out years before Stan. Mike Smith of Fairbanks, and Andy Bassich and Don Woodruff from Eagle, were showing up at meetings and testifying. Singly and severally, they submitted conservation-minded proposals to the Board of Fisheries and applied what pressure they could. Unfortunately, it wasn't much of a contest. The upriver people would typically be represented by Zuray and a few other guys in their jeans, flannel shirts, and go-to-town sneakers, doing the best they could. But the downriver commercial fishing interests were organized by a professional consultant; they occupied a large section of the hotel lobbies where the meetings took place; they had secretaries staffing tables stocked with position papers and equipped with laptop computers. One year, the commercial-fishing interests chartered a fifty-seat airplane to bring lower river people in to testify at a Board of Fisheries meeting in Anchorage. "They packed the room full of people," says Zuray. "Seventy-six people, I believe, testified at that meeting. And four of them, me, Virgil, Andy Bassich, and Mike Smith [all from upriver] testified

PHOTOGRAPHS
Subhankar Banerjee
and related visual campaigns

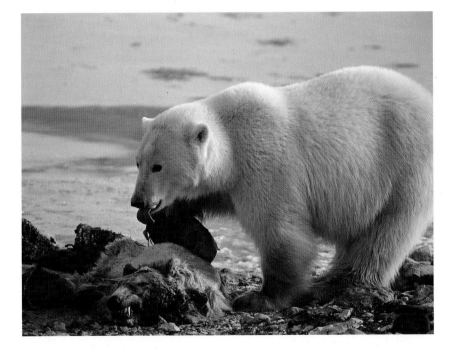

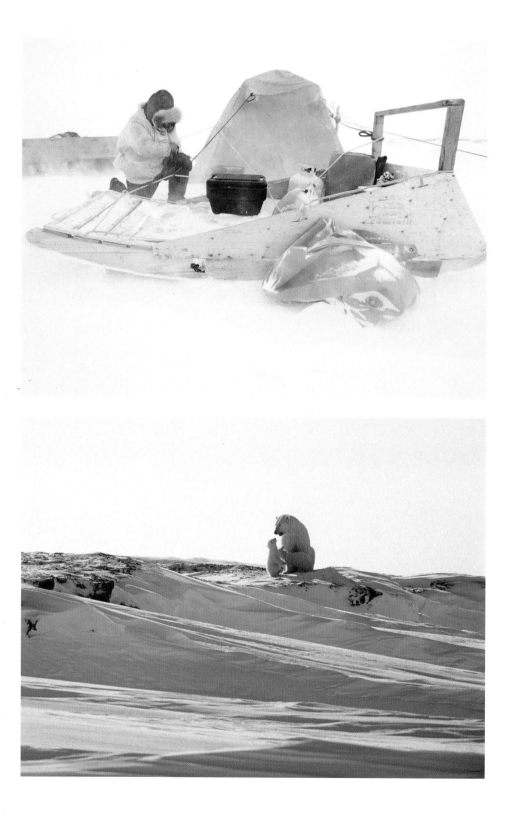

PLATE 4

Musk oxen in the haze of a toxic north, Canning River Delta, Arctic National Wildlife Refuge, May 2001. See my introduction for more on the subject of Arctic haze.

(Opposite) **PLATE 2**

Robert Thompson securing a tent in a blizzard that lasted twenty-nine days with four calm days in between. The temperature was about -40°F; wind speed about 65 mph; wind chill about -110°F; Brownlow Point, Canning River Delta, Arctic National Wildlife Refuge, along the Beaufort Sea coast, March 2002.

(Opposite) **PLATE 3**

Mother polar bear with two cubs play near their den, Brownlow Point, Canning River Delta, Arctic National Wildlife Refuge, along the Beaufort Sea coast, March 2002. The Arctic National Wildlife Refuge coastal plain is the only land conservation area in the United States for denning polar bears. Climate change is severely impacting marine species that critically depend on sea ice, including polar bears, walrus, ringed seals, and seabirds. Additionally, there is the threat of oil development both onshore and offshore in the Beaufort and Chukchi seas that will exacerbate the fate of these bears.

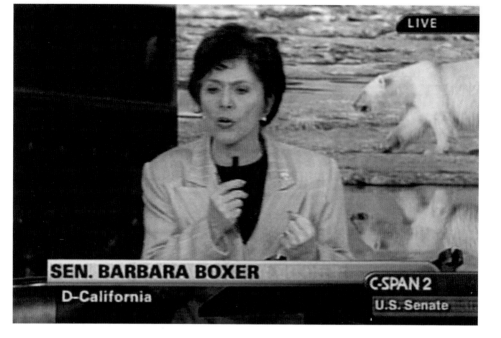

PLATE 5

Screenshot from C-SPAN 2, March 19, 2003.

"Cast your eyes on this," implored Senator Barbara Boxer, a Democrat from California, as she stood on the Senate floor and showed her colleagues a picture of a polar bear.... Taken by Subhankar Banerjee in the Arctic National Wildlife Refuge (ANWR), the photograph, according to Boxer, offered compelling visual evidence as to why drilling should not take place in this remote Alaskan landscape.... So on March 19, 2003,... the Senate, much to the dismay of the Bush administration, approved Boxer's amendment by a vote of 52–48, thus forestalling, at least temporarily, plans to drill in ANWR.
—Finis Dunaway, "Reframing the Last Frontier: Subhankar Banerjee and the Visual Politics of the Arctic National Wildlife Refuge," in *A Keener Perception: Ecocritical Studies in American Art History*, Alan Braddock and Christoph Irmscher, eds. (Tuscaloosa: University of Alabama Press, 2009).

(*Opposite*) **PLATE 6**

Penny ad. In 2005, during a difficult phase of the campaign to protect the Arctic National Wildlife Refuge from oil drilling, fellow activist Carol Hoover and I co-designed an ad, in collaboration with Alaska Wilderness League, Gwich'in Steering Committee, and The Wilderness Society. The photograph we used is of a pregnant female caribou migrating over the frozen Coleen River in the Arctic Refuge that I took in early July 2002. On November 14, the ad was placed in the *New York Times*, *Washington Post*, and *USA Today*. The following month, with bipartisan support in the US Congress, President Bush's attempt to open the Arctic Refuge to oil drilling was defeated, again.

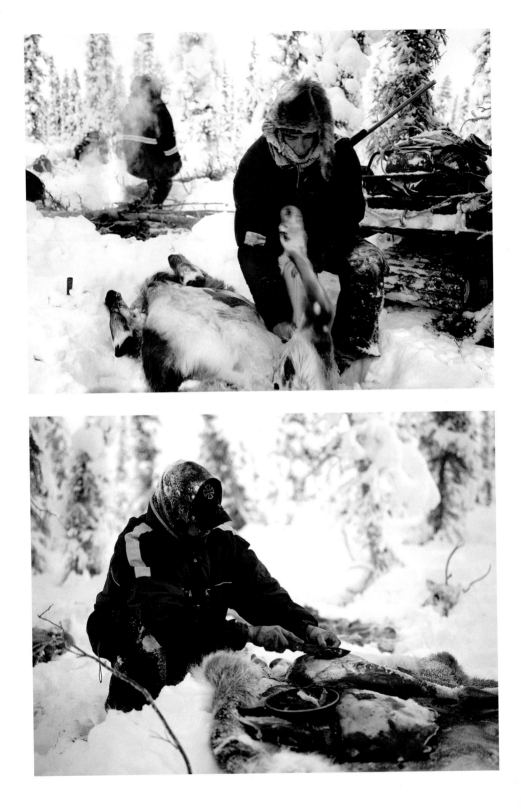

PLATE 9

At the Corral, Matvey Nikolayev gathering reindeer (image detail), camp 11, Tomponski Region of the Verkhoyansk Range, the coldest inhabited place on Earth, Yakutia, Siberia, Russia, November 2007. See Piers Vitebsky's essay for more on the Eveny culture.

(*Opposite*) **PLATES 7 AND 8**

Gwich'in caribou hunt. Charley Swaney (top), Danny Gimmel (bottom), near Arctic Village, Alaska, January 2007.

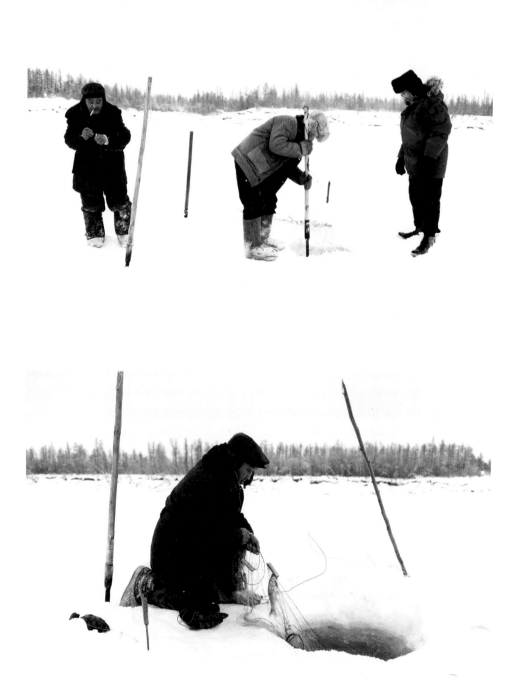

PLATE 12

Evdokya Shalugina is preparing fish for drying. Dry fish is eaten throughout the winter and is an essential component of the grub box during hunting trips. We ate a lot of fish that Evdokya prepared in many different ways—I remember eating seven meals a day.

(*Opposite*) **PLATES 10 AND 11**

Ice fishing on Yasechneya River: (top) Nikolai Shalugin, Yuri Shalugin, and Vyacheslav Shadrin; (bottom) Nikolai Shalugin; Yakutia, Siberia, November 2007. During our visit Nikolai mostly caught white fish, some grayling, and two lingcods, one of which he sliced in extremely thin and long strips that we ate frozen raw, while sharing stories in his small cabin at midnight.

 In November 2007, on an assignment from *Vanity Fair*, Robert Thompson and I visited Nelemnoye, the Yukaghir community along the upper Kolyma River in Siberia. The community depends on subsistence hunting and fishing. Due to climate change, decreased abundance and local and global extinctions of Arctic-adapted fish species are projected for this century. At the end of the eighteenth century the Yukaghir people occupied the vast and entire territory of the Sakha Republic (Yakutia), which is the largest subnational entity in the world. For many reasons, including Tsarist expansion, Sovietization, disease, and the expansion of other indigenous tribes, the Yukaghir population has declined rapidly, and today they inhabit only two communities along the Kolyma River with total population of about 1,500. From our hosts, Yakutsk-based Yukaghir cultural activist Vyacheslav Shadrin and other community members, we learned that they are determined to revitalize both the Yukaghir language—now spoken by about eight people—and their traditional culture.

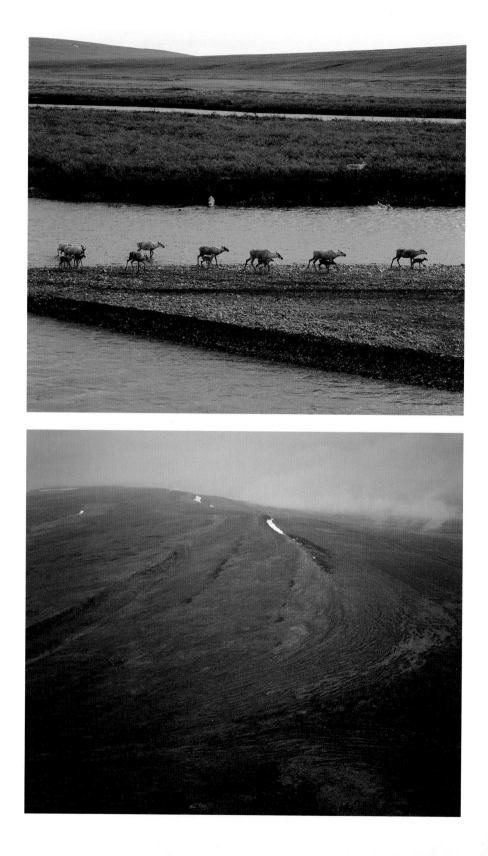

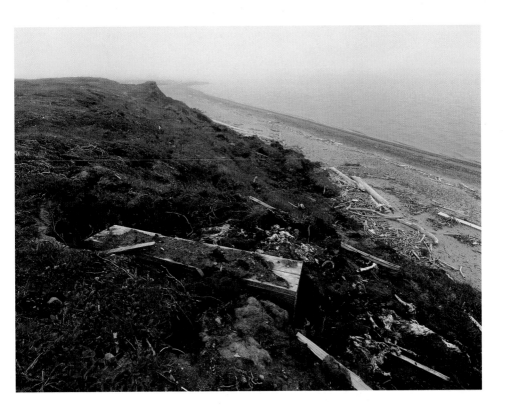

PLATE 15

Exposed Coffin, Barter Island, August 2006. The permafrost around the coffin melted away, exposing it. Robert Thompson speculated that perhaps a grizzly bear broke it open and scattered the bones, and that perhaps the coffin is not of an Iñupiaq, but possibly of a commercial whaler of the late nineteenth century. Arctic warming increases the thawing of permafrost, which releases methane—a ticking time bomb of the Arctic. Methane is about twenty-five times more potent as a greenhouse gas than carbon dioxide. There is an enormous but unknown amount of methane trapped in the Arctic permafrost—terrestrial and subsea—and it is already escaping with warming. The result of widespread methane release in the Arctic could be catastrophic for the planet, affecting all of us. As permafrost thaws, ponds connect with the groundwater system, leading to the drying of steams, lakes, and wetlands that significantly impact the ecology and local communities.

(*Opposite*) **PLATE 13**
Caribou and calves from the Western Arctic Caribou Herd crossing Kokolik River during return migration from their calving ground in the Utukok River upland, National Petroleum Reserve–Alaska, June 2006.

(*Opposite*) **PLATE 14**
Caribou tracks on coal seams in the Utukok River upland, National Petroleum Reserve–Alaska, June 2006.

PLATE 18

Known and Unknown Tracks, Teshekpuk Lake wetland, July 2006. When I shared this photograph with environmental groups, it instantly raised a controversy. To the conservationists, the faint caribou tracks were well-known, but what were these linear tracks? With some research it was discovered that they are the imprints left behind by heavy 3-D seismic exploration vehicles—a technology that has existed only a few years, and no oil company should have had permits to explore this protected northeast section of the Teshekpuk Lake Special Area. The photograph was used in the "Save TLake" campaign to oppose oil and gas development in the wetland. When the Bush administration granted permission to open up the area for oil and gas development the conservation community filed a lawsuit against the US Department of Interior. In September 2006, the District Court of Alaska ruled in favor of conservation, on the grounds that the government had not done enough ecological studies and did not make a persuasive case that development would ensure safety for the sensitive ecology and way of life of the Iñupiat communities who depend on the wetland.

(Opposite) **PLATE 16**

Beluga whales with calves, between Kasegaluk and Oomalik lagoons, along the Chukchi Sea coast, July 2006. An estimated sixty thousand beluga whales migrate through and spend the summer months in the Chukchi Sea. About four thousand of those animals are known to calve along the Kasegaluk Lagoon. On this day in early July, we had seen nearly one thousand whales with newborn calves within a one-mile stretch.

(Opposite) **PLATE 17**

Brant and Snow geese with chicks, Teshekpuk Lake wetland, July 2006.

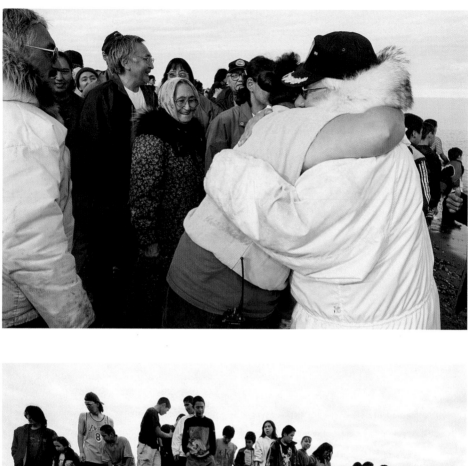

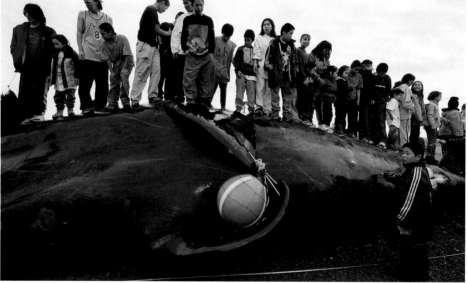

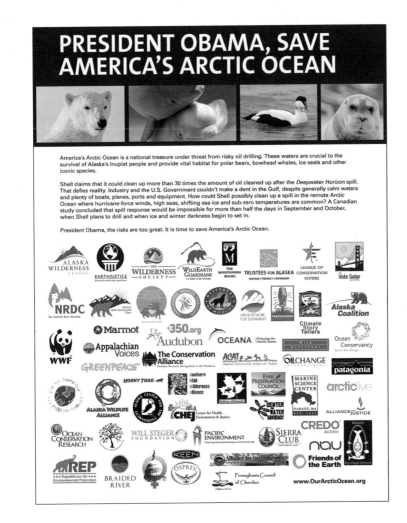

PLATE 21

During September 2011, United for America's Arctic, a coalition of more than sixty-five organizations, was founded with the leadership of Alaska Wilderness League. The organization that I founded, ClimateStoryTellers.org is a part of this coalition. On November 2, 2011, the UAA ran an ad in *Politico* to urge President Obama to save America's Arctic Ocean from Shell's drilling plan.

(*Opposite*) **PLATE 19**

Whaling captain James Lampe is being congratulated after a successful bowhead whale hunt, Kaktovik, September 2001.

(*Opposite*) **PLATE 20**

Children gather on top of a whale, Kaktovik, September 2001.

 Letter to Young Americans

Subhankar Banerjee, 09.09.2010
Photographer, writer, activist, founder
ClimateStoryTellers.org

You're young. The world in front of you does not seem very bright right now. I'm writing this letter with all that in mind. Your future is in your hands. Start the climate revolution now. Come November you must vote and you must vote with climate in your mind.

 After The Arctic Spill -- Shell, Palin and Obama

Subhankar Banerjee, 12.05.2010
Photographer, writer, activist, founder
ClimateStoryTellers.org

Did the administration approve Shell to go drill in the Arctic or not and if yes, then when? The truth it seems is somewhere in between.

Read Post | Comments

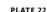
PLATE 22

Screenshots from *HuffPost Green* page. In 2010, Shell spent a lot of money on ads to pressure the Obama administration into granting them the necessary permits to drill in the Beaufort and Chukchi seas of Arctic Alaska. Those ads and my writing found convergence on *HuffPost Green*. I would post an article, and almost immediately it would be surrounded by Shell's ads—above, or below, on the side, and the page banner—with an attempt to drown the content of the article. Then, I would write up an article responding to the ad. This process went on throughout the fall. For more on this issue see my essay "BPing the Arctic?"

that there's a problem on the Yukon River, and nobody's admitting it, and here's the data. And the other seventy-two of them testified basically that they were going to starve to death, you know—I'm joking about that—but basically, 'We're going to starve to death if these proposals pass.'" None of the conservation proposals submitted by the upriver people passed.

The Board of Fisheries consists of a group of citizens—political appointees—who rely on technical advice provided by the ADF&G. Every third year the board hears proposals dealing with the Yukon area, and at each such meeting for over a decade the upriver people submitted proposals urging regulation to address the decline in king salmon size and the loss of big females. They called for the river-wide elimination of drift net fishing; they proposed a river-wide reduction in the depth of the nets; and they asked that the maximum allowable mesh-size for all gillnets be reduced to six inches.

Prior to 2010, the mesh size allowed on the Yukon River was by regulation... unregulated. A fisherman could use as large a mesh size as he wanted. Some biologists say that the Yukon, as of last year, was probably the last large-mesh commercial fishery for salmon in the world. In any case, the fishermen were using very large meshes, usually 8 to 8.5 inches (measured between diagonal corners when stretched). Smaller fish could go through such a net, but the bigger ones are caught very effectively. The females tend to be larger than the males, so the large-mesh nets effectively target the large, highly fecund females.

Essentially, large-mesh nets selected the larger, older fish, especially females, and removed them from the population before spawning. If smaller-mesh nets were used, most of the larger kings could bounce off and swim around it. But use of the large mesh amounted to a combination punch: first, the genes for large fish were being disproportionately removed from the gene pool; and second, small-fish genes were amplified, because fish with those genes were more likely to go on to spawn. Consequently, all of the environmental forces that had favored king salmon to evolve into a very large fish now would be out of phase with the actual size of the fish. Whatever other environmental forces may also be at work, this particular gear type was, in effect, changing the genetics of the Yukon kings.

Not until 2010 did the Board of Fisheries finally agree to establish a maximum mesh size. Unfortunately, the board put the limit at 7.5 inches, which Zuray and the upriver fishermen felt was the worst possible move. They wanted a 6-inch maximum or no change at all. The forty- and fifty-pounders had been essentially fished out, and a 7.5-inch mesh, they felt, would simply

target the next-largest fish remaining: the thirty-pounders. Fish and Game's commercial fish managers quietly supported the change, tacitly conceding a point they had ardently denied for years: that there was a problem with the size of the Yukon kings. But it was not the come-to-Jesus moment it might appear to be because a Fish and Game study suggested the most effective net size for catching king salmon was the 7.5-inch mesh. In Zuray's view, Fish and Game's new regulation likely will not enhance the run by putting sufficient large fish on the spawning ground, but rather better ensure that the largest remaining kings are caught by fishermen before they can breed.

Of course it makes sense—so long as the run is healthy—to have a significant commercial fishery at the mouth of the river. There, the kings are just in from the sea, dime-bright, and plump with their maximum oil content. They have their greatest market value in the lowest portion of the river and, as Fish and Game frequently points out, the people in this part of Alaska are very poor. The US census data for the district that includes the Yup'ik Eskimo villages of the lower Yukon River show the residents to be 90 percent Alaska Native, with a very low level of formal education, and to be one of the most impoverished districts in the nation. Twenty-nine percent of the residents have incomes below the federal poverty level. On the other hand, the census district next door, which includes nearly all of the upriver Athabascan villages almost to the Canadian border, itself has a poverty level of 25 percent. And because the fish arrive in somewhat poorer condition at upriver locations, the fishermen there have less of an opportunity to sell their catch. Thus the upriver people's need for salmon is based more on traditional fishing for food, rather than on sales and exportation to the fish-hungry Japanese or the lox market in New York. Even though subsistence fishing has priority in law over commercial fishing, the messy business of allocation does not generally favor the upriver subsistence fishermen. In effect, the upriver fishermen get the least desirable fish, courtesy of nature, and have no clout either, courtesy of politics.

In a state where the phrase "economic development" has become a mindless mantra guiding all decisions on resource development, it is tempting to assume that political pressure directly influences agency policies favoring commercial fishing. But Fred Andersen says that's an oversimplification. Andersen's twenty-eight-year career with the ADF&G includes sixteen years managing the middle and upper Yukon fishery and seven more years monitoring subsistence fishing on the Yukon for the federal government. "In general, Fish and Game does a great job managing the state's fisheries. The problem

is with the parochial Yukon River managers whose decisions turn out to favor lower Yukon commercial fishing interests over those of conservation and subsistence users and Canada." The federal government is charged with protecting subsistence fishing, and they could weigh in. But, since Monty Millard's death, "they are not inclined to intervene," says Andersen,—especially for most of the last decade, when a strong states' rights message was coming down from the George W. Bush administration. "The Fish and Wildlife Service just waits for the state to do something and they follow suit. They will not oppose or get out in front of the state, even when they have the authority."

To be fair, those who manage this fishery face an almost impossible task. Management decisions are based on a dog's breakfast of science, politics, ideology, and money interests. They are made in the context of a rolling crisis that sometimes can only be met with wild-ass guesses (blow twice into your fist and throw the dice). The degree of disarray belies the degree of importance. A lot of people have a lot at stake—not to mention a culture, not to mention an extraordinary animal. "I have heard it said, and I agree," says Andersen, "that the Yukon is probably the most complex salmon fishery in the world. You've got an immense and muddy river essentially two thousand miles long." You cannot see the fish at all until they leave the silty main stem for clear water tributaries. "You've got a run of fish that may take six weeks from the mouth to the upper spawning streams." And there are four separate runs of salmon in the Yukon: kings, summer chums, fall chums, and a run of coho in the fall. In turn, each run in is usually made up of several discrete pulses.

"The managers are asked to divine not only run strength," says Andersen, "but stock composition—how many of that total run are going to what region of the drainage. And there's on the order of probably three hundred or more spawning streams there." *Divine* is the right word, because the counting techniques employed are fairly primitive, notoriously wrong, and in part extrapolated from data that ADF&G withholds. A sonar unit near Pilot Station in the lower river detects some of the fish, but not all. And it cannot distinguish between small kings (most kings are small now) and similarly sized chums or whitefish, all of which may be mixed in together. At one point ADF&G acknowledged their sonar Chinook counts had been high by 40 percent for many years. "Pilot numbers have been all over the board with respects to actual abundance," says Andersen, "which is pretty much unknowable anyway." In 2005, ADF&G replaced one of its two sonars with another type that presumably detected kings not picked up by the older one. This

convenient presumption instantly boosted the run estimate by 30 percent, allowing managers to suggest the run was improving.

Once the strength of the run is divined, says Andersen, the managers must put sufficient breeders onto the spawning grounds while giving a reasonable allotment to both commercial and subsistence fishers. To do that, they alternately open and close commercial and subsistence "windows." And because several species of salmon are moving up the river at once, in multiple pulses, for up to a month and more, strung out over hundreds of miles of river, the managers must choreograph commercial and subsistence openings and closings in six fishing districts and ten subdistricts concurrently.

If that hasn't given you a headache, consider this. In Alaska, the Yukon River passes through both state and federal land. Subsistence fishing is treated one way under state law, differently under federal law. So a given fish heading upriver repeatedly crosses jurisdictional boundaries, alternating subjection between state and federal regulations. While ADF&G regulates four different kinds of king salmon fisheries on the Yukon (subsistence, commercial, sport, and personal use), most of the kings caught in Alaska originate in Canada. And that country's Department of Fisheries and Oceans applies *different* regulations to four *differently* defined fisheries (First Nations, domestic, sport/recreational, and commercial). Naturally, there's an international treaty to throw into the bouillabaisse, so add the State Department and the Pacific Salmon Treaty (1985), to which the Yukon River Salmon Agreement was appended after seventeen years of contentious negotiation.

Finally, list among the parties of interest a welter of non- or quasi-governmental organizations in the form of aboriginal tribes, Native corporations, tribal councils, village councils, fishermen's associations, several federal subsistence advisory councils, and state advisory committees. "The Alaska Department of Fish and Game has a very, very tough task," says Anderson. "But the complexity itself is an argument for conservative management—for backing off and for erring on the side of conservation." And this, says Andersen, the agency has not done. His review of the ADF&G's management oscillates between the genuinely sympathetic and, as he says, "pretty goddamned critical."

Brushed off by ADF&G, ignored at the Board of Fisheries, Stan Zuray and his friends tried the Yukon River Drainage Fisherman's Association (YRDFA), on whose board Stan sat. Like nearly every other party to the discussion, YRDFA is heavily influenced by the powerful commercial interests of the lower river. Still, Zuray made his case each year, recounting how the king buyers who came upriver in the 1980s refused to buy a fish smaller than fourteen

pounds. In a few years, the minimum was twelve pounds. Then ten. "The last half dozen years," says Zuray, "up to 2007 when upriver commercial king fishing ended, they'd take anything we got." But the downriver fishermen were hard to convince that something was seriously wrong. "And YRDFA operates by consensus," says Zuray, "so any disagreement means no action is taken." Twice in 2007 he insisted the executive committee vote on the question of whether or not there was a problem with Yukon king salmon declining in size. Twice the result was one vote shy of unanimous—Stan's being the only affirmative vote each time.

Still, he had hopes that at least science would be on his side, that objective research would validate his observations. But somehow, none of the agencies ever quite managed to conduct a study capable of answering the pertinent question. There was always some reason to consider the scientific research to be inconclusive, especially as to whether fishing practices might be involved in the kings becoming smaller. Reading the studies, one gets the sense that the writers are working awfully hard to *keep* from saying something. Many resort to evasive formulations, noting that none of the studies "has been able to exclude the possibility that other factors," such as environmental conditions, are the cause. Of course, we may never be able to "exclude the possibility" of some environmental factor at work, while it still may be possible to prove statistically that a given fishing practice causes size decline. Statistics prove that smoking causes lung cancer, even if we cannot prove that a particular lung cancer was caused by smoking. Yet it is *known* that reducing smoking in a large population *will* reduce the incidence of lung cancer.

Some biologists, too, express frustration with the lack of focused research. University of Alaska fisheries biologist Chris Stark says, "They can't see anything yet—that's correct. And if you don't look you can't see anything." Fred Andersen goes further. "I don't think they wanted the answer. I really don't," he says, speaking of the fishery managers. "I think that the very essence of this is that those guys just didn't want to deal with the shitstorm of protest that would blow up if they took the draconian measures that were required."

Neither was Stan, who was gradually absorbing the sensibilities of a scientist, much impressed with the seriousness of the agencies' approach. For one thing, the sampling was pretty haphazard. "There's all these data sets. This one's from 1979 to 1984, then that project ended. Then there's another one from, you know, '77 for three years, then that one ended. Then there's a weir project. There's just not much consistency. I thought to myself, *Nobody's monitoring this.*"

Zuray was likewise underwhelmed with the agencies' experimental technique. Some of their data were not randomly sampled. Sometimes sampling did not extend for the full duration of the run. Or the size data was a mixture of samples taken from both fish wheels and nets. Or the nets were of different sizes. By now Stan knew all these things made a difference. "I mean, it just wasn't good data, not as far as assessing the size." For him there was really only one option. He would get his own data, and he would do it properly. He would build the most reliable database on Yukon king salmon in existence and one that directly addressed the problems affecting fishermen.

At first, Stan had no idea how wholeheartedly he would take to the science of fish data collection, or how far into these dark arts he would stray. The chum tagging he'd agreed to do for Monty Millard in 1996 was actually directed by a young biologist named Tevis Underwood. A few years into the project, Underwood noticed that tagged fish were not showing up in recapture wheels upriver. In fact, sometimes they showed up many miles *down*river. They seemed injured, disoriented, even dying en route. Underwood thought it likely the fish suffered too much trauma banging around in the wire mesh of the fish wheel baskets, being jammed together in the submerged "live box," and finally getting scooped out, measured, tagged, and heaved back into the river. He asked Stan to help redesign the fish wheel to be more fish friendly. After all, the scientists didn't want to eat the salmon; they just wanted to take some measurements and leave the fish to go spawn. In particular, Underwood wondered if a video camera might be employed to count fish.

The wheel that Stan Zuray designed and built with Tevis Underwood's help (and in consultation with Dave Daum, a computer whiz at Fish and Wildlife) was a wonder, a Buck-Rogers-meets-Fred-Flintstone machine incorporating, among other things, springy webbing for the baskets, a slippery plastic slide, an on-board computer, a waterwheel generator, a solar panel, deep-cycle batteries, an infrared sensor, lights for nighttime operation in the fall, and a 7-Eleven–style surveillance video camera. The "capture" took place on camera as the fish slid straight back into the river. Hundreds of short movie clips showing sliding fish was saved on a small removable disk in the laptop. At day's end, Zuray could run his boat over to the wheel and retrieve the disk—both fish and man much less worse for wear. (Later on, Stan reduced the labor further with a wireless transmitter beaming the data across the river to his camp.) This system was adopted at other sites on the Tanana and Yukon Rivers and became the standard for research fish wheels thereafter.

The only real problem came when Underwood gave Stan his laptop computer and told him, "It's your project, go write the report." For all his mechanical competence, Stan had never used a computer or even a typewriter. Nor did composition come easily. When the laptop's battery ran out five hours later, Stan had produced his name, address, and the word *Introduction*.

But, encouraged by Tevis Underwood and some of the other Fish and Wildlife Service field biologists (like Dave Daum and Randy Brown), as well as visiting scientists from the States, Zuray banged out his first grant proposal in 2000. He became an independent contractor, catching and measuring fish, assessing such things as the size, health, and abundance of the salmon runs. With something like a convert's zeal, he became devoted to the collection and purification of data. The next year he landed another grant to utilize a locally available pool of nascent scientific talent: the high school-age bush kids scattered along the river at various fish camps. The kids already knew a great deal about handling fish, and the older ones could run boats. Now Zuray and various scientists trained them to carefully and consistently record good data—data that could stand up to any challenge. "I worked for him for seven summers," says one young man, now a biology major in college. "And he's a Nazi when it comes to making sure that the data is accurate and unbiased. He's always all about getting good dater," he says, cheekily imitating Stan's New England-bred intrusive *r*.

"That's why we started doing what we are doing," says Zuray. "We started dabbling in 2001. And by 2004 we had the protocols down. We knew what we had to do. We'd worked with enough experts. By 2004, our Student Data Collection Project was now a database that to this day is recognized as some of the best data that's taken on the Yukon River. Even by ADF&G, who a lot of times didn't really appreciate what we were doing."

What Stan and the kids did over the years—with the significant cooperation of the other subsistence fishermen at the Rapids—was to collect meaningful data that were beginning to prove what ADF&G had steadfastly discounted: that there was, among other things, a decline in size in Chinook salmon, a decline in the percentage of females, and the prevalence of a lethal disease called Ichthyophonous. Of 5,806 kings Zuray has randomly sampled between 2004 and 2010, none weighed fifty pounds. Only two exceeded forty pounds. Thirty-pound fish have become rare. In 2010, the average weight of a Yukon king caught in fish wheels at the Rapids was 10.8 pounds, with a scant 14 percent females. In the five years prior to 2009, only a single fish was caught in the forty-pound range. Of the 1,002 kings Zuray sampled in 2010, only 6

were more than thirty pounds. It is almost to the point, says Zuray, where the number of fish caught in the thirty-pound range equals what they used to catch in the fifty-pound range. "We've probably lost *twenty pounds* off the top end."

All the data are public information, obtained with public funding, so Zuray makes use of it on his personal website (www.rapidsresearch.com), which he constructed himself. Here he has organized an enormous array of Chinook and chum salmon data, technical information, annotated spreadsheets, charts and graphs, government reports, professional papers, photos of his troop of student-technicians in action, videos of fish wheels in motion, and links to other pertinent sites. At a time when the ADF&G's reports were fairly plainly illustrated, Stan's were festooned with full-color bar charts and multi-axis graphs showing complex run timing comparisons. "I heard that people were asking Fish and Game why their charts weren't as good as mine," Stan says with a cackle. Not long ago he was in Fairbanks at the Fish and Wildlife Service offices helping Tevis Underwood learn to do double-axis graphs, and they laughed at how roles had reversed.

He also posted his own daily fishing report that anyone who signed up could receive via e-mail. Where he offered opinion, he generally wrote in a polite, understated way, though irony and sarcasm were tools in his kit. Sometimes he proposed steps that might be taken to restore the run. It was his own site; he produced it on his own time. Nobody paid him anything to do it, as his elaborate disclaimers assert. Biologists from all over the greater Northwest noticed his work. Jim Winton, Supervisory Research Microbiologist at the Western Fisheries Research Center (Seattle), wrote to say, "Your student project is the best long-term disease project I know of in terms of data quality, data access and value for money." Dick Kocan, a research professor at the University of Washington says, "I know a lot of scientists here in Seattle who follow his web site on a regular basis; it's a fundamental part of their everyday education." Larissa Dehn, a professor at the University of Alaska, wrote, "Long-term data sets are invaluable in this effort and Stan has an uninterrupted time series dating back to 1999 . . . I have come to respect Stan as a great scientist. . . ." In a word, Stan's data really *was* the best data on the Yukon.

But where support for his work splits, Zuray says, "is where the biologists and the managers separate." As Stan's records grow into a significant database, and as he got better at sharing his information, managers at ADF&G seemed to become nervous. One e-mail from the ADF&G notes that "everyone appreciates the quality and timeliness of information your project provides," but goes on to say that some ADF&G managers consider his comments to be

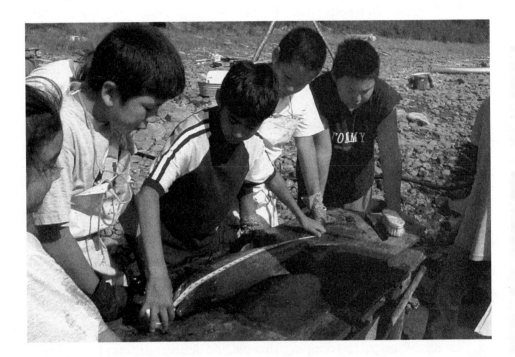

Boys taking king salmon data at Rampart Rapids, along the Yukon River. *(Photograph by Stan Zuray, 2004.)*

"egregious" and asks that he "tone your run assessments down a little." When Stan advised his readers that he would begin offering "positive ideas to help the king runs," an ADF&G manager named Steve Hayes responded within half an hour: "May be a better idea not to use the rapids test fish wheel project for this. I am not sure it is in the funding guidelines."

But soon he got a tip from a pal within one of the agencies that certain mangers were "pissed off" about his dispatches. They intended, said the informant, to press the Yukon River Panel "to limit what you can say while being paid by Panel funds." The Panel is the US and Canadian body established under the Pacific Salmon Treaty to jointly set harvest and escapement goals and to fund research. Actually, Zuray's critics went further than trying to restrict his commentary. Despite excellent reviews from field biologists, a virtual who's who of top ADF&G and Fish and Wildlife Service managers all sent comments to the Yukon River Panel in late 2002 that seemed aimed at cutting Zuray's video wheel project all together. The project was "obsolete in the face of increased mortality from excessive handling of fish," said Bonnie Borba from ADF&G. It would only be providing "run timing and river conditions," said Russ Holder from the Fish and Wildlife Service. Gene Sandone, the regional supervisor for Arctic-Yukon-Kuskokwim commercial fisheries, who supervised just about everybody working on Yukon River salmon for the ADF&G, noted that the efficiency of Zuray's wheel in 2002 "increased during times of high water and this was not corrected for in-season." Zuray scrambled to collect some responses into a letter he sent to a supportive panel member, but as it turned out, that member did not attend the meeting, and Stan's rebuttals were not heard. If there was a coordinated effort to eliminate Zuray's funding, it worked. With ADF&G's recommendation, the Yukon River Panel ended its support of the video fish wheel project.

At that time, Stan had two grants underwriting his video work. The Yukon River Panel paid for counting fall chum, and the federal Office of Subsistence Management (OSM) paid for counting Chinooks. To an unwholesome extent, there is a great deal of interlocking membership on the various fisheries advisory boards and commissions. OSM's technical review team was dominated by the same people who sat on the Yukon River Panel. "I was told to not even waste my time trying to renew my OSM grant in 2003," says Zuray, "so I didn't." He collected king data for 2003, but after that Zuray was out of business, his fish sampling operation had been totally shut down, his rise as a credible spokesman for conserving the king salmon had been blocked.

But not for long. Riding to the rescue—quietly, not wanting to make a fuss—came the Canadians. "In the spring of 2004 I was told through back

channels that the Canadian portion of the Yukon River Panel would like to fund me again, and that they would stand behind me if I put in for funding. So I did, and they have backed me ever since."

Incredibly, the "increased mortality from excessive handling" reference in Bonnie Borba's disparaging comments referred to Tevis Underwood and Zuray's early work showing that fish held in "live boxes" were being harmed. ADF&G had been using live boxes on its research wheels for thirty years with no one picking up on the problem. Then Tevis and Zuray started tagging, and within two years they identified the trouble and pioneered the fish-friendly modifications that have become standard practice. All of this Borba knew before performing the intellectual contortionism necessary to hang "increased mortality" and "excessive handling" on them.

Russ Holder apparently did not notice that Zuray's wheel provided more than "run timing and local river conditions." Among the things Holder overlooked was that the data from Stanley's wheel better predicted the actual number of Chinook delivered to Canada than did ADF&G's analysis that drew on a vastly more extensive and costly censusing apparatus. (Not for nothing the Canadians liked him.)

Mr. Sandone criticized Zuray for not applying a correction in season (Summer 2002) when the water levels were high. The idea is that the catch rate of a given fish wheel might vary as water levels rise and fall, even if the passage of fish was constant. The variance might be in a known relationship to water level, and so a correction factor might be devised and applied to the catch figure. Two things struck Zuray as especially amazing about Sandone's statement. One is that such a correction formula had not been invented until *after* the 2002 season, so it could hardly have been applied "in season." The second is that the formula, now a standard tool on research wheels, was invented by Stan. Though one person might see the formula as a fisherman's gift to the scientific community, Mr. Sandone apparently faults him for not having invented it earlier.

Stan was back in business. But as late as 2010, ADF&G advanced the notion that if there was a problem with the king run, it might be that management was allowing *too many* kings to reach the spawning grounds. At one point, an ADF&G statistician concluded that the fish were actually getting bigger. But the truth was the size of the kings making it upriver declined every year, except in 2009, which was a special—and very interesting—case.

The 2009 run was projected to be poor. So there were lots of meetings around the state that winter, says Zuray, and everybody knew there would be

significant closures to fishing during the summer of 2009. There was even talk of "whole pulse closures," meaning that a pulse of kings would be protected all the way up the river. Fish and Game would close off fishing in a particular district just as that pulse of fish was about to enter it, and open it again only after the pulse had passed through. By doing this, district after district, all the way to the Canadian border, they could ensure significant border passage.

This, as one of Stan's several confidants within ADF&G suggested, presented a unique opportunity to collect a special kind of data. Zuray should get a new permit to catch and weigh fish during the closure, suggested his friend, and he would be wise to do so without anybody knowing about it. "Because if they knew what I was up to they'd stop me from getting the permit," he says. The permit he already held for catching fish for the video project did not allow him to actually handle the fish—the fish slid immediately back into the river. He did weigh other fish, but they were either his own subsistence harvest or that of the other subsistence fishermen around the Rapids, and he didn't need a permit to weigh people's catch. But because no one could fish at all during the closure, and because his video permit didn't allow him to handle the fish, he needed a new research permit. "So that winter I just tucked it into my video permit application—the permit I send in every year." Though it is likely nobody in management noticed, Zuray had added to the terms of his annual permit that he would be allowed to catch and handle three hundred Chinook salmon during any closure that might be ordered.

"I figured the managers knew that if they were to restrict fishing that much—like a whole-pulse closure—that a lot more big fish would make it to the upper river. And that was not the kind of information they wanted put out, because they had denied in the past—at lots of meetings everywhere— they had always denied that closing fishing to that extent would have that effect. They had always said that the problem is out in the ocean; they said the problem is with the Bering Sea pollock fishermen taking too many Chinooks; the problem was *not* large-mesh gillnets in the lower river. And they did not want to have definite, stark, in-your-face data about how much better off the fish are going to be if they managed the fishery this way."

The little drama played out exactly as the co-conspirators anticipated. A whole-pulse closure was indeed declared on the first pulse of Chinooks, and when that pulse reached the Rapids, having been protected all the way upriver from the mouth, Zuray saw what he expected. Big fish. Lots of them. When he passed this information on, his inside man said to him, "Well, maybe it's time to flush the crooks out."

That night, Zuray posted his update and included a picture showing his student techs at the fish wheel, weighing kings during the closure. The next day he presented a little summary of his data, showing a whopping 50 percent increase in weight over the previous year's pulse-one. The percentage of females shot up from a miserable 7 percent the previous year to 29 percent. Even though the run was not yet half over, he had already sampled as many greater-than-twenty-five-pound fish as he would ordinarily see in two to three years' complete runs.

When Zuray checked his e-mail the next morning, he had a message from ADF&G requesting he call "before the bureaucratic brush fires start to flare up." People at ADF&G's commercial fishing division were not happy and were demanding to know what the hell Stan Zuray was doing weighing fish during the closure and under what authority. Stan was asked to send off to ADF&G a more detailed description of his weighing methodology, but, no matter how upset commercial fishing managers were, it was too late. Stanley had the data, and he would publish it. It would show a significant jump in the size of king salmon for 2009. The 2009 fish were 22 percent larger than the average weight of fish sampled over the previous four years. And in 2009 there were 440 percent more fish over thirty pounds compared to the previous four years' numbers. A little bit of guerilla data gathering had pierced the agencies' inflexible public position and shown exactly how to put larger (and hence more fecund) fish onto the spawning grounds. The data demonstrated to the satisfaction of many that at least part of the problem with the declining size of king salmon was *not* due to uncontrollable environmental conditions in the ocean, but because of overfishing on the lower river. And that was a condition ADF&G *could* control, if they only would. "We took one of the poorest runs recorded at the mouth and made it into one that not only met border escapement but did it with some of the best female rates and sizes in years," he says. "Just think what we could have done with some of those larger runs of the past when problems were just starting."

It took a decade of argument and, above all, a decade of data, but by 2009 YRDFA finally and formally agreed unanimously with Zuray that the king salmon were shrinking and the run was in trouble. Even the Alaska Department of Fish and Game's John Linderman (Gene Sandone's replacement) vouchsafed in an interview that "there's definitely a strong indication, and pretty conclusive, that we have seen . . . a decline of older and larger king salmon within the Yukon." Still, ADF&G not only comes late to the party, it comes empty-handed. Its policies follow a familiar pattern: the upper limits on harvest are pushed up and the lower limits on escapement are pushed down.

In 2010, the ADF&G members of the Yukon River Panel pressured the far too-complacent Canadian members into accepting a lower Chinook escapement goal into Canada. The 2010 escapement did not meet even this lowered goal.

Moreover, ADF&G continues to attempt to publish in the scientific literature unsupported claims that tend to discredit Stan Zuray's data. On each of multiple occasions, these papers have been rejected in the peer-review process. Recently, Stan and two distinguished scientists from Washington state collaborated on a paper that challenges the Alaska Department of Fish and Game's allegations. That paper has been accepted for publication by the lead journal of the American Fisheries Society. The lead author is Stanley Zuray.*

In its biased accommodation of lower Yukon River commercial fishing interests, ADF&G—with the US Fish and Wildlife Service passively in attendance—has presided over the near extinction of the Yukon kings. Partly in consequence, an ancient human culture dependent on that fish slides closer to extinction as well. Meanwhile, Stan Zuray collects and interprets his data and waits for the day when the agencies charged with fish conservation awaken to their mission.

NOTE

* Zuray, Stanley, Richard Kocan, and Paul Hershberger. "Synchronous cycling of ichthyophoniasis with Chinook salmon density revealed during the annual Yukon River spawning migration;" *Transactions of the American Fisheries Society* (in press).

Following Cranes to the Arctic

GEORGE ARCHIBALD

❖

Out of the blue on July 13, 2010, I received an e-mail from Dr. George Archibald, renowned crane biologist, conservationist and co-founder of the International Crane Foundation. He wrote, "I just visited Alaska with your friends at Arctic Treks (Jim Campbell, Carol Kasza, and their son Kyle) and was thrilled to fly over the migration of thousands of caribou as they moved north to escape the bugs. Although thrilled to experience the wildlife and wilderness, I also observed from the air the massive petroleum developments and have renewed concerns." I responded happily, "You may not remember me, but I met you very briefly at Peter Matthiessen's reading of his book, The Birds of Heaven: Travels with Cranes, *at the Smithsonian, many years ago." Just about the time his e-mail arrived, I was beginning to think about* Arctic Voices. *So, after a few e-mail exchanges, I made a request to him to write an essay about his recent trip to Arctic Alaska. He generously agreed. Some of you might be familiar with the famous dance photograph—Tex, the whooping crane, with her partner, George, the biologist (if not, just Google it, and you'll see it's an unforgettable image).*

The dance was to encourage one of the last surviving members of this highly endangered species to shift into reproductive condition. Later he appeared on The Tonight Show with Johnny Carson and recounted the tale—Tex successfully laid a fertile egg, following artificial insemination, but the end of the story was tragic, as she died after the hatching of her one and only chick. George has since worked to save many species of cranes and their habitats all over the world. Today, it is not possible to think about conservation of cranes without George Archibald. I was pleasantly surprised when on April 13, 2011, I received his draft—he takes us not only to Arctic Alaska, but also to Canada and Russia.

❖

THE FAR north of Asia and North America has a mysterious and inexplicable magnetic-like pull on one's soul. Its silence is luscious, landscapes are vast and glorious, and wildlife, when it appears, is conspicuous and fascinating. Siberian, whooping, and sandhill cranes led me to the Arctic of Russia, Canada, and the United States.

I am a Canadian from a rural area of the maritime province Nova Scotia. Our home was surrounded by Acadian forests, a diverse mixture of deciduous and coniferous trees. Although thrilled by the infrequent appearance of deer, moose, and bear, the forests seemed a bit foreboding: one could easily get lost. Driving at night one always looked forward to the lights of the next dwelling. But I was not afraid of the wilderness. I respected it and loved it. Perhaps I was imprinted on it!

During two of the summers of my undergraduate years in the 1960s, I worked at Al Oeming's Alberta Game Farm. Al had a contagious and consuming interest in cranes, a group of birds I had read about but never experienced because of their absence in eastern Canada. There were many sandhill cranes in Alberta, and Al wanted me to raise some from eggs collected from wild cranes to develop rearing techniques that might eventually be applied to the rare whooping cranes that nested nearby in the Northwest Territories.

In late March we flew low over wetlands with bush pilot Charlie Fix, looking for a ring of open water surrounding a low platform crane's nest created from vegetation piled into a heap. Having spotted one, we landed on a nearby open stretch of water from which I walked through the marsh to collect the eggs. Amidst swarms of mosquitoes and knee-deep water, I entered the world

of cranes and searched for the special spot, which was much more easily observed from the air than the ground.

Once, when Charlie flew away to look for more nests, I sat on a beaver dam and listened to the underscore of marsh music created by sparrows, blackbirds, wrens, rails, and frogs. Suddenly, the symphony was dominated by the sonorous wind instrument owned by a crane. Loons that create glorious music on the lakes of Nova Scotia had their counterpart in the marshes of Alberta. But that crane music stirred something deeper in me. It seemed like an ancient voice calling for help in the future.

A few years later as a graduate student at the Laboratory of Ornithology at Cornell University, I discovered Aldo Leopold's *Marshland Elegy*. Leopold captured in words what I felt about cranes:

> When we hear his voice we hear no mere bird. We hear the trumpet in the orchestra of evolution. He is the symbol of our untamable past, of that incredible sweep of millennia which underlies and conditions the daily affairs of birds and of men. . . . The sadness discernible in some marshes arises, perhaps from their once having harbored cranes. Now they stand humbled, adrift in history.

Through my interest in Leopold, I met fellow student and crane enthusiast Ron Sauey. In 1973 we co-founded the International Crane Foundation (ICF) on the Sauey farm near Baraboo, Wisconsin, about ten miles from Aldo Leopold's shack.

ICF is dedicated to the conservation of cranes worldwide. The size and beauty of cranes, their primeval calls and their graceful postures and dances, have inspired humans since times untold. Consequently, today, cranes are powerful ambassadors for the conservation of the wetlands and grasslands.

RUSSIA

A few months after the collapse of the USSR, my Russian colleagues invited me to join them on a month-long expedition to northwest Siberia—the breeding grounds of the last two pairs of Siberian cranes, which migrate thousands of miles to winter in India.

From the coastal city of Salekhart, we traveled in a huge helicopter south over the ruins of camps from the Gulag to the basin of the Kunovat River, a western tributary of the mighty north-flowing Ob River. About a mile from

the nest of a pair of Siberian cranes, the helicopter hovered low over a wetland as we gently dropped into a sedge meadow, ourselves and containers with all the provisions for the next month. Before I jumped into the marsh, the pilots vigorously shook my hand and passed me a gorgeous knife as a memento for being one of the first visitors from the west to set foot on land that had been closed to the outside world for seventy years. They promised to return to collect us at noon on an appointed date at the end of June.

Camped among spruce and birches on a knoll beside a brook in a vast wetland complex that included lakes, marshlands, and forests, I was privileged to share the wilderness and its treasures with Russia's leading ornithologist and close friend and mentor, Professor Vladimir Flint, and several other ornithologists. Years ago, I nicknamed him Vladoka because of his passion for refreshing beverages. Vladoka and I often took long hikes into the wilderness. He insisted that conversation be kept to a minimum while experiencing pure nature. Walking slowly, we looked, we listened, and we discovered treasures. When we came to a spot with an especially pleasing view, we found a place to sit, watch, talk, and enjoy a splash of vodka. As one learned to manage the mosquitoes, it was paradise!

Although my focus was on the Siberian cranes, being a birder I was enthralled by the number and diversity of other species on this transitional landscape between the boreal forest to the south and the open tundra to the north. A white wagtail often perched atop my tent and sang. His calls were part of a chorus that included the brambling, waxwing, yellow wagtail, blue throat and many other songsters. Hazel grouse wandered near our camp. Black grouse called from their lek in the distance. Goshawks nested in a nearby tree. The lakes were dotted with a variety of waterfowl, including whooper swans, Arctic and red-necked loons, black scoters, smew, pintails, and widgeon ducks. A pair of bean geese had a nest along a stream. The colorful ruffs displayed at their lek beside a small lake. And the wetland that was home to the Siberian crane nest was also used by the musical curlews and other shorebirds. Everyone was busy reproducing during the narrow window between June and September.

The wilderness was also home to indigenous people, the Khanty, who are reindeer herdsmen and fishermen. We visited a summer camp of several families upstream from the cranes along the Kunovat River. Several canvas-covered teepees were summer homes for the Khanty. Sturdy Arctic dogs were tethered here and there, and beautifully formed wooded sleighs that were placed upside-down on low platforms revealed that the Khanty moved from

one place to another. There was a huge and elevated platform covered with conifer boughs, surrounded by shallow pits that emanated clouds of smoke from burning boughs, which provided a smoke-filled sanctuary for reindeer from clouds of mosquitoes. Mosquitoes do not like smoke.

In our honor, a large bull was lassoed, its velvet-covered antlers were severed at the base, and the palmate end was opened and offered to the guests as a special treat. After a few bites and profuse thanks, I concentrated on photography.

Siberian cranes are protected by the Khanty as treasured birds that are considered to bring good fortune. If a pair of cranes is nesting in a particular wetland, domestic reindeer are not allowed to graze there. And after the Khanty kill a brown bear, they dress as Siberian cranes and dance around their campfire to drive away the lingering spirit of the bear.

Many Khanty have left the wilderness and successfully joined contemporary Russian society, but a few hundred remain in their traditional lifestyle. The Kunovat Nature Reserve was established to protect both the Siberian cranes and the Khanty. But we were there to study the cranes.

I first caught a glimpse of Siberian cranes from the helicopter the day we arrived. One crane was sitting on its nest in a shallow wetland surrounded by forest. From a distance it resembled a swan. As the helicopter circled near the knoll of forest that was to host our camp, a second Siberian crane stood at the edge of a lake, perhaps half a mile through the forest from the nest. During the next month in this land of the midnight sun, when the weather permitted, I tried to learn more about the world's most endangered crane species through observations of the cranes at the nest and on their feeding areas.

The male and female exchanged incubation duties every few hours. After leaving the nest, the male would fly away. In contrast, when not incubating, the female usually remained to forage not far from the nest. After the first egg hatched, the cranes stopped incubating the second egg but remained near the nest for several days until the chick was more mobile. Then they disappeared into the forest. I wondered if the male led his family to better feeding areas, discovered during his forays throughout the incubation period.

My colleagues collected the second egg while it was still warm, and substituted it into the nest of a pair of Eurasian cranes several miles from our camp.

Two years later, that pair of Siberian cranes failed to return to the area, leaving but a single nesting pair in the Kunovat Basin. One summer their prefledged chick was color-banded. That autumn this last pair to visit Keoladeo

National Park, India, appeared with that banded chick. This was the first conclusive proof connecting the breeding and wintering grounds.

They continued to nest until 2002. In 2003, they failed to return to their breeding grounds, and the following winter, Siberian cranes were not spotted in India. Colleagues in Afghanistan met a hunter who claimed to have shot a Siberian crane in the spring of 2003. Although the Siberian cranes are perhaps extirpated from western Siberia, a flourishing population of more than 3,500 cranes breed in Yakutia, eastern Siberia, and winter in China. But this population is now threatened by water development projects in China. Thus the International Crane Foundation considers the Siberian crane the most endangered of the fifteen species of cranes, although the whooping crane and the red-crowned crane have fewer numbers.

Although the Siberian cranes have vanished, the wilderness that supported the Siberian cranes remains intact as the Kunovat Nature Reserve. One day, if the security of cranes can be assured during their passage to India, Russian colleagues hope to reintroduce Siberian cranes using captive-reared birds trained to follow ultra-light aircraft along the ancestral migration route.

In the meantime, I cherish the memories in the wilderness with the Siberian cranes, the plethora of other wildlife, the silence, and the special fellowship with dear friends with whom contact was so restricted during the Cold War.

CANADA

The wilderness of northern Canada holds two of the world's largest protected areas: Wood Buffalo National Park (WBNP; 17,300 square miles) and the Thelon Wildlife Sanctuary (TWS; 26,000 square miles). The only viable population of wild whooping cranes nests in WBNP, and the continent's one of the largest herd of caribou—the Beverly herd, roam across the tundra and taiga of TWS.

In the early 1990s I had briefly visited WBNP to transport whooping crane eggs for captive breeding centers in the US. Those trips were anxiety-laden as I cared for my precious cargo on chartered flights. In Fort Smith, the community near the nesting area of the cranes, I heard about the wonders of WBNP and of the great herds at TWS. But there was never enough time to visit.

The idea of combining a trip to both destinations became a reality in 2004, following a chance meeting of an Arctic enthusiast and ecotourism professional, Tom Faess, who had stopped at my home to buy chicken eggs during a winter visit to his relatives in central Wisconsin. Two years later, in August,

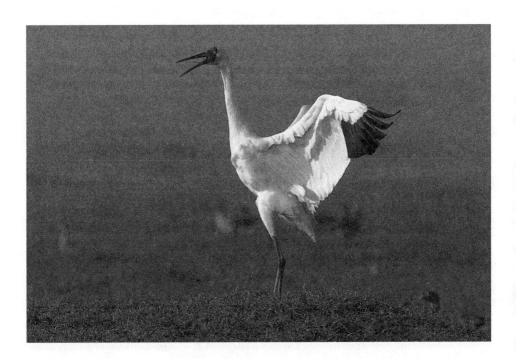

Siberian Crane, Keoladeo National Park, Bharatpur, India. *(Photograph by N. C. Dhingra, 1999.)*

I met twelve members of ICF in Edmonton for an adventure to both WBNP and TWS. We flew commercial to Yellowknife (the capital of the Northwest Territories) and then by charter to Fort Smith, to spend several days exploring WBNP. From Fort Smith we continued by floatplane over the breeding grounds of the whooping cranes and on to Tom's remote camp at Whitefish Lake, the source of the Thelon River.

Although it was exciting to experience the continent's northernmost white pelicans fishing among the rapids of the Slave River beside Fort Smith, and to encounter mighty bison spread like cattle along roads through the forests, and to spot a few white dots—whooping cranes—on the wetlands of WBNP, it was not until I walked into the silence of the wilds near Tom's camp at Whitefish Lake that I felt the spirit of the wilderness.

Tom's camp was on an esker—those long hills of sand that were once the bottoms of rivers running through glaciers that scraped clean the granite of the Canadian Shield. The esker was populated by numerous ponds, forests of spruce and birch, and tundra, with its complex mixture of mosses and berries. Our arrival was carefully planned to follow the summer's surge of mosquitoes and to coincide with the southern migration of the caribou that had moved north ahead of the insect hatch to exploit lichens exposed by spring melt. It was a prelude to autumn, when the tundra is painted in reds and yellows.

Not far from the camp and under some fallen trees that offered a degree of shelter, there was a wolf den that had been inhabited through spring and early summer. The wolves had departed, perhaps to follow the caribou. But grizzlies were around. Fortunately, we never encountered one during our long walks. Their hair-filled and enormous droppings were silent testimony to their size and menu. A few male caribou with handsome racks appeared now and then. But the Biblical herds were absent, perhaps delayed by a warmer summer. We encountered small groups of muskoxen and were careful to maintain a safe distance.

Birds were omnipresent and spectacular. A pair of handsome gray gyrfalcons with two noisy fledged young lived in the forest that surrounded the grass-covered peak of a hill. Several miles along the lake shore, a pair of merlin had three chicks near fledging. Pine siskins, harris, white-throated sparrows, and redpolls were common, together with Lapland longspurs and American pipits that apparently nested farther north. Large lakes in the esker had a few broods of surf and white-winged scoters. The silence was also sometimes broken by the distant calls of loons and Canada geese. Tom told us that the predominant and delightful silence around us was a prelude to the noise that

would come later in August as thousands of waterfowl from the Arctic would migrate south across the tundra.

Although nights were short, on occasion they were punctuated by the glory of the northern lights—the aurora borealis. Patches of vertical streaks in white, green, and red danced across the sky, appearing and disappearing, always moving. I was so mesmerized by the spectacle that I did not want to sleep during a night when they were strongest. From my sleeping bag on the sand beside the lake, I watched the show until I was captured by sleep. When I awoke, the outer layer of my sleeping bag was soaked in dew as I gazed east to a breathtaking scene: rising sun illuminated in a multitude of colors the bottom of a thin layer of clouds. Such pieces of paradise appeared between stretches of strong winds, rain, and even snow!

Down the lake near the merlin's nest was an archeological site where in former years researchers had unveiled the artifacts of hunters and fishermen that had been at that location for about eight thousand years. Perhaps a mile in the opposite direction from Tom's camp, large circles of stones on the open tundra marked the location of the tents of Dené Indians who had gathered there from distant locations in 1946 to make a critical democratic decision regarding whether to remain in their traditional lifestyle on the barrens or move to modern towns. The stones held down the bases of their tents. The vote of young people to leave overpowered the vote of the Elders to remain. Only the stones, and a few derelict cabins a few miles away, remained of a people who hunted the barrens since the retreat of the glaciers.

In response to the absence of humans, the caribou and muskoxen, and undoubtedly their predators, the wolves and bears, have increased. But now an ominous threat looms. Rich deposits of uranium and diamonds have been discovered on the barrens and many are concerned about the welfare of the caribou. Tom and his colleagues had been pleading for conservation of the wilderness. Then, one winter, Tom's camp was mysteriously vandalized, ostensibly by bears but perhaps baited ones. Then his ecotourism permit was denied by the government. Efforts are apparently being made to silence conservationists.

Undoubtedly, we were privileged to experience the wilderness of the Northwest Territories during that peaceful interlude between the departure of the Dené and the arrival of the developers. I cherish the memories of those wide horizons, the silence broken only by the calls of birds, and the glory of the northern lights.

UNITED STATES

The magnificent photos by Subhankar Banerjee, and the moving essays about the Arctic National Wildlife Refuge by well-known writers in the acclaimed book *Seasons of Life and Land,* led a senior supporter of the International Crane Foundation to discuss with me her interest in visiting the refuge. Through arrangements made by a travel company in Fairbanks, Alaska, in early July of 2010, four IFC members and two guides took a chartered flight from Coldfoot, Alaska, through the valleys of the Brooks Range and then over the tundra of the North Slope just west of the wilderness protected by the Arctic Refuge. We partly followed the north-flowing Colville River to the Arctic Ocean. On Anachlik Island, in the delta of the Colville, a pioneering couple, Jim and Teena Helmericks, have a landing strip and a welcoming home in a deltaic paradise for aquatic birds.

The Helmericks' home is the only inhabited dwelling on the island. Weather permitting, the runway that borders the river offers an easy landing for small aircraft. Along the boardwalk over the tundra between the landing strip and the house, we were thrilled by the aerial displays and songs of semipalmated sandpipers that hovered and scurried nearby, apparently concerned that we were too close to their nests and young. Near the house the medium-size Sabine's gulls, with beautifully marked wings in black, white, and gray, circled around as they searched for fish in the river and the plethora of ponds and lakes sprinkled across the tundra. Lapland longspurs and snow buntings crowned at the Helmericks' feeder outside the kitchen window. While the songs of savanna sparrow and the barks of willow ptarmigan floated in from the nearby tundra. Blessed with blue skies that continued in various intensities of illumination twenty-four hours a day, we had optimal conditions for birding.

Among hundreds of pairs of nesting Pacific brant geese were scattered pairs of snow and white-fronted geese nesting on the ridges beside the ponds, in company with nesting king eiders; long-tailed, pintail, mallard, and green-winged teal ducks; red-breasted mergansers; red-throated, pacific, and yellow-billed loons; and tundra swans. The Sabine's gulls and Arctic terns and perhaps the glaucous gulls nested on sandy islands, and the landscape was colored by no less than fifteen species of shorebirds, three species of jaegers, the occasional peregrine and gyrfalcon, and the rough-legged hawk. So much was happening, it was almost impossible to concentrate on a single dramatic event. And without Jim's leadership, we were afraid to walk anywhere for fear of stepping on nests or chicks. I cannot imagine a more perfect spot to have

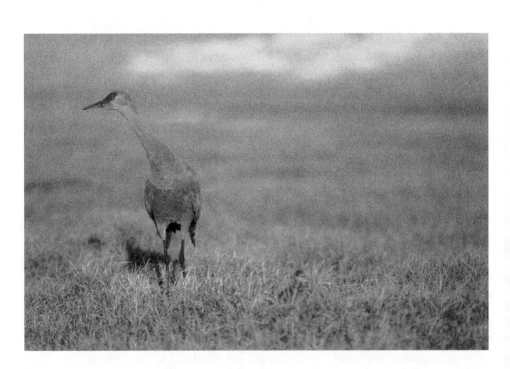

Sandhill crane with chick, coastal plain of the Arctic National Wildlife Refuge. *(Photograph by Steven Kazlowski, July 2001.)*

an ornithological research center to monitor various populations of birds and their food sources in response to the activities of humans and the changes in the fragile Arctic climate.

The astounding density and diversity of breeding birds is driven by the high productivity and vastness of Arctic wetlands. Thousands of years of freezing and thawing of the permafrost created rectangular fissures through which water and sediments moved to create symmetrical ridges soon covered by vegetation. When the Colville River floods, the ponds receive nutrients and fish that are trapped as water recedes. The ecosystem also supports billions of mosquitoes! The net result is an abundance of food in the air and in the water for such a variety of birds.

We relished the bird show for three nights and two days, but I averaged only a few hours of sleep in this Land of the Midnight Sun. There was just too much to experience. The pilot arrived on the fourth morning, and we departed east across the petroleum developments at Prudhoe Bay that edged near the western border of the Arctic Refuge.

As we flew eastward from our avian Eden, we continued to soak in the majestic wetland landscape composed of rivers, lakes, ponds, and marshlands. However, imagine our mental transition as our Eden faded and oil and gas developments erupted below as the wetlands were overlapped by a treelike complex of roads. Each major branch led to dozens of oil drilling stations, each complemented by buildings and parking lots and each with an artery of oil leading to a central pipeline trunk that is forty-eight inches in diameter and runs eight hundred miles south to the port of Valdez.

But soon the shock of the petroleum industry was behind us as we approached the Arctic Refuge and, at last, a Biblical herd of migrating caribou!

Apparently urged on by fresh hatches of mosquitoes, they were running north—cows, bulls, and some calves in a herd whose numbers we were incapable of counting. The pilot changed direction and flew low along the west side of the herd for fifteen minutes before reaching the north end of the stampede. Then he veered east, leaving the herd behind as we approached the delta of the Canning River in the heart of the refuge.

The plane landed on grassland near the coast. Thousands of dried droppings attested to the importance of that grass to the geese that prepared for their long flight to breeding sites on the Arctic islands. A narrow line of dark blue open water that separated the shimmering white ice pack from the mainland was punctuated by several snow-white tundra swans. Wildflowers and silence were everywhere as we shared lunch in the sun-drenched stillness.

Later we arrived in the Iñupiat village Kaktovik on Barter Island at the east side of the refuge. We lodged at one of the town's two hotels. Nearby, the tundra spread to the south and west, and east to Canada.

We observed a few lovely avian friends during an adventure of discovery that began midafternoon and, for me, continued until three in the morning. A single snowy owl stood out like a huge white dot on the tundra, on which many pairs of widely scattered pairs of American golden plovers had youngsters. The behavior of a pair of lesser sandhill cranes suggested that they had a nest or chicks, but despite hours of careful observation, I could not determine if or which. There was no place to hide, and the adult cranes kept an eye on me from afar. The most awe-inspiring event was sitting beside a pond dotted by dozens of twirling red-necked phalarope and the occasional red phalarope. They spun on the spot as they continually grabbed mosquitoes! Looking back at the Arctic Ocean, I was amazed to see what appeared to high white cliffs of ice extending along the coastline—an optical illusion over the flat expanses of white. It was another twelve hours in paradise.

We were scheduled to fly commercial from Kaktovik to Fairbanks the following morning, but dense fog suddenly appeared and remained for the next two days. The fog was so thick that airplanes could not land, and we dared not venture out onto the tundra for fear of getting lost. So we joined the Iñupiat community members to celebrate a Memorial Gospel Jubilee that began with games in the community center on Saturday afternoon followed by a talent show at the same venue from seven until midnight. Perhaps a major portion of the community were included in the latter, with acts ranging from Eskimo rap to a morality lecture, singing of hymns, and a Johnny Cash impersonation, as eleven men provided backup on electric guitars. It was all hometown and it was absolutely thrilling. The Jubilee was dedicated to a man and his teenage son who had been swept away by a high wave. A huge, freshly painted paper mural of the ocean, the land, the village, the people, and the wildlife stretched across the width of the community center, providing a fitting backdrop for both the talent show and the church service the next morning.

I was touched by the senior lady pastor. She mentioned the grief of the community over the loss of their friends. Then she asked the congregation for the names of loved ones they had lost over the years. Prolonged silence broken by a few sobs was followed by a quiet utterance of names. The pastor wrote them down as they were spoken. She ended the service with a prayer to thank God for the lives of those who had departed, and for the gift of life

for those remaining. Everyone's spirits lifted, and we proceeded to a party on the beach, the grand finale of the Memorial Gospel Jubilee.

A long wall of black canvas had been erected to block the strong west wind that gusted along the beach. Elders dressed in traditional Iñupiat regalia, teenagers in blue jeans, women playing volleyball, babies on many a lap, and an abundance of food both traditional (fresh caribou, whale blubber) and contemporary (hamburgers and chips) were assembled for an afternoon of fun. There was a large cardboard box with a slit on top that I assumed was for donations. As I was about to contribute, I was stopped. "No sir, this box is for letters to the dead!" The celebration ended by the burning of the box to send off the letters to departed loved ones. It was another deeply moving moment shared by the community and four white friends who felt so accepted, especially the ninety-two-year-old lady from Louisiana who did everything with high energy, exuberance, and a wide smile for all.

Just as the Arctic Ocean bathes the coasts of three continents, the Antarctic Ocean does the same for four continents. I always considered those oceans so widely separated—that is, until January 2011, while I was on the waters south of the Cape of Good Hope, where the north-flowing currents of the Atlantic Ocean meet the south-flowing waters of the Indian Ocean. I was amazed to meet Sabine's gulls and red phalaropes that had thrilled me near the Arctic Ocean of Alaska. The gulls looked the same, but the phalaropes were in their gray and white winter plumage. Suddenly the world shrank.

We are all connected. We must all work together between earth's poles to maintain the biological and cultural diversity that still is so vivid, especially in the high Arctic, where cranes, indigenous people, and northern lights still dance.

Broken Promises

The Reality of Big Oil in America's Arctic

PAMELA A. MILLER

❖

Over the past decade I reached out to a few people, again and again, for resources on all things Arctic. Pamela (Pam) Miller is one of those generous souls who always offered her help, including crucial research for this anthology. I first met Pam in Washington, DC during an activist campaign in 2001. In the 1980s she had worked as a federal wildlife biologist for the Arctic National Wildlife Refuge. It was the Reagan era—there was an enormous push to open up the Arctic Refuge to oil development. She remembers the time: "We got memos and gag orders. We couldn't even answer public inquiries about whether snow geese were present on the refuge, or when the caribou were done calving due to public interest environmental lawsuits. All of our work as agency biologists and managers was under a political microscope, and so extreme care (sometimes to the point of censorship) was given." In the late 1980s, she left her job as a federal biologist, and ever since has dedicated her life as a conservationist to preserve Arctic Alaska. In 2003, as an independent consultant, Pam wrote a report for The Wilderness Society titled, "Broken Promises: Reality of Big Oil in America's Arctic." This historic report exposed

the lies and misinformation that was being perpetuated by the oil industry and their allies in the George W. Bush administration, who had made opening the Arctic Refuge coastal plain to oil development a top priority. I urged Pam to look at that report and make any necessary updates. She did. It is being published here with permission from The Wilderness Society.

❖

PROPONENTS OF opening the coastal plain of the Arctic National Wildlife Refuge to oil development consistently argue that oil drilling will not harm the environment of the refuge. They say drilling Alaska's North Slope has been clean, and cite several factors they claim would make future oil development environmentally benign. They profess a commitment to strict environmental regulation, and they assert that new technologies—particularly ice roads and directional drilling—would reduce even further any impact of drilling in the Arctic Refuge.

This report assesses those claims by comparing them with the documented impact of past and present North Slope oil development, the industry's environmental track record at Prudhoe Bay and in the National Petroleum Reserve–Alaska (NPR–A), real technological trends in the oil industry, and other factors. The result is a clear record of *broken promises* on the North Slope that casts serious doubt on the reassurances being made by drilling proponents and their allies today.

BROKEN PROMISE #1
Oil Development on the North Slope Has Not Been Environmentally Benign

Three decades of oil industry public relations have drilled away at one familiar theme that belies the reality on the ground: that new technologies, particularly directional drilling and in recent years use of so-called ice roads, have made oil development on Alaska's North Slope better for the environment.

The Promise
"The New Technology . . . Directional drilling, ideally suited for North Slope operations, enables the reservoir to be tapped more than one mile from the

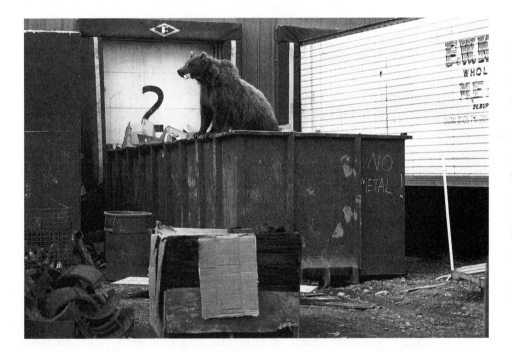

Grizzly bear scavenges from a dumpster, Deadhorse, Prudhoe Bay. As oil development expands farther into wildlife habitat, human-wildlife interactions can take a tragic turn. This grizzly bear became conditioned to garbage waste and was later killed. *(Photograph by Florian Schulz, 2000.)*

pad . . . no unsightly drilling rigs are left to mar the landscape; they are moved as soon as their task is done. Only a relatively small system of flow lines will be installed above ground to carry the oil from each well to the gathering centers. Formal cleanup programs keep Prudhoe Bay part of the wilderness. No longer do abandoned oil drums litter the areas."

—British Petroleum, 1978[1]

The Reality

Prudhoe Bay and thirty-five other producing fields today sprawl across 1,000 square miles,[2] an area the size of Rhode Island.[3] There are more than 6,100 exploratory and production wells,[4] 225 production and exploratory drill pads, over 500 miles of roads, 1,100 miles of trunk and feeder pipelines, two refineries, 20 airports, 115 pads for living quarters and other support facilities, five docks and gravel causeways, 36 gravel mines, and a total of 27 production plants, gas processing facilities, seawater treatment plants, and power plants.[5]

Prudhoe Bay air pollution emissions have been detected nearly 200 miles away in Barrow, Alaska.[6] The oil industry on Alaska's North Slope annually emits approximately 70,413 tons of nitrogen oxides, which contribute to smog and acid rain.[7] This is more than twice the amount emitted by Washington, DC, according to the Environmental Protection Agency (EPA), and more than many other US cities.[8] Other regulated pollutants include 1,470 tons of sulfur dioxide, 6,199 tons of particulate matter, 11,560 tons of carbon monoxide, and 2,647 tons of volatile organic compounds annually, according to industry records submitted to the Alaska Department of Environmental Conservation (ADEC).[9] North Slope oil facilities release large quantities of greenhouse gases, including 24,000 metric tons of methane[10] and 7.3 to 40 million metric tons of carbon dioxide annually.[11]

More than a spill a day continues by the North Slope oil industry. By 2009, ADEC reported over 6,000 spills of toxic substance totaling over 2.7 million gallons for the 14-year period.[12] Forty different substances, from acid to waste oil, have been spilled during routine operations. There were 2,958 spills between 1996 and 2002 totaling more than 1.7 million gallons of toxic substances, most commonly diesel, crude oil, and hydraulic oil.

Pollution in the Arctic has more severe and persistent effects than in temperate regions. Recovery from spills in the Arctic is slower due to cold temperatures, slower growth rates for plants, and longer life spans of animals.[13] Even localized, relatively small spills can have tragic consequences; a polar bear died after licking spilled ethylene glycol.[14] While many spills affect only gravel pads,

these can become contaminated and pose long-term restoration problems. For example, the ADEC lists over 100 contaminated sites caused by the North Slope oil industry.[15] The effects of a large oil spill in coastal or marine waters could be devastating due to difficulty of cleaning them up, especially in broken ice.[16]

NATIONAL RESEARCH COUNCIL FINDS
WIDESPREAD IMPACTS ON THE ARCTIC

While industry focuses attention on the direct "footprint" where facilities will be built, harmful effects of the industrial network extend well beyond the sites of constructed facilities. A major study by the National Research Council released as a 304-page book, *Cumulative Environmental Effects of Oil and Gas Activities on Alaska's North Slope* in March 2003 documented significant cumulative impacts of oil and gas development on wildlife, the land, wilderness values, and Native American cultures across an extensive area of the North Slope. Even considering the application of "new technology," the study concluded significant effects from oil industry operations are expected to continue expanding.[17]

The negative effects of oil development on animals and vegetation extend well beyond the immediate footprint of development, according to the NRC study. Even considering technological improvements, adverse effects on caribou are expected to increase due to the density of infrastructure development and the area over which it is spread. The study found "the common practice of describing the effects of particular projects in terms of the area directly disturbed by roads, pads, pipelines, and other facilities ignores the spreading character of oil development on the North Slope and the consequences of this to ... wildland values over an area far exceeding the area directly affected."[18]

According to the NRC, wildlife impacts from oil industry operations and infrastructure on the North Slope include direct mortality of grizzly bears, reduced reproductive rates of birds such as brant due to predation, and altered distribution of caribou calving and reduced reproductive productivity. Habitat for breeding and molting birds has been directly altered by gravel fill in wetlands.

"The extent of disturbance greatly exceeds the physical 'footprint' of an oil-field complex," according to caribou biologists.[19] Caribou use of preferred habitats declined substantially as the density of roads increased, according to studies of the Kuparuk oil field.[20] Caribou densities decreased within 4 kilometers of pipelines and roads, and there are region-wide changes in calving distribution for the Central Arctic Herd at Prudhoe Bay.[21]

Seismic exploration surveys have covered virtually all of the North Slope, with over 32,000 miles of seismic trails made from 1990 to 2001.[22] Seismic exploration involves bulldozers and 56,000 pound thumper trucks that cause long-term damage by disturbing the fragile tundra vegetation and permafrost. Endangered whales over 100 miles away may detect noise from seismic exploration. According to subsistence hunters, "...pods of migrating bowhead whales will begin to divert from their migratory path at distances of 35 miles from an active seismic operation and are displaced form their normal migratory path by as much as 30 miles."[23]

RECENT OIL COMPANY FINES AND PENALTIES

Environmental
In 2006, BP had the largest crude oil spill in the North Slope oil field history, caused by pipeline corrosion due to poor maintenance and lax government oversight. Major fines were imposed:

- $25 million fine. BP. May 2011. BP paid civil penalty under the Clean Water Act, Clean Air Act and pipeline safety laws, and agreed to run a pipeline integrity management program on 1,600 miles of pipelines as part of a settlement for its 212,000 gallon oil spill from North Slope pipelines in 2006.[24]

- $20 million fine. BP. October 2007. Criminal penalties and probation for knowingly neglecting corroded pipelines, causing crude oil spill to fragile tundra and a lake.[25]

- $675,000 civil assessments and costs. BP. November 2002. Fine for spill cleanup problems with 60,000 gallon Prudhoe Bay pipeline spill ($300,000 waived by the ADEC if spent on environmental project to increase using low-sulfur fuel use in school buses).[26]

- $300,000 fine. BP. June 2002. BP paid fine for delays in installing leak detection systems for Prudhoe Bay crude oil transmission lines.[27]

- $412,500 fine. BP. April 2001. EPA reduced the total penalty down to only $53,460 because BP voluntarily disclosed violations of the Clean Water Act. From 1996 to 2000, BP failed to properly analyze discharges

from the Prudhoe Bay Central Sewage Treatment facility, and the Endi-
cott and Prudhoe Bay Waterflooding operations.[28]

• $22 million fine. BP. February 2000. The federal court ordered BP to
pay $6.5 million in civil penalties and $15.5 million in criminal fines
and to implement a new environmental management program, and
to serve 5-years probation for its late reporting of hazardous dumping
down the Endicott wells.[29]

• $3 million fine. Doyon Drilling. 1998. This BP contractor pled guilty of
15 counts of violating the Oil Pollution Act of 1990 for dumping haz-
ardous wastes down the Endicott wells.[30]

• $51,000 penalty. BP. June 1993. Alaska Department of Environmental
Conservation found violations of the state emission standards and the
conditions of BP's Clean Air Quality permit for flaring that resulted
in black smoke emissions at the Gathering Center 1 processing plan;
assessed penalty reduced to $10,000.[31]

Health and Safety

• $1.4 million fine. BP. January 2005. The Alaska Oil and Gas Conservation
Commission fined BP for safety violations after a Prudhoe Bay oil well
explosion and fire.[32]

• $6,300 civil fine. BP. January 2003. Alaska Occupational Safety and
Health (AKOSH) proposed fine for violations of state's worker safety
law in failing to protect workers in an explosion that killed a worker.[33]

• $67,500 civil fine. Houston/NANA (owned by Arctic Slope Regional Corpo-
ration and NANA Regional Corporation). March 2002. The AKOSH pro-
posed fine to this Trans-Alaska Pipeline Contractor for failing to report 142
instances of worker injuries or illnesses from 1999 to 2001.[34]

• $50,000 fine. Alyeska Pipeline Service Co. 1999. US Department of
Transportation fine for two incidents of over-pressurization of the
Trans-Alaska Pipeline. Since 1992, five other instances of high pressure
occurred, and $100,000 in fines were paid.[35]

BROKEN PROMISE #2
Directional Drilling's Exaggerated Claims

Proponents of increased drilling on the North Slope, and boosters of drilling in the Arctic National Wildlife Refuge in particular, often claim that "directional" or "horizontal" drilling would allow them to tap oil resources while minimizing disturbance on the surface. However, their claims for the technology have been exaggerated.

The Promise

"With new horizontal drilling, companies make one hole and tap reserves up to 7 miles away."[36]

—Interior Secretary Gale Norton, April 5, 2001

"In order to lessen the environmental impact of man's presence, road construction is kept to a minimum. There is only one major road servicing the drilling program on the 400-square mile Prudhoe Bay field . . . Buildings are built on top of pilings . . . A number of wells are drilled from each pad—a technique adopted from years of offshore drilling technology—and angled (directionally drilled) into the target area in the producing formation."

—American Petroleum Institute, 1983[37]

The Reality

In fact, directional drilling would do little if anything to mitigate the full impacts of oil production in the Arctic Refuge. Permanent gravel roads and/or busy airports are still used for access, and production well sites must be connected by pipelines. Intrusive, noisy and damaging seismic surveys on the surface are still necessary for exploration.

Throughout the North Slope oil fields, the average distances of horizontal drilling have remained surprisingly constant, contrary to media portrayals and claims of drilling proponents. The average horizontal offset distance for production wells drilled in 2002 was 1.04 miles compared with 1.02 in 1989 and 0.91 miles in 1972. The average for all wells except exploratory wells for the 1990s was 1.09 miles compared with 0.83 miles in the 1980's, according to the GIS analysis of Alaska Department of Natural Resources well data.[38] No wells have been drilled beyond a four-mile horizontal offset; the maximum horizontal offset distance drilled is 3.78 miles, in 1997. As of August 2009, State of Alaska records show that a single well had been drilled four or more miles away.[39]

Economic factors play a major role in determining whether extended reach wells are drilled at all. In 2000, BP noted, "the company stopped drilling extended reach wells—those which reach out a long distance from the pad—after oil prices crashed in the late 1990's, because extended reach drilling, ERD, is expensive."[40]

The Interior Department has made it clear that directional drilling has major limitations. The Minerals Management Service explained some of the limitations of directional drilling in 2001:

> Extended-reach drilling has not been used, or proposed, for a new startup development project. Additionally, extended-reach drilling wells are planned and approved as single-well projects, not as a comprehensive development program. Information on the long-term viability of extended-reach drilling wells for production is limited, and industry has little experience in the use of extended-reach drilling wells for gas- or water-injection wells.[41]

The Bureau of Land Management explained that two exploratory wells needed to be drilled on different pads about three miles apart, not drilled directionally from one site [within the NPR–A]:

> Based on site-specific conditions, one additional alternative was considered, but eliminated from detailed evaluation. This alternative involves drilling all wells from a single ice pad (i.e. directional drilling). However, the distance separating the targets at the two drill sites is farther than the capability of the drilling rig currently stored at Puviaq.... In addition, extended reach drilling methods are rarely employed for exploration wells when alternatives are available. Drilling a vertical well provides far better exploration data than drilling a deviated well ... the extent of commercial oil and gas prospects on CPAI [ConocoPhillips Alaska Inc.] leases cannot be determined if the applicant is not allowed to drill the minimum number of wells needed to define prospective oil and gas deposits. Accordingly, alternatives involving drilling at fewer sites or drilling fewer wells than applied for were considered but eliminated from further evaluation in this EA.[42]

The Bureau of Land Management said in 2003, in its plan for new leasing in the NPR–A:

> Extended-reach drilling methods are rarely employed for exploration wells because they are more costly than vertical wells and are more difficult to effectively log and sample by coring... There are physical limitations, including topside rig power (torque),

drillpipe strength, downhold frictional forces (drag), and unstable formations . . . which limit the capability of extended-reach wells. The cost of extended-reach wells is considerably higher than conventional wells because of greater distance drilled (measured depth) and problems involving well-bore stability. Alternative field designs must consider the cost tradeoffs between fewer pads with more extended-reach wells as opposed to more pads containing conventional wells. In most instance, it is more practical and cost effective to drill conventional wells from an optimum site, [than] it would be to drill ERD wells from an existing drill site.[43]

Even at the recently developed Alpine oil field—touted as a model of new technology—the average production well as of 2003 has extended only 1.4 miles laterally from the wellhead (measured as the horizontal offset difference between the drill hole on the surface and its location downhole), according to GIS analysis of data from the Alaska Department of Natural Resources. By 2009, additional drilling at Alpine resulted in 6 percent of all wells having been drilled 3+ miles horizontal distance, with an average horizontal offset for production wells of 1.87 miles, and a single well was drilled over 4 miles away for a maximum distance of 4.025 miles.[44]

Contrary to the rhetoric about new technology at Alpine, the proliferation of additional drill sites—even at locations only four miles away from the main production pad—shows that the claim that directional wells tap reservoirs four to seven miles away is at best misleading. Even where directional drilling is employed, development results in inevitable and unacceptable impacts to sensitive areas, such as wildlife disturbance, noise and air pollution.

BROKEN PROMISE #3
The "Winter Only" Fallacy

The oil industry's supporters have claimed that oil development only occurs in the winter months on Alaska's North Slope, and therefore has no impact on wildlife and habitat. Such claims ignore the impact of winter exploration on wildlife and the environment and ignore the vital fact that the permanent installations required for full-scale oil production operate year-round.

The Promise
"Oil and gas activity only takes place in the winter time—not in the summertime."
—Senator Ted Stevens, Congressional Record, April 10, 2002

The Reality

While most oil exploration takes place during winter, this activity can still create significant environmental damage. Winter exploration can disturb polar bears in their maternity dens and frighten sensitive musk oxen, year-round residents of the coastal plain. Exploration also impacts fish habitats in rivers and lakes by removing massive amounts of water, and seismic trails damage plants and permafrost.

More importantly, once oil is discovered, efforts to recover it continue year-round. Yearlong vehicle traffic, production plant noise, helicopter and airplane traffic, air pollution, and other activities create inevitable conflicts with wildlife in every month and season. Oil companies have never ceased production activity in the summer months on the North Slope.[45]

> . . . There was Phillips' chopper right there across main channel. They went right over the caribou back toward Alpine, and those caribou that we were going to get [hunt], they took off. We're going to see this every year. There is so much traffic with Alpine and their studies during our subsistence months, in summertime. I only got one caribou this summer. All we see is traffic up in the air. And the herds we used to see . . . gone. With the opening of NPR–A we will only see more (airplanes).
>
> —Dora Nukapigat, Nuiqsut, 2002[46]

With Alpine's "roadless" model, the initial oil field had two production drill pads connected by permanent road, but this was not attached to the existing oil road network due to the expense of building a bridge over the Colville River. Any development like this is dependent on yearlong access for equipment and personnel for production.

Air travel in and out of Alpine provides a stark example of the high degree of disruptive activity that occurs in the summer and a clear example of the industry's broken promises. During the permit-review stage of the Alpine project, ConocoPhilips, (then ARCO) stated in 1997, "use by aircraft will be restricted during the six weeks when birds are nesting in the region." The oil company said they'd need one flight every two to three days during summer for construction (13 per month), as well as during production operations.[47]

This prediction was off by a factor of more than a hundred. Between June 1 and July 15, 2000, 1,980 airplane and helicopter take-offs and landings occurred at Alpine—an average of 44 per day, including large DC-6 and C-130 cargo planes[48] during the bird-nesting season.[49] These summer flights supported production drilling, in-field road improvements and maintenance, installation

of equipment and buildings, major structural modifications on gravel pads, and other construction.[50]

Construction of BP's Northstar offshore oil field also involved substantial air and sea traffic as well during the summer months—with over 2,300 one-way flights were planned to take place from late August to November and overlapping with fall migratory bird staging—and requiring about 35,000 trips by bus, truck, and other land vehicles during summer and by ice-road winter. Year-round helicopter access continues during oil production operations.[51]

Studies by the US Fish and Wildlife Service and university biologists documented significant behavioral effects to the Pacific brant, a species of waterfowl of significant subsistence value, from helicopter overflights in the Teshekpuk Lake area.[52] Molting brant did not habituate to repeated aircraft disturbances,[53] and migration success may have been reduced.[54]

BROKEN PROMISE #4
Ice Road Travel Season Is Melting Away

Ice roads have received a lot of discussion as a panacea for environmentally damaging oil development. Yet the promise of this technology is flimsy. The season during which such roads are practical has been dramatically reduced by global warming, and areas like the Arctic National Wildlife Refuge lack sufficient water to build the required ice roads.

The Promise
"*Exploration and development is done in the harsh winter months, which allows the use of ice airstrips, ice roads and ice platforms.... When the ice melts in late spring, there is little remaining evidence of the work—and minimal impact on the land.*"[55]
—Senator Frank Murkowski, December 10, 2000

The Reality
Global warming, a direct result of burning fossil fuels, is diminishing the ability to use ice roads. Each year, the Alaska Department of Natural Resources determines when the Arctic tundra is sufficiently frozen to permit travel by heavy machinery and construction of ice roads. In 2003, this time was later into the winter season then ever before.[56] Increasingly, the ground is not sufficiently frozen in some regions of the North Slope before the Department approves tundra travel. Climate

change researchers have noted that "the number of days that ice roads can be used for transportation and oil exploration has been severely reduced since the 1970s."[57]

"Over the past decade, ice road use on the North Slope has been shortened from 204 to 124 days. This has resulted in less time to build ice roads, complete drilling operations, and remove the drill rig. This restriction becomes a greater issue as exploration activities extend west into the NPR–A."
 —Bureau of Land Management, 2002[58]

Global warming is not the only impediment to construction of ice roads and pads. Some parts of the North Slope—including the coastal plain or "1002 area" of the Arctic National Wildlife Refuge—lack sufficient water for ice road construction to be practical. As a result, the industry is lobbying the state and federal governments to roll back stipulations that limit the use of permanent gravel roads and airports for exploration and development.

Construction of ice roads requires enormous quantities of fresh water, mostly in the winter when liquid water is limited. According to Alaska Department of Natural Resources, North Slope oil exploration and development consumed 1.5 billion gallons of water in 2000, mostly for ice roads and pads.[59] Vast quantities of water have been extracted from lakes and rivers in the Prudhoe Bay oil fields and the NPR–A, which are dominated by many freshwater lakes.

The Arctic Refuge coastal plain, however, has few lakes, and water resources are far more limited. There is simply too little water to construct the ice roads that drilling supporters have been promising. Even drilling exploratory wells in the Refuge would require huge amounts of water for ice roads, pads, ice airstrips, drilling, and drill camps. That water just isn't there.

The US Fish and Wildlife Service has concluded that:

- Oil and gas development would cause major effects on the water resources of the coastal plain.[60]

- There is only enough winter water for about seven miles of ice roads, one ice airstrip, or two ice pads in the 237 miles of rivers across the coastal plain.[61]

- Only ten lakes in the coastal plain have sufficient liquid water below ice during the winter that could be used for ice road construction; 40 percent of the volume is in a single lake.[62]

• Most of the coastal plain 1002 area is not within ten miles of these lakes—the maximum distance from a water source considered feasible for construction involving ice roads.

A 1995 US Fish and Wildlife Service report reconfirmed earlier conclusions: "Additional investigations since 1987 substantiate the fact that water in the 1002 area is very limited and the impact upon water resources should be considered major."[63]

In 2003, the NRC study found that ice roads might not be a viable alternative to gravel in areas with few lakes (e.g., the Arctic Refuge coastal plain).[64]

The likely alternative? Excavate gravel from the river beds and other sites to build water reservoirs and permanent roads, permanently impacting fish and wildlife habitat in the process.

As senator, Frank Murkowski talked at great length about ice roads and asserted that gravel roads are not needed for oil development in the Arctic National Wildlife Refuge. In one of his first acts as governor of Alaska, Frank Murkowski pushed for a new permanent road to be built on the North Slope from the Trans-Alaska Pipeline to the NPR–A.

The Promise

"Now let me show you how we operate. I said we are not going to have roads. We are not going to open up gravel pits. That is drilling in the Arctic. That is the same as in the 1002 area of ANWR. That is a winter road. It is a road that is frozen. It works fine.... Where are they talking about these big gravel roads? It isn't done anymore. We use technology."[65]

—Senator Frank Murkowski, April 17, 2002

The Reality

"Build a permanent new road west off the Dalton Highway to the village of Nuiqsut. The road would make it easier for oil and gas explorers to push into promising frontier areas west of existing oil fields around Prudhoe Bay . . . the proposed road would be built on state land, possibly beginning next winter."

—Governor Frank Murkowski, February 14, 2003[66]

"Ice road seasons are shrinking, yet the oil industry is trying to extend into NPR–A, and it's a tough show for them ... The ice road season has shortened from 204 days down to 124 days.... At the same time, they're trying to [go] further

and further west, and they're having some water shortage problems . . . If we are going to develop NPR–A, we should look for ways to accelerate development of it."
—Mike McKinnon, Alaska Department of Transportation, 2002[67]

In 2009, Alaska's Governor Sarah Palin began subsidizing a proposed 100-mile long permanent, gravel road to Umiat. Now, aggressively pushed by Governor Sean Parnell—a former ConocoPhillips executive—Alaska Department of Transportation's preferred route would start from the Dalton Highway and Trans-Alaska Pipeline inland by a new corridor traversing the foothills and major rivers and requiring a huge bridge over the Colville River to resulting in new, major access route into southerly NPR–A.[68] The nearby Nunamiut community of Anaktuvuk Pass opposed this proposed road in key subsistence resources areas north of them during 2011.[69]

<div align="center">

BROKEN PROMISE #5:
Alpine Is No Environmental Showcase

</div>

The oil industry and its supporters consistently cite the recent Alpine oil development, like the Endicott oil development before it, as a state-of-the-art showcase for new technology. The Bureau of Land Management has cited the Alpine project—which was originally permitted in 1988 as a facility with two drill sites linked by three miles of road—as a "model" for predicting future scenarios in environmental impact statements (EIS) addressing the Western Arctic (NPR–A). Yet the sprawling, piecemeal development that has actually occurred at Alpine has far exceeded initial disclosures by industry, and its environmental and other impacts are increasingly alarming.

The Promise
"Smallest footprint ever . . . we'll develop Alpine from just two drill sites of less than 115 acres."
—ARCO, "Alpine—Discovering the Future," 1998

The Reality
In 2003, ConocoPhillips announced plans for developing five additional production well sites and eventually ten more that will connect to Alpine. Once the five first new satellites are constructed, the Alpine Project will include 25 miles of permanent gravel roads, 19 miles of which would be on the NPR–A; two airstrips; a 150-acre gravel mine; and 60 miles of pipelines.[70] This pattern of incremental expansion of oil field development has been reported over and over again across Alaska's North Slope.

concerns about the gradual sprawl of the North Slope's industrial complex. In comments to the US Army Corps of Engineers (1997) the agency stated,

> The incremental environmental changes caused by the proliferation of new development projects are of concern to the NMFS. The proposed project will forever change the landscape, and while ARCO will endeavor to minimize those changes, there will be no mitigation that will be able to replace the functions and the values of this area, as it now exists. Also, should a commercial operation be realized, the subsequent development to bring the field into full production could be substantial. For example, the infrastructure for the Alpine Development Project is already being viewed as the 'gateway' for development in the National Petroleum Reserve.[71]

Alaska Native residents, particularly the Iñupiat from the Nuiqsut—the village closest to Alpine, have raised serious concerns as well:

> I am a subsistence hunter, and what you were saying about the potential development to our sensitive area ... clenched my heart with anger. I don't want to tell my kids, "This is where I used to hunt." You have touched a sensitive part of where we hunt now. I remember going to meetings before Alpine was developed, and I remember Mark Major [ARCO, now ConocoPhillips] saying, "Alpine is going to be small ... you are going to hardly even notice we are there." I think that is just a doorstep for you to go that way (to the west). "Oh yeah, we want to build a pipeline now this way, we found more oil. . . ." Where are we going to go?"
> —Dora Nukapigat, Nuiqsut, 2002[72]

Abandonment of previous restrictions has been commonplace. Even though the US Army Corps of Engineers Clean Water Act permit for the Alpine oil field included a condition requiring "roadless" satellite production facilities for future additions in the Colville River Delta,[73] at least one of the currently planned projects will connect with a road.

In fact, ARCO asserted in its application to develop Alpine that leasing or development in the NPR–A would be highly unlikely.[74] The eventual three new satellites in the NPR–A were not even contemplated in the environmental reviews on Alpine. The Corps of Engineers did not evaluate this future activity, even though seismic surveys had already begun in the area.

There really is no such thing as "roadless" development on the tundra. Every onshore oil field uses roads to transport people, and equipment, and even the initial Alpine had three miles of roads. In addition to the new roads proposed for

Alpine oil field. *(Photograph by Subhankar Banerjee, July 2006.)*

the Alpine satellites, other new roads are planned. To the east of Prudhoe Bay, Exxon has proposed 15 miles of new roads connecting together new drill pads, jet airport, dock, and drill sites for its Point Thomson gas hydrocarbon project.[75]

Oil companies have continued to build new gravel roads connecting oil fields to the existing permanent road network since discussions about the Alpine "roadless model" began. For example, the Tarn and Meltwater oil fields were developed between 1998 and 2001 with 20 miles of new road as well as a new 25-acre gravel mine.[76]

The bottom line is that permanent gravel roads are still standard practice for oil development in America's Arctic. Once the oil fields are built, the network of roads and pipelines sprawls out across the tundra.

BROKEN PROMISE #6
Environmental Regulation of Alaska Oil Drilling Activities Are Getting Weaker, Not Stronger

The US Interior Department and the State of Alaska have promised to apply the "strictest" environmental standards to leasing and development proposed for the Arctic National Wildlife Refuge. But a look at their recent actions cast serious doubt on the reliability of this pledge. In fact, the state and federal governments have weakened existing lease stipulations and standards for oil development across America's Arctic.

The Promise

Stipulations protect surface resources and subsistence activities throughout the [Northeast NPR-A] planning area. The plan also protects key surface resource and use areas identified throughout the planning process by strict restrictions on surface activities and, in 13 percent of the area, through a decision not to offer lands for oil and gas leasing. Included amount the areas receiving special protections are important habitat for waterfowl and caribou in the vicinity of Teshekpuk Lake, wildlife habitat and recreation and scenic areas along the Colville River and some of its tributaries, and subsistence use lands critical to local residents near Teshekpuk Lake and several rivers and creeks.
—Interior Secretary Bruce Babbitt, October 1998[77]

The Reality

There were stipulations imposed in that [Northeast NPR-A] plan two to four years ago, that are not reflective of the new technology today. One of the things BLM

is going to go back and look at is the NPR-A Northeast land use plan that was adopted, are those stipulations need to be reflective of new technology, and can we in fact not make them black and white but ways to look at them so we don't inhibit the opportunities for exploration and we are sure that the environment is going to be protected.

—Deputy Interior Secretary Steven Griles, February 28, 2002[78]

Environmental lease stipulations do not provide long-term effective protection for sensitive areas because the oil industry can and does put political pressure on the agencies to remove or loosen those restrictions later. The federal Bureau of Land Management (BLM) attached stipulations to its leases in the Northeast corner of the NPR-A in 1999 that limit oil companies to "roadless development" (unlike state leases). But ConocoPhilips is now planning a 22-mile road that would violate the road ban.[79] To permit construction of the proposed road, a stipulation set by Interior Secretary Bruce Babbitt on the leases must be rolled back.[80] In 2008, Interior Secretary Dirk Kempthorne removed the strict stipulation prohibiting permanent roads by the Final Supplemental Plan for Northeast NPR-A.[81]

Lease stipulations would also have to be cast aside for the proposed Lookout production drill site within NPR-A. This site is located in the Fish Creek buffer zone area, where permanent oil and gas surface facilities were prohibited under the 1999 Record of Decision on the lease sale.[82] The development plan was approved by BLM during the Bush administration in 2004,[83] but final siting decisions and permitting remain underway.

The proposed Northwest NPR-A Oil and Gas Leasing Plan[84] contains dramatically weaker lease stipulations than those required under Secretary Babbitt's 1999 plan for the Northeast NPR-A to mitigate environmental degradation. The oil and gas industry has pushed for leasing 100 percent of the area as well as for weaker environmental requirements (Alternative A of the EIS).[85] BLM proposes between nine and twenty lease stipulations in the Northwest Area, compared with 79 in the 1998 final decision for the northeast NPR-A.

A closer look at the plan for the northwest NPR-A shows that roughly 50 percent fewer mitigation measures are proposed compared with the northeast NPR-A lease sales. Forty restrictions that were included in the 1998 NPR-A northeast plan are completely absent from the 2003 NPR-A northwest plan. The dropped restrictions include waste prevention, disposal, and spills; ice roads and water use; overland moves and seismic work; exploratory drilling; facility design and construction; ground transportation; air traffic; oil field abandonment; and protection of subsistence hunting resources.

There are additional measures listed, called Required Operations Proce-dures, but they would not be attached to the leases themselves. Rather their application would be left to the discretion of the local agency bureaucrat. As it is, the existing lease stipulations for the northeast plan contain loopholes, and many of the stipulations are being rolled back, as described above.

Alternative A of the NPR–A northwest EIS contains no buffer zones (set-backs for permanent facilities) from important rivers and streams. While Alternative B does identify areas where there might be vaguely defined "addi-tional mitigation or design features," they are not true buffer zones where no permanent facilities or "surface occupancy" would be allowed.

This is not just a numbers game. Key environmental practices that were required in the 1998 NPR–A northeast plan and that industry claims as "standard practice" have been dropped for the northwest planning area of the NPR–A, and further-more, BLM has announced plans to re-evaluate leasing the Teshekpuk Lake goose molting area—deleted from the leasing program by Interior Secretary Babbitt in 1999—and industry is pressing to weaken the stipulations for the Northeast Plan area.[86] The final northwest NPR–A plan did roll back stipulations as described here, however, due to community and public concerns, it also included a 10-year deferral area which surrounded Kasegaluk Lagoon Special Area and Wainwright. In 2008, Secretary Kempthorne signed off on an amended plan for the northeast NPR–A which indeed rolled-back important lease stipulations. However, due to major concerns by local tribes and governments, a successful legal challenge by conservation organizations and their mobilizing hundreds of thousands of public comments, a 10-year deferral of leasing of key wetlands north and east of Teshekpuk Lake was put in place during the Bush administration.[87]

Since his election as Governor in November 2002, former Senator Frank Murkowski took actions with grave ramifications for oversight of future oil field development. By Executive Order, he abolished the permitting respon-sibilities of the Alaska Department of Fish and Game Habitat Division, which has authority over activities in rivers and streams containing anadromous fish, and moved them to the Alaska Department of Natural Resources (the agency responsible for oil and gas leasing and mining).[88] He appointed Randy Reudrich, chairman of the Republican Party of Alaska, to the Alaska Oil and Gas Conservation Commission—the oversight agency for well safety.[89] Mr. Reudrich had been the general manager of Doyon Drilling, a contractor to BP, when the company illegally dumped hazardous wastes into Endicott oil wells.[90]

In 2011, Alaska's Governor Sean Parnell let the Alaska Coastal Management Program expire.[91] This program had implemented the federal Coastal Zone Man-agement Act through local and statewide environmental, subsistence, hazard, and

other standards and gave a voice to Alaska's citizens and coastal residents in major industrial projects that affected the environment they depend upon. Governor Murkowski already had weakened the program by shifting its operation to the Department of Natural Resources (which also promotes oil leasing and development) and removing the right of communities to set their own, higher standards to protect the coastal environment.[92] Ironically, this program also provided "streamlining" of permitting processes through project coordination by State agencies.

CONCLUSIONS

In their push to open the Arctic National Wildlife Refuge to oil development, the big oil companies and their allies in the US Congress and the State of Alaska say that impacts of drilling have been small and will be reduced by new technological improvements. Yet the industry has already caused significant environmental damage, the "new" technologies are not new, their benefits are often exaggerated, and "new" practices are often not used at all due to economics or practical reasons. Even as industry touted "new" technologies, the former Bush administration and a string of Alaska's governors (Palin, [Frank] Murkowski, and Parnell) created a legacy of weakened regulations and standards on oil and gas development.

Senator Lisa Murkowski has proposed the latest scheme for opening the Arctic Refuge to oil corporations, the so-called "directional drilling" bill. This Trojan horse would pry open the entire 1.5 million-acre coastal plain of the Arctic Refuge to leasing and oil development.

No matter the improvements, oil and gas drilling is the technology of the last century. True "new technology" in the twenty-first century will advance from human conversations and innovations that create sustainable communities in a society that gains energy through efficiency and conservation, and captures renewable sources including those yet to be imagined.

Most Americans maintain that there are places so special that they should be off-limits to oil drilling and industrial development, and they believe the coastal plain of the Arctic National Wildlife Refuge is one of them. No matter how carefully planned and executed, oil exploration and development would industrialize the unique biological heart of the Arctic National Wildlife Refuge and its wilderness would be lost—forever.

In 2011, the Obama administration stood up for the Arctic Refuge. The US Fish and Wildlife Service's draft Arctic Refuge Comprehensive Conservation Plan included, for the first time in history, a recommendation for Wilderness designation for the

Refuge's embattled Coastal Plain. Nearly a million people submitted comments asking that the Coastal Plain be kept off-limits from oil and gas development.

At fifty-plus years old, the Arctic Refuge holds valuable lessons for our twenty-first-century challenges of living sustainably and bringing new energy paths to fruition that don't require extraction of fossil fuels in our treasured places, and that reduce global warming pollution. The refuge, with its time, freedom, and millennial-old cultures rooted in this place offers recurring lessons. This is a human value of wilderness that is our obligation to pass on.

NOTES

1. BP Alaska Inc., *North Slope Alaska: Man and the Wilderness* (2008) p. 23.

2. State of Alaska, Department of Natural Resources, Division of Oil and Gas, Alaska Oil & Gas Report, November, 2009. http://dog.dnr.alaska.gov/Publications/Documents/AnnualReports/2009_Annual_Report.pdf.

3. National Research Council (NRC), *Cumulative environmental effects of oil and gas activities on Alaska's North Slope* (Washington, DC: National Academies Press, 2003) p. 141.

4. Well data compiled by Doug Tosa, Alaska Center for the Environment, 2011; Alaska Oil & Gas Conservation Commission, 2011; www.state.ak.us/local/akpages/ADMIN/ogc/publicdb. shtml; Department of Natural Resources (ADNR), 2011, Division of Oil and Gas, www.dog. dnr.state.ak.us/oil/products/data/wells/wells.htm.

5. NRC, 2003, pp.43–44, 141, 156, 197 (444 miles gravel roads, including exploration).

 ADNR, Historical and Projected Oil and Gas Consumption, 1999. Appendix B, p.51.

 ADNR. November 22, 2002. Current well information. Division of Oil and Gas.

 W. L. Pamplin, Construction-related impacts of the Trans-Alaska Pipeline System on terrestrial wildlife habitats. Joint State/Federal Fish and Wildlife Advisory Team. {145 miles TAPS}.

 ADNR. June 22, 1993. Final Best Interest Finding, Lease Sale 75A, June 22, 1993, p. 41.

 State of Alaska, DNR. May 30, 2001. North Slope material sale contracts pit information. Fairbanks.

 US Army Corps of Engineers. June 24, 1997. Colville River 17 permit (4–960869) to Nuiqsut Constructors {Alpine gravel pit}.

 US Department of the Interior, Bureau of Land Management. November 2002. Final environmental impact statement: Renewal of the Federal Grant for the Trans-Alaska Pipeline System Right-of-Way. Vol. 2, Table 3.5–1; Vol. 7, Map Atlas pp. 1–6.

 US DOI, BLM. 2003. Northwest National Petroleum Reserve–Alaska, Final Integrated Activity Plan/ Environmental Impact Statement, Vol. 3, Table IV-09.

6. D. A. Jaffe, R. E. Honrath, D. Furness, T. J. Conway, E. Dlugokencky, and L. P. Steele, "A determination of the CH4, NOx and Co2 emissions from the Prudhoe Bay, Alaska Oil Development," *Journal of Atmospheric Chemistry* 20 (1995): 213–227.

7. US Army Corps of Engineers, "Final Environmental Impact Statement, Beaufort Sea Oil and Gas

Development/ Northstar Project," Vol. III (1999), Table 5.4–6, data from ARCO and BPXA, 1994, as reported to Alaska Department of Environmental Conservation. Emissions estimates based on fuel consumption for Prudhoe Bay, Endicott, Lisburne and Kuparuk oil field main production facilities but does not include Alpine, Badami, Pt. McIntyre oil fields, Tarn, Northstar or four Trans-Alaska Pipeline Pump Stations, nor emissions from drill rig engines or vehicles.

8. EPA, "National Air Pollutant Emissions Trends: 1900–1998," March 2000, www.epa.gov/ttn/chief/trends98/emtrnd.html. DC- 23,000 short tons; Rhode Island- 35,000 short tons; Vermont- 46,000 short tons (Table 2.2). According to EPA, "the emissions of each pollutant are estimated for many different source categories, which collectively account for all anthropogenic emissions. The report presents the total emissions from all 50 states." (p. iii).

9. US Army Corps of Engineers, "Final Environmental Impact Statement Beaufort Sea Oil and Gas development/Northstar Project," Volume III, Table 5.4–7, June 1999.

10. D. A. Jaffe, *Journal of Atmospheric Chemistry*, 1995.

11. S. B. Brooks, T. L. Crawford, and W. C. Oechel, "Measurement of carbon dioxide emissions plumes from Prudhoe Bay, Alaska oil fields," *Journal of Atmospheric Chemistry* 27 (1997): 197–207.

12. "North Slope Spills Analysis: Final Report on North Slope Spills Analysis and Expert Panel Recommendations on Mitigation Measures," Nuka Research & Planning Group, LLC for the Alaska Department of Environmental Conservation, November 2010, http://www.dec.state.ak.us/spar/ipp/ara/documents/101123NSSAReportvSCREEN.pdf.

13. "Arctic Pollution Issues: A State of the Arctic Environment Report," Arctic Monitoring and Assessment Programme (AMAP), Oslo, Norway, 1997, p. 157.

14. S. E. Amstrup, C. Gardner, K. C. Myers, and F. W. Oehme, "Ethylene glycol (antifreeze) poisoning in a free-ranging polar bear," *Veterinary and Human Toxicology* 31, no. 4 (1989): 317–319.

15. Alaska Department of Environmental Conservation, Contaminated sites database, January 15, 2003.

16. National Research Council, 2003, pp. 100, 106.

17. National Research Council, 2003, pp. 140–141, 155–159, 47; see also "Report Brief," NRC, 2003, http://books.nap.edu/html/north_slope/reportbrief.pdf.

18. National Research Council, 2003, pp. 5, 47, 116, 148.

19. C. Nellemann and R. D. Cameron, "Cumulative impacts of an evolving oil-field complex on the distribution of calving caribou," Can. J. Zool 76(1998): 1425–1430.

20. C. Nellemann, and R. D. Cameron, "Effects of petroleum development on terrain preferences of calving caribou," *Arctic* 49, no. 1 (1996): 23–28.

21. R. D. Cameron, W. T. Smith, R. G. White, and B. Griffith, "The Central Arctic Caribou Herd," US Geological Survey 2002, Arctic Refuge Coastal Plain Terrestrial Wildlife Research Summaries, Biological Science Report, USGS/BRD/BSR-2002–0001, http://alaska.usgs.gov/BSR-2002/index.html.

22. National Research Council, 2003, 154.

23. Minerals Management Service, "Arctic seismic synthesis and mitigating measures workshop proceedings," March 5–6, 1997, Barrow, Alaska, Anchorage OCS Study MMS 97–0014, (1997), 68.

24. Department of Justice, Press Release, May 3, 2011, http://opsweb.phmsa.dot.gov/

pipelineforum/docs/BP%20North%20Slope%20Release%2005%2002%2011.pdf; see also EPA, "BP North Slope Clean Water Act Settlement," May 3, 2011, http://www.epa.gov/compliance/resources/cases/civil/cwa/bpnorthslope.html.

25. Loy Wesley, "BP fined $20 million for pipeline corrosion," *Anchorage Daily News*, October 26, 2007.

26. State of Alaska. November 14, 2002. BPXA Flowline 86-D Settlement Agreement.

27. "State Fines BP," *Fairbanks Daily News-Miner*, June 5, 2002.

28. US EPA Region 10. April 17, 2001. Consent agreement and final order in the matter of BP Exploration (Alaska) Inc. {three different ones} Docket No. CWA-10–2000–0205 (Prudhoe Bay Central Sewage Treatment Facility); Docket No. CWA-10–2001–0073 (Endicott Water-flood Operations); Docet No. CWA-10–2001–0072 (Prudhoe Bay Waterflood).

29. "BP settles for $15.5 million," *Anchorage Daily News*, February 2, 2000.

30. "Poisoning the Well," Alaska Forum for Environmental Responsibility, 1997.

31. Alaska Department of Environmental Conservation vs. BP Exploration (Alaska) Inc. June 9, 1993. Compliance order by consent (Gather Center 1 facility and flare pad and flare pit).

32. "BP to dole out $1.4 million for safety violation cases," *Anchorage Daily News*, January 8, 2005.

33. "Safety officials propose fine against BP," *Anchorage Daily News*, January 31, 2003.

34. "Contractor faces OSHA accusations," *Anchorage Daily News*, March 9, 2002.

35. "Feds fine pipeline manager," *Anchorage Daily News*, March 18, 1999.

36. "Norton Praises Oil Drilling Practices," *Denver Post*, April 5, 2001.

37. "Oil, Gas, and the Challenge of the Arctic,"American Petroleum Institute, 1983.

38. Data analysis by Conservation GIS Center. 2003, using Alaska Department of Natural Resources North Slope well data base, October 2002. Drilling distance was calculated as horizontal offset between tophole and bottom hole location for 4305 wells that have been drilled (exploratory wells and those with insufficient data were excluded; all types of production wells are included). The average distance for all wells was 0.90 miles.

39. Out of 5549 wells drilled on the North Slope from 1969–2009, the maximum distance was 4.025 miles for a well drilled in 2007; fewer than 2 percent extend more than three miles horizontal offset of three miles or more, according to analysis of Alaska Oil and Gas Conservation Commission well database (See Anne E. Gore, *Broken Promises*, 2nd Edition, The Wilderness Society, 2009, 12 and 14.

40. "BP plans busy exploration season, both in NPR-A and satellites," *Petroleum News Alaska*, October 2000.

41. Minerals Management Service. 2001. Liberty Development and Production Plan Draft Environmental Impact Statement. Appendix D-3–2.

42. BLM. 2002. Environmental Assessment: EA: AK-023–03–008. National Petroleum Reserve–Alaska (NPR-A) Exploration Drilling Program Puviaq #1 and #2 Exploration wells. Cono-coPhillips Alaska, Inc.

43. BLM. 2003. Northwest NPR-A Draft IAP/ EIS. P. IV-20, IV-21.

44. See *Broken Promises*, 2nd Edition, 2009; additional analysis by the author and Alaska Center for the Environment GIS Center based on Alaska Oil and Gas Conservation Commission well database, August 2009.

45. ConocoPhillips and Anadarko. September 2002. (oil company project proposal) Supporting

Documentation for Alpine Satellite Development Program, Final introduction and project description.

46. S. McIntosh, *Draft NPR-A subsistence Advisory Panel Meeting Proceedings, August 15, 2002, Nuiqsut, Alaska,* Sponsored by US Department of the Interior, Bureau of Land Management, 2002.

47. ARCO Alaska, Inc., Anadarko Petroleum Corporation, and Union Texas Petroleum, *Alpine Development Project: Environmental Evaluation Document,* Table 2.3.1, September 1997 (revised).

48. Phillips Alaska, Inc., *Colville River Unit Satellites Development Project, Revised environmental evaluation document,* Submitted to US Army Corps of Engineers, Alaska District, June 21, 2002, 2–30.

49. C. B. Johnson, B. E. Lawhead, D. C. Payer, J. L. Petersen, J. R. Rose, A. A. Stickney, and A. M. Wildman, *Alpine avian monitoring program, 2000. Third annual report.* Prepared for Phillips Alaska, Inc. and Kuukpik Unit Owners. ABR, Inc., Fairbanks, May 2001, i.

50. C. B. Johnson, B. E. Lawhead, J. R. Rose, J. E. Roth, S. F. Schlentner, A. A. Stickney, and A. M. Wildman, *Alpine avian monitoring program, 1999. Second annual report.* Prepared for Phillips Alaska, Inc. and Anadarko Petroleum Corporation. ABR, Inc. Fairbanks, August 2000, 5.

C. B. Johnson, B. E. Lawhead, D. C. Payer, J. L. Petersen, J. R. Rose, A. A. Stickney, and A. M. Wildman, *Alpine avian monitoring program, 2000. Third annual report.* Prepared for Phillips Alaska, Inc., and Kuukpik Unit Owners. ABR, Inc., Fairbanks, May 2001, i.

51. National Research Council, 2003, 66.

52. D. V. Derksen, K. S. Bollinger, D. Esler, K. C. Jensen, E. J. Taylor, M. W. Miller, and M. W. Weller, *Effects of aircraft on behavior and ecology of molting black brant near Teshekpuk Lake, Alaska,* Final report submitted by US Fish & Wildlife Service, Alaska Fish & Wildlife Research Center, Anchorage, OCS Study MMS 92–0063, 1992.

53. K. C. Jensen, "Responses of molting Pacific black brant to experimental aircraft disturbance in the Teshekpuk Lake Special Area, Alaska," (PhD dissertation, Texas A&M University. 1990).

54. M. W. Miller, "Route Selection to Minimize Helicopter Disturbance of Molting Pacific Black Brant: A Simulation," *Arctic* 47, no. 4 (1994): 341–349.

55. Sen. Frank Mukowski, "Drilling Won't Make it Less of a Refuge," *Washington Post Outlook* section essay, December 10, 2000.

56. "Tundra Open," *Petroleum News Alaska,* February 16, 2003, A11.

57. O. P. Smith and W. B. Tucker, "Start to Plan for Arctic warming," Op-Ed, *Anchorage Daily News,* January 24, 2003, B-6.

58. BLM. 2002. Environmental Assessment: EA: AK-023–03–008, National Petroleum Reserve–Alaska (NPR-A) Exploration Drilling Program Puviaq #1 and #2 Exploration wells, ConocoPhillips Alaska, Inc., 4–22.

59. National Research Council, 2003, 40.

60. US Department of the Interior, Arctic National Wildlife Refuge, Alaska, Coastal Plain Resource Assessment, Report and recommendation to the Congress of the United States and Final Legislative environmental impact statement, 1987, Washington, DC, 166.

61. S. M. Lyons, and J. M Trawicki, "Water resource inventory and assessment, coastal plain, Arctic National Wildlife Refuge, 1987–1992 Final Report," Anchorage: Water Resource

Branch, US Fish and Wildlife Service, 1994. (An estimated 9 million gallons was found; each mile of ice roads needs about 1.5 million gallons).

British Petroleum. "BPXA-NPR-A Five Year Trailblazer Winter Exploration Program, Plan of Operations, October 18, 2000, Revision 2," 2000. (Ice pad, 600'x600' requires 3,600,000 gal; airstrip, 5,200'x200', construction and maintenance require 8,000,000 gallons).

62. G. V. Elliott, "Quantification and distribution of winter water within lakes of the 1002 area, Arctic National Wildlife Refuge, 1989," US Fish and Wildlife Service, Alaska Fisheries Technical Report No. 7, Anchorage, 1990, 9. This takes into account that only 15 percent is removed (current practice recommended by Alaska Department of Fish & Game).

63. US Fish and Wildlife Service, "A preliminary review of the Arctic National Wildlife Refuge, Alaska, coastal plain resource assessment: report and recommendation to the Congress of the United States and Final Legislative Environmental Impact Statement," Anchorage, 1995.

64. National Research Council, 2003, 129.

65. Senator Frank Murkowski, Congressional Record, April 17, 2002, S2861.

66. Governor Frank Murkowski, "Speech to Arctic Power (February 14, 2003)," *Anchorage Daily News*, February 15, 2003. Oil called key to budget balance, Ideas: Governor floats notions including road across the Slope.

67. "Road to NPR-A," *Petroleum News Alaska*, September 29, 2002.

68. Alaska Department of Transportation & Public Facilities and US Army Corps of Engineers, Foothills West Transportation Access EIS, 2011, http://www.foothillswesteis.com/.

69. Esther Hugo, "Anaktuvuk Pass Residents Fear Impact of Road, Community Perspective by Mayor of Anaktuvuk Pass," *Fairbanks Daily News-Miner*, May 14, 2011, http://www.newsminer.com/view/full_story/13276908/article-Anaktuvuk-Pass-residents-fear-impact-of—road.

70. "Supporting Documentation for Alpine Satellite Development Program, Final introduction and project description," ConocoPhillips and Anadarko, September 2002.

71. National Marine Fisheries Service. 1997. Comments on US Army Corps of Engineers permit no. 2–960874, Colville River 18.

72. S. McIntosh, *Draft NPR-A subsistence Advisory Panel Meeting Proceedings, June 6, 2002, Nuiqsut, Alaska*, Sponsored by US Department of the Interior, Bureau of Land Management, 2002, 29.

73. US Army Corps of Engineers, Permit evaluation and decision document. Application No. 2–960874. Colville River 18, February 13, 1998:

> "Permit Special Condition #10. If additional oil and gas development occurs between the East and Nechelik channels of the Colville River delta with pipeline connections to the Alpine facility, it shall be accomplished with a minimum of additional fill. Within this region, the design of fields with pipeline connections to the Alpine facility shall incorporate the concept of roadless satellite production facilities. Exceptions may be granted in cases where alternative designs are environmentally preferable or if roadless design is infeasible."

74. Anadarko Petroleum Corporation and Union Texas Petroleum. Alpine Development Project: Environmental Evaluation Document, ARCO Alaska, Inc., September 1997 (revised) 4–176, 4–177.

75. ExxonMobil, Point Thomson Gas Cycling Project, Environmental Report, Fig. 2–1, July 30, 2001.

76. US Army Corps of Engineers, Public notice of application for permit (October 11, 2000),

Kuparuk River 128 (4–2000–1037), p. 1 {Meltwater field development}; US ACE, Public notice of application for permit (August 26, 1997), Kuparuk River 124 (4—970705) p.1 {Tarn field}.

77. Bruce Babbitt, Secretary of the Interior, "Record of Decision, Northeast National Petroleum Reserve-Alaska Integrated Activity Plan/Environmental Impact Statement," October 7, 1998, http://www.blm.gov/pgdata/etc/medialib/blm/ak/aktest/planning/nenpra_feis_1998. Par.36593.File.dat/1998_NE-NPR-A_ROD.PDF.

78. "Deputy Interior Secretary Steven Griles at Senate Energy & Natural Resources Committee Hearing on Oil and Gas Production on Public Lands," Alaska News Nightly, February 28, 2002.

79. "Supporting Documentation for Alpine Satellite Development Program, Final introduction and project description," ConocoPhillips and Anadarko, September 2002.

80. "Stip. 48. Permanent roads (i.e., gravel, sand) connecting to a road system or docks outside the planning area are prohibited, and no exceptions may be granted. Permanent roads necessary to connect pads within independent, remote oil fields are allowed but they must be designed and constructed to create minimal environmental impacts. Roads connecting production sites between separate oil fields may be considered if road-connected operations are environmentally preferable to independent, consolidated operations that each include airstrip, housing, production, and support facilities. This exception will only be granted following consultations with appropriate Federal, State, and NSB regulatory and resources agencies, and the appropriate level of NEPA review." Interior Secretary Bruce Babbitt, Northeast National Petroleum Reserve–Alaska, Integrated Activity Plan/ Environmental Impact Statement, Record of Decision, October 1998.

81. "Northeast NPR-A Final Supplemental IAP/EIS," BLM, 2008, http://www.blm.gov/ak/st/ en/prog/planning/npra_general/ne_npra/northeast_npr-a_final.html; Interior Secretary Kempthorne, "Record of Decision for Supplemental Northeast NPR-A IAP/EIS," July 16, 2008, http://www.blm.gov/pgdata/etc/medialib/blm/ak/aktest/planning/ne_npra_final_supple-ment.Par.91580.File.dat/ne_npra_supp_iap_rod2008.pdf.

82. "Supporting Documentation for Alpine Satellite Development Program, Final introduction and project description," ConocoPhillips and Anadarko, September 2002.

 Babbitt. 1998. Figure II.C.1 (buffer zone); p.5; Stipulation 39d, p. 36.

83. "Alpine Satellite Development Plan Final EIS BLM," September 2004, http://www.blm.gov/ eis/AK/alpine/dspfeisdoc.html; Rebecca W. Watson, Asst. Secretary for Land & Minerals Management, DOI. November 2004. Record of Decision, Alpine Satellite Development Plan Final EIS. http://www.blm.gov/eis/AK/alpine/pdf/rod.pdf.

84. "Northwest National Petroleum Reserve–Alaska, Draft integrated activity plan/ environ-mental impact statement," Bureau of Land Management, January 2003.

85. "Oil industry seeks full NPR-A access," Alaska Oil & Gas Reporter, February 23, 2003, B3.

86. "BLM reviews NPR-A restrictions," Alaska Oil & Gas Reporter, February 16, 2003.

87. Northeast NPR-A Final Supplemental IAP/EIS, BLM, 2008, http://www.blm.gov/ak/st/en/ prog/planning/npra_general/ne_npra/northeast_npr-a_final.html; Interior Secretary Kempthorne, Record of Decision for Supplemental Northeast NPR-A IAP/EIS, July 16, 2008, http://www.blm.gov/pgdata/etc/medialib/blm/ak/aktest/planning/ne_npra_final_supple-ment.Par.91580.File.dat/ne_npra_supp_iap_rod2008.pdf.

 See further explanation of the legal deficiency of the amended Northeast NPR-A IAP/ EIS from January 2005 and its Record of Decision on January 11, 2006 which was vacated by the US District Court for the District of Columbia on September 25, 2006 in its decision

in *National Audubon Society v. Kempthorne*: http://www.blm.gov/ak/st/en/prog/planning/npra_general/ne_npra/ne_npra_feis.html.

88. "Murkowski issues habitat division order," *Fairbanks Daily News-Miner*, February 12, 2003.

89. "Ruedrich, Palin win state jobs," *Anchorage Daily News*, February 19, 2003.

90. "Statement of Randy Ruedrich, General Manager, Doyon Drilling, Inc., before the Committee on Energy and Natural Resources," United States Senate, July 18, 1995 (Hearing on Alaskan Oil Production/Technology), 3.

91. "Parnell denounces 'bad faith' in coastal negotiations," *Juneau Empire*, May 23, 2011, http://juneauempire.com/state/2011–05–23/parnell-denounces-%E2%80%98bad-faith%E2%80%99-coastal-negotiations.

92. Glenn T. Gray. "Proceedings of the 14th Biennial Coastal Zone Conference New Orleans, La., July 17 to 21, 2005," 2005, http://www.csc.noaa.gov/cz/CZ05_Proceedings/pdf%20files/posters/Gray.pdf.

From Kivalina

A Climate Change Story

CHRISTINE SHEARER

❖

In July 2010, I received an e-mail from Anthony Arnove to provide a blurb for a forthcoming book by Christine Shearer, Kivalina: A Climate Change Story. *He also e-mailed me the book draft. I read it and e-mailed him back my blurb within a few days. I have spent time in Point Hope and Point Lay, two Iñupiat communities along the Chukchi Sea, north of Kivalina. So, I was familiar with Kivalina's struggle with climate change induced erosion but did not have knowledge of the lawsuit, or the larger history of corporate deception that Christine wrote about in her book. The following month, I founded ClimateStoytellers.org to share such stories widely, and invited Christine to contribute. She did. The following year, her book came out, and the first reading was at the Elliott Bay Book Company—an independent bookstore in Seattle, a favorite of mine, as I lived in the city for nearly a decade. On August 3, 2011, I attended her reading with a few friends. Here is an excerpt from* Kivalina: A Climate Change Story.

❖

Kivalina: A Climate Change Story *by Christine Shearer was published by Haymarket Books in 2011.*

Due to the lack of ice formation along the shores of Kivalina, by October 2004 the land began failing. . . . The island seemed to be falling apart and disappearing into the Chukchi Sea before the very eyes of its inhabitants. Volunteers from the village began to work feverishly to hold the island together but every effort, every object placed along the edges, was being sucked into the angry sea. . . . Evacuation by air was not an option because of the weather conditions and because the village was surrounded by the rough waters of the sea storm. This meant evacuation was also not an option by boat to the mainland. There was nowhere to go and nothing the volunteers did worked to keep the island together—the people were trapped!

—Kivalina Tribal Administrator Colleen Swan

IN FEBRUARY 2008, a tiny Alaska Native village named Kivalina filed suit against twenty-four fossil fuel companies for contributing to the village's erosion through large amount of greenhouse gas emissions, and for creating a false debate around climate change. The lawsuit was filed in conjunction with environmental justice and indigenous rights organizations as one of several steps in a broader push for climate justice, aiming to help Kivalina residents draw attention to their situation and call for action from government and corporate officials that had so far largely ignored them.

The Native Village of Kivalina lies approximately 120 miles north of the Arctic Circle, on the tip of a thin, 8-mile-long barrier reef island. The population of about four hundred is primarily Iñupiat, with ancestry to the area going back thousands of years to some of the first settlements in the Americas. The Iñupiat have been able to survive in the harsh Arctic region through an understanding of and close connection to the cycles and rhythms of the land, with the Iñupiaq words for the different seasons translating into their hunting and gathering cycles. This understanding permeates their culture—that is, their daily life—and their ability to live off the land, sustaining themselves and their community, is a source of pride and values. Like many Alaska Native villages, Kivalina has retained a largely subsistence lifestyle.

Kivalina residents report first noting erosion of the island in the 1950s, and in 1992 the community voted to relocate, selecting a new site by 1998. As they tried to engineer the move, however, they found that a government body to assist communities with relocation does not exist. There is also no policy in place—nationally or internationally—to help communities relocate due to

Colleen Swan, spring whaling camp, near Kivalina. *(Courtesy Colleen Swan, 2011.)*

climate change, even though a December 2003 Government Accountability Office report found that at least four Alaska Native villages were in "imminent danger" from flooding and erosion, aggravated by rising temperatures, and would have to relocate—among them Kivalina.

According to City Administrator Janet Mitchell, "We talked to everyone we could. But the word relocation does not exist at the federal level, and I doubt it exists at the state level." Tribal Administrator Colleen Swan reported a similar experience: "There wasn't anyone we could talk to about global warming and what it was doing to our environment. There's no agency in the federal government that deals with climate change." Residents also received little relocation help from their representative tribal corporation, the Northwest Arctic Native Association (NANA), created by the 1971 Alaska Native Claims Settlement Act (ANCSA) and seemingly more focused on economic growth than tribal assistance. Caught within gray areas of US and tribal political representation, Kivalina has been struggling to relocate for almost two decades with little success, as climate change comes more quickly and severely, putting the entire village in danger.

The erosion of Kivalina and the difficulty facing its residents as they try to relocate raises issues of climate justice, as the people there have lived a relatively low-energy, subsistence lifestyle for millennia, yet are facing some of the biggest impacts from climate change. Climate justice is an extension of civil rights and environmental justice movements, which acknowledge that risks to public well-being are unequal, reflecting broader social inequality. Historic discrimination, uneven political representation, and economic inequality have concentrated many working-class and communities of color in more hazardous areas with fewer resources to minimize harms, like Kivalina.

Iñuit populations in the Arctic are among the most *vulnerable* to climate change because of the sensitivity of the Arctic to heat, their reliance on the land and water for subsistence, and the lack of resources to protect themselves from climate changes. Like many Native American communities, Alaska Natives have incomes well below the national and state average. The ANCSA of 1971 organized the indigenous population of Alaska into regional tribal corporations, with a portion of the proceeds from the corporate projects going to Alaska Natives, who are considered shareholders. The projects have brought in some money, but not enough to lift many rural villages above poverty levels. Individuals vote for tribal corporation directors, but directors are then free to determine the activities of the regional corporations. This has created tensions between regional corporate directors who want to extract natural resources for profit and Alaska Natives who regard such practices as antithetical to traditional subsistence

ways. While some regional corporations have been successful through such endeavors as logging, mining, and collaborating with oil companies, others have struggled, finding the abrupt transition from subsistence living to capital accumulation difficult, especially in regions not rich in resources. The disparity in resources is somewhat compensated by a mandated 70 percent sharing of resource revenues among all tribal corporations statewide, but there are still notable discrepancies in regional corporate performance.

Making money is not necessarily the goal of many Alaska Natives, however, particularly those in rural villages more concerned with sovereignty and subsistence rights. While the US government currently recognizes more than two hundred Alaska Native tribal councils, their sovereignty is limited: federal and state Supreme Court decisions in the late 1990s ruled that Alaska Native villages are "sovereigns without territorial reach," with "inherent sovereignty" to regulate domestic affairs but not to extend such rule beyond their territory or people. Left in legally ambiguous gray areas still under contest, village tribal councils frequently have strained relations with regional corporations, due to disputes over resource exploitation and leadership, as well as with the state of Alaska, which is often unresponsive to native rights. There is a "trust relationship" between the federal government and Native American tribes, referring to the federal government's promise—laid out in treaties—to protect and promote tribal self-governance in compensation for the loss of their lands. Native Americans have argued that the trust relationship constitutes legally binding obligations, but the relationship has been interpreted differently and unevenly by US judges.

The struggle for Native American rights is regarded as an early stream of the environmental justice movement. Following the civil rights movement, many inner-city residents, activists, and scholars began calling attention to the concentration within poor and working-class communities of "locally unwanted land uses" such as city dumps, chemical plants, and oil refineries, particularly in communities of color due to the history of residential segregation and discrimination, restricted access to mortgages and loans ("redlining"), zoning practices, and lack of representation on local planning boards.

Awareness of and actions against land-use inequities grew alongside similar struggles, such as the campaign by farm workers (largely immigrants) to protect themselves against harmful pesticides, the anti-toxics movement set off by the contamination of Love Canal, and long-standing indigenous struggles against the overdevelopment of native lands. By the 1990s, these and other struggles had been identified as a broader environmental justice movement (EJM). In contrast to the environmental movement, the EJM defines "the environment" not as nature per se, but as where people work, live, and play.

Within the United States, activist and litigation organizations have developed around environmental justice issues, many of them small and grassroots groups that respond to local issues as they develop. The organizations employ a variety of techniques, with litigation just one of several tools including political participation in local development decisions, direct actions, and mobilization of affected communities. The movement's main goal, as articulated by EJM legal advocate Luke Cole, is to "rightly challenge, first and foremost, the legitimacy of the decision-making process and the social structures that allow such decisions to be made without the involvement of those most intimately concerned."

Cole was one of the key lawyers in the Kivalina lawsuit, before a car crash took his life in June 2009. After graduating with a law degree from Harvard, he went on to intern for public rights activist Ralph Nader, and then to co-found the San Francisco–based Center for Race, Poverty, and the Environment in 1989. At the Center, Cole worked with communities around the Bay Area and Central Valley of California for cleaner air and water. In 2001, Cole traveled to Kotzebue, Alaska, to help lead a seminar on indigenous environmental law.

At the conference he met residents of Kivalina. They told him about the poisoning of their water by the Red Dog Mine, the world's largest zinc operation, fifty miles east of Kivalina. The mine was a project of Kivalina's regional corporation, NANA, and had become a source of income for them, but a source of harm for Kivalina, according to residents. They told Cole that since the mine began operations in 1989, the Wulik River—their primary source of freshwater—sometimes ran in bright colors, tasted funny, and contained many dead and deformed fish. They had reported these problems to NANA and state officials, but nothing had been done. Cole worked with the residents to investigate the mine, found it was in violation of its discharge permits, and filed a lawsuit, leading to a settlement six years later. The long-term health effects from the river's contamination remain to be seen.

According to Luke Cole: "During this time I was going up to Kivalina three, four times a year in the context of this litigation and I was seeing what residents were reporting to me as changes from global warming. I would go up there in September and there was no sea ice. Now, Kivalina is north of the Arctic Circle, and there should be ice but there wasn't. So I asked about it and they said they had been noticing it for many years, but that it had been getting worse."

Despite the long-standing stance of hesitation and skepticism by the executive branch, the US government itself was documenting the effects of climate change in Alaska, particularly on native villages. In 2000, the US Global Change Research Program released its National Assessment Synthesis (NAS) report on climate change, a summary of climate science, which the

fossil fuel–based Competitive Enterprise Institute later sued the government for releasing. The report noted Alaska's climate had warmed an average of 4 degrees Fahrenheit since the 1950s, and as much as 7 degrees Fahrenheit in the interior during winter. Permafrost, the permanently frozen subsoil that underlies most of Alaska, was thawing, causing damage to overlying infrastructure and contributing to soil erosion and landslides. Sea ice had retreated 14 percent since 1978 and thinned 40 percent since the 1960s, leaving coastlines vulnerable to erosion and flooding.

The NAS report also noted that climate change was already affecting life in Alaska Native villages. In December 2003, the Government Accountability Office went on to report that most of Alaska's more than two hundred native villages were affected to some degree by flooding and erosion, with thirty-one facing imminent threats "due in part to rising temperatures that cause protective shore ice to form later in the year, leaving the villages vulnerable to storms."

As with the pollution from Red Dog Mine, the people of Kivalina had reported the effects of warming temperatures but then hit a dead end. They had voted to relocate in 1992, petitioned various government bodies to begin a relocation process, and found there was no process in place to assist them. Meanwhile the need to relocate grew more urgent as the effects of climate change accelerated the village's erosion and left residents increasingly in danger from storms.

Similar effects were impacting indigenous communities throughout the Arctic. In 2005, an Iñuit petition was filed with the Inter-American Commission on Human Rights, created in 1959 to uphold and investigate violations of the 1948 American Declaration of the Human Rights of Man. The Iñuit petition alleged the US government was violating the human rights of Arctic people by refusing to limit greenhouse gas emissions. Seeking caps on US emissions, the petition also called for the commission to produce plans to protect Iñuit culture and resources through adaptation assistance. The petition was rejected one year later by the commission, which maintained that the charges outlined in the petition were insufficiently supported for making a determination. The same year, the US Army Corps of Engineers issued a report stating the situation in Kivalina was "dire" and that the entire town needed to be immediately relocated, at an estimated cost ranging from $100 million to $400 million, according to various government estimates.

In September 2007, Kivalina officials received a fax from the National Weather Service reporting winds in the area were expected to hit with a wave height of up to eight feet. The village faced the danger of a spill from their fourteen

large fuel tanks. Fearing flooding, the Northwest Arctic Borough decided to initiate a precautionary evacuation. Those wishing to leave were transported via cargo planes and off-road vehicles. Some residents remained, either by choice or to help protect the seawall and village.

Kivalina residents Dolly and Reppi Swan, and their friend David Frankson, vividly recalled the 2007 storm. Dolly said of the storm: "It was kinda scary, it's hard to put into words. It was so different to watch that big storm coming in. You would not want to be around here. It's like, I wanted to get on the first plane out of here. But I stayed. Reppi asked me to, he wanted me to be with him. We sent our children to be evacuated."

Reppi, in turn, stayed because his father instructed him to, as part of his duties with Kivalina Erosion Control. He worked during the storm protecting the shoreline: "The work was dangerous. One time before the storm we were setting bags into the water and one of the guys was setting bags and tripped right into the water. He was getting so used to it, running down, taking bags and bringing them back up, and the bags have loops on them, when he started running down his feet got caught, and he fell right into the water. So we grabbed him."

David Frankson helped the people of Kivalina evacuate. While trying to move the people out, he encountered difficulties: "We were supposed to go to Kotzebue but the FAA [Federal Aviation Administration] said no. . . . They said the pilots could not exceed their hours. So we took our four-wheelers down to Red Dog Mine. Men, women, and children. But the children were too young to go there, it was very dangerous." Other residents took on more of the emotional labor during the evacuation, such as resident Margaret Baldwin: "It was really scary, some children were crying, without their parents, I had to comfort them, comfort the children. Small kids."

After the storm, the Army Corps approved construction of a seawall for Kivalina. Relocation, however, remained necessary, yet there was still no policy in place to assist the people.

Shortly after the evacuation, Kivalina residents began debating other options for protecting themselves. Cole suggested a climate change lawsuit, positioning the situation within an environmental justice framework, as the only way to give the people of Kivalina a voice, however imperfect the suit might be: "No one asked the people of Kivalina, y'know, 'Would you like to have your environment ruined?' A lawsuit is the only way they have of expressing themselves in the environmental justice process. It's late in the day, it's inadequate, it's a blunt tool, it's the only tool they have left."

Cole spoke to lawyer Heather Kendall-Miller of the Native American Rights Fund (NARF), which provides legal representation for Native Americans. Working in Anchorage, Kendall-Miller was acutely aware of the climate change issues facing native villages and interested in branching out legally in that area, but had not yet found a way. "My primary line of work is litigating subsistence and tribal sovereignty cases. Climate change is outside [NARF's] scope but it became necessary when we saw how drastic the effects were on the people that we work with and serve." She noted that while the federal government has a trust relationship with Kivalina, it would be difficult to legally enforce federal assistance with the village's relocation, making her receptive to pursuing the case as a matter of environmental pollution and public nuisance.

Kendall-Miller had already been approached about such a possibility by Matt Pawa, a lawyer at a small Boston firm that had filed the first federal global warming nuisance case with attorneys general in *Connecticut v. AEP*. Together Cole, Kendall-Miller, and Pawa considered filing a claim on behalf of Kivalina and discussed this option with the village. After several meetings, the Kivalina City and Tribal Councils agreed. Pawa then recruited Steve Berman and Steve Susman, both high-profile litigators involved in the state tobacco lawsuits—Berman on the side of states and Susman on the side of tobacco companies—as well as several other public rights lawyers.

On February 26, 2008, Kivalina, in both capacities as a native village and city, filed a legal claim in the United States District Court for the Northern District of California against twenty-four oil, electricity, and coal companies: ExxonMobil, BP, BP America, BP Products, Chevron Corporation, Chevron USA, ConocoPhillips, Royal Dutch Shell, Shell Oil, Peabody Energy, AES Corporation, American Electric Power Company, American Electric Power Services Corporation, DTE Energy Company, Duke Energy, Dynegy Holdings, Edison International, MidAmerican Energy Holdings Company, Mirant Corporation, NRG Energy, Pinnacle West Capital Corporation, Reliant Energy, Southern Company, and Xcel Energy. The claim alleges that the defendants are significant contributors of greenhouse gas emissions, exacerbating global warming and the erosion in Kivalina, constituting a public nuisance under federal and state common law. The suit seeks damages of up to $400 million, the estimated cost of relocating the village. In addition, there are secondary claims of conspiracy and concert of action against ExxonMobil, AEP, BP, Chevron, ConocoPhillips, Duke, Peabody, and Southern Company for conspiring to create a false scientific debate about climate change to deceive the public. The defendants in the

first claim were selected for being among the largest emitters of green-house gases, while those in the secondary claim were selected for, in the words of Luke Cole, "going above and beyond" in their efforts to deceive the public about global warming.

The lawsuit cuts across many aspects of climate change, as illustrated by the different but interconnected motivations of the lawyers who filed the claim. Steve Susman, for example, is particularly focused on addressing climate change, and holding fossil fuel companies accountable, similar to the tobacco lawsuits. His involvement in the Kivalina case is notable both because he is a high-profile litigator who charges up to a thousand dollars an hour for his services, and because he was involved in the tobacco suits—on the side of tobacco. In interviews, Susman has attributed his interest in global warming to his wife who, during our phone interview, was correcting him or adding tidbits in the background as we spoke. He briefly recapped his growing interest in climate change: "In the fall of 2005, I was with my wife and helping her organize a Yale conference on climate change. I went with her and didn't know anything about it and started reading materials on the plane and it sounded very interesting to me, it sounded a lot like tobacco had sounded, and so I just right then and there, and a bit at my wife's urging, decided it was something I was going to get interested in." Shortly afterward, Susman worked pro bono to help thirty-seven Texas cities stop the construction of coal-burning electric utility plants in the state.

Susman saw many parallels with the tobacco suits in the form of the misinformation campaigns, but also recognized that such tactics can be hard to prosecute:

> It's very much a legal gray area. Companies enjoy a First Amendment right to petition the government and speak their minds, it's part of free speech. Even if they are saying it in conspiracy and collusion with one another, as long as they are saying things, expressing opinions, it is protected by the First Amendment. And that's clearly an argument [defendant companies] are making against us in this case, that we are just complaining about something that is protected by the First Amendment, the Noerr-Pennington doctrine, so I think it is very difficult under existing law to hold companies responsible for promulgating bad science. Laws can be passed but right now it is very difficult to hold people responsible for promulgating junk science. However, to the extent that there is a good faith belief on their part, they enjoy that right, so we could try to prove they knew the information they were spreading was false and being used to deliberately influence public opinion—that would override their First Amendment rights.

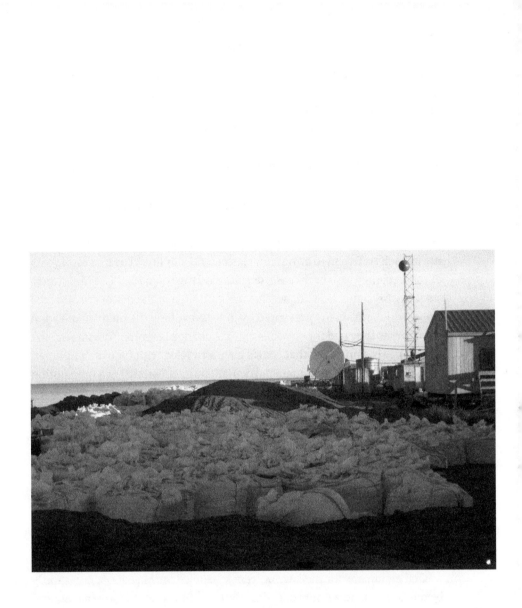

Sandbags for protection of Kivalina shoreline, along the Chukchi Sea coast. *(Photograph by Christine Shearer, August 2008.)*

This is why, Susman said, lawyers prosecuting such cases strive to get to the discovery phase of a trial in order to demonstrate industry knowledge of the falsity of their claims. Indeed, public health historians affirm such documents have been crucial to their research. Without documentation, allegations that corporations know they are misrepresenting science remain in the realm of speculation, in both the court of law and, in many ways, the court of public opinion. Steve Berman, who helped gain the release of the internal documents of tobacco manufacturer Liggett and secure the industry's settlement of the state suits leading up to the master national settlement, believes concrete evidence of industry knowledge is an important factor but not in itself sufficient to bring about successful liability: "The first forty years of tobacco, they won every case, despite evidence of harm." The first step to a successful claim, he said, was having a case reach the discovery and trial stage, which was being prevented by judges invoking the political question doctrine, as they had for previous climate change lawsuits: "What is or isn't a nuisance is something that courts have struggled with for over a hundred years. If you want to point to a particular law in effect, that is a preemption issue, but I don't think a proper analysis is the political question. With a political question, everything gets knocked out, you don't have to deal with the other issues." A political question, in effect, means that a legal claim is an issue for the executive and legislative branches, not the courts.

Defendant companies, in their response, split up into three groups: power, oil, and coal. Each group filed multiple motions to dismiss. Although none of the defendant lawyers agreed to an interview or to be quoted, some spoke to me to help clarify the specifics of the legal arguments in the motions. If the judge were to accept the defendant motions for dismissal, Kivalina's lawsuit would be thrown out before going to the discovery and trial phase.

Oral arguments for the lawsuit were scheduled for May 2009. But, shortly before, Judge Saundra Armstrong of the Northern District of California announced that a hearing would not be necessary. On September 30, 2009, Judge Armstrong issued a ruling. She ruled that the political question doctrine did apply—the Kivalina claim, she said, necessarily involves cost-benefit analyses that the executive and legislative branches must speak to before the judicial branch can act, making the claim a "political question" preventing legal adjudication.

Judge Armstrong also went on to deny the village of Kivalina legal standing to bring the case, arguing that global warming is too ubiquitous to be "fairly traceable" to the defendants' emissions, as required for standing, and that while states have the right to bring public nuisance suits, Kivalina does not,

thereby denying Kivalina's rights as a sovereign nation. In dismissing Kivalina's claim on grounds of both political question and legal standing, Judge Armstrong declined to address the secondary claims of civil conspiracy and concert of action. The actions of defendant fossil fuel companies in denying climate change went unaddressed.

With Kivalina's claim dismissed for now and the fate of future climate change lawsuits uncertain, the village's longtime residents must look to other means to protect themselves and their homeland.

In August 2009, I phoned Kivalina City Administrator Janet Mitchell for an update on the relocation. She sounded quite despondent. This was hard because during my visit the previous year, Janet had been the most upbeat of the people I'd met, knowing the task ahead was difficult but confident that it could be achieved, that various projects and agencies could come together to make Kivalina's safe relocation possible. Such optimism was now completely stripped from her voice. When I asked what progress had been made on the relocation, she replied with a flat "None." Indeed, in talking to her it became quite clear that, beyond completion of the seawall, little else had moved forward with the village's needed relocation. Without the support to move things forward, the informal plan is apparently to secure the village of Kivalina where it is, on an island that is eroding underneath their feet.

This is the situation of Kivalina today. Fighting to be relocated, and hoping until then that their seawall proves resilient. Despite ancestry in the harsh Arctic going back thousands of years, this may prove the most difficult struggle yet. And the world keeps warming, the ice keeps melting, and the storms keep coming.

Although climate change is often discussed as an environmental problem, its root causes are social. It stems from the fossilized carbon emissions we spew into our atmosphere and from the relations of power that make addressing this problem so difficult. The dangers of climate change have become clear, imperiling people throughout the world like those in Kivalina, and it is time to act. To fail to do so is to leave this issue to the small number of powerful players who exert so much influence over US and global policy, many of whom have worked very hard to dispute and downplay climate change and block meaningful action. We cannot afford to leave the fate of our planet in their hands. It is up to all of us.

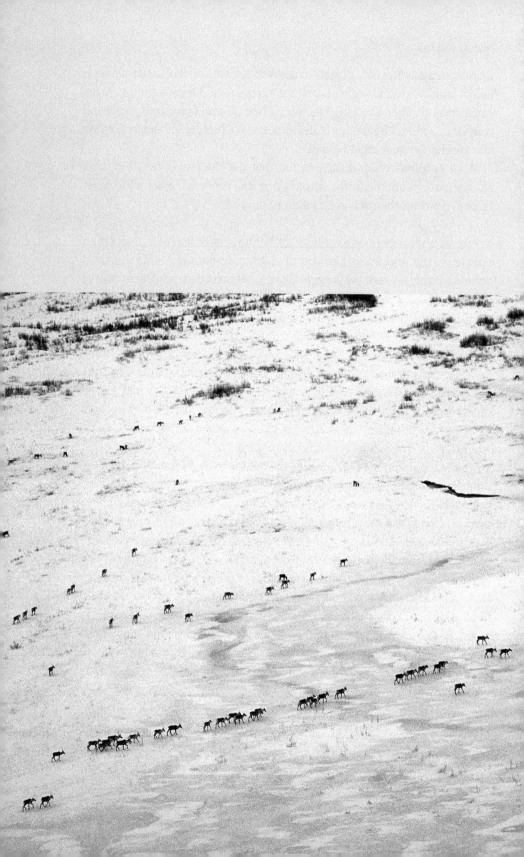

PART THREE

we are the
caribou people

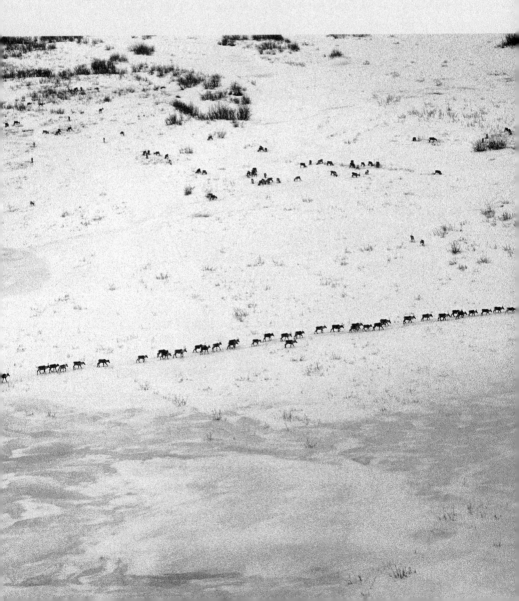

Caribou are not just what we eat; they are who we are. They are in our stories and songs and the whole way we see the world. Caribou are our life. Without caribou we wouldn't exist.

—SARAH JAMES

Pregnant female caribou from the Porcupine River Herd migrate over the frozen Coleen River, on their way to the coastal plain for calving, Arctic National Wildlife Refuge. *(Photograph by Subhankar Banerjee, early May 2002.)*

From People of the Deer

FARLEY MOWAT

❖

Farley Mowat's two-volume epic, People of the Deer *and* The Desperate People, *has been my guiding light as I think about the Arctic—the land, the animals, and her people. In 1946, twenty-five-year-old Mowat began a two-year stay with the Ihalmiut in the barren grounds, which would be today's southern part of the Nunavut Territory in Arctic Canada. The back cover of the 1981 Bantam paperback edition of* The Desperate People *states:*

> They could survive anything in the Arctic wilderness—except the white man. Early in this century, the Ihalmiut, People of the Deer, numbered in the thousands (about 7,000 people in 1886). They were rich, the caribou were abundant. The children in their tents were happy and there was never any fear of hunger. Then came slaughter of the herds and starvation of the flesh. When Farley Mowat came to share his life with Ihalmiut, their numbers had dwindled (to about 40 souls), yet their courage was undiminished. This is Farley Mowat's indictment

of their torturers and his tribute to the last survivors—brave, proud in their age-old way of life and now, sadly, fighting to save themselves from extinction.

Since the word deer *covers a broad range of species and subspecies across the planet, it is worth noting that Mowat is referring to the barren ground caribou of the Arctic—the same species discussed in all of the other stories in this chapter. He saw the Ihalmiut as "People of the Deer." As you'll see a bit later, from the stories of Jonathon Solomon, Sarah James, and Reverend Trimble Gilbert, Gwich'in people see themselves as "the caribou people." Here is an excerpt from the chapter "Eskimo Spring" in* People of the Deer, *where Mowat shares a sense of "what was" and "what is."*

❖

People of the Deer was first published in 1951 by Little, Brown & Company; the latest edition will be published by Douglas & McIntyre in 2012. *The Desperate People* was first published in 1959 by Little, Brown & Company; a paperback edition was published by Bantam in 1981.

AS I became more competent with the language I discovered that the talk of the People was largely devoted to times past. It almost seemed as if the Ihalmiut were making a deliberate effort to relive those dead days, as if they wished me to see them, not as they are, but as they had once been. Slowly and carefully they used words to rebuild the old shattered pattern of life as it had been in the Barrens, so I might also live with them in those happier times. And it was not long before their efforts began to have the desired effect, and I could see, in my mind's eye, something of the richness and vigor of the life the People had led in those vanished years when a man might stand on a hill and though he looked to the east, to the west, to the north, or to the south, he would not know where the land was, for all he could see was Tuktu the deer. All he could hear was the sound of their feet. All he could smell was the sweet scent of the deer.

In the days that are gone, the deer came out of the forests in spring and the doe's bellies hung heavy with fawn, and the strident demand of new life rang through the land. Then the People would come from the tents which stood by the abandoned igloos of winter, and the old men and old women stood by and smiled a toothless welcome for Tuktu. The hunters came from the tents

and saw to it that the kayaks were ready. If the kayaks coverings were torn, then the women hurriedly soaked hides in the melting streams and stretched the new skin over the slim ribs of the hunting craft.

When the deer began to cross the thawing rivers that ran near the camps, the men went out to hunt. They carried their deer spears and they pushed their kayaks into the ice-filled waters of rivers and lakes. The women walked down the shores of the places where converging rows of stone pillars had been built many generations before to funnel the migrating herds to where the hunters waited. These fences were put right by the women, for the winter gales might have toppled the stones and torn off the headpieces of moss which help make the pillars look like men to the deer.

As soon as these deer fences were ready, the women and the young children would go out into the plains which were still covered with yielding spring snow. There they lay hidden in depressions amongst the rocks or in the moss until a deer herd came by. As the deer passed, the watchers shouted and jumped to their feet and closed in behind the fear stricken beasts, driving them into the embrace of the stone fences. The deer ran down between the narrowing arms of the fence until they came to the bank of the river and to the place appointed to the hunters. As the fleeing animals entered the water, the kayaks were unleashed against them and the spring killing began. Spears flashed in the sun and dead deer floated down with the current into the bays below.

The spring was a time of great killing and yet the People took only enough in those days to meet their needs until fall. For the hides of the spring deer are useless for clothing and the meat is lean and lacking in fat.

There was much gorging of fresh meat in the spring, for when the sun again stands high in the sky, the bellies of men revolt from the dry meat and the frozen meat that is their diet all winter. Down in the backwaters of the bays on the river, the old men pulled the floating bodies ashore and women came with their sharp curved knives and flensed the deer where they lay. Then, bent double under the weight of fresh meat and of great bundles of marrowbones, they went back to the camps. But not all of the carcasses of the deer were butchered and skinned; a great many were only gutted and anchored with rocks deep under the fast, cold flow of the waters where the meat would stay fresh well into the last days of summer.

After the herds had passed by to the north, the People moved their camps up to the slopes of the hills so that the long winds could battle the flies which were coming. Here the People lived till midsummer, awaiting the return of the deer.

Summer was the time of eggs and young birds. Even the children went daily out over the plains with their toy slings and bows to search for the eggs and the young of the ptarmigan, of the curlew, the ducks, and even of the tiny song birds of the Barrens. The men too did not let their hunting skills grow rusty, for they searched out the dens of the great Arctic wolves and took enough pelts for mats and for the trimming of parkas. But during most of the summer the men worked at building new kayaks, repairing their sleds, and preparing for the return of the herds. In the evenings they went to the hilltops and started into the flaming sky of the north, waiting and watching for sight of the deer.

By midsummer the first herds of does were again passing down into the land of the People, and for a month the hunting was done out on the plains. At this time of the year, and until the deer had again swung to the north, the skins were still of little value, except for those of the fawns, and there was no need for a large kill. So the hunters went out with the bows made of the springy horn of the musk ox, and they stalked the deer over the hills and killed only a few, picking the fattest beasts with great care.

At last, in late summer, the herds again swung to the north and passed out of the Ihalmiut land. This was the time of greatest activity during the year, for it was known that when the deer came back again it would be only for the brief few days as they fled south before the approach of winter; and after that the herds would not be seen again in the land until spring. It was known that when the deer came for this last time to the Little Hills, they would not linger but would come like a flood and pass quickly. All things had to be ready to greet their arrival, for the lives of the People depended on the success of the fall hunt.

The last rotten ice was all gone from the rivers and from most of the lakes before fall and so the deer followed new routes, swinging along the curved shores of the great lakes, and crossing the rivers just below or above open bodies of water. In the land of the Ihalmiut there were many such crossing places, all of ageless antiquity, where the deer were funneled by the lakes and hills into narrow defiles. To those places the People now moved their tents, setting up hunting camps a few miles away from each crossing so the presence of the tents would not interfere with the movements of the deer.

In the old days the Ihalmiut told me about, there would be thirty or forty tents near each of the seven most famous crossing places scattered over the land. In these camps the men worked lovingly on their kayaks and sharpened the copper points of their spears till they were as keen as fine razors. The women roamed the land all about, and heaped up piles of willow twigs against

the days when they would build the biggest fires of all the year to render down the sweet deer fat. The youths paddled for two or three days to the north and camped on the hilltops from which they could see the approach of the deer and carry the warning back to the camps.

The men who were too old to hunt watched for signs. They watched for a sudden upswing in the numbers of foxes and wolves and for the forming of the great flocks of scavenger gulls that accompany the herds; but most of all they watched for flights of ravens coming out of the north, for these are the sure heralds of the approach of the deer.

Excitement and tension built up in the camps as the fall days slowly passed. There were alarms, occasioned by small wandering herds that happened into the land ahead of the migration. And as always some of the People wondered if this time, by some terrible malice of fate, the deer might fail to move south by the particular crossing where the skin tents stood waiting. There was no sleep and little rest. At night the drums sounded and the voices of the hunters sang the songs of the killing of Tuktu, or the People told tales of the deer they had seen and killed in their time, until the late dawn crept into the sky.

Then on a day in October there would be snow in the air. A kayak would sweep up the river out of the north, and the man in it held his spear aloft as a signal. "They come!" was the cry in the camps, and the hunters ran to their places and the women and children ran to the tops of ridges north of the crossing.

This was the time of the great slaughter. Swimming the rivers, the deer met the repeated onslaught of the kayaks. At the valleys and gullies the deer met the hunters. Blood flowed at the crossings and the hunt went on far into each night.

In the camps huge fires burned all day and all night and blocks of white deer fat began to mount up in the tents. On the bushes which spread their dead leaves in the hollows, thin slices of meat were laid out to dry until the valleys and hills about the camps by the crossings glowed a dull red under the waning sun. All over the land, but most thickly about the deer crossings, little cairns of rocks sprang up like blisters on the gray face of the plains. Under these cairns were the quartered bodies of deer. On the sandy shores by the tents, many thousands of fine hides lay staked out with their naked sides upward, and women and children worked over these hides, cleaning and scraping them thin.

The excitement mounted to a frenzy of action until, in less than a week from the day the man in the kayak had first signaled the approach of the deer,

the great herds were gone. The crossings were empty of living deer and the dead remained there.

The snows came, and all things—save man and the ravens—turned as white as the snow. The ptarmigan found their white feathers, the fox turned white, and the weasel. The snowy owls drifted out of the more distant north and they too were white, as white as the great Arctic wolves.

Then it was winter and the great herds were gone, but there still remained game to hunt out on the bleak winter plains. In the valleys protected by hills, so that the snow did not drift thickly over their floors, and in the high places where the wind kept the land scoured free of snow, and the lichens were not too deeply buried, there were still a few deer who had been caught, and cut off, by the advent of winter.

If it happened that by accident or bad luck a family of the People became short of meat in the winter, then food could still be procured by a good hunter. It was harder to hunt Tuktu in winter, for then the deer were in small groups, widely spaced, and they were wary. Only when the ground drift was thick or during a blizzard could they be approached by the hunters.

But if the deer were hard to hunt, they could be easily trapped. When a hunter set out, not from need, but from a desire to eat of freshly killed meat, he might choose to dig a pit in the side of a drift. The pit had high walls, sometimes built up with snow, and there was a ramp up one side also built of hard snow blocks. On the top a thin layer of brush covered with snow concealed the trap, and for bait there was a handful of moss, or better yet, a piece of frozen urine of a man or of a dog. It is a strange fact that the deer smell urine from a great distance in winter, and because it is salty they will abandon all caution to reach it. Even the wolf knows this, and often a wolf will lie hidden near a snow hummock where he has urinated, knowing that if there are deer near at hand, they will come to the bait.

Sometimes, if the snow was not deep enough for a pit, the hunter dug a sloping trench, only as wide as a deer, into a snowbank. At its end he would place the bait, and when a deer descended the sloping incline, it could neither back out nor turn around, and so it was caught.

Briefly that was the way of things in the old days the Ihalmiut remembered so well and talked of so freely. But the way of things now is so bitter that it was hard for me to persuade the People to speak of the present. For a while I knew no more about it than I could see for myself, or had picked up from Franz. Then little by little I began to gather odd fragments of tales from the time that is now, and at last I was able to reconstruct the present pattern of

life as it is shown by the happenings which took place under the Little Hills in the spring of 1947.

I have already written of what came to pass by Ootek Kumanik in that fateful spring when Franz found the two orphans, Kunee and Anoteelik. I also mentioned three other families who had fled eastward in search of help. Now I will take up their story and complete it, so you will see the new way of life in the plains as I came to see it, and so you will understand why the Ihalmiut dwell so much on the days when the deer were many, and life was good to the People.

The story was told to me—mainly by Ohoto—in a series of short incidents spread over a year in time. Some of the details and much corroboration came from others of the Ihalmiut, particularly Ootek and Owliktuk. But in some places I had to supply the continuity of events from what I know of the men and women concerned, and from what I know of their land. This tale therefore is not given to you as being completely factual in all its details. Nevertheless it *is* a true history of one spring in the present years of the Ihalmiut.

Because it is primarily Ohoto's story I have chosen to let him be the spokesperson for all:

In the time of my father we of the People exchanged our spears and our bows for the rifles of white men and in the early years of my youth the rifles gave us meat when we had need, and though the old ways had changed a little, life in this land was still a pleasant thing.

But now, often enough we do not have any shells for the rifles we own, and that seems strange to me. When the white men first came to the edge of our land and told us of the virtues of guns, we believed them. When they told us to put by the ancient deer hunts of our People and turn to the killing of foxes instead, we did what they wished and for a time all was well, and we prospered. Like most of the People I became a fine hunter of foxes from the days of my youth, and I knew all the ways they might be caught. But I did not know much of the hunting of Tuktu as it was done in the days of my father, for I never needed to know while there were shells for my rifle.

Now, often enough, there are no shells for the rifles, and I cannot tell why, for I still trap many foxes as the white men wished me to do, yet when I take my catch to the wooden igloo in the South, there is no one to greet me but Hikik the squirrel. It was that way first on a winter many years before you came into the land, and I remember the winter well, for the traders told us they must have many foxes that year. They were so anxious that we gave up the great fall hunt of the deer and used all of our skill and our strength to trap foxes,

believing we could trade them for food at the place of the white man and so we would have little need of deer meat. But when, in midwinter, we took our pelts south, the door of the wooden igloo stood open and the white man had gone, leaving only the smell which lingered for many long years. Only dead things lay in his camp. The boxes were empty and there was no food in the place and no shells for our guns, so we could not even hunt meat for ourselves.

Indeed I remember that winter, though I wish it would go from my memory. Epeetna, who was my first wife died during that time and my two children died with her. Nor was I alone in hunger and sorrow for in the camps of the People only one out of five lived to see spring.

Some of those who survived tried to return to the old way of living given us by Tuktu the deer, but it was found that we did not have the old skills we needed. Some hoped and believed the white man would return and so, stubbornly, clung to their fox traps. These are gone. Only those remained who tried to return to the deer, and few of these are still alive.

Then five winters after the first white man went away, another came in his place. Once again we threw away the pursuit of the deer, for we felt this time the white man would surely remain. Once more we had shells for our guns, and all things seemed well, yet last winter the white man again left the land, and again we had nothing to eat but the skins of foxes we had trapped for the trade.

Why is it you white men should come for a time, stay for a time, and then suddenly vanish when we are most in need of your help? Why is it? Why can we not take our fox pelts to the trader and have shells for our guns in return, for this is what the trader taught us to do? This mystery I cannot understand....

Well, because we did not have shells, we did not have enough meat in the camps during the winter. You have already heard of the winter I speak of, and of the death of the parents of Kunee and Anoteelik by the shores of Ootek's Lake. But you have not yet heard how it went with those of us who fled toward the East where we had heard a rumor of the presence of a new trader.

There were four hunters living on the shores of Ootek's Lake and their families were as I shall tell you. There was Angleyalak, his wife, his old mother, and his children Pama, Kunee, and Anoteelik. There was Ootek, and Howmik his wife, and a child in her womb and another in her amaut. There was Owliktuk, his wife, and his mother and his children. There was myself, and Nanuk my wife, my old father called Elaitutna, and the children Aljut and Elaitutna who were the sons of my wife by a man who is dead.

In the late months of the winter I speak of, Ootek and Angleyalak took all of the dogs we four families still had and traveled south to the camp of Franz to

Ohoto making the string figure called Tuktoriak—Spirit of the Deer. *(From* People of the Deer.*)*

tell him of our need, which was great. While they were gone I went out alone over the snow-covered land to seek out the caches of deer meat Franz had made as bait for his fox traps in the fall. I found only one cache, for the snow had hidden the rest. And the one I found had also been found by Kakwik the wolverine, who had left only bones and chewed skin for me.

When I came in empty-handed from my trip over the Barrens, I found Ootek and Angleyalak had returned from the South. They told us Franz had little food to give to the People, for his own caches were empty. Then I knew a very great fear, for the deer could not come again to our land until long weeks had passed.

Although we did not have hope, still while we had dogs to pull our long sleds, we went out to hunt on the sterile slopes of the snow. But when the dogs began to die from their hunger, we could go no more to the plains. That did not matter, for there was nothing to hunt and had there been, we had no shells for our guns.

One night we heard that the old woman, the mother of Angleyalak, had gone from the igloo and had not returned in the morning. It was our duty to mourn. My wife went to the igloo of Angleyalak and when she returned she told me the wife of that man was sick nearly to death, with the evil which lies in the lungs.

The sickness of death was not far from us all. In our igloo, the boy Elaitutna sat as still as his grandfather, and neither spoke when I came in, nor went from the igloo. Young Aljut still had life enough to help me dig under the snow for old bones that might have some strength left upon them.

Nanuk had grown desperate for the lives of her children and on a day she whispered to me that we must kill the old man, my father, and so have food for the starving bellies of ourselves and the children. I could not bring myself to agree to her plan, for Elaitutna had been a good hunter all the days of his life and he had given freely of his strength and his years to me and my family in the days that were gone. But Nanuk was desperate as only a woman can be, and so she spoke directly into the ears of the old man who sat on a far part of the high sleeping ledge, his wrinkled eyes closed. Elaitutna did not open his eyes as she spoke, and for a long time it seemed he had not heard the urgent voice of my wife. Then at last he slowly nodded his head and we knew he was willing that we should take what little of life remained in his heart.

I would not help, and when Nanuk got the rawhide and tried to tie the noose in its end, her fingers shook so that she could not tie the knot. At last she flung the cord from her and threw herself, weeping, on the ledge between her two children. So Elaitutna lived a while longer.

It was more than three weeks since we had eaten meat, and we lived only on scraps of old bones and on the dog and human excreta found near the camps. At last Ootek and Owliktuk came to my igloo and Ootek told us that in the summer he had heard of a white man who was said to have built a log igloo on a lake many days to the east of our camp. He and Owliktuk had decided to abandon their igloos, and journey east out of the land of Little Hills, to seek the white man. I agreed to go with them for it was certain death to remain. But when we asked Angleyalak to come with us, he refused, saying his woman was dying and he would not leave her to die by herself.

There were three living dogs in our igloos and these we killed and ate, even to their guts and their skin; and so we had enough strength to start out on our journey.

The bright sun brought the first warmth of spring on the day we set out. We walked slowly and the men, being strongest, carried a few skins to make shelters, and they also carried the children. The women and old ones carried only themselves—and that was enough.

When we came to Halo Lake we found only the families of Halo, Miki, and Yaha. Hekwaw and Katelo had gone with their surviving families, leaving behind in their igloos the bodies of their wives Eepuk and Oquinuk. Hekwaw and Katelo had fled out into the plains, hoping to reach a far valley where they believed some deer might have wintered. But no one at Halo Lake ever expected to see any of these people again in his life—though before spring they returned, having found and killed a few deer.

In this place we heard news of the camps on Kakumee Lake, and we heard that Kakumee and all of his people were living and had enough meat to eat. Yet we knew there was no use traveling there to ask him for food, for being an evil man he would have turned us away and set devils against us.

We spoke to the three families who remained by Halo Kumanik of our plans to go eastward for help, and these people decided to join us, for they too lived with the dead and with the presence of death and they had but little hope for their lives.

It was a good thing for us that they came, for Miki owned a spit-rifle [a .22] whose bullets are as small as a bee and can kill ptarmigan or hares, though they can seldom kill deer. Miki also had some of the little bullets, a present from Franz in the early days of the winter.

We traveled for two days before we were out of sight of the hills of our land, a distance a strong man could have walked in half a day. But we had no strength, and we had to stop every few feet while the women and old people

rested their bodies on hummocks of snow, and tried not to complain of the dull pain in their bellies.

On the fourth day we came to the edge of the forests and here by good luck we found the corpse of a deer the wolves had killed and half eaten. Enough still remained for us, who were more hungry than wolves. We cracked all the bones and in a tin pot that Yaha had brought we made a good soup, for now we were in a land where the little-trees are and there was wood to burn.

We stayed for two days in that place, until the deer that Amow the wolf had given to us was gone to the last shred of sinew which had clung to the skull. Our strength was little renewed and we pushed on into the thin forests for another three days before we knew that we could not go any further. There was no food where we halted, not even a ptarmigan to be seen, but nevertheless we put up our shelters, for at least we had wood and we could keep warm by the fires. We melted snow and drank great quantities of warm water to still the agony of the teeth that gnawed at our bellies.

On the second day at that camp, we had luck once again. Ootek had borrowed the spit-rifle of Miki and gone hunting alone, for Miki did not have the strength to walk in the deep snow of the forests. Ootek came suddenly on a hare, and by falling on his knees in the snow he managed to aim, and to kill the hare as it watched him from the edge of the woods.

Now when he brought the hare into camp, I thought the women would be frantic to eat it, for the women had much reason to eat. Ootek's wife carried only dry breasts to feed her young child and she also carried a new child who starved in her womb. My own wife should have snatched at the hare to give life to Elaitutna and Aljut, and the others of the women should have fought for the meat.

But this did not happen. The women decided that the three men whose bodies had suffered the least damage from famine alone should eat the hare, in order that its flesh would enable these men to travel on to the trader and bring his help back to all the others of our party who could push on no further.

So we took the hare into the bush, Ootek, Owliktuk and I, where the smell of the cooking could not reach the noses of those who had given up their share of the food. Though it was a terrible torture to wait while it cooked, we had to cook the meat, for our bellies would have retched it up had we eaten it raw. I wolfed down my portion and did not let myself think of the children who lay in the shelter at the camp. Then with the sharp pangs of food on our stomachs, we three set out down the course of a small frozen river to find the place of the trader.

It was a two-day march, though we traveled fast, before we came to the shores of a lake, and across it saw the walls of a log igloo which could only belong to a white man. It was the trader. Surely it was a great thing we had found him in all of the land there was to search. We hurried over the lake, and the white man's dogs heard us and howled as we came near.

We knew then that the famine was done—done with and gone. Already I found myself beginning to forget what had happened in the camps of the People under the Little Hills. There was no longer any need for the strength which does not come from the muscles but from the spirit. My legs gave away beneath me and I fell in the snow, yet I did not care for I knew we were safe.

The trader, a short little man, came out of his igloo and looked at us as we sat and lay in the snow. We laughed with embarrassment when he saw us, for we were ashamed of our weakness, and we were ashamed that we could not speak his language.

We got to our feet and stood there not sure what we should do. At last Ootek pointed to the hollows that lay on his cheeks, and showed how his ribs stuck out from his belly. I lay down again in the snow and closed my eyes like a dead man so that the *Kabluna*—the white man—would know how it was at the camps.

And the trader—did not understand!

He went to his cabin and brought back a fox pelt, holding it up with one hand, and stretching the other hand out to us. Then a great sickness filled me, for we had no fox pelts to trade. Starving men cannot trap fox pelts and I saw that if pelts were demanded there could be no help for the People.

When we showed him we had no foxes, the white man suddenly grew very angry and I thought perhaps he had not understood why we came. Again and again we tried to show what our need was, and again and again we lifted our parkas so he could see the bones of our bodies. But something was wrong, and he did not understand.

As I think back on it now I know the trader could not have understood what we tried so hard to tell him, for no man who has food will turn away one who is hungry. We knew this man had food, for his dogs were fat and well fed, and we would have been glad for some of that dog food, if he had only not misunderstood what we said.

Perhaps he was afraid of us three, for Ootek still carried the rifle of Miki, and perhaps this strange white man was afraid. I know he went back to his cabin and when he came to the door he had a deer rifle in the right hand, and in his left hand a sack of flour, but so small a sack that it could have been

carried by a child. He flung us the flour and slammed the door shut—and we never saw him again.

I had a wild thought that I should take Miki's rifle and shoot this man, so we could take what we needed out of his little log store. But the thought was born only in the memory of the boy Elaitutna who was dead now, whether he still breathed or not. The thought flickered and passed. And we three turned away and went back to the west to the camps of those whose lives were in our hands.

There were no words between us—all words were dead. We ate none of the flour, and so in our weakness it took us four days to return, and I crawled the last little way to the fire.

Elaitutna, my father, was finished. He was still sitting by the door of the shelter, but frozen and stiff with his eyes closed as they had been at the end of his life. I was afraid Nanuk would speak and demand that we eat the flesh of the dead, but she was too weak to speak and the body of my father sat there where it was.

The flour we brought from the white man was enough for a single small meal for each one who lived in the camp. Many could not retain the raw flour, but it did not matter for it could only hold off the devils of death for a day.

In the tent of Owliktuk, his wife held a dead child to her breasts, and this child was Oktilohok. Owliktuk could not make her release it, so it too stayed in the tent.

So also in the tent of Ootek and Howmik. One child lay dead on a scrap of deerhide, the other near death in her womb.

Then it was my turn to mourn for the death of a child. Elaitutna did not wake to my calling, and his small hands were frozen by the frost which was colder than ice. After him Aljut, the son of my wife, died and was gone. Death meant nothing to us in that place. There was no weeping, and no woman cried out the laments of the dead. Death meant nothing to us in that place. . . .

But those were terrible days, days I do not wish to remember. Let them be forgotten in your ears and in your hearts. I will say nothing more of that time.

Two days after our return from the place of the white man, Tuktu came at last and so the rest of us lived. It was the deer in the end, the deer who alone in all of the world know the needs of the People, who took pity on us in our camp by the edge of the forest when there was no pity in all of our land. Tukoriak—the Spirit who lives in the deer—sent a great buck into our camp and made him stand so close, and so foolishly by the fire of Ootek, that Ootek was able to kill the deer with the tiny bullets of Miki's rifle.

That was in the spring of the year. Late in the spring we returned to Ootek Kumanik, there to find the wolverine-scattered bones of Angleyalak, his wife and his daughter. These bones we buried, as we had buried our dead in the foreign lands of the forest. But for a long time we thought the devils had taken Kunee and Anoteelik, and we were very glad in our hearts when we heard they were safe.

So ends Ohoto's memory of the spring of the year 1947—a year that belongs to the present—a year that took twelve lives from the twoscore people who were the survivors of the thousands of men who roamed the plains country only a few decades ago.

Caribou Currency

SETH KANTNER

✣

My favorite hang-out place in Fairbanks, each time I'm enroute to the Arctic is Gulliver's Books—an independent bookstore. There, in 2006, I picked up a copy of Ordinary Wolves, *a novel by young Alaskan writer Seth Kantner. I took it upstairs to the bookstore café, where I usually read. I had some break-fast and one cup of coffee, then another, and another . . . I continued to read. I can't remember what time I left the bookstore, it must have been evening, but the reading continued through the early morning hours until I turned the last page.* Ordinary Wolves *is one of the most important literary works written on Alaska, and about the north. Unsurprisingly, the book received rave reviews across the country and became a bestseller. Seth was named Alaska State Literary Laureate, which he declined so he could focus on his next book,* Shopping for Porcupine. *In July 2010, I asked him to contribute an essay in* Arctic Voices *on caribou—the Western Arctic herd. He agreed and asked, "What would be your ideal vision for my essay?" I responded, "Tell us a good story." He did.*

✣

ON THE ice my dad stops walking. He's wearing baggy drab green wind pants and a blood- and pitch-stained parka with a wolverine ruff. Slung on his back is his .270 rifle; across his shoulder he carries a double-bit ax. My brother and I stop a few yards behind. We're six and seven years old, but we know well not to crowd together on new ice.

The river has finally frozen enough to walk on, and it fills our chests with exhilaration to be able to walk on top of water after the summer of bogs and bugs and birds and green things growing. Now we're moving back into winter, and we are winter people.

We've all been shuffling our mukluks, to keep from slipping on the black glare ice with fresh powder snow on top. Behind us three trails show where we left the grassy bank in front of our sod igloo and started upriver. We're out scouting for firewood. And meat. We always need meat.

We boys stay silent, glance at the side of my dad's face—to see if he's thinking the ice might be unsafe, or why he stopped so suddenly. We follow his gaze. He's not looking at the ice. He's listening, and watching a raven.

The river is white, and quiet now that the center ice ceased moving two days ago, and the only sounds we hear are the pant of the raven's wings, and the occasional unnerving galactic-stomach sound of cracks echoing across the quarter-mile-wide new ice. To our left the spruce ridge is dark, the willow thickets reddish brown, and the grass along the riverbank tawny yellow in the October sun.

Two caribou scramble out of the willows. They clatter across the frozen gravel along the shore at the mouth of Amaktok, leap the heaped ice pans, and sprint out onto the river ice.

"Cow and calf," my dad whispers. On the ice, we all simultaneously bend our knees, gradually folding down to the snow so as not to show up so dark on the glaring white.

"We're not trying to get them, right?" my older brother asks.

"No. I think—"

A black wolf plunges out of the willows. It bounds across the gravel, onto the ice.

On the snow-covered glare ice the cow caribou slips, falls. And then her calf falls. The wolf races toward the caribou.

"Will you try to shoot the wolf?" I whisper hopefully.

"No. Just watch."

The wolf sprawls on his side.

The caribou get up and run. The cow falls. The calf splays out beside her.

The wolf is gaining, close behind. His front legs slip sideways, his throat hits the ice.

The cow gets her footing, hobbling. We see her front leg flapping, the bone shattered. The calf runs down the river ice, straight our way. At the same moment the wolf scents something. He turns to black stone, staring straight at us—then flees toward shore. He vanishes into the willows.

My dad sighs. "We interrupted here. Wolf had that one. He won't be back now." He pulls his rifle off his back, loads the bolt, drops the running calf. The boom echoes and rolls back from the timber along the far bank. Kneeling on the snow, he swivels, his knee sweeping snow aside, exposing black ice. He finishes off the wounded cow. My brother and I dig under our snow pants, in our inside pockets, for our sharp little knives.

We clean the animals, roll aside the entrails, dark gut piles on the snow. Ravens caw their approval from the sky. We save the hearts and tongues, livers and kidneys and briskets, and then hurry home to get a sled. We drag the caribou home on the wooden basket sled, and up onto the grassy shore. There are no tracks of anyone else, anywhere. No sign, no other people sounds, just my family out in the wilderness.

My mom walks down with a knife. The four of us gather around the larger animal like wolves. We cut the leg skin off the cow at the third joint, and the bone at the second joint, and then skin out the leggings for mukluks. My mom spreads those flat on the ice—far enough offshore so overflow water won't freeze them in. Then we skin the entire calf and cut up the meat to cook first. My dad skins rapidly and cleanly, with his fists, the way the older Eskimos do. My brother and I skin the beautiful silvery calf leggings, slicing up the front of the front legs, the back of the back legs, and then slowly and carefully around the black hooves, keeping all the skin.

The calf is too young to peel sinew off the back to make thread for skin sewing like we do with big bulls. None of the meat has much fat. My mom comments on that. If this were a big bull—and we were lucky—she'd be saving itchaurat fat, kidney fat, intestine fat, back fat, all kept separate, to be rendered in winter on the stove and poured in jars. The lower leg bones would be kept for marrow.

When we're done, my mom sticks the warm wet calf hide and leggings flat to the cold ice. My parents talk it over, and decide to leave the cow whole, the skin left on, to protect the meat from drying out in the wind and insulate it from seasonal temperature fluctuations. Our only freezer is the outside air. But winters are very cold, a deep freeze.

First day of Freezeup; Seth retrieves fish nets and hunts caribou before pulling the boat in for winter, Kobuk River. *(Photograph by Stacey Glaser, 1989.)*

We stack the unskinned animal with a dozen other whole frozen bulls, on a log rack to keep them up from shrews and voles. We scrub the blood off our fingers and knives with snow, and finally go inside and eat the liver, fried with itchaurat fat from a previous caribou. My mom puts the brisket and tongues on to simmer for dinner. We still haven't scouted for firewood. That will be another day.

At that time, 1971 I guess it was—sitting here at my computer now it feels more like 1671—my family lived here along the Kobuk River; a couple hundred river-miles inland from the mouth at Hotham Inlet; just south of the Jade Mountains, in the Brooks Range. Back then, local people used mostly Eskimo place names, and I don't believe that many local Eskimos had heard of or thought about the English name—the Brooks Range. I'd certainly never heard of it. Something that big, people just called the mountains.

Another thing that a lot of the people—Native and non-Native—living off the land hadn't heard of or thought about yet was the Alaska Native Claims Settlement Act (ANCSA), which Congress passed down in the States in 1971.

Folks that my family interacted with were more worried about the weather, the ice conditions, caribou and wolves and other animals, and feeding their families. The land was simply the land. No lines, no signs, no borders. The mountains to the north were the back wall of our world. In my mind, those mountains and the wilderness beyond went on practically forever—to the sea ice, which continued to the North Pole, and on to more sea ice—no roads, no cities, just endless wild land and ice that animals came from. The first time my family climbed to the top of the Jades, sure enough, we saw mountains upon mountains stretching north into blue diamond distance.

To the south and east are lower, rounded mountains. Occasionally, we saw an airplane fly over the tundra flats below the Waring Mountains. My brother and I knew America was in that direction, as were people, and Fairbanks, and a place we and most of our childhood friends had heard of but never been to: Anchorage.

Seventy miles downriver, and twenty-five miles upriver, were much realer places, the villages of Kiana and Ambler. When we did see people, they generally came along the river—from east or west. Most were hunters, hunting caribou and wolves, black bear and wolverine, geese and ducks and beaver. Others were travelers, visiting relatives in distant villages. From the north came caribou, migrating through in countless thousands during the fall; from the south they marched back in the spring.

In that sense, our relatives and other friends from the Lower 48 were wrong in a comment they used in the letters they sent, fretting about how

we lived out "in the middle of nowhere." Literally and figuratively, we lived at a crossroads of the two most important creatures in our lives, caribou and people. So, actually, our home was right in the middle of everywhere.

My family lived in the sod igloo my parents built here in 1964 with dirt and moss and spruce poles and logs. I was born at home the first winter. The Iñupiaq name for the rock bar in front of our home was Kapikagvik, but the better known name was Paungaqtaugruk—the name of the two-mile-long bluff we lived on along the river.

In those days, fall was the beginning of the year. Fall was the season when people got ready for winter—picking berries, seining fish, caching their summer dried fish, hunting caribou. Winter was what our lives were about. Winter was who we were. Even spring was basically warmer, sunnier winter with good-traveling snow and ice, and new birds arriving. Summer was largely a mosquito-infested interim while we waited for fall to get ready for winter and the ice and snow necessary to travel the land again.

When I was learning to crawl and walk, my dad shot sixty to eighty bull caribou each year, mostly in the fall. He didn't have a chainsaw at first, or fish-nets to catch food, and had to go out every day to hunt to feed his dog team and family, and keep us warm. Eskimo existence in the Arctic had long been based around those needs—meat, fat, and wood.

Only Outsiders—people from cities or the states—ever asked, "What do you do for a living?" Locals thought that the weirdest of questions. What a strange thing to ask. Didn't everybody hunt, fish, and gather wood? But Outsiders always asked, immediately after asking your name.

Those years were significant years, although few thought about it then. The 1960s marked a historical turning point for humans and caribou and their relationship with each other. That was the decade when snowmobiles arrived in the Arctic. The machines began displacing dog teams. By 1970, Northwest Alaska was drastically different than ten years earlier.

Working dogs were traded off, given away, shot, and left idle chained to stakes. Snowmobiles were purchased. Dog teams demanded endless hunting, endless food from the land—caribou and fish. Dog teams could not out-run caribou. But, dog teams made hunters, and hunters were our heroes. It was a tough windblown frostbitten mosquito-bit hard circle of life—for humans and dogs—no question, but it was a circle of sorts.

Then along came the amazing snowmobiles. They could chase down spring caribou, sit motionless all summer, lunge to life the following fall, haul huge loads of wood, cover long distances in mere minutes, pack perfect trails.

Unfortunately, snowmobiles, like dog teams, had demands, albeit different ones. They needed to be fed gasoline and oil and spare parts, which required something that wasn't making babies out on the land, something you couldn't hunt—money. Although, to be fair, trapping back then did make people some cash, and those first years most people believed that yes, they could go on hunting and trapping for enough cash to feed their snowmobiles.

And why wouldn't people who had lived off the land in a vast wilderness believe exactly that? Why would we suspect otherwise? Why wouldn't we gratefully embrace a machine as magical as a snowmobile to make our lives easier, and to make it so we didn't have to hunt so constantly?

Those first years, my dad crawled inside every night—we had a traditional tunnel entrance to our sod igloo—and pulled off his fur parka and slurped hot soup. Then at the kerosene lamp on his hewn workbench, he'd reload the brass cartridges he'd spent that day, carefully weighing gunpowder and pressing in new primers and bullets. His rifle was a used Husqvarna .270, made in a country thousands of miles north, actually beyond north—at the far edge of this wilderness. He mostly hunted on foot, wearing various caribou skin mukluks designed for various weather conditions. We ate caribou most meals. He had to get the caribou before the first week of October when the big fat bulls went into rut and got "stink," as villagers called it. If the herds didn't show up until after the first week of October, then he'd have no choice but to shoot what he called "teen-agers." He'd lie on the tundra in the wind, watching them for a long time—to make sure the young bulls were eating and not fighting—to avoid the bad flavor of rut meat. He seldom shot cows or calves, but we ate nearly everything that moved—beaver, otter, bear, muskrat, porcupine, rabbit, lynx, and all kinds of birds and fish—and it was easy to make room for the occasional cow and calf. Size and antlers meant nothing; fat was the distinction between good meat and poor. No one wanted skinny meat. Skinny meat meant a poor hunter, and traditionally poor hunters and their families starved.

A few days after getting the two caribou, my dad tells us of spotting the black wolf up on the tundra. Again, he didn't try to shoot the wolf. Our dad is odd that way, he respects and values living where not all the greatest hunters are human. To my brother and me this makes as little sense as that question, "What do you do for a living?" But maybe somewhere in there lie the answers to both.

We kids don't see the wolf again. The snow is getting deeper, we can't snowshoe as fast or as far as my dad does. The caribou are all but gone now

for the winter, and the land feels empty with their passing. Big dark deep stormy winter is here.

After the ice is thick enough, our family travels upriver to the Eskimo village of Ambler, for Thanksgiving Potlatch. As usual, the date marks the first real cold temperatures, thirty below, and after we get there it drops to forty, and finally fifty. We kids have to ride in a sleeping bag in the sled, bundled up in thick cold-weather mukluks with the caribou hair-in on the inside, and caribou socks inside that with grass packed underneath, and our mittens sewed to our sleeves and without thumbs.

In Ambler we stay at Tommy and Elsie Douglas's chilly plank house, and sleep on the floor on caribou hides. The next day, the big day, we bundle up and walk up the ridge to the Friends Church for Potlatch. Inside the giant log cabin, people take off their parkas and hats and mittens but leave on their snow pants and mukluks. Men walk up and down the rows of wooden benches portioning out servings of caribou soup, fried caribou meat, chunks of boiled caribou head, baked whitefish, Pilot Crackers, raw frozen stink trout, akutuq made with caribou fat and berries, sliced liver in caribou stomach contents, sliced bear fat, slushy salmon berries, blueberries, cranberry sauce, seal blubber, red Jell-O, frozen raw grayling.

Back down at the Douglas's the adults unpack the food, and we all eat around the wooden table. We leave our mukluks on—things on the floor will freeze rapidly. The adults tell stories and laugh. Elsie chides my dad for not shooting the black wolf. As dusk falls, Tommy disappears outside. Suddenly the house is bright. Two hanging bulbs have become baby suns. It's magical, to have darkness vanish into golden light. Especially in November, above the Arctic Circle—we have a lot of darkness, and a lot more ahead.

The windows look painted black, and outside the snow is darker blue-gray now than it was. To us kids this seems a strange phenomenon—how brilliant light inside a house makes the world outside so dark. Out there Tommy is fiddling with his old rusty diesel generator, which provides enough electricity for a light bulb or two in each of a half dozen cabins that he runs wires to. Tommy is an entrepreneur. The other villagers are like us at home downriver—they burn kerosene lamps.

When the meal is over and the table cleared, Elsie lays out Sears & Roebuck brown parcel paper. Carefully, she copies her fur parka pattern from tattered paper to the blank paper. Elsie speaks slowly to my mom, in broken English, her pencil stub halting each time she straightens up to explain how to sew a parka from caribou calf skins. The parka is going to be for me. Calfskin is

thinner, softer, lighter—good for a child's parka. Adults wear parkas made from early fall adult caribou skins.

By midwinter, my mom is nearly done sewing the parka. I've already pulled it over my head countless times, to try it on as she fits the body, sleeves, shoulders, neck, throat, and hood. The throat area still is unfinished; she's waiting for Elsie's help sewing that, but I'm allowed to start wearing it outside. It's common knowledge that the hood and throat on parkas are tough to get right; the best Eskimo seamstresses are the ones who make perfect hoods where almost no wind and cold comes in around the face and throat. Their patterns are sought after, as are the warm hunting parkas they fashion. These things are of utmost importance, and everyone knows it.

The men who are the most successful hunters and the women whose stitches are the tiniest and tightest and their fur garments the warmest—those individuals retain the status as the highest heroes in our world.

Whenever I pull on my parka, caribou hair drifts down. Whenever I pull it off, more hair floats out. Caribou hair remains in my hair, on my flannel shirt, on my mom's pants from sewing, on the floorboards—everywhere. We wear caribou socks, caribou mukluks, sleep on caribou skins. Everything we own is sprinkled with caribou hair. Most of our friends and the people we know have caribou hair all over their houses and blankets and shirts, in their tea and on their lips. We hardly notice. I love my caribou parka. It's toasty warm and comfortable, and light, and easy to run in. Why would stray caribou hair ever bother anyone?

Within a couple years I grew out of that parka. The calfskin was thin, the shoulder seams kept tearing out. Caribou have hollow hair and it is weak hair, and eventually my parka had cold spots. The shedding had grown worse and worse, as caribou garments always do. The sinew thread started to part.

Around that time, I acquired my first sled dogs. My dad had already gotten rid of his team and was on his second snowmobile. (The first, with two tracks and wooden skies, had blown a piston—its only piston!)

In the village post office more and more catalogs were coming, and we received a Parts Unlimited catalog with snowmobile parts. When ordering a drive belt, my dad noticed nylon insulated snowmobile suits—cheap, out of style, on sale. He ordered one for my brother and one for me—thank goodness, because wearing too many furs was making us look backwoods, backward. In the village, most people by then had shifted to Sorrel shoepacks, nylon snow pants, snowmobile suits, and nylon coated parkas.

Villagers continued a life focused more or less around gathering from the land. My family, too, continued hunting and trapping and fishing and living

off the land. But each year we bought a little bit more of what we called "store-bought stuff." Anything that cost money we considered carefully before buying. For example, rope was worth buying—making rope out of sealskin was time-consuming and immediately too many animals wanted to eat that kind of rope. Ammunition and traps went without saying. Sugar and coffee and flour and kerosene had long been staples. Buying meat was beyond absurd, as would have been buying snow, or bottles of water.

Around that time, the village of Ambler got a genuine telephone. People waited in line to use it. The limit was five minutes, you paid cash for the minutes. A well was drilled and a pump house built. Kids led me and my brother there to see the amazing sight—press the big white button and water gushed out of a hose. Even in winter the water gushed. There was a big glacier from kids pressing the button.

Slowly we heard rumors of a thing called Pipeline Jobs. And the North Slope. The Pipeline. Prudhoe Bay. The north slope of what, no one said. What was said—in not so many words—was that this was a pipeline of green cash from the States; people lucky enough to get those Pipeline Jobs were bringing home sled-loads of it.

Slowly we heard rumors of a thing called ANCSA—something about Native corporations? Unlike the Pipeline, to most people this made absolutely no sense—weren't Eskimos people living off the land, and wasn't that lifestyle the polar opposite of corporations?

Slowly we heard of a strange new word: *subsistence*. No one knew quite what that one meant or why anyone needed such a word to describe normal life.

Bigger things thundered in, real things, far too substantial to compare with rumors. A government agency began to build real American homes—with bedrooms and store-bought doors with knobs and plywood walls painted green—for the villagers. The houses had wall sockets—which meant electricity. And flush toilets that you couldn't throw caribou bones into—which meant running water and a sewer. But far more dazzling than all that was the giant white saucer that siphoned down the world on one channel—the Alaska Satellite Television Demonstration Project.

Then a lawsuit in the mid-1970s suddenly required the state of Alaska to build immense new high schools in every tiny village. And staff those schools. In many communities this brought new airports. More small planes were in the sky, and thundering Hercules planes, too, freighting in all those new store-bought items.

Another congressional act designated millions of acres in the northwest Arctic to be set aside for parkland. National Park Service rangers came north.

My family suddenly lived in the Great Kobuk Sand Dunes National Park. Those rangers immediately got everyone's attention by ticketing the first people they saw hunting caribou from boats. Eskimo people. Everyone grew nervous, scared, mad, confused. Times were changing. If you couldn't hunt caribou in the river, what in the world might happen next?

Meanwhile fur prices rose. Commercial salmon prices rose. There were more summer construction jobs. Indeed, folks could pay for their new snowmobiles and new outboards, and still—to a certain degree—go on living off the land.

The Western Arctic caribou herd—which everyone had simply termed "caribou" before the state biologists got involved—began to increase rapidly in numbers, too. Hunters had more snowmobiles, bigger boats, and Honda three-wheelers to travel out greater distances to hunt, return home quicker—and still be in time to catch *Dallas* and *The Six Million Dollar Man* on television.

Villagers and people living outside of villages continued to eat caribou, fish, berries, and seals, but they also were enjoying more and more store food. Every day at school, kids ate lunches brought in by barge and plane. More catalogs come in the mail. More young people could help the Elders fill out those baffling catalog order forms. Folks ordered more and more food and candy and pop and Pampers, and nylon jackets, synthetic insulated parkas, and even the seamstresses ordered Tuscany lambskins for their traditional parkas. The lambskins were beautiful, soft, and warm and they never shed. They were also very expensive. Out on the trail, people still wore beaver hats and wolf and wolverine ruffs, and once in a great while someone still wore mukluks.

Things were changing. Everyone saw it, but we as people weren't changing that much, right? We'd never be like people down in the States, or even Anchorage or Fairbanks. We were people who lived off the land. We would continue to live off the land. Hunters were still our number-one heroes, but now basketball players were heroes, too, and coming up fast behind the old hunters.

I'm sixteen and my brother and I are done under-ice fishing for whitefish for our dog team. The ice is getting too thick to chop down through, and the catch is waning this late in the season. Trapping season is about to start, and I'm excited to begin what I like best—trapping by dog team. But before that, my brother and I travel to Ambler to be flown to Fairbanks with other kids from various villages—for a preview of Petroleum Engineering at Tanana Valley Community College in Fairbanks. Word is that Bush kids need opportunities, training, and job skills to meet the future. The state of Alaska has brand-new money and is paying.

In a classroom we learn superficial facts about the Pipeline, oil, and metallurgy, and other things, and at the end of the week are flown by Alaska Airlines jet to Prudhoe Bay. We descend into a whiteout. The engines whine and rev in pitch. I'm in a window seat, peering down at gray snow under the plane, with occasional dark shrubs, and suddenly white painted lines on a dark strip of ground. The huge airplane touches down on what appeared to be stormy tundra but in reality is a paved airport. Looking out the window, slowly my brain accepts that we are north of my home, and on an industrial complex. It makes the world feel much smaller, which should make me feel bigger, but it doesn't do that.

Our class is bused around the sprawling oil city. We get to walk on the Arctic Ocean sea ice—a place I've never been before. The thin layer of ice along the shore is rubbery and bends—saltwater ice. We get to wear cool hardhats and sport SOHIO Basecamp guest badges, and see where the oil comes from; we are treated like adults, and then finally we're taken to the cafeteria. The food is beyond amazing—pies and cakes and steaks and ice cream. Anything we want, all we want. "Take more. Take more. Take some with you, why don'tcha?"

I leave with a heavy paper shopping bag of desserts. Waiting for the bus, the bottom of the bag gets wet in the blowing snow and tears open. Styrofoam trays of desserts leak everywhere. I'm disappointed. But I'm a hunter-gatherer from way back; I gather the yellow pies and chocolate cakes in my jacket. I want to take some all the way home to the Kobuk River to show my parents. Prudhoe Bay is amazing, one of the most amazing places any of us has ever been. And we are treated like princes. I tuck away my red, white, and blue guest pass to show my family and friends. (I still have that SOHIO guest pass at our old sod house. It's a little moldy these days.)

At home, a year later my lead sled dog dies; I loan out my remaining dogs, attend college in Fairbanks. I drop out after a year and try to go back to trapping. Fur prices have dropped drastically. Caribou, though, are more plentiful than they ever were when I was a kid. The state bag limit now is five per day, every day of the year. No one needs that much. No one can hunt every day anymore—it's too expensive and too easy to get too much.

I travel my family's old trails. Nothing quite makes sense. I build some traditional basket sleds, get some odd jobs, start taking wildlife photographs; there I find something as tough as the old dog team hunting days. I snowshoe along behind wolves, wolverine, bears, moose and muskoxen. I find myself in the path of thousands and thousands of caribou, pouring across the land. I find myself valuing something that had always been just plain normal. I

still hunt for food but somehow I'm not a real hunter anymore. I'm no longer who we were and yet no closer to having an answer for that question: "What do you do?"

During this time, my best friend from Ambler, Alvin Williams, goes to work at a new mine on the northwest Arctic coast near Kivalina. I'd heard rumors of the mine, heard it was a zinc mine. "It's called Red Dog," Alvin explains. "When they get done they say it's supposed to be second biggest lead and zinc mine in the world."

He goes back to work. His sister goes to work there, and his friends. More and more people from the village go off to work at Red Dog Mine. I go back to college, and summers I commercial fish in Kotzebue; I rub shoulders with very smart people and learn different things about caribou and their seasonal migrations through the Red Dog area, their diseases, their habits, their food, their predators. I learn about Arctic char (trout) and how they live in the rivers that Red Dog's toxic wastes flow into, and how the char switch rivers some winters, and the same fish will then swim up the Kobuk River. I learn about bears and seals and other predators concentrating heavy metals in their fat, from the food they eat. I start learning about minerals, and how northern Alaska is blessed—or cursed—with oil to the north and to the west, and with billions of tons of coal along the north side of the Brooks Range, and with lead and zinc at Red Dog and further north. And worst of all, a mammoth deposit of high-grade copper, gold, silver, lead, and zinc that stretches across five river valleys—rivers that all drain straight into the Kobuk upstream from the village of Ambler. Fifty miles of mountains formed of some of the richest mineral deposits left on earth.

I learn that, strangely, the new national parks are on the most beautiful land, but somehow circumvent the richest mineral deposits. I begin to wonder: Who came up with the original idea to make every Native person in Alaska a member of a corporation? Was it plain irony, or accident, or planned? The Eskimos I grew up with were certainly not begging to be members of a corporation. Sometimes I feel like someone designed this. It's too perfect. If the corporation builds a mine, people get jobs—and dividends. What except family could demand more loyalty?

Between all the coming and going, fall and winter and spring still find Alvin and me hunting together. Hunching over a caribou he's cleaning, he informs me that Red Dog is now the largest lead and zinc strip mine in the world. Beside him, skinning my caribou, I nod that I'm hearing, and mention that lead is not that healthy for fish or caribou or us. We shrug and smile at the pretty sky, and scrub our bare hands with clean snow.

Red Dog Mine—the second largest zinc and fourth largest lead mine in the world, Western Arctic, Alaska. *(Photograph by Florian Schulz, 2009.)*

Sadly, that too is already twenty years ago.

Now, it's almost too boggling to list all that has landed on us since.

The Internet has come to northwest Alaska. Rap music. Cell phones. Canadian whiskey. iPods. eBay. YouTube. Low-rise jeans. And what we call the Cabela's Army—hundreds and hundreds of camo-clad white sporthunters from the Lower 48 and beyond, descending here each fall. They come to hunt caribou, moose, grizzly bear, wolves, and whatever else they can "bag." They buy nothing here, care nothing, and want nothing local—except the "big game." They have already Googled us from afar, and that apparently is plenty.

Meanwhile, the word *subsistence* has ascended to the top, a loaded word, overflowing with politics, hatreds, and righteousness, a tie to the past, central to all the rhetoric about the future. Also at the top of the new list is the word *jobs.*

Meanwhile we've got our second round of monster new schools, new state-of-the-art clinics, new dumps, new airports, new fuel tank farms, hundreds of new trucks, and thousands of four-wheelers and snowmobiles and outboard motors. Nearly everyone has satellite or cable TV. Stove oil heats most homes and schools and businesses across the Arctic. Planes, big and small, zip the sky, hauling loads of freight, mail, passengers, countless loads to every village, multiple airlines flying in nearly every day of the year—looking down and spotting caribou and wolves, bears and seals and musk oxen and every other animal down below. Word flashes out to hunters by text, Facebook, e-mail—even cell phone from the sky.

Everyone has been to Anchorage. People go there to get X-rays and braces on their teeth, to shop, to attend Alaska Federation of Natives meetings and Subsistence conferences, to visit, to fish. To drink.

American television beamed north is full of reality shows about—Alaska. One even goes so far as to show a fantastically expensive caribou hunt and claim it is Subsistence.

Out on the trail, we kick our Cabela's Trans Alaska shoepacks on the plastic skis of each other's aluminum and plastic snowmobiles; we walk around each other's UHMW plastic sleds and compare notes about Google Earth and where the caribou are crossing. The dog teams are few and far between, and made up of bouncy little shorthaired racing dogs, pulling high-tech aluminum and titanium sleds, often powered by chicken, beef, or even lamb flown in from New Zealand.

And that's only people and material things—that doesn't even start to include climate change: the warm winters and thin ice, the tall new brush

and baby green spruce sprouting up on tundra, the forest fires and the new bugs, and draining lakes and mid-winter rains.

Now this whole area is called the "NANA Region," and the Native Corporation pays dividends and provides jobs. Every local Iñupiat Eskimo is part shareholder in a multi-million-dollar corporation. NANA now is king. And the king wants those millions of tons of copper, silver, and gold; the king is mobilizing to build roads and railroads and strip mines in the heart of the most important caribou lands on the planet.

But if you can turn your back to the wind, not see or know all that—out on the country, out on the land, the caribou are in storm and cold right now; they are cratering down through drifted snow to get to the tundra to feed. Those hunters, the wolves, they are there, too. Neither has changed hardly a blink in the last how many thousand years. We are the ones who have changed. And I'm afraid we've only just begun.

We'll Fight to Protect the
Caribou Calving Ground and
Gwich'in Way of Life

JONATHON SOLOMON, SARAH JAMES,
and TRIMBLE GILBERT

❖

In 2001, soon after George W. Bush became president of the United States, he made opening up the coastal plain of the Arctic National Wildlife Refuge—the calving ground of the Porcupine River caribou herd—to oil development a top priority of his energy policy. Alarmed by this, the Gwich'in Nation called an emergency gathering in Arctic Village, Alaska. I attended that gathering on an invitation from Elder Sarah James, whom I had met only a few weeks prior during an activist campaign in Washington, DC. It was late June, I pitched my tent in Sarah's front yard—loons were calling from nearby lakes. The gathering was uplifting with music, dancing, and twenty-four hours of food—caribou, moose, ducks, fish; but most important it was a call to action to stop the proposed drilling. There, I met Reverend Trimble Gilbert. His remarkable fiddle music in the community hall, late into the night and early morning hours, had all of us on our feet, dancing—I learned how to dance the Gwich'in way. I also met Elder Jonathon Solomon from Fort Yukon, whose speech about why we must protect the caribou calving ground I'll not forget. Over the years, I've spent much time

with all of them, in their villages, in Washington, DC, and in many lecture halls where we did joint events. In 2004, Sarah and I did an event at Harvard University when the dogwoods were in full bloom, and in 2009 in Copenhagen during the UN Climate conference, where we participated in Klimaforum09—"the global civil society counterpart to the UN conference;" and in 2005, I attended a Gwich'in gathering in Fort Yukon where Jonathon asked the "real Indian" to speak—I did. The following year, Jonathon passed away and we lost one of the most inspiring cultural activists. I attended the memorial service in Fairbanks, and another in Fort Yukon. What follows are three testimonies by Jonathon, Sarah, and Trimble, as a collective voice of "We." It is a story of the Gwich'in Nation's ongoing fight through a unified voice, the Gwich'in Steering Committee, to protect the caribou calving ground. In this battle that spans nearly twenty-five years, they collaborate closely with environmental organizations, religious organizations, and other indigenous communities across the US and beyond. Each testimony has specific time markers: Jonathon in 1988 and Sarah in 2001, when the refuge came under attack from two different administrations—Ronald Reagan and George W. Bush, respectively; Sarah in 2009 to bring attention to climate change in the Arctic; and Trimble in 2010 in support of wilderness designation of the Arctic Refuge coastal plain. The caribou calving ground in the Arctic Refuge continues to remain free of oil development.

❖

JONATHON SOLOMON:
Testimony Before the US Congress (1988)

Mr. Chairman, members of the committee.

I am Jonathon Solomon from Fort Yukon, Alaska. With me today are Kay Wallis, also of Fort Yukon, and Gladys Netro of Old Crow, Yukon Territory, in Canada.

Thank you, Chairman Miller, for your invitation to the Gwich'in people to testify here today. We are honored to be here to speak for our people.

This is a historic time for the Gwich'in Athabascan Indians of northeast Alaska and northwest Canada, a turning point in our history. Something is happening. You can feel it when you walk down the streets of our villages. Everywhere you go there is a growing knowledge that we can and must make a better world for ourselves and for our future generations.

Last January, leaders from each of our communities met together in Fort Yukon. They decided to call a rare gathering of all our people together—the Gwich'in Niintsyaa. The last gathering like this took place sometime last century. They are called at times of extreme importance or danger when the entire nation must be consulted.

The gathering—Gwich'in Niintsyaa—took place in Arctic Village, June 5–10, 1988. For a whole week we listened to the advice of our Elders and others—everyone speaking our own language.

The gathering was to address a single question: What must we do to ensure our culture and traditional values remain a real option for our future generations?

Our leaders spoke with a single voice. We were told to do three things to preserve our culture: (1) free ourselves from alcoholism, (2) improve the education of our children, and (3) protect the calving and post-calving grounds of the Porcupine caribou herd.

Our people and our Gwich'in culture have lived in this region for thousands of years. Before that our first ancestors were living here for who knows how many more thousands of years.

For all those hundreds and hundreds of generations we have been nomadic hunters, and we continue to be hunters to this day. Ours is a rich land, and our people lived well most of the time. Our people rise and fall with the caribou. I was told of times when the smoke of the fires rose like the quills of a porcupine, there were so many camps in the hills. Later, disease killed many of our people— around 1920, I think—and the caribou died off at about that time as well. This is the belief and the history of our people; that our future and the future of the Porcupine caribou are the same. Now the caribou and our people are both coming back again. In every village you will see many children now, and others who left for the cities and other places are returning to the villages now, too.

Today there are about eight thousand to ten thousand Gwich'in. We mostly live in and around sixteen communities in our homeland: Arctic Village, Venetie, Fort Yukon, Beaver, Birch Creek, Chalkyitsik, Circle, Eagle Village, and Salmon Village in Alaska; and Old Crow, Fort McPherson, Arctic Red River, Dawson, Mayo, Aklavik, and Inuvik in Canada. Fairbanks and Whitehorse are the nearest cities, and many people live there as well.

Please understand, we are a modern hunting culture—one of only a few left in the modern world. Our people are caribou people. Caribou provides not only food and materials for our people, but also our spiritual life. For many, the traditional life is the only alternative to alcohol and the streets. Without caribou, who are we? What do we have to offer our children? I have

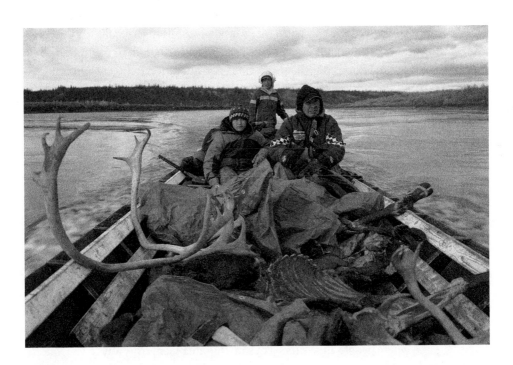

Joe Tetlichi, his son Jamie (driving the boat), and nephew Shane returning to Old Crow with caribou meat, Porcupine River, Yukon Territory, Canada. *(Photograph by Subhankar Banerjee, September 2006.)*

been coming to this town and traveling for my people for more than twenty years now, and I still get sick if I do not bring dry meat with me. We just cannot get by on the food here. It is a small thing, but it's an example of what I'm talking about. It's the same for our people when they go into the hospital. We always bring them Native foods. If we do not, often they just won't get better.

The issue is not just the caribou, either. All the land and animals here are important and respected by our people. It is our backyard, and we feel about it just like you do about yours. More so, because we cannot move to another place to live our lives. They are all connected with this land right here, where our parents and grandparents and their grandparents have all lived and are buried.

At the end of the Niintsyaa we passed a resolution that calls for the calving and post-calving ground of the Porcupine caribou herd be protected as wilderness. I hope you will give serious consideration to this resolution and take action to allow our people to continue their culture.

Congress has the power, but no one has the right to deny the Gwich'in our own means of subsistence. This principle is clearly stated in the International Human Rights Covenants, and is recognized by civilized nations everywhere. Make no mistake, this is our life at stake here—the life of a modern hunting culture that is alive and healthy and growing.

We are determined to take responsibility for our future. We are winning our fight with alcohol. We have kept our language and customs and values. We will overcome our dependency on government aid. Our communities are strong and growing. We are united and positive about our future, but we need your help. In the name of all our people we ask you to vote to make the 1002 Area of the Arctic National Wildlife Refuge *wilderness*.

I want to say one more thing about wilderness. For this area you should make clear that subsistence activities are to be protected. You define wilderness as a place where people are visitors. I'm sure this area seems this way to you, but to us this whole region is occupied already. Where you see empty land, I see a hundred camps still used by our people. Where you see a faraway reserve, we see our backyard. This should not really be a problem, but we recommend that you restate the subsistence priority and list cultural preservation as a purpose of the Refuge.

Finally, I would like to read the resolution of our people (attached).

Thank you for inviting us to testify on this issue, which means everything to our people.

Mahsi Cho. (Thank you.)

Jonathon Solomon

❖

Jonathon Solomon presented the above testimony on July 7, 1988, before the Second Session of the One Hundredth Congress during the Arctic National Wildlife Refuge Oversight Hearing before the Subcommittee on Water and Power Resources of the Committee on Interior and Insular Affairs House of Representatives. The testimony is published here with kind permission of the Gwich'in Steering Committee that the author helped found and in which he was active until his death in 2006.

❖

GWICH'IN NIINTSYAA

Resolution to Prohibit Development in the Calving and Post-Calving Grounds of the Porcupine Caribou Herd

WHEREAS: For thousands of years our ancestors, the Gwich'in Athabascan Indians of northeast Alaska and northwest Canada, have relied on caribou for subsistence, and continue today to subsist on the Porcupine caribou herd which is essential to meet the nutritional, cultural and spiritual needs of our people; and

WHEREAS: The Gwich'in have the inherent right to continue our own way of life; and that this right is recognized and affirmed by civilized nations in the international covenants on human rights. Article I of both the International Covenant of Civil and Political Rights, and the International Covenant on Economic, Social and Cultural Rights read in part: " . . . In no case may a people be deprived of their own means of subsistence"; and

WHEREAS: The health and productivity of the Porcupine caribou herd, and their availability to Gwich'in communities, and the very future of our people are endangered by proposed oil and gas exploration and development in the calving and post-calving grounds in the Arctic National Wildlife Refuge—Coastal Plain; and

WHEREAS: The entire Gwich'in Nation was called together by our chiefs in Arctic Village, June 5–10, to carefully address this issue and to seek the advice of our Elders; and

WHEREAS: The Gwich'in people of every community from Arctic Village, Venetie, Fort Yukon, Beaver, Chalkyitsik, Birch Creek, Stevens Village, Circle, and Eagle Village in Alaska; from Old Crow, Fort McPherson,

Arctic Red River, Aklavik, and Inuvik in Canada have reached consensus in our traditional way, and now speak with a single voice.

NOW THEREFORE BE IT RESOLVED:

That the United States Congress and President recognize the rights of our Gwich'in people to continue to live our way of life by prohibiting development in the calving and post-calving grounds of the Porcupine caribou herd; and

BE IT FURTHER RESOLVED:

That the 1002 Area of the Arctic National Wildlife Refuge be made Wilderness to achieve this end.

Passed this 10th day of June 1988, in Arctic Village, Alaska.

SARAH JAMES: WE ARE THE ONES WHO HAVE EVERYTHING TO LOSE (2001, 2009)

I say we came a long ways. We still got long ways to go, for our children who are not born yet and for our Elders who are not here today.

I'm from the Gwich'in Nation, located in northeast Alaska. I live in Arctic Village, which is about 115 miles north of the Arctic Circle. We live in cabins. We don't have running water. I live off the land. I grew up off the land, and my parents raised me up without any cash or pay. No eight-hours-a-day work. We lived on the land, and that's how I grew up.

From the time I was very young, I remember my father going out hunting. He had a trapline up on the Salmon (*Sheenjek* in Gwich'in language) River, a hundred miles from his nearest neighbor. I had seven brothers and sisters, and we had to work to survive. I helped with chores every day. I cut wood, snared rabbits, and fished for grayling. Sometimes I'd go beaver snaring with my father, to help him and to learn the way. I never went to school until I was thirteen. I learned from living out in the wilderness, our natural world. It's a good life—fishing, hunting, and gathering berries and roots.

Jonathan Solomon (center), with wife Hannah Solomon and son David Solomon; during the Drum-Sing-Dance to Protect the Arctic National Wildlife Refuge vigil, across from the Smithsonian National Museum of the American Indian, Washington, DC. (*Photograph by Subhankar Banerjee, September 2005.*)

We never got bored. In fall we had ice skating and fishing. In winter we played in snowdrifts. And in the evenings my older brother, Gideon, would read to us. My dad would make snowshoes and toboggans and harnesses—everything that we used. And we would help with that. Everything that we wore, our mom sewed. And she did the tanning, fur sewing, and beadwork.

There are fifteen Gwich'in villages that expand from the northeast Alaska interior over to the Yukon Territory and the McKenzie Delta area of the Northwest Territory in Canada. There are eight thousand Gwich'in who live in this vast area. We used to be nomadic people, following the caribou, and that's how we made it year to year, for thousands of years. But now our kids have to go to school, so we live in villages. Our kids have to live in two worlds. We tell them, "Respect your Elders," and at the same time we tell them, "Go get your higher education."

We are the caribou people. To us, the caribou are like the buffalo are to the Plains Indians in the United States. It is our food on the table. Today, 75 percent of our food is wild meat: mainly caribou, moose, birds and ducks and fish, and small animals. And it's our clothing, it's our tools, and it also used to be our shelter—caribou skin hut. And that's how we are. Caribou are not just what we eat; they are who we are. They are in our stories and songs and the whole way we see the world. Caribou are our life. Without caribou we wouldn't exist.

There is the US–Canada border, but to Gwich'in, we don't see border. To caribou, they don't see border.

In June 1988, our Gwich'in Elders got concerned about the oil companies wanting to drill where the caribou have their calves—in the coastal plain of the Arctic National Wildlife Refuge. So they called a meeting in Arctic Village. People came in from all our villages. Our chiefs went up into the hills and around a campfire they made a pact to protect the birthplace of the Porcupine caribou herd and our Gwich'in way of life. The Gwich'in Steering Committee was formed and we agreed unanimously that we would speak with one voice against oil and gas development in the birthing and nursing ground of the Porcupine River caribou herd.

The corporations refer to the area as ANWR ("Anwar"). But the coastal plain of the Arctic National Wildlife Refuge is a birthing place for so many creatures that we call it *Ilzhik Gwats'an Gwandaii Goodlit*. That means the "Sacred Place Where Life Begins." This is true not only for the caribou but for many life forms. It's a birthplace for many species of birds that fly from all over the world to nest here. Fish come here from the Arctic Ocean to spawn. Polar bears den along the coast. Wolves and grizzlies and wolverines have their young here. And this place has polar bears, brown bears, and black bears—all three species exist at once.

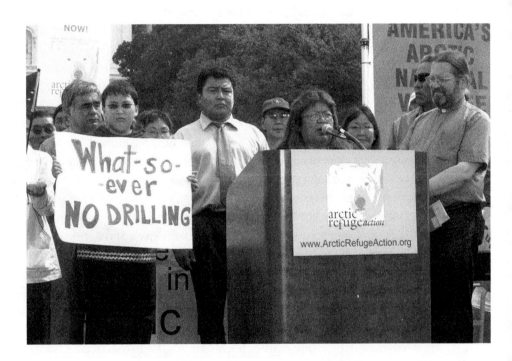

Sarah James speaking at an Arctic National Wildlife Refuge rally in Washington, DC. *(Photograph by Subhankar Banerjee, September 2005.)*

Our fight is not just about the caribou. It's for the whole ecosystem of Gwich'in country. It is indigenous rights, it is tribal rights, it is national environmental rights in the United States, and it is human rights to us—a struggle for our rights to be Gwich'in, to be who we are, a part of this land.

It is also women's rights, because women give birth. That's the most powerful thing that we have as a woman. And that goes for all life, all living things. When I had my baby boy, I wanted a place where it is quiet, where it is clean, and where it is private. I believe it is the same for all living things.

Where I am from we've still got clean air and water and we want to keep it that way. There are places that shouldn't be disturbed for any reason. Some places are too important, made especially for the animals. The caribou calving ground must be left alone.

Our way of life is also being threatened by climate change, which is real and more noticeable in the Arctic. Climate change is also a human rights violation. We have to do something about climate change. It's very unpredictable weather—too much snow one year, not enough the next. When there is too much snow, the caribou cannot make it to their birthing ground. That's the only safe and healthy place to have their calves, and they can't make it. The cows miscarry their calves because of the hard times.

In Alaska there are about two hundred villages, and most of them are like Arctic Village, where they live in the traditional way, and respect this way of life. There are about sixty villages along the Yukon River, and during spring 2010, twenty of those villages were flooded, and there was fire all summer long. There was hardly any visibility. Some of the villages are eroding away. When there is change to the weather it confuses us, and it confuses the animals. Now that the ice is melting, polar bears can't get their food, they can't get their seals. They're coming inland, which is very unusual. It's not their habitat. All these things are happening in Alaska, in the Arctic. Climate change is real in the Arctic.

Maybe there are too few of us to matter. Maybe people think Indians are not important enough to consider in making their energy decisions. But it's my people who are threatened by potential oil development and climate change. We are the ones who have everything to lose. The Gwich'in are going to fight as long as we need to. We know that without the land and the caribou, we are nobody.

My hope is to see 350 ppm carbon dioxide in the atmosphere become a reality, to see the Arctic National Wildlife Refuge coastal plain become permanently protected, and to see that we make a transition from oil use to clean energy. They are all connected.

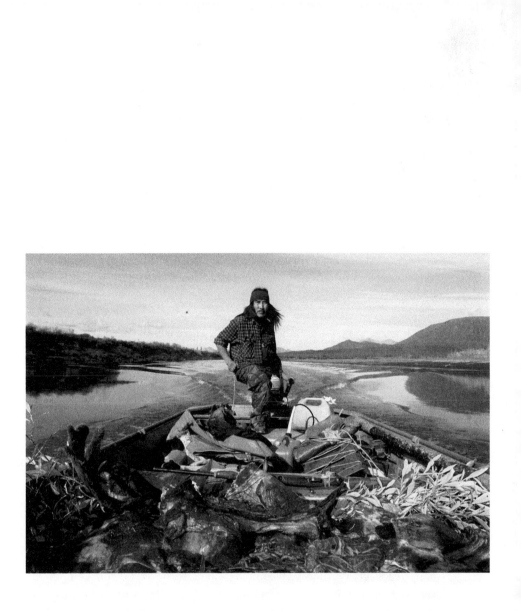

Jimmy John brings moose meat back to Arctic Village, East Fork of the Chandalar River, Arctic National Wildlife Refuge. *(Photograph by Subhankar Banerjee, August 2002.)*

❖

The above statement by Sarah James was adapted from a testimony by her published in
Arctic Refuge: A Circle of Testimony (Minneapolis: Milkweed Editions, 2001) and a speech
by her during the 2009 UN Climate Change Conference in Copenhagen. The speech was
filmed by Subhankar Banerjee and was shown in his photo-video installation as part of
the exhibition (Re-)Cycles of Paradise (Copenhagen in 2009 and Mexico City in 2010),
organized by ARTPORT and sponsored by Global Gender and Climate Alliance and the
International Union for Conservation of Nature.

❖

REVEREND TRIMBLE GILBERT:
Letter to Richard Voss (2010)

I was born in 1935. I remember the country up there in the Arctic National
Wildlife Refuge. There was plenty of wildlife at that time. There were
many fish, and it was so noisy to hear all the ducks coming back in our
Arctic area. There were a lot of ptarmigans, you couldn't even sleep some-
times—it was so noisy. Slowly, since more and more human activities,
the wildlife population is really down. It's really sad this time of the year
for me—there's not many birds and other kind of wildlife, it's changed
so fast. That worries me.

Another thing, the oil spill last week, it's a big one (in the Gulf of Mexico).
It's easy to ruin the animals, to kill off some animals. We know we have many
oil spills in the North Slope, and we had the *Exxon Valdez* oil spill, maybe that's
one of the reasons the birds and other animal population is really different now.

We've been here thousands of years. We survived with our bare hands,
many years ago. We didn't have much—no knife, no ax, no gun. Our people
were very strong. With the traditional knowledge they survived during the
cold weather for thousands of years. I want to see our people continue to live,
where I live. I love the country.

I grew up with healthy people, no one complained about any sickness, just
traditional food, people work every day, probably more than eight hours every
day. It's changed now. People really changed, some of them all they can see
is money, it's not good for some of us. Even old people, they worked so hard.
Now something else affects our people, no one is really healthy. Same as the
animals, the way we are losing the animals, and the environment, and also
the weather is changed. Our people saw the vision a long time ago, 1900 or

Reverend Trimble Gilbert in the front yard outside his home in Arctic Village. *(Photograph by Subhankar Banerjee, January 2007.)*

maybe before, and they talk about what is going to happen today, they said hard time is coming, that is where we are at today. It's a good life but no one is really healthy now, it's very sad to see that.

There is a value in protecting the land the way it is, especially with all this climate change. We have to teach our young people about our traditional knowledge and then they can survive. They can still know how we lived a long time ago. There are still a lot of good things going on among the Native people. The whole Yukon Flats, we look out for each other, different communities, we share food among each other, its gone on for thousands of years, no one has forgotten about good thing going on a long time ago. I know the kids are still doing that and they learn from their grandfather and grandmother. I like to see more kids learn how we live, to look after one another, to share food with one another, so the land survives.

The refuge and its coastal plain are important to the caribou and to the Gwich'in people. About fifteen years ago, or maybe less, I worked with a Bureau of Indian Affairs team. They were working up there with helicopter and hired Elders to go out with them. That's the only time we were really lucky to be out there to go see old sites, the caribou fence, old traditional areas, fishing place, and all that, I think they did record it. That's a very important place—the fence, the corral—people used those before the white man came into our country. They hunted with bow and arrow. My father worked with the Elders, and I worked with the Elders, and we got a lot of information from them. We know the old sites are out there. I'd like to see in near future, that we go out and take a look at it, and put the cultural areas in the refuge on the map so that next generation will know how much Gwich'in people used this refuge area before us. It's still there.

What can Fish and Wildlife do in the management plan for the refuge? I'd like to see Fish and Wildlife and our people work together. More of our people—from Fort Yukon, Arctic Village, and Venetie—work with Fish and Wildlife, and in that way communicate more with one another. It's important because a lot of the time we don't communicate too much with Fish and Wildlife. The language is another problem. I know there's a lot of Native people, Athapaskan people, don't understand what's going on in a big meeting, we don't even have an interpreter. A good thing I've seen going on in Canada, all the Elders sitting at a table, they use earphones and someone translates the language to them, that way they can understand what we have been talking about. If the Elders understand what issue we're talking about, then a lot of them can stand up and say something to us. We can't do it without them, they know a lot about the past. Another thing that is missing every time a big meeting goes on is that it happens fast, but we need to spend more time. It would be good for us to work with Fish and Wildlife.

In 1988 we had the Gwich'in Gathering in Arctic Village, and all the Elders from Alaska and Canada were there. We still remember what they said—protect the Arctic Refuge for the future. We never did give up on that. So the wilderness review and wilderness recommendation for the coastal plain is an important part of the plan you are doing now to protect the lands.

Subsistence is very important to the Native people of Alaska. Arctic Village is still traditional subsistence community. I'm happy each year, to be where I come from. My life is there, all the food I've been eating is there, and the clean water, and we protect all of it. We need and want to continue to see the refuge protected for the future. It looks to me that it's the only area protected and we can keep it that way forever for the future generations, not only for the Native but also for the non-Native to see what we have up there.

The Gwich'in Gathering is coming this summer. I want to see more Elders to be involved. I like to listen to them about what they think about the refuge. We have to show our children why we want to protect that area. We can have a table so the kids can do the drawing. Also some of the traditional value should be there. Not only the kids, but also the non-Native and visitors could see how we live. They will know where we come from and how we survive in the cold weather for thousands of years.

Wilderness means Arctic Refuge will be protected forever from oil and gas and too much activity. The caribou is there, moose is there, sheep are there, polar bear, grizzly bear, birds, and other animals, ground squirrel, and all that. We want to protect that area so we will protect those animals for the future, that's what we want to see. I support the wilderness protection for the coastal plain of the refuge.

I grew up with traditional people and spiritual people. I listened to them. I understand their language. Even though they've all passed on, I'm still living in Arctic Village. I try to speak for my people about the land all the time. I try to protect my traditional value and protect the land and water. I don't worry about myself, but I worry about the next generation. We have to stand together and fight for this land we have.

❧

This statement has been adapted from a letter by Reverend Trimble Gilbert, dated May 2, 2010, to Richard Voss, refuge manager of the Arctic National Wildlife Refuge in Fairbanks. The letter is the author's comments on the Arctic National Wildlife Refuge Comprehensive Conservation Plan and Wilderness Review.

❧

Caribou Time

NICK JANS

✤

If you're curious about the Western Arctic of Alaska, the best place to start would be the writing of Nick Jans—his many books of short stories. Nick is a master storyteller. In the late seventies, he journeyed to Alaska in his grandpa's '66 Plymouth Belvedere. In the opening story in A Place Beyond, *he writes about his response when his parents would ask, "When are you coming home?":*

> *"I don't know. Next year," I said, believing the sound of my own voice. But a year became five, then ten. Even though I was now teaching English, history, and math in the Ambler school, putting my education to good use and getting paid for it, my parents' questions never quite stopped. What was I doing up there, hauling water in buckets and peeing in an outhouse? When was I going to get on with my life?*

He never left Alaska.

I asked Nick if he would tell us a story about the seasonal life of caribou. What follows is that and more—about the Western Arctic caribou herd,

and the people who depend on the caribou. It's composed of three parts: an excerpt from the story "The River of Their Passing" in The Last Light Breaking: Living Among Alaska's Iñupiat Eskimos; *an excerpt from the story "The Hardest Season" in* A Place Beyond: Finding Home in Arctic Alaska; *and an original story he wrote for* Arctic Voices *based on a recent trip to the Kokolik-Utukok Uplands.*

♣

The Last Light Breaking: Living Among Alaska's Iñupiat Eskimos *was published in 1993, and* A Place Beyond: Finding Home in Arctic Alaska *was published in 1996, both by Alaska Northwest Books.*

THE RIVER OF THEIR PASSING

Willard Outwater leans into his binoculars, pointing across the Kobuk River toward a distant shimmer of movement. Everyone turns, suddenly attentive.

"Bulls?" asks Clarence Wood, shading his eyes. Willard relaxes, his Eskimo face split by a broad smile. "Just small ones," he says. We lean back; there is a fresh pot of coffee on the camp stove, a crystalline late August afternoon, and no hurry. Soon it will be time to eat. The aroma of caribou soup and roasting ribs wafts through camp.

"We just finish breakfast, all right, but *aarigaa* that fresh caribou meat," says one of the women. "That's what we come here for. The meat." On the beach below the high bank, a half-dozen carcasses lie on a bed of cut willows. One of the men works with an ax, lopping off antlers. Another cleans a rifle. Up in the two canvas wall tents, the Elders rest while the women cook. Boys tend the fire, serve coffee, haul water. And always there is a lookout, scanning the north bank of the Kobuk, waiting.

It's caribou time at Onion Portage in northwest Arctic Alaska. The midnight sun of summer has faded, and the first frosts have burnished the tundra to shades of red and brown. Willow, birch, and balsam poplar blaze yellow—a last burst of color before the long, white winter settles in. The air is so clear that distant mountains seem to be perfect miniatures you could reach out and touch with your hand. There might be more spectacular scenery in Alaska,

but none more haunting. Looking out over this land, you sense that this is a place where time doesn't exist. It has always been this way.

Through the mountains come the caribou in seemingly endless skeins, trotting down passes grooved with their trails, restlessly pushing toward their wintering grounds south of the Brooks Range. This biannual migration from their calving areas on the Arctic slope is something beyond mere spectacle; each year I find myself overwhelmed by the passing of the caribou, at a loss to explain, even to myself, what I've witnessed.

The numbers alone are staggering. The western Arctic caribou herd is the largest in Alaska, more than 350,000 animals—down from a record half-million peak (the largest herd ever recorded in Alaska) and still one of the largest single herds of mammals on earth. Their total range spans roughly 140,000 square miles, a roadless expanse stretching from Barrow in the north, east to the pipeline, south to Bettles, and southwest to the Bering Sea coast—an area almost as big as Iowa, Illinois, and Michigan combined.

There's an old Native saying: no one knows the ways of the wind or the caribou. And indeed, *rangifer tarandus*, the barren-ground caribou, has always been a creature of mystery. Along with the grizzly, Dall sheep, and musk oxen, caribou survived the Pleistocene epoch and prospered while other species died out. They're unlikely-looking survivors at best. Barrel-chested, low slung, spindly legged, with shaggy salt-and-pepper coats, bulging eyes, and enormous antlers, caribou seem more like a practical joke on the deer family than the incredibly tough, beautifully adapted creatures they are. Their thick bodies are powerful and designed to retain heat; the stick-thin legs are tireless. Coats of multilayered, hollow hair are superb insulation as well as a built-in life preserver; even a dead caribou floats like a chunk of dry wood. Caribou can wade through six feet of snow on hooves like snowshoes, swim for miles, sleep comfortably at 40 below zero, and prosper on a diet of frozen lichen. The most impressive gift of all, though, is the caribou's ability to navigate unerringly over vast distances.

From June through August, the caribou of the western Arctic herd roam on the north flank of the Brooks Range in bands of several to tens of thousands. They seek areas of low predator and insect concentrations, and sometimes range out onto coastal ice or climb mountains to avoid the plague of mosquitoes, warble, and bot flies that assail them. They calve in these ancestral grounds, and then wander, feeding heavily, building up weight for the winter. By September a prime herd bull will have two inches of fat on his rump and weigh over 350 pounds.

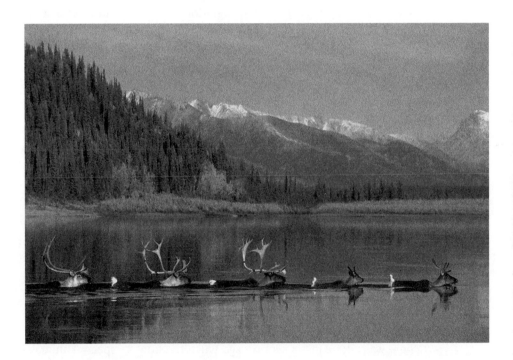

Caribou from the Western Arctic Herd crossing Kobuk River. *(Photograph by Nick Jans, 1997.)*

As the migration time nears, the herd begins to drift south. This is by no means a steady movement; a band may march fifty miles south, reverse their course the next day, and then swing to the west for no apparent reason. But finally, in response to cues known only to the caribou (the wind, perhaps, or the amount of daylight, the angle of the sun, or a sudden snow) they surge southward. When they're moving in earnest, trotting together in long files, nothing can turn them; they plunge through rivers, clamber over mountains, and seem to almost ignore the dozens of Eskimo hunters waiting at crossings to make their fall harvest. There is no exact timetable for their travels, no certain route. Some years the fall migration is brisk and purposeful, with most caribou crossing the Kobuk River between mid-August and the end of September. In other years, the movement may be more sporadic and last well into November. A valley overflowing with caribou one year may be nearly silent the next.

I recall a one-time spectacle roughly twenty years ago, when a huge band— ten, maybe even twenty thousand—milled around in the rolling hills behind the Iñupiaq village of Ambler for two weeks, trapped on the north bank of the Kobuk by flowing ice just before freeze-up. No one could remember so many so close to town. They bulldozed trails through the willows in sight of the village school, plowed up the tundra, and dozens of confused animals trotted into town as if to visit, sending the hundreds of chained sled dogs into a frenzy. Pilots had to buzz strays off the runway before they could land, and the kids I taught made a game out of hiding by trails and counting how many animals they touched. Village men shot more than a hundred, and filled their meat caches to overflowing, but the caribou kept coming. The next year, caribou were relatively scarce near Ambler; many crossed the Kobuk near the Squirrel River, seventy miles to the west.

There was a time just a century ago when the hunters speared animals from kayaks, set snares of rawhide thong on brushy trails, or drove bands of caribou into natural cul-de-sac where they were taken with bow and arrow. Every scrap was utilized: skins for clothing and tents; bones and antler for tools; stomach contents for greens—but that time is passing, as ancient traditions meet the onrushing future. Now, vegetables are likely to come from cans, and jackets made of nylon, polyester fleece, and down.

Still, the fall caribou hunt carries forward the same subsistence tradition practiced for centuries. It's far more like gathering than hunting, as it's understood in the Lower 48. A premium is placed on fat rather than horn size, and most animals are shot at point-blank range in the water, often with

a single .22 caliber rifle shot to the base of the skull. Then the buoyant car-
casses are towed to shore for butchering and transport. Some women—and
many over sixty are experts—can skin a big bull perfectly in minutes, down
to the hooves. Often, though, carcasses are transported skin-on and whole
to protect the meat, with lower legs and heads removed. Certain choice
delicacies, including ribs with fat, heart, and tongue, are often eaten fresh,
roasted or boiled in camp. If the weather turns unexpectedly warm, meat
may be carved into strips for drying, with smudge fires to keep insects at bay.
Trophy racks attached to heads are left on the riverbank for the ravens and
bears, throats carefully slit to let the animals' souls escape and be reborn,
according to ancient custom. But even most Iñupiat have largely forgotten
the many small ceremonies of reverence their fathers knew; forgotten the
time, just a century ago, when the caribou disappeared from most of the
region, and people sometimes starved.

A single family may use a dozen or more caribou a year, and more than half
are taken during the autumn migration. The hunt ends when the boats are
full, heaped with carcasses. If the caribou are early or late, or cross somewhere
else, hunters may stay a week and go home empty-handed. The land gives
freely, or inexplicably withholds its riches.

I think back to one September day years ago. I'd made camp where the
confluence of two rivers forms a funnel for caribou, a few miles west of Onion
Portage. The roughly triangular field there has been a pathway for genera-
tions; some of the trails are a foot deep, and bleached antlers and bones lie
scattered across the tundra. I'd traveled fifty miles from Ambler to escape the
seasonal commotion along the Kobuk—boats roaring back and forth, camps
at every bend, volleys of gunfire. I had my rifle with me, but wanting was only
a pretense, an excuse to offer my Iñupiat friends if they asked. I'd come for
something else—just to watch, to see. Here there was only the voice of the
land, wind, and water and the hush of huge, empty space. I'd been waiting for
two days, staring out across the tundra, slowly emptying myself of thoughts,
waiting at this place as men must have always done.

I was on the morning's fourth cup of coffee when the alders on the slope a
mile off began to move. It might have been the wind, but the motion was too
great, too sudden. I adjusted my binoculars, and bushes became caribou—
dozens, then hundreds streaming toward me. I dashed to the blind I'd made at
the center of the field and waited, pulse thundering in my ears as they came.
At first there was only a mass of shapes, but then the white manes and gold-
tinted antlers of the herd bulls shone in the low sun, and I could pick out calves

skittering along the fringe of the on-pouring mob. I became aware of a low, steady commotion: grunts between mothers and calves, click of antlers and leg tendons like a thousand castanets, and beneath it all, the muffled thud of hooves. Strung out in a long file ten abreast, they poured down the hill, more than a thousand now. Crouched behind my flimsy wall of brush and burlap, the leaders nearly upon me, I fought back the urge to run.

Twenty yards away, the lead cow sensed me. She froze, staring, and her alarm rippled back through the herd until the front ranks had all come to a halt. They stood stiff-legged and silent, regarding this strange-smelling thing that blocked their way. Then, without an outward sign, they reached a consensus and began to move again. The herd surged forward, parted to include me, and I became an island in the river of their passing. I had meant to count—as a way of explaining to myself and others what I'd seen—but numbers were suddenly meaningless, impossible. Through the morning and into the late afternoon the caribou eddied around me and flowed past. Now and then one would give a start and roll its eyes, but most simply glanced my way and trotted past, intent on their timeless, urgent business to the south.

THE HARDEST SEASON

Steve and I lean against our snowmachines, looking out across the rolling, open country along the shoulder of the Cosmos Hills. It's one of those crystalline Arctic spring afternoons, so quiet you can hear the creak and rustle of winter collapsing. Even strained through dark glasses, the glare hammers my eyes. Tundra stretches east, broken by thin lines of spruce, and blue shadowed mountains drift beyond. The cry of a distant raven cuts the silence.

"They're out there somewhere," Steve murmurs. In every direction the snow is torn, trampled, pawed down to bare ground in places. Trails grooved two feet deep toward Ingichuk Pass. We can see at a glance that many of the hoofprints are fresh, the edges not yet blurred by melt or sifting snow.

The western Arctic caribou herd is marching toward their calving grounds in the Utukok Hills, just inland from Point Lay. After wintering on the windswept tundra between the Kobuk and the Yukon, they face an impossible journey, up to three hundred miles through the jagged sprawl of the Brooks Range. Late April and May in the Arctic means breakup: a time of melting snow, rotting ice, and bottomless trail. To traditional Iñupiat, trapped by the thaw in their camps, this was a season of hardship, perhaps starvation. Even bull moose

sometimes give up and die in spring slush. Yet the caribou pour northward at breakup, shrugging off the impossibility of their going.

Many won't make it. The weak starve or fall to disease; others drown in ice-choked rivers, or stumble and break legs. Native hunters on snowmobiles roar out to fill empty meat caches, greeting passing bands with volleys of gunfire. And wolves, the caribou's ancient companions, are never far away. Tufts of hair and splintered bones lie scattered across the tundra, marking kills.

But the caribou press on, straggling north in long files, heads down. The cows, especially, sense the urgency. Most are pregnant, soon to give birth, and their young stand a far better chance if born on the calving grounds. The huge, loose herd that forms there, hundreds of thousands of caribou gathered like individual cells of a huge single organism, offers insulation from predators as well as insects. There can only be so many wolves or mosquitoes per square mile. By bunching together, the caribou improve their odds.

Steve and I crest a ridge and there, as far as we can see, are caribou: bands of ten to fifty, heads down, grazing. A few animals spot us, but we're a quarter mile away, too far to cause alarm. We leave our machines and creep forward, cameras ready, intent on getting close.

"Stay low," I whisper. There's not much cover, but we follow a line of scrub willow to within two hundred yards, then inch closer, crouching in the snow.

These aren't the same animals that swept south last fall, white manes gleaming, clashing horns. If the southward migration of the caribou can be compared to the advance of an army, the northward return has the aspect of retreat, of beaten survivors straggling back home. Their coats are sunbleached, dingy, shedding in clumps. The spectacular curving antlers of the big bulls have long since been shed; their ribs show through. Some have lost fifty pounds, a seventh of their prime weight.

First there was the frenzy of the October rut, when the bulls threw all their energy into fighting and mating, exhausting fat reserves just as winter set in. Then came seven months of storms and deep cold, of pawing through the snow for mouthfuls of frozen moss. Now they face the hardest season of all.

Not all the caribou's adversaries are obvious. Beneath the shabby coats, just under the hide, are hundreds of inch-wide festering cysts, each cradling a white segmented grub—the larva of the warble fly, a parasite so fierce it seems predatory. Laid on the leg hair during summer, the larvae penetrate the hide and migrate to the animal's back. They spend the winter burrowed into their host, feeding steadily, draining away energy. Now that spring is here, the grubs gnaw through the hide and drop onto the tundra, pupate until summer, and

sprout wings to plague the caribou anew. It's no wonder that a single warble fly can stampede an entire band into a thirty-mile gallop—something no wolf pack could ever do.

Then there are botfly larvae, clustered at the back of the throat in clotted masses that interfere with breathing. These, too, are nearing maturity, at a time when the caribou have no strength to spare.

Despite—or perhaps because of—constant hardship, the caribou prosper. There are thirteen separate Alaskan herds, each defined by its own ancestral calving grounds. No matter how far they travel, caribou return to that one area each spring, drawn by some inner music. In a life of wandering, the memory of birth offers the only certain destination.

I work quietly, edging closer a few feet at a time, pausing now and then to change camera lenses. As we move inside a hundred yards, a few cows show signs of agitation—staring stiff-legged, then turning heads, scanning for other threats. Gradually they relax, go back to pawing and feeding. We slide forward again, and without warning, one animal rears up and spy-hops on her hind legs, and alarm surges like a wave through the herd. Dozens of animals join the stampede. A muffled thunder rises from behind the ridge, and suddenly we find ourselves on the edge of hundreds of caribou we hadn't seen, galloping past in a snow clouded blur, cows, bulls, and yearlings running heads out, nostrils flared. A thousand, I count to myself. Two thousand. More.

The band slows and gathers itself, forgetting us and its momentary panic. As we watch, they trot uphill toward Ingichuk Pass, thousands moving as one, heading north, hearing only the song that leads them home.

IN THE CALVING GROUND

I sat on the crest of a high tundra bluff, alone on a bright autumn evening. Two hundred feet below, the Kokolik River carved a meandering arc northwest toward the Chukchi Sea. Around that silvery thread, rolling tundra stretched over the horizon and off the edge of the earth in a vertigo-inducing sprawl.

I'd tagged along on a Sierra Club–sponsored float trip. We'd come to glimpse a vast, seldom-visited area: the uplands on the far northwestern edge of the Brooks Range. This country, much of it lying within the National Petroleum Reserve—Alaska and most of the rest owned by the state or the Arctic Slope Regional Corporation (ASRC), remains a forgotten corner of the state.

The barren ridges and tussock flats of the upper Utukok and Kokolik are

Coal seams in the Utukok River upland, National Petroleum Reserve-Alaska. *(Photograph by Subhankar Banerjee, June 2006.)*

the western Arctic caribou herd's ancestral calving grounds. State biologist Jim Dau says, "No matter how far caribou wander, they almost always sort themselves out and return to their own calving grounds. It's pretty amazing how they do that." *Why* they do it is another question. Predator numbers in the uplands are low, and the near-constant wind, coupled with well-drained ground, help keep hordes of mosquitoes and parasitic flies somewhat at bay—though local infestations can be intense on the few windless summer days. As the snow melts, emerging cotton grass shoots provide vital, high-quality nutrition for the nursing cows. Making this long, difficult journey, through melting snow and across ice-flowing rivers, translates into survival for the great, collective being of the herd. Rather than a wasteland, this harsh terrain is a necessary haven; and the caribou themselves are the lifeblood of an enormous ecosystem that extends as far as the Seward Peninsula, two hundred miles to the south, and as far east as the headwaters of the Noatak River, three hundred miles to the east.

Truly, the caribou are a keystone species that shape the land. The fortunes of many animal species, as well as plant communities, are tied directly to the condition of the herd. Wolves, grizzlies, foxes, wolverines, and ravens all depend directly on caribou for food; moose and sheep are also preyed upon more heavily when caribou numbers are low. Grazing, browsing, and trampling affect most tundra plants; the millions of tons of droppings and remains of dead caribou provide nutrients to poor, thin soils. Even the land is shaped, marked by thousands of miles of beaten trails, used by other creatures.

Halfway through the second day of our raft trip down the Kokolik, we spotted dark seams woven into a riverside outcropping—the reason an invisible ax hangs over this country. Later that day, a geologists' helicopter racketed overhead, a link to the survey markers we'd seen driven into the tundra. The rich fossil record we'd marveled at translated into an ancient swamp of the late Cretaceous period. Thick layers of rotting matter had been deposited, buried, and compressed over the eons, creating the fuels on which we've come to depend: oil, natural gas, coal. Most proven, large-scale reserves of the first two lie farther north, on the edge of the Arctic coastal plain. Before us, vast seams of coal lay just below the hooves of the caribou and the nests of falcons, millions of acres, almost as far east as the pipeline. Entire bluffs we passed were black with the stuff. These contiguous coal fields north of the Brooks Range cover thirty thousand square miles—a bit larger than West Virginia, where companies remove entire mountaintops to get at a single rich seam. In Arctic Alaska, we're talking not billions, but a possible maximum of

4 trillion tons, much of it just barely subsurface—up to 9 percent of all the coal on the planet.

And it's not just any coal. Much of the Utukok–Kokolik Uplands Area, as well as tracts farther east, holds some of the world's finest bituminous coal: low-sulfur stuff that burns cleaner and hotter than most other grades. Also, it's relatively close to hungry, coal-fueled Asian markets. In China alone, a new coal-fired power plant goes online every week, and India as well is sprinting toward a vastly expanded, coal-reliant power grid. As the Arctic continues to thaw at an accelerated pace, the ice-free season in the Arctic Ocean continues to lengthen, and with it, the window for direct, more economical shipping routes. A barge port, built for the massive Red Dog lead-zinc mine, already exists near Kivalina, on the Chukchi Sea coast; what's needed is a transport link connecting the coal to that port, or to a yet-to-be-created and closer new port. One might expect the huge worldwide demand for coal-fired power; but even in the US, 50 percent of electricity still comes from coal-fired plants, and there is no exit strategy on the ever-warming, smog-hazed horizon.

No wonder that BHP Billiton, the world's largest mining company, in partnership with the Native-owned ASRC, had been intensively probing an especially rich feature near the coast around Point Lay known as the Deadfall Syncline, as well as drilling exploratory boreholes into promising areas across 1.75 million acres of ASRC land. Though BHP in 2009 suspended their active prospecting in the area due to economic concerns, in 2010 they filed the necessary paperwork to keep their fingers firmly in the pie.

Hundreds of miles away, just north of the central Arctic Iñupiat village of Anaktuvuk Pass, another company, Mill Rock Resources, is probing another lode of coal that lies on state land. Like most prospects in the Arctic, the coal lies so close to the surface that strip mining is the best (indeed, the only possible) means of extraction. The scale of the potential operation is mind-boggling. Imagine a network of enormous mine pits and clusters of prefabricated steel buildings stretching over the horizon, linked by a network of gravel roads swarming with house-size Terex ore trucks and giant excavators—in the heart of a landscape that today remains as primordial and boundless as any on earth.

Of course, development on such a scale, in such a climactically extreme and remote location, poses a number of intertwined challenges. The first involves access; the creation of either a heavy-duty road or rail bed that can bear the weight of the massive equipment and material going in, and millions of tons of coal going out. The cost of building such infrastructure spanning delicate permafrost soils, wetlands, and many stream crossings is breathtaking—tens

of millions of dollars per mile, and bound to rise with every spike in oil prices. For example, a recent 2011 estimate for a two-hundred-mile road linking the rich mineral deposits in the upper Kobuk Valley with the Dalton Highway (otherwise known as the pipeline Haul Road, the only road in Alaska's Arctic connecting to the outside world) came in at around $4 billion. The developers of Arctic coal would, of course, like the state to dig into its coffers to provide a transportation corridor, as they did with the Red Dog Mine in the late 1980s. In his 2011 State of the State Address, Alaska Governor Sean Parnell affirmed that the state would provide $8 million to the Department of Transportation for preliminary work on a road reaching to Mill Rock's prospect and far beyond, to the outpost of Umiat, deep in the heart of the central Arctic coal fields. Though the initial sum represents droplets in a vast bucket, it's clear that the state has pushed its ante onto a high-stakes table. As oil revenues continue to dwindle, Alaska is searching for its next big fix, and coal development, though perhaps not a solution by itself, is surely seen as a major part of the state's economic future.

A second issue with developing Arctic coal is land reclamation. Even under Alaska's unabashedly pro-development policies and guidelines, strip mines must be restored to original condition—a tricky and expensive business (if even possible) on remote Arctic permafrost. Add to that the resistance of many Iñupiat Eskimos from the villages Anaktuvuk Pass, Point Hope, and Point Lay, the only humans—fewer than fifteen hundred—close enough to be directly affected by coal development. Though the twenty-first century rushes on, bringing change at a breathtaking pace—sod huts and dog teams to Internet and cell phones in three generations—residents still depend on the land and its gifts for both material and spiritual sustenance, as they have for centuries. There are few, if any, Native households where caribou meat, berries, furs, and other bounty aren't regarded as prized and necessary resources. The general fear is that mining on such a scale, while providing well-paying jobs relatively near home villages, will disrupt centuries-old patterns of subsistence. Residents of Point Hope and Point Lay have complained that BHP Billiton's exploration helicopters have already altered caribou movements; and in the case of Anaktuvuk Pass, Mill Rock's proposed mining area lies square across a main migration path for the Central Arctic herd. Considering that the Anaktuvuk people are descended from nomads who relied on the pass to funnel caribou to their waiting bows and lances (*Anaktuvuk* roughly translates to "Place of Caribou Droppings"), it is no surprise that the village tribal council stands united in its opposition to nearby coal development,

and has sent a resolution expressing strong concern—so far unanswered—to Governor Parnell.

The caribou continue to ebb and flow across the land, unaware of the looming threat to their survival. Most biologists agree that disturbance of the calving grounds will drive caribou to less favorable places, which will lead to diminished survival of young. Ultimately, this translates to a decline that may not be reversible. Caribou make their rigorous journeys to specific calving grounds due to biological selection, honed over centuries. Caribou don't wander because they want to; their very survival depends on these journeys. Restricting their range may very well be a death sentence to the collective being of the herd. It's no accident that worldwide, caribou are most abundant where roads and human disturbances are fewest, and that they are in decline or absent from former areas of abundance pierced by roads and development, even if such impacts seem relatively moderate. For example, there are no more caribou wandering the woodlands near Caribou, Maine. The last of that herd disappeared more than a century ago. The building of Alaska's Taylor Highway, cutting through the range of Alaska's Fortymile herd, coincided with a sharp decline in their numbers. Whether overhunted due to improved access, deflected, or driven out makes little difference. The end result is the same: they're gone.

Not only would the western Arctic land and its ecology be utterly transformed by removal of coal, but burning it en masse, even afar, would hasten the already astonishing rate at which the Western Arctic has warmed—up to 10 degrees Fahrenheit. Once-crystalline air in northwest Alaska is now often tainted with a visible haze laden with sulfur dioxide, mercury, and greenhouse gases traced directly via chemical signatures to coal combustion. Heavy metals precipitate over water and land, and become increasingly concentrated as they move up the food chain, which ends with bears, seals, whales, walruses, and humans.

Drastic action is required by all of us—governments, conservation agencies, corporations, and most important of all, the public—to change our course. It's not only the fate of the Arctic and its caribou that hang in the balance, but our own. The time for action is now.

arctic ocean is our garden

It feels as if the government and industry want us to forget who we are, what we have a right to, and what we deserve. They repeatedly overwhelm us with information, requests, and deadlines, and it seems as if they hope that we will either give up or die fighting.

We are not giving up.

We must fight.

—CAROLINE CANNON

Elder Isaac Akootchook and whaling captain James Lampe offer a prayer to thank the creator and the whale for offering food for the community, Kaktovik. (*Photograph by Subhankar Banerjee, September 2001.*)

From **Arctic Dreams**
Imagination and Desire
in a Northern Landscape

BARRY LOPEZ

❖

In his National Book Award–winning masterpiece, Arctic Dreams: Imagination and Desire in a Northern Landscape, *Barry Lopez wrote beautiful prose about the far north, including Arctic Alaska. The book has long been a guidepost for me. Initially, I wanted to select an excerpt from what he wrote about Alaska, but instead, I ended up choosing something else for* Arctic Voices. *When you think about the north, I surmise you imagine ice, polar bear, caribou, but do you think about the salmon, yellow-billed loon, and narwhal as signature species of the north? In this volume, Dan O'Neill writes about king salmon, Jeff Fair about the yellow-billed loon, and the essay that follows is about the narwhal—an excerpt from the chapter "Lancaster Sound:* Monodon monoceros" *in* Arctic Dreams. *While the story is situated in the high Arctic of Canada, Barry's first sighting of this mythic species happened in the subarctic of the Bering Sea. He also wrote about the threat of oil and gas development in the Lancaster Sound. Since then, there has been a proposal to set aside part of the Sound as a National Marine Conservation Area. On*

December 3, 2011, I retrieved the following text from the Wikipedia page on Lancaster Sound:

> *A National Marine Conservation Area designation precludes oil and gas development, and so questions arose when the Nunavut Impact Review Board approved a NRCan [National Resources Canada] Geological Survey of Canada proposal to perform seismic testing for oil within Lancaster and Jones Sound in August and September 2010. . . . In June 2010, communities and groups came out against seismic testing in Lancaster and Jones Sound. . . . In late July NRCAN announced that plans for seismic testing were proceeding despite the unanimous opposition of Inuit communities and supporting organizations. In a major ruling on Aug 8, 2010, a Nunavut court sided with Inuit and stopped the planned seismic testing citing the risks to marine animals and cultural heritage. The federal Conservative government announced on December 6, 2010, that it will establish the boundaries of a new marine park in Lancaster Sound.*

I also learned from a Pew Environment Group webpage (retrieved on December 3, 2011; http://oceansnorth.org/lancaster-sound) that "Shell Oil has offshore oil and gas leases totaling 8,700 square kilometres (3,400 square miles) just east of Lancaster Sound."

❖

Arctic Dreams: Imagination and Desire in a Northern Landscape *was published by Vintage Books in 1986.*

LANCASTER SOUND:
Monodon monoceros

I am standing at the margin of the sea ice called the floe edge at the mouth of Admiralty Inlet, northern Baffin Island, three or four miles out to sea. The firmness beneath my feet belies the ordinary sense of the phrase "out to sea." Several Eskimo camps stand here along the white and black edge of ice and water. All of us have come from another place—Nuvua, thirty miles to the south at the tip of Uluksan Peninsula. We are here to hunt narwhals. They are out there in the open water of Lancaster Sound somewhere, waiting for this

Calm Bay, Hooker Island, Franz Josef Land. *(Photograph by Stuart Klipper, 2009.)*

last ice barrier to break up so they can enter their summer feeding grounds in Admiralty Inlet.

As I walk along the floe edge—the light is brilliant, the ceaseless light of July; but after so many weeks I am weary of it; I stare at the few shadows on the ice with a kind of hunger—as I walk along here I am aware of both fear and elation, a mix that comes in remote regions with the realization that you are exposed and the weather can be capricious and fatal. The wind is light and from the north—I can see its corrugation on the surface of the water. Should it swing around and come from the south, the ice behind us would begin to open up. Traverse cracks across the inlet, only a few inches wide yesterday, would begin to widen. We would have difficulty getting back to Nuvua, even if we left at the first sign of a wind shift.

I am not so much thinking of these things, however, as I am feeling the exuberance of birds around me. Black-legged kittiwakes, northern fulmars, and black guillemots are wheeling and hovering in weightless acrobatics over the streams and lenses of life in the water—zooplankton and Arctic cod—into which they plunge repeatedly for their sustenance. Out on the ice, at piles of offal from the narwhal hunt, glaucous and Thayer's gulls stake a rough-tempered claim to some piece of flesh, brash, shouldering birds alongside the more reticent and rarer ivory gulls.

Birds fly across these waters in numbers that encourage you to simply flip your pencil in the air. Certain species end their northward migration here and nest. Others fly on to Devon and Ellesmere islands or to northwest Greenland. From where I now stand I can study some that stay, nesting in an unbroken line for ten miles on a cliff between Baillarge Bay and Elwin Inlet, a rugged wall of sedimentary and volcanic rock pocked with indentations and ledges, rising at an angle of 80 degrees from the water. More than fifty thousand northern fulmars. At other such rookeries around Lancaster Sound, guillemots, murres, and kittiwakes congregate in tens and even hundreds of thousands to nest and feed during the short summer. Gulls, Arctic terns, snow geese, eiders, red-breasted mergansers, and dovekies have passed through in droves already. Of the dovekies—a small, stocky seabird with a black head and bright white underside—something on the order of a third of the northwest Greenland population of 30 *million* passes over Lancaster Sound in May and June.

On the white-as-eggshell ice plain where we are camped, with the mottled browns and ochers of Borden Peninsula to the east and the dark cliffs of Brodeur Peninsula obscured in haze to the west, the adroit movements of the birds above the water give the landscape an immediate, vivid dimension:

the eye, drawn far out to pale hues on the horizon, comes back smartly to the black water, where, *plunk*, a guillemot disappears in a dive.

The outcry of birds, the bullet-whirr of their passing wings, the splashing of water, is, like the falling light, unending. Lancaster Sound is a rare Arctic marine sanctuary, a place where creatures are concentrated in the sort of densities one finds in the Antarctic Ocean, the richest seawaters in the world. Marine ecologists are not certain why Lancaster Sound teems so with life, but local upwelling currents and a supply of nutrients from glacial runoff on Devon Island seem critical.[1]

Three million colonial seabirds, mostly northern fulmars, kittiwakes, and guillemots, nest and feed here in the summer. It is no longer the haunt of ten thousand or so bowhead whales, but it remains a summering ground for more than 30 percent of the Beluga whale population of North America, and more than three-quarters of the world's population of narwhals. No one is sure how many harp, bearded, and ringed seals are here—probably more than a quarter of a million. In addition there are thousands of Atlantic walrus. The coastal regions are a denning area for polar bear and home to thousands of Arctic fox in the summer.

I am concerned as I walk, however, more with what is immediate to my senses—the ternlike whiffle and spin of birds over the water, the chicken-cackling of northern fulmars, and cool air full of the breath of sea life. This community of creatures, including all those invisible in the water, constitutes a unique overlap of land, water, and air. This is a special meeting ground, like that of a forest's edge with a clearing; or where the fresh waters of an estuary meet the saline tides of the sea; or at a river's riparian edge. The mingling of animals from different ecosystems charges such border zones with evolutionary potential. Flying creatures here at Admiralty Inlet walk on ice. They break the pane of water with their dives to feed. Marine mammals break the pane of water coming the other way to breathe.

The edges of any landscape—horizons, the lip of a valley, the bend of a river around a canyon wall—quicken an observer's expectations. That attraction to borders, to the earth's twilit places, is part of the shape of human curiosity. And the edges that cause excitement are like these where I now walk, sensing the birds toying with gravity; or like those in quantum mechanics, where what is critical straddles a border between being a wave and being a particle, between being what it is and becoming something else, occupying an edge of time that defeats our geometries. In biology these transitional areas between two different communities are called ecotones.

The ecotone at the Admiralty Inlet floe edge extends in two planes. In order to pass under the ice from the open sea, an animal must be free of a need for

atmospheric oxygen; the floe edge, therefore, is a barrier to the horizontal migration of whales. In the vertical plane, no bird can penetrate the ice and birds like gulls can't go below water with guillemots to feed on schools of fish. Sunlight, too, is halted at these borders.

To stand at the edge of this four-foot-thick ice platform, however, is to find yourself in a rich biological crease. Species of alga grow on the bottom of the sea ice, turning it golden brown with a patchwork of life. These tiny diatoms feed zoo-plankton moving through the upper layers of water in vast clouds—underwater galaxies of copepods, amphipods, and mysids. These in turn feed the streaming schools of cod. The cod feed the birds. And the narwhals. And also the ringed seal, which feeds the polar bear, and eventually the fox. The algae at the bottom of this food web are called "epontic" algae of the sea ice. (Ringed seals, ivory gulls, and other birds and mammals whose lives are ice-oriented are called *pagophylic*.) It is the ice, however, that holds this life together. For ice-associated seals, vulnerable on a beach, it is a place offshore to rest, directly over their feeding grounds. It provides algae with a surface to grow on. It shelters Arctic cod from hunting seabirds and herds of narwhals, and it shelters narwhals from the predatory orca. It is the bear's highway over the sea. And it gives me a place to stand on the ocean, and wonder.

I stood still occasionally to listen. I heard only the claver of birds. Then there was something else. I had never heard the sound before, but when it came, plosive and gurgling, I knew instinctively what it was, even as everyone in camp jumped. I strained to see them, to spot the vapor of their breath, a warm mist against the soft horizon, or the white tip of a tusk breaking the surface of the water, a dark pattern that retained its shape against the dark, shifting patterns of the water. Somewhere out there in the ice fragments. Gone. Gone now. Others had heard the breathing. Human figures in a camp off to the west, dark lines on the blinding white ice, gesture toward us with upraised arms.

The first narwhals I ever saw lived far from here, in Bering Strait. The day I saw them I knew that no element on the earth's natural history had ever before brought me so far, so suddenly. It was as though something from a bestiary had taken shape, a creature strange as a giraffe. It was as if the testimony of someone I had no reason to doubt, yet could not quite believe, a story too farfetched, had been verified at a glance.

I was with a bowhead whale biologist named Don Ljungblad, flying search transects over Bering Sea. It was May, and the first bowheads of spring were slowly working their way north through Bering Strait toward their summer feeding grounds in the Chukchi and Beaufort seas.

The day we saw the narwhals we were flying south, low over Bering Strait. The ice in the Chukchi Sea behind us was so close it did not seem possible that bowheads could have penetrated this far; but it is good to check, because they can make headway in ice as heavy as this and they are able to come a long way north undetected in lighter ice on the Russian side. I was daydreaming about two bowheads we had seen that morning. They had been floating side by side in a broad land of unusually clear water between a shelf of shorefast ice and the pack ice—the flaw lead. As we passed over, they made a single movement together, a slow, rolling turn and graceful glide, like figure skaters pushing off, these fifty-ton leviathans. Ljungblad shouted in my earphones: "Waiting." They were waiting for the ice in the strait to open up. Ljungblad saw nearly three hundred bowheads waiting calmly like this one year, some on their backs, some with their chins resting on the ice.

The narwhals appeared in the middle of this reverie: two males, with ivory tusks spiraling out of their foreheads, the image of the unicorn with which history has confused them. They were close to the same size and light-colored, and were lying parallel and motionless in a long, straight lead in the ice. My eye was drawn to them before my conscious mind, let alone my voice, could catch up. I stared dumbfounded while someone else shouted. Not just to see the narwhals, but *here,* a few miles northwest of King Island in Bering Sea. In all the years scientists have kept records for these waters, no one had ever seen a narwhal alive in the Bering Sea. Judging from the heaviness of the ice around them, they must have spent the winter here. They were either residents, a wondrous thought, or they had come from the nearest population centers the previous fall, from waters north of Siberia or from northeastern Canada.

No large mammal in the Northern Hemisphere comes as close as the narwhal to having its very existence doubted. For some, the possibility that this creature might actually live in the threatened waters of Bering Sea is portentous, a significant apparition on the eve of an era of disruptive oil exploration there. For others, those with the leases to search for oil and gas in Navarin and Norton basins, the possibility that narwhals may live there is a complicating environmental nuisance. Hardly anyone marvels solely at the fact that on the afternoon of April 16, 1982, five people saw two narwhals in a place so unexpected that they were flabbergasted. They remained speechless, circling over the animals in a state of wonder. In those moments the animals did not have to mean anything at all.

We know more about the rings of Saturn than we know about the narwhal. Where do they go and what do they eat in the winter, when it is too dark and

cold for us to find them? The Chilean poet and essayist Pablo Neruda wonders in his memoirs how an animal this large can have remained so obscure and uncelebrated. Its name, he thought, was "the most beautiful of undersea names, the name of a sea chalice that sings, the name of a crystal spur." Why, he wondered, had no one taken Narwhal for a last name, or built "a beautiful Narwhal Building?"

Part of the answer lies with a regrettable connotation of death in the animal's name. The pallid color of the narwhal's skin has been likened to that of a drowned human corpse, and it is widely thought that its name came from the Old Norse for "corpse" and "whale," *nár + hvalr*.

W. P. Lehman, a professor of Germanic languages, believes the association with death is a linguistic accident. The Old Norse *nárhvalr* (whence came the English *narwhal*, the French *narval*, the German *Narwal*, etc.), he says, was a vernacular play on the word *nahvalr*—the way *high-bred corn* is used in place of *hybrid corn*, or *sparrowgrass* is used for *asparagus*. According to Lehman, *nahvalr* is an earlier, West Norse term meaning a "whale distinguished by a long, narrow projection" (the tusk).

Some, nevertheless, still call the narwhal "the corpse whale," and the unfounded belief that it is a cause of human death, or an omen or symbol to be associated with human death, remains intact to this day in some quarters. Animals are often fixed like this in history, bearing an unwarranted association derived from notions or surmise having no connection at all with their real life. The fuller explanations of modern field biology are an antidote, in part, to this tendency to name an animal carelessly. But it is also, as Neruda suggests, a task of literature to take animals regularly from the shelves where we have stored them, like charms or the most intricate watches, and to bring them to life.

The obscurity of narwhals is not easily breached by science. To begin with, they live under water. And they live year-round in the polar ice, where the logistics and expense involved in approaching them are formidable barriers to field research, even in summer. Scientists have largely been limited to watching what takes place at the surface of the water in the open sea adjacent to observation points high on coastal bluffs. And to putting hydrophones in the water with them, and to making comparisons with the beluga whale, a close and better-known relative. About the regular periodic events of their lives, such as migration, breeding, and calving, in relation to climatic changes and fluctuations in the size of the population, we know next to nothing.

Narwhals are strong swimmers, with the ability to alter the contours of their body very slightly to reduce turbulence. Their speed and maneuverability are

sufficient to hunt down swift prey—Arctic cod, Greenland halibut, redfish—and to avoid their enemies, the orca and the Greenland shark.

Narwhals live in close association with the ice margins and are sometimes found far inside heavy pack ice, miles from open water. (How they determine whether the lead systems they follow into the ice will stay open behind them, ensuring their safe return, is not known.) They manage to survive in areas of strong currents and wind where the movement of ice on the surface is violent and where leads open and close, or freeze over, very quickly. (Like seabirds, they seem to have an uncanny sense of when a particular lead is going to close in on them, and they leave.) That they are not infallible in anticipating the movement and formation of ice, which seals them off from the open air and oxygen, is attested to by a relatively unusual and often fatal event called a *savssat.*

Savssats are most commonly observed on the west coast of Greenland. Late in the fall, while narwhals are still feeding deep in a coastal fjord, a band of ice may form in calm water across the fjord's mouth. The ice sheet may then expand toward the head of the fjord. At some point the distance from its landward to its seaward edge exceeds the distance a narwhal can travel on a single breath. By this time, too, shorefast ice may have formed at the head of the fjord, and it may grow out to meet the sea ice. The narwhals are thus crowded into a smaller and smaller patch of open water. Their bellowing and gurgling, their bovine moans and the plosive screech of their breathing, can sometimes be heard at a great distance.

Extrapolating on the basis of what is known of the beluga, it is thought that narwhals breed in April and give birth to a single, five-foot, 170-pound calf about fourteen months later, in June or July. Calves carry an inch-thick layer of blubber at birth to protect them against the cold water. They appear to nurse for about two years and may stay with their mothers for three years, or more. Extrapolating once again from the beluga, it is thought that females reach sexual maturity between four and seven years of age, males between eight and nine years.

Narwhals are usually seen in small groups of two to eight animals, frequently of the same sex and age. In the summer, female groups, which include calves, are sometimes smaller or more loosely knit than male groups. During spring migration, herds may consist of three hundred or more animals.

Narwhals feed largely on Arctic and polar cod, Greenland halibut, redfish, and other fish, on squid and to some extent on shrimps of several kinds, and on octopus and crustaceans. They have a complex, five-chambered stomach that processes food quickly, leaving undigested the chitinous breaks of squid

and octopus, the carapaces of crustaceans, and the ear bones and eye lenses of fish, from which biologists can piece together knowledge of their diets.

If you were to stand at the edge of a sea cliff on the north coast of Borden Peninsula, Baffin Island, you could watch narwhals migrating past more or less continuously for several weeks in the twenty-four-hour light of June. You would be struck by their agility and swiftness, by the synchronicity of their movements as they swam and dived in unison, and by a quality of alert composure in them, of capability in the face of whatever might happen. Their attractiveness lies partly with their strong, graceful movements in three dimensions, like gliding birds on an airless day. An impressive form of their synchronous behavior is their ability to deep-dive in groups. They disappear as a single diminishing shape, gray fading to darkness. They reach depths of a thousand feet or more, and their intent, often, is then to drive schools of polar cod toward the surface at such a rate that the fish lose consciousness from the too-rapid expansion of their swim bladders. At the surface, thousands of these stunned fish feed narwhals and harp seals, and rafts of excited northern fulmars and kittiwakes.

Watching from high above, one is also struck by the social interactions of narwhals, which are extensive and appear to be well organized according to hierarchies of age and sex. The socializing of males frequently involves the use of their tusks. They cross them like swords above the water, or one forces another down by pressing his tusk across the other's back, or they face each other head on, their tusks side by side.

Sitting high on a sea cliff in sunny, blustery weather in late June—the familiar sense of expansiveness, of deep exhilaration such weather brings over one, combined with the opportunity to watch animals, is summed up in a single Eskimo word: *quviannikumut*, "to feel deeply happy"—sitting here like this, it is easy to fall into speculation about the obscure narwhal. From the time I first looked into a narwhal's mouth, past the accordion pleats of its tongue, at the soft white interior splashed with Tyrian purple, I have thought of their affinity with sperm whales, whose mouths are similarly colored. Like the sperm whale, the narwhal is a deep diver. No other whales but the narwhal and the sperm whale are known to sleep on the surface for hours at a time. And when the narwhal lies at the surface, it lies like a sperm whale, with the section of its back from blowhole to dorsal ridge exposed, and the rest of its back and tail hanging down in the water. Like the sperm whale, it is renowned for its teeth; and it has been pursued, though briefly, for the fine oils in its forehead.

Like all whales, the narwhal's evolutionary roots are in the Cretaceous, with insect-eating carnivores from which we, too, are descended.

The two greatest changes in its body have been in the way it now stores and uses oxygen, and in a rearrangement of its senses to suit a world that is largely acoustical, not visual or olfactory, in its stimulations.

When I breathe this Arctic air, 34 percent of the oxygen is briefly stored in my lungs, 41 percent in my blood, 13 percent in my muscles, and 12 percent in the tissues of other of my organs. I take a deep breath only when I am winded or in a state of emotion; the narwhal always takes a deep breath—its draft of this same air fills its lungs completely. And it stores the oxygen differently, so it can draw on it steadily during a fifteen-minute dive. Only about 9 percent stays in its lungs, while 41 percent goes into the blood, another 41 percent into the muscles, and about 9 percent into other tissues. The oxygen is bound to hemoglobin molecules in its blood (no different from my own), and to myoglobin molecules in its muscles. (The high proportion of myoglobin in its muscles makes the narwhal's muscle meat dark maroon, like the flesh of all marine mammals.)

Changes in the narwhal's circulatory system—the evolution of *rete mirabile,* "wonder nets" of blood vessels; an enlargement of its hepatic veins; a reversible flow of blood at certain places—have allowed it to adapt comfortably to the great pressures it experiences during deep dives.

There is too little nitrogen in its blood for "the bends" to occur when it surfaces. Carbon dioxide, the by-product of respiration, is effectively stored until it can be explosively expelled with a rapid flushing of the lungs.

It is only with an elaborate apparatus of scuba gear, decompression tanks, wet suits, weight belts, and swim fins that we can explore these changes. Even then it is hard to appreciate the radical alteration of mammalian development that the narwhal represents. First, ours is largely a two-dimensional world. We are not creatures who look up often. We are used to exploring "the length and breadth" of issues, not their "height." For the narwhal there are very few two-dimensional experiences—the sense of the water it feels at the surface of its skin, and that plane it must break in order to breathe.

The second constraint on our appreciation of the narwhal's world is that it "knows" according to a different hierarchy of senses than the one we are accustomed to. Its chemical senses of taste and smell are all but gone, as far as we know, though narwhals probably retain an ability to determine salinity. Its tactile sense remains acute. Its sensitivity to pressure is elevated—it has a highly discriminating feeling for depth and a hunter's sensitivity to the slight turbulence created by a school of cod cruising ahead of it in its dimly

lit world. The sense of sight is atrophied, because of a lack of light. The eye, in fact, has changed in order to accommodate itself to high pressures, the chemical irritation of salt, a constant rush of water past it, and the different angle of refraction of light underwater. (The narwhal sees the world above water with an eye that does not move in its socket, with astigmatic vision and a limited ability to change the distance at which it can focus.)

How different must be "the world" for such a creature, for whom sight is but a peripheral sense, who occupies, instead, a three-dimensional acoustical space. Perhaps only musicians have some inkling of the formal shape of emotions and motivation that might define such a sensibility.

The Arctic Ocean can seem utterly silent on a summer day to an observer standing far above. If you lowered a hydrophone, however, you would discover a sphere of "noise" that only spectrum analyzers and tape recorders could unravel. The tremolo moans of bearded seals. The electric crackling of shrimp. The baritone boom of walrus. The high-pitched bark and yelp of ringed seals. The clicks, pure tones, birdlike trills, and harmonics of belugas and narwhals. The elephantine trumpeting of bowhead whales. Added to these animal noises would be the sounds of shifting sediments on the sea floor, the whine and fracture of sea ice, and the sound of deep-keeled ice grounding in shallow water.

The narwhal is not only at home in this "cacophony," as possessed of the sense of a neighborhood as we might conceivably be on an evening stroll, but it manages to appear "asleep," oblivious at the surface of the water on a summer day in Lancaster Sound.

Narwhals, it is believed, use clicking sounds to locate themselves, their companions, their prey, and such things as floe edges and the trend of leads. Pulsed tones are thought to be social in nature and susceptible to individual modification, so each narwhal has a "signature" tone or call of its own. Pure-tone signals, too, are thought to be social or communicative in function.

I dwell on all this because of a routine presumption—that the whale's ability to receive and generate sound indicates it is an "intelligent" creature—and an opposite presumption, evident in a Canadian government report, that the continuous racket of a subsea drilling operation, with the attendant din of ship and air traffic operations, "would not be expected to be a hazard [to narwhals] because of . . . the assumed high levels of ambient underwater noise in Lancaster Sound."

It is hard to believe in an imagination so narrow in its scope, so calloused toward life, that it could write these last words. Cetaceans may well be less

"intelligent," less defined by will, imagination, and forms of logic, than we are. But the *idea* that they are intelligent, and that they would be affected by such man-made noise, is not so much presumption as an expression of a possibility, the taking of a respectful attitude toward a mystery we can do no better than name "narwhal." Standing at the edge of a cliff, studying the sea-washed back of such a creature far below, as still as a cenobite in prayer, the urge to communicate, the upwelling desire, is momentarily sublime.

I stare out into the Lancaster Sound. Four or five narwhals sleep on the flat calm sea, as faint on the surface as the first stars emerging in an evening sky. Birds in the middle and far distance slide through the air, bits of life that dwindle and vanish. Below, underneath the sleeping narwhal, fish surge and glide in the currents, and the light dwindles and is quenched.

The narwhal's fate in Lancaster Sound is clearly linked with plans to develop oil and gas wells there, but current hunting pressure against them is proving to be as important a factor. In recent years Eskimo hunters on northern Baffin Island have exhibited some lack of discipline during the spring narwhal hunt. They have made hasty, long-range, or otherwise poorly considered shots and used calibers of gun and types of bullets that were inadequate to kill, all of which left animals wounded. And they have sometimes exceeded the quotas set by Department of Fisheries and Oceans Canada and monitored by the International Whaling Commission. On the other side, Eskimos have routinely been excluded from the upper levels of decision-making by the Canadian government in these matters and have been offered no help in devising a kind of hunting behavior more consistent with the power and reach of modern weapons. For the Eskimos, there is a relentless, sometimes condescending scrutiny of every attempt they make to adjust their culture, to "catch up" with the other culture brought up from the south. It is easy to understand why the men sometimes lose their accustomed composure.

In the view of Kerry Finley, a marine mammal biologist closely associated with the Baffin Island narwhal hunts, "It is critical [to the survival of narwhals] that Inuit become involved in meaningful positions in the management of marine resources." The other problems, he believes, cannot be solved until this obligation is met.

I would walk along the floe edge, then, in those days, hoping to hear narwhals, for the wonder of their company; and hoping, too, that they would not come. The narwhal is a great fighter for its life, and it is painful to watch its struggle.

When they were killed, I ate their flesh as a guest of the people I was among, out of respect for distant ancestors, and something older than myself.

NOTE

1. Lancaster Sound has been proposed as a world biological reserve by the International Biological Programme and singled out by the United Nations as a Natural Site of World Heritage Quality. The stability of this ecosystem is currently threatened by offshore oil development and increased shipping traffic.

We Will Fight to Protect the Arctic Ocean and Our Way of Life

ROBERT THOMPSON, ROSEMARY AHTUANGARUAK,
CAROLINE CANNON, *and* EARK KINGIK

❖

Iñupiaq conservationist Robert Thompson has been a mentor to me since I began my engagement with the Arctic—in his village Kaktovik, along the Beaufort Sea, in March 2001. Over the past decade, we spent a lot of time together—in the Arctic National Wildlife Refuge; lobbying in Washington, DC; giving talks together in many venues across the US; and a three-week-long trip to Siberia to visit two indigenous communities, the Eveny and the Yukaghir, on assignment from Vanity Fair. *Robert has been fighting oil development in his homeland for nearly three decades—onshore drilling in the coastal plain of the Arctic Refuge, and more recently offshore drilling in the Arctic Ocean.*

Iñupiaq conservationist Rosemary Ahtuangaruak is also a mentor to me. No one in Arctic Alaska has spoken out with as much first hand experience and as passionately about the health impacts of oil development on the North Slope as Rosemary. As a community health aide, she watched more and more people get sick as oil development got closer to and spread around her village—Nuiqsut, an Iñupiat community that was her home from 1986

until 2010, when she moved to Barrow. At times, powerful pro-oil development people tried to discredit her: "She doesn't know what she is talking about." But they could not silence her. In late 2010, when Shell was spending a lot of money on ads and kept pressuring the Obama administration to grant them the permit to drill in the Arctic Ocean, I invited Rosemary to contribute a story for ClimateStoryTellers.org that I had founded only a few months before. Her story, "Shell's Arctic Drilling Will Destroy Our Homeland and Culture," was widely distributed in the progressive media.

I first met Iñupiaq Elder and conservationist Earl Kingik in Fairbanks in 2006. Then Secretary of Interior Dirk Kempthorne had come to Fairbanks to listen to the people about oil and gas development—a nationwide initiative he had launched called "the listening session." After he listened to the audience, who were overwhelmingly in opposition to drilling in the Arctic Refuge, the Teshekpuk Lake Wetland, and the Beaufort and Chukchi seas, he told us that he heard our concerns but he must follow the mandate of the President—sell all this land and water to Big Oil. To remember the farcical nature of his listening session, I took a photograph of my friends—Robert Thompson, Luci Beach, Earl Kingik, Sarah James, Rosemary Ahtuangaruak, Pamela Miller, Fran Mauer, Richard Fineberg, and Aaron Wernham. In 2002, Robert, Rosemary, Earl, and other indigenous activists from Alaska founded REDOIL—Resisting Environmental Destruction on Indigenous Lands.

In 2007, Peter Matthiessen and I visited Point Hope—an Iñupiat village along the Chukchi Sea, considered the oldest continuously inhabited settlement in North America. There, I met Iñupiaq conservationist Caroline Cannon. Then, as a council member of the Native Village of Point Hope and later as its president, Caroline has been fighting offshore oil development with her impassioned leadership.

Here are four testimonies—by Robert, Rosemary, Caroline, and Earl—their collective voice to protect the Beaufort and Chukchi seas and their way of life.

❧

ROBERT THOMPSON:
Why Can't We Get Answers to Our Questions? (2011)

My wife, Jane Thompson, and I live in Kaktovik, Alaska. Our town is on Barter Island, an island on the Beaufort Sea, bordering the Arctic National Wildlife

Refuge. I am Iñupiaq. My people have resided here for thousands of years. I believe my people are here because of the marine mammals. The central part of our culture is the bowhead whale.

Our culture is in serious peril now. Quite possibly we may be seeing the end of it due to the quest for oil. Shell Oil and other companies are proposing to drill for oil in the Arctic Ocean. Alarmed by such destructive projects, in 2002 I became a founding member of Resisting Environmental Destruction on Indigenous Lands (REDOIL)—an organization founded and operated by indigenous people of Alaska.

My family name is Aveoganna. My mother was originally from Wainwright, an Iñupiat village on the northwest coast of the Chukchi Sea. She moved to Fairbanks, where I was born. After I married Jane Akootchook, we began to travel to Kaktovik, her hometown, frequently, starting in 1972. In 1988, I made Kaktovik my home.

Our culture is based on hunting activities. I have hunted marine animals, such as bowhead whales, polar bears, and seals; land animals, such as musk ox, Dall sheep, brown bears, and caribou; and waterfowl along the coast. The activities we participate in are communal activities. It is much more than just acquiring meat—it is interaction with other people and a tie to the past.

My first successful bowhead whale hunt occurred during the spring of 1970. I was on the whaling crew of my uncle, Winfred Ahvakana, at Point Barrow—the largest Iñupiat village, at the confluence of the Beaufort and Chukchi seas. We used traditional equipment—an *umiat*, a traditional boat made from bearded seal skins, and paddles—to pursue the whale.

I have been a member of my wife's father Isaac Akootchook's whaling crew for many years. I feel very fortunate to be a part of these hunts that take place in the Beaufort Sea. The Kaktovik whale hunt typically begins on Labor Day weekend in early September, and continues until the village has met its annual harvest quota of three whales—typically through September, and sometimes into October.

All of the activities related to whaling give our people purpose. Whaling involves many members of the community who participate in different ways: crew members go out in the boat; nearly everyone participates in the butchering of a whale; many women cook the meat; people in the community, including myself, use baleen from the whale to make model boats or other crafts. Whale *maktak* and meat is shared amongst everyone in the community. Were it not for the whales, other marine life, and birds, I feel that our ancestors could not have survived in the Arctic.

Each part of the year has unique activities that we look forward to. Spring is the time to hunt waterfowl—eider and other ducks, and geese along the coast. We hunt bearded and ringed seals every year in the Beaufort Sea. The seals provide us meat and oil. We use the oil as dipping sauce for frozen fish and dried meat. I have seen many ringed and bearded seals in coastal waters of the Beaufort Sea—from Flaxman Island and the mouth of the Canning River, about sixty miles west of Kaktovik, to the waters a few miles east of Kaktovik. I hunt seals in open water by boat from July through September, often in conjunction with trips when I go camping and caribou hunting. During summer months I also fish with nets along the Beaufort Sea coast for char and whitefish, also known as Arctic cisco.

The ocean has sustained Iñupiat people for thousands of years, and I wish to pass that along to future generations to enjoy as I have. I fear that if Shell's proposed exploration drilling activity proceeds, our culture and the ocean that we depend on could be seriously harmed.

I am concerned that the animals of the Arctic are already very stressed by climate change, and that all of the industrial activities associated with Shell's exploration drilling will only increase the stress that these animals have to endure. Shell's proposed activities, which include icebreaking, drilling with a drillship, and traffic from support vessels and helicopter and aircraft flights, could have a devastating impact on our culture. The increased noise pollution from these industrial activities has the potential to divert bowhead whales from their migratory path or chase them from their feeding grounds to areas beyond where we can reach them by our traditional means. If Shell's activities deflect the whales or pollute the ocean so that the whales cannot survive, we will not be able to hunt bowhead whales, and a central part of our culture, which has existed for thousands of years, will be lost. It pains me to think that our culture could be displaced by the actions of a foreign corporation.

Oil companies do not have the technology to clean up oil in the Arctic Ocean. We have asked very basic questions, but we, the indigenous people, were not given the respect of having our concerns addressed. In public meetings in Kaktovik, I have repeatedly asked the Mineral Management Service and Shell this question: Can oil be cleaned up—from on the ice, in the water, and under the ice in the Arctic Ocean? No one has adequately answered this question in the affirmative. The president of Shell Oil has not answered this question, our congressional delegation has not answered this question, nor has the government of Alaska. It is such an easy question. Why can't we get

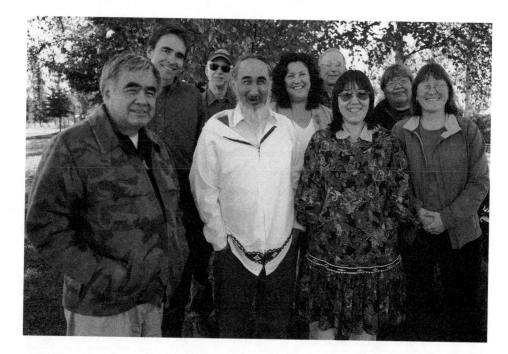

After Secretary Kempthorne's Listening Session in Fairbanks: "We were pissed; we only smiled for the photo." From left to right: (1st row) Robert Thompson, Earl Kingik, Rosemary Ahtuangaruak; (2nd row) Aaron Wernham, Luci Beach, Pamela Miller; (3rd row) Richard Fineberg, Fran Mauer, Sarah James. The Secretary of Interior Dirk Kempthorne had come to Alaska to listen to the people. After hearing overwhelming opposition to oil and gas development in the Arctic National Wildlife Refuge, Teshekpuk Lake Special Area, and the Beaufort and Chukchi seas from indigenous people and conservationists who had gathered, Secretary Kempthorne told the audience that he had listened to everyone's concerns but that he had to follow the President's [George W. Bush] mandate [to open up the Arctic to oil and gas development]. *(Photograph by Subhankar Banerjee, August 2006.)*

an answer? Quite possibly because it cannot be cleaned. I read a recent report from the Bureau of Ocean Energy Management that states if an oil spill were to happen late in the drilling season, it would be next year before any possible cleanup would happen. We wonder: How can our government do this to us?

It gets worse. The ice is moving. Nine months after a spill, the oil would have traveled three hundred to five hundred miles. A requirement for drilling in the Arctic mandates that the US Coast Guard be responsible to oversee spill response. But there is no Coast Guard operation in the Arctic. They don't have any boats up here. There are 280 people living in Kaktovik. There were 23,000 people who worked on cleaning up the *Deepwater Horizon* oil spill in the Gulf of Mexico. We couldn't accommodate that many people here. Shell Oil's response: The Coast Guard is not needed; they do not do clean up anyway. To have Shell Oil responsible for cleanup oversight is not acceptable. On the honor system? Not acceptable to us. Shell is a for-profit corporation; its interests are not the same as ours.

We have become more aware of the oil industry's lack of cleanup abilities because of the recent spills in the Gulf of Mexico and off the coast of Australia. The public is aware of the inadequate spill response, in spite of having more than a thousand boats and more than twenty-three thousand people to do the cleaning in very benign weather. There was no ice covering the spill. The oil industry has told us that oil spill response was developed in Norway. A very recent spill in Norway indicates by their own admission that they didn't have adequate clean-up abilities. Several years ago, a spill of twenty-five thousand barrels happened off the shore of Norway in twenty-two-foot-high seas. I do not recall anyone reporting that any of it was cleaned.

We are told that dispersants would be used to minimize spill effects. Dispersants were used in the Gulf spill. Studies have shown that dispersants have adverse effects. We ask: How long will oil be toxic in the cold Arctic water? No answer. We ask: How effective will dispersants be in the Arctic environment? Still no answer that would be acceptable to anyone but the oil industry. To a layman, the dispersants are used to keep the oil from coming to the surface where it can be seen—out of sight, out of mind.

Our federal government had oil exploitation in the Arctic Ocean on a very fast track. Environmental concerns were ignored. In 2010, corruption was uncovered in the Mineral Management Service, and that division of the Department of Interior was abolished and replaced with the Bureau of Ocean Energy Management, Regulation and Enforcement (BOEMRE). Court proceedings were initiated and rulings in favor of the environment finally

prevailed, with the board of the Environmental Protection Agency denying Shell an air quality permit for their 2011 exploration drilling in the Arctic seas. In my opinion, until the federal government and Shell and other companies can definitively demonstrate that spilled oil can be effectively cleaned up in the Arctic Ocean, exploration drilling and oil development should not occur in the Beaufort and Chukchi seas.

Will drilling be stopped to protect the Iñupiat culture? I think not. Our country has a history of disregarding indigenous cultures. Many indigenous people were put on reservations so people from the dominant culture could access what the indigenous communities had. Will concern about the amount of pollution that will be created from burning the estimated 25 billion barrels of oil (that could be extracted from the Arctic seas in Alaska) affect the decision? I think not. I traveled to Los Angeles forty-five years ago, and they were living in smog then. When I traveled there a few years ago, they were still living in smog. Perhaps this calculation might sway people to start the transition to clean alternative energy: 25 billion times 42 gallons per barrel times 5 dollars per gallon. This is the approximate amount of money that would go to a foreign company—Shell Oil. And the oil will go to the world market; we'll not get any price break here in the US.

We Iñupiat wonder, why doesn't the oil industry drill off the coast of California? Why not near Florida? Why not off the Atlantic coast? People know there is oil over there. It would be cheaper, with a shorter distance to move it. Drilling in the Arctic Ocean is an environmental justice issue; it is a human rights issue. Sometimes I think we might lose our culture, our way of life; people don't care, and greed for oil and money might prevail. But then I think, by stating my opinions, future generations of Iñupiat will know that some of us cared and tried to stop what is being done to us.

I am also a wilderness guide for visitors to the Arctic. On one side of my home is the Arctic National Wildlife Refuge and on the other is the Beaufort Sea. I have guided photographer Subhankar Banerjee since 2001. During 2001 and 2002 we traveled together four thousand miles in the Arctic Refuge in all seasons. Since then we have done many trips together, including a trip to Siberia to meet two indigenous communities there, the Eveny and the Yukaghir. I have also guided other photographers and writers who came to our homeland from many other countries, including Australia, New Zealand, India, South Africa, England, the Netherlands, Switzerland, and France. I want the world to know about our culture and the animals that live here, with the hope that they will help us fight our fight against the industrial destruction of our homeland.

During the Bush administration, we faced the serious threat of opening up the Arctic National Wildlife Refuge to oil development, something my wife and I have opposed since 1988. The oil lobby group, Arctic Power, in Alaska, and pro-development politicians were saying to mainstream media that the majority of people in Kaktovik want to open up the Arctic Refuge to oil. There was a survey done sometime around 2000 that showed that 72 percent, a majority of people in Kaktovik, support development. This was a survey conducted by pro-oil people—but people like me, my wife Jane, her sister Susie, and others who oppose development weren't even asked to participate in the survey. The survey wasn't done in an open public format. For a little while I began to believe in the results of the survey, but then in 2005, I decided to circulate a petition in Kaktovik to oppose oil development in the Arctic Refuge. We had 57 people sign the petition. To provide a perspective, Kaktovik at the time had a population of about 275 to 300 people, and in the previous election, 97 people voted. We realized that 57 people out of 97 who voted is a majority. The same year, Senator Joe Lieberman entered our petition in the congressional record—I watched the news on CNN from my living room in Kaktovik.

However, the pro-oil politicians continued to misrepresent us. Senator Lisa Murkowski visited Kaktovik. I spent nearly two hours with her and told her all about the petition and told her that it is a real possibility that the majority of people in Kaktovik oppose oil development in the Arctic Refuge. But later on Alaska news on television, she said that a recent survey showed that a large majority of people in Kaktovik supports development and didn't mention a word about our petition.

I'll speak out every chance I get when politicians misrepresent us. I have been to our capitol many times to inform members of Congress about our concerns. We bring them information about the need to protect places from oil exploitation. We bring factual information. It is our hope that if people have good information, they will make the right decisions.

In addition to the threat of oil, we're experiencing firsthand the most severe impacts of climate change in the Arctic every day. In 2010, I traveled nine thousand miles to Cochabamba, Bolivia, on an invitation from Bolivia's President Evo Morales as part of a group of nineteen indigenous people from North America. The purpose of the gathering was for indigenous people from many nations to address their concerns about climate change. President Morales and many others did not believe that the 2009 United Nations Climate Change Summit in Copenhagen adequately addressed the concerns

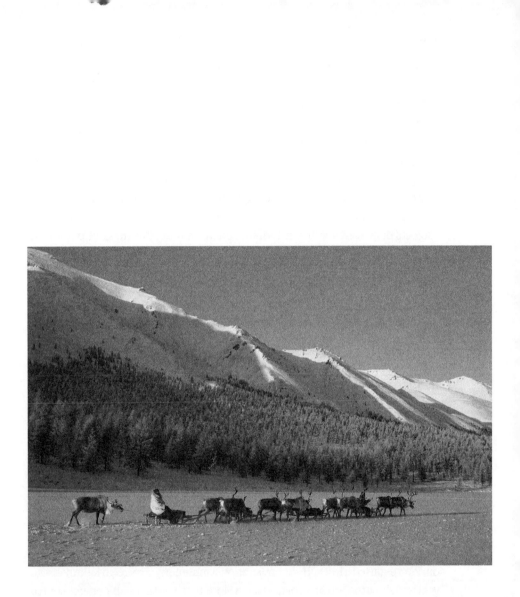

From Eveny reindeer camp along the Korechan River valley to Zaboina, Maksim Nikolayev drives the reindeer sledge with Samona Kurilova in the middle and Robert Thompson in the back, Verkhoyansk Range, Yakutia, Siberia. *(Photograph by Subhankar Banerjee, November 2007.)*

of indigenous peoples. We, the indigenous people who are close to the land, have no doubt that climate change is happening, and we understand the seriousness of it. Cochabamba is at a high elevation and is almost a desert. One of the local stories we heard at the gathering was that the glaciers from which the Bolivians get their water supply are disappearing. An indigenous woman from the Amazon told us a story about how Alcoa, the aluminum company, came into the Amazon and over time built 350 dams on the Amazon and its various tributaries to support the massive energy needs required to produce aluminum. Instead of benefiting the local indigenous population, the projects displaced about a million people to support this massive operation. They were trying to stop one last dam. She told us, "If Alcoa tries to build it, there will be war."

The experience made an impression on me. We felt we were part of a movement in which people are acknowledging climate change and are attempting to do something about it. The one message that came through was that we must take care of the earth. We are very aware of the seriousness of what we must do. It is the life of the earth, and our lives and the lives of future generations, that are in peril.

The effects of climate change are caused by our excessive use of fossil fuel. As the effects become more obvious, the oil industry accelerates the efforts to drill in more difficult places. We must stop our dependence on oil. It is taking our country down—we're spending money on dirty energy sources and fighting wars in faraway places to protect our oil interests. Everyone must begin to make the change from fossil fuel to clean, sustainable energy sources.

We founded REDOIL in order to preserve our culture by protecting our lands from exploitation. We are dedicated to making the transformation from oil to clean energy, to advocate for clean sustainable energy that is not dependent on oil. We've started a REDOIL demonstration wind-energy project in Kaktovik. Our goal is to show to the people of the North Slope that wind is a viable energy source. It blows here enough for electricity generation 99 percent of the year. Today, Kaktovik burns on average one thousand gallons of diesel a day for electricity generation. In addition, we burn diesel to heat homes. Right now, the commercial rate in Kaktovik for diesel is $7 per gallon. With wind energy, we could be saving about $2.5 million per year just for electricity generation in my small community of about three hundred people in the Arctic. This would be an ideal place to start using wind for energy. We're determined to show that it is possible.

We need to change to clean energy, now! Perhaps by doing so, we will protect the planet's last pristine places for future generations—mine and yours. If

we don't, future generations will look at us and they will wonder: What kind people were they, to use up all the resources and not be concerned about what was left for us? We don't want Shell or any other oil company coming here to destroy the Arctic National Wildlife Refuge or the Arctic Ocean. We'll continue to fight the destruction of our homeland from climate change and by the oil companies.

ROSEMARY AHTUANGARUAK:
Arctic Oil Development Is Destroying Our Health and Culture (2011)

I have lived on the coast of the Arctic Ocean for most of my life. I lived in Nuiqsut, an Iñupiat community on the Beaufort Sea coast of Arctic Alaska from 1986 until May 2010, when I moved to Barrow, the largest Iñupiat community, at the confluence of Beaufort and Chukchi seas. After graduating from the University of Washington Medex Northwest Physician Assistant Program, I was employed as a health aide in Nuiqsut for fourteen years. There are no resident doctors in the villages; they travel there three or four times a year, and the health aides work with them to provide health care for our village.

I raised my family in Nuiqsut. I have one daughter, four sons, four grand-daughters, and six grandsons. I live a traditional lifestyle—hunting, fishing, whaling, and gathering. I also teach our family and community members the traditional and cultural activities as my Elders taught me. We hunt and eat various birds, including ptarmigan, ducks, and geese; fish, including char, salmon, whitefish, Dolly Varden, grayling, pike, trout, and cisco; land mammals, including caribou, moose, and musk oxen; and marine mammals, including bearded seals, walruses, beluga, and bowhead whales. We also harvest berries, plants, roots, and herbs.

We work together in harvesting plants and animals. We have extensive shar-ing traditions that unite our families and communities. Other communities share their harvests with my family and we share our harvests with others. These sharing patterns have given us much of the variety of foods that we eat. We also share our harvest with those in need. We need food from the land and the seas to survive through the long, dark winters.

I embrace the traditional and cultural activities that I learned from my Elders and extended family members. My mother taught me the land hunting skills that she learned from her parents and family. Other family members

taught me how to hunt whales and other marine mammals. Sharing and passing these traditions onto my children, grandchildren, and families is very important to me.

The village where I raised my family, Nuiqsut, is located west of the Arctic National Wildlife Refuge and the Prudhoe Bay oil fields, near the Beaufort Sea coast in the Colville River delta. Nuiqsut is surrounded by oil pipelines from the Alpine oil field less than four miles away, often referred to as an example of industry's footprint. When the oil industry first proposed to build the Alpine oil field next to our village, we were promised jobs and a small industrial footprint. The footprint has grown to more than 570 acres, and very few people from our community were offered jobs to build the continuously evolving fields around us.

Tons of toxic pollutants are emitted near our community from the Alpine development. Air pollution is visible over the North Slope as a yellowish haze. Nitrogen oxide emissions from these oil fields are more than twice the total emitted in Washington, DC. During the winter, many natural gas flares occur, which caused me to have many busy nights on calls responding to community members' complaints about respiratory illnesses.

When I started my career as a health aide in 1986, there was only one asthma patient in my community. By the time I went to the University of Washington for my physician assistant certificate in 1989, there were about twenty-five. When I came back in 1991, there were thirty-five. When I took a break from my job as a community health aide in 1997, there were sixty people who had to use respiratory medications—a 600 percent increase in respiratory patients in a village of 400 people. When I stopped working at the clinic in 2000, there were seventy-five, with the numbers still increasing.

What was contributing to this increase in respiratory illnesses? The most overwhelming issue was that oil development around Nuiqsut had increased, and had gotten closer. The worst nights on call were nights when many natural gas flares occurred. Those flares release particles that traveled to us. Increased concentrations of particulate matter from flares occur during inversions, a bowl-like trap, with cold air trapped by warm air.

When I was in Nuiqsut, there was a report called the "health consultation" that came out. It was first discussed in Barrow and then it trickled back to Nuiqsut. The report suggested that we not consume more than six burbots in a year, because there were contaminates in the fish. The authors of the report did not come to our village for a whole year. Finally, when they did come, they said to go ahead and eat the fish, because there are other foods that have

Whaling captain Chuck Hopson and his crew pauses for a prayer prior to heading out on the pack ice for spring whaling, Barrow. *(Photograph by Steven Kazlowski, April 2007.)*

higher levels. They did not take into consideration the way we eat the fish, the quantities we eat, and that the liver is a delicacy that is shared with the Elders and children. We might serve six livers during one meal. The highest concentration of PCB and DDT was in the liver. The efforts of our people to share this delicacy meant we were giving it to the people most at risk.

There are other persistent organic pollutants that are now concentrating in our animals. There are studies of polar bears that are showing health concerns. These pollutions from industry elsewhere are coming to our lands because of the way air currents and precipitation work. These faraway toxins add to what is coming from our homeland—the oil fields of Prudhoe, Alpine, and Kuparuk. These persistent organic pollutants concentrate in us through consumption of our food. They accumulate in our bodies, our livers, our kidneys, our breast milk, and our children.

In April 2011, I traveled to Washington, DC to testify at a hearing on the Clean Air Act. Certain members of the US House of Representatives were planning to undermine this crucial act that protects our health. The Clean Air Act has saved more than two hundred thousand lives and prevented millions of asthma attacks, heart problems, and other serious illnesses. Those deaths weren't prevented, those illnesses weren't averted, and those kids weren't saved because the Environmental Protection Agency went door to door to polluters and said, "Pretty please, won't you clean up?" Lives are saved and health is improved when we let the experts at the agency responsible for making sure our air and water are clean and safe set the standards and then hold polluters accountable.

Air pollution isn't the only problem. We have water quality changes, land use conflicts, oil spills, noise pollution, increased traffic, and disturbances to fish and wildlife species. Also, the social fabric of the community is under stress: truancy, vandalism, domestic violence, alcohol and drug abuse, and suicide all increased after oil development came near Nuiqsut.

Our food sources have also undergone great changes since oil development surrounded us. Seismic vibrators looking for oil and frequent helicopter flights have disturbed the caribou herd near where I used to live. The migration used to come right into our town, but the caribou do not come through Nuiqsut anymore, and most of our hunters have found it takes many trips to harvest caribou. Our Elders tell me that the caribou are having problems, as more caribou are seen with illnesses.

I traveled to all the North Slope Iñupiat villages in 2010. Community members shared concerns about our animals, from the lemmings in Point Lay to the seals in Barrow, Wainwright, and Point Hope. All villages expressed

concern about traditional and cultural activities changed by the oil and gas activities. Fish have been decreasing in numbers, and multiple species are being affected. Fish caught in our nets have been deformed and look yellow, or have been found with increased parasites or tumors in the muscle or reproductive glands. Some are skinny and taste bitter.

I have seen firsthand how the Alpine oil field affected our cultural camp at Nigliq and on the Colville River. There is a growing need to work in cultural camps that teach the next generation our hunting traditions. But teaching the young harvesters our traditions is getting harder because of the oil and gas development that drives animals away from our camp. For example, the caribou herds are kept miles away by traffic that includes freighter flights, helicopters, and airboats. When industrial activities that conflict with traditional and cultural activities are permitted to dominate our landscape, traditional usages of the areas that have persisted for generations lose out to expanding oil and gas infrastructure.

These impacts from onshore development are a harbinger of what could come with proposed offshore drilling.

More than anything else, Iñupiat communities across the Arctic coast of Alaska primarily depend on bowhead whales for subsistence food, and our culture is tied intimately with the whales and the sea.

The federal government has already sold leases to Shell in the Chukchi and Beaufort seas, and is now considering allowing exploratory drilling there. I am concerned that Shell's exploration drilling, icebreaking, aircraft and helicopter flights, and other noisy activities in the Chukchi and Beaufort seas will keep whales from their feeding areas or otherwise harm them. Any changes in the whale populations could affect our hunting. If the whale hunts are less successful, I fear that the community will suffer as it has in the past during times of shortage. To give an example, in the early 1990s, seismic activities and exploration drilling in Camden Bay severely affected our whaling. The following winter, I heard of an unusually high rate of domestic violence in Nuiqsut, and increases in suicide attempts and suicides. I heard of and witnessed increases in drug and alcohol use as well. As a community health aide, I listened to people's stories of how difficult it was to hunt without success—that winter was worse. The experience prompted me to speak out at meetings about oil development.

I am also concerned that helicopters and other aircrafts associated with Shell's offshore drilling will affect caribou along the coast, and make the

caribou avoid hunting areas, including traditional migratory routes and areas used for insect relief.

The disconnect between our concerns and continual government permitting of oil and gas activities in our region is stark. Generations of our people have discussed and put together comments, mitigation measures, restrictions, and prevention attempts. Yet the government has not prevented the loss of traditional and cultural activities, impacts that the Council on Environmental Quality for the Bush administration told us were illegal. State and federal governments push the permitting process without looking at the losses created for us. We pushed for deferral and permanent restrictions of industrial activities during our whaling at Cross Island, and we were kept out of meetings that changed these discussions. That also was illegal, yet the Obama administration has allowed industrial activities to continue. The National Marine Fisheries Service has stated that oil and gas activities should be postponed until baseline data can be obtained, yet no new information exists to guide decisions. We fought for restrictions that were not honored.

In early November 2010, there were federal government hearings in several Iñupiat communities, including Barrow, Kotzebue, Point Hope, Point Lay, and Wainwright, to hear our concerns about Shell's Arctic drilling. I attended the hearing in Barrow, where I've been living since May of 2010. About sixty people attended the Barrow hearing, and, overwhelmingly, the statements were in opposition to Shell's drilling plan. The hearing showed the continued concerns of the lack of ability to respond to a spill, the lack of taking the concerns of the people into meaningful consideration, the lack of willingness to protect our traditional and cultural activities, and the stress and strain this is causing to our people. The destruction stays with us while the benefits are taken elsewhere. None of it is worth the risk to harvesting, sharing, celebrating, consuming, teaching, constructing crafts, preparing foods, planning, feasting, dancing, and singing.

Hotdogs offered by industry in their meetings cannot replace the loss of our traditional and cultural foods and activities.

Our way of life could be destroyed in an instant if Shell were to drill and cause a large oil spill. In 2010, I traveled to the Gulf of Mexico to learn more about the communities, animals, and ecosystems impacted by the tragic BP oil spill. I returned, having witnessed the trauma of the people who felt the devastation to that area. That trip is a strong burden that I'll carry with me for the rest of my life. It brought tears to my eyes—fumes of the spill were permeating the air. It got into our clothes, into our nose, and into our hair.

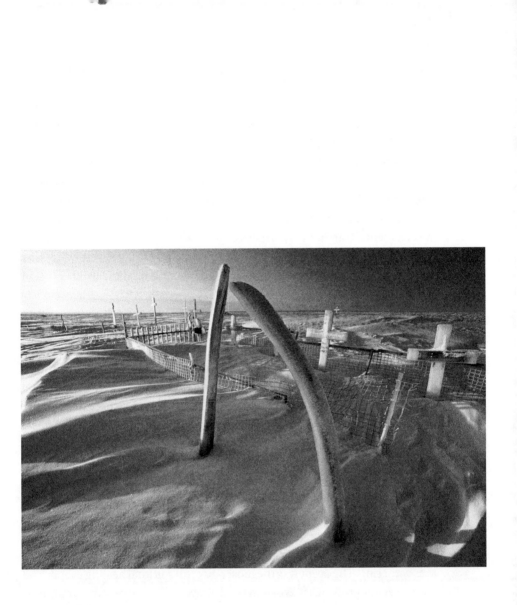

Iñupiat cemetery marked by bowhead whale jawbones, Kaktovik. *(Photograph by Subhankar Banerjee, November 2001.)*

As we traveled out onto the water, it only got worse. The people living down there had no escape—the natural smell of the ocean was nonexistent.

The Arctic's extreme conditions and isolation make it nearly impossible to clean up an oil spill. All this is widely known, yet the federal government is still allowing the oil industry to push forward with aggressive drilling plans as if disasters like last year's *Deepwater Horizon* spill in the Gulf of Mexico or the *Exxon Valdez* spill twenty-two years prior in Prince William Sound never happened. If it is allowed to happen in the Arctic, my home, my culture, my people will be destroyed forever. We want to be Iñupiat into the future, not just residents in an industrialized area destroyed by Shell's offshore oil drilling. Our animals, land, and seas in the Arctic are already severely stressed by climate change. We don't want Shell's dangerous offshore drilling to add to our difficulties.

With prayers and guidance from our Elders, I have worked on issues to promote the protection of our health, traditions, and culture. New opportunities arise when I share stories with others who can affect decisions that impact where I live. One such opportunity was when I met a grandmother at a community health aide training. Rita Pitka Blumenthal, from the Bethel area in southwest Alaska, is a traditional healer who has used the gifts of touch taught by her Elders on patients who come to the Alaska Native Medical Center and the Alaska Native Traditional Health Center for care. She heard me speak at the Bioneer's Conference and encouraged me to participate at the International Council of Thirteen Indigenous Grandmothers gathering. Three grandmothers from Nuiqsut gave me the support to speak out at the ninth grandmothers' gathering, which took place in Anchorage, Alaska, in May 2011. The theme was "Healing the Spirit from the Light Within." I prayed before I entered the clinic and any meeting, and for insight on how to participate in this gathering. The event was the most powerful spiritual healing event that I have ever undertaken. I was blessed with prayer and fire ceremony, traditions and culture from all over the world coming to Anchorage to bless Mother Earth and pray for healing from all the things that have been happening.

It had been a long, tiresome process, attending up to thirty meetings in one month related to the oil and gas development process. I had faced many companies with multitudes of staff and dollars, government agencies and researchers looking to promote changes to the lands and waters where I live. The process had really taken a toll on my health and my family more than I realized. Through the process of prayer and blessing at the grandmothers' gathering, many layers of pressure and oppression were lifted as a veil, drifting

away with the smoke of the bonfire. I know I would not be the same person writing this if I had not participated.

Take time to keep your inner light strong, eat your traditional foods, spend time in your special places, and share the stories of your Elders, of the lives and the places that are important to you. Bring these stories to the meetings in your communities to help protect the health, tradition, and culture. Build your inner light by working with those around you to help share ways that can keep our lands and waters healthy, protecting our future generations. I want to offer much thanks to all who have helped me along my path, especially my mother and family, all the Elders of Nuiqsut, and the people who shared their stories with me.

Nearly nine years ago, we founded REDOIL to share information among tribal people, to help inform decision making, and to improve ways to work on our issues. We'll continue to fight destructive oil development practices in our Arctic homeland.

This essay is adapted from several writings by Rosemary Ahtuangaruak, including an essay titled "Shell's Arctic Drilling Will Destroy Our Homeland and Culture," published on ClimateStoryTellers.org on November 23, 2010; an April 13, 2011, testimony in front of the United States House of Representatives Committee on Energy and Commerce, Subcommittee on Energy and Power; an April 1, 2003, op-ed titled "The View Out My Window," published in the Anchorage Daily News *when the author was Mayor of Nuiqsut; a March 13, 2003, testimony for BLM's NPR–A NW Hearing in Washington, DC; and her standing declaration to oppose offshore oil development in support of the legal suit brought by the Native Village of Point Hope against the US Department of Interior, Shell, and Conoco Phillips.*

CAROLINE CANNON:
Testimony in Support of a Legal Suit (2009)

The Native village of Point Hope is a federally recognized tribal government under the 1934 Indian Reorganization Act, as amended in 1936 for Alaska Natives. The village, as directed by its council, is dedicated to protecting the interests, traditions, and way of life of its members, including advocating for the protection of subsistence resources in the Chukchi Sea upon which our culture and nutrition depends.

Point Hope is known to be the oldest continuously inhabited village in North America. The population varies from eight hundred to nine hundred community members depending on the season. We rely on subsistence resources

such as bowhead whale, beluga, seal, polar bear, fish, caribou, ducks, and geese. When we are very fortunate, we are able to harvest salmonberries and blueberries to supplement our diet. It is important therefore that our lands and water are clean for the animals and the plants.

In 1958, the US Atomic Energy Commission devised Project Chariot, a proposal to construct an artificial harbor at Cape Thompson about thirty miles from Point Hope on the North Slope of Alaska. Their plan was to create the harbor by burying and detonating a string of nuclear bombs.

With Project Chariot, the federal government took advantage of us. They treated us like we were nonexistent people. They had no consideration. They were ready to relocate us and told us that the radiation wouldn't harm us. They took something away from us then. It was trust. We were emotionally damaged—feeling that we didn't count, that we were nothing.

It seemed as if everyone supported Project Chariot but us, a few scientists engaged in environmental studies under Atomic Energy Commission contract, and a handful of conservationists. After a prolonged, controversial and incredibly draining fight, we were successful in stopping this plan. This story is documented in a book called *The Firecracker Boys*.[1]

Our tribal council at that time was very determined and felt that they had to do all they could to preserve our way of life. We still feel like that to this day. We must fight and do all we can to preserve our way of life even if we feel like we have been fighting the same fight for the last fifty years.

Even though the bombs were not detonated, the area is still radioactively contaminated by an experiment to estimate the effect that radioactive materials would have on water sources. Materials from a 1962 nuclear explosion at the Nevada Test Site were transported to our homelands in August 1962, used in several experiments, and then buried.

The federal government forgot about it for thirty years and when finally it was rediscovered, it turned out that there were low levels of radioactivity at a depth of two feet from the ground where our people and animals pass. Even though the government said they did the cleanup, there are still documents the government will not give us, through the Freedom of Information Act or otherwise. Who knows what those documents contain? The trust is gone. For a number of years we suspected that something was out there.

Many of our young people have died of cancer. My own daughter was diagnosed with leukemia in August of 2005, which is known to be linked to exposure to radiation. To see young people die in big numbers like that is alarming.

When I was mayor of Point Hope, I was invited to Washington, DC along with others from our community, for a ceremony in which President Bill Clinton made a public apology to Point Hope over Project Chariot.

We also had the White Alice Communications System. It was a United States Air Force telecommunication link system constructed in Alaska during the cold war. The system connected remote Air Force sites in Alaska, such as Aircraft Control and Warning, Distant Early Warning (DEW) Line and Ballistic Missile Early Warning System, to command and control facilities and in some cases it was used for civilian phone calls. Both Cape Lisburne and Point Thompson White Alice sites are located near Point Hope. Vandalism, unsafe conditions and environmental concerns led the Department of Defense to remove the physical structures at the sites between the late 1980s to the early 2000s. Cape Thompson and Cape Lisburne were found to be contaminated because of PCB usage and fuel leakage from storage tanks.

We continue to be highly concerned about contamination at Project Chariot and White Alice sites. We fear that they haven't been cleaned up properly, and that our subsistence foods are still contaminated.

The cultural and subsistence traditions of Point Hope are inextricably linked to the health of the Arctic ecosystem and the resources of our traditional lands and waters. I have been a subsistence user all of my life. I participate in hunting *Agviq* (bowhead whale). My parents were both known to have been successful whaling captains, as were my grandparents. I am currently the assistant to my sister-in-law's whaling crew, while my brother is the whaling captain.

Preparation for whaling is a yearlong process. We normally start preparing in March for the hunt: sewing the skins; preparing the tools; and clearing out the underground freezers that were built generations ago. We haven't always had to clear the freezers but a lot has changed with the Arctic warming: We have to clean them out now because they are melting.

Our hunt is in the spring. In June, we share and celebrate for three days the landing of our whale. The celebration is open to anyone who wants to come. The ladies have a special day during the three-day celebration, when we celebrate our firstborn sons and initiate them. We give gifts to the female Elders. The gifts are items that are hard to come by, like furs and things that are sewn. There are then two days of dancing where we sing our traditional whaling songs that have been handed down through the generations. This is also the time we as a community acknowledge our responsibility to share with those who are less fortunate.

We hunt *Uugruk* (bearded seals) right after the whaling feast. We hunt for the skins and the food. It takes six skins to cover a whaling boat. When

that's done, we prepare our food to last for the year. We save a little portion of whale for Thanksgiving, Christmas, and first slush ice. Throughout the year, ceremonial dances surround all of our celebrations of the whale and our subsistence harvest. This is not an individual endeavor or even just a family endeavor. The whole community taught us to whale.

All that I have learned from whaling is from the Elders. I remember many years ago there were a lot of public meetings. During those meetings, several respected Elders stood up and told us to be prepared to protect our way of life. I remember one in particular said that the money will run out from all of these projects. As long as we keep up our way of life, Mother Nature will always take care of us and won't fail us. We must always respect it and it will respect us.

My Iñupiat traditions and subsistence way of life are precious to me and my community. Our ocean is our garden; it is what sustains us physically and spiritually as individuals and as community members. This way of life is what I hope to pass onto my grandchildren, through them to their children and so on. It's my responsibility to make sure that my children and grandchildren can live this lifestyle.

This whaling season we were out for five days and landed nothing. That's very unusual. Last year we couldn't put up our tents because the ice was very thin—an effect of Arctic warming. The men went out and left the women onshore because it was so dangerous. We were anxious this year. We hope and pray that they land a whale. There were two times that I can remember that we didn't land a whale and when that happens, even though Barrow and the other communities will share with us, the circle isn't complete when you aren't a part of the harvest. Something is just missing from our year-'round ceremony—it's as if I've lost a part of my identity.

We are already suffering from the stresses of global climate change. We see the results of the melting sea ice on nearly a daily basis. Severe erosion, stronger storms, and more dangerous seas are just a few of the impacts that we are facing. The environmental damage—like that being caused by global warming—is interfering with our rights to life and to cultural integrity.

Unfortunately, climate change is not the only threat with which we are faced. We are now facing the more imminent threat of oil and gas development in our waters. The way we look at it is, it's like a monopoly—only a few people will benefit from this development, and we will suffer. The fact that the United States has sold oil leases in the traditional waters of the Native village of Point Hope in the Chukchi Sea causes my community great alarm. This drilling plan and the associated seismic testing, increases in vessel traffic,

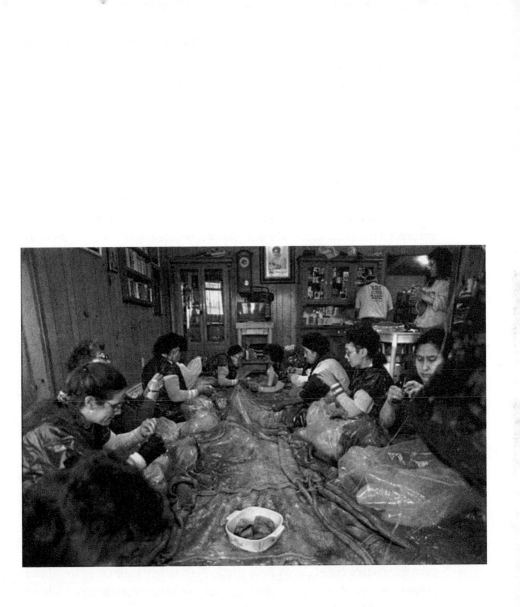

Women gather in whaling captain's home to sew skins for the umiak, Barrow.

(Photograph by Bill Hess, 1987.)

proposed large onshore and offshore infrastructure projects, and projections of oil spills in our unindustrialized homelands is extremely stressful. Our traditional knowledge indicates that each of these things independently threaten the existence of our traditional culture. We are already facing the consequences of climate change and the industrialization of the Beaufort Sea coast. This cumulative stress may prove to be a tipping point.

Not only am I concerned about these activities because of the possible impacts to my health and the health of my children and grandchildren, but also because those areas are the source of our food and other resources that are central to our cultural traditions. Those areas are also the home to animals that we do not eat, but nevertheless respect and revere.

I believe that seismic activities and other oil and gas activities that are happening now and that will happen in the future as a result of the Mineral Management Service's (MMS) five-year plan and lease sales under it, such as sale 193, are an imminent threat to our existence.

We were always taught as children to be extremely quiet on the ice. When a whale is spotted, we would communicate to people onshore and in the other boats by using our paddles, taking care to not make a sound. We found that even the dog teams onshore would distract the whales. They are so sensitive that we have to keep very quiet. Our traditions have taught us that noise drives the animals away and that something as quiet as a heavy footfall will scare them off. We cannot expect seismic activities to have less of an impact. The whales divert their path with seismic. The walrus do as well. When this happens, we spend time, money, and energy pursuing them and still end up with nothing. We are forced to travel farther from shore in our attempt to get our whale, walrus or seal, causing safety problems and stress and worry to family and community members. This worry isn't for nothing. These are not calm waters free of debris. We have always been taught to be very careful and constantly vigilant because of how quickly everything can change while on the ice or in the water. By going farther offshore to hunt, we increase the possibility of our equipment failing and worse still the risk that someone will be seriously injured or even killed. Neither are we prepared for this individually as subsistence users nor as a community in terms of our search and rescue capabilities. These are not issues that we should be forced to face.

It is my understanding that there is no proven technology to clean up oil spills in the Beaufort, Chukchi, or Bering seas, including in solid or broken ice conditions, and even in open water, especially when the sea is rough, as it often is. I am haunted by the worry that an oil spill will occur in our waters. I

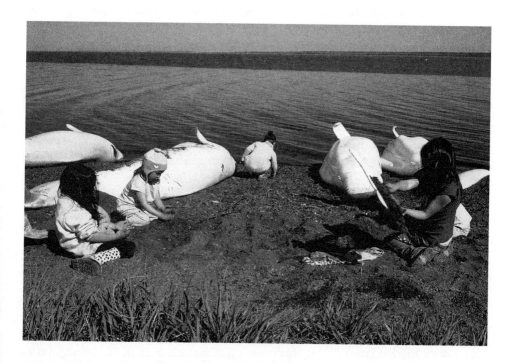

After a beluga whale hunt: children play on a barrier island, along the Kasegaluk Lagoon and Chukchi Sea, across from the Iñupiat village of Point Lay, 2007. *(Photograph by Subhankar Banerjee, July 2007.)*

envision what our home would be like if such a disaster would occur. I know that we don't have the resources in Point Hope to respond to such an event.

I've seen our brothers and sisters in the Southeast suffering from the impacts of the *Exxon Valdez* oil spill. The damage can last a lifetime. I remember the pictures and imagine the same hundreds or thousands of people that worked in Prince William Sound invading our home, disrupting our culture and our community, and accomplishing little.

I worry that our land and water would forever be contaminated by oil. Our area is much harsher than that of the southeast, and the impacts of such a spill could be a hundred times worse than it was in Prince William Sound. It would definitely impact our animals. They would be depleted.

I know we have to fight for our rights to a clean environment and the continuation of our culture and traditions, because that is what our Elders have dictated. We are to do everything in our power to protect our water, our land, our way of life. I worry that we continually have to work with lawyers and go to the courts to find a solution to this injustice, and that the time and money involved will stress our already overstressed resources to a breaking point. We are overwhelmed by these government and industry forces, and yet they keep coming back time after time, trying to wear us down.

We are mentally overwhelmed by the government's many confusing processes, with their seemingly overlapping purposes, short deadlines, and huge amounts of technical and other information to process. It has been extremely stressful to me and others in the community to attempt to review and respond to all of these various activities, which are happening at such a rapid pace, and to be criticized by government and industry people if we do not appear to understand what exactly is going on. We do not have the staff and resources to feel as if we can adequately review all of the documents and properly present our concerns.

The volume of work and the fast pace of agency action are not the only problems. We also have to attend meeting after endless meeting, sometimes at the expense of being able to gather our food. And we have to repeat ourselves over and over again, both to the same audiences that don't seem to hear or respect what we are saying, and to the constantly shifting audiences that come to our community to talk about oil and gas industrial development. People come and go into our community with one proposal or another. It is too easy to forget who is who and what is what.

At times, I feel like a victim in my own home and not a full participant in

the decision making process that affects the lives of me, my family, my tribe, and my community.

I know that we deserve to be respected and heard not just as individuals or as community members but as a sovereign government to whom the United States owes a trust responsibility. We expect the United States to honor this tradition and work cooperatively with communities in order to preserve our traditional way of life.

The government and industry continue to ignore our concerns and run roughshod over our community. The federal government is continually violating their trust responsibility to us. The DC Circuit Court found that the government violated the law in approving the 2007–2012 Outer Continental Shelf leasing program in the Arctic seas. We always knew that the government did not value our environment, and the court agreed.

It feels as if the government and industry want us to forget who we are, what we have a right to, and what we deserve. They repeatedly overwhelm us with information, requests, and deadlines, and it seems as if they hope that we will either give up or die fighting.

We are not giving up.

We must fight.

The proposed oil and gas activities affect not simply our ability to feed ourselves and others in the community, or the cultural traditions around our subsistence activities, or just our enjoyment of those activities, but they affect the very foundations of who we are as individuals and as a people. We have a right to life, to physical integrity, to security, and the right to enjoy the benefits of our culture. For this, we will fight.

We believe it is only right that the government has to start over from step one. To follow the law and respect our rights as a federally recognized tribe and as citizens of the United States, the government should have to make a new decision without the weight of existing leases or planned lease sales tainting what must be an objective decision. The industry should not have greater rights than we do just because they paid money to the federal government for a lease in the Chukchi Sea. Our culture can never be bought or repaired with money. It is priceless.

❖

The above statement is adapted with minor edits from a testimony signed and dated May 22, 2009, by the author in support of the legal suit with the following particulars:

Filed in the United States District Court for the District of Columbia Circuit

Case No. 07–1247

Center for Biological Diversity (Petitioner)

v.

United States Department of the Interior (Respondent) and

American Petroleum Institute (Intervenor)

consolidated with case

Case No. 07–1433

Native Village of Point Hope, Alaska Wilderness League, and Pacific Environment (Petitioners)

v.

United States Department of the Interior (Respondent)

❖

EARL KINGIK:
Testimony in Support of a Legal Suit (2008)

I have lived in Point Hope, Alaska, for fifty-nine years. I am a tribal member of the Native village of Point Hope. For twelve years, I worked as the Wildlife and Parks Director for the Native village of Point Hope. I have served as a member of the Alaska Beluga Whale Committee and the Western Arctic Caribou Working Group. I am also a member of Iñupiat Community of the Arctic Slope.

I have been a member of Resisting Environmental Destruction on Indigenous Lands (REDOIL) for six years. I have also been a member of Alaska Wilderness League for three years and sit on the League's Environmental Justice Advisory Council.

I am a subsistence hunter and whaler. I hunt many animals, including bowhead and beluga whales, several other marine mammals, waterfowl, and caribou. I do not hunt killer whales or gray whales, because I believe they are sacred animals. I hunt to provide food for my family and the rest of the community.

I have been a whaling crew member for forty-six years. Each year, from April to June, I spend two-and-a-half months whaling. During this time, I commit most of my time to hunting beluga and bowhead whales. If we do not meet our quota of bowhead whales during the spring, I go out whaling again in the fall, during September and October, if the weather permits.

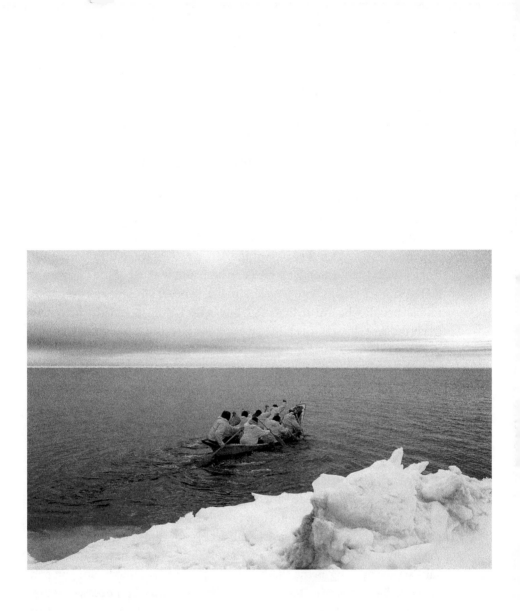

Whaling crew on Chukchi Sea, Point Hope. *(Photograph by Steven Kazlowski, May 2008.)*

My crew and I usually go out between eight and thirty miles out to sea to hunt whales. When we catch a whale, we have to tow it to shore to butcher it. We cannot travel very fast when we are towing a whale. We use several boats with paddles to tow a whale to shore because we do not want to disturb other whales by using an outboard motor. We don't do any duck hunting or rifle shooting when a whale is sighted. We try hard not to spook the whale. When towing a whale, it typically takes sixteen hours to get to shore from eight miles to twelve miles out. If we do not get the whale butchered within seventy-two hours after catching it, the meat may become rotten.

We use all parts of the whale, except for the head, which we throw back into the ocean, so that the spirit of the whale will return to the ocean. Meat from whales that I catch with my crew is shared with all of the villagers in Point Hope, as well as with people who live in other villages, and even with Iñupiat people who live in Anchorage and in the Lower 48. I share with others freely because I have learned that the more you give, the more you will receive.

Aside from whales, I hunt other marine mammals year 'round, including bearded seals, spotted seals, polar bears, and walrus. From June through October, I also fish for king salmon, dog salmon (also known as chum salmon), humpback salmon (also known as pink salmon), herring, tomcod, ocean trout, and whitefish, as these species pass Point Hope during their annual migrations.

Many of the animals we hunt migrate through the Bering and Beaufort seas, as well as the Chukchi Sea. Animals that pass through all three seas include bowhead whales, beluga whales, gray whales, killer whales, walruses, bearded and other seals, and a wide variety of fish—from king salmon to tomcod. A number of migratory birds—including eiders, eagles, murres, and pintails—pass over all three of these seas as well. Because of these migratory patterns, the health of the Bearing Sea and Beaufort Sea is just as important for our subsistence hunting as the Chukchi Sea. I plan to continue hunting in and near the Chukchi Sea and teach the younger generation for the rest of my life.

I enjoy going to the coast of the Chukchi Sea near Point Hope not only to hunt, but also to view animals, including birds, and whales. Even though I do not hunt gray whales and killer whales, I have seen these animals in the Chukchi Sea many times. I especially enjoy every time I see a gray whale because they migrate from so far away to feed in the Chukchi Sea. Their presence is a reminder of the health of the Chukchi Sea and the bounty that it provides to a variety of fish, birds, and marine mammals.

I have spent many years teaching the younger generation how to hunt marine mammals and waterfowl. I teach them to respect the ocean and its

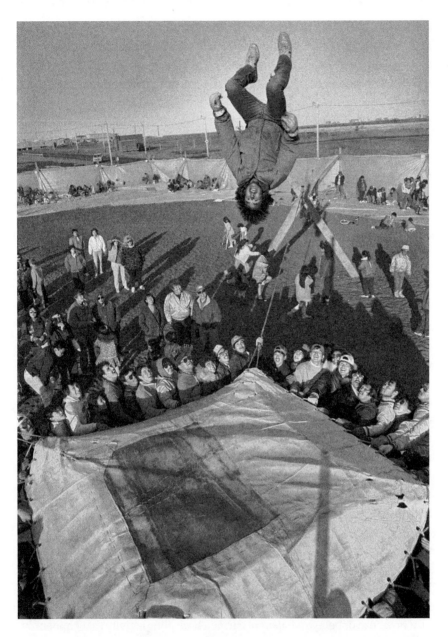

Blanket toss during Nalukataq in Barrow—the spring whaling feast. A blanket made from the skins of the successful umiaks (traditional whaling boats) was brought out. The first people to be tossed during breaks in the afternoon serving were children. Come night, in the time of twenty-four-hour sunshine, the youth and adults took over the blanket. Big Boy Neakok performed his famous flips. *(Photograph by Bill Hess, 1988.)*

animals. I teach them that the ocean is our garden and that we must respect what it provides for us. I feel very strongly that we must protect the ocean and its wildlife, because the people of Point Hope need the food and other resources that the ocean provides in order to survive the harsh conditions of the Arctic.

I am very concerned about how our whales and seals will react to oil and gas activities associated with Lease Sale 193, including seismic activities and increased vessel traffic. I am concerned that the Minerals Management Service (MMS), by authorizing the oil companies to do these things, may damage our way of life. All I have to do to see what will happen is to look at what is happening with bearded seals and bowhead whales near Prudhoe Bay. The animals are migrating out farther, and as a result, hunters from Nuiqsut and Barrow are risking their lives by going out farther to hunt. Once an animal is disturbed by the noise, it will tell the other animals not to go to that area. Whales use their tails to communicate with each other. During our spring whale hunt, when we see a whole whale coming out of the water and splashing hard, we know he's telling the other whales there's an open path so please come. The whales are so sensitive to noise that once we start shooting, they completely disappear for a few days.

I fear that such impacts may already be taking place due to the seismic activities that have recently taken place in the Chukchi Sea. During the past two years, I have seen fewer gray whales than usual near Point Hope. I fear that they may be avoiding the area because of the noise created by the seismic activity going on in the Chukchi Sea. Not seeing as many of these sacred animals in these years has greatly upset me.

If whales, seals, and other marine mammals are diverted away from Point Hope by oil and gas activities, and we must go farther offshore to hunt, we will have to deal with a big swell and the third current, where we are not supposed to hunt. The farther out my whaling crew and I go, the greater the risk to our safety. If we catch a whale farther from shore than normal, it would take a long time to tow it ashore, and there is a greater risk that the meat will spoil before we can butcher the whale.

If bowhead or beluga whales are harmed by drilling activity that happens in the Beaufort Sea, this, too, could affect me and others in Point Hope, because those are the same animals that migrate past Point Hope each year. They are the same animals that we hunt, and if the whale population suffers, then our harvest may suffer in turn. We are very concerned about these harms. We do

not have farms or livestock in Point Hope that could provide us with alternate foods if there is a shortage of subsistence foods.

I worry that oil and gas exploration and development, including seismic activities, will have negative health impacts on people in Point Hope. I already see it starting to happen. One problem is that when we replace our healthy subsistence foods with store-bought foods, people get sick. Right now people are getting store-bought food because we only caught two whales last spring and only a few caribou. This is not enough for the people in Point Hope and the friends and family we feed throughout Alaska and the Lower 48, so people have to buy food. We are afraid that the lack of animals is from current exploration in the Chukchi Sea and from exploration and development in other parts of Alaska, and we worry that it will get worse with more exploration and development. I am also worried that there will be social problems because oil development will cause things to change too quickly in Point Hope. Some of the social problems associated with increased development include alcohol and drug abuse, depression, anxiety, and domestic violence.

I have attended public hearings and other meetings regarding the MMS's plans to permit oil and gas activity in the Arctic Ocean. I attended the MMS's five-year plan and Lease Sale 193 meeting in Point Hope in November 2006 and made many comments. I attended the North Slope Oil and Gas Forum meeting in Barrow in September 2007, and an Arctic Slope Energy Services meeting in Point Hope in February 2008 to discuss seismic activities. I have also traveled in Alaska and to Washington, DC to speak with the MMS about oil and gas activities. In February 2008, I traveled to Anchorage to protest at the MMS's Lease Sale 193.

I try to take every opportunity I can to participate in the public process and to make my concerns known to the MMS. But I get frustrated. I attend all the meetings and ask questions, but the MMS has no answers. They always tell us they need more information. When they come up here, they give us as little as two days' notice. They don't advertise the meetings in newspapers or on the radio like they should. They only advertise by posting something at the store the same day as the meeting or the day before. They also sometimes come up while we're busy, like during whaling season. For example, there was a hearing on the draft programmatic Environmental Impact Statement on seismic surveys in Point Hope in April 2007, but I had to miss it because I was whaling.

I consider the ocean to be our precious garden, which we have to respect and protect. We must fight to protect all three of our seas in the Arctic Ocean—the Bering, the Chukchi and the Beaufort.

❖

The above statement is adapted with minor edits from a testimony signed and dated October 20, 2008, by the author in support of the legal suit with the following particulars:

Filed in the United States District Court for the District of Alaska

Case No. 1:08-cv-00004-RRB

Native Village of Point Hope, et al., (Plaintiffs)

v.

Dirk Kempthorne, Secretary of the Interior, et al., (Defendants) and

Shell Gulf of Mexico, Inc., and CononoPhillips Company (Intervenor-Defendants)

 This is an ongoing case and has carried over to Ken Salazar, Secretary of the Interior in the administration of President Barack Obama.

❖

NOTE

1. Dan O'Neill, *The Firecracker Boys* (New York: Basic Books, 2007).

Dancing for the Whales

Kivġiq and Cultural Resilience Among
the People of the Whales

CHIE SAKAKIBARA

❖

I first became familiar with Chie Sakakibara's ongoing work in the Iñupiat community of Barrow through a story I published on ClimateStoryTellers. org in December 2010. "Iñupiaq People Ask: 'Will We Be the Victims of the Next Oil Spill Disaster?'" was co-authored by Chie and her colleague Harvard Ayers, Professor Emeritus of Anthropology at Appalachian State University in Boone, North Carolina, and senior author and co-editor of Arctic Gardens: Voices from an Abundant Land, which was published in 2010. In the essay that follows Chie writes about Kivġiq—"a three-day celebration that involves sharing of bounty, songs, dances, gifts, and happy moments." In Arctic Village and Fort Yukon, I've seen caribou skin hut dances—through the performance, festivities and sharing of food, the Gwich'in people, who call themselves "the caribou people," honor their cultural and economic ties to the caribou, and renew their resolve to fight oil development in the caribou calving ground in the Arctic National Wildlife Refuge. Here is Chie's story about the importance of Kivġiq to the Iñupiat people, who call themselves "people of the whales" as

they struggle with Arctic warming and fight proposed oil drilling in the Arctic Ocean, where the whales make their home. Her book, On Thin Ice: Iñupiaq Whaling, Climate Change, and Cultural Resilience in Arctic Alaska *will be published by University of Arizona Press in Fall 2012.*

❖

AS MY plane lowered its altitude, I looked over the vast, frozen Chukchi Sea coated by almost flawless snow. Patches of unseasonal open water repeatedly caught my eyes as the destination approached. The sun has returned to the northern land after its nearly two-month-long absence. Soon it will be a whaling time. Noting the crispy outside temperature of 20 degrees below zero, I thought about how my whaling family cuts the ice to create a smooth path to the edge of the shorefast ice, to build a whaling camp for spring whaling. My body and soul remembered the beauty of the ice and the taste of unimaginably bitter cold air of 90 degrees below zero with the wind chill factor from the last time I was out at the whaling camp. After an almost thirty-six-hour journey from the heartland of the Appalachian High Country, I stepped onto the snowy tundra above the Arctic Circle. The moment I walked into the small airport terminal in Barrow, I saw the sea of smiling faces and waves of happy dancing motions. "Welcome home!" With a huge grin on her face, Flossie Nageak—my sister—ran up to me and embraced me firmly. I was home.

Barrow, Alaska, holds nearly five thousand people. Point Barrow, the northernmost point of the United States, parts the Arctic Ocean into the Beaufort and Chukchi seas. Barrow has been my adopted hometown since the commencement of my dissertation fieldwork in 2004. I have made countless trips to this hometown of heart literally from anywhere and everywhere. This time I was here to participate in *Kivġiq*. *Kivġiq* is a three-day celebration that involves sharing of bounty, songs, dances, gifts, and happy moments. Previously known as the Inviting-In Feast (Hawkes 1914) or the Messenger's Feast (Riccio 1993, 2003), *Kivġiq* now takes place in Barrow in February every other year. Other Native groups—the Chukotkans from Siberia, Canadian Inuit, and Greenlandic performers—are invited to participate. According to the late Vincent Nageak Sr., a Barrow Elder and Flossie's father-in-law, animals brought this event to the Iñupiat (North Slope Borough 1993). Until then, there was no music or drums among the people. The Iñupiat decided to

honor the animals with a feast, which became the origin of *Kivġiq*. Songs are the gifts from the animals, and hunters and their families are responsible for entertaining their animal spirit guests. Drum performances activate powerful interactions between performers and animal spirits. This reciprocity between animals and music is particularly pronounced between the bowhead whales (*Balaena mysticetus*) and the Iñupiat, as the people revere the whale as their cultural icon.

The Iñupiat call themselves the People of the Whales. The whale brings the ocean's energy into the tundra, animals, and humans. The whale fuels people's energy, animates the Arctic world, and fills imaginations. Through my research on Iñupiat cultural resilience and climate change, I learned how the Iñupiat make conscious and unconscious efforts to secure their relationship with the whales through traditional expressive culture (Sakakibara 2008, 2009, 2010). My fieldwork eventually became synonymous with my personal growth and fulfillment through participation in Iñupiat subsistence activities and everyday life, generously supported by my adopted family and friends. The People of the Whales became my teachers. Embracing their values of tradition and innovation, Iñupiat mobilize their cultural expressions as an elastic bond to preserve and develop their relationship with the whales. In many different ways and contexts, the People of the Whales taught me how the traditional Iñupiat–whale relationship is not a miner's canary, but rather an agent of innovation and adaptation.

As Flossie fed me with fresh *maktak* (bowhead whale blubber) and caribou soup, family members came to the house, one after another. It was a joyful reunion. When I was here two months earlier, during Thanksgiving, I learned that Barrow had survived difficult times of intense debates about offshore oil exploration that had made many fearful. In November 2010, after the sun had hidden beneath the horizon for the winter, a series of community meetings were held regarding how to deal with the potential offshore oil drilling that might pollute their ocean. Royal Dutch Shell was putting pressure on the Obama administration for a five-year permit to conduct seismic surveys in the Chukchi and Beaufort seas, the place the Iñupiat people called "our garden." The bowhead whales—the cornerstone species of the Iñupiat way of life—as well as other marine species will likely be lost forever as soon as a spill occurs, or even before that, when a seismic survey is conducted. The Iñupiat were concerned that icebreakers and drill ships would disturb the bowhead whale migration on which they depend.

The Native villages and environmental groups sued American regulators

for breaking a 1970 law on environmental impacts. As a result, the Iñupiat won a commitment from Shell to halt all offshore operations during the whaling seasons and whale migration, even if the corporation managed to proceed with drilling any time in the future. The good news is that Shell Oil has abandoned their plan to drill in Alaska's Arctic seas in 2011. This decision to forego any plans to drill in the Arctic Ocean in 2011 removed pressure that the corporation has been putting on the government to rush decisions on drilling in Arctic waters, and also relieved tremendous tensions among the Iñupiat. On the last leg of my long flight to Barrow, an Iñupiaq woman who sat next to me mentioned that Mayor Edward Itta, of the North Slope Borough, will step down after six years of leadership later in the year. Looking me in the eye, she firmly continued: "We need a very strong leader for us at this time to win this oil battle."

Following the good news, *Kivġiq* became the time of big celebration—a celebration of Iñupiat cultural survival based on their sustainable relations with the whales as revealed in *Kivġiq's* origin story.

Iñupiats often explain how "the whale is the drum and the drum is the whale." Traditional drum membrane is often made of the linings of whale livers, stomachs, or lungs (Sakakibara 2009). During the time that I spent with the *Kivġiq* performers, I learned how singing, dancing, and drumming provide the means by which Iñupiats reconstruct the whaling cycle, their calendar based on their relationship with the whales. Today, Iñupiat music is a means of adapting to environmental transformation and an indicator of a transforming environment. Drum performances and their recent resurgence in community events indicate increasing cultural identity. The Iñupiats newly endowed their performance with an invitation for the whales to join their domain by reversing the human–whale relationship: Traditionally, it was the whale that brought music and festivity to the people, but it is now the Iñupiat who bring music to the whales to repair the broken whaling cycle as an act of collaborative reciprocity. In 2011, I saw *Kivġiq* as a powerful metaphor of the rise of Iñupiat cultural resilience at a time of great environmental and political uncertainty.

Kivġiq was banned by missionaries in 1914 as a pagan practice. It was reinstated in 1988 after a seventy-four-year absence. The renewed *Kivġiq* festivities, the accompanying pan-Arctic display of a shared cultural heritage, and the celebration of recent political victories rejuvenated Iñupiat identity and became a new cultural emblem for the people of the north.

The timeframe of its revival followed the formation of the Alaska Eskimo Whaling Commission (AEWC), which was created to fight against the

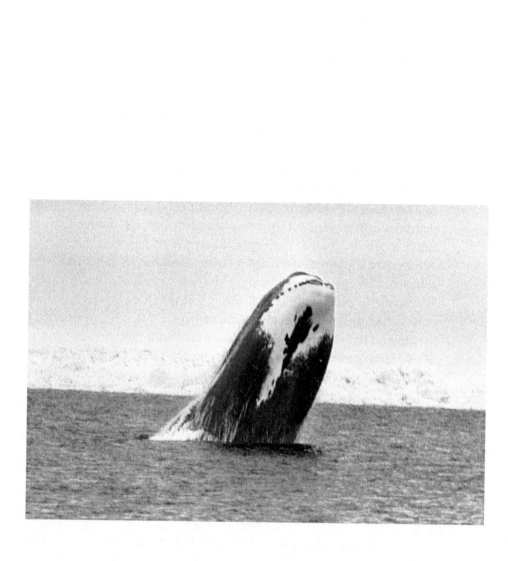

Bowhead, Chukchi Sea. *(Photograph by Bill Hess, 1986).*

International Whaling Commission (IWC) prohibition against indigenous whaling of 1977. The AEWC's major task is to negotiate with non-indigenous organizations, primarily the United States federal government and the IWC, about management plans in general and the whale quota system in particular. "*Kivġiq* gets people together just before the whaling preparation begins. It's all about whaling," said George Ahmaogak Sr., the former North Slope Borough mayor who brought back the *Kivġiq* tradition. The primary purpose of the resurrection was to return to the traditional Iñupiat values to combat recent environmental and social problems emerging on the North Slope.

The rebirth of the event indicates how the social function of Iñupiat tradition has changed more than its form: It is now more secular and more invested with political meaning, as it also invites the participation of non-indigenous organizations and individuals, especially representatives from the State of Alaska and the International Whaling Commission. *Kivġiq* has become a way to communicate with other cultural groups and help the Iñupiat reaffirm their pride as the People of the Whales. But more than that, it is a time for everyone to reconfirm their northern kinship and heritage.

The gym of Barrow High School was packed with spectators as various *Kivġiq* dance groups alternated to occupy the floor. The whaling dance was one of the most popular performances. It reenacts the entire process of looking for a whale, hunting, making prayers, landing the whale, and sharing the whale with other villagers. The animated and comical choreography of the whale amused the audience and reminded them of the fast-approaching whaling time and the joy associated with the season. At the end, everyone in the audience was invited to dance with the performers, exchanging gifts and sharing joys together. A great sense of unity and happiness was in the air.

CLIMATE CHANGE AND THE IÑUPIAT WHALING CULTURE

In combination with the fear of offshore oil drilling, climate change further strains the resilience of the People of the Whales and this problem increases their vulnerability. The whaling tradition is being jeopardized as thinning sea ice, changing ocean currents, and new wind directions and climatic hazards threaten the lives of people who adjust to cope with altered environmental conditions. Undoubtedly, the Arctic peoples are standing on the northernmost frontier of climate change. The Iñupiat, their indigenous neighbors in the Arctic and sub-Arctic, and most climate scientists agree that anthropogenic

climate change is the major cause of recent alterations in physical, biological, cultural, and social systems across the Arctic.

The Arctic has warmed at nearly twice the rate of the rest of the world over the past century. Scientists predict that warming trends in the Arctic will continue to outpace other global regions, and that the Arctic Ocean will be ice free in the summer in twenty years with most of its melt occurring in the next decade (*Arctic Climate Impact Assessment* 2005). Native peoples are cognizant of these observations, and they are also concerned about the actual and potential impact of climate change on their cultural, spiritual, and economic health. The IPCC's *Fourth Assessment Report* (2007) stated that impacts on ice, snow, and glaciers would be significant, which would result in a tremendous impact upon the people's subsistence. Updates to these reports suggest that changes are occurring faster than anticipated (ACIA Scientific Report 2005): In 2007, Arctic sea ice reached a record low (NASA Earth Observatory 2007), and in 2008, both the northeast and northwest passages were ice free for the first time in recorded history (Revkin 2008). In September 2010, the minimum level of sea ice was the third lowest ever recorded in the Arctic Ocean (US National Snow and Ice Data Center 2010). Thinning sheet ice is a major problem. Climate warming directly affects ice cover of the Arctic Ocean. Reduction of ice platforms is a crucial issue that affects subsistence hunters and wildlife such as seals, walruses, polar bears, and whales. At the end of summer 2009, 32 percent of the ice cover was second-year ice. Third-year and older ice was 19 percent of the total ice cover, the lowest in the satellite record. In September 2010, the minimum level of sea ice was the third-lowest ever recorded in the Arctic Ocean.

During the Northern Hemisphere winter of 2010–11, unusually cold temperatures and heavy snowstorms plagued North America and Europe, while conditions were unusually warm in the Arctic. The US National Snow and Ice Data Center (NSIDC) reported that in January 2011, Arctic sea ice was at its lowest extent ever recorded. Iñupiat hunters were also aware of the delayed formation of the sea ice, which resulted in the low quality of shorefast ice during spring whaling.

The transformation of the Arctic environment puts unbearable stress upon northern peoples. In the past, the governments of Arctic nations required indigenous groups to adapt their seminomadic lifestyle to become residents of permanent settlements, to efficiently incorporate them into national governance Now, due to climate change, the Iñupiat community of Shishmaref, Alaska (population approximately 562), is being forced to relocate to a nearby

mainland location that has access to the sea. Relocation from, and the loss of, a homeland often causes strong reactions among place-based people. Point Hope, Alaska (population approximately 674), was relocated in 1977, and the experience left the villagers with long-lasting emotional trauma (Sakakibara 2008). "Overnight, everything was gone. Bang, a storm took our houses one right after another," one of my collaborators described. To him and to many other villagers, the disappearing Old Town still remains a special place they call home.

Recent shifts in climatic conditions have caused oceanic current changes, influencing both migration patterns and the timing of the ice-loving bowhead whale migrations (Dixon 2003). With the warming ocean temperature, the bowhead whales arrive earlier in northern Alaska from the coast in the spring and return from the Beaufort Sea to the coast later in the fall. Bowheads have evolved as ice whales, feeding on krill that inhabit the ocean near ice, and it is unknown if the bowheads or their food supply can adjust to ice-free waters (Tynan and DeMaster 1997). The potentially ice-free Arctic Ocean—the Northwest Passage in particular—will open the major routes for increased shipping, disturbing bowheads further still. The impact on whalers is not unexpected: northward shifts in bowhead migration require whalers to use more fuel, gear, physical strength, and time to hunt. Some whalers even now cannot afford to go whaling because of the effects of climate change.

On the other hand, gray whales (*Eschrichtius robustus*) are expanding their range as ice cover decreases (Reynolds et al. 2005). Can the Iñupiat learn to hunt and eat the gray whale? "Gray whales?" offered a young whaling captain who had recently inherited the title from his father: "No, we will only hunt the bowhead." Iñupiat whalers are now obliged to make adjustments to their whaling cycle in order to accommodate environmental shifts, but so far, hunting the gray whale is not an option.

PEOPLE OF THE WHALES IN THE LAND OF OIL

At the Barrow High School gym where *Kivġiq* took place, banners of all the dance groups in attendance were displayed across the ceiling over the stage. Banners in honor of generous donors and sponsors of the event were also on display. Along with the banners of Alaska Airlines, the Arctic Slope Regional Corporation (ASRC), and Ukpeaġvik Iñupiat Corporation (UIC), there were banners with the names of oil companies. While the crisis has passed for the

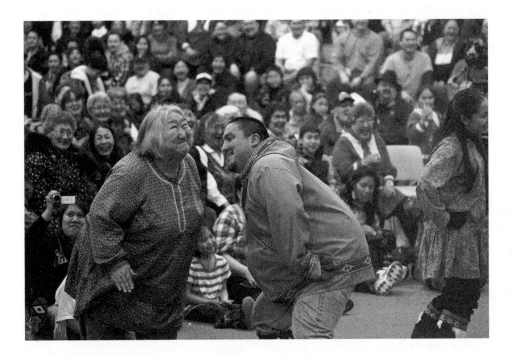

Kivġiq: The Raven Dance, Surrimanichuat, Barrow *(Photograph by Bill Hess, 2011).*

year 2011 in the Arctic Ocean, the largest resident of the Arctic Ocean—the bowhead whale—and their habitat is never safe. Despite the relief that the Iñupiat enjoy for the time being, they are also keenly aware that this is no more than a delaying action, and the oil company has not given up on Arctic drilling. To add more complication, the intricacy of Shell's involvement in the North Slope economy has caused an inevitable cacophony among the Iñupiat. However, as the people say, "the whale brings us together" remains true. "We always survived difficult times. We are the strongest people on the earth. That is why God placed us on the top of the world," as the late Pamiuq Elavgak of Barrow once remarked to me. "Whatever change happens, we shouldn't be disconnected [from our land and ocean]. We should always be in the circle of the whale."

Iñupiat cultural resilience exemplifies an adaptive mechanism that is crucial for all human survival. The Iñupiat have shown me some of the complex pathways along which they construct adaptive strategies to retain their bond with the whales and their way of life. Their subsistence is built on change; change and continuity are closely interrelated, and coping with change often facilitates human–environment integrity. As my Iñupiat collaborators continually emphasized, to keep their whaling traditions as the environment transforms around them is a way to strengthen their identity and nurture their survival. Inevitably, the future holds further changes and challenges, but Iñupiat relations with the whales continue to be an active agent in the process. In this context, *Kivgiq* will continue to serve as an occasion to remind the residents at the top of the world why the People of the Whales are icons of cultural resilience.

I would like to acknowledge the support provided by the Arctic Social Sciences Program in the National Science Foundation, logistical support by the Barrow Arctic Science Consortium and the North Slope Borough Department of Wildlife Management, and grants from the Center for Ethnomusicology and the Earth Institute both at Columbia University. I am especially grateful for the friendship and inspiration provided by Aaron Fox, Chair of the Department of Music at Columbia University, with whom I share the love of the Arctic. Last but not least, my deepest gratitude goes to the people of the North Slope Borough of Alaska, for their continuous encouragement, friendship, and love—Quyanaqpak.

BIBLIOGRAPHY

Dixon, J. C. 2003. Environment and environmental change in the Western Arctic: implications for whaling. In McCartney, A. P. (Ed.), *Indigenous ways to the present: Native whaling in the Western Arctic*. Edmonton: Canadian Circumpolar Institute Press.

Hawkes, E. H. 1914. *The dance festivals of the Alaskan Eskimo*. University of Pennsylvania, the University Museum Anthropological Publications, *VI* (2): Philadelphia: The University Museum.

Louter, J. [film director], 2008: *The Last Day of Shishmaref*. The Netherlands.

NASA Earth Observatory. 2007. Record Arctic Sea Ice Loss in 2007.

http://earthobservatory.nasa.gov/Newsroom/NewImages/images.php3?img_id=17782

National Snow and Ice Data Center (NSIDC), 2010, October 4. "Weather and feedbacks lead to third-lowest extent." http://nsidc.org/arcticseaicenews/ (Retrieved on October 30, 2010.)

———. 2011, March 2. "February Arctic ice extent ties 2005 for record low; extensive snow cover persists." http://nsidc.org/arcticseaicenews/ (Retrieved on March 21, 2011.)

North Slope Borough. 1993. *Taking control: The story of self determination in the Arctic*. Barrow,

AK: North Slope Borough Public Information Division.

Sakakibara, C. 2008. "Our home is drowning: Climate change and Iñupiat storytelling in Point Hope, Alaska. *The Geographical Review* 98 (4): 456–475.

———. 2009. " 'No Whale, No Music': Contemporary Iñupiaq Drumming and Global Warming." Polar Record 45 (4): 289–303.

———. 2010. "Kiavallakkikput Aġviq (Into the Whaling Cycle): Cetaceousness and Climate Change among the Iñupiat of Arctic Alaska." *Annals of the Association of American Geographers* 100 (4): 1003–1012.

Tynan, C. T., and DeMaster, D. P. 1997. Observations and predictions of Arctic climatic change: Potential effects on marine mammals. *Arctic, 50* (4): 308–322.

Reynolds, J., Moore, S., and Ragen, T. 2005. *Climate change and Arctic marine mammals—an uneasy glance into the future*. Unpublished presentation. Barrow Arctic Science Consortium, Barrow, AK.

Riccio, T. 1993. A message from Eagle Mother: The Messenger's feast of the Iñupiat Eskimo. *The Drama Review* 37 (1): 115–146.

———. 2003. *Reinventing traditional Alaskan Native performance*. Studies in Theatre Arts, *17*. Lewinston: The Edwin Mellen Press.

reporting from the field

Out of the wind, leaned back against soft lichens on the rocks, we breathe in a vast, beautiful, and stirring prospect. High snow-streaked peaks rise to the south and west, and to the north, the gray torrent, curving west under its cliffs, escapes the portals of the foothills and winds across the plain toward the hard white bar on the horizon—the dense wall of fog that hides the Beaufort Sea. This wild, free valley and the barren ground beyond is but a fragment of one of the last pristine regions left on earth, entirely unscarred by roads or signs, indifferent to mankind, utterly silent.

—PETER MATTHIESSEN

Scientists from Stephen Brown's arctic shorebirds research team retrieve birds caught in a net to study birds' general health—take blood samples, measure weight, attach colored markers if necessary to track individual birds after release (detail). (*Photograph by Subhankar Banerjee, August 2006.*)

From Coming into the Country

JOHN MCPHEE

❖

In 1977, John McPhee's Coming into the Country, *about Alaska, was published. It is a masterpiece of American literature. The volume is composed of three books: Book I—At the Northern Tree Line, "The Encircled River"; Book II—In Urban Alaska, "What They Were Hunting For"; and Book III—In the Bush, "Coming into the Country." In "The Encircled River" John writes about his trip to the Western Arctic, in particular about two rivers that he floated—the Salmon and the Kobuk. A few years later, Kobuk Valley National Park was established and the Salmon River was designated a National Wild and Scenic River in the Alaska National Interest Land Conservation Act (ANILCA) of 1980, the largest conservation legislation in the US that protected 104 million acres in Alaska, including significant areas in the Arctic. A thorough discussion of ANILCA is beyond the scope of this volume. In his book* Alaska's Brooks Range: The Ultimate Mountains, *conservationist and National Park Service planner John Kauffmann who accompanied McPhee, quotes what President Jimmy Carter said as he signed ANILCA on December 2, 1980:*

Never before have we seized the opportunity to preserve so much of America's natural and cultural heritage on so grand a scale. . . . I've seen firsthand some of the splendors of Alaska. But many Americans have not. Now, whenever they or their children or their grandchildren choose to visit Alaska, they'll have the opportunity to see much of its splendid beauty undiminished and its majesty untarnished.

Let us celebrate. The mountains . . . the rivers and lakes that harbor salmon and trout, the game trails of caribou and grizzly in the Brooks Range, the marshes where our waterfowl summer—all these are now preserved, now and, I pray, for all time to come.

It is worth noting that ANILCA also preserved something more—the way of life of the indigenous communities of Alaska. In fact, one of the persisting misconceptions that is promoted by pro-development groups is that if an area is designated wilderness in Alaska, the Native people will not be able to continue their subsistence hunting, fishing, gathering on those lands as they have always done. This is a lie. I've seen Robert Thompson fighting time and again this misperception in Kaktovik—his own community. Here is John McPhee reporting from the Western Arctic.

❖

Coming into the Country *was published by Farrar, Straus and Giroux in 1977.*

MY BANDANNA is rolled on the diagonal and retains water fairly well. I keep it knotted around my head, and now and again dip it into the river. The water is 46 degrees. Against the temples, it is refrigerant and relieving. This has done away with the headaches that the sun caused in days before. The Arctic sun—penetrating, intense—seems not so much to shine as to strike. Even the trickles of water that run down my T-shirt feel good. Meanwhile, the river—the clearest, purest water I have ever seen flowing over rocks—breaks the light into flashes and sends them upward into the eyes. The headaches have reminded me of the kind that are sometimes caused by altitude, but, for all the fact that we have come down through mountains, we have not been higher than a few

hundred feet above the level of the sea. Drifting now—a canoe, two kayaks—
and thanking God it is not my turn in either of the kayaks, I lift my fish rod
from the tines of a caribou rack (lashed there in mid-canoe to the duffel) and
send a line flying toward a wall of bedrock by the edge of the stream. A grayling
comes up and, after some hesitation, takes the lure and runs with it for a time. I
disengage the lure and let the grayling go, being mindful not to wipe my hands
on my short. Several days in use, the shirt is approaching filthy, but here among
grizzly bears I would prefer to stink of humanity than of fish.

Paddling again, we move down long pools separated by short white pitches,
looking to see whatever might appear in the low hills, in the cottonwood, in
the white and black spruce—and in the river, too. Its bed is as distinct as if the
water were not there. Everywhere, in fleets, are the oval shapes of salmon. They
have moved the gravel and made redds, spawning craters, feet in diameter. They
ignore the boats, but at times, and without apparent reason, they turn and shoot
downriver, as if they have felt panic and have lost their resolve to get on with
their loving and their dying. Some, already dead, lie whitening, grotesque, on the
bottom, their bodies disassembling in the current. In a short time, not much will
be left but the hooking jaws. Through the surface, meanwhile, the living salmon
broach, freshen—make long, dolphinesque flights through the air—then fall to
slap the water, to resume formation in the river, noses north, into the current.
Looking over the side of the canoe is like staring down into a sky full of zeppelins.

A cloud, all black and silver, crosses the sun. I put on a wool shirt. In
Alaska, where waters flow in many places without the questionable benefit of
names, there are nineteen streams called Salmon—thirteen Salmon Creeks,
six Salmon Rivers—of which this one, the Salmon River of the Brooks Range,
is the most northern, its watershed wholly above the Arctic Circle. Rising in
treeless alpine tundra, it falls south into the fringes of the boreal forest, the
taiga, the upper limit of the Great North Woods. Tree lines tend to be digital
here, fingering into protected valleys. Plants and animals are living on margin,
in cycles that are always vulnerable to change. It is five o'clock in the after-
noon. The cloud, moving on, reveals the sun again, and I take off the wool
short. The sun has been up fourteen hours, and has hours to go before it sets.
It seems to be rolling slowly down a slightly inclined plane. A tributary, the
Kitlik, comes in from the northwest. It has formed with the Salmon River a
raised, flat sand-and-gravel mesopotamia—a good enough campsite, and,
as a glance can tell, a fishing site to exaggerate the requirements of dinner.

There are five of us, four of whom are a state-federal study team. The
subject of the study is the river. We pitch the tents side by side, two Alpine

Draw-Tite tents, and gather and saw firewood: balsam poplar (more often called cottonwood); sticks of willow and alder; a whole young spruce, tip to root, dry now, torn free upriver by the ice of the breakup in spring. Tracks are numerous, coming, going, multidirectional, tracks wherever there is sand, and in gravel if it is fine enough to have taken an impression. Wolf tracks. The pointed pods of moose tracks. Tracks of the barren-ground grizzly. Some of the moose tracks are punctuated with dewclaws. The grizzlies' big toes are on the outside.

The Kitlik, narrow, and clear as the Salmon, rushes in white to the larger river, and at the confluence is a pool that could be measured in fathoms. Two, anyway. With that depth, the water is apple green, and no less transparent. Salmon and grayling, distinct and dark, move into, out of, around the pool. Many grayling rest at the bottom. There is a pair of intimate salmon, the male circling her, circling, an endless attention of rings. Leaning over, watching, we nearly fall in. The gravel is loose at the river's edge. In it is a large and recently gouged excavation, a fresh pit, close by the water. It was apparently made in a thrashing hurry. I imagine that a bear was watching the fish and got stirred up by the thought of grabbing one, but the water was too deep. Excited, lunging, the bear fell into the pool, and it flailed back at the soft gravel, gouging the pit while trying to get enough of a purchase to haul itself out. Who can say? Whatever the story may be, the pit is the sign that is trying to tell it.

It is our turn now to fish in the deep pool. We are having grayling for dinner—Arctic grayling of firm delicious flesh. On their skins are black flecks against a field of silvery iridescence. Their dorsal fins fan up to such height that grayling are scale-model sailfish. In the cycles of the years, and the millennia, not many people have fished this river. Forest Eskimos have long seined at its mouth, but only to the third bend upstream. Eskimo hunters and woodcutters, traversing the Salmon Valley, feed themselves, in part, with grayling. In all, perhaps a dozen outsiders, so far as is known, have traveled, as we have, in boats down the length of the river. Hence the grayling here have hardly been, in the vernacular of angling, fished out. Over the centuries, they have scarcely been fished. The fire is high now and is rapidly making coals. Nineteen inches is about as long as a grayling will grow in north Alaska, so we agree to return to the river anything much smaller than that. As we do routinely, we take a count of the number needed—see who will share and who can manage on his own the two or three pounds of an entire fish. Dinner from our supplies will come in hot plastic water bags and be some form of desiccated mail-order

stew—Mountain House Freeze Dried Caribou Cud—followed by Mountain House Freeze Dried fruit. Everyone wants a whole fish.

Five, then. Three of us pick up rods and address the river—Bob Fedeler, Stell Newman, and I. Pat Pourchot, of the federal Bureau of Outdoor Recreation, has not yet cast a line during the trip. As he puts it, he is phasing himself out of fishing. In his work, he makes many river trips. There will always be people along who want to fish, he reasons, and by removing himself he reduces the number. He has wearied of take-and-put fishing, of molesting the fish, of shocking the ones that, for one reason or another, go back. He says he wonders what kind of day a fish will have after spending some time on a hook. John Kauffmann has largely ignored the fishing, too. A National Park Service planner who has been working for five years in Arctic Alaska, he is a New England mastertouch dry-fly fisherman, and up here his bamboo ballet is regarded as effete. Others taunt him. He will not rise. But neither will the grayling to his Black Gnats, his Dark Cahills, his Quill Gordons. So—tall, angular—he sits and observes, and his short gray beard conceals his disgust. He does agree to time the event. He looks at his watch. Invisible lines, glittering lures go spinning to the river, sink in the pool. The rods bend. Grayling do not sulk, like the salmon. They hit and go. In nine minutes, we have our five. They are seventeen, eighteen inches long. We clean them in the Kitlik, with care that all the waste is taken by the stream. We have a grill with us, and our method with grayling is simply to set them, unscaled, fins intact, over the fire and broil them like steaks. In minutes, they are ready, and beneath their skins is a brown-streaked white flesh that is in no way inferior to the meat of trout. The sail, the dorsal fin, is an age-old remedy for toothache. Chew the fin and the pain subsides. No one has a toothache. The fins go into the fire.

We have moved completely out of the hills now, and beyond the riverine fringes of spruce and cottonwood are boggy flatlands and thaw lakes. We see spruce that have been chewed by porcupines and cottonwood chewed by beavers. Moose tend to congregate down here on the tundra plain. In late fall, some of the caribou that migrate through the Salmon Valley will stop here and make this their winter range. We see a pair of loons, and lesser Canada geese, and chick mergansers with their mother. Mink, marten, muskrat, otter—creatures that live here inhabit the North Woods across the world to Maine. We pass a small waterfall under a patterned bluff—folded striations of schist. In bends of the river now we come upon banks of flood-eroded soil—of mud. They imply an earth mantle of some depth going back who knows how far from the river.

Brown and glistening they are virtually identical with rural stream banks in the eastern half of the country, with the difference that the water flowing past these is clear. In the sixteenth century, the streams of eastern America ran clear (except in flood), but after people began taking the vegetation off the soil mantle and then leaving their fields fallow when crops were not there, rain carried the soil into the streams. The process continues, and when one looks at such steams today, in their seasonal varieties of chocolate, their distant past is—even to the imagination—completely lost. For this Alaskan river, on the other hand, the sixteenth century has not yet ended, nor the fifteenth, nor the fifth. The river flows, as it has since immemorial time, in balance with itself. The river and every rill that feeds it are in an unmodified natural state—opaque in flood, ordinarily clear, with levels that change within a closed cycle of the year and of the years. The river cycle is only one of many hundreds of cycles—biological, meteorological—that coincide and blend here in the absence of intruding artifice. Past to present, present reflecting past, the cycles compose this segment of the earth. It is not static, so it cannot be styled "pristine," except in the special sense that while human beings have hunted, fished, and gathered wild food in this valley in small groups for centuries, they have not yet begun to change it. Such a description will fit many rivers in Alaska. This one, though, with its considerable beauty and a geography that places it partly within and partly beyond the extreme reach of the boreal forest, has been thought of as sufficiently splendid to become a national wild river—to be set aside with its immediate environs as unalterable wild terrain. Kauffmann, Newman, Fedeler, and Porchot are, in their various ways, studying that possibility. The wild-river proposal, which Congress is scheduled to act upon before the end of 1978, is something of a box within a box, for it is entirely incorporated within a proposed national monument that would include not only the entire Salmon River drainage but also a large segment of the valley of the Kobuk River, of which the Salmon is a tributary. (In the blue haze of the Interior Department terminology, "national monument" often enough describes certain large bodies of preserved land that in all respects except name are national parks.) The Kobuk Valley National Monument proposal, which includes nearly two million acres, is, in area, relatively modest among ten other pieces of Alaska that are similarly projected for confirmation by Congress as new parks and monuments. In all, these lands constitute over thirty-two million acres, which is more than all the Yosemites, all the Yellowstones, all the Grand Canyons and Sequoias put together—a total that would more than double the present size of the National Park System. For

cartographic perspective, thirty-two million acres slightly exceeds the area of the state of New York.

Impressive as that may seem, it is less than a tenth of Alaska, which consists of three hundred and seventy-five million acres. From the Alaska purchase, in 1867, to the Alaska Statehood Act, of 1958, Alaskan land was almost wholly federal. It was open to homesteading and other forms of private acquisition, but—all communities included—less than half of one percent actually passed to private hands. In the Statehood Act, the national government promised to transfer to state ownership a hundred and three million acres, or a little more than a quarter of Alaska. Such an area, size of California, was deemed sufficient for the needs of the population as it was then and as it might be throughout the guessable future. The generosity of this apportionment can be measured beside the fact that the 1958 population of Alaska—all Natives included—was virtually the same as the population of Sacramento. Even now, after the influx of new people that followed statehood and has attended the building of the Trans-Alaska Pipeline and the supposed oil-based bonanza, there are fewer people in all Alaska than there are in San Jose. The central paradox of Alaska is that it is as small as it is large—an immense landscape with so few people in it that language is stretched to call it a frontier, let alone a state. There are four hundred thousand people in Alaska, roughly half of whom live in or around Anchorage. To the point of picayunity, the state's road system is limited. A sense of the contemporary appearance of Alaska virtually requires inspection, because the civilized imagination cannot cover such quantities of wild land. Imagine, anyway, going from New York to Chicago—or, more accurately, from the one position to the other—in the year 1500. Such journeys, no less wild, are possible, and then some, over mountains, through forests, down the streams of Alaska. Alaska is a fifth as large as the contiguous forty-eight states. The question now is, what is to be the fate of all this land? It is anything but a "frozen waste." It is green nearly half the year. As never before, it has caught the attention of conflicting interests (developers, preservers, others), and events of the nineteen-seventies are accelerating the arrival of the answer to that question.

For a time in the nineteen-sixties, the natives of Alaska succeeded in paralyzing the matter altogether. Eskimos, Indians, and Aleuts, in coordination, pressed a claim that had been largely ignored when the Statehood Act was passed. Observing while a hundred and three million acres were legislatively prepared for a change of ownership, watching as exploration geologists came in and found the treasure of Arabia under the Arctic tundra, the natives proffered

the point that their immemorial occupancy gave them a special claim to Alaskan land. They engaged attorneys. They found sympathy in the federal courts and at the highest levels of the Department of the Interior. The result was that the government offered handsome compensations. Alaska has only about sixty thousand natives. They settled for a billion dollars and forty million acres of land.

The legislation that accomplished this (and a great deal more) was the Alaska native Claims Settlement Act, of 1971. Among events of significance in the history of Alaska, this one probably stands even higher than the State-hood Act and the treaty purchase, for it not only changed forever the status and much of the structure of native societies; it opened the way to the Trans-Alaska Pipeline, which is only the first of many big-scale projects envisioned by development-minded Alaskans, and, like a jewel cutter's chisel cleaving a rough diamond, it effected the wholesale division, subdivision, patenting, parceling, and deeding out of physiographic Alaska.

Because conservationists were outraged by the prospective pipeline, Congress attempted to restore a balance by including in the Native Claims Settlement Act extensive conservation provisions. The most notable of these was a paragraph that instructed the Secretary of the Interior to choose land of sufficient interest to its national owners, the people of the United States, to be worthy of preser-vation not only as national parks and national wild rivers but also as national wildlife refuges and national forests—some eighty million acres in all. Choices would be difficult, since a high proportion of Alaska could answer the purpose. In the Department of the Interior, an Alaska Planning Group was formed, and various agencies began proposing the lands, lakes, and rivers they would like to have, everywhere—from the Malaspina Glacier to Cape Krusenstern, from the Porcupine drainage to the Aniakchak Caldera. Congress gave the agencies—gave the Secretary of the Interior—up to seven years to study and to present the case for each selection among these national-interest lands. Personnel began moving north. Pat Pourchot, for example, just out of college, had taken the Civil Service examination and then had wandered around the Denver Federal Center looking for work. He had nothing much in mind and was ready for almost any kind of job that might be offered. He happened into the Bureau of Outdoor Recreation. Before long, he was descending Alaskan rivers. He had almost no experience with canoes or kayaks or with backpacking or camping, but he learned swiftly. John Kauffmann (a friend of mine of many years) had been planning new Park System components, such as the C&O Canal National Historic Park and the Cape Cod National Seashore. Transferring to Alaska, he built a house in Anchorage, and soon cornered as his special province eight and a third million acres of the central

Brooks Range. When confirmed by Congress, the area will become Gates of the Arctic National Park. It is a couple of hundred miles wide, and is east of the Salmon River. For five years, he has walked it, flown it, canoed its rivers—camped in many weathers below its adze-like rising peaks. Before he came up here, he was much in the wild (he has been a ranger in various places and is the author of a book on eastern American rivers), but nonetheless he was a blue-blazer sort of man, who could blend into the tussocks at the Metropolitan Club. Unimaginable, looking at him now. If he were to take off his shirt and shake it, the dismembered corpses of vintage mosquitoes would fall to the ground. Tall and slim in the first place, he is now spare. After staring so long at the sharp, flinty peaks of the central Brooks Range, he has come to look much like them. His physiognomy, in sun and wind, has become, more or less, grizzly. Any bear that took a bite of John Kauffmann would be most unlikely to complete the meal.

Now, resting on a gravel island not far from the confluence of the Salmon and the Kobuk, he says he surely hopes Congress will not forget its promises about the national interest lands. Some conservationists, remaining bitter about the pipeline, tend to see the park and refuge proposals as a sop written into the Native Claims Settlement Act to hush the noisome ecomorphs. Those who would develop the state for its economic worth got something they much wanted with their eight hundred miles of pipe. In return, the environmentalists were given a hundred and thirty words on paper. All the paragraph provided, however, was that eighty million acres could be temporarily set aside and studied. There was no guarantee of preservation to follow. The Wilderness Society, Friends of the Earth, the Sierra Club, the National Audubon Society, and other conservation organizations have formed the Alaska Coalition to remind Congress of its promise, of its moral obligation, lest the proposed park and refuge boundaries slowly fade from the map.

The Kobuk is, in places wide, like the Yukon, but its current is slower and has nothing of the Yukon's impelling, sucking rush. The Yukon, like any number of Alaska rivers, is opaque with pulverized rock, glacial powder. In a canoe in such a river, you can hear the grains of mountains like sandpaper on the hull. Glaciers are where the precipitation is sufficient to feed them. Two hundred inches will fall in parts of southern Alaska, and that is where the big Alaskan glaciers are. Up here, annual precipitation can be as low as fifteen inches. Many deserts get more water from the sky. The Arctic ground conserves its precipitation, however—holds it frozen half the year. So this is not a desert. Bob Fedeler, whose work with Alaska Fish and Game has taken him to rivers in much of the state, is surprised by the appearance of the Kobuk. "It is amazing

to see so much clear water," he says. "In a system as vast as this one, there is usually a glacial tributary or two, and that mucks up the river."

Standing on the shore, Fedeler snaps his wrist and sends a big enameled spoon lure, striped like a barber pole, flying over the water. Not long after it splashes, he becomes involved in a struggle with something more than a grayling. The fish sulks a little. For the most part, though, it moves. It makes runs upriver, downriver. It dashes suddenly in the direction of the tension on the line. His arms now oscillating, now steady, Fedeler keeps the line taught, keeps an equilibrium between himself and the fish, until eventually it flops on the dry gravel at his feet. It is a nine-pound salmon, the beginnings of dinner. Stell Newman catches another salmon, of about the same size. I catch one, a seven-pound adolescent, and let it go. Pat Pourchot, whose philosophical abstinence from fishing has until now been consistent, is suddenly aflush with temptation. Something like a hundred thousand salmon will come up the Kobuk in a summer. (They are counted by techniques of aerial survey.) The Kobuk is three hundred miles long and has at least fifty considerable tributaries—fifty branching streams to which salmon could be returning to spawn—and yet when they have come up the Kobuk to this point, to the mouth of the Salmon River, thirty thousand salmon turn left. As school after school arrives here, they pause, hover, reconnoiter—prepare for the run in the home stream. The riffles we see offshore are not rapids but salmon. Pourchot can stand it no longer. He may have phased himself out of fishing, but he is about to phase himself back in. Atavistic instincts take him over. His noble resolve collapses in the presence of this surge of fish.

He borrows Fedeler's rod and send the lure on its way. He reels. Nothing. He casts again. He reels. Nothing. Out in the river, there may be less water than salmon, but that is no guarantee that one will strike. Salmon do not feed on the spawning run. They apparently bite only by instinctive reflex if something flashes close before them. Pourchot casts again. Nothing. He casts again. The lure this time stops in the river as if it were encased in cement. Could be boulder. Could be a submerged log. The lure seems irretrievably snagged—until the river erupts. Pourchot is a big man with a flowing red beard. He is well over six feet. Blond hair tumbles across his shoulders. The muscles in his arms are strong from many hundreds of miles of paddling. This salmon, nonetheless, is dragging him up the beach. The fish leaps into the air, thrashes at the river surface, and makes charging runs of such thrust that Pourchot has no choice but to follow or break the line. He follows—fifty, seventy-five yards down the river with the salmon. The fish now changes plan and goes upstream. Pourchot follows. The struggle lasts thirty minutes, and the energy drawn away is almost

half Pourchot's. He wins, though, because he is bigger. The fish is scarcely larger than his leg. When, finally, it moves out of the water and onto the gravel, it has no hook in its mouth. It has been snagged, inadvertently, in the dorsal fin. Alaska law forbids keeping any sport fish caught in that way. The salmon must take the lure in its mouth. Pourchot extracts the hook, gently lifts the big fish in his arms, and walks into the river. He will hold the salmon right side up in the water until he is certain that its shock has passed and that it has regained its faculties. Otherwise, it might turn bottom up and drown.

If that were my fish, I would be inclined to keep it, but such a thought would never cross Pourchot's mind. Moreover, one can hardly borrow the rod of a representative of the Alaska Department of Fish and Game, snag a salmon while he watches, and stuff it in a bag. Fedeler, for his part, says he guesses that ninety-five per cent of salmon caught that way are kept. Pourchot removes his hands. The salmon swims away.

The salmon—filleted, rolled in flour, and sautéed on our pancake grill—is superb among fishes and fair among salmon.

The people of Kobuk are among the few Eskimos in Alaska whose villages are well within the tree line. They have a culture that reflects their cousinship to Eskimos of the coast and that borrows also from the Indians of the Alaskan interior. The combination is unique. At first glance—plywood boats, Evinrudes—they may seem to be even more a part of the world at large than they are of this Arctic valley. Much of their clothing is manufactured. They use rifles. They ride on snow machines. They seine whitefish and salmon with nylon nets that cost upward of four hundred dollars. Now and again, they leave the valley in search of jobs. They work on the pipeline. Without the river and the riverine land, though, they would be bereft of most of what sustains them. Their mail-order likeness to the rest of us does not go very deep. They may use Eagle Claw fishhooks from Wright & McGill, in Denver, but they still know how to make them from the teeth of wolves. They may give their children windup toys, but they also make little blowguns for them from the hollow leg bones of the sandhill crane. To snare ptarmigan, they no longer use spruce roots—they use picture wire—but they still snare ptarmigan. They eat what they call "white-man food," mainly from cans, but they also eat owl soup, sour dock, wild rhubarb, and the tuber *Hedysarum alpinum*—the Eskimo potato. Some of them believe that Eskimo food keeps them healthy and brown, and that too much white-man food will turn them white. Roughly half their carbohydrates come from wild

food—and fully four-fifths of their protein. They eat—and, more to the point, depend on—small creatures of the forest. Rabbit. Beaver. Muskrat. Thousands of frozen whitefish will be piled beside a single house. At thirty below, white fish break like glass. The people dip the frozen bits in seal oil and chew them. From fresh whitefish, as they squeeze, they directly suck roe. They trade mud-shark livers for seal oil from the coast. Mud sharks are freshwater, river fish, and for maritime Eskimos the liver of the mud shark is an exotic and delicious import. The forest Eskimo has a reciprocal yen for seal oil. When a Kobuk woman goes "fishing for seal oil," mud sharks are what she is after. Loon oil is sometimes substituted for seal oil, there being a great deal of oil in a loon. Sheefish, rare in the world and looking like fifteen-pound tarpon, make annual runs up the Kobuk. They are prized by the people.

On nothing, though, do the forest Eskimos depend so much as on caribou. They use the whole animal. They eat the meat raw and in roasts and stews. They eat greens from the stomach, muscles from the jaw, fat from behind the eyes. The hide goes into certain winter clothing that nothing manufactured can equal.

The people of the National Park Service, for their part, seem to be amply sensitive to the effects their efforts might have. They intend to adjust their own traditions so that Alaskan national park land will not abridge but will in fact preserve native customs. Under the direction of Douglas Anderson, of the Department of Anthropology at Brown University, an anthropological team commissioned by the Park Service has recently described and voluminously catalogued what must be every habit, tic, and mannerism, every tale and taboo—let alone custom—of the Kobuk River natives. The anthropologists make a convincing case for helping the people preserve their modus vivendi, but the most vivid words in the document occur when the quoted Eskimos are speaking for themselves:

Eskimos should make laws for those people outside. That would be just the same as what they try to do to us. We know nothing about how they live, and they know nothing about how we live. It should be up to us to decide things for ourselves. You see the land out there? We never have spoiled it.

Too much is happening to the people. Too many outside pressures are forcing in on us. Changes are coming too fast, and we are being pushed in all different directions by forces that come from someplace outside. People thought that the land-claims settlement was the end of our problems, that it meant the future was secure; but it was only the beginning. Even before the lands were all selected the government wanted pipeline easements and

road corridors right through our territory. These would take away strips miles wide, cutting right across our land. And instead of open access to the land, the Eskimos might be surrounded by huge pieces of country that are declared national resources for all the people. Land that has always belonged to the natives is being parceled up and divided among the takers.

The forest Eskimos' relationship with whites has made them dependent on goods that need to be paid for: nylon, netting, boat materials, rifles, ammunition, motors, gasoline. Hence, part of the year some Eskimo men leave the river to find jobs. These pilgrimages to the wage economy are not a repudiation of the subsistence way of life. They make money so that they can come back home, where they prefer to be, and live the way they prefer to live—foraging in the wild country with gasoline and bullets. If subsistence living were to be, through regulation, denied to them, the probable result would be that the government would have to support them even more than at present—more aid to dependent children, more food stamps—for they would not be able to find sufficient work, at home or on seasonal trips outside, to support their families.

As long as I have the land and nobody tries to stop me from using it, then I'm a rich man. I can always go out there and make my living, no matter what happens. Everything I need—my food, clothes, house, heat—it's all out there.

 And another thing, too. If we have nothing of our Eskimo food—only white-man food to live on—we can't live. We eat and eat and eat, but we never get filled up. Just like starvation.

Breakfast in the frying pan—freeze-dried eggs. If we were Kobuk people, one of us might go off into the watery tundra and find fresh eggs. Someone else might peel the bark from a willow. The bark would be soaked and formed into a tube with the eggs inside, and the tube would be placed in the fire. But this is not a group of forest Eskimos. These are legionaries from another world, talking "scenic values" and "interpretation." These are Romans inspecting Transalpine Gaul. Nobody's skin is going to turn brown on these eggs—or on cinnamon-apple-flavored Instant Quaker Oatmeal, or Tang, or Swiss Miss, or on cold pink-icinged Pop-Tarts with raspberry filling. For those who do not believe what they have just read, allow me to confirm it: in Pourchot's breakfast bag are pink-icinged Pop-Tarts with raspberry filling. Lacking a toaster, and not caring much anyway, we eat them cold. They invite a question. To a palate without bias—the palate of an open-minded Berber, the palate of a traveling

Martian—which would be the more acceptable, a pink-icinged Pop-Tart with raspberry filling (cold) or the fat gob from behind a caribou's eye?

Fedeler had picked up cups of blueberries to mix into our breakfast pancakes. Finishing them, we prepared to go. The sun was coming through. The rain was gone. The morning grew bright and warm. Pourchot and I got into the canoe, which, for all its heavy load, felt light. Twenty minutes downriver, we had to stop for more repairs to the Kleppers, but afterward the patchwork held. With higher banks, longer loops, the river was running deeper. The sun began to blaze.

Rounding bends, we saw sculpins, a pair of great horned owls, mergansers, Taverner's geese. We saw ravens and a gray jay. Coming down a long, deep, green pool, we looked toward the riffle at the lower end and saw an approaching grizzly. He was young, possibly four years old, and not much over four hundred pounds. He crossed the river. He studied the salmon in the riffle. He did not see, hear, or smell us. Our three boats were close together, and down the light current on the flat water we drifted toward the fishing bear.

He picked up a salmon, roughly ten pounds of fish, and, holding it with one paw, he began to whirl it around his head. Apparently, he was not hungry, and this was a form of play. He played the sling-the-salmon. With his claws embedded near the tail, he whirled the salmon and then tossed it high, end over end. As it fell, he scooped it up and slung it around his head again, lariat salmon, and again he tossed it into the air. He caught it and heaved it high once more. The fish flopped to the ground. The bear turned away, bored. He began to move upstream by the edge of the river. Behind his big head his hump projected. His brown fur rippled like a field under wind. He kept coming. The breeze was behind him. He had not yet seen us. He was romping along at an easy walk. As he came closer to us, we drifted slowly toward him. The single Klepper, with John Kauffmann in it, moved up against a snagged stick and broke it off. The snap was light, but enough to stop the bear. Instantly, he was motionless and alert, remaining on his four feet and straining his eyes to see. We drifted on toward him. At last, we arrived in his focus. If we were looking at something we had rarely seen before, God help him so was he. If he was a tenth as awed as I was, he could not have moved a muscle, which he did, now, in a hurry that was not pronounced but nonetheless seemed inappropriate to his status in the situation. He crossed low ground and went up a bank toward a copse of willow. He stopped there and faced us again. Then, breaking stems to pieces, he went into the willows.

We drifted to the rip, and down it past the mutilated salmon. Then we came to another long flat surface, spraying up the light of the sun. My bandanna, around my head, was nearly dry. I took it off, and trailed it in the river.

In the Great Country

PETER MATTHIESSEN

✣

In early September 2001, I went to New York City after having spent several months in the Arctic National Wildlife Refuge. My hope was to raise some money to support my ongoing work in the Arctic. Then, 9/11 happened, and I ended up staying there for nearly six weeks. During that time, on invitation from Reverend James Parks Morton, I gave a lecture at the Interfaith Center of New York. There, I met Peggy Harington, director of programs at the center. She introduced me to Peter Matthiessen. I had read Peter Matthiessen's many books, fiction and nonfiction, about the natural world—animals and birds, and about indigenous communities. For a while, I began showing up at his book readings. Finally, I met him. I asked if he would provide a blurb for my forthcoming book on the Arctic Refuge. He declined and said, "I no longer do blurbs and forewords." I took that as a cue and made a bold proposal, "Will you come to the Arctic with me?" I had done my research—he likes fishing—so I said, "You'll catch Arctic char every day." He responded immediately, "In that case, yes." I've had the good fortune of taking Peter to Arctic Alaska

three times so far—in 2002, in the Arctic National Wildlife Refuge; in 2006, in the Utukok River Uplands in the Western Arctic; and in 2007, to the Iñupiat communities of Point Hope and Point Lay. We have done many events together, including a Lannan Foundation Cultural Freedom event in Santa Fe in 2004; an UNEP climate change symposium in Brussels, Belgium, in 2007; and the annual Lyceum II lecture at the University of Utah in Salt Lake City in 2008—mere days before Peter received the National Book Award for his epic novel Shadow Country. *I've been very fortunate to have Peter as my friend and mentor, and when I needed help he always came through with empathy and generosity. What follows is an excerpt from two essays Peter wrote about the Arctic National Wildlife Refuge—"In the Great Country," published in 2003 in my book* Arctic National Wildlife Refuge Seasons of Life and Land; *and "Inside the Endangered Arctic Refuge," published in the October 19, 2006, issue of* The New York Review of Books.

❖

WILD NORTHERN Alaska is one of the last places on earth where a human being can kneel down and drink from a wild stream without being measurably more poisoned or polluted than before; its heart and essence is the Arctic National Wildlife Refuge in the remote northeast corner of the state, the earth's last sanctuary of the great Ice Age fauna that includes all three North American bears, gray wolves and wolverines, musk ox, moose, and, in the summer, the Porcupine River herd of caribou, 123,000 strong. Everywhere fly sandhill cranes and seabirds, myriad waterfowl and shorebirds, eagles, hawks, owls, shrikes and larks and longspurs, as well as a sprinkling of far-flung birds that migrate to the Arctic slope to breed and nest from every continent on earth. Yet we Americans, its caretakers, are still debating whether or not to destroy this precious place by turning it over to the oil industry for development.

A wildlife sanctuary in northeast Alaska had already been established when, in 1968, an oil-bearing geological formation called the Barrow Arch with exceptionally promising strata was discovered at Prudhoe Bay, an obscure location on the Beaufort Sea on Alaska's north coast. In 1977, with the completion of the Trans-Alaska Pipeline System (TAPS), the first oil flowed from Prudhoe over the mountains of the Brooks Range to Port Valdez, eight hundred miles to the south.

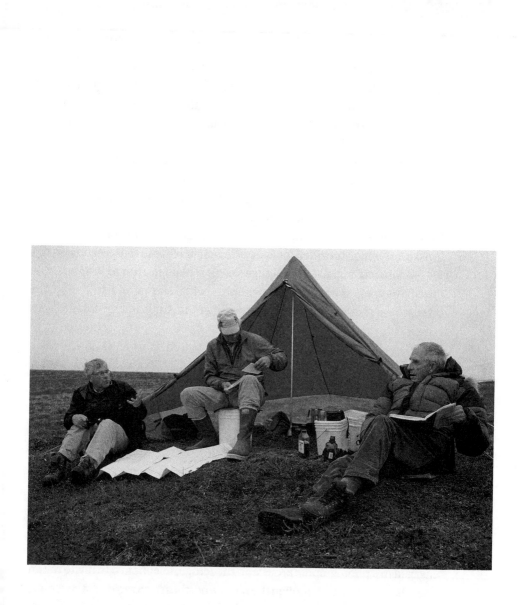

From right to left: Peter Matthiessen, Jim Campbell, and Tom Campion, Utukok River upland, National Petroleum Reserve-Alaska. *(Photograph by Subhankar Banerjee, June 2006.)*

Three years later, in 1980, Congress more than doubled the size of the sanctuary with the creation of the Arctic National Wildlife Refuge in a huge wilderness directly east of the north end of the pipeline. Most of the 19.6 million acres permanently set aside for wildlife protection were steep rocky mountains uninhabitable by large creatures other than the white Dall mountain sheep. The one great wildlife region inside the refuge was the flat coastal plain between the Brooks Range foothills and the Beaufort Sea.

Even so, the refuge legislation might not have passed without concessions to Big Oil's lobbyists and aides, deeply embedded in Congress and the White House. The most significant concession was Section 1002 of the enabling legislation, which provided for later assessment of fossil fuel potential in the 1.5-million-acre region of the refuge's coastal plain nearest to Prudhoe, followed by a congressional decision on whether oil leasing and drilling would be approved there. Thus when one speaks of the Arctic Refuge dispute, one is implicitly referring to the 1002—or "Ten-Oh-Two"—as the contested area, somehow diminished by a numbered designation, is widely known today. How sad that this land, so vital to the native Gwich'in and Iñupiat peoples, should be the center of what has become the longest and most acrimonious environmental fight in American history.

Ever since my first visit in May, 1957, when the land was still under snow, I had longed to return to the Arctic coastal plain which includes the Arctic National Wildlife Refuge—during the brief summer breeding season, but because the refuge has no roads or facilities—no real access, in fact, except by light aircraft—the journey to a region so remote that few have ever seen it had always seemed too difficult and expensive. Almost a half-century would pass before this opportunity arose, and it came from a most unlikely source. Subhankar Banerjee, a young Indian who grew up in Kolkata, India, and had engaged in a photographic project on the refuge, telephoned to invite me on a ten-day river journey through the remote northeastern region of the refuge, from the Brooks Range foothills north across the tundra to the Arctic coast, making camp here and there along the way.

A tall, lean young man of thirty-four with an infectious smile and unbounded enthusiasm, he had no trouble persuading me that his exciting project was an immediate and effective way to help forward a cause I had first advocated forty years before, and again in that critical period in the late eighties, in a preface to the Natural Resources Defense Council publication called *Tracking the Oil*.

By then I had heard from the sponsor and leader of our expedition, a businessman from Everett, Washington, named Tom Campion, who dedicates a

substantial percentage of his income to helping save the wilderness Arctic from despoliation. The group included my son Alex, an environmentalist who is presently the Hudson Riverkeeper and head of the environmental organization of the same name, Campion's wife, Sonya, her niece, Andrea Maki, and his friends Mark Skatrud, Mike Matz, Jim Mankopf, and Jed and Joann Marshall, as well as our guides (the proprietors of Arctic Treks), Jim Campbell and Carol Kasza. We flew to Fairbanks on July 12, 2002, going on to Arctic Village the next morning and crossing the Brooks Range that same day into one of the earth's most remote wildernesses, the Arctic National Wildlife Refuge, which encompasses all the sub-Arctic and Arctic ecosystems, from the boreal forest of the Porcupine River Uplands to the dry Arctic tundra of the coastal plain.

On a broad bend where a gravel bench on the willow bank is wide enough to handle its small tires, the aircraft drops us near the river. Though the clouds thicken, with hard rain in the mountains, night will not fall under the midnight sun, and the bush pilots Dirk Nickisch and Kirk Sweetsir (whom Campion refers to as "the Irk brothers") have the expedition on the ground in time for a late supper. Mosquitoes rise in swirls around our heads as tents are pitched in a grassy meadow among willows; the cook tent goes up near the river's edge where the cool wind upriver from the sea holds them at bay. Proliferating in this fleeting season of unfrozen water, these pesky creatures are the living fuel that sustains the swarming bird life of the Arctic and thereby justifies their noisome existence.

Where a tributary stream winds down out of the eastern ridges, joining the Kongakut a half-mile above camp, we climb the soft green moss and tus- socks of wet tundra to the high rock outcrop on the ridge. Out of the wind, leaned back against soft lichens on the rocks, we breathe in a vast, beautiful, and stirring prospect. High snow-streaked peaks rise to the south and west, and to the north, the gray torrent, curving west under its cliffs, escapes the portals of the foothills and winds across the plain toward the hard white bar on the horizon—the dense wall of fog that hides the Beaufort Sea. This wild, free valley and the barren ground beyond is but a fragment of one of the last pristine regions left on earth, entirely unscarred by roads or signs, indifferent to mankind, utterly silent.

The Arctic light in the long sunny evenings is so limpid and so lovely that one can scarcely bring oneself to go to bed. The camp is already on "Arctic time," which means no more than staying up well past the midnight sun. In the pallid dawn, Mark, Tom, and I are the only ones who rise more or less

early out of long habit, and sit with our coffee by the cook tent on the square white food buckets that serve the camp as seats, scanning the landscape for wild creatures, talking softly so as not to wake the others.

By midmorning our companions emerge, and by noon we have launched the river rafts.... In the lead, two kayaks are dived on by nesting glaucous gulls and the quick, forked-tailed Arctic terns; at its nest scrape on the gravel, a tern feeds its craning chick a silverling that glitters like tinsel, as its mate dips and lifts over the rapids, silver minnows bright in its crimson beak. In autumn, this species turns up in small numbers on my home coast on Long Island, New York, but the last place I'd seen it was on winter range in Tierra del Fuego and the Antarctic Peninsula. The Arctic tern has the longest migration of any bird on earth, an astonishing round-trip journey of twenty-four thousand miles each year.

Downriver, a cow moose with her big calf have come down to drink; wary, the enormous deer plunge like horses up the bank and disappear over the rise behind the blowing grasses. Ahead lies the coastal plain, flat, flat, flat, but this lower estuary is partially clogged by overflow ice, which forms where the river freezes to the bottom and the dammed-up current spreads over the ice, freezing hard in layer after layer and building platforms sometimes ten feet high that do not always melt away in summer. Mergansers hurtle up and down the river, the first loons and eider and a bufflehead appear, then a small dark duck, probably a harlequin, heads upstream a tributary braid.

Tonight camp is made on soft, wet moss at the foot of the last river bluff before the plain. An hour before we came ashore, we had seen two figures waving from the high rim of the escarpment—Subhankar and his partner, an Iñupiaq named Robert Thompson. Camped a half-mile upriver, they turn up at our camp in time for supper. Subhankar tells us that this very day, he and Robert found gyrfalcons and peregrines nesting on rock towers close together; in recent days, they have seen musk oxen here as well as grizzlies.

Setting off next morning for the falcon nests, I climb the steep tundra slope behind the camp, my eyes at the level of a sun-shimmered bed of fresh blue lupine and translucent yellow poppies whose airy petals, strewn like bright sundrops on green beds of grass and mosses, are mixed with white bear flowers, Arctic forget-me-not, pink Siberian phlox, and the bog rosemary. I am soon overtaken by Subhankar and Robert, and Alex catches up with us on the crest of the plateau, from where we can see the opaque white horizon that marks the sea fog and the polar ice along the coast. These low hills west of the river—Robert points—are a favorite denning area of female polar bears; the

Pacific loon on nest, near Turner River, Arctic National Wildlife Refuge. Loons are among the oldest surviving species on earth—they have been around for more than 20 million years. The male and the female share nesting duties, giving each other breaks to go feed. In addition to the threat of oil development in their Arctic habitat, the large lakes that loons critically depend on are disappearing rapidly due to arctic warming—permafrost is thawing and the water is draining away, leaving the lakes dry. *(Photograph by Subhankar Banerjee, June 2002.)*

refuge has the highest density of denning bears on the North Slope. Because the Brooks Range draws close to the coast here in far northeast Alaska, the rivers are steeper and swifter, with bluffs and cutbanks where the torrents have cut through. Since these valleys cross the prevailing winds, they accumulate snowdrifts much earlier in winter than occurs on the more gradual flat plains to the west, and these early drifts are sought by pregnant polar bears for digging out dens in which to hibernate and bear their young.

A golden eagle flaps downriver far below and a gyrfalcon passes rapidly overhead. The tundra meadows are broken here and there by dolmenlike monoliths like giant headstones, and bountiful wildflowers watered by melting permafrost flourish in the soft carpet: Against the background of its rock towers and the farther mountains, this high plateau is mysterious and very beautiful.

In early spring, the caribou herd in the Porcupine River drainage starts north toward Ivvavik—"a place for giving birth, a nursery"—a Canadian national park that includes the Yukon coastal plain where part of the herd remains behind to calve while the rest tend westward into the Arctic Refuge. Two months ago, this plateau was crossed during spring migration by herds that appeared out of the Yukon Mountains to the east. With the longest migration of any terrestrial mammal—2,500 to 3,000 miles in its meanderings, or 800 miles in a straight line southeast to northwest—the big deer with long legs on a light body is also the most efficient walker; the broad hooves adapted to snow and swimming are seemingly analogous to the big, broad paws of polar bears and wolves. When the snow here is still too deep for foraging, the caribou climb to the wind-scoured heights, where the snow cover is thinner. Near-vertical tracks stripe the alpine slopes, straight up to the point where bare rock replaces alpine tundra vegetation. These windswept plateaus on the river bluffs, where willow tips and the tussock growth form of the Arctic cotton grass may poke through the snow, are also a winter habitat for musk oxen.

Where the westering caribou descend into the willow bottoms and ford the river, we follow their tracks to the foot of the escarpment and continue southward up the valley to a group of rock towers high on the grassy inclines. Here Subhankar points out the gyr nest on a rock ledge high above. Two big gray chicks are still hunched on the nest, and a half-fledged sibling flaps and flops on the rocks below. From a craggy outcrop that commands a view of the broad Kongakut Valley, the adult bird, a gray gyrfalcon, screeches a brief warning but otherwise sits still as stone, its pale buff breast and yellow talons shining in the sun.

On the next turret, on an open ledge, is the large crude nest of the rough-legged hawk that commands the rock above; from higher up, on a farther

tower, comes the high screaming of peregrines, one of which darts into the sky over the valley and cuts back at once toward its hidden eyrie. To see the rough-leg, golden eagle, peregrine, and gyr in the same hour and location is a rare experience, and an unlikely one outside the Arctic Refuge.

Returning to camp, Alex and Subhankar walk the upland tussock underneath the cliffs, to avoid mosquitoes, while Robert and I choose the harder ground and better walking of the willow bottoms. In the maze of big deer prints—moose and caribou—we look for sign of musk oxen, finding wolf instead. Seeing fresh grizzly scat all along our path, I am content that my companion wears a .45 Long Colt six-shooter on his belt that is heavy enough to drag his pants down on that side as he rolls along.

Asked if his people had any name for this coastal plain that the Gwich'in refer to as the Sacred Place Where Life Begins, Robert looks at the open landscape all around, bemused, as if he were thinking. "It's just home," he says finally. "To us, it's home." That word, the way he used it, had a capital H.

Next day the last foothills are left behind as the river descends into the flat coastal plain of the barren ground. The river has cleaned itself of the storm roil of a few days ago, brought down from the mountains by the rain; today it is clear jade over the stones, fresh turquoise in the channels. In the brilliant clarity of the pure light, the whites of the white birds seem to flash against the green-gray monotones of tundra.

Icy Reef is a gravel spit perhaps a hundred yards across and four feet above sea level that separates Siku (Ice) Lagoon from the polar seas. There we fortify the tents against the wind by pounding in heavy stakes culled from the silver driftwood stacked on the reef's spine; the line of driftwood travels the length of the narrow island, east and west for perhaps fifteen miles, disappearing into the mist in either direction.

Crowding the reef's outer beach are the sculpted forms of stranded icebergs, whose delicate pinnacles and arches, tilted mushrooms, and cantilevered shelves are marvelously balanced and supported. They extend offshore a quarter-mile to a half-mile, like floating sculptures brilliantly reflected in the still black water that the white masses shelter from the wind. The Arctic ice pack, at this time of year, is perhaps five miles farther out to sea, in the realm of the bowhead whale, ringed seal, and polar bear, whose carnivore's dense scat and big prints in the sand, perhaps months old, have deteriorated little in this arid place.

The wind off the ice bites through the light fabric of my summer tent. A day later, we travel east down the Siku Lagoon toward Demarcation Bay, near

the Yukon border. In a kayak, I set out ahead into the glassy stillness, the great silence. Where the sea has broken through the barrier island, a large pale grayish seal—the bearded seal, I think—parts the surface in the cutway and slides beneath again, but another is so taken aback by its sudden confrontation with a black gliding thing that it somersaults backward in a great thrash as it disappears.

An owl-like stump on a silver log turns out to be a snowy owl, pale silver gray; with deceptive speed, it crosses the lagoon to the tundra rim, where it resumes its existence as a stump. On that low cliff where the barren ground touches the sea walk the misted silhouettes of caribou, and near the caribou a pair of sandhill cranes is calling—the little brown crane, or Canadian crane, as the smallest race of this far-flung species is known. The two that answer from far off are probably not a separate pair: At this time of year it seems more likely that the parent birds, out foraging, are each accompanied by one of their two fledged young, maintaining the family unity with rolling cries.

A white owl swings out over the ice before heading back down the seacoast toward the west. On the beach crest, upright and heraldic on a silver limb, a magnificent peregrine, gray-blue above and lightly barred ivory on the breast and belly, watches the half-man in the black craft without the smallest shift or twitch of wing. I drift for a long time in the light of endless day, wondering why two adult owls and an adult peregrine were drawn to the bony reef, where there is no water nor good habitat for vole or lemming.

This morning we travel to the eastern end of Icy Reef, where the chartered planes will pick us up day after tomorrow. . . . By nine in the morning on July 23, when Kirk Sweetsir lands his Cessna on the gravel bench that crests the reef, the day is clear. With Robert and Subhankar, who caught up with us last evening after two days at the raptor nests upriver, I go out on the first flight west over the 1002, the coastal plain of the Arctic Refuge which we will cross on our way to Kaktovik.

Looking for musk oxen, the plane flies low along the coast, which is sprinkled white by a hundred pairs of tundra swans. Two cow moose with well-grown calves are perhaps a mile apart, throwing big shadows in the morning light. . . .

Crossing the Aichilik delta, the plane enters the 1002—what the oilmen refer to as "the *An*-War." In its olive monotones and grassy ponds, this disputed area is indistinguishable from the Kongakut tundra except that as the plane flies west, the Brooks Range recedes into the southern mist and the coastal

plain widens, until finally the mountains disappear entirely. This wider plain, far from the mountains, is the heart of the Porcupine herd's 740-square-mile calving ground.

It is now late July, and the herd, with its new young, has already returned inland; on the myriad trails that web the odd, polygonal surface of the tundra, a lone deer plods southward, head low under its great antlers. The huge herd, packed close to protect itself against botflies and mosquitoes, is already returning through the mountains, and some will arrive in the Gwich'in country in late summer and early autumn.

When our expedition into the Wildlife Refuge passed through Arctic Village on the way north, the Gwich'in leaders were away at a tribal meeting in Old Crow, a Porcupine River village in the Yukon. Anxious to listen to the Indian point of view, I returned to Arctic Village a fortnight later.

Back in 1971, Arctic Village and Venetie chose not to participate in the Alaska Native Claims Settlement Act (ANCSA), which was granting nearly $1 billion and 44 million acres of territory to the Native Americans and settling indigenous land claims for those tribes which accepted oil development and the construction of the pipeline. Refusing to accept the ANCSA terms, the two Gwich'in villages held out for their original tribal land claim of 1.8 million acres, in the full knowledge that this brave commitment to the integrity of their ancestral lands and their traditional ways would condemn them to a life of bare subsistence.

Arctic Village, a scattered assembly of forty-odd log cabins built on granite ridges that overlook the serpentine bends, oxbows, and channels of the East Fork of the Chandalar River just south of the southwestern corner of the Refuge, is one of the most remote settlements in this enormous state. High in the foothills of the Brooks Range, seventy-five miles north of the Arctic Circle and more than a hundred from the nearest road, it was chosen as a place to settle by the formerly nomadic Gwich'in because its sheltering forest provided timber for cabins and fuel and a variety of fur animals, and its river abundant fish. More important, it is winter range for part of the Porcupine caribou herd. Leaving smaller companies behind, the main herd drifts south and east into the Porcupine River drainage and Canada's Yukon Territory, where most of the animals will overwinter. The fifteen Gwich'in villages in northeast Alaska and northwestern Canada, consisting of about seven thousand people, are scattered along the caribou migration route, and all need caribou meat—about twelve animals per family—to see them through the long hard winters.

To the Gwich'in, the caribou calving ground in the coastal plain of the Arctic National Wildlife Refuge is known as Izhik Gwats'an Gwandaii Goodlit—roughly, "the sacred place where life begins"—the life, that is, of Caribou, which is not understood as something apart from the life of Gwich'in, the People. According to their own traditions, these indigenous Athabaskan Indians have hunted caribou in the northern forests for perhaps ten thousand years: the myth, culture, economy, and future of the fifteen Gwich'in villages depend on this big deer as the Plains tribes once depended on the bison and the Pacific Northwest tribes on the salmon. In their creation story, told to me by Elder Reverend Trimble Gilbert, Caribou holds a piece of Man's heart in its heart, and Man a piece of Caribou, so that each will know what the other one is up to.

How truly sad it seems to me, after fifty years as an environmentalist, that so many years of progress in conservation and sustainable energies, together with the world's great hopes for control of carbon dioxide emissions from the burning of fossil fuels that might defer the coming cataclysm of global warming, are being blocked, stalled, derailed, and turned back toward the past by the oil and automotive industries and their team in Washington. Indeed, I am outraged that the last pristine places on our looted earth are being sullied without mercy, vision, or good sense by greedy people who are robbing their fellow citizens of the last natural bounty and profusion that Americans once took for granted. Many years will be lost trying to undo some of the recent reckless damage to clean air and water, old-growth forest, biodiversity, and many other crucial aspects of our environment that is being perpetrated for the profit of a few by our government.

"If we fail to save the land, God may forgive us," as a Togiak Elder has said, "but our children won't."

PHOTOGRAPHS AND DRAWINGS
Artists Engage

PLATE 23

East Greenland Sea. In 2007, I co-exhibited with photographer Stuart Klipper at the Milwaukee Art
Museum. I long admired his Antarctica photographs, a selection of which was exhibited at the
New York Museum of Modern Art in 1991, "Projects: Stuart Klipper: On Antarctica 1989." In 2008,
Chronicle Books published Stuart's magnificent panoramic format book *The Antarctic: From the Circle
to the Pole.* As I was preparing to present art for this volume, I asked him if he had any work from the
Arctic. He sent me a selection. The earliest photograph is dated 1976, taken in Greenland. Today it
is not possible to think about photography of ice—its presence and its absence—without Stuart's
photographs that span more than four decades. *(Photograph by Stuart Klipper, 1981.)*

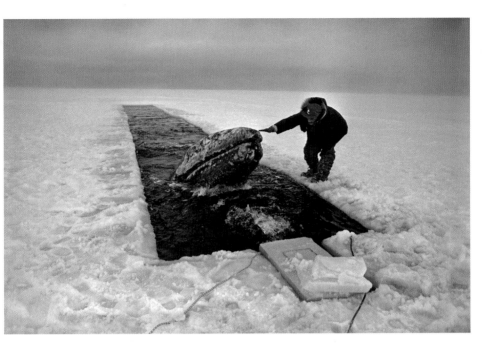

PLATE 26

Malik Says Goodbye. For the remarkable story of the Great Grey Whale Rescue of 1988 about the efforts the Iñupiat people of Barrow made to help two grey whales that were trapped in ice, see Bill Hess's thirteen-part photo essay at http://www.logbookwasilla.com/logbookwasilla/2012/2/3/the-movie-big-miracle-and-what-i-witnessed-in-real-life-part.html. *(Photograph by Bill Hess, 1988.)*

(Opposite) **PLATE 24**

Kunuk's (Jonathan Aiken, Sr.) crew prepares to shove off after the bowhead surfaces, Chukchi Sea, off of Barrow. *(Photograph by Bill Hess, May 1987.)*

(Opposite) **PLATE 25**

Naluqatuk prayer. A blessing for four bowheads at the spring whale feast in Barrow. *(Photograph by Bill Hess, June 1988.)*

No photographer has engaged as deeply, with as much empathy, and for as long with the northern indigenous communities of Alaska, as Bill Hess. Bill first went to Barrow in spring 1985. Later that year he "started up *Uiñiq*—a new pictorial magazine of life in the eight Iñupiat villages of the North Slope Borough." His remarkable book, *Gift of the Whale: The Iñupiat Bowhead Hunt, a Sacred Tradition* was published by Sasquatch Books in 2003. As I was pulling together these images, Bill was in India and emailed me, "I wish we could include some of my recent work so that readers could see that I still work in the Arctic." Indeed, Bill is currently working on his book, *Kivġik—The Messenger Feast.* One photograph from the Kivġik series is included in Chie Sakakibara's essay on page 343.

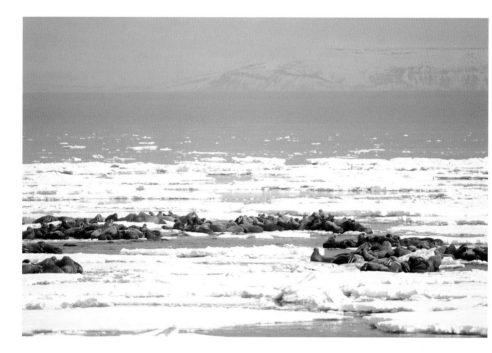

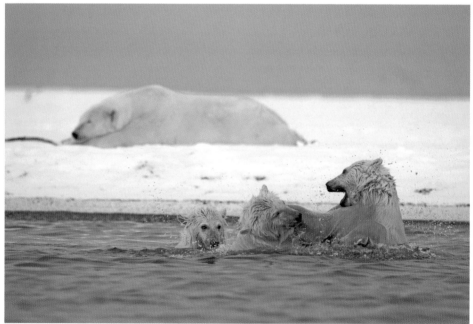

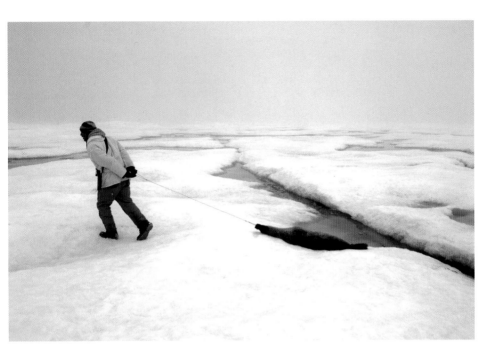

PLATE 29

Iñupiaq seal hunter Mike Dirks pulls a ringed seal over the frozen Chukchi Sea near Point Hope. *(Photograph by Steven Kazlowski, July 2006.)*

(Opposite) **PLATE 27**

Walruses on pack ice of the Bering Sea. *(Photograph by Steven Kazlowski, April 2002.)*

(Opposite) **PLATE 28**

Juvenile bears play in the water of the Beaufort Sea, near Kaktovik. *(Photograph by Steven Kazlowski, September 2011.)*

During 2001 and 2002, I spent a lot of time photographing alongside Steven (Steve) Kazlowski in Kaktovik and the Arctic National Wildlife Refuge. Steve's primary obsession has been polar bears. His photo-essay book, *The Last Polar Bear: Facing the Truth of a Warming World*, was published by Moun-taineers Books in 2008. Each autumn I eagerly wait for his new photographs from the Arctic. I would say Steve is the most engaged photographer of Arctic wildlife, working today.

PLATE 30

Narwhals (*Mondon monoceros*), Lancaster Sound. While the polar bear is the icon of global warming vulnerability, some recent scientific studies predict that narwhals might be more at risk due to Arctic warming. See Barry Lopez's essay on narwhals of Lancaster Sound. *(Photograph by Charles "Flip" Nicklin, 1987, Minden Pictures; from his book* Among Giants: A Life with Whales *published by University of Chicago Press in 2011.)*

(Opposite) **PLATE 31**

River 1, Position 13, 69°40'53"N, 49°54'06"W, altitude 715m. *(Photograph by Olaf Otto Becker, July 2007.)*

(Opposite) **PLATE 32**

Point 660, 2, 67°09'04"N, 50°01'58"W, altitude 360m. *(Photograph by Olaf Otto Becker, August 2008.)*

 Both plates 31 and 32 are from Olaf Otto Becker's book, *Above Zero* published by Hatje Cantz in 2010. In December 2009, during the UN Climate Conference in Copenhagen, I participated in the exhibition (Re-)Cycles of Paradise organized by ARTPORT and commissioned by Global Gender and Climate Alliance. While there, I saw an exhibition of Olaf's Greenland photographs at the National Museum of Photography. On December 15, 2009, the *New York Review of Books* presented a blog piece "Olaf Otto Becker: Greenland Melting," in which senior editor Eve Bowen writes, "Unsentimental and astoundingly beautiful, they show a violently shifting ice-filled landscape at arresting points of stillness."

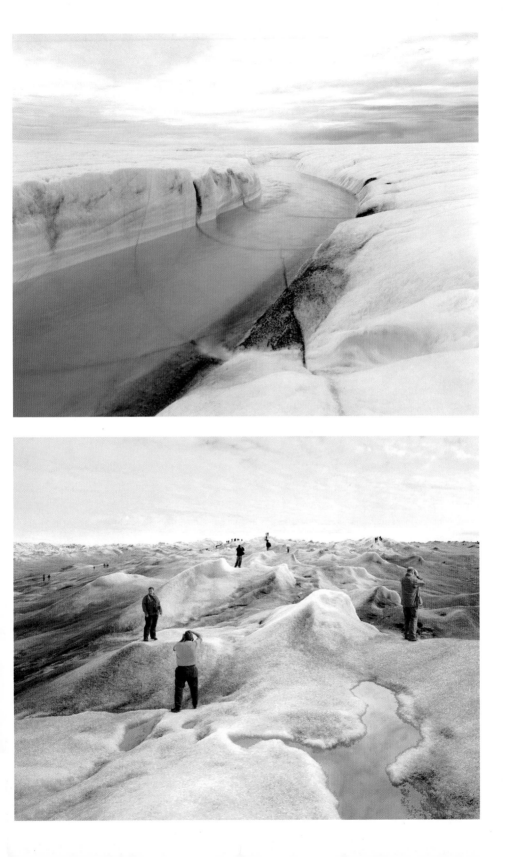

PLATE 33

In The Summer Tent, 20" x 26", pencil, ink, and pencil crayon on paper. (Drawing by Annie Pootoogook, 2002.)

(Opposite) **PLATE 34**

Bear by the Window, 20" x 26", ink and pencil crayon on paper. (Drawing by Annie Pootoogook, 2004.)

(Opposite) **PLATE 35**

Memory of My Life: Breaking Bottles, 20" x 26", ink and pencil crayon on paper. (Drawing by Annie Pootoogook, 2002.)

I contributed an essay and photographs to the fall 2008 special issue "Gender on Ice" of *The Scholar & Feminist* webjournal published by the Barnard Center for Research on Women (barnard.edu/sfonline/ice). The issue also included a presentation of remarkable drawings of Inuit artist Annie Pootoogook. In an essay on Pootoogook's art, Debora Root writes,

"[T]here is something profoundly disturbing about her images of the everyday, where the figures seem to float in space as they go about their business. . . . [W]hat we see in Pootoogook's images is an integration of elements, an integration characteristic of lived experience. Her work presents culture as a fluid entity, and makes it very clear that Southern elements are being taken up and interpreted actively, rather than by passive recipients or victims of colonialism. Yet that history is there, situated in the sometimes difficult lived culture she depicts, yet by no means ethnographic. And sometimes her vision is ironic, sometimes not." (Courtesy of Dorset Fine Arts, Toronto; photographs courtesy of Feheley Fine Arts, Toronto.)

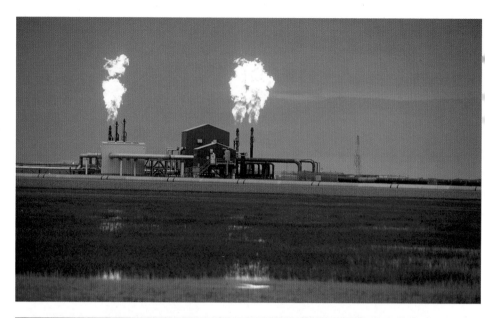

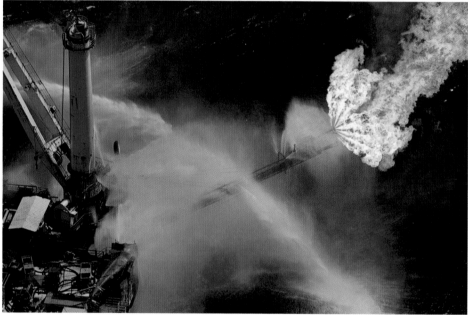

PLATE 36

Gas flaring at Gathering Center 1 production facility at Prudhoe Bay. *(Photograph by Pamela A. Miller, 1988.)*

PLATE 37

On April 20, 2010, the *Deepwater Horizon* rig exploded, killing eleven workers and gushing 4.9 million barrels of oil into the Gulf of Mexico. This image was first published in "The BP oil disaster: A year in photography" by Erika Blumenfeld, in *Al Jazeera*, April 23, 2011. *(Photograph by Erika Blumenfeld, July 12, 2010.)*

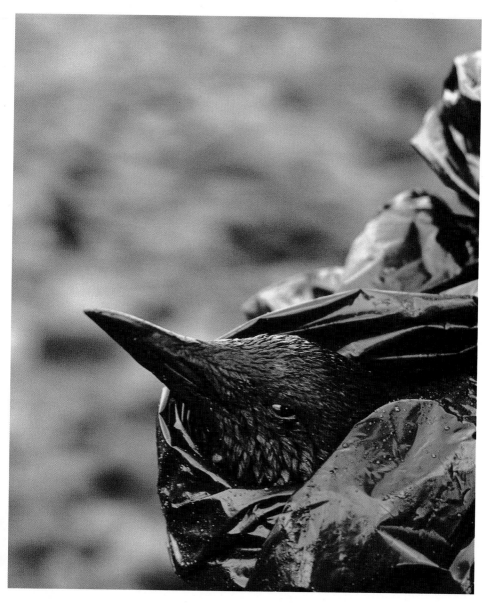

PLATE 38

An oiled pigeon guillemot, one of over 100,000 seabirds killed by the *Exxon Valdez* oil spill, is held in a garbage sack by rescuers. It later died. This photograph by Natalie Fobes appeared on the cover of the January 1990 issue of *National Geographic Magazine* that included a major article on the *Exxon Valdez* spill. Natalie testified for the plaintiffs in the state and federal lawsuits. When the case went to the US Supreme Court, her photographs were presented to the justices so they could see how horrible the spill was. According to the attorneys, this had not been done before in the Supreme Court. *(Photograph by Natalie Fobes, April 1989.)*

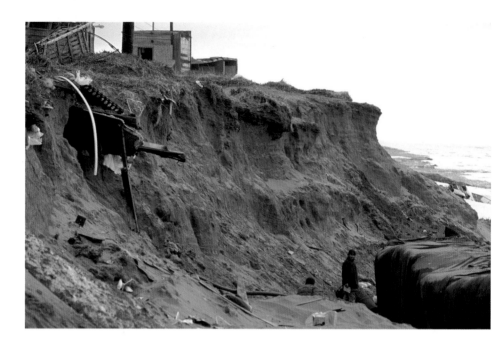

PLATE 39

Coastal erosion and thawing of permafrost, Shishmaref, along the Bering Sea, Alaska. In June 2001, I had camped alongside photographer Gary Braasch in the Kongakut River valley in the Arctic National Wildlife Refuge. Gary was already engaged in his extensive documentary project *World View of Global Warming* (www.worldviewofglobalwarming.org), which resulted in the book, *Earth Under Fire: How Global Warming Is Changing the World* (Berkeley: University of California Press, 2007). "The Iñupiaq who inhabit the village of Shishmaref have survived here for generations but can't halt the rising Bering Sea and the thawing of permafrost within the dunes. In 2002 residents voted to move their village to higher, more protected ground away from the ocean, giving up their traditional home, fishing, and sealing sites." *(Photograph by Gary Braasch, June 2001.)*

(Opposite) **PLATE 40**

Where There Should Be Ice, East Greenland, from the series "The Last Iceberg." *(Photograph by Camille Seaman, 2006.)*

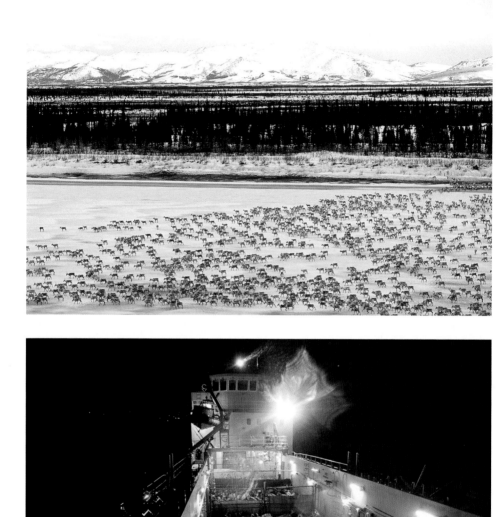

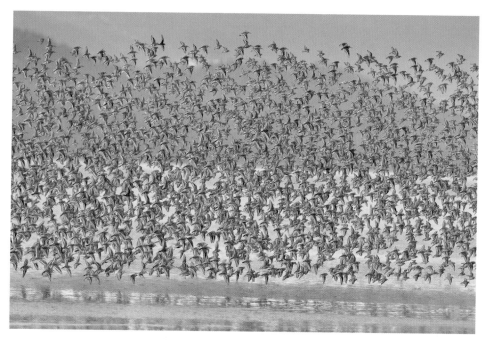

PLATE 43

Sandpipers, Prince William Sound. Sandpipers in Prince William Sound grow restless as they prepare to migrate north to their breeding grounds in the Arctic. Millions of migratory birds depend on the Arctic for their survival. German photographer Florian Schulz and I have spent much time discussing the role of photography in wildlife conservation. Florian's primary focus has been on the idea of ecological corridors through his ongoing project "Freedom to Roam" (www.visionsofthewild.com/projects.html). His first book, *Yellowstone to Yukon: Freedom to Roam* was published by Mountaineers Books in 2008. He is currently completing another similar project "Baja to Beaufort." *(Photograph by Florian Schulz, 2007.)*

(Opposite) **PLATE 41**

Spring migration, caribou from the Western Arctic Herd migrating north, on Kobuk River. *(Photograph by Seth Kantner, late April 1998.)*

(Opposite) **PLATE 42**

Benjamin Drummond and Sara Joy Steele's long-term documentary project *Facing Climate Change* (bdsjs.com/facing-climate-change) began with a series of stories about Sámi reindeer herders in Norway. These reindeer are transported by boat because of development on their traditional pasturelands and migration route. When faced with challenging climate conditions, privatization from oil companies, mining operations, and cabin building limit the ability of herders to keep their animals "exactly in the right place at the right time," says Niklas Labba. *(Photograph by Benjamin Drummond; Text by Sara Joy Steele, 2006.)*

PLATE 44

Greenland #27, 66" x 50", soft pastel on paper. In 2007, I had co-exhibited with photographer Rena Bass Forman at the Milwaukee Art Museum. Later I came to know the marvelous drawings by her daughter Zaria Forman. Rena tragically passed away from a brain tumor in 2011. I invited Zaria to contribute her art for this volume. Of her work she writes, "In my work I explore moments of transition, turbulence and tranquility in the landscape and their impact on the viewer. In this process I am reminded of how small we are when confronted with the powerful forces of nature." (Drawing by Zaria Forman, 2008.)

Coast to Coast

Perilous Journeys with Arctic Shorebirds

STEPHEN BROWN

❖

In the preface of the book Arctic Wings: Birds of the Arctic National Wildlife Refuge *that was edited by Stephen Brown, I wrote, "In the fall of 2002, I supported an event with Peter Matthiessen for the Manomet Center for Conservation Sciences in Plymouth, Massachusetts. Early in the day, Stephen Brown and his wife Metta McGarvey, Wayne Petersen, and other good friends took us out birding on Plymouth Beach. That day we saw American Golden-Plover, Ruddy Turnstone, Dunlin, Semipalmated Sandpiper, and Semipalmated Plover; species that Peter and I had seen only a couple of months before in the Arctic Refuge. . . . Stephen had been conducting extensive shorebird research on the Arctic Refuge coastal plain." Every summer since, Stephen with his wife Metta and other team members returned to the Arctic Refuge to continue their research. What follows is an essay Stephen wrote for Arctic Voices—a story about their ongoing Arctic shorebird study. On November 22, 2011, Stephen e-mailed me, "I did have a great season in the Arctic, although Metta couldn't come this year. She was helping manage our contract on the BP oil spill—we*

did all of the assessments for all the Gulf states for shorebirds, a really mas-
sive project with seventy-seven full-time people. It totally dominated our
year, and we've basically had no life at all other than work this whole past
year. It is winding down now though, which is a relief. I hope our work will
contribute to the assessment of the impacts and eventual restoration of the
Gulf. I am already planning for our next season in the Arctic Refuge, and I
am also coordinating nine other Arctic field sites—we are trying to measure
shorebird survival rates across the entire Arctic so we can compare survivor-
ship and determine what limits populations. A really ambitious project, which
also overwhelms me at times." Someday we'll learn about their research in
the Gulf of Mexico, but for now, here is their Arctic story.

<div align="center">❖</div>

FLYING OVER the coastal plain of the Arctic National Wildlife Refuge in June,
the starkly beautiful peaks of the Brooks Range rise below us to the south, and to
the north the verdant green tundra slopes down to the blue lagoons and sandy
barrier islands of the Beaufort Sea. In the distance, the Arctic sea ice recedes in
long expansive icefields, stretching as far as the eye can see toward the North
Pole. As the skis of our de Havilland Beaver touch down on a semifrozen lake,
the windshield disappears in a wash of slush that sprays up through the cracks
around the door. Glad that Arctic lakes freeze to the bottom and thaw from the
top, we slide to a stop and our pilot captures the moment perfectly, saying only,
"Bummer, dude!" We drag our gear through eight inches of slush to a small ridge.
It takes three days to find a better landing strip so we can get the rest of the crew
flown in. Eventually we settle in, and the eight of us live in tents through five
weeks of snow and regular visits from passing grizzly bears.

 Being a shorebird biologist in the Arctic is not for the faint of heart, but
only those fortunate enough to spend time on the tundra in June have the
opportunity to experience the annual symphony of hundreds of thousands
of shorebirds filling the landscape with songs. Standing on the Arctic coast
at the peak of breeding season, shorebirds surround us. For millions of years
these tiny birds have overcome tremendous obstacles migrating from winter-
ing grounds ranging from the tip of South America to the southern United
States, to nest and raise their young, feasting on the explosion of insect life
that happens during the short Arctic summer.

Shorebirds are a diverse group that actually uses a wide range of habitats in addition to shoreline. The group includes the familiar sanderling, which runs up and down with the waves and inhabits childhood memories of visits to the beach for people throughout the Western Hemisphere. Other shorebird species such as the semipalmated sandpiper prefer very different habitats, from mudflats to wetlands. Yet others such as buff-breasted sandpipers forage in upland prairies, while lesser yellowlegs nest in trees in the boreal forests of North America. Plovers and sandpipers are the largest groups, but shorebirds also include oystercatchers, avocets, and stilts.

Manomet Center for Conservation Sciences has been championing this group of imperiled birds for more than forty years. Early in the 1970s, Brian Harrington, now Senior Scientist emeritus, came to Manomet to explore the life history and threats facing Red Knots, a striking shorebird that travels from southern South America to the Arctic every year. Brian tells their story in his book *Flight of the Red Knot*. Realizing that shorebirds use so many different sites during their migration, and that the only way to count them and monitor the health of their populations would be with the help of a large number of volunteers, Brian started the International Shorebird Survey. For forty years, hundreds of citizen scientists from around the Western Hemisphere have contributed thousands of counts of shorebirds in their local area, collectively creating the longest-running effort to track this group of birds. Unfortunately, our analyses of the data are not encouraging.

Most shorebird species are in serious decline. The species that nest in the Arctic are declining steadily, and many will become endangered in our children's lifetime if we do not take corrective action soon. One of the most common species, the semipalmated sandpiper, numbered in the millions during counts by Canadian biologists across its wintering grounds on the northern coast of South America in the 1980s. Current counts in the same areas by scientists from the New Jersey Audubon Society show that the species has declined by about 80 percent. This shocking result emphasizes the critical need to find out why shorebirds are declining and take immediate action to recover their populations before it is too late.

There are many ideas about what may be causing the problem: the extensive loss of coastal wetlands along shorebird migration routes, overhunting in the early twentieth century, the many toxins that wild birds are exposed to, the impacts of a changing climate, and a host of other potential factors. But because we don't know what caused the decline of the populations of Arctic shorebirds, we cannot effectively target conservation actions to address the

root causes of the declines. For this reason, a large partnership of conservation groups called the Arctic Shorebird Demographics Network (ASDN), which includes state and federal biologists, and university scientists from the United States and Canada, have come together to try to understand what is causing these declines and what can be done about it. One major piece of the puzzle is what happens in the Arctic, where shorebirds go each spring to mate, nest, and replenish their numbers.

I first went to the Arctic National Wildlife Refuge in 2002 with colleagues from the US Fish and Wildlife Service and the US Geological Survey to find out how many shorebirds were nesting on the coastal plain. Early work had been done at several remote camps scattered across the coastal plain in the 1980s by the Fish and Wildlife Service, but the data were too sparse to extrapolate the findings from those few camps to understand the health of shorebird populations throughout the vast Arctic coastal plain. We started a program called PRISM in 2002 (Program for Regional and International Shorebird Monitoring) with partners from the United States and Canada to develop a technique that could fill this gap in our knowledge.

The method we use is conducted in three steps. First, several people spend an entire breeding season on several small plots of about forty acres, where they tirelessly search for shorebird nests. Finding a shorebird nest on the tundra is remarkably like finding a needle in a haystack. Tundra is like an uneven field filled with ridges and balls ranging in size from a baseball to a bowling ball. The tiny shorebird nests tucked into small bowls nestled deep in the sedges, camouflaged to make them blend in, are almost invisible to all but the most trained eye. To find these nests, we track the birds by following their behavior and learn to recognize when one is near a nest. Occasionally we get lucky and see a bird actually leave a nest.

Once all the nests are found on these small plots, which can take from a few days to several weeks depending on the richness of the site for shorebirds, the next step is to have someone who knows nothing about what has been found conduct a very rapid survey of the same forty-acre plot in seventy-five minutes. Obviously, these rapid surveys miss many of the birds, although trained observers can do remarkably well once they understand the subtle cues the birds give that indicate nesting behavior. Some birds slink off when first spotted, sometimes even acting injured in an attempt to lure a potential predator away from their nest. Others sing to mark their territories or fight with neighboring birds of the same species in pitched aerial battles to defend their females. Using these and many other cues, we estimate how many birds

Stephen Brown with a dunlin, Teshekpuk Lake Special Area. Shorebirds disperse across the tundra to find suitable nesting sites, so finding birds like this Dunlin is a challenge, but small colored markers help scientists follow individual birds, and sometimes even result in sightings on their wintering grounds thousands of miles away. *(Courtesy Stephen Brown, 2008.)*

there might be and then compare that estimate to the real number already found by the patient work of the first crew. Over several years of fieldwork with many partners from across the Arctic, we add up many such comparisons between the number of birds actually present and the number of birds found during our rapid surveys to calculate a detection rate. The detection rate is just a simple measure of how good our surveys are, and give us a method for calculating how many birds we are likely to miss on a future survey.

Finally, we use the rapid-survey technique at randomly chosen sites across each study area, and correct these estimates using the detection rate for each surveyor that tells us how many birds on average are missed during the rapid surveys. This simple technique allows us to estimate how many birds use a very large area in the short time when the birds are nesting. We then can extrapolate the results to estimate the populations of shorebird species across the entire North American Arctic.

During one phase of the project we spent two summer field seasons surveying the entire coastal plain of the Arctic National Wildlife Refuge, which is about the size of the state of Delaware. What we learned from this project was that a great many shorebirds—about 230,000 individuals of the ten most common species—use the Arctic Refuge coastal plain to nest and breed. We also learned what habitats each species prefers. Although the tundra looks unvarying to an untrained eye, birds choose sites with characteristics that suit their particular needs. Some species, such as the red-necked phalarope, prefer areas with many small ponds, where they forage by swimming in small circles to stir up tiny aquatic animals, which they capture with their tiny pointed bills. American golden plover, one of the most striking shorebirds with their black and white plumage flecked with gold, prefer higher ground for nesting but with an ample supply of wetlands nearby in which to forage. Some species, such as semipalmated sandpipers, are widespread and fairly common throughout the entire coastal plain, while others concentrate in a small strip along the coast. All of these details are important when considering the impact of losing tundra habitat to development.

After we finished our surveys in the Arctic Refuge, we started a similar two-year project from 2007–08 farther west, in the National Petroleum Reserve–Alaska, in the Teshekpuk Lake Special Area, which is home to an impressive diversity of wetland birds and teems with activity during the short nesting season. We used the same techniques we had developed for the Arctic Refuge. With up to thirteen researchers working around the clock during the breeding seasons we put together the largest data set ever compiled for

A buff-breasted sandpiper engages in a courtship display on the coastal plain; Jago River. This spe-
cies, a long-distance traveler that migrates each year from Argentina to the Arctic Refuge coastal
plain to nest and rear their young, has a tiny world population—only about fifteen thousand. Their
nesting habitat in the Arctic is on the drier coastal terrain where oil facilities tend to be constructed.
This bird has been placed on the Audubon Alaska WatchList, which notes birds with declining or
vulnerable populations and serves as an early warning to alert land owners, industry, resource man-
agers, and the public to take steps to prevent populations from becoming threatened or endangered
with extinction. *(Photograph by Subhankar Banerjee, June 2002.)*

the 1.7-million-acre special area. We were amazed by what we found—we documented the highest density of nesting shorebirds we had seen at any of our study sites across the Arctic. Surveying plots with so many nesting birds was challenging in a mere seventy-five minutes, but very exciting, and each day our survey crews would return with tales of new discoveries and even higher numbers of birds.

We also captured birds all across the Special Area to test them for avian influenza and then released them back to the wild. At the time there was great concern that the disease could spread from Asia, where it was breaking out in poultry farms and spreading to wild birds, and could pose risks to wild birds in North America or even spread to humans. But in all our sampling we never detected the disease, which was a huge relief for us—and also for the shorebirds, who didn't need another major problem to add to their long list of threats.

REMARKABLE MIGRATIONS:
Shorebirds Across the Hemisphere

How a juvenile shorebird finds its way from the Arctic to southern South America without any help from its parents, who leave several weeks before their offspring are big enough to migrate, is one of the great mysteries of animal migration. We know from studies of other birds that they know what general direction to go and how far, and they use many cues such as the position of the sun and stars, and even the earth's magnetic field, to help them find their way. To make these remarkable migrations, birds require a tremendous amount of energy.

Before either adults or juvenile birds can leave the Arctic, they must quickly gain weight, putting on enough fat to fuel their long flights. This is the time of year when the seasonal abundance of insects is so crucial. Some shorebirds actually double their weight before their southbound migration, which requires what we call staging areas—mudflats with very high densities of the invertebrates the birds eat to achieve this remarkable feat. For birds born in the Arctic, a small string of coastal mudflats along the Arctic Ocean are the only places where they can do this before the harsh winter closes in by late August.

To identify these critical sites and try to protect them for future generations, we set out on our first expedition along the coastline of the Arctic Refuge in

2006 in a small rubber boat, not knowing exactly where we might find the shorebird staging sites. Previous work had located a few areas with large numbers of juvenile shorebirds, but there had never been a complete survey of all the river deltas in the Arctic Refuge. At these special places, rivers flow north from the Brooks Range and drop their sediments as they enter the Arctic Ocean, and create large mudflats rich in nutrients that support an abundance of invertebrates—these are like restaurants for shorebirds.

We spent five summers surveying the entire Arctic Refuge coastline every year from late July through mid-August, the peak of the shorebird staging season. Getting to these areas was not easy. We used our small rubber boat to travel along the coastline, but the mudflats where the shorebirds feed are very shallow, so we had to anchor our boat when it was too shallow to go any farther and walk ashore. Starting out, the water was typically mid-thigh level. Then we'd walk up to a mile through the water and across the slippery mudflats in chest waders, just to get to the places where we could start our surveys. We covered long stretches of slippery mud, counting birds to identify the most important areas, stopping occasionally to pull our colleagues out of the mud they had sunken into. Eventually we would stop for the day, carry all our gear ashore, and set up a small camp for the night. We slept well at the end of the day!

The nature of the work seemed to invite adventure. One year an unusually large storm hit us as we were camped along the coastline. When we started the survey, the summer sea ice was only a few miles offshore, but by the end of the survey it was hundreds of miles away. As the Arctic sea ice has receded in recent years, the distance over which the wind blows has increased, allowing larger waves to form. In this unusually bad storm, the anchor cleats were torn off the boat, whereupon it washed ashore and was buried in tundra peat that was rapidly eroding off the banks. After laboriously digging it out, another series of large waves buried it again, and we had to start over. After three days of pounding, the storm eventually subsided and we were able to continue our survey.

Another year, three of our crew were thrown from their boat by a wave and found themselves swimming in the Arctic Ocean during a storm—not a good place to be. They kept their wits about them and managed to climb onto the overturned boat, and thankfully the onshore wind pushed them to safety. During the three days they waited for the storm to subside so they could be rescued, a polar bear clawed its way into their tent to explore what was inside. It was a very stressful way to be woken up! Fortunately, the shouting of three biologists convinced the bear to look elsewhere for its next meal.

We met the meanest grizzly bear we have ever encountered during the same year. It saw us in our boat coming up the Canning River, and rather than running away like most tundra bears, it decided to come after us in our boat. This was extremely unusual bear behavior, so we hastily got our boat running and headed up the river. Not to be deterred, the grizzly swam back to shore and ran up the shoreline faster than our boat, then swam out after us again! Eventually it gave up and went back to shore, but since it had seemed so intent on having us for dinner, we watched it very carefully for the rest of the day to be sure it stayed on its own side of the river.

In spite of the difficulties, we managed to finish surveying the coast every year and learned a great deal about which locations are critically important staging sites for Arctic breeding shorebirds. We originally thought that we would find special areas along the coast that were used by many more birds than average, but instead, we found something much more complex. While some areas do have higher numbers of birds on average than others, any of the major coastal mudflats can be important in a particular year. The places with the highest numbers of birds changes from year to year, presumably as the populations of invertebrates fluctuates, underscoring the importance of protecting all of the major coastal mudflats for shorebirds. A doctoral student from the University of Alaska at Fairbanks established three camps on the coast where repeated counts showed when the peak abundances occurred each year. Recently, another doctoral student has begun a detailed study of the distribution of the invertebrates that shorebirds eat to shed more light on why particular areas are preferred in any given year. In the first step of the study, critters were collected and identified, which had never been done before. We still have a great deal to learn. Understanding where the birds can find enough food to fuel their remarkable southward migrations is a critical step to protecting them in the future.

HEMISPHERIC COLLABORATIONS TO
PROJECT SHOREBIRDS

What limits shorebird populations? It is difficult to track shorebirds throughout their whole life cycle, since they cover vast distances and use many different habitats that span the entire hemisphere. This makes it very difficult to know when and where birds are experiencing life-threatening problems that affect the health of their populations. In 2010, we founded a new partnership

to try to solve this problem by measuring how long individual shorebirds live. The project, called the Arctic Shorebird Demographics Network, just completed its second year of research. Partners worked at nine different sites across the entire North American Arctic, from Nome, in western Alaska, to Churchill, in the central Canadian sub-Arctic. In Alaska, a team from Simon Fraser University runs a site near Nome; the Wildlife Conservation Society in the Teshekpuk Lake Special Area; the US Fish and Wildlife Service in Barrow and at Cape Krusenstern; and in the Arctic Refuge a camp is led by Manomet Center for Conservation Sciences and Arctic Refuge staff. In Canada, sites at the Mackenzie River Delta and at East Bay on Southampton Island are led by the Canadian Wildlife Service, and work at Churchill is led by Trent University and Cornell Laboratory of Ornithology. It takes all of these partners working closely together to span the enormous geography of shorebird habitats in the Arctic.

The best time to track shorebird survival is on the breeding grounds because individual birds of many species come back to the same area to breed. It is important that the same methods be used at all of the sites, so we developed a common set of procedures, not an easy task given all the different goals of the partners at each site. Then we set out to capture and band birds so they could be individually identified and tracked. We use tiny plastic color bands that don't interfere with the birds' flight, which makes it possible for observers to identify them wherever they are seen across the hemisphere. Some birds have small flags with a code of letters and numbers, making them easier to spot. In addition to these small colored bands, we also use metal bands with unique numbers written on them in case the color bands wear out. We will spend the next four summers at the same sites to find out how many of the birds survived to return to their nesting grounds. At the same time, we are measuring how many chicks hatch successfully and what factors influence the survival of nests. Taken together, these data will help us discern whether the factors adversely affecting populations occur more frequently on their Arctic breeding grounds or during the wintering period in southern regions, which will help guide our conservation work to protect the birds.

Putting these conservation measures on the ground also requires collaboration at an enormous geographical scale. One of the largest programs working to protect shorebirds is based at Manomet. The Western Hemisphere Shorebird Reserve Network is a group of critical sites throughout the hemisphere that have been selected based on the large numbers of shorebirds that use them each year. The shorebird network works closely with land owners, and often

with state and national governmental agencies, to craft agreements making the protection of shorebirds a part of their site management. From the Arctic to the tip of South America, hundreds of organizations work together to help ensure that these sites will still be available for shorebirds when they arrive again on their annual journeys.

As you walk along the shoreline on your next visit to a beach or while birding at a wetland, you may be lucky enough to spot one of these special birds that has carried its band all the way from the Arctic. If you spot one, report what you saw at www.reportband.gov or www.bandedbirds.org. In return, you will find out when and where it was first banded. Imagine how far that bird has flown, and how far it still has to go. One of the longest surviving shorebirds known, a red knot first banded in 1995 in Rio Grande, Tierra del Fuego, Argentina, has now flown back and forth to the Arctic seventeen times, more than the distance to the moon. Only with help from all of us can we understand the challenges these shorebirds face on their remarkable expeditions and ensure that they still embark on their long journeys when our grandchildren look up at the skies to marvel at their flight, or delight at watching them running up and down the beach, always staying just ahead of the next breaking wave.

In Calloused Human Hands

Tuullik, Teshekpuk, and Our Western Arctic

JEFF FAIR

❖

The first essay in Arctic Wings: Birds of the Arctic National Wildlife Refuge *was "Angels in the Mist" by wildlife biologist and writer Jeff Fair. Jeff began his piece with an experience at the Canning River Delta, in the far western edge of the Arctic Refuge with these words:*

June 4, 1:07 AM: All night long under the midnight sun, the Arctic sings its spring song. Floating in from somewhere behind the wind are the voices of this land: the various musics of Greater White-fronted and Canada Geese, Pacific and Red-throated Loons, and Long-tailed Ducks (we used to call them Oldsquaws), along with a few quieter fowl I cannot name. Nestled in the candlelike glow inside my yellow tent, I lie awake, listening.

In September 2011, Audubon *magazine contacted me about providing photographs for an article on the Western Arctic by Jeff Fair. I agreed with enthusiasm. In the November-December 2011 issue,* Audubon *published*

"The Other Arctic." With Jeff's article, Audubon included an advocacy postcard with my photograph Known and Unknown Tracks *(plate 18) on the face, and on the back, a letter to Interior Secretary Ken Salazar that ends with these words: "I urge you to NOT ALLOW OIL DRILLING in the vital wildlife habitat around Teshekpuk Lake." I was also familiar with another essay, "Cry of the Loon," which Jeff had written for* Audubon *in the March 2004 issue. So, I urged him to combine those two pieces for* Arctic Voices. *He generously agreed. It is published here with permission of* Audubon *magazine.*

✤

BARELY 10 feet above the golden, hay-scented tundra, a yellow-billed loon streaks into view from the east. Ten pounds of flesh and feathers hurtles by at 60 knots, head low and headlong in loon flight, ivory-colored bill aglow in the Arctic sun. I can hear its rapid wing beats slice the morning air as it jets over a pair of loons I've been watching. In response, the larger of the two stretches its neck horizontally over the water and issues an urgent yodel, penetrating and surprisingly loud.

Defiant and defensive, this is the territorial call given by males declaring their home lake off limits to other loons in order to protect their family and food resources—the whitefish, char, and blackfish that live beneath them. What may sound to the uninitiated like a mad, otherworldly screech, is not. "The loon's song is the voice of the earth," an Iñupiaq Elder once told me. "They speak for this land."

The yellow-billed loon: *Gavia adamsii* to scientists, *Tuullik* to the local Iñupiat who share its landscape and once knew this bird intimately, eating its eggs and using its skin for ceremonial parkas and insulated food pouches. Some Iñupiat heard an augury of death in *Tuullik's* calls, or forecast the weather according to the direction *Tuullik* took on its morning flight.

The yellow-billed loon closely resembles its first cousin, the common loon, with its striking chessboard plumage, garnet eyes, haunting calls, and similar nesting behaviors. But its bill is distinctive. Unlike the common loon's black, chisellike beak, the yellow-bill's glows bright as an Arctic buttercup. Carried slightly upraised, it lends the bird an air of pride, say some observers. Breeding is confined to the tundra lakes and brief summers of the high north. Wary,

Jeff Fair with a yellow-billed loon, Teshekpuk Lake wetland. *(Photograph by Ken Wright, 2010.)*

reclusive, and secretive, yellow-billed loons are known to disappear at the approach of a single biologist a mile away. These birds are hard to find, difficult to study, tough even to count. We do know they are rare: The worldwide breeding population may number as few as 16,000. Because of vulnerability to habitat loss and human disturbance, the yellow-billed loon is included on the Audubon WatchList as a species of global concern. Human-caused mortality was the final factor that convinced the US Fish and Wildlife Service to declare G. adamsii a candidate species for listing under the Endangered Species Act in March 2009.

As I listen, the loon's yodel dissipates across the low-lying tundra; there is no topography here to produce an echo. Daunted, perhaps, the intruder banks left, then disappears toward another lake. The scene strikes me as metaphorical: The loon's attempt to safeguard resources is not the only such attempt here on the vast and fruitful coastal plain of Alaska's Western Arctic. Not by a long shot.

Mention Arctic wildlife and most people imagine an area on the eastern end of Alaska's North Slope: the beleaguered Arctic National Wildlife Refuge. But to the west of Prudhoe Bay there's an additional 23 million acres of unsung wilderness: the National Petroleum Reserve–Alaska, or NPR–A. It's even larger than the Arctic refuge, teeming with wildlife—and in need of greater conservation protection.

Though the reserve's name makes it sound like a giant oil reservoir waiting to be tapped, it holds much more. This Western Arctic wilderness, the largest federal holding in the United States—an area the size of Indiana—is home to three species of loons; hundreds of thousands of caribou; grizzlies and wolves in numbers long ago erased from the Lower 48; and skeins of pintails and long-tailed ducks, Pacific black brant, tundra swans, king eiders, and white-fronted geese lacing the spring and autumn skies. Now and then a surreptitious wolverine, too lanky and long-legged to be a bear, appears in the low rays of the midnight sun. From the river bluffs hundreds of falcons and eagles take wing. And on the reserve's fringes, where it slips under the Beaufort Sea to the north and the Chukchi Sea to the west, it is refuge to seals and birthing belugas and the terrestrial domain of polar bears—icon of the North—swimming in from the retreating sea ice. A bleak and empty land suited only for oil development? No way.

Thirty-five years ago Congress mandated that "maximum protection" for the reserve's fish, wildlife, and other natural "surface values" be balanced

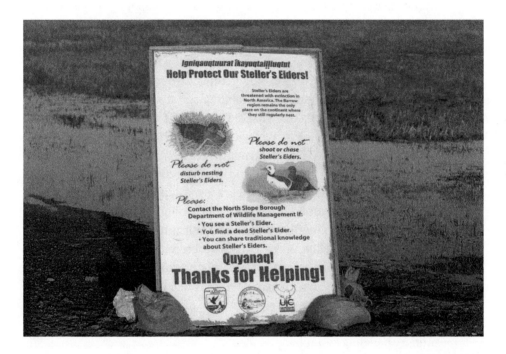

Sign on species protection about endangered Steller eider, National Petroleum Reserve-Alaska, near Point Barrow. Only a few hundred are left in North America. *(Photograph by Steven Kazlowski, June 2006.)*

against any energy exploration and development. The reserve was even considered for national wildlife refuge status. The 1976 act further authorized the Interior Secretary to establish "special area" protections for regions of particular importance to wildlife, specifically Teshekpuk Lake, along the Colville River, and the Utukok Uplands, for their rich waterfowl and caribou habitats. Kasegaluk Lagoon followed later for its own superlative and unique habitat.

But that "maximum protection" has never been realized. Under both Democratic and Republican administrations since Jimmy Carter, the reserve's wildlife has enjoyed only a series of localized and temporary protections.

The Reagan years saw the NPR–A's first oil lease sales. The George W. Bush administration sold the most; in 2004 alone Bush sold leases covering roughly 1.4 million acres and nearly blanketing the primary concentration of the reserve's yellow-billed loon breeding grounds. Two years later Bush attempted to lease the most critical and irreplaceable habitat around Teshekpuk Lake—in fact, everything but the lakebed itself. The National Audubon Society, Alaska Wilderness League, Center for Biological Diversity, Natural Resources Defense Council, Northern Alaska Environmental Center, Sierra Club and The Wilderness Society sued to prevent the leases—and won. The effect of the court ruling was to return the environmental analysis back to the Bureau of Land Management, which announced in 2008 that it would defer leasing the most sensitive goose-molting wetlands around Teshekpuk Lake until 2018.

The business of selling oil leases took a hit recently when the US Geological Survey reduced its estimate of how much crude could be pumped from the reserve by more than 90 percent—from 10.6 billion barrels to 896 million (500 million at current market prices). As a result, oil companies gave up many of their leases, including most of those beneath the yellow-bills' primary breeding grounds.

Still, the tug-of-war between energy and environment is far from over. The USGS describes gas stores within the reserve as "phenomenal," and Alaskan politicians are eager to open the valve.

Meanwhile, the hottest oil prospects remaining in the reserve appear to lie directly beneath the goose-molting area and caribou calving grounds next to Teshekpuk Lake. Although many leases were relinquished, the winter of 2011–2012 was to be the busiest winter for drilling new wells on Alaska's coastal plain since 1969.

There is good news, however. Even as the energy companies bore into the tundra, there could be a chance—unprecedented in the history of the

reserve—to protect key wildlife areas from further drilling and establish conservation measures across the entire region. The Bureau of Land Management is currently working on a "comprehensive plan," an evaluation of all the reserve's resources that would give the BLM the opportunity to delineate zones for lease sales while protecting key habitats in special areas like Teshekpuk. The plan, to be shaped by public comment after its draft environmental-impact statement comes out, may be the last hope for providing the mandated conservation balance in the reserve as terrific pressures mount to "drill, baby, drill" and as industrial infrastructure creeps west from Prudhoe Bay to the Colville River Delta, where ConocoPhillips has planned to build a bridge, road, and pipeline into the reserve.

"The proposed road and bridge project would be the first permanent infra-structure for oil development within the NPR–A, and the manner in which this proceeds has important implications for future development," said Eric Myers, Audubon Alaska's policy director. "What's [most] important is how and where any development takes place. And that the new BLM planning effort offers the opportunity to avoid the kind of industrial sprawl we see across the central Arctic from Prudhoe Bay."

In my role as a field biologist studying loons, I've crammed boots, bin-oculars, layers of fleece and wool, and mosquito head nets into my old pack and made more than a dozen summer forays into the vast, lake-riddled grasslands that comprise the heart of Alaska's Western Arctic. I work with a team of biologists attempting to understand and to conserve the yellow-billed loon, one of the rarest birds nesting in the United States. Each year approximately 3,500 of these birds return to the reserve, where they have only a brief open-water season to nest and raise their young (some lakes never thaw entirely during the far north's fleeting summers). The loons are already threatened by the pollution contaminating their wintering grounds in Asian waters, as well as by accidental drownings in gill nets. Industrial development now threatens to invade the breeding grounds of these retir-ing loons with construction noise and traffic; habitat loss to drilling pads, pipelines, and roads; changes in water flow and lake levels; and, of course, contaminating spills. Currently the development connected to Prudhoe Bay averages more than a spill per day. Most are small, but even small spills can oil loons and kill their eggs.

On the Fourth of July in 2002, a handful of USGS research biologists and I first set foot on the tundra to begin our yellow-bill studies. It was snowing. Some of their two-egg nests had already hatched. We banded and measured

the loons we captured, and took blood and feather samples to test for poisons. We also fitted a few of them with satellite transmitters, which would eventually divulge their migration route—not to the Gulf of Alaska, as many biologists had presumed, but directly to the Yellow Sea off China and some to the Sea of Japan.

Seismic exploration, to first identify the most favorable geology for oil, had long been underway. From the air we observed the wide swaths of vegetation crushed down by huge Caterpillar-drawn trains; these machines crisscross the wilderness on winter snows that are often too thin to protect the layer of life beneath. Caches of fuel drums littered the landscape. We observed one of the Cat trains, brightly painted and standing out like a circus in the middle of the Arctic steppe, parked for the summer by a BLM airstrip.

I don't remember ever touching a living loon that first trip, though our team captured a few. I do remember finding a yellow-billed loon carcass, withered down to feather and bone out on the lakeside tundra, in the company of spent caribou antlers, the eggshells of white-fronted geese, and the lovely, ubiquitous blooms of Dryas integrifolia. But I'll never forget my experience with the living incarnation of Tuullik during our second trip, in 2003.

A loon's wail had broken the silence beneath the wide Arctic sky, a cry almost wolflike, with the tenor of a bassoon in its upper ranges, or of a storm wind howling through telegraph wires across the Wyoming rangelands. It was early July, and I lay flat upon the soft sphagnum tundra to avoid being seen from the lake. My colleague, Joel Schmutz, the USGS research biologist leading our small band, was hiding behind a low hill half a mile away with a view of our operation. His voice crackled over the radio: "Count to 10 and fire." Ten seconds later I pressed a button on the radio control, and down by the lake the spring of a hoop trap flipped its delicate mesh over a yellow-billed loon that had just returned to its nest. I sprinted to the lakeshore and spread a blanket over the bird to calm its struggle until the airplane could retrieve us. Moments later I was holding, in calloused human hands, the wildest spirit of the North.

I cannot say that I felt proud to be handling our elusive quarry. Trapping this innocent creature at its nest and burdening it with technology seemed far too intrusive, almost irreverent. But this is where our addiction to oil and our quest for conservation have intersected. Kneeling there upon the Arctic tundra, clutching the very voice of this landscape in my hands, it struck me that, in a larger way, we Americans now hold the wild spirit of

our final wilderness in the calloused grips of our industry and science. My indelicate act was a metaphor of our role in conservation history.

Base camp that year was located in a field of Arctic poppies by the shore of a large lake near the Topagoruk River, inside the reserve. It consisted of four tents and a cooking area set far off down the lakeshore, should a grizzly find it tempting. The largest tent, a stout, gray cubicle dubbed the Bomb Shelter by its maker, served as the operating room in which Dan Mulcahy, a USGS veterinarian with a long trail of experience and success, would surgically implant the transmitters. Loons and other birds that dive underwater for fish cannot tolerate the drag of an external device. Mulcahy employs extraordinary antiseptic precautions and monitors each loon's heart rate with an esophageal stethoscope, which amplifies the sound of its heartbeats. His careful proficiency blunted the edge of the guilt I felt.

A few nights later, Schmutz and I would capture the study's final loon, No. 12. This bird was so wary that before it would return to its nest, where we had carefully hidden the hoop trap, the pilot had to move the airplane from a neighboring lake and fly out of sight.

Back at base camp, with No. 12 under Mulcahy's meticulous ministrations, I stood in what felt like midmorning sunshine—it was actually close to midnight—gazing out across the last great American prairie. From somewhere around a point of land, a pair of tundra swans appeared. I remember them as twin spots of bright, warm life in a harsh and beatific land. A Pacific loon's caterwauling yodel rang across the lake. And then a yellow-bill responded in a similar but different language, deeper and more plangent, from a place we could not see.

When the loon song quieted, I heard a solemn drumbeat emanating from the direction of the Bomb Shelter. It was the living pulse of a loon's heart, wild and tenacious. Amplified so, it sounded for all the world like the heartbeat of the land itself—the very life-spirit of this last frontier—which we endeavor to keep alive in the face of our own intrusions.

Most years since then we have returned, sometimes more than once, to continue our studies. This late June morning I am back, watching my quarry from a low hillside of cottongrass and purple flowered moss campion by the Ikpikpuk River on the western edge of the Teshekpuk Lake Special Area, the first conservation battlefield in the reserve.

Teshekpuk Lake, the largest lake north of the Brooks Range: big enough to create its own weather—a layer of sea fog avoided by pilots. Hundreds of thousands of birds migrate here to nest each summer, returning from five

continents and all the world's oceans. Tundra swans, imitating the hoarse croaks of sandhill cranes, fly in from North Carolina. Greater white-fronted geese arrive from Texas with their delightful laughter. Buff-breasted sandpipers from Argentina appear in their diminishing numbers, the males immediately performing unabashed dances to attract mates. Bar tailed godwits, with their long upswept bills and eponymous sideways striped tails, wade up to their belly feathers along the lake's edges, a prelude to additional foraging in western Alaska. Once fully fattened, they will fly nonstop back to New Zealand across the broad Pacific, burning half their body weight on the way.

Up to 37,000 Pacific black brant—one-third of the world population—from across at least 10 different nesting colonies in Alaska, Canada, and Russia flock to the region every year to an array of lakes primarily north and east of Teshekpuk. Here they find nutritious sedges to fuel the production of new feathers and the coming autumn migration, ample area to escape predators while they're flightless, and an undisturbed setting for both. Some 35,000 white-fronted geese plus thousands of Canada and snow geese raise the molting population some years to nearly 100,000. From our floatplane they appear as small flocks, racing in unison at the sound of our engine, eventually coalescing into throngs of thousands. Along the shorelines we kick through windrows of molted feathers, gathered up by the Arctic wind. "These wetlands are internationally recognized as the most important goose-molting habitat in the circumpolar north," Eric Taylor, the US Fish and Wildlife Service's waterfowl management branch chief in Alaska, told me. But it wasn't birds alone that caught the attention of Congress in 1976.

The most prominent sign of mammalian life are the caribou trails that cross the tundra, and the small, pearly white antlers dropped by the cows after they give birth in mid-June. The Teshekpuk Lake Caribou Herd has traditionally birthed its young northeast, east, and southeast of the lake. The slowly growing herd—68,000 strong when last counted, in 2009—migrates around the big lake from calving areas to insect-relief areas (windier areas near sea or lake or on ridges, where mosquitoes and bot flies cannot swarm). The herd passes through two narrow corridors between Teshekpuk and the Beaufort Sea—a route that industrial intrusion could obstruct. When the herd disperses through autumn and winter it supplies roughly 5,000 animals annually to feed subsistence families from Nuiqsut to the Chukchi Sea.

From Teshekpuk Lake on the flat northern coastal plain south to the

Brooks Range foothills, where the source of the Utukok, Kokolik, and Colville rivers arise, the topography builds dramatically into a panorama of green rolling prairie. The cottongrass tussocks grow larger as well. Attached to the ground by narrow pedestals, they are impossible to walk on and tiresome to step between. Better to hike the stony ridges or a caribou trail. There are plenty of the latter. Here on the Utukok Uplands the Western Arctic Caribou Herd—the largest in Alaska—calves each June. I came to see them in July 2003, when the caribou were just beginning their journey toward their wintering grounds, south of the Brooks. The herd's population was at its cyclical peak, some 490,000, migrating across an area the size of Montana. Grizzlies and wolves would come to test the mettle of mother caribou with new calves and to prey upon the old and lame. Behind them, cleaning up the carcasses, would drift the ghostlike wolverines, rarely seen but as populous here as anywhere on earth.

When the herd had passed, I climbed a ridge and tried to comprehend this huge and quiet wilderness. I remember standing there, surrounded by beautiful pastoral grasslands as far as I could see east and west. Not a road or building or another human. Dark, jagged peaks of the DeLong Mountains in the western Books clawed at the clouds to the south. To the north the earth settled, feeding the wild rivers that drain the place: the Utukok and Kokolik to the northwest, and the Meade and Colville to the north and east. My only company was the sough of the wind and the high-pitched growls from a long-tailed jaeger whose hunt I had interrupted. I felt as though I'd been dropped off in the late Pleistocene on a Dakotan prairie.

In the Utukok Uplands the drainages of all four rivers have carved out bluffs where Arctic peregrine falcons, gyrfalcons, golden eagles, and rough-legged hawks hide their nests. Along the riverbanks you might find the remnants of past towns, hunting blinds, the occasional whalebone sled runner, and chert points knapped out by hunters from a few hundred to 13,000 years ago.

Drop down the Utukok, floating its rapids beneath the wings of eagles and falcons, to its mouth, and you drift into Kasegaluk Lagoon, a large expanse of shallow waters separated from the Chukchi Sea by 125 miles of sand and cobble barrier islands that, come summer, are as picturesque as Caribbean strands, though a bit cooler. As many as half of the world's Pacific black brant come wheeling in here in late August or early September, filling the sky with their wavy, overlapping vees. Drawn to rich fields of estuarine green algae, they refuel for their flight to the eelgrass beds of

Izembek Lagoon en route to wintering grounds in Baja Mexico. Long-tailed ducks, with their elaborate chocolate parfait plumage, are regulars here, and the threatened spectacled eiders with their goggle-like facial markings nest on the mainland. Pacific loons, elegant in their gray velvet hoods, seek out inland lakes, while their smaller cousins, the red-throats, nest on tiny ponds and fish in the lagoon. Thousands of ink-bellied dunlins and red phalaropes (a shorebird species in which the female is the more brightly colored and the male incubates the eggs) add to the greatest variety of feathered species in all of Alaska's lagoons.

Up to a thousand ice-loving and potentially threatened spotted seals (fodder for polar bears) gather on the barrier islands on summer days, barking at times like a kennel of dogs. More and more walruses haul out here as well; as the Arctic warms and their favored sea-ice retreats northward. Beluga whales arrive in small groups to form their greatest congregations along the eastern Chukchi coast. They molt here in their shallows, where the gravel provides a place for them to roll and dance to rub off their old outer skin. Some take advantage of the protected waters to give birth. Abundant fish and shrimp feed the seals and whales, which, along with the walruses, provide subsistence food for the local Iñupiat. Threatened polar bears stalk these strands; more and more often the pregnant females den here come winter, rather than swimming out to the retreating sea ice. And a handful of grizzlies mosey down the long river corridors from the foothills to gorge on the carcasses of marine mammals washed up by the sea.

Back in those uplands, a short walk east from the Utukok headwaters, you come to Storm Creek, the westernmost tributary of the Colville River. The Colville flows east from there and then north, meandering some 300 sinuous miles so scenic they earned it (along with the Utukok) a nomination for Wild and Scenic Rivers status. From source to sea delta, it remains largely unmarred by man. World-record numbers of raptors flock to the top of its bluffs, inlaid with 100-million-year-old fossils, to hatch and raise their young. Hundreds of pairs of rough-legs and dozens of pairs of gyrfalcons nest along the Colville and its tributaries.

You could drift down that splendid river for days, weeks, through the uplands beneath the tilting of eagles and the riverside bluffs, camping on the sandy beaches, exploring the dry and wet tundra plains, and northward into the lakelands where Steller's and spectacled eiders (both threatened

species) and loons share their secrets. A few Arctic pilgrims have made this journey. Not many.

On the broad Colville River Delta, whose westernmost slice lies within the reserve, great congregations of brant and white-fronted geese and a well-studied scattering of yellow-billed loons raise their young. It is here on this delta that ConocoPhillips planned in 2011 to build a road, bridge, and oil pipeline across the Nigliq Channel—the eastern boundary of the reserve—to a new project known as CD-5 (Colville Delta Number 5). By entering the reserve with a road directly on the path toward those critical habitats around Teshekpuk Lake, the project contradicts a provision that was intended to avoid the needless construction of roads in the Colville River Delta, and sets the stage for more permanent roads and the industrial sprawl everyone promised to avoid. Even the US Army Corps of Engineers denied the permit first time around—rare for the Corps in these parts.

But hope remains for long-lasting conservation. When the BLM announced its planning process in July 2010, the Alaska Wilderness League, Audubon Alaska, Natural Resources Defense Council, Northern Alaska Environmental Center, and The Wilderness Society seized the opportunity to make recommendations for permanent protection strategies in the four existing special areas—Teshekpuk Lake, Utukok River Uplands, Colville River, and Kasegaluk Lagoon special areas—and for four proposed new special areas: Dease Inlet-Meade River, Peard Bay, Southern Ikpikpuk River, and Delong Mountains and Arctic Foothills.

The proposed special areas were designed to realistically expand and ecologically complete the original designated areas. The Dease Inlet and Meade River Special Area, for example, would enlarge the Teshekpuk Lake area westward to include the full heart of yellow-billed loon nesting habitat and more of the spectacular matrix of lakes and ponds and tundra that fills every summer with waterfowl and shorebirds. Reaches along the coast would help protect polar bears and ringed and spotted seals. The southern Ikpikpuk River's bank-nesting peregrines and rough-legs would be covered in parallel to the similar habitats on the Colville River, but in this case adjacent to the Teshekpuk Lake Special Area, which already includes the northern Ikpikpuk. The Peard Bay area would include precious coastal and inland habitats contiguous with the Kasegaluk Lagoon, and the Delong Mountains and Arctic Foothills would extend conservation consideration

to the Western Arctic Caribou Herd's migration routes through the upper foothills and into the mountains.

This has not been an effort to lock up the reserve against development, say conservationists. Neither has it been an attempt to prevent the region's oil from being drilled. Much of the reserve would remain open for drilling, including many tracts within special areas where it might occur under certain conditions or restrictions (including directional drilling to reservoirs beneath critical habitats). "Within an area the size of Indiana, it's entirely appropriate that there be key places protected and set aside for wildlife," said Nils Warnock, Audubon Alaska's executive director, "and the protection of wildlife and special areas was one of Congress's stated goals."

Pressured by Americans' agitation over gasoline prices and a push for greater domestic oil production, President Obama directed the Interior Department to conduct annual lease sales in the reserve, "while respecting sensitive areas." He is "opening up the reserve," some critics charged. (To the contrary, the reserve has been "open" for oil leasing to private companies since 1981. Nearly 6.5 million acres have been leased, though many of those leases have now been relinquished or have expired.)

While previous administrations collectively had attempted to offer leasing on all of the critical habitats around Teshekpuk, Obama extended protections during an August 2010 lease sale when he withheld tracts surrounding Teshekpuk Lake "because of migratory bird and caribou habitat concerns"—a conservation gain unparalleled to date.

At this writing, Americans still do not know whether the Interior Department will continue respecting sensitive areas and keep the land around Teshekpuk off-limits to leasing. Will the BLM's draft comprehensive plan offer sufficient protections within the special areas? Will it respect and integrate the newly proposed areas? The plan, expected in 2012, will demonstrate this administration's regard for the conservation integrity of the reserve; input during the public comment period that follows will reflect the American people's.

Even drilling every bit of oil possible in the reserve would not affect the price at the pump, drilling critics contend. The volume is insignificant, the oil would not reach refineries for years to come, and the best evidence suggests that it is oil speculators and not supply volume that have caused gasoline prices to skyrocket.

The cost of gasoline and the political issues of oil leasing and conservation strategies mean nothing to the wild geese, the innocent caribou, or the rare

yellow-billed loon. The politics seem far off even to me, here in the gathering golden light of an Arctic morning. In this primeval setting, it is the loon's song that will celebrate and defend its territory. But in a larger way, both the celebration and defense—in this case, stewardship—of 23 million acres of one of our nation's only Arctic ecosystems will depend upon the voices of humans, who also speak for this wild earth.

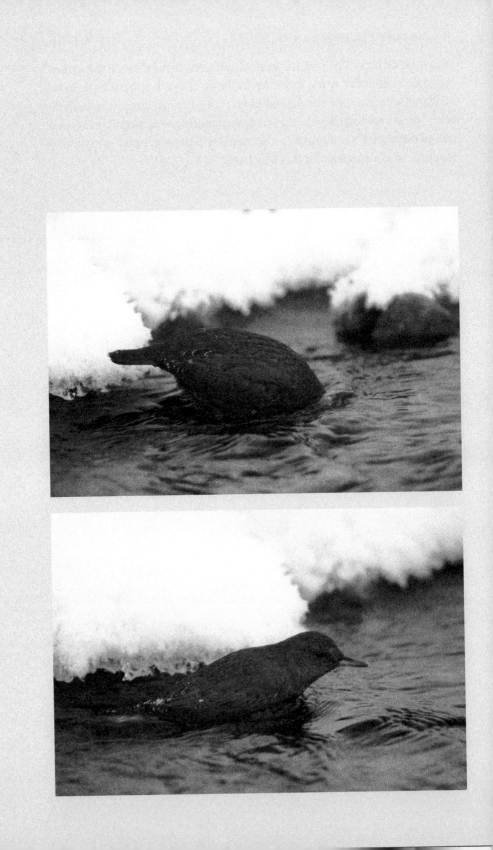

decade, after decade, after decade . . .

That so many of us have over the decades had to fight again, again, and yet again to preserve the Arctic Refuge, that after half a century it still remains vulnerable, fills me with frustration and indignation. Why should we constantly have to argue about saving a place of such beauty and intrinsic value? Those who condemn the area should have to explain truthfully why it should be sacrificed with such casual arrogance to special interests. The Arctic Refuge retains its ecological integrity, a range of habitats from tundra and mountains to boreal forest. At a time of rapid climate change, the Arctic Refuge offers a unique natural laboratory to compare with other northern areas. But this gift of an unspoiled landscape needs no such scientific justification: it must be preserved for its own sake as an icon of America's natural heritage and our role in nature.

—GEORGE B. SCHALLER

Food from the river: Robert Thompson catches grayling, and an American dipper catches a worm, in the Hulahula River; temperature was about minus 40 degrees, Arctic National Wildlife Refuge. (*Photographs by Subhankar Banerjee, November 2001.*)

From Two in the Far North

MARGARET E. MURIE

❧

In April 2003, The Mountaineers Books published my book Seasons of Life and Land: Arctic National Wildlife Refuge. *The first slide-lecture was at the National Museum of Wildlife Art in Jackson, Wyoming, as part of a weeklong Earth Day celebration that was organized by the Murie Center. I stayed in a charming wood cabin in the center's campus, inside the Grand Teton National Park. So, I made a request to visit Mardy—Margaret E. Murie (1902–2003), widely regarded as the Grandmother of the Conservation Movement. The family generously agreed. There I was with a few friends in Mardy's living room showing her the book. We placed it on her lap and kept turning the pages, until the two photos of the Sheenjek River Valley appeared. She stopped, lifted her head slightly, and said in a soft voice, "I want to go with him. I want to go with him." Then she looked at me and said, "Look around the house. Olaus's drawings are here." I did. I don't remember how much time had passed, but it was time for me to leave, as I had a dinner appointment. I went to her, held her hand, and told her, "I have to leave." She responded, "Stay here. I want to go with you. I want to go with you." I told*

her, "I'll be back." Six months later Mardy passed away at age 101. The legendary 1956 biological expedition led by renowned wildlife biologist Dr. Olaus J. Murie and his wife Mardy, into the Sheenjek River Valley, changed everything for the conservation of Arctic Alaska, including establishment of the Arctic National Wildlife Range in 1960, later renamed Arctic National Wildlife Refuge in 1980. Mardy wrote in her book:

> *On December 7, 1960, I walked out to our Moose post office for the mail and our postmaster Fran Carmichael said: "There is a telegram for you." (We had no phone in those days.) I floated back that half mile through the woods on a cloud, burst in through the front door. "Oh darling, there is wonderful news today!" Olaus was at his table at the back of the room, writing. I held out the telegram to him; he read it and stood and took me in his arms and we both wept. The day before, December 6, Secretary Seaton had by Executive Order established the Arctic National Wildlife Range!*

Olaus passed away in 1963. Mardy continued her fight on behalf of the Arctic National Wildlife Refuge—with trips to Alaska in 1964, 1967, 1976, 1980, 1985, and 1987—until she passed away in 2003.

Here is an excerpt from Mardy's book Two in the Far North—*composed of two pieces from the sections "North Again" and "Caribou," both from the chapter "Sheenjek."*

❖

Two in the Far North was first published by Alfred A. Knopf, 1962. The latest edition was published by Alaska Northwest Books in 1997.

NORTH AGAIN

We first loved Jackson Hole, the matchless valley at the foot of the Teton Mountains in Wyoming, because it was like Alaska; then we grew to love it for itself and its people. Olaus was sent here by the Biological Survey in 1927 to make a complete study of the life history of the famous elk herd; here we made our home for thirty years and here our three children, Martin, Joanne, and Donald, grew up. As this chapter opens they have all found careers, married,

Mardy Murie writing in her journal by the Sheenjek River. *(Courtesy The Murie Center, 1956.)*

and given us three grandchildren. Joanne and Norman, in New York City, were awaiting their first child, which was expected to arrive in July, and I was torn between going on an expedition to Arctic Alaska with Olaus and being with our only daughter at such an important time. But Norm, a sociologist, was confident and comforting: "Don't worry, Mardy. She'll have the best of care. And just think—when 'he' grows up he can tell his pals: 'When *I* was born, my grandmother was on an Arctic expedition!'"

May 1956. Ten years before, Olaus had left the government service to enter the struggle to preserve our remaining wilderness; he became director of the Wilderness Society, but still lived in Jackson Hole. In the absorbing, demanding, never ceasing battle of these ten years, our thoughts were still in Alaska, and our news from up there after World War II was not always heartening. It began to appear that even the vastness of Alaska's wilderness would not remain unexploited without some special legal protection. Thoughtful people both in and out of Alaska were concerned, for the Age of the Bulldozer had arrived. Scientists like Starker Leopold, Lowell Sumner, F. Fraser Darling, and George Collins, who had recently traveled in Arctic Alaska, began writing and talking to Olaus.

One day when we were in New York City, Olaus called up Fairfield Osborn, president of the New York Zoological Society. "I think Mardy and I should go to the Brooks Range."

"Well," Fairfield answered, "isn't that something that *we* ought to be interested in?"

So it happened. We were going North again, our expedition financed by the New York Zoological Society and The Conservation Foundation, and sponsored also by our Wilderness Society and the University of Alaska, whose new president, our old friend Ernest Patty, was eager to encourage research in Alaska.

On this half-overcast, mild first day of June, Olaus and I and Dr. Brina Kessel, a young woman professor of zoology at the University of Alaska, flew by the regular air service to Fort Yukon, traversing in sixty minutes what had taken two weeks in 1926, and there, with no delay, had been "inserted" with our baggage into a Cessna 180, equipped with wheeled landing gear.

The exploratory flights had been made the week before by Keith Harrington, a bush pilot for Wien Alaska Airlines, who was stationed at Fort Yukon. He had flown the two young men of our party, Bob Krear and George Schaller, up the Sheenjek River the day before and landed them, on wheels, on the ice of one of the lakes. So far as anyone seemed to know, this was the first such landing on ice in the Sheenjek Valley.

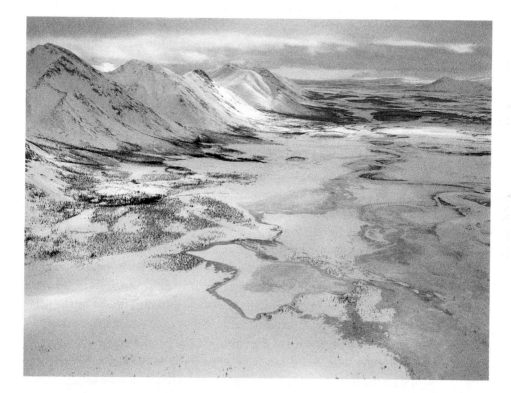

Sheenjek River valley. *(Photograph by Subhankar Banerjee, May 2002.)*

Olaus had pondered over what part of the Arctic this party should investigate. We were to make a detailed and concentrated study of a comparatively small area. We had been in the Koyukuk, which was to the west, and in the Old Crow and Porcupine area, on the eastern side. Other scientists had given good reports on parts of the northern side of the range, Herb and Lois Crisler having spent two years over there. The valley of the Sheenjek was the heart of the whole area which George Collins, Starker Leopold, and Lowell Sumner had suggested should be designated as an Arctic Wildlife Range, and at the same time the region least visited. The only scientific reports available were those on the geology of the area, by the early and incomparable pioneers of the US Geological Survey—John Mertie, Gerald Fitzgerald, and their companions.

There are several ways of describing a river and its valley. For example, one of Mertie's Survey bulletins begins: "The Chandalar-Sheenjek district . . . consists of an irregular area of about six thousand square miles that lies between parallels 66028' and 690 north latitude and meridians 143025' and 147035' west latitude. This area includes mainly the valleys of the Sheenjek River and the East Fork of the Chandalar River from their headwaters in the Brooks Range southward to their debouchures into the Yukon Flats."

Then we can look at a topographic map of northern Alaska. We see that the Brooks Range extends across almost the whole width of Alaska, tapering into lowlands at the east near the Canadian border. In the last two hundred miles of the eastern part of the high mountains, three rivers, flowing from the crest of the range southward, can be seen: the East Fork of the Chandalar, the Sheenjek, and the Coleen. The last two, after flowing mainly south and a little east for two to three hundred miles, flow into the Porcupine, the great river which comes angling in from the northeast, from Canada. About twenty-five miles below the mouth of the Sheenjek, the Porcupine joins the Yukon.

For a better look at the area, let's go back to the Cessna. Brina, efficient young scientist that she is, had a flight map in her hand and ticked off the features of the land as we flew over them, every few moments bringing the map forward over my right shoulder and pointing out something she had recognized and correlated with the map. She and Keith shouted confirmation over the roar of the motor. The day had been hazy, but pale blue sky showed ahead of us far to the north.

We flew over the brown tundra-like muskeg of the Yukon Flats' northward extension for a half hour. Then Keith shouted in my ear: "Weather is better ahead. We'll fly straight in."

The brown country, partially clothed in the dark green of spruces, now had

small hills and shallow valley's, and we began to catch glimpses of the river, the river of all our anticipation and planning—the Sheenjek. It was free of ice and shone gunmetal silver, to join the wide Porcupine. The fascinating thing about the view from aloft is that the whole earth north of you seems tilted up, so that those far mountains are at a level with your plane, and the river seems to be flowing down over a huge slant.

The top of the slope, still far off in the distant north, was a great curve of mountains—the Brooks Range. It was getting closer every minute—snow on top, some dramatic sharp shoulders shining in the hazy sunlight, but the lower slopes free of snow and black in the distance. So far all the lakes below us were open, black and shining. Then Keith pointed out, over a low saddle to the west, Old John Lake on the East Fork of the Chandalar, and through my glasses I could see it was all white, still frozen. We were now passing Helmet Mountain and the Koness River, the main tributary of the Sheenjek from the west, and far to the east, alone against the sky, a black pyramid, Spike Mountain. Here was the dividing line in temperature, it seemed, for the lakes now were white with just a black rim of water around their edges.

At this time Olaus, sitting on the baggage behind Keith, was watching the country with a serene, untroubled look—getting back North at last!

Suddenly we came between two sets of hills and saw before us a delta-shaped valley, all brown and dotted with lakes, and the river winding down through it and off to the right, to the east. And then the mountains were below us, reaching around on either side of the valley, and to the north, at the head of the valley, high beautiful rugged peaks, from which the river must come. I took a deep breath and shouted to Keith: "What's this interesting-looking place?"

"Well, this is where you'll be making your home for a while."

Immediately we began to loose altitude and, in what seemed only a moment, we were circling above a fairly long lake lying in a bed of the river—the river winding around the west end of the lake and then east again and on south. The lake was pinched almost into two separate segments, and there on the one nearer the river, on a little shelf above the frozen lake, we saw the three tents. Around we went, banking again, and down and down, and suddenly and as gently as a hawk, onto the ice, the wheels crunching merrily along, an hour and a half from Fort Yukon! "We're here! We're here! Isn't it lovely?" cried Brina.

And there came George, the tall warm-blooded one, running out onto the ice, with his red-plaid flannel shirt sleeves rolled to the elbow; and there was Bob, his movie camera on its tripod on the ice taking in our arrival. George's first words were: "Brina! Two ptarmigan nests with seven eggs already!"

That exclamation set the tone of our first weeks in the Sheenjek.

In this day and age, it is a rare experience to be able to live in an environment wholly nature's own, where the only sounds are those of the natural world. Here at our lake, all sounds were truly charming. Nearly always a little breeze was whispering through the small scattered white spruces on the mossy hillside; there was the splash of a muskrat diving off the edge of the ice; ptarmigan were crowning, clucking, talking, and calling all around us; tree sparrows and white-crowned sparrows sang continually—their voices were an almost constant background to all the other sounds. We heard the scolding chatter of Brewer's blackbirds and, what at first seemed very strange up there in the Far North, the voice of the robin, our close friends of all the mild, domesticated places.

These were the voices of the hillside around the camp. From out on the lake, as the ice receded from the shores more each day (and the days were warm and never-darkening), we heard other sounds, which were equally charming and exciting. Predominant in the lake chorus was the *ah-HAH-wi, ah-hah-HAH-wi* of the old squaw, and there was the *churring* sound of the white-winged scoters, the cheerful little three notes of the baldpate, and at times the excited voices of the gulls.

Our lake was about a mile long and a half mile wide, divided into two wings by a neck of tundra. Far across from us, we sometimes heard the indescribable haunting call of the Arctic loons, and then all the binoculars would be snatched up for a glimpse of these beautiful patricians of the North.

CARIBOU

All these weeks at our still unnamed lake, we had seen no sign of caribou; so it was really exciting on the morning of the fifteenth to hear Bob report that he saw a calf, already able to run away quickly, on the hillside back of camp. And early the next morning Olaus saw one beautiful young bull, with a full set of antlers in velvet, in the scattered small spruces behind camp.

All that day we lived in a terrific tearing wind—a most dramatic moving pageant of clouds of every description racing across the valley, pouring over the peaks, sailing on over the passes to the east toward the Coleen, until finally, toward evening, the sky was all blue and bright again. Just before dinner I walked up the slope behind camp toward the mountain, and stood and searched the whole visible world with the glasses. I especially searched the

western landscape, for Olaus was sure the caribou had all been somewhere to the west all this time, having their calves. Whitecaps still dotted our lake, but the landscape was quiet; nothing moved except one of our gulls, startlingly white against the blue sky. After the wind, it all seemed breathlessly still, as though we were all waiting for something.

After dinner, as Bob and Brina and I were finishing the camp work and Brina gathered her gear to go set mousetraps as usual on the southern side of the lake, the three of us suddenly stopped what we were doing and looked at one another. We were conscious of a strange sound, way over toward the river. "Surely there couldn't be a cat train way up here," Brina said.

"Oh, Brina, what a horrible thought!"

"Well, it sounds just like a freight train coming along in the distance," Bob said. "Could it be some wind still blowing in one of those canyons over there?"

A few moments later Bob called to me: "Mardy, are your glasses here? There's something out on the flat, over toward the river; a big bunch—boy, are they kicking up the dust! Yes, it *is*—caribou, caribou!"

There was a wild scramble now—Bob getting his movie camera and going off on the run, his camera on his tripod over his shoulder. . . .

Brina and Olaus and I kept going uphill, trying to get above for a good look, and finally we collapsed on a high slope, on the grass, and settled down to look and listen. They were traveling steadily along, a great mass of dark-brown figures; bulls, cows, calves, yearlings; every combination of coloring, all bathed in the bright golden light of this Arctic night. The quiet, unmoving landscape I had scanned so carefully from the ridge before dinner had come alive—alive in a way I am not competent to describe. The rightful owners had returned. Their thousands of hoofs, churning through the gravel and water of the creeks and the river, had been the great mysterious "train" we had heard and puzzled over. Now they added their voices. Individually, the voice is a low or medium *oink, oink,* very much like that of a big pig. Collectively, they make a permeating, uncanny rumble, almost a roar, not to be likened to anything else I can think of. But the total effect of sound, movement, the sight of those thousands of animals, the clear golden western sky, the last sunlight on the mountain slope, gave one a feeling of being a privileged onlooker at a rare performance—a performance in nature's own way, in the setting of countless ages, ages before man. How fortunate we were, to be camped at one of the great crossroads of the caribou!

Bob came climbing up the slope and sat with us. Olaus and Brina were trying to count now, and the vanguard of animals was beginning to move rapidly

on up through the woods at the northern end of our mountain, up through the woods this side of the big creek, into the valley leading over toward the Coleen. But the herd still occupied the whole length of the big muskeg flat clear to the river, which stretched for at least a mile. Now some were feeding, some even lying down, and the background chorus continued. Calves ran here and there, and we were glad to see them. Small groups split off and came back toward our camp. There were many bulls in dark summer coat, with great antlers looking back against the sunlit green muskeg. Some had black patches of new hair on their backs like saddles, light underneath; some were still in faded winter coats. Every kind and variety was here; something, in some valley west of here, had brought them together into this sixteen-hundred-strong herd of talking, grunting pilgrims—they traveled as though they had a goal and knew the way and were not stopping.

From the diary:

July 18: Yesterday, though it brought no baby news, was a full and interesting day. The mail was made ready and then, because we rather expected the two Indians to come over, I made a big stew and cooked fruit for lunch, then started washing clothes. (Our big food drum and the old Geological Survey one, standing on end together, made a fine kitchen table.) At ten there was still no signal smoke from across the river, so Bob set off anyway and soon returned with the two Indians and introduced them all around—Ambrose William and a younger one, David Peter. They had not signaled because the river had dropped again and they got across without needing the boat. Olaus was sitting outside making a drawing of a brown lemming Brina had caught, and the two sat near him on gas-can seats; Brina joined them, and while I finished the washing I listened to a most interesting four-way conversation about animals, birds, Indians, and Eskimos. Olaus began taking down Indian names for birds, and David Peter became so interested and amused that he was soon volunteering names. He has a wonderfully sweet smile. He was trying to give Olaus a name for a certain duck; he hesitated, searching for a word, and said: "I no speak very good English."

Olaus laughed. "Well, I don't speak very good Indian either!" They were discussing our loons, and Brina brought out the Peterson guide, and both the Indians were very much interested in all the pictures. Then I brought out *Olaus's Field Guide to Animal Tracks*, and Ambrose was immediately absorbed in that, looking closely at every picture.

We had a very jolly lunch, but afterward the sky became overcast, with a cool breeze. Brina went into the cook tent to put up mouse skins and Olaus

went to help her and they invited the two guests inside too. Ambrose had such a thin-looking jacket I was afraid he was cold, and I think he was glad to get inside. At three o'clock Brina, with her sharp ears, heard a plane coming. It was Keith.

Someone at Fort Yukon—Keith thought it was Cheeks—had sent up a whole fresh frozen king salmon weighing about twenty pounds. Ambrose had brought us a beautiful piece of moose, so we gave them half the salmon, along with a few other things, and they assured us they now had enough of everything to see them home to Arctic Village. They had received a box of supplies on the plane too. It will take them two weeks to get home—three days to walk across to the East Fork of the Chandalar, then a few more days to hunt and shoot caribou, build a skin boat from the caribou skins, and load the dogs, meat, and everything into the skin boat, and then the rest of the time traveling down the East Fork to Arctic Village. If they get seven caribou, they can make a thirty-foot boat; if five caribou, a shorter boat.

Now they loaded up their packs and came to shake hands all around. "Thank you very much; you sure treat us good," said Ambrose, and "Goodbye, sir," when he shook my hand!

"*Mahsik, mahsik,*" David said, smiling. This is their word for "thank you," which they had taught us earlier in the day and which we all had been using.

It was a moment of real feeling on the part of every one of us. We had had a good day of fellowship and fun and sympathy, we stood rather sadly, watching them trudge away across the muskeg again. It had been a full day for all of us.

With evening, as so often happens, the blustery overcast day was gone. Now there was sun and a bright sky and a warm gentle breeze. Olaus and I felt the need of walking, and went up the slope of Camp Mountain, over a moss-covered rock slope, up under the shallow cave in the rock face which is filled by one of the largest eagle nests ever. Olaus had discovered it soon after our arrival; it is centuries old, it seems, and must be six to ten feet across. The rock all around is covered with the red lichen that so often grows under and around nests, and Olaus thinks the nest fertilized the amazing thick growth of moss on the slope beneath. Here also are flowers of many kinds, white and blue and yellow, and lichens of other colors, and even some kind of fern in the little rock niches. A beautiful little spot at the foot of that stark gray limestone mountain, with life and music furnished by a whole family of phoebes, flitting from rock to rock, uttering their sweet *phoebe* over and over, answering one another. A little symphony, and a symphony of soft colors on the birds, too.

It is colder at night now. We've been tying down the front flap of the tent, which makes it much warmer. Ambrose said: "Dis country—first of August, daytime all right, but nights cold!"

As I write, Olaus and I are north of camp, up by the mouth of the big creek, where he has been making plaster casts from many of the tracks of our caribou migration, and writing his notes while sitting on the creek bank.

One of the things Ambrose told me was the story of Chief Christian, grandfather of the Daniel Christian whose cache we had found. Ambrose said that he himself is the only one who has come over into the Sheenjek nearly every year, but once long ago he was over here with Chief Christian. "Dat Chief Christian, he's a good man. You know, one time he kill white moose? Dat moose now Fairbanks at dat school?" (I told him I knew the moose and had seen it, mounted, in the University of Alaska museum.)

"Chief Christian, he give dat moose; he want it in school, for kids to see. He give it to government for dat; then government, he gonna pay him one hundred dollars for it, but he don't want that either. He want to *give* that moose for school, for kid. He's a good man."

We talked to Ambrose about naming this lake; he said they have no name for it, but "I guess call it Last Lake, dat be all right. Dis the last lake. No more good lake up above here—some small lake, but no good."

So our lake is named—at Last! We explained to the Indians our Lobo name and what it means, and they thought it a good name too.

from **Being Caribou**

KARSTEN HEUER

❖

*The same month, April 2003, when I met Mardy, a young Canadian couple—
wildlife biologist Karsten Heuer and his wife, filmmaker Leanne Allison—left Old
Crow, a Vuntut Gwitchin village in northwestern Yukon, in Arctic Canada, for
a remarkable journey they named, "Being Caribou." For five months they were
out in the wild, with caribou from the Porcupine River herd, as they migrated
from their winter range in Yukon and Alaska, to the calving ground in the coastal
plain of the Arctic National Wildlife Refuge, and fall migration back toward
the winter range. I, on the other hand, was in the urban jungles giving talks. In
September, our paths crossed in Washington, DC—we were there, along with
many activists from across the US to educate the lawmakers why the Arctic
Refuge coastal plain must remain off-limits to oil. The Canadian Embassy hosted
an evening event with two talks—I spoke, and then Karsten and Leanne shared
their stories, images, and some film clips. They didn't have time to become
urban, yet: "Five days and seven airports had come and gone since we'd left Old
Crow, and although our bodies were in America's capitol city, our spirits were*

somewhere far behind." We sat in the audience, mesmerized. In 2005, Karsten published his book Being Caribou, *and Leanne, her film with the same title. During the George W. Bush era, the book and the film became crucial advocacy tools in the fight to preserve the Arctic Refuge from oil development—we prevailed! My challenge was how do I select an excerpt from Karsten's book for* Arctic Voices? *It's a journey—we need to read the whole thing. Finally, I took cue from the epilogue where he describes an encounter with a Senate staffer: "We tried everything to pull her back, telling her about the bugs and wolves in the hopes she might conclude the caribou already went through enough, but when it came to oil development, her mind was made up." If you look at my photographs of pregnant female caribou migrating over frozen Coleen River (pages 220–221), or over high mountains of the Brooks Range (page 419), you might conclude that it is an arduous journey, sure, but generally it looks rather peaceful. Karsten and Leanne witnessed something else in* Being Caribou. *Here is an excerpt from the book, composed of two parts, one from the chapter "Early Spring Migration" and another from the "Epilogue."*

❖

Being Caribou *was published by The Mountaineers Books in 2005.*

EARLY SPRING MIGRATION

It was somewhere on the tattered edge of tree line that we saw our first wolf, and when we did, the ribbons of caribou that had been continually surging past us for two days suddenly ceased.

"What's going on?" I wondered aloud as more than a dozen lines of caribou funneled into a V-shaped gully then stopped. They'd been coming for more than an hour, trickling over the ridge we'd camped atop the night, a net of dark, moving lines covering the white slope we'd descended all morning. But now, backing up above the bottleneck of rock at the bottom of the gully was a reservoir of caribou thousands deep. Leanne set up the tripod and began to film.

"There!" she said, looking through the zoomed-in viewfinder. "To the right."

Using binoculars, I focused on the dot she was looking at: an animal half the size of all the others and 100 yards below the lead caribou, crouched motionless behind some rocks.

Pregnant female caribou from the Porcupine River Herd migrate over Brooks Range Mountains, on their way to the coastal plain for calving, Arctic National Wildlife Refuge. *(Photograph by Subhankar Banerjee, early May 2002.)*

"Any others?" I asked, searching the adjoining gullies and hollows for pack mates.

Leanne shook her head.

The seconds ticked past while the wolf remained in position and the mountainside of caribou grew quiet. Even from where we sat watching, more than a mile away, the tension was palpable. Palms sweating and hearts pounding, we waited, stamping warm blood into our feet. After five long minutes, the standoff finally broke.

It took just a fraction of a second for the closest caribou to react to the lunging wolf, and when they did, the entire mountain of animals moved in unison, erupting in a wave of flashing, spinning bodies like a turning, choreographed dance. What had been a stagnant mass of animals suddenly became a single, fleeing organism, and it veered left then right as it surged upward, pulsing silver and black like a school of darting fish. I lowered the binoculars and stood mesmerized by the pattern, watching as 2,000 animals turned back on themselves, rushing for the ridge in a dark cloud of retreat. Columns of snow rose from within the stampeding herd, spreading like a veil behind them, and into it charged a dark smudge that began to close in.

When the wolf was within a few strides of the nearest animals, the blanket of caribou began to unravel from the bottom up. Chasing first one animal and then another, the wolf tried to isolate its victim, but what had started as a straightforward ambush turned into chaos. With the fabric of the herd shredding in all directions, the wolf followed first one thread and then another, hooking left, right, then left again, losing ground with each switch. Indecision led to hesitation, and after a couple of last, desperate lunges, its all-out gallop faltered to a trot.

Leanne and I stood in silence, frozen with awe, as the last of the caribou disappeared over the ridge.

"Can you believe that just happened?" I finally whispered.

But she was too busy to answer, still recording as the wolf lay panting and gulping mouthfuls of snow.

*April 15—Upper reaches of Waters River, Yukon—*In six short days, we have skied and stumbled our way into a river of life, leaving behind the frenetic months of fund-raising, food preparation, and research that typified the winter in Calgary. No traffic jams, no scheduled phone calls, no long nights of letter writing while the brakes of buses and trucks screech outside. In a week, we have traded people for caribou, high-rises for soaring mountains, and a gridlock of streets for winding valleys. There's still pressure, but it's different,

surging through instead of gathering within us. No schedules, no timetables, no flashing lights and signs saying which way to go next. It is wolves that tell us when to stop and caribou that urge us forward, pushing and pulling us across this landscape from behind and ahead.

Reluctant to lose our momentum, we pushed hard for the next two days, racing up and down ridges on a widening trail as group after group of caribou passed. Cows, yearlings, and two-year-olds came in surges that were hundreds of animals strong and, after detouring around our hunched over figures, disappeared into the next valley, up the next mountain, and around the next corner in quickening waves.

"We gotta do something or we're gonna fall behind," I said, watching as yet another band of animals cantered up behind and cut into the soft snow to push around us. We'd detoured only 100 yards away, and we could hear the huffs and grunts of the lead cow from where she churned forward chest-deep while the others followed single-file behind.

I recalled what we'd heard and read about caribou movements before leaving—how a bull had traversed 500 miles in a month, how two cows had wandered 400 miles in three weeks, and how a calf had covered 50 miles a day at two weeks of age—and tried not to despair. The average pace gave us more hope—15 miles a day in spring, summer, and fall—but even that was depressing, considering that we'd failed to cover even half that distance on all but one of the last seven days.

"I don't know," I said, as another pod of animals took shape on the ridge behind us. "They can't keep coming forever. Sooner or later, something's got to change."

And that afternoon it did. After a week of sunshine, a wall of clouds blew in from the west and snagged on the peaks, plunging us into a world of swirling snowflakes and mist. Hunkering deep into our parka hoods, we pushed on despite the wind and snow, stopping to camp only after the tracks we followed had all but disappeared.

"There is more out there," I reported the next morning after one of my many trips outside.

"More what?"

"Tracks." I said. "Fresh. They must've passed without us hearing."

Ignoring our protesting bodies, we packed up and moved again.

It took only ten minutes to know we'd made a mistake. The caribou too had stopped, and we found them bedded on the ridge in veils of gauzy mist. It was like walking through a stream of illusions; shapes we assumed were boulders

suddenly rose and drifted deeper in the clouds. There were no sounds to match the action—the falling snowflakes and thick fog muffled everything—and we moved from one encounter to the next without forewarning. It was thrilling to be so close to the caribou, but we knew it was wrong. Pregnant cow after pregnant cow startled at the sudden sight of us, and on the verge of stumbling into a third group, we stopped, dropped our packs, and pulled out the frozen tent. After traveling a grand total of 500 yards, we resolved to call it a day.

No sooner were we inside the tent, however, than the sound of footsteps had me looking outside. I turned excitedly back to Leanne, already pulling myself from the bag.

"It's clearing and they're moving! Let's go!"

"Moving? How many?"

"Two."

"Two? C'mon, Karst. Give it a rest. You've got the runs; I'm on the way to getting them; we're exhausted, cold, and wet; and you want to pack up just to move a few hundred yards more?"

I looked out as she scolded me, watching as another cloud bank rolled in, wondering if I was obsessed.

Before I could answer my own question, the two cows lay down and began chewing their cud.

When I looked out the tent door the next morning, the storm had washed all the tracks clean, but not much else had changed from the previous days. The sky was clear again, the sun was shining, and scribing across the ridge beside us was another mob of jogging cows. Pausing long enough to gulp down a lukewarm breakfast before setting off after them, we braced ourselves for another discouraging day. But four hours later, after half-skiing and half-falling in a pinball descent into the narrow valley, we emerged into a different scene.

"We've been spat out of the hills," said Leanne, as the steep walls leaned back and a vast, U-shaped trench opened before us. It was more a wide basin than a valley, fringed on one side by the western flank of the Richardson Mountains and on the other by a series of low bumps that separated it from a prairie of white.

"Still Old Crow Flats?" asked Leanne.

I glanced beyond the bumps to where she pointed. It didn't look anything like the ocean of trees and frozen lakes we'd looked out over just a week before, but it was part of the same endless knot of streams, lakes, and wetlands around which we'd been arcing while following the mountains. There

were a few green fingers of forest still jutting north, but the majority of trees had petered out, making it difficult to know what was frozen land and frozen water in the huge, white plain. In the distance, a dark cliff materialized and disappeared in a mirage of heat waves.

"Hot," I said, peeling off a jacket and stuffing it in my pack.

Leanne nodded as she gestured north with an open hand.

"It seems to be slowing the caribou down."

Indeed, the last animals to have passed us earlier that morning could be seen in the distance, a hundred-odd caribou fanned out on the south-facing slopes, feeding on the occasional patch of snow-free ground. Except during the brief storm the night before, this was the first time on the trip that we'd seen caribou stand still.

They didn't stay put for long, however. By the time we'd covered half of the 2 miles separating us, they were moving again—but only as far as the next island of melted-off grass. Happy they hadn't gone far, we skirted around them, finding our own knoll of snow-free tundra to camp on, only to have the caribou climb down and, in turn, slip past us. Here, they didn't have to churn through soft snow to get around us. Open, treeless, and scoured by a winter's worth of wind, what was underfoot was as hard as concrete. There were no huffs as the caribou passed, no grunts, just the soft click of tendons ticking like hundreds of clocks as we dropped off to sleep.

The wide Driftwood River Valley, along with sunlight growing warm enough to melt snow during the peak of the afternoons, was the perfect setting for a game that unfolded between us and the caribou over the next two days. Or, more accurately, two games: a tortoise-and-hare-type chase, played out as a giant version of connect-the-dots. The dots were snow-free patches of lichen and sedges; the hares were the caribou moving between the dots. The tortoises were us.

So many of the caribou looked alike that it was impossible to say who was gaining and who was falling behind, the tortoises or the hares. Just when I thought I'd identified a unique cow from the day before—with a broken-off antler, for example—another would appear that looked exactly the same. But it didn't matter. Compared to the rush that had consumed us in the mountains, just being among caribou without the soft snow and trees to bog us down was enough. Our packs were getting lighter, our muscles were stronger, and we were covering twice as many miles with half the effort. Despite the fear I'd had while looking down from the airplane, we were moving into the white nothingness with relative ease.

More comfortable and better rested than I'd felt since we'd started, I looked back on the puzzle of caribou behavior and suddenly realized how it all fit. Of course the caribou had rushed through the mountains. They had to: it was the transition zone between where they could dig for food (in the sheltered forests below the tree line) and where they wouldn't have to dig at all (the windswept, sun-baked slopes flanking Old Crow Flats). And of course they'd impeccable timing. If they'd arrived a week earlier, the sun wouldn't have had the energy to melt off the concrete-like layer of snow covering their food, and if they'd waited longer, they would have spent valuable energy wallowing in the same deep, soft snow they'd endured all winter. Instead, they were capitalizing on the delicate balance between winter wind and spring sun.

I shared my realization with Leanne as we admired another evening procession of animals plodding past our tent in parallel lines. Behind them, a flock of ptarmigans lifted out of a clump of willows, leaving a trail of white feathers hanging in the breeze.

"So you think the rush is over?" she asked, after absorbing what I'd said. "You think this is one of those migrations that drifts instead of races to the Arctic coast?"

She was talking about a rare trend we'd found embedded in the maps and statistics about the spring migration: every few years, when conditions were perfect and they'd left their wintering grounds early, the caribou meandered more than hurried to their calving grounds.

It was exactly what I was thinking, but I didn't dare admit it for fear of how premature it might sound.

Had another wolf not arrived, the peaceful state we'd happened upon in the Driftwood Valley might have lasted indefinitely. Later that evening, however, a lanky gray animal slunk out of a shadowy draw, and every feeding, resting caribou within sight came alert.

It wasn't the same wolf we'd seen before—this one was much larger and lighter colored—and this time we weren't watching from a mile away. Camped on a rib of rock that rose a few hundred feet from the valley floor, we were like a couple of eagles perched on a midstream boulder, watching currents of predator and prey about to collide. Along one side of the rock rib walked the wolf, on the other waited the caribou, 400 yards apart in a standoff that was about to explode.

The wolf didn't hurry into the chase. Careful not to look right at the caribou, it angled toward them, its late-evening shadow contracting and expanding like a dark spirit as it padded across the snowdrifts. Hitting our ski tracks on

its casual, oblique line, it stopped for a moment, sniffed, then looped away, approaching twice more before mustering the courage to hop across the double set of strange, parallel trails. When it did, the closest group of caribou took a perfectly coordinated step back.

The wolf got within 300 yards of the vigilant, waiting animals then stopped and sniffed the wind. Almost four hundred caribou had bunched together by then, and the sound of stomping feet and snorting animals drifted up and over us like a building wave of applause. The wolf took two more steps forward, stopped and sniffed again, then looked up and down the line.

"Here we go," I whispered.

Leanne swung around from where she sat hunched over the film equipment and told me to hush. By the time she turned back, the chase was on.

Sitting much closer than we had to the last hunt, I was struck most by the noise as the caribou took off—hooves pounding hard snow like hail pelting a quiet lake. But soon it was the patterns that once again had me mesmerized: lines of caribou bunching into larger and larger clumps until the herd moved like a giant inkblot, seeming to float more than flee, drifting farther into a checkerboard of shadow and light.

I didn't think the wolf had much chance of succeeding when it first took off, but what it lacked in speed it made up for in endurance.

Breaking through the crust every third or fourth stride, it pursued far into the distance, neither gaining nor losing ground until it was more than a mile away. Then, with a few of the weaker caribou tiring, it began to close in.

The whole group of caribou surged in a last-minute burst of speed, but it was no use. Seconds later the gray wolf was into the back of the herd, breaking it apart, isolating a victim. A few of the stragglers veered from the main group and the wolf followed, honing in on a tired youngster moving a step slower than the rest. The young caribou, not quite a year old, swerved once, stumbled, and when something roared into its flank, spun to face its demise. Pouncing, the wolf yanked at its neck, and the two animals crashed into the snow, locked together as a half a dozen convulsions ensued.

For the next few minutes, the other caribou continued to run, tracing a broad circle that eventually brought them to a standstill just 100 yards from the panting wolf. Hooves pranced and legs stamped as they rid themselves of their adrenaline, then they stood quiet again, alert, waiting, watching just as before. But it was the end of the chase, not the beginning, and with one caribou dead, there was no reason for the dance between predator and prey to resume just yet. The wolf turned to the carcass, ignoring the line of caribou, and the

caribou, in turn, filed 100 yards behind the wolf as they pushed forward on their unstoppable journey north.

EPILOGUE

Leanne and I stood mesmerized in the subway station as lines of commuters poured down the escalators and stairways in a flurry of feet and legs. A twinge of recognition ran through me—not of place but of movement—and then the reality of where I stood rushed back in: the background din of sirens and bumper-to-bumper traffic; the panhandlers and security guards watching our every step; the buzz of helicopters circling the grid of high-rise buildings twenty-four hours a day. Five days and seven airports had come and gone since we'd left Old Crow, and although our bodies were in America's capitol city, our spirits were somewhere far behind.

Our feelings of disconnection peaked when we walked off the train, crossed the park, and without even thinking found ourselves veering to a patch of bare dirt on our way to Capitol Hill. There were no hoofprints, of course—Washington, DC is more than 4,000 miles from the range of the Porcupine Caribou Herd—and for a moment I felt silly for looking. But the embarrassment soon passed, for when I flipped the situation back on itself, I realized it only balanced out what was equally if not more ridiculous about the state of affairs across the street. Seated in their whitewashed chambers, members of the US Senate and Congress who had never seen a caribou would soon determine whether one of the wildest, freest herds in the world would live or die.

We'd known beforehand that going to Washington so soon after our trip would be a shock. Even Old Crow, with its six streets, sewer truck, and couple dozen pickups, had seemed overwhelming when we'd first arrived back, but the invitation from an Alaskan conservation group to lobby on behalf of the caribou was too good to resist. They would set up meetings for us with senators and members of Congress; they would pay for a hotel. All we had to do was get there—and shave and get a haircut along the way.

After five months of moving under our own power, it was strange to sit and be moved, touching down in Inuvik, Dawson City, Whitehorse, Calgary, Toronto, and finally Washington with little sense of what lay between. All we felt and knew about a place was what we gleaned from its airport, and the trend was more stress the farther south we went: more televisions flashing in the lobbies; more billboards over the baggage carousels; more people pacing

the halls with hands-free microphones, gesticulating madly as they talked and shouted to people no one else could see. I tried to stay open, to absorb everything, but by the time we reached Washington, I sensed parts of me that had taken months to open while moving with the caribou were already beginning to close down. And they had to. Life in the modern technological world carries none of the subtleties of living with caribou. There's too much to absorb, too much for sharpened senses to do anything but go dormant if one wants to survive. The instinctual search for tracks the next morning would be the last wild act to run through my body for a very long time.

Leanne and I had few expectations when we walked up the marble steps and into the first of four meetings with senators and congressmen, but we were nonetheless disappointed when it was an aide who sat down with us instead of the decision maker himself.

"You've got five minutes," she explained, pointing to the full room where men in suits of all sizes and stripes waited their turn outside the door: the American Automakers Association, Focus on the Family, the National Rifle Association—we were just two more people in an endless stream of lobbyists she had to listen to as we championed yet another cause. Searching for the right words to put into the right sentences, Leanne and I did our best to give an overview of what we'd learned about caribou on our trip.

The aide looked interested at first; she even moved to write something down when we mentioned the skittish cows on the calving grounds, but soon her leg was going again, bobbing in time with the second hand on the clock. We tried everything to pull her back, telling her about the bugs and wolves in the hopes she might conclude the caribou already went through enough, but when it came to oil development, her mind was made up.

She pushed the small stack of photos back toward me and slid back her chair. "That sounds like a wonderful trip," she acknowledged, "but the bottom line for voters on this issue is cheap gas."

"Pardon me?" I asked, unsure I'd heard right.

"I know it sounds terrible," she apologized, "but it's true."

The initial shock of what she said had worn off by the time we emerged on the outside steps an hour later, and in its place was frustration and despair. None of the other aides we'd met with had been as blunt and forthright as she, but behind their doublespeak was the same message. I looked out at the lines of traffic crawling past, at the limousines idling in the parking lot, and concluded that if change was what we wanted, then we had to take a different tack.

"We need to work from the bottom up," I said to Leanne. "We need to

mobilize the voters. We need these people to feel the pressure from the people who put them in office."

I waited for her answer, for some sort of agreement, but she was too busy wiping her eyes.

Throughout the process of writing this book, and while Leanne edited and codirected the award-winning film about the journey, we both wondered whether it was a eulogy we were producing or a successful call to action. Time will tell, I suppose, but unfortunately time is running out.

Shortly after being reelected in November 2004, Bush and his administration, along with a new majority of Republican senators, didn't wait long before embedding a predrilling resolution for the Arctic National Wildlife Refuge in a proposed budget for the entire country. It is a sneaky, underhanded method of moving a controversial issue through the political process, but when it comes to oil, this government isn't known for playing fair. Now, as I write this epilogue in summer 2005, one crucial vote remains. Sometime this fall, after months of discussion and refinements, the Senate and House of Representatives are expected to vote on whether or not to adopt the entire budget. Political analysts think it will pass.

If it does it will be a huge blow to the caribou, the Gwich'in people, and all other life that depends on that critical swath of coastal plain, but the fight to conserve the calving grounds won't be over. New court cases will be filed; environmental assessments challenged; protests, rallies, and other forms of civil disobedience organized and carried out. And maybe they will buy time needed for the much larger shift that's required for the caribou and everything else on this planet to survive: the shift away from overconsumption and our polluting, plundering use of petroleum through the adoption of other, cleaner, healthier sources of energy, such as solar, hydrogen, and wind.

A number of blueprints are emerging for how we can do this, plans to guide us beyond a few token windmills and hybrid electric gas cars and back to local, rather than global, chains of supply and demand. Real Cost Accounting is one of them; the New Apollo Project is another—paths that have been laid out for us to follow if we can only stop long enough to see and hear what's really going on. Our clean air is disappearing, the very climate that supports us is changing, and the last of the world's big wildernesses—the reservoirs of knowledge and instinct that flicker inside all of us—are disappearing, all so we can save a few dollars on our next tank of gas.

And what about thrumming? Since returning from our journey, I have read books on infrasonic communication among elephants, sifted through journal

articles about whale song, and stumbled across human accounts of similar phenomena, as in the poetry of Rilke. But I have found nothing about caribou.

"Sounds like a perfect doctoral project to me," said an excited thirty-year veteran of caribou biology to whom I talked extensively after the trip. "If you're interested, give me a call here at the university."

I thought about it for a few days but never got back to him. Some things aren't meant to have the wildness and mystery strangled out of them. Some things are best left in mystery.

Some things just need to be left alone.

From Midnight Wilderness

DEBBIE S. MILLER

❖

Few people have come to know the Arctic National Wildlife Refuge as intimately as writer Debbie Miller and her husband pilot Dennis Miller. Debbie's book Midnight Wilderness: Journeys in Alaska's Arctic National Wildlife Refuge *is based on her thirteen years of exploring more than a thousand miles in the refuge. It has become an Alaska classic and has remained a crucial advocacy tool for protection of the Arctic Refuge from oil and gas development. I stayed at Debbie's home in Fairbanks several times enroute to the Arctic, where moose would regularly visit her vegetable garden, to chomp down whatever was growing. One time I saw no fence around the garden, but bright yellow crime-scene tape, all the way around. Apparently, a young moose was ignoring any kind of fence she was putting up, until finally she learned from a friend that only thing that works is yellow crime-scene tape, and sure enough, the moose didn't bother her again, at least for that summer. Debbie is a celebrated children's author, and she works hard to inspire young people about the natural wonders of the north. More than twenty years ago when I became the outings chair of the southern New Mexico group of the*

Sierra Club in Las Cruces, I was given a small book, The Redbook: Outing Leader Handbook *(San Francisco: Sierra Club Council, 1992). I still remember, on page 1, John Muir reasoned: "If people in general could be got into the woods, even for once, to hear the trees speak for themselves, all difficulties in the way of forest preservation would vanish." Here is an excerpt from the chapter "Coming Home" in* Midnight Wilderness *in which Debbie introduces her first daughter, Robin, then a toddler, to the Arctic National Wildlife Refuge.*

❖

Midnight Wilderness: Journeys in Alaska's Arctic National Wildlife Refuge *was first published by Sierra Club Books in 1990. The latest edition was published by Braided River in 2011.*

COMING HOME

We step off the twin-engine Navajo at Barter Island into surprisingly balmy air. The airstrip sits on a finger of land that juts into the Beaufort Sea and points toward the North Pole. The only sign of civilization across this giant sweep of mountain, plain, sea is the lone dot of Kaktovik, an Iñupiat village, and the DEW (Defense Early Warning) station, with its two microwave towers rising above the plain like a pair of giant Mickey Mouse–shaped ears.

Don Ross, a friend and pilot, meets us at the airstrip. Earlier, he had offered to fly Robin and me into the Aichilik River drainage in the Arctic National Wildlife Refuge. Dennis, under contract with the US Fish and Wildlife Service, is busy flying caribou surveys.

Dust and gravel fly for a few moments as we touch down and wheel to a halt. I'm anxious to unstrap and jump out. Our home for the next two weeks lies in the foothills of the Brooks Range, in a wildlife-rich transition zone between the mountains and the plain. From our location on the Aichilik, we can look north beyond the opening of the valley, across the coastal plain, and south to the higher peaks along the spine of the Brooks Range. Broad, gently sloping valleys flow toward us from the east and west. Our vantage point offers spectacular views in every direction, and the site is ideal for observing wildlife moving up and the down the valley.

Robin is delighted to wake up when we emerge from the plane. She stands on the tundra and bends her knees a few times, testing the ground's spongy texture. Then she squats down and looks at the new tapestry of plant life. The dwarfed Arctic plants are built to her scale. When I see her smile at the tundra, her face within inches of a white dryas flower, my worries of bringing a toddler to the Arctic dissipate.

Within an hour a small group of caribou moves into the Aichilik River Valley from the west, down the naked tundra slopes that grace the Egaksrak River. They trot along the opposite slope from our camp, heading toward the coastal plain, where most of the Porcupine caribou herd is located. Many of the dozen animals filing by us are cows and calves, although there are a couple of bulls mixed with the group. From my arms, Robin silently watches her first caribou.

As we set up camp, Robin is excited about her new surroundings. She bellies along the tundra, touching, smelling, and tasting all the new Arctic plants. Like any toddler, she equally uses all her senses when discovering a new world. Bearberry leaves, lichens, mosses, dwarfed willows, blooming dryas, and last summer's withered leaves are densely matted together, forming an intricate puzzle of surprises for her.

Once again we've returned to the land without sunsets; there are only sunrolls. As evening approaches, Robin and I watch the golden orb roll behind a ridge for a time, then reappear low along the northern horizon, casting an amber glow on the tundra. Robin seems puzzled by her shadow, which has grown long in the midnight sun.

When we crawl into our sleeping bags, it feels good to be on the ground once again, positioning our bodies around the tundra's bumps, snug in our dome tent. We are truly alone in this most remote northern wilderness, with only a layer of nylon separating us from the wild.

A southeast breeze caresses our tent as I drift off to sleep. The soft steady churning of the Aichilik River blends with the music of golden plovers, Lapland longspurs, sandpipers, and redpolls. With no nightfall we will hear bird songs throughout the twenty-four-hour day.

On July 2, we awaken to a clear, beautiful day, with a gentle breeze to keep the mosquitoes grounded. While we eat breakfast, a group of twenty bull caribou and a lone cow file down the river. Robin has a close look at all of them. She is wide-eyed and occasionally points at the animals while whispering, "Ahhh . . . Ba." The group is enroute to the coastal plain, walking at a steady gait, passing two strangers without noticing.

Robin on coastal plain of the Arctic National Wildlife Refuge. *(Photograph by Debbie S. Miller, 1987.)*

The bulls carry new sets of velvet-covered antlers which appear to waver slightly as they walk. The nonsolidified bone, dense with blood capillaries, has not fully hardened. The ornate antlers will lose their sheaths of cattail-like fur by the end of August and gain their protective calcified bone in preparation of the fall rut.

Robin and I take a morning hike up the valley along the rover's edge. I do most of the walking, while Robin has a free ride on my back. We pass several semipalmated plovers as they scurry along the gravel bars near their camouflaged ground nests. This small shorebird, with the distinguished black ring draped around its neck, migrates as far south as Patagonia for the winter months.

At the moment the plovers appear to be Robin's favorite bird, and she tries to mimic their piping. "Peep . . . peep," she calls to them, reaching toward them from the pack.

On the way back to camp, we spot a cow caribou heading up the valley. I wonder if she is in search of her missing calf. Later back at camp, we spot a lone caribou calf on the opposite side of the river, searching for its mother. Its nose to the ground, the calf trots up the valley, stopping here and there to look around; then it urgently moves on.

In the evening we crawl into the tent as a cold breeze begins to funnel up the valley from the north. We fall asleep in our woolen hats with our sleeping bags snug around our chilled faces. I sense that we're in for a change of weather.

For the past two days we've experienced a steady Arctic gale out of the northeast. Seldom has it let up. Robin takes a few steps outside the tent, then gets blown off her feet onto the tundra. She quickly learns that we need the tent's shelter. We spend hours reading six children's books, again and again, until I can recite them from memory. When I begin to go crazy from the repetitious reading, we play every possible game that can be invented for a toddler in a tent: hide-and-seek in the sleeping bags; gymnastics, with me as a balance beam; and tent basketball—throwing a tennis ball into a cooking pot, boot, or hat.

The sky is crystal clear, yet the oppressive wind keeps us tentbound hour after hour.

After two days, the wind finally begins to calm in the evening. The Aichilik Valley of a few hours ago is transformed: Colors that were washed out in the midday sun are richer, more vivid. Faded greens are deepening to the color of a spring-green meadow. Yellows are turning to a brilliant gold. Dull gray mountains take on new relief and a gradient of colors ranging from soft lavenders to charcoal blacks. Lengthening shadows reveal outcroppings, ridgelines, and

distant valleys that were invisible in the bright sunshine. The midnight light brings the smallest plants and highest peaks into three-dimensional viewing. The tundra is no longer flat, the mountains no longer sheer.

We awaken early from intense heat, like two pots baked in a kiln. With temperatures in the 80s, this is the hottest day so far. It is dead calm, and I suspect the caribou must be running for the coast to cool off and seek relief from the swarming insects. This buggy-hot day should drive the caribou together to begin their post-calving aggregation. I suspect Dennis is out flying with other biologists, closely tracking the herd's movements in preparation for a census count.

Robin and I walk up to a bluff above camp to scout for caribou. We discover a caribou carcass from last winter. The rib cage is partially intact, and its two jawbones lie face-to-face. Caribou fur is scattered everywhere, and wolf tracks surround the site.

Back at camp we drink lemonade by the quart and create some shade by placing Robin's poncho over the spotting scope tripod. While we sweat in the heat, four ravens fly just over our heads and cackle at us. Robin looks up smiling and waves at them as they make cartwheels in the sky. She calls to them, "Da . . . dai, da . . . dai." It is the first time Robin has ever observed ravens at close range, and the first time she has ever spontaneously waved at any creature, including man.

Robin and I sit in what little shade the tent and hanging poncho provide. Suddenly I notice something moving in the willow bushes. The hump of some blond, furry animal is about three hundred yards from our tent. For a moment I think it's a small grizzly, and my heart starts pounding. Within a few seconds I see it's a wolf with its head lowered, pawing at the ground. At first glance, all that was visible was its light-colored back.

The wolf gradually walks our way; we remain motionless next to the tent. Robin spots the approaching creature, a dog in her mind, when it is about one hundred yards from the tent. The wolf draws closer and closer, walking very slowly with its tongue hanging out, panting in the midafternoon heat. Its fur is bleached white and mangy as it is shedding its old coat. The wolf looks tattered and tired after a long day on the prowl.

The closer the wolf approaches, the more excited Robin becomes. She stands on her feet and starts to babble. I explain to her that it's a wild dog and tell her she can't pet it. That makes no sense to her. She wants to charge over to the animal and give it a big hug, so I grab the back of her T-shirt to hold her in place, and caution her in a whisper to keep still.

The wolf approaches within forty yards of the tent (I paced it off later). This is the closest encounter I've had with a wolf, and I'm mesmerized. As the wolf comes parallel with us, Robin calls out in a loud voice, "Da . . . da . . . da!" and reaches out toward the wild dog. I think she expects the wolf to walk over to her for a pat. She calls a second time, "Da . . . da," and the wolf stops and stares at Robin a few moments, although it feels like hours.

In all our years in Alaska, I have heard only one account of a wolf attacking a trapper, yet I am still worried that Robin might appear to be just the right-size prey, and somewhere in the back of my mind I remember reading about a wolf species in India that reportedly nabs little children. Fact or fiction? I guess with some certainty that this wolf has probably never seen a human toddler and is probably just curious.

After a long stare at Robin, the wolf continues on past camp, walking a weary pace. A few moments later Robin calls a third time, and the wolf turns around and looks at her again briefly, then proceeds up the valley. Robin quietly watches the wolf until it is completely out of sight.

This particular wolf is a member of one of at least six known packs that reside in the refuge on the north side of the Brooks Range. It is roughly estimated by Alaska Department of Fish and Game (ADF&G) that 5,200 to 6,500 wolves reside in Alaska as of 1988, and these numbers fluctuate, depending on the availability of prey and on annual mortality. Anywhere from two hundred to three hundred packs of wolves may roam throughout northern Alaska, and their territories are extremely variable, depending on food sources. If a wolf pack lives in a valley where it has easy access to a residential moose or sheep population, the wolves may have a very small home range. Other packs may have to travel great distances to survive, following migratory caribou or preying on whatever small game they can catch.

Although Canada, Alaska and the Soviet Union have largely stable or increasing gray wolf populations, the status of gray wolves and other subspecies throughout most of the continental United States and around the world is very poor. The historic range of gray wolves in North America once extended throughout the vast majority of America's states, as far south as northeastern Florida and southern Texas, and into central Mexico. Over the years gray wolves have been eliminated by humans or pushed out of their former range because of agriculture and industrial development.

Minnesota is the only state of the lower forty-eight that has a well-established gray wolf population, approximately twelve hundred to fifteen hundred wolves. Wisconsin has about twenty-five wolves that are part of a

reintroduction program, and about fifteen wolves have moved south from Canada to Glacier National Park in Montana, reestablishing a small population. Efforts may continue to reintroduce wolves into other areas of their historic range, although there is much controversy over the issue, particularly among livestock growers.

Wolves once extensively occupied most regions in both the Old and New Worlds, and as in the United States, they have been eliminated from most of their former ranges on the planet. At a 1988 international wolf symposium, it was reported that many wolf populations around the world are either threatened or in danger of extinction. Norway and Sweden share a total wolf population of 11 animals, while northern Finland has 10 to 20 wolves, with another 60 who live along the Soviet Union-Finland border. A few hundred wolves live in Italy and Israel and feed primarily at garbage dumps. Portugal has about 150 to 200 wolves, but that population is declining because of decreased habitat. Spain and Poland have relatively stable wolf populations; each country has about 800 to 1,000 wolves. An estimated maximum of 50 wolves remain in Mexico, where habitat loss and competition with the cattle industry have reduced their numbers. Wolves continue to be trapped, poached, and poisoned throughout the world, and their future can be considered bleak.

Although millions of square miles of habitat are available for an estimated thirty to sixty thousand gray wolves in Canada and for those in Alaska, there are still conflicts between humans and wolves. Of the nine provinces in Canada, six provincial governments conduct predator control programs to protect livestock, and three provinces use predator control for wildlife management. Wolves no longer occupy their former range in southern portions of Alberta, Saskatchewan, and Manitoba, where much of their habitat has been lost to agricultural development.

Within Alaska, the greatest conflict between wolves and man is hunting competition over moose or caribou. In past years, when moose or caribou populations have diminished as a result of sport or subsistence hunting pressure, wolf or bear kills, or severe winters, the ADF&G has enacted controversial wolf control programs, largely through aerial shooting, in an effort to elevate prey populations. Such control programs have never been proposed or enacted within the federally controlled Arctic Refuge.

Hunting and trapping of wolves is allowed within the refuge, and illegal poaching does occur. Since Alaska's northeastern corner is so remote and there are few human residents, wolf numbers have remained relatively stable over time. Yet there have been documented reports of illegal aerial shootings

that have wiped out entire packs in some drainages. Also, the rabies virus has killed off a number of wolves on the north side of the Brooks Range.

Given the fact that wolves have become threatened, endangered, and have disappeared in many parts of the world, it is a rare experience to be able to watch, and in the case of Robin, talk to, a member of one of the northernmost wolf packs in the United States. The Arctic Refuge, and other northern undeveloped regions provide the last stronghold for the gray wolf.

In the late evening I drift off to sleep watching Robin's innocent face in her adult-size sleeping bag. I think about wolves, grizzly and polar bears, Dall sheep, and the many birds that have inhabited this refuge for centuries. I wonder if one hundred years from now this northeastern corner of Alaska will still be a wildlife and wilderness sanctuary, for my grandchildren and great-grandchildren, or will our insatiable appetite for resources and our mushrooming world population swallow this landscape and eliminate its free-roaming residents.

As I watch Robin sleeping, I think of the words of David Brower. Instead of pampering ourselves with conveniences and depriving future generations by unwisely consuming all our oil, "we should stop stealing from children." Oil and wilderness have one thing in common: there is a finite amount of both. What we take out of the ground, we can't put back. What wilderness we alter or destroy, we can't re-create. If we industrialize the wildest corner of America for temporary economic gains, we are robbing from future generations of mankind and wildlife.

Saving the Arctic National Wildlife Refuge

GEORGE B. SCHALLER

❖

In late September 2001, I gave a talk at the Wildlife Conservation Society (WCS) in New York. In the audience was renowned wildlife biologist Dr. George B. Schaller, then Director of Conservation Sciences at WCS. After the talk, he and I traveled in his car from the Bronx to the Central Park Zoo, also run by the WCS. I complained to him about the polar bear there, which seemed totally out of place and badly confined. I had read many of his books, including The Serengeti Lion, The Last Panda, *and* Wildlife of the Tibetan Steppe. *I also knew that as a young biologist George had accompanied Olaus and Mardy Murie in the 1956 legendary biological expedition in the Sheenjek River Valley that helped create the Arctic National Wildlife Range in 1960, later renamed Arctic National Wildlife Refuge in 1980. So, I asked if he would write an essay about that expedition in my forthcoming book* Seasons of Life and Land: Arctic National Wildlife Refuge. *He did—"Arctic Legacy." In 2006, he returned to the Arctic Refuge, after fifty years. Back in Fairbanks, after the trip, he gave a talk at the University of Alaska that I attended. Later that evening we*

had dinner together and talked about our fight to protect the Arctic Refuge, during the George W. Bush era. As I was putting this anthology together, I urged him to write an essay combining his experience from the 1956 expedition and the one in 2006, and any other thoughts he had since. He said he had just written such a piece, and e-mailed me the draft, and mentioned that an abridged version is to appear in the Fall 2010 issue of Defenders—*magazine of the Defenders of Wildlife. The essay that follows is the full version. On February 10, 2011, George e-mailed me, "If you don't get an answer to one of your letters from me, it means I'm in India, China, or somewhere; I'll be out of the country most of the time until late in the year. Please make suitable changes in the article so that it is not outdated." I cannot think of any other wildlife biologist who continues to conduct studies on so many species across the planet, help their survival with various conservation plans, and inspire so many young biologists as George Schaller. But he is also a celebrated writer and won the National Book Award for his book* The Serengeti Lion, *and he is an accomplished photographer as well.*

"It is inevitable, if we are to progress as people in the highest sense, that we shall become ever more concerned with the saving of the intangible resources, as embodied in this move to establish the Arctic Wildlife Range."
 —Olaus Murie, 1959 Senate testimony

HERE ON June 26, 1956, it was still light at eleven o'clock in the evening in this land of the midnight sun. We had flown in with bush pilot Keith Harrington to this last lake in the upper Sheenjek Valley, which we referred to merely as Last Lake, although the Gwich'in Indians call it *Ambresuajun.* The Sheenjek River flows south through the foothills of the Brooks Range in northeastern Alaska; to the north, beyond the 9,000-foot peaks, the Arctic slope extends to the polar Beaufort Sea. Gray-cheeked thrushes sang and a pair of mew gulls called by the lake as we set up our tents. Still restless and inspired by a limestone peak behind camp, I started up toward the sun glow on its summit. An hour and a half later I had climbed the 2,500 feet to the top. Standing alone on the peak, at the convergence of rock and sky, there was nothing to distract from the beauty around me. Mountains extended to the horizon, those toward the

1956 Sheenjek expedition. From left to right: Brina Kessel, George Schaller, Doc Macleod, Margaret Murie, and Olaus Murie. *(Courtesy The Murie Center, 1956.)*

north capped with glaciers and snow. No buildings disrupted the landscape, and the only roads were those made by caribou.

Far below among the patchy spruce I could see the white dots of our tents. Olaus Murie, famous naturalist and president of The Wilderness Society, was there with his wife Mardy, and so were Brina Kessel, ornithologist and professor at the University of Alaska, and Bob Krear, like myself a graduate student. Sponsored by the New York Zoological Society (now the Wildlife Conservation Society) and the Conservation Foundation, we had come to the Sheenjek Valley to study its natural history and to absorb its "precious intangible values," as Olaus phrased it. But our main aim was to gather the kind of information that would ultimately lead to the protection of this vast wilderness, the last great wilderness in the United States. Mardy talked of "the personal well-being purchased by striving—by lifting and setting down your own legs, over and over, through the muskeg, up the slopes, gaining the summit." I had lived up to her philosophy in this small way, and returned to camp at two-thirty in the morning.

A progression of perfect days followed as we hiked, observed, took notes and shared what we had seen. Brina concentrated on birds and by summer's end had tallied eighty-five species, among them gyrfalcon, red-throated loon, and golden plover. Bob was excellent at fly fishing, and he supplied me with grayling to measure and age (the oldest was seven years and weighed sixteen ounces) and cook for delicious meals. Olaus taught me to identify the contents of grizzly scats, mainly grasses and roots, and of wolf scats, with the hair of caribou and ground squirrel. "Gee, this is wonderful," he would say, pulling apart a scat, and showing in every way that one must not just glance at something but look deeply into it.

I voraciously collected a sample of everything that I could pluck or grab, delighted with the splendid variety of plants and animals around me. My plant press ultimately held 138 kinds of flowering plants—delphinium, lupine, anemone, buttercup, and rhododendron, to name just a few—and 40 kinds of lichens. My alcohol-filled vials preserved twenty-three spider species and many insects, including three kinds of mosquito that had come to inspect me. I trapped voles and lemmings for the University of Alaska museum. Several Gwich'in came from Arctic Village, forty miles away, to visit our camp, among them Margaret Sam. When fifty years later we had lunch again, her main memory was of me sitting at the camp table and for mysterious reasons skinning mice and stuffing the skins with cotton.

We all admired Olaus and Mardy for their curiosity and responsive heart to

everything around them. By word and example they stressed that conservation depends on science and on accurate information, but that, just as important, it is a moral issue, of beauty, of ethics, and of respect and compassion toward all living beings. Their wisdom has remained with me always.

Olaus urged me "to explore the country," which I did by wandering off alone for a week to the headwaters of the Sheenjek. There at the crest of the Brooks Range, close to glaciers, was a band of a dozen magnificent Dall sheep rams. I photographed the glaciers, not realizing that someday these scenes would be of scientific interest. To the north was the coastal plain, where polar bears den and 180,000 caribou of the Porcupine herd, as it is called, were now gathered on the greening tundra to have their young. That area is the biological heart of the region, one the Gwich'in named "the Sacred Place Where Life Begins." Snow fell as I descended into the valley of the east fork of the Chandalar River and from there hoped to find my way back east to the Sheenjek.

I was asleep on a river bar when, at five in the morning, grunts, churning gravel, and rushing water startled me awake. A herd of caribou flowed down the shadowed valley toward me. I lay still, a mere driftwood log, as many animals passed within sixty feet. They surged by at a hectic pace, wave after wave poured past. In early June many caribou had traversed the Sheenjek on their way to the Arctic slope to calve. Now, on July 16, they were back, a wild river of life, always moving, moving toward a distant ridge. The Porcupine herd defines this Arctic ecosystem with its migrations, both in the US and across the border in Canada, and it is a symbol of this wilderness.

With the earliest bird migrants, we left the Sheenjek in early August. We had marveled at the remarkable diversity of life and now had to fight for its protection. If a refuge could be established, the Gwich'in would still be able to hunt for subsistence, as would the Iñupiat in the village of Kaktovik on the coast, and trophy hunters would be allowed to hunt Dall sheep and caribou on license. Olaus and The Wilderness Society initiated a campaign to protect northeastern Alaska with quiet persistence, and they were joined by many Alaskans, such as those of the Alaska Conservation Society, Tanana Valley Sportsmen Association, and Fairbanks Garden Club. A few years earlier, in 1952, I had seen the first tentative oil development on the Arctic Slope along the Colville River, just west of Prudhoe Bay. With vague concern I wrote Secretary of Interior Fred Seaton on November 25, 1957, that unless the area is protected it "may well in future years resemble one of the former Texas oil fields."

On December 6, 1960, at the end of the Eisenhower administration and a year after Alaskan statehood, Fred Seaton issued a Public Land Order

establishing the Arctic National Wildlife Range, 14,000 square miles in size. We were jubilant. At that time I was still idealistic and naïve, assuming that any protected area would be safe from exploitation. But with the discovery of oil at Prudhoe Bay in 1968 and the completion of an 800-mile oil pipeline south to the coast in 1977, the tranquil Arctic Range became the center of one of the great conservation battles of the century, not only over land but also over the fundamental values of American society.

In 1980, President Carter doubled the size of the Arctic Range to 31,000 square miles, an area almost as large as Maine, and it was renamed the Arctic National Wildlife Refuge. Most of the original Arctic Range was given wilderness designation under the Wilderness Act—except that 2,300 square miles of the coastal plain, named Section 1002, were excluded by Congress pending review because of potential oil.

My disquiet of the late 1950s hardened into certainty that politics, greed, and lack of social responsibility would without hesitation destroy this unique corner of our planet unless prevented from doing so. Decisions regarding the Arctic Refuge by the Reagan and two Bush administrations and various members of Congress, especially the three from Alaska, were now fuelled by the oil lobby. Beginning in 1987, British Petroleum and other oil companies lobbied hard for drilling rights in the Arctic Refuge. George Bush the Elder obsessively made drilling there the centerpiece of his energy policy. Never mind that it remained unknown how much oil was beneath the refuge. Only one test well had been drilled by Chevron and the results were kept secret, but the mean estimate was 3.2 billion barrels, a mere 200 days of US consumption. Oil conservation through raising gas mileage standards of vehicles and by funding development of alternative energy sources was not on the agenda. The oil was essential for "national security," we were told, but not mentioned was that Alaska exported oil to Asia. The Department of Interior under Secretary Donald Hodel authorized leasing of the Arctic Refuge to oil companies. Quietly ignored was the fact that much of the Arctic Slope had already been leased but had not even been drilled. The coastal plain of the Arctic Refuge represents only 4 percent of the total area, yet the pressure to invade it was tremendous, one fortunately resisted by most members of Congress.

Alaska's ex-Senator Ted Stevens became a rabid proponent of drilling, even though in the 1950s, while he was at the Department of the Interior, he had himself helped establish the Arctic Refuge. Now he proclaimed: "It is a barren desert, a frozen wasteland." Oil and politics mix very well in Alaska. One oil executive called the Arctic Refuge "a flat, crummy place. Only for oil would

anyone want to go up there." If you seek a different viewpoint, you should look at the stunning photographs of the varied beauty of the plants and animals in Subhankar Banerjee's book, *Seasons of Life and Land*. When an oil company said that its development would be "roadless," it later had to explain, "Roadless never meant no roads, only that construction of permanent roads would be minimal." It was claimed that drilling in the Arctic Refuge would damage only 2,000 acres. Not mentioned was that this referred only to drilling pads, and not at all to the many roads, gravel pits, pipelines, production facilities, housing, and other infrastructure. No matter how cynical one is, it's hard to keep up with the lies, distortions, and deceptions in these arguments.

Here are a few statistics from Prudhoe Bay. The industrial zone covers 800 square miles, an area the size of Rhode Island. There are 500 miles of road, 3 airstrips, 1,100 miles of pipeline, 170 gravel drilling pads, and 25 production facilities. Some 40,000 gallons of oil waste are dumped on the tundra daily, and 400 to 500 small to large oil spills are recorded annually. Emissions of nitrogen oxide and sulfur dioxide, both compounds of acid rain, are twice that of Washington, DC. These figures are from the late 1980s, when oil production was 2 million barrels a day, as compared to about half that today. Pollution may be less, but the infrastructure will remain for the ages. I visited Prudhoe Bay in 2006 and thought that those who find splendor and spiritual value in industrial sprawl should by all means vacation there.

The battle for Section 1002 continued throughout the 1990s and on to the present. Various members of Congress issued in effect a contract on the refuge, and toyed with various means of destroying it. A budget resolution in 1995 assumed $1.4 billion in revenue from oil leases, but President Clinton vetoed the entire federal budget because of this provision. The Wilderness Society, Alaska Wilderness League, Defenders, and others urged President Clinton to declare Section 1002 a National Monument under the Antiquities Act of 1906, but sadly he failed to respond.

When Bush the Younger became president in 2001, his administration more than ever became a subsidiary of Big Business and Big Oil, and in this it was abetted by various members of Congress. A Defense Authorization Bill was introduced that would mandate drilling in Section 1002, and the House Resources Committee passed an Energy Security Act with the same provision. Backdoor legislation was attempted by attaching drilling provisions to unrelated bills, such as the Railroad Retirement Bill and the Farm Bill. The 110th Congress tried to attach this provision to twenty bills, and each required an Arctic shootout between House and Senate. Fortunately none passed.

Instead of passing realistic energy conservation laws, the petro-politicians used cynical scare tactics to confuse the public: lack of Section 1002 oil, they said, will increase electricity shortages, raise gasoline prices, slow the economy, and endanger national security at a time of war. The implication is that those who oppose drilling are unpatriotic. On the contrary: Patriotism consists of ignoring propaganda and fighting the proponents of plunder and pollution with integrity on behalf of America's future. The devious assaults on the Arctic Refuge are not just ecological vandalism, greed without redeeming features, but are also undemocratic, given that two-thirds of the public opposes drilling.

Many Alaskans may support drilling, but not the Gwich'in of Arctic village. They say simply: "The caribou are not just what we eat, it's who we are." They know that their culture depends on the caribou that calve in Section 1002. The Iñupiat at Kaktovik were all for drilling, for the bounty of dollars it promised, until they realized that an oil spill in the Beaufort Sea could ruin their subsistence culture of fishing for Arctic char and hunting for bowhead whale. Now more than half have reconsidered their position.

Late in 2008, Bush the Younger rushed through a plan from Shell that would allow the oil company to drill offshore near Kaktovik. The drilling would be directional and require no extensive development on land, it was claimed. A Federal Appeals Court halted the plan because of lack of scientific data. Yet in October 2009 Shell received a permit for exploratory drilling in the Beaufort Sea.

That so many of us have over the decades had to fight again, again, and yet again to preserve the Arctic Refuge, that after half a century it still remains vulnerable, fills me with frustration and indignation. Why should we constantly have to argue about saving a place of such beauty and intrinsic value? Those who condemn the area should have to explain truthfully why it should be sacrificed with such casual arrogance to special interests. The Arctic Refuge retains its ecological integrity, a range of habitats from tundra and mountains to boreal forest. At a time of rapid climate change, the Arctic Refuge offers a unique natural laboratory to compare with other northern areas. But this gift of an unspoiled landscape needs no such scientific justification: it must be preserved for its own sake as an icon of America's natural heritage and our role in nature.

When the fiftieth anniversary of the Murie Expedition approached, the Murie Center in Moose, Wyoming, suggested a visit back to the Arctic Refuge. I happily agreed. Jonathan Waterman, an adventurous author who has made many journeys through the Arctic Refuge and has written vividly about them

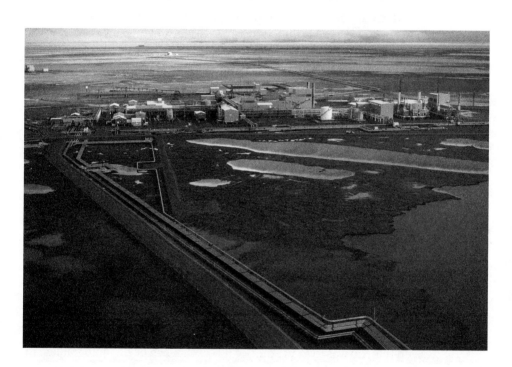

Industrial sprawl at Prudhoe Bay. *(Photograph by Subhankar Banerjee, 2002.)*

in his book, *Where Mountains are Nameless*, agreed to organize our return in 2006, funded by the National Geographic Society and Patagonia Company. Three graduate students came with us this time—Martin Robards and Betsy Young, from the University of Alaska, and Forrest McCarthy, from the University of Wyoming. Gary Kofinas, professor at the University of Alaska's Institute of Arctic Biology, also joined the team.

First we descended the Canning River in rubber rafts from the Brooks Range, across the western edge of Section 1002 almost to the Beaufort Sea. I can still hear Jonathan urging us paddlers, "Draw hard left, pull, pull!" as a fierce wind buffeted us. There were scattered bands of caribou. An estimate for the Porcupine herd is now 120,000, fewer for unknown reasons than in the 1950s. We met a bear, too. Gary bent over a fresh bear track to examine it, not noticing a bear examining him until I drew his attention. The bear moved in a semicircle until our unwashed scent hit, and then bolted. There were also many birds we had not seen on the Sheenjek, such as the ruddy turnstone and parasitic jaeger. A remarkable total of more than 200 bird species have so far been recorded in the Arctic Refuge. Above all, the tundra still stretched in all directions without building or pipeline. It has endured. By contrast, that March of 2006, the main pipeline at Prudhoe Bay leaked 270,000 gallons of oil onto the tundra, and another big spill, unreported, is also said to have occurred because of corrosion. British Petroleum had not checked its pipeline for corrosion in seven years!

Later, as we flew up the Sheenjek Valley to Last Lake, I landed with my dreams and memories, a pilgrimage into the past. With relief and delight, I found that very little had changed. A pair of mew gulls still claimed the lake. By comparing photographs of our old camp site with the spot today, we found that a few of the spindly spruce had died but that others survived. Forrest's task on this trip was to locate precise places that had been photographed in the past 50 to 100 years and compare these with today. He found that glaciers have retreated and shrubs have invaded areas that were formerly tundra. When we spoke with Gideon James, a Gwich'in Elder, about climate change, he provided important insights. "Vegetation grows thicker," he said, and caribou don't go to these places now; the ice of lakes is thinner so "people don't go out into the middle no more." And there were never tundra fires in the past, but there are today. And, he noted, a bluebird was for the first time seen at Arctic Village.

Roger Kaye, of the Fish and Wildlife Service, which administers the Arctic Refuge, flew to our camp one day to share experiences. The author of

an important book on the Arctic Refuge, *Last Great Wilderness,* he and his coworkers have for years dedicated themselves to the preservation of the region, and I greatly admired their knowledge, moral values, and attention to detail—camp fires are no longer allowed in the refuge, garbage must be taken out, and we even exported our feces.

Five decades after my first ascent, our whole team climbed the mountain by camp. I was a little slower than before, requiring an extra hour more. As we sat on the summit among cushions of yellow-flowered saxifrage, I was elated beyond measure. Olaus and Mardy had a vision that we inherited as a sacred trust and were now passing on to future generations, a wilderness that was still pristine and tranquil. Martin Robards rightly noted, "How magical to return after fifty years and find things the same."

Only constant vigilance, commitment, and clarity of purpose have prevented this natural treasure from yielding its timeless beauty to the forces of destruction. It represents America's pact with wildness and wilderness better than any other place. President Obama must now invoke his powers to declare the coastal plain, Section 1002, a national monument. Or Congress can declare the coastal plain a Wilderness Area and have President Obama sign this into law.

As Mardy Murie wrote: "I hope the United States of America is not so rich that she can let these wildernesses pass by—or so poor she cannot afford to keep them."

we gather; we speak out; we organize

And in ten years when we look back on this and we're still breathing clean air and we're still drinking clean water, you know, you can take pride in the fact that you were involved in defeating this. And you can tell your grandchildren that we had to fight for this, and that it's their duty then to continue fighting for this, because there will be other people coming.

—CHIEF DACHO ALEXANDER

BP's Gulf oil devastation prompted Arctic Native people of the Gwich'in Nation to send an aerial message with their bodies to protect caribou calving ground in the Arctic National Wildlife Refuge and threatened Yukon River salmon in the Yukon Flats National Wildlife Refuge. (*Courtesy Gwich'in Steering Committee, photograph by Cammy Roy, July 21, 2010.*)

A Brief History of Native Solidarity

MARIA SHAA TLÁA WILLIAMS

❖

In 2005, Gwich'in villages across Alaska and Canada came together to discuss the impending threat of oil development in the Yukon Flats National Wildlife Refuge. I attended the gathering, and there I met Professor Maria Shaa Tláa Williams. She was editing an anthology and invited me to contribute an essay, which I did. Four years later, her groundbreaking book Alaska Native Reader: History, Culture, Politics *was published. In the preface, Maria writes:*

> *The writings in this volume are often "counter" stories or histories and relay new ideas and concepts that have not been included in most history books on Alaska. I grew up reading about the brave pioneers who came to Alaska or the early Russians who "discovered" my ancestral land. Most non-Native people do not realize what an affront this is—to read about the "discovery" of the place that is our home/ heart/spirit and where my ancestors have lived and hunted since the end of the Pleistocene age, as if we have been somehow invisible all these tens of thousands of years. . . . Alaska is home to distinct cultural and ethnic groups that speak over*

twenty different languages. These include 225 federally recognized tribes. Pejorative terms such as "Eskimo," "Aleut," and even "Indian" tend to diminish the diversity of cultures and are simplistic and in most cases mistaken. Within the past twenty years the self-designative terms such as "Yup'ik," "Yupiaq," "Iñupiaq," "Unangan," and "Alutiiq/Sugpiaq" are becoming symbols of the change that has taken place as Native people correct the colonial naming process.

Here is one of Maria's essays from the anthology.

❖

The Alaska Native Reader: History, Culture, Politics, *edited by Maria Shaa Tláa Williams, was published by Duke University Press in 2009.*

ALTHOUGH LONG-STANDING trade relations existed between the different ethnic groups or nations in Alaska, war and hostilities were also common and it was not until the twentieth century, as a direct result of colonial pressure, that unification between all Alaskan indigenous societies took place.

Up until the 1950s, Alaska Native people were subject to colonial and genocidal pressures. Disease, Christian missionaries, destruction of indigenous religions, forced Western-style boarding schools, restriction on hunting, fishing and other subsistence practices, and the strict English-only policies all took a tremendous toll on Alaska Native societies and almost destroyed them. Alaska Native people were not considered or even consulted in decisions by the federal, territorial, or state government. During an era in which racism was commonplace, Native people were viewed as inferior.

A unique set of circumstances, along with a determined group of Alaska Native leaders, led to a statewide solidarity movement that ensured the survival of Alaska Natives into the twenty-first century. It is important to look at the overall picture, which begins with how Natives were viewed in the twentieth century, in order to understand the political and historical events that led to the Native solidarity movement of the 1960s.

TERRITORY OF ALASKA:
Status of Alaska Natives, 1900–1950

Native peoples were devastated and barely survived the crippling epidemics of the nineteenth and early twentieth centuries; the Christian missionaries,schools, and government organizations that supported complete assimilation of Native people did not tolerate their spiritual and philosophical beliefs. The mission, state, and BIA schools oppressed traditional practices and languages. There was an expanding Anglo-American population that came north to seek land, wealth, and independence and escape, viewing Native people as primitive and therefore as obstacles to the development of Alaska's land and resources.

As with the rest of the United States, racism and segregation were practiced in most communities that had a mixed population until after World War II. It was not unusual to see signs in cities such as Juneau, Sitka, Fairbanks, Anchorage, and Nome that stated "No Dogs or Indians Allowed." Or areas that were reserved for "Whites Only" or "Eskimos Only." The newcomers to the Alaska territory were in search of opportunities, some on the run from their pasts; many were unfortunately racist and did not believe that indigenous societies had anything to offer. Schools were segregated until after World War II—a territorially run educational program for whites and a federally run program for Natives. It was thought best to keep white children from Native children since government officials felt, among other things, Native people "could not conform to white standards of health and sanitation." Newspapers such as the Fairbanks *Daily News Miner* and the Juneau *Empire* often had racist editorials. In 1926, the Fairbanks *Daily News Miner* stated: "Alaska—a White Man's Country." The article remarked, "Notwithstanding the fact that the Indians outnumber us, this is Whiteman's country, and it must remain such" (February 13, 1926). The editors of the paper reflected the Anglo populations' fears of any Indian or Native group having power or rights. *The Daily Empire*, a Juneau newspaper, called Tlingit attorney William Paul Sr. a "menace" in 1924 because he secured Native voting rights (October 7, 1924).

Alaska Natives had protested the encroachment of non-Natives onto their land for mining, trapping, and settlement; however, most of their protests were ignored. In many cases the territorial or federal government supported the settlement of non-Natives onto traditional Native lands. In 1884 the US Congress enacted laws that limited Native subsistence fishing but encouraged the larger white operated canneries. The canneries nearly wiped out entire

salmon runs, leaving Native subsistence fishermen with nothing. The various gold discoveries in Nome, Fairbanks, and Juneau brought thousands and thousands of gold miners whose rights were protected, yet the Native people on whose land they were on had no rights or recourse whatsoever, and could not even stake their own claims.

In 1915 the Alaska Railroad had plans to build a railroad through burial grounds near Nenana. The Athabascan Tanana Chiefs protested the movement of non-Natives in their traditional hunting and fishing areas and stated that the land was theirs and they alone had authority over who could use the land and its resources. The Tanana Chiefs managed to get the Alaska railroad to reroute, but this type of action was an exception: usually Native protests fell on deaf ears.

THE ALASKA NATIVE BROTHERHOOD

The Alaska Native Brotherhood (ANB) formed in 1912 in Sitka and was the only Native political organization in the state until the 1960s. The organization had an active and radical political stance that enabled indigenous people to secure many rights. Little statewide political solidarity existed due to the large geographic region of Alaska and the scattered and diverse indigenous populations. The leadership of the Alaska Native Brotherhood represented a new generation of Tlingit, Haida, and Tsimshian; they had been educated by the mostly Presbyterian missions in Southeast Alaska, mastered the English language, and were familiar with Western laws and the US government. The ANB recognized that Western acumen was necessary in order for their livelihood, culture, and land base to survive. They adopted Robert's Rules of Order and elected presidents, treasurers, and secretaries.

The ANB began exploring political and legal avenues to obtain equal treatment for Native people and made remarkable pathways for Native civil and human rights. William Paul Sr., a Tlingit attorney, secured Native voting rights in 1922, two years before the United States Congress established voting rights and US citizenship for American Indians. In fact, William Paul was the first Native person elected to the territorial legislature in 1924. He and the ANB organized southeastern Indians into bloc voting. This became an effective means of getting Natives elected and other individuals that believed in equal rights. In order to counteract the new Native vote, the legislature enacted the racist Alaska Literacy Law in 1926, which mandated that an individual could

vote only if they were able to read the constitution of the United States; at the time most Natives were not literate in English. William Paul managed to add a grandfather clause that kept the law from applying to people that had already voted, thus keeping intact over a thousand Tlingit, Haida, and Tsimshian votes.

The Alaska Native Brotherhood and Sisterhood (ANB/ANS) fought segregation and voting laws since their inception and pursued justice and equality for Native people. Because of their political activity they were viewed as progressive radicals by the existing press, but were effective and pro-active in securing many of their goals. William Paul Sr. sued and won a court case in 1929 that allowed Southeast Indian children to attend public schools. Previously only white students could attend these public schools. This was an initial step to end segregation in Alaska. It was not until World War II that segregation was outlawed in Alaska.

Native people were viewed as unsanitary and savage. This supported the status quo of the values of the time, and unfortunately reinforced an illusion of superiority and justified any wrongful actions toward indigenous people. The 1945 Territorial Legislature came under fire for supporting the anti discrimination bill. During the heated debate, Elizabeth Peratrovich (Tlingit) of the Alaska Native Sisterhood addressed the legislature. Her testimony was powerful and her dignity and answers to questions brought forward by Senator Allen Shattuck and others won accolades. Peratrovich's composure and wit received applause from the senate floor and the law passed. According to accounts, her presence and speech were unexpected and "stunned onlookers into silence."[1] Territorial Governor Ernest Gruening later credited Peratrovich and her testimony for getting the act passed.

Because of the outspoken actions of people like Elizabeth Peratrovich, along with other individuals, Native and non-Native, the Alaska Anti-Discrimination Bill passed and was one of the first equal rights bills in the United States. The US Congress didn't deal with civil rights until the 1950s.

THE ALASKA STATEHOOD ACT—
Status of Alaska Natives 1950–1959

Ironically the Statehood Act of 1959 became a political turning point for Alaska Natives when Alaska became the forty-ninth state in the Union. By the 1950s Alaska Natives witnessed the demise of their traditional religions, educational practices, and self-determination.

At the time of statehood, the average Native person had barely finished the sixth grade. The tuberculosis rate, which showed marked improvements since statehood, in 1966 was still ten times the national average. The infant mortality rate was among the highest in the world. When Alaska became a state the Alaska Native could look forward to a life expectancy of 34.7 years, while his fellow Alaskan who happened to be white could expect to live for 70 years.[2] Although Alaska Native people faced many challenges, little solidarity existed, except in Southeast Alaska. The ANB attempted to organize other Native people into ANB "camps" around the state, but geography, a scattered population, and cultural differences prevented the formation of other Alaska Native Brotherhoods from organizing. The ANB was viewed as a Tlingit, Haida, and Tsimshian political organization and non-southeast Natives did not feel comfortable with the aggressive political stance that the ANB represented.

The proverbial Phoenix rose from the ashes beginning in 1959 as a direct result of the Statehood Act. The Statehood Act recognized the Native right to aboriginal lands but did not include safeguards for protection or reference to the size of aboriginal lands. Though the rights were recognized, they still had to be fought for. The Act authorized the state government to obtain title to 103 million acres of land. This created problems for the Native people since the new state government began claiming lands that were used by Natives. The Statehood Act specifically stated that the only lands the state of Alaska could claim must be vacant, unappropriated, and unreserved. The state simply ignored Native rights to lands. Village land, including some burial sites, was selected without consultation with the local Native community. Even worse, plans were made for proposed nuclear testing and dam sites that would destroy the land on which local indigenous people were dependent for food and sustenance. The state also began enforcing laws through the US Fish and Wildlife Service that restricted hunting. This created the greatest threat to Native cultures since the epidemics and Christian missionaries of the nineteenth and early twentieth centuries. Throughout the first half of the twentieth century Natives experienced traumatic hardships in terms of diseases, loss of self-determination, Christian missionaries, and encroachment on their traditional lands, and, because of the Statehood Act, were now looking at the end-of-the-line in terms of cultural survival.

THREATS TO THE NATIVE LAND BASE

Of the numerous threats to the Native population, the threat to the Native land base was one of the worst. The people behind the state and federal development schemes of Alaska's land and resources viewed Native people as roadblocks to their plans. These included atomic testing and the building of massive dams. During the 1950s the Atomic Energy Commission (AEC) was experimenting with atomic explosions and underground testing in the Arctic. The AEC had begun doing nuclear testing and had plans to detonate atomic bombs that were over ten times larger than the bombs dropped on Hiroshima and Nagasaki in Cape Thompson, Alaska, just off the Chukchi Sea, under the ruse of creating a deep water harbor. Three Iñupiat villages, Point Hope, Noatak, and Kivalina, were within forty miles of the proposed blast site and the communities were not considered in the plans of the AEC.

The chairman of the AEC, Lewis Strauss, created a propaganda program called "Plowshares" with the stated intention of turning nuclear weapons into tools of constructive use, using the metaphor from the Bible of turning swords into Plowshares. The weapons branch of the AEC, a military division, in fact administered Plowshares. The geographical engineering project for northern Alaska was called "Project Chariot" and Edward Teller, the "father of the hydrogen bomb," was the director. Teller came to Alaska several times, meeting with politicians and businessmen in order to advance Project Chariot. The AEC excluded the Iñupiat people from early discussions, even though they were touting the validity of Project Chariot to the Alaska Legislature, governor, and local business organizations. The AEC had no problem withdrawing over sixteen hundred square miles of land and water in the Cape Thompson area for their planned experiment in 1958, even though the Iñupiat people had made earlier attempts to claim the same land under the Alaska Native Allotment Act. The Iñupiat were initially fearful of having their environment contaminated. Unfortunately all of their fears became validated as they learned more about radioactivity. The villages depended on caribou and marine mammals. The short food chain would have poisoned the Native population with radioactivity. At the time, atomic testing was done above ground, causing the air to become contaminated. The Chariot blasts would have been below ground, but would have blasted significant amounts of radioactive debris into the air. Caribou feed mostly on lichen, a rootless form of vegetation that receives its nutrients from air. The lichen would have absorbed the radioactive fallout, and then been eaten by caribou, which are then eaten by people. Once the issue of the

possible affects of radiation on the Iñupiat was raised, Teller counteracted the facts with lies. Teller stated that the Iñupiat people would actually benefit from the experiments. In November 1959, the Point Hope Village Council petitioned the AEC and condemned the project. The AEC finally visited Point Hope in 1960 to explain the project and to allay the fears of the community. At that time, the AEC stated that the fish in and around the area would not be radioactive and there was no danger of poison to anyone eating the fish and that the "effects of nuclear weapons testing never injured any people, anywhere, that once the severely exposed Japanese people recovered from radiation sickness . . . there were no side effects." The people of Point Hope were justifiably skeptical of the project and distrustful of the government and unanimously voted against the proposal. In 1961 the residents of Point Hope sent a letter of protest to President Kennedy stating that the blasts were "too close to our homes at Point hope and to our hunting and fishing areas." Because of the impending threats, the Iñupiat villages began uniting in their struggles. Another incident that became part of the ongoing struggle of subsistence hunting was the Eider Duck Incident.

In 1916 the US signed an international treaty with Canada and Mexico, which banned the hunting of waterfowl from March to September, called the Migratory Bird Treaty Act. Migratory waterfowl were only in Alaska from March through September. Indigenous hunters were prevented from hunting birds that continue to form a core of their diet. For many years the law didn't pose a problem because no one knew much, nor cared about Alaska Natives duck hunters. But when the Statehood Act of 1959 became a reality, more rigid control of federal laws followed—including enforcing the ban on hunting of waterfowl. Harry Pinkham, the white federal warden, arrested John Nusinginya, a resident of Barrow, for hunting an eider duck. Sadie Neakok, the first Alaska Native magistrate, and the Barrow villagers responded en masse.

> When one hunter was arrested for violating the absurd law, she [Sadie Neakok] quietly organized the rest of the village to protest—by breaking the same law, overwhelming the game warden's administrative capacities, drawing forth the spectre of mass jailings and community emergency, and, most important, pressuring the state to change the regulation. It was, perhaps, judicial activism at an awkward peak—but it brought necessary change for the people of Barrow.[3]

A delegation of leaders requested that Pinkham meet with the local residents. When Pinkham arrived, there were over one hundred hunters with eider ducks. The hunters had written statements that said they had taken the

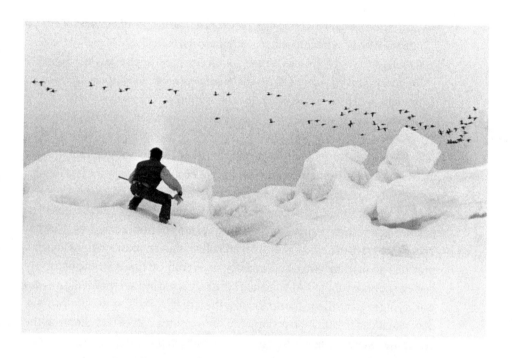

The west wind has closed the lead. From safe ice, eider ducks are hunted, in Barrow. *(Photograph by Bill Hess, 1987.)*

ducks out of season in direct violation of the law. They also had signed a petition to President Kennedy demanding that they be allowed to hunt migratory waterfowl since they had done it for thousands of years.

In 1961 the Association of American Indian Affairs (AAIA), under the direction of Laverne Madigan, sponsored a conference in Barrow because of US Fish and Wildlife Service's ban on hunting migratory waterfowl and concerns over Project Chariot. The AAIA was a progressive organization that supported indigenous rights. The 1961 conference in Barrow had the following opening statement:

> We the Iñupiat have come together for the first time ever in all the years of our history. We had to come together in meeting from our villages from the Lower Kuskokwim to Point Barrow. We had come from so far together for this reason. We always thought our Iñupiat Paitot [Aboriginal hunting right] was safe to be passed down to our future generations as our fathers passed down to us. Our Iñupiat Paitot is our land around the whole Arctic world where the Iñupiat live.

In the historic November 1961 meeting the Iñupiat people from several villages met in Barrow and formed the *Iñupiat Paitot* or People's Heritage, the first Iñupiat political organization. The newly formed organization focused on the proposed atomic blasts around Cape Thompson. Another outcome was the establishment of a Native statewide newspaper. In 1962, an Iñupiaq artist from Point Hope, Howard Rock, founded the *Tundra Times*. Henry S. Forbes, the east coast multi-millionaire, provided about thirty-five thousand dollars in start-up funds for the paper. He was on the board of the AAIA and had been contacted by Laverne Madigan, who was trying to locate financial backing for the struggle. The first two issues of the paper included information on Project Chariot. Howard Rock was chosen as the editor and was assisted by Tom Snap, who had been writing for the Fairbanks *Daily News Miner*. This was the state's first statewide Native newspaper.

The *Tundra Times* gave a voice to Alaska Natives and communication on the statewide level was now possible—a real Native solidarity movement had begun. Growing opposition in the form of environmental and human concerns prevented Project Chariot from becoming a reality, but it was a major battle for the Iñupiat and one that motivated them into political action. The Iñupiat Paitot had a second annual meeting in 1962 in the village of Kotzebue. Twenty-eight delegates from all the northern Iñupiat villages met and stated the need for schools, housing, and employment, and to counter the threats to their livelihood. The head of a newly formed Athabascan organization, Al

Joe filling up beach racks at Rampart Rapids with fall chum salmon, along Yukon River. *(Photograph by Stan Zuray, 2004.)*

Ketzler Sr., from Nenana, was a guest speaker. Ketzler proposed congressional action to establish land ownership for Native people, something the ANB had advocated for many years.

RAMPART DAM PROJECT

The US Army Corps of Engineers had plans of creating a dam along the Yukon River in the Athabascan area near Rampart which would flood several villages and destroy all the hunting, fishing, and trapping in the area. The Rampart Canyon Dam and Reservoir Project included plans to build a man-made reservoir larger than Lake Erie and bigger than the state of New Jersey. The federal Rampart Dam Project proposed that an electric power plant be created along with a recreation area. The five million kilowatts of power would hopefully attract industry and aluminum mining to the region. The village of Stevens fought the claim and filed a protest in June 1963. Over a thousand residents of the Yukon Flats area filed claims to over a million acres of land, which were adjacent to the Yukon River, their lifeline for survival. The dam was not built due to the protests of the US Fish and Wildlife Service and not Native protests. Their studies indicated that the dam and reservoir would have detrimental affects on the fish and wildlife habitat in the area.

The Alaska Native subsistence and traditional way of life were increasingly threatened after the Statehood act. The attitude at the time was anti-Native rights and the state and federal land selections presented a clear and imminent danger to Native people and their traditional way of life throughout the state.

The *Tundra Times* editor Howard Rock, and other Native leaders such as Al Ketzler Sr., began traveling and writing letters to different villages from 1962–64 in an effort to mobilize and instruct the villages on filing land claims with the Department of Interior to protect their homelands. They also sent a petition to Secretary of the Interior Stewart Udall in 1963, which had over one thousand signatures from twenty-four different villages. The petition requested a land freeze be imposed to stop federal and state land selections until aboriginal rights could be established. As a result of the petition, Udall created the Alaska Task Force. The Task Force Report stated that Native land rights needed to be addressed through Congress and this had to be done as quickly as possible.

THE PETROLEUM FACTOR

For years the Iñupiat had cut out pieces of oil-soaked tundra for fuel use in an area southeast of Point barrow at Cape Simpson and at another location southeast of Kaktovik in Angun Point. The petroleum find was originally recorded by Leffingwell, a geologist, as he and his Iñupiat guides and crew mapped the entire Arctic coast in a 1907–14 expedition, but due to isolation and limited technology, no test wells were drilled until the 1960s. In 1967, a test well hit pay dirt in Prudhoe Bay. The area represented the largest petroleum deposit in North America (to date it has yielded over twelve billion barrels of oil). The Arctic Slope Native Association flexed their political muscles in a shocking maneuver by claiming 58 million acres of land north of the Brooks Range—where the Prudhoe Bay oil fields lay. The land claim was based on aboriginal use and occupancy from time immemorial.

In 1966, Emil Notti, then president of Cook Inlet Native Association, called for a statewide meeting to address the issue of land claims. Notti was concerned over a BIA plan, the proposed "final solution" to the land problem in Alaska. He sent letters to different people around the state in an effort to discuss land claims. Howard Rock, beginning in July 1966, began headlining the meeting and urging people to attend. Over three hundred people, representing more than seventeen Native groups, attended the October 1966 meeting in Anchorage, Alaska. The meeting was financed by the Cook Inlet Village of Tyonek, which had recently won a major settlement from oil leases on their lands. Notti chaired the meeting and they elected a board of directors and called themselves the Alaska Federation of Native Associations. It was also at this meeting that Willie Hensley presented his legal study of Alaska's land, which indicated that Natives still owned Alaska's lands; the claims had never been extinguished. At their second meeting in 1967 the group renamed itself the Alaska Federation of Natives or AFN and elected Emil Notti as its first president. During the second meeting in 1967 the delegates from the different Native organizations cemented their constitution and solidified its political structure. The second meeting brought even more attention. Businessmen and government officials courted the Alaska Native delegates; especially since oil revenues were at stake. Native people now had a new source of power and everyone knew it. Native people were finally being considered in the land claims of Alaska.

The AFN became the first Native organization and played a key role in the subsequent land claims settlement. One of the first problems they addressed

was obtaining a land freeze to prevent the state of Alaska from gaining title to their aboriginal lands. The AFN's primary goal was a land settlement—they pushed for a land freeze and succeeded. Stewart Udall, the Secretary of Interior, imposed a land freeze on all federal land transfers to the state of Alaska until Congress could resolve the land claims issues.

By 1967 there were so many land claims in Alaska that they exceeded the actual size of the state by 20 percent. The process was exacerbated by the pending oil development plans for the Prudhoe Bay oil fields. The land freezes literally stopped any leasing of lands by oil companies. The state government and oil companies were upset over the land freeze. Alaska Governor Walter Hickel filed a lawsuit against Udall in an attempt to force the transfer of lands to the state. The Alaska District Court sided with the state, but the 9th Circuit Court of Appeals overturned the ruling. It was a very intense period of time. Sentiment in the late 60s was still anti-Native. During a 1968 Senate Interior Committee hearing in Anchorage, the spokesman for the Alaska Miner's Association made a statement that reflected a common view at the time: "neither the United States, the state of Alaska, nor any of us here gathered as individuals owes the Natives one acre of ground or one cent of the taxpayer's money." Prominent Native testimony included William Paul Sr., Chief Andrew Isaac of Tanacross, Peter John of Minto, Walter Soboleff, John Klashnikoff of Cordova, and many others. The AFN land claims battle was very complicated because it involved the interests of state and federal governments and the oil companies. There were various bills that were introduced, and many more were inadequate. AFN had to lobby hard for a fair and just bill that would include land entitlements and no involvement with the BIA and protection of subsistence hunting and fishing. There were many Native leaders, who fought hard, with little financial gain. Oil companies and a favorable climate for Native rights prevailed and, for better or worse, President Richard Nixon signed the Alaska Native Claims Settlement Act (ANCSA) in 1971.

The rise in statewide Native political action did not begin until 1966,[4] yet within a few years Native people had managed to get the US Congress to pass a law that established their land rights, and monetary compensation for lands that were lost. There were many factors involved in the decade preceding the ANCSA settlement, but the primary factor was Native solidarity. During the 1960s the growing number of Native organizations helped fuel a statewide solidarity movement and created the AFN and the *Tundra Times*. Initially these institutions were powerful organizations paving the way for a stronger Native identity.

The Native solidarity movement led to a stronger identity for Native people, coupled with a more local control of resources and for education of their children. Today, forty years after AFN's founding, new and younger Native generations are being born into a world with a fresher perspective of who they are and who they might become. The Native solidarity movement of the 1960s turned the tide of negative identity and racism around and created an environment of empowerment for Native people.[5]

NOTES

1. Nora Dauenhauer and Richard Dauenhauer, eds. *Haa Kusteeyi Our Culture: Tlingit Life Stories* (Seattle: University of Washington Press, 1994).

2. Ernest Gruening, *The State of Alaska: A Definitive History of America's Northernmost Frontier* (New York: Random House, 1968).

3. See http://www.alaskool.org.

4. The first statewide Native organization was formed as the Alaska Native Federation in 1966. In their next meeting in 1967, they changed their name to the Alaska Federation of Natives (AFN).

5. See the following periodicals for more information: Juneau *Empire*, October 7, 1924; Fairbanks *Daily News Miner*, February 13, 1926; Nome *Nugget*, March 4, 1944; Nome *Nugget*, March 10, 1944.

We'll Fight to Protect
the Gwich'in Homeland and Our Way of Life

Arctic National Wildlife Refuge and
Yukon Flats National Wildlife Refuge

CHIEF DACHO ALEXANDER, MARILYN SAVAGE,
and MATTHEW GILBERT

❖

*Maria Shaa Tláa Williams ended her essay with the passage of the Alaska
Native Claims Settlement Act (ANCSA) of 1971, the largest land claims settle-
ment in US history. A thorough discussion of ANCSA is beyond the scope of
this volume. In short, "The settlement extinguished Alaska Native claims to
the land by transferring titles to twelve Alaska Native regional corporations
and more than two hundred local village corporations. A thirteenth regional
corporation was later created for Alaska Natives who no longer resided in
Alaska" (retrieved from Wikipedia on December 21, 2011). One of the original
twelve corporations is Doyon, which is mentioned in the following pages.*

*The Gwich'in communities of Alaska live on or near two contiguous refuges—
Arctic National Wildlife Refuge and Yukon Flats National Wildlife Refuge—that
together span over 28 millions acres, making it one of the largest protected
ecocultural habitats in the entire Arctic. Both these refuges have come under the
threat of oil development. What follows are three testimonies: on Yukon Flats
Land Exchange, by Chief Dacho Alexander and Marilyn Savage; and on Arctic*

National Wildlife Refuge, by young Gwich'in writer Matthew Gilbert. To this day, Arctic Refuge remains free of oil development. In 2005, I attended a Gwich'in gathering in Fort Yukon where Gwich'in communities came together for the first time to discuss the impending threat of oil development in the Yukon Flats. After four days of numerous testimonies the Gwich'in Nation passed a resolution to oppose the land exchange. On July 8, 2009, Anne Gore wrote a short news piece titled "Yukon Flats Safe at Last!" in the website of The Wilderness Society that began with these words: "Last week the US Fish and Wildlife Service announced its decision to identify the 'no action alternative' for a proposed land exchange under consideration for the Yukon Flats National Wildlife Refuge in Alaska. This means the agency has no plans to move forward with a land exchange, which would have traded lands now in refuge protection for lands owned by the Doyon Corporation and allowed oil and gas development on more than 200,000 acres adjacent to a designated Wild River and National Recreation Area." In light of this victory, we begin with Chief Dacho Alexander's historic testimony in 2008, in which he said, "When ANCSA (Alaska Native Claims Settlement Act) was passed in 1971 by Congress, I don't think that they had anticipated that the corporations would start selling out their own people."

❖

CHIEF DACHO ALEXANDER:
Testimony on Yukon Flats Land Exchange (2008)

My name is Dacho Alexander. I am the First Chief of the Gwichyaa Zhee Gwich'in Tribal Government. Gwichyaa Zhee is the Gwich'in name for Fort Yukon. Fort Yukon is the largest village in the Yukon Flats National Wildlife Refuge. There are about five hundred to six hundred people in Fort Yukon. In the 11 million acres of the Yukon Flats there are approximately thirteen hundred people that live there, and almost 95 percent of us are Gwich'in. When I was growing up, my dad always used to tell me that we live in paradise, you know, and I'd always roll my eyes, 'cause, I mean, all I could see was a few spruce trees and some water and, you know, there was no mountains, there was no palm trees. This didn't look like Shangri-la.

Anyhow, when I was eighteen I left the village. I bought myself a motorcycle and for the next ten years I traveled around the world on my motorcycle, on foot, on car, on bus, and however else I could get around. Well, I came back

to the village because he was right, he was right we live in the most beautiful part of the world. We are very fortunate and the people that live there in Fort Yukon, in Beaver, in Stevens, in Arctic, in Venetie, we all understand that. We live in paradise, we do, and we invite you all there. Come enjoy the clean air, the clean water; come fish; you guys are always welcome in the Yukon Flats.

About four years ago, when this Yukon Flats Land Exchange agreement for oil development, in principle, between the Fish and Wildlife Service and Doyon was reached, we didn't know about it.

I guess the first thing that I would like to say is that Doyon is not a tribal government. Doyon is not a tribal association. They're not even a Native association. Doyon is a corporation, just like Exxon Mobil, just like BP, just like Dow Corning, just like every other corporation out there whose best interest is profit. I mean, that's why they were developed, for profit.

When ANCSA (Alaska Native Claims Settlement Act) was passed in 1971 by Congress, I don't think that they had anticipated that the corporations would start selling out their own people. A more cynical view would be that they did anticipate that the corporations would be selling out their own people. And in doing that, that's the reason why government has a first buy-back policy. Government gets the first choice to buy back any Native lands.

And that's exactly what's happening here today, is we got our corporations selling our lands to the government. Those lands don't come back.

We knew, well, rural people knew that when ANCSA was passed, that this day would come. Thirty-seven years ago, they knew that this day would come when corporations no longer hold the same values as villagers, as Native people.

The transformation for Doyon is complete. They are no longer a Native corporation. And now they are willing to sell you out. They are selling you out. They put a price tag on everyone in here. This is how much you are worth to Doyon. Doyon has put a price on our land. Who here can do that? I think you have to be thirty-seven years removed from the village to be able to do that. And now that's exactly what it is. We have been marginalized. A price tag has been put on everything that is in Doyon land, on Doyon land. That tree over there, it's got a price tag. That blade of grass, that has a price tag now. That muskrat that's swimming down the creek, that's got a price tag. Every single thing within our area, our traditional area here that Doyon owns has a price tag now. All you have to do is come up with the money to offer to them.

And that's exactly what happened; Fish and Wildlife came up to them and said, "This is what we're willing to do for you." Doyon said, "Sold." They

Chief Dacho Alexander during a meeting on Yukon Flats Land Exchange, Fort Yukon. (*Photograph by Pamela A. Miller, 2008.*)

thought so little of us that they felt like they didn't even need to consult the tribes because our value was that low. We only accounted for a small percentage of their profit, and so they didn't feel like they needed to contact us.

And even when we contacted them, they said, "It's a done deal." And like we heard our corporation board member say earlier that Doyon had told them that either we get on board, or the people and the flats are going to lose out. Well, that sounds like blackmail, you're either with us or you're against us.

They said it was a done deal, to step out, don't do nothing. And now they're coming here and they're still telling us the same thing. Doyon is telling us that whether or not this exchange goes through, they're still going to be drilling in Doyon lands.

Well, I made the promise to Tom Melius (Alaska regional director of the US Fish and Wildlife Service) today that after we defeat Doyon and we defeat this land exchange, the Gwichyaa Zhee Gwich'in Tribal Government will keep Doyon out of all of our traditional lands. And I'm making that statement today.

We all know what happens when development gets their foot in the door. Doyon would like to say, "Yeah, this is only going to be confined to Beaver and the Birch Creek area," but we know now that it's much bigger than that.

We know that when their proposed agreement came out in 2004, Doyon was saying that there was 173,000 barrels of oil in the land. Now they're saying that it's 800,000 barrels of oil. Well, you're talking about a substantial difference here.

The price of oil has changed from thirty-two dollars a barrel to one hundred dollars a barrel. So we're talking about a lot more land here. First of all, the whole appraisal process, I think, is flawed from the beginning, because they're taking the value of this land based on their personal values, the way that the people *Outside* value land, not the way that we value land. Imagine if we were the ones that were able to put the price tag on these lands that are going to be traded. Why don't we get that opportunity? Why don't we get to say how much these lands are worth?

Well, you know why, because then Doyon wouldn't be able to sell them. Because we all know here that these lands are invaluable. Once you give them away, once they're destroyed, they don't come back. There's no getting back these lands. When was the last time the government gave back land? It's not going to happen.

I find it really ironic that we here, thirteen hundred people in the Yukon Flats, are the ones continually having to remind Fish and Wildlife Service what

their mandate is. We're here protecting the refuge, and now it's the Fish and Wildlife Service that we have to protect the refuge from.

The same thing with Doyon. Doyon was entrusted, in 1971, to protect our lands for us. And now here we are trying to protect our lands from Doyon. But let me tell you what, we are going to win here. We are going to keep people out. Whether Tom Melius hears our voices today or not, there will be no drilling in the Yukon Flats. As long as I'm here, and I know there's a lot of other people here, we'll never allow it.

We will continue to protect these flats from the government, from the corporations, for our children. We don't own these lands. Once you start thinking that you own these lands, you put a value on it. These lands we're only holding in trust for our children, and our grandchildren, and for their children. We can't take away that right from them.

For twenty thousand years the people of the Yukon Flats, the Gwich'in people have protected our area from outside encroachment. People have always wanted to come into the flats, whether it's from the north or from the south. They know that we're in a very fortunate position here. We're in a protected land here.

There are a lot of reasons why people have wanted these lands, and there are reasons why we fought and died to protect these lands. And most of us here know that. Most of us here recognize the values of these lands—they are priceless.

There's a lot more that I would like to say, but for this they want specific information. I say come up here and tell exactly what you think. If you think that this is a bad idea, you just come up here and tell them that this is a bad idea.

You don't need to explain why. You don't need to tell people that well, I analyzed the Draft Environmental Impact Statement (DEIS), and on page E7, it says here—no, you don't need to say that. Just come up here and say that this is a crappy deal, take it home, I don't want it. Come up here, speak out, and get recorded.

And now I'll give my comments about what is included in the DEIS and why it's insufficient. I feel the DEIS is insufficient in many ways. I feel like the appraisals of the land need to be included in this document. I don't think that it should be included in a supplement. I also don't believe it should be included at any other time. I believe that with the information that we have now, it needs to be included now, not later, not after this is done.

This is important because we don't even know what lands we're talking about. We don't know the size of lands. We don't know where the lands are

located, so it's impossible for us to make meaningful comments on this land that we don't even know where it is. It's ridiculous. The other thing is that, again, the price of oil has changed. We need to have the document reflect how much land are we talking about here. It needs to be included in the document.

Also, air quality and other environmental things need to be addressed. According to their document they did studies on the North Slope. And according to the studies on the North Slope, they say that impact won't be that bad. But we don't live on the North Slope. We're colder than the North Slope. We live in a bowl. We don't got no wind.

They need to come here and do baseline data on all the information that's going to be included in the DEIS. No studies from other areas. Alaska is an enormous state with complex geology, with complex topography, weather, everything else. And to make blanket statements, a one-size-fits-all isn't being accurate. And I believe that this document can be accurate with a little bit of effort.

We don't want this thing pushed through because we want more time to understand it. We want more time to understand what are the actual effects. We want baseline data. We want a scientist to come here to test our air and say: "According to the information that I've gained from studying Fort Yukon, from studying Birch Creek for the past year, this is how the air acts, this is what drilling will do." Not, "this is the way it is up on the North Slope." That doesn't cut it. We need to know specific information.

There needs to be, included in the EIS, a spill response. How do we respond when a spill does happen? What do we do? Is there a plan in place? They say in 48 hours spilled oil could reach the mouth of Birch Creek or Beaver Creek. And then how long before it goes all the way to the rest—down the Yukon? What kind of plans are in place to mitigate that? To reduce the threat?

There are many things in this document that are either inaccurate or insufficient, and I believe that everyone here needs an opportunity to review the document because you people are going to see things that need to be added, and that are insufficient. Because you may know somebody, or you may use an area that they don't have included. That needs to be included. We need more time to review the document. I asked Doyon when they were here a few weeks ago whether Doyon would agree to extending the comment period. Doyon said that they would request that, if the villages asked for it. We need to ask for an extension. We need more time to review this document because this document right here, and ultimately the decision made by this man sitting right here, Tom Melius, is going to affect your children, and their children, and

their children. He has the ultimate say. That's it. He is the man who is going to make the decision whether or not this thing goes through.

And so it's important that everybody here speak out and let him know what you think, because he says he hasn't made up his mind yet, and so what you do say is worth something. I know it's really hard, but just getting up and saying, "I don't want this," it's going to go on the record, and it's going to mean something.

And in ten years when we look back on this and we're still breathing clean air and we're still drinking clean water, you know, you can take pride in the fact that you were involved in defeating this. And you can tell your grandchildren that we had to fight for this, and that it's their duty then to continue fighting for this, because there will be other people coming.

This isn't the first time—I mean, Rampart project. They wanted to flood us out. You know, Project Chariot, Cape Thompson. You know, they wanted to use nuclear weapons to blow a harbor there. The US government and corporations have endless harebrained schemes on ways to make money. You know, ultimately it's the indigenous populations who pay the price.

If we stop this now, it's going to help indigenous peoples all over Alaska. People who have resources on their land are going to be fighting against their corporations, and that will give them the strength to fight the corporations. The corporations aren't right. They don't hold the same values as you do. Again, I know it's hard to get up here and speak in front of people, but I really encourage you to do so.

❖

This statement is adapted with minor edits from two public testimonies by Chief Dacho Alexander. The testimonies were made on February 20, 2008, in Fort Yukon, and on March 4, 2008, in Anchorage, during public hearings of the US Department of the Interior—Fish and Wildlife Service Proposed Land Exchange Yukon Flats National Wildlife Refuge Draft Environmental Impact Statement.

❖

MARILYN SAVAGE:
Testimony on Yukon Flats Land Exchange (2008)

My name is Marilyn Savage. I was born and raised in Fort Yukon. I live in Fairbanks raising my four grandchildren, because some of them have special needs. And I go back to Fort Yukon in the summer, and go fishing.

I just came back from Fort Yukon. I was there for the Yukon Flats Land Exchange hearings. I heard all the people there. They're my people. I was part of that crowd that was in opposition of the land trade in Fort Yukon, because if you disturb the Yukon Flats Refuge, what's to say you're not going to disturb the Arctic National Wildlife Refuge, or any other refuge in the state?

In Fort Yukon I heard that Doyon is saying, "We're good stewards of the land." I mean, what's this $22 million that they have to pay in fees for waste down the oil well up north?[1] I mean, that's not good stewards to me.

I'm talking because I have grandchildren. I'm raising four of them by myself. I want that land stay sacred so my grandchildren can have the benefits of the land, just like I did. I mean, I enjoyed it and I got where I got from my grandparents and my ancestors. I'm fighting for my grandkids.

Native life is what I really enjoy, as best part of my life was growing up as a Native family. My dad took us up to fish camp every summer, loaded up the little boat with all the ten kids. And my mother raised us. We still live off the land.

Our Native people are few in numbers. We don't have the money that oil people have. We don't have the money that executives have. We don't make the money you guys make. But we're happy. We want this kind of life we live. I never change my mind since the time I was little. Never change my mind that I want to live this lifestyle.

I don't want to change my food. I don't want to change my culture. I thank God today. He gave us this place to live, this planet. If we don't take care of it like we're supposed to, we're going to pay for it one of these days. And we already are starting to pay for it. We're losing our Native people to drugs and alcohol, time and time again. But who introduced it? It's not just in Fort Yukon or Rampart, it's all over the world, and it's a problem, all right.

But I don't want my people wiped out just because we have a little more money from oil drilling. I want my grandkids to enjoy the life that I lived. I want them to know that fish and caribou and moose and beaver are going to be there.

It is the best life to wake up in fish camp, you're in a hot tent, the sun is straight overhead shining through the tent and saying it's time to get up and the fish wheel is turning and you hear that—the creaking of our fish wheel and the water

Marilyn Savage with kids on the Yukon River during Gwich'in Nation Gathering in Fort Yukon. *(Photo-graph by Pamela A. Miller, 2010.)*

running. Then you hear the fishtail splashing around and you know you got to get up, Mom's going to holler, "Say, it's time to cut the fish, get up, get the wood to smoke it." We got to start cutting it. We knew that we had to. And we saved the fish guts. We took it back to Fort Yukon thirty miles down, put it in the ground for our garden, after we harvest our garden. And our fish cache was full of fish.

Anyway, I was going to say that all four days, all this traveling with the public hearings, I hear the process. We're in this process. I'm so sick of it.

But the Native people, the indigenous people have a process also. Remember it. We have a process. We go by seasons. We got to go hunting and bring the meat home. We got to teach our kids, including our Native language. We got to go fishing. We got to supply for the dogs. We still do all those things.

The best time of my life is when it was duck season. We're at fish camp, we got the fire going, we pluck all the ducks, singe it, and you knew the smell, that's what makes the soup, the singeing the ducks. And you clean the intestine, gizzard, and the heart, you save that, take it out of there, clean it. You clean it real good and you put it on the fire, the intestine, and it sizzled up, curled up. And it cooked in the fire. That's the best thing. It was better than candy for us, when we were growing up. And if you have stomach trouble, my dad would always say that's the best thing for stomach problems. He always ate some for his stomach problems.

Anyway, the best times of my life, and it still is, is my Native subsistence way of life.

We still got kids to raise. They won't know how to take care of the land after it's been used up, tainted, from all the oil drilling. The food's not going to be there.

I tell you about grandmas. I thought I was the only one that had the best grandma in the world in Yukon Flats—Julia Peter. And I owe her a lot of respect. She taught me her stories. She knew how to do everything. And she was kind of gruff, but that's how they are.

We lived in Beaver Creek. My grandfather, Abraham Peter, was the best trapper in fur-bearing animals. He always knew how to get the meat back to the village.

On holidays, on Christmas, there was dancing. My grandmother loved to dance. She even hook up the dogs in Beaver Creek and went from Beaver Creek to Fort Yukon by herself with her dancing slippers just to dance. Then she'd hook them back up and go back home with some candy or some groceries. She brought a whole sled full for her relatives to Fort Yukon. That's how we are, we share and we participate in our cultural activities. And we can't live without it. You can't take that away from us. I don't think we would let you, or let anyone take that away. That's our right.

We cannot say now, "Oh, we give up. We're not going to take care of the land, we give to some white people, I don't disrespect what you are, but we give it away to some non-Natives so they could do what they want with it because we don't want to take care of it."

Well, I don't want to tell my grandkids, great-grandkids, "Oh, I'm sorry. You know, I'm sorry I didn't take care of it, didn't fight for you." We're always going to fight for our land. That's all we have.

We're not going to share our lands to be destroyed. We don't want to. We want to live the way we want to, and we have that right. My kids have that right. Every one of you has that right, to keep the refuge a refuge.

You know that if we had a major oil spill, how long it will take to get to the river? Forty-nine hours. That's what the biologist figured out.

And do you know that we have harsh climates, it's cold. This winter was cold for two weeks. My brother, he's a physician up there, who live up there during that time said that Yukon Flats is flat, it's in a basin, and every time it was ice fog, you can't get a plane in there or out of there. You cannot because you can't see. There's no lights to see on the airfield. If you sock that pollution (from oil drilling and spills) down underneath for two weeks, guess who gets to live it and breathe it—children, and Elders with health problems.

My life and the lives of my kids are at stake here.

I want you to understand that I don't take lightly to being imposed upon. My family, who I love, my land that I love, my air that I breathe, I don't want anyone to taint it, to destroy it. I don't want to see black smoke blowing around there.

We had enough already—we barely control the forest fires, you know that's due to climate change. And that was hard for our people. Elders had to be moved to Fairbanks so they could be near a hospital to breathe, get oxygen. And that was no good. They didn't like it in Fairbanks. We had to send them food—Native food from Fort Yukon so they could have their own Native foods in the hospital or wherever they stayed. It's hard.

And that's the only way we want to live, our Native way.

One more thing, if you open a road,[2] it's going to kill us. That's what makes Fort Yukon and Yukon Flats unique. We're sort of isolated. We can go up the river, travel the country like that. You can drive to Circle and go in a boat. What's wrong with that? We love it, it's nice. That's our rivers. Our rivers are just beautiful. We see animals walking on the banks. It's the best feeling you can get, and I don't want that destroyed.

I know Doyon is our corporation. They need to listen to us, because every year we have to go to annual meeting, we listen to them. They tell us what

to do. But now they need to turn around and listen to us for once. We're not going to stop talking.

❖

This statement is adapted with minor edits from a testimony by Gwich'in Elder Marilyn Savage. The testimony was made on February 21, 2008, at the Noel Wien Library in Fairbanks, during public hearings of the US Department of the Interior—Fish and Wildlife Service Proposed Land Exchange Yukon Flats National Wildlife Refuge Draft Environmental Impact Statement.

❖

MATTHEW GILBERT:
Letter to Senator Daniel Akaka about
Arctic National Wildlife Refuge (2005)

I am Gwich'in Athabascan from Arctic Village, Alaska. We are called the Caribou People: the caribou is the basis of our culture and whole livelihood. Caribou plays an intricate role in every area of our life. From caribou we get clothes, tools, jewelry, shelter, stories, legends, songs, dances, and spirituality. Caribou is also our biggest source of food. There is nothing we do in our everyday life—even today—that is not related to or influenced by the caribou.

I've been protesting against opening the Arctic National Wildlife Refuge to oil and gas drilling since I was nine years old. I was an innocent kid holding up two marker-colored banners made by two other kids, posing for a photographer. I ended up in *Time* magazine. From there, it never stopped.

Arctic Village, where I grew up, is in a valley at the foot of the Brooks Range on the southern edge of the Arctic National Wildlife Refuge. The caribou migrate over a mountain by our village every fall, which is our hunting season. I will try to describe what caribou means to the Gwich'in. The Porcupine caribou herd is the main critical food source for the Gwich'in, and has been for twenty thousand years. To put it formally, it has been our main economic system. It's not just our food, it's a lot of things.

The caribou is our economy. We use nearly everything from the caribou; we make it last year-round. Our women dry caribou meat in smoke caches, a "Gwich'in beef jerky," so to speak. Some people roast caribou ribs on a

barbeque, like any barbeque. My aunt even makes New York-style steaks out of the meat.

The distant-time stories of the Gwich'in Athabascans are filled with animals and trees that would speak and reason like people. The natural laws were explained through legends and stories. Ancient heroes set the precedents for society and nature through their deeds and accomplishments. These stories remind Gwich'in that they are vital players in the natural world. In order to understand Gwich'in culture, one must understand the moral structure of these stories and legends. Long ago, our heroes set the natural law for animals such as the eagle, and we are empowered by these creation stories. We naturally managed the wildlife and plants of our land. But now we feel this sacred authority is being threatened by proposed oil exploration and development in the calving grounds of the caribou—the 1002 Area on the Arctic Refuge coastal plain.

Most of the traditional Gwich'in feel that if you harm the environment and wildlife, you harm the Gwich'in. If we destroy the environment, Gwich'in Elders say we can still be human living in the cities, but inside, we will decay until the end of the ages.

A people's cultural and social fate is in the hands of congressmen. The Gwich'in are asking for more help and allies to protect the Refuge.

WHAT IS THE SOCIAL IMPORTANCE OF CARIBOU?

When a hunter shoots a caribou, he brings it back to distribute it among the Elders and the people. Gwich'in people want this; they expect this, and in our culture, sharing doesn't have the same meaning it does in Western culture. When you give something in Arctic Village, it's expected. Long ago in our societies, sharing was not occasional. It was done so much that it was considered natural. Most of us are diluted with the Western culture enough to thank those who give us meat, but when I gave some dry meat to a fellow Gwich'in in Anchorage, where I attended college, I never expected a thank you, and I didn't want one. She was one of my people and she needed caribou. I gave it: it was as simple as that. In this way, caribou solidifies our community.

Most people think subsistence is simply hunting to Alaska Natives and nothing more, but what they fail to realize is that it is not just hunting. The very act of hunting caribou and moose defines us as who we are—it is our

culture. You cannot limit our hunting by seasons any more than you can limit how much dough or cheese an Italian can use when making pizza or how much one can dance each year. The word *subsistence* in English refers to a low standard of living, whereas to Alaska Natives it means the exact opposite: it means a way of life that brings a rich lifestyle and fulfillment. The English word is not capable of defining the holistic sense of our culture.

MY GWICH'IN BOYHOOD

As a child, I remember visiting dozens of family camps planted all over the mountain above our village with my grandfather. These trips satisfied the adventures I naturally craved as a child. When we visited these camps, I felt a sense of community never felt in the village—a friendly and welcoming atmosphere. I cannot help but wonder if this was the feeling my ancestors had when they visited each other's camps.

After we visited the camps, we'd go over the mountain and onto the tundra to track the caribou. On the mountain you can see the entire valley below; it's beautiful. In mid-autumn, the mists off the horizon make the land glow blue. This is the scenery you would see as you were bringing a caribou back to the village from atop the mountain. This beautiful way of life will end if we do not have the caribou. We cannot sincerely call ourselves Gwich'in if we don't have the caribou.

I shot my first caribou when I was thirteen. I consider it my rite of passage for being Gwich'in. To shoot something twice your size that can feed an entire village is a life-changing experience. Traditional hunting practices of the Gwich'in mold the men of our village; it demonstrates whether they will be useful as a hunter or not. It is also significant in teaching young children about who they are and what they will be doing one day. Consequently, subsistence is a complex network that incorporates the entire Native community. Hunting caribou is the wellspring of our culture; we are the caribou people.

My experiences growing up in Arctic Village demonstrates to me that I cannot live there without being directly or indirectly affected by the caribou.

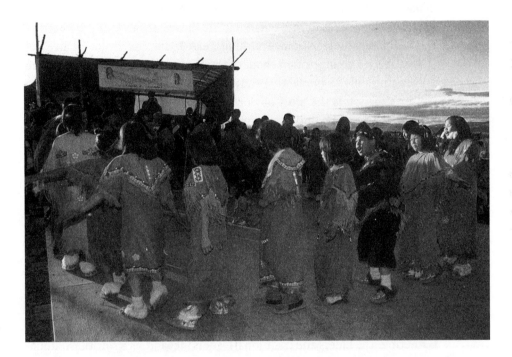

Caribou Skin Hut Dance during Gwich'in Nation Gathering in Arctic Village. *(Photograph by Subhankar Banerjee, June 2001.)*

GLOBAL WARMING

Climate change is affecting every facet of Gwich'in life. The Gwich'in Elders had a prophecy in the old days about a time when the weather would warm and change. The Elders were also aware of the ozone layer. They called it *Zhee vee Luu* in Gwich'in. They knew something was happening to it. They also foretold changes with animals, and that different animals would move up this way.

To us Gwich'in, and all Alaska Natives, the changes are affecting our daily lives and our relationship to the land. Gwich'in communities are experiencing climate changes including increased forest fires, permafrost melting, riverbanks eroding, lakes drying out, a decline in whitefish, unhealthy berries, and loss of reliable subsistence hunting areas. Today, it is harder for an Elder to fully teach a young person about the land he grew up on because the land is changing and the animals are shifting migrations.

Our situation is the most obvious when it comes to energy and global climate change. The impacts of fossil fuels, energy depletion, and global warming on us is a small-scale model for what's going to happen to the United States in the future if our society doesn't shift to a new way of life. We need to reach equilibrium with the natural world to save our planet. We can begin our way to this goal by boosting and industrializing renewable energy, cutting fossil fuel consumption on the micro and macro levels, growing our food, and reforming and greening our cities and villages.

THE GWICH'IN GATHERING

In the fall of 1988, Gwich'in Athabascans made history by holding a Gwich'in Gathering. The Elders and traditional leaders met and set a spiritual foundation for a thirty-year campaign to protect the Arctic National Wildlife Refuge from oil and gas development. It was probably the most powerful Native stand since Elizabeth Peratrovich won civil rights for Alaska Natives in 1945.

The Gwich'in Nation's stand soon gained world recognition. Gwich'in were going to fight the encroaching industrial greed of America. As a kid, I remember the leaders with their traditional talking sticks on stage speaking passionately. Though at that young age, the topic was new and unfamiliar, I nonetheless saw the sincerity of the Gathering and respected it, even as a kid.

The *Gwich'in Niintsyaa* event was historic consciously to the adults and subconsciously to kids. The kids at the Gathering, myself included, knew

something important was happening. Years later, we kids took up the fight for the refuge. Now, when we are advocating for the issue, we reference the Gathering as the important event that stirred the Gwich'in Nation and its environmental allies to action.

The 1988 Gathering also widened our worlds as village kids. Never had we seen the village so diverse, excited, and populated. Never had the village become so cosmopolitan. We played with kids from all over the place who educated us with their cultures and foreign personalities. We grew as people because of the Gathering and the ones that followed, but, most importantly, we kids respected ourselves more as Gwich'in people.

The refuge is the "Sacred Place Where Life Begins" for Gwich'in Athabascans. It has helped us maintain a good life for millennia. It means where *our* life begins. The caribou is one with Gwich'in. Caribou gave me my identity as a Gwich'in; the caribou has ensured our survival since the beginning. Now it is our turn to ensure theirs.

❖

This essay is partially adapted from a letter written by Matthew Gilbert in 2005 to US Senator Daniel Akaka (D-Hawaii), urging him to oppose a budget resolution that included legislation to open the Arctic National Wildlife Refuge coastal plain to oil drilling.

❖

NOTES

1. BP paid $22 million in fines for late reporting of hazardous dumping down wells at its Endicott oil field on Alaska's North Slope; BP's contractor Doyon Drilling pled guilty to fifteen counts of violating the Oil Pollution Act of 1990 and paid $3 million in fines. See "Broken Promises" (p. 179).

2. Doyon proposed a road through Victoria Creek in White Mountains National Recreation Area next to Beaver Creek Wild River and north through Yukon Flats Refuge Crazy Mountains Wilderness Study Area to the Yukon Flats Refuge lands to be traded away for oil development.

Past and Present, Culture in Progress

VELMA WALLIS

✣

In 2001, soon after I got to Fairbanks, I read Velma Wallis's debut novel Two Old
Women—*a story of survival inspired by an Athabascan legend she heard from her
mother. To get that book published was quite a challenge—its publisher Epicenter
Press was still in its infancy when Velma submitted her manuscript. Through a
grassroots campaign, enough money was raised to get the book published. So
far, it has sold more than 1.5 million copies and has been translated into seventeen
languages. Since then, she wrote another novel,* Bird Girl and the Man Who Fol-
lowed the Sun, *and an extraordinary memoir,* Raising Ourselves: A Gwich'in
Coming of Age Story from the Yukon River, *which I use when I teach a class. On
July 31, 2010, I wrote to Velma requesting her to write an essay for this volume.
To my delight, she responded the same day: "Yes, I would be willing to submit an
essay for your anthology. I was just at the Gathering in Fort Yukon. It was hectic
because I worked as a gofer in the background. I loved the sheer physical work
that it took to get something like that together." She was referring to the Gwich'in
Gathering to discuss and renew their resolve to protect the habitats of caribou*

(Arctic National Wildlife Refuge) and salmon (Yukon Flats National Wildlife Refuge). What follows is not about the Gathering or oil, but a story in which she weaves humor, pain, joy, and sorrow toward healing, with stories.

✢

WHEN I was young, I remember a quiet stillness about Fort Yukon. There were no street lights, yet our eyes adjusted to the dark outlines of night. In the winter, stars, northern lights, and the moon reflected brightly off the snow. Sometimes the night seems brighter than the days because our sun is below the horizon during the winters.

My Aunt Nina used to tell us about how the children of her days loved this type of moonlit night, when they could frolic just like the rabbits that they could see jumping to and fro. I have had such nights. We almost never wanted to come back inside, and my mother had to scold us as we reluctantly came into the house, throwing a wistful look over our shoulders.

You always hear people of my generation telling these kinds of stories. To the young, I am sure we are like old, senile people who remember a time and world gone by. But for people my age, it seems like just yesterday, and in that space of time to now, I have seen many changes, right up to now, when I am using this computer to write this article, and to send it instantly. It is amazing to me that such technology exists.

My village, Fort Yukon, was established in 1847. The Hudson Bay Fur Traders came up the river and made camp at the confluence of the Yukon and Porcupine Rivers, intent on developing fur trading commerce with the Gwich'in, who have roamed this part of the land for at least ten thousand years. It amazes me how people from untouched cultures can be quickly won over, and it was so with my people. My grandmother, Martha Wallis, remembered a time when she first met some men who cajoled her into trading her moose-skin dress for a calico one. Of course, it had taken some talking and gesturing to get a newborn customer of Western goods. Shortly after, my grandmother returned to complain that her dress had torn in the woods. Being the tradesmen that they were, the Hudson Bay fur traders dug out needle and thread and showed my grandmother how to repair her dress. After that, my grandmother was never to look back with any great regret. She went onward with such gusto and admiration for all these things that were to make her life easier.

Before that, my grandmother knew times of struggle and starvation. The Gwich'in, just like every other Native American tribe, had their ways of survival and understanding of the land they inhabited. There were rules for every man, woman, and child for these cultures to have survived for as long as they had. The land, animals, and elements all worked in harmony with these rules and regulations that these people had developed over the years. You could say that the people had come to an understanding. I remember my mother telling me of the young girls who had just gotten their periods and how they had to be sequestered from the rest of the group. The mother or another older woman would take the girl a distance away. They would set up camp, and then the older woman would train the younger one for the life of a wife, mother, and helper to her husband. It was a type of finishing school, harsh but necessary in those times. My Aunt Nina participated in this ritual. She was a good daughter and tried hard to please her parents. But her older sisters mocked the ritual. By then, they were well entrenched in the Western culture and felt a little foolish about the things that their parents taught at home.

My grandmother said that this ritual would ensure longevity, and when my aunt told this story to me, she told it with a certain bravado, for her sisters had not lived long due to the epidemics. But my aunt did break one rule. She remembered seeing her father, and although it was forbidden to look at any of the men lest you give them bad hunting luck, she made eye contact with him, and he had winked at her. My aunt told me this story when she was well into her seventies, and she was so girlish when she recounted this particular memory that I could tell she had loved her father greatly.

Then the great epidemics came. When I used to take my children for immunizations, they would take one look at the needle and freak out. I would have to calm their fears, but I also reminded them of the time when there were no such shots, and mothers would have to stand helplessly by and watch their beloved children die.

When my Aunt Nina told of these times, you could tell she wasn't completely healed. Her heartbreak was still there when she told of her daughter, Nina Clara, dying from typhoid fever, and there wasn't anything she could do but watch and moan to God to save her child. When the child died, my aunt said she did not want anyone to touch her child. She had a long vigil before she let them bury her.

My father, too, had his sorrows with the epidemics. His first wife and daughter succumbed, and he was never the same. But the time came when he met my mother, and they embarked on the journey of building a family.

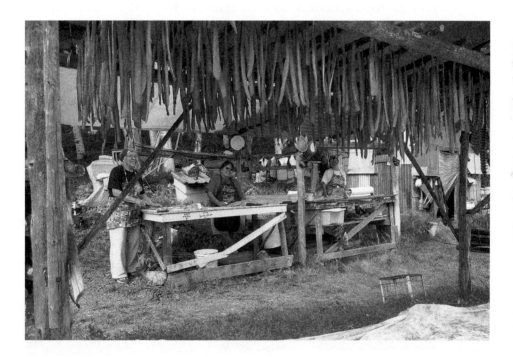

Happy fish cutters, Rampart Rapids along the Yukon River. *(Photograph by Stan Zuray, 2010.)*

Our lives were built around the Yukon River. Even in a time when our culture was slowly changing to more modern ways, the Yukon River was always like a steady, life-giving companion to us. To those of us who lived by the Yukon, fish was our life, just like caribou is the life to those Gwich'in who live up near the migratory path, just like whitefish is known to the people up in Chalkyitsik. You could say that, for us, it was all about the fish.

It wasn't always like that, though. Back before the coming of the white man, we Gwich'in were nomadic. We all knew each other. We knew one another's lineage, and although sometimes we feuded, we were relatives and friends. Now, due to the Canadian and United State borders, Gwich'in on either side are like strangers. But we do share the common ground today of fighting for our right to still live off the land as our people from the past did.

When I was growing up in Fort Yukon, such things were unfathomable. Who would know then that today the world would shrink and resources would be wanted by many more people from different walks of life? It is much more complicated today than just putting in your fish wheel and getting enough fish for your family and dog team. It's no wonder that people of my generation tend to remember back then with such fondness. When I was younger, I loved Dolly Parton. Such an artist! One of her songs had a line that goes something like this, "In the good old days, when times were bad," and that is just how it always is. The lesson is, enjoy today because rules and regulations change and tomorrow could be worse.

Life in Fort Yukon was not idyllic. My parents got kind of carried away and made fifteen of us kids. My mother used to joke that had she heard of birth control, we might not have been born. Of course, she was just joking, or at least I think she was. She joked about a lot of things. She called her first group of kids her first "litter," and she referred to us younger ones as her second "litter." Many people would take offense at my mother's brand of humor, but you had to know her to really appreciate her, and although she could have very well meant every word she said, she was a loving creature and we would hardly take offense.

With their first batch of children, my parents lived out in the woods. In the winter, my father trapped in a land not too far from Fort Yukon that we call *Negookwandah,* which means "foxhole lake." Years later, when the lakes were practically dried out due to environmental changes, I saw that little hill where my mother said a fox always harbored her litter. I checked out the hill, but there was no hint of her den, nor would there be because my father's land had been burnt out from a devastating fire years past.

The land was given to my grandmother, Martha, by an old man who used the land before. Back then, it was typical for someone to use land and then hand it on to someone else. My grandmother spent the rest of her life trapping and hunting this land. Then my father supported his growing family from this land.

My Uncle Lee Henry, from Beaver, used to tell me stories of how he and my father would trap a hundred muskrats a night. When I tried to trap that land some twenty-five years later, the lakes were drying out, and I managed to get thirteen muskrats. My brother was lucky to snare a couple of beaver. It was slim pickins for us.

But back then, the land was lush and lavish. My mother said that before the fire, the land reminded her of the story from the Bible where Adam and Eve roamed the land and got what they needed. Years later, when I took her back so she could sober up, she fell off the toboggan, and she looked around with her booze-induced ashen face and yellowed eyes, and tears fell down her parched skin as she beheld the tall black skeletons of trees against the cobalt blue of winter skies. I looked with her and saw what I saw, and could not see her memory.

But in their time, my parents supported a big family from the land. My father hunted farther upland. Back then, my mother was his right hand, and his left. She was the sous chef to his chef status. She made sure all the winter supplies made it up to the cabin, and he did the heavier tasks of taking the dogs, fish, fuel, and other things that would not fit in a chartered flight. When I tell the story today, I make honorable mention of these pilots who used to haul people all over the place with floats and skis, no matter the terrain or weather. One day I or someone else will tell the story of these guys and their planes, who helped people like my parents.

My mother's duties on top of watching small children were to cut and chop wood, cook for man and dog, and keep the wheels of a trapline family rolling smoothly. My father knew his wife was a good person, and he trusted her to do these things. In truth, if my mother had ever gone on strike, my father would have failed. But she was right behind him when he looked back to check.

From stories told by my older siblings, they were always busy. My mother would give the older sisters, Hannah and Clara, the task of watching the younger ones. All the older kids learned to do things long before their time. Children raised in the woods become self-sufficient. My older siblings were tough, until they returned to Fort Yukon after trapping season. Then my mother said they all caught colds and any other sickness that assailed the townspeople.

In the summer, my father made a habit of getting wood to make extra money to supplement his fuel needs for fishing. My mother would sell beadwork that she had made all winter long to the tourists and nurses. This money helped her buy goods from the Northern Commercial store. Now that store is known as the Alaskan Commercial store. These stores are in most Alaskan villages to this day.

Back then, the store was into fur trading. My father would sell his furs to the trader represented there and in turn would get us things we needed. My parents had an ongoing account at that store. They would get things on credit and pay it off with furs. To me, as a child, this seemed like a magical transaction. I didn't understand that they paid blood, sweat, and tears to buy those things.

In 1959, a school was built for both Indian and white children for year-round use. Before that, the schools were segregated. My parents gave up moving out to the woods so the older ones could go to middle and high school. The second litter knew only a time of growing up in our two-room cabin along the Yukon River.

In the summer, my parents fished for king salmon. My father would take my older brothers and disappear down the river to the fish wheel that father had built with young spruce poles as the snow melted. Then my father and brothers would return with tubs of big fish. My mother would always be ready with sharpened knives, a smudge fire in the fish cache, and her tea and cigarettes, ready for action. She kept us younger ones busy by making us go down to the riverbank and scour the shores for dry driftwood that we'd haul back with a wooden wheel barrow.

We were like wild puppies set free in the summer. We were given few rules: No playing near the Yukon. No going to certain people's houses, and play only in the neighborhood. Every now and then, we would wander uptown out of burning curiosity and were chased back downtown by bullies. We knew why we were told to stay nearby.

My father had a team of dogs that he kept year-round. I vaguely remember dog names like Huddy, Sparky, Whitey, Pony, and Valentine. The dogs were huge, and to me they seemed savage. Some of them had colored eyes, and they always seemed intelligent and calculating; if I got too close, I imagined they might swallow me up in one gulp.

We kids had the task of feeding them during the winter. My brothers would cook the food in the big black pots that people made from fifty-gallon drums that were cut in half, and after the food cooled, we younger ones would take ladles and divide an even amount of the goop in a mix of dog pans. It was

smelly stuff made of fish parts, oatmeal, rice, and maybe rabbit guts. The dogs barked, growled, and pulled on their leashes as we tried to hurry and serve them. For me it was always traumatic. Maybe something happened between me and a dog when I was younger, but those dogs scared me, especially when they were hungry. I would throw their pots of food at them, and they would swallow everything we gave them. Even as young as I was, I knew they were hard workers. I witnessed them taking my father out to his trapline, I witness them helping my brothers haul wood and water. I knew those dogs deserved every morsel sent their way.

Despite the fact that the dogs scared me, I would sit in their bedding and hold their puppies. There was always an older person to supervise these visits, and me and my younger siblings would hold possessively onto these pups and never wanted to let them go. Even the smell of dog fur, dog grass, and mother's milk did not deter our visits to the doghouse when puppies were born.

Later, when the puppies grew older and left the house, we ran wild with them. Once, a bunch of kids stole our puppies when my father was out firefighting, and my mother could not be bothered about the stolen puppies, and so I went to these people's house and demanded our puppies back. The parents just stared at me with smiles on their faces, and did not deny nor admit to anything. When I heard the puppies in their back porch, I went there and set them free. The puppies and I ran all the way home.

My mother sewed our school clothes. We always got two pants from her, same pattern, same fabric: blue, black, or brown corduroy. Our parkas were the same fabric, too. And we got two canvas boots per year, each of us. So my mother made at least thirty canvas boots a year.

Canvas boots are warm and fun. They have moose-skin soles, and the uppers are canvas right up to the knees. We tied them around the ankles to keep sturdy and at the knee to keep the snow out. When our usually busy mother had time, she would sew rickrack around the upper rims and put colorful yarn balls on the tips of the laces. They were fun because when they got worn, they eventually became black and slippery and we used them to skate across the hardened winter roads.

Clothing was not a fashion thing for us. It was a function thing. When bell bottoms came in style my mother belled out the bottom of my brown corduroys just once, and just once I was in semi-league with the other kids uptown whose parents always kept them in fashion.

My father ordered us three sets of clothes during the year, one for Christmas, one for Fourth of July, and one for school. I enjoyed the brand new smell of

clothes. In spring we had rubber boots, and in summer we had canvas-upper tennis shoes from a local store owned by Ivar Peterson, an entrepreneur.

We played with anything we could find when we were not supervised. We were strictly forbidden to play with my father's traps and animal stretchers, but we tried to anyway. But there's only so much you can do with these implements, and they weren't much fun, and the stretchers smelled of animals. But we certainly played with my father's toboggan, and his snowshoe tub, a big, long, rectangle contraption made of galvanized steel. We used it as a boat on dry land. My father used the tub to bend wood for his sleds and snowshoes, and it was blackened from many fires, and our hands would be black when we were done playing.

Of all the worries my parents had while raising us, they worried most around springtime when the Yukon began to break up. The ice would cascade by like ferocious yawning monsters, and the whole of Fort Yukon would be hypnotized by this event. The Yukon use to flood our village until the Red Cross moved everyone up to a hill, where the town still stands today. But my family and a few others were river addicts, and we stayed where we were despite the threat. It only flooded once in my time. I was at rat camp when it happened, and there were huge chunks of ice on land. The family members that were there melted the ice to clean out the muddied houses.

Growing up, we ate only animals that my parents harvested from the land. In the winter it was moose, ducks, geese, fish, and rabbits. In the spring it was ducks, geese, muskrats, beaver, and whitefish. In the summer it was whitefish, ground squirrels, porcupine, king salmon, king salmon, and king salmon. We would look into the big pot on the stove and there would be boiled salmon. For lunch it was baked salmon, for snacks it was salmon on top of Sailor Boy crackers. We knew these as our daily foods, and it wasn't until we started school that us children saw peanut butter and jelly sandwiches, and macaroni and cheese, and whatever other processed foods were slowly coming our way back then. At school, we would get a glimpse of the world outside.

I remember we visited the nurse in the clinic behind us. She was a nice person and loved baking apple pies for my father. We would sit on the steps outside with her. Once we got in an argument about Alaska. We told her we were separate from the United States, and she tried to explain that we were a part of the United States. No matter how hard she tried to explain that we were part of a country, we thought she was just plain ignorant not to know that the United States and Alaska were completely separate. We had to call an impasse because neither of us would give way on our beliefs.

Katlyn Beth Zuray packing meals—king salmon fillet—for college, along the Yukon River. (*Photograph by Stan Zuray, 2011.*)

About the time my grandmother Martha passed in 1968, I began to notice change. It's odd, but the day she passed I saw change.

The summer had been stifling hot and smoky. A vast fire from Chalkyitsik burned our way, and my father's trapping land was burning. My grandmother was frantic. Some Gwich'in believed if you planted a tree in your youth and tended to it all your life, that when the tree died, you died. My grandmother had such a tree on the land that burned. She implored my dad to save that tree but the fire was too big, and he scoffed at the idea of superstitions. My mother tried to convince him how important this tree was to my grandmother, but my father made up his mind about such things.

Not long after, my grandmother passed. I stood watching from a distance. Children were forbidden to be boisterous during death. I watched people paying their last respects to my grandmother.

When she died, the weather changed immediately. There was a big rainbow across the river. The rains came and soon after the fire was doused.

To me it was as if the time my grandmother died, a time died with her passing.

Maybe it was because I was a child who watched and wanted answers that I noticed change.

My father and mother were alcoholics. They were binge drinkers. There were times we had a good life worth noting, and then when the drinking came, you just wanted to forget the things said and done. These things changed us, and set us on a lifelong course of dealing with demons, and healing.

My father had gotten sick from diabetes. He tried to change his eating habits and lifestyle, and for a good many years he did. He and my mother were the parents a child could dream about. We were happy. My father began to accumulate new motors, new appliances for my mom, and I think he had a plan.

One time he tried to get me to save money for a bike. He gave me a glass mustard jar, and told me when I had filled it up with pennies and nickels and dimes, he would match it with a new bike. I tried. But the local theater won over, and much to my father's disappointment I broke the bank and headed to a movie. I regretted it, but being a survivor I borrowed other kids' bikes.

I don't to this day know what changed my father's mind about being sober, but one day he just decided, and he drank until he died. My mother was devastated and sought her solace in the bottle.

By then things were changing in our villages, and for Native people throughout Alaska. In our village we saw the arrival of a little black and white television.

I'd like to boast that I was haughty when it came to this new thing in our lives, but I bought right into it, and watched television like there was no tomorrow. It was with the same intenseness that we used to watch the ice floes go by, and we could not turn our eyes away.

We were introduced to *Sesame Street, The Electric Company, The Young and the Restless, As the World Turns,* and countless other shows that portrayed a world new to ours.

It wasn't until the eighties, when I was in my twenties, that I noticed that our way of communicating with each other as Gwich'in and neighbors was changing. No longer were children listening to Elders tell stories; no longer were Elders telling stories. Not only that, we were acting more like television characters. I remember mimicking John Denver by saying things like *groovy, far out,* and *peace, man.* J.J., from the show *Good Times,* was like a brother to me. We had two local television operators, and they would tell all the local news and announcements, and keep the television on until one. Then they'd play the national anthem. We were being well trained to spend ten hours of precious time a day in front of the television.

It's the first time we became conscious of advertising. Until then, I never noticed that there were many brands of just about everything out there. Changes!

Some changes have been gradual, and some have been overnight. Some have been good, and some have been bad.

I have watched my own village lose a lot of people to the disease of alcoholism. I used to be judgmental about it, but now I see if we are to win against substance abuse, we have to recognize it as a disease as sure as cancer and tackle it from that direction. My family members still struggle daily with this problem, and on some bad days it looks like a losing battle. But that war is still on, and the victor will bring more change.

That change is education. People are a little iffy about education in our villages. Education and subsistence still have a hard time being bedfellows, but as time passes I see more and more people going to school and getting degrees, and then going back to their villages to make a difference. That difference will be more sober people making healthy changes.

And it has always been about the land. They will go back to the land. They will hunt and fish with their children. They will walk the land. They will camp.

This past summer when I was in Fort Yukon, I saw fish wheels turning around every corner of our river. The young people are finding their way.

My storytelling is from our people. There have always been storytellers.

The ones endowed with memories and observations are the ones who tell the stories. The stories I have found are collective memory keepers for the group, when they don't have the time or the energy to tell stories. People always told me that the stories I wrote tell their story. No matter where they are from and what walk of life, they tell me that I tell their story through my stories.

As a storyteller, I am glad to share my stories. There are many stories yet to be told. As we heal and adjust along the way, we will hear more stories. The story I like to tell best is of our younger generation, who seem to have feet in each of the two cultures that came together once upon a time, and they have managed to be comfortable in both worlds. But the great concern when cultures get interrupted is when the dominant one wins over. As a storyteller, it's always good to remind our younger ones. They need that foundation in this big world where there are many cultures. It's good to know who we are, the fish people, the caribou people, or just the Gwich'in people.

From **The Reindeer People**

Living with Animals and Spirits in Siberia

PIERS VITEBSKY

❖

In September 2007, I received a request from Vanity Fair *magazine—to take photographs in Siberia that would accompany an article by Alex Shoumatoff on climate change in Russia with a focus on Siberia. The magazine gave me two months of research time. The first book I read was* The Reindeer People: Living with Animals and Spirits in Siberia, *by Cambridge University anthropologist Piers Vitebsky. The book, based on nearly twenty years of field work with the Eveny people of northeast Siberia, opened up my mind about the north in ways that I had not thought about before. The book's jacket states:*

> *Piers Vitebsky shows how Eveny social relations are formed through an intense partnership with these extraordinary animals (reindeers) as they migrate over swamps, ice sheets, and mountain peaks. . . . The Soviets' attempts to settle the nomads in villages undermined their self-reliance and mutual support. . . . The narrative gives a detailed and tender picture of how reindeer can act out or transform a person's destiny and of how prophetic dreaming about reindeer*

fills a gap left by the failed assurances of the state. Vitebsky explores the Eveny experience of the cruelty of history through the unfolding and intertwining of their personal lives.

In early November, Robert Thompson and I traveled to Siberia—we spent three weeks with the Eveny reindeer herders in the Verkhoyansk Range—the coldest inhabited place on earth (plate 9), and later with the Yukaghir people in Nelemnoye along the upper Kolyma River (plates 10–12). I also read another book, Soul Hunters: Hunting, Animism, and Personhood among the Siberian Yukaghirs, *by Rane Willerslev, a former PhD student of Vitebsky. Reading these books, (briefly) visiting some these communities, and over the years, traveling in other indigenous communities in the US, including Alaska and Hawaii, I learned that indigenous communities are determined to preserve their languages and cultural traditions despite repeated onslaught from the dominant societies. It makes sense to end this book with an essay entitled, "Outliving the End of Empire." Here is an excerpt from how Piers ends his book* The Reindeer People.

❖

The Reindeer People: Living with Animals and Spirits in Siberia *was published by Houghton Mifflin Company in 2005.*

EPILOGUE: OUTLIVING THE END OF EMPIRE

Every time I fly over this land, I try to name the places I have visited and recall the events associated with them: the mountain-top in camp 7 where I built a cairn with Gosha and Yura, the river in camp 8 where Kesha told me about his swan as we fished through the ice, the pass nearby where I huddled on a sledge with Lyuda and little Diana, another pass on the way from camp 7 to camp 3 where our girls cried in the blizzard. When I flew back across the area where I had just left Vladimir Nikolayevich to continue his midwinter hunt, I could trace the tracks of our journey together, and even work out some of the sites of our overnight halts. Half a mile above Vladimir Nikolayevich and his *uchakhs*, the pilot dipped his wing in greeting.

The threads of human movement are so far apart that if you did not understand the signs, you might imagine this landscape was uninhabited. But to the

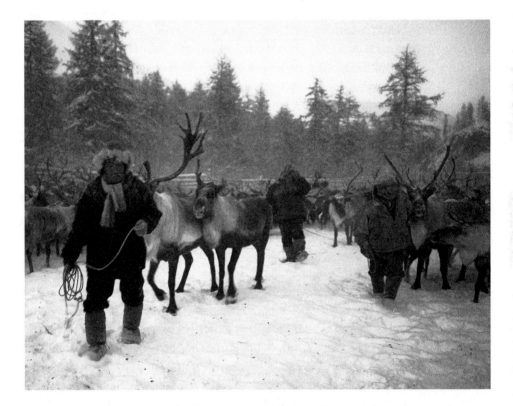

Ilya Golikov, Matvey Nikolayev and grandmother Osenina Dariya Mikhailevna counting and separating reindeer at the corral, Camp 11 along Korechan River valley, Tomponski Region, Verkhoyansk Range, Yakutia, Siberia. (*Photograph by Subhankar Banerjee, November 2007.*)

attentive eye, winter reveals every step taken by human or animals, even a mile below. Sometimes, my aircraft inches past a caravan of sledges as they wind along a frozen river, their movement almost imperceptible except for a slowly extending furrow in the virgin snow. There is usually someone on board who can name the solitary figure on the lead sledge and say where he is going and why. The deeply snowdrifted western slopes of the Verkhoyansk Range, where I have never been overland, are too remote and difficult for domestic herds, and there are only the occasional sledge-trails of the most experienced hunters seeking small groups of wild reindeer and single elks. Once made in early winter, an animal's prints may remain discernible until May or June. If one could follow them forever, as in a string maze puzzle, one would catch up with every single creature.

The marks left by a herd of domestic reindeer are quite different. The secret growth of the richest lichen is betrayed through the snow by the densest churning up of hooves, while the outer edges of a lichen bed preserve the thinner marks of sallies and retreats by leaders and followers, like solar flares lashing out from the seething surface of the sun. The area around the winter hut of their herders is different again, as an undifferentiated trampling by human feet thins out into a fan of repeated short walks to a woodpile or a frozen river, and finally to the separate traces of single journeys which may extend for a hundred miles beyond.

The reindeer people of Siberia have been compelled to adapt many times over: to their challenging landscape from time immemorial, to the arbitrary violence of Cossack fur-bandits and the casual greed of tsarist officials, to the paternalistic and systematically violent onslaught of the Soviet State and the indifference of the so-called market economy. But Ivan, Granny, Lidia, and Gosha; Kesha and Lyuda; Kostya, Vladimir Nikolayevich, Vitya, Tolya, and Afonya are not passive victims. They are intelligent, flexible people, politically alert, whose inner spiritual life and reserves of irony allow them to survive and look out for each other, even while they see their world for what it is.

The emotional journey of the reindeer peoples of Russia has been hard, and the feeling of loss that I sense in so many people does not come from naïve nostalgia, whether theirs or mine. The Soviet ideal of progress was based on a rejection of the past: graves were to be forgotten, children were to be separated from their primitive, deported, or murdered parents, dead shamans were not to be reborn. This catalogue of sacrifices is now seen to have been in vain: the Soviet project was too ambitious—or perhaps even fraudulent. Now, in addition, they learn that their bodies have been irradiated, their Farm directors have lost direction, their local economies are bankrupt,

the helicopters on which they have been led to depend have been grounded forever, and their children are killing themselves.

Russia's population of domestic reindeer has plummeted from 2.2 million in 1990 to 1.1 million today. Is this the beginning of the end of yet another branch of human civilization, as one Russian reindeer specialist has put it? Eleven thousand years after the great wild herds retreated from central and southwestern Europe and two thousand years after they were first saddled in Inner Asia, is the Age of Reindeer nearly over?

Certainly, the relation between reindeer and humans in Russia is undergoing a realignment. The decline in domestic reindeer is balanced by a corresponding rise in the number of wild reindeer, which are increasing to fill their vacated ecological niche. From a mere 200,000 in 1961, wild reindeer in Russia have increased till they also number 1.1 million, said to be the first time in 150 years that the figures for domestic and wild reindeer in Russia have been the same. Other practices that formerly limited wild reindeer have also been curtailed. Until around 1990, the huge herd on Taimyr Peninsula was being culled at the rate of 50,000 a year to feed the region's industrial towns, but this has ceased with the disappearance of the aviation to gather up such large quantities of meat.

The increase in wild herds is monitored by biologists and wildlife departments. I have seen young observers from the local Ministry of Natural Resources sitting on the plastic sofa of the aviator's hut playing cards or comparing notes by species and river in their exercise books as they wait to be called to their spotter plane. These boys, plotting the tracks and movements of wild animals in late winter when the revealing snow is still on the ground, have taken over one of the many roles of the flying shaman. Their work has expanded from the shaman's task of guiding hunters to their prey to include modern conservation and management, as well as giving advance warning when wild reindeer threaten to invade and abduct domestic herds.

Without the standardizing influence of Soviet policy, the destinies of different herding regions are increasingly diverging. The species *Rangifer tarandus* continues to retreat from the south, and the heartland of the reindeer now lies firmly in the far North. In the southern forest regions where the species was first domesticated, reindeer herding is steadily dying out, and of the unique Tofalar breed of reindeer on the Mongolian border, fewer than 1,000 animals remain. The Native communities that live by reindeer herding in southern regions such as Tuva, Khabarovsk, and Sakhalin are already endangered peoples.

The habitat and lifestyle of the forest reindeer herders in the south are generally closer than those of Sebyan to earlier Tungus forms. I have twice stayed with a camp of Evenki who keep small herds and hunt wild reindeer for food and sables for cash, migrating across the border between the Sakha Republic and the Amur district. Though at first sight their dense southern forest seems vast, they form a small enclave in Russianized territory and are boxed in on several sides by large-scale mining of coal and of gold whose tailings pollute their rivers.

These southern Evenky live near a branch of the Trans-Siberian Railway, whose mineral traffic brings them more problems than benefits. In the far North, by contrast, the viability of reindeer herding depends on access to transport and the market, and generally deteriorates as one moves from the relatively well-connected flatlands at the western end of the Russian Arctic to the high and remote mountain ranges of the east.

In the European part of the Russian North, the number of domestic reindeer has stayed fairly constant since 1990, and across the Urals among the Nenets on Yamal Peninsula it has even risen. The Nenets people have preserved a strong kinship system as well as trading networks with the outside world. Even in the Soviet times some 40 percent of the region's reindeer remained in a family ownership, and with the liberalization of the 1990s they have moved energetically into selling velvet antlers to middlemen from China and Korea. Further east in the Sakha Republic, the number of domestic reindeer has dropped by more than half, from 343,400 in 1992 to 136,900 in 2002. As a small component of these figures, the decline in Sebyan does not look at all bad: from 20,000 in 1998 to 16,000 by the mid-1990s, more recently remaining steady at around 17,000–18,000.

In Chukotka in the far northeast, the collapse of reindeer herding has been catastrophic. In Soviet times the homeland of the Chukchi people was turned into a frantically overproductive reindeer factory, which yielded a high proportion of all Russia's reindeer meat. By 1980, the sparse vegetation of this one harsh, windswept district was being chewed by 540,206 domestic reindeer and trampled by their 2,160,824 hooves.

The Chukchi were much more vulnerable than the Nenets of Yamal. They owned a mere 5 percent of the reindeer they herded, making them completely dependent on the State farms that employed them. When the Farms were broken up in the early 1990s and their assets privatized, the herders were still missing six or eight years' back pay, which they would never receive, and had no other assets. Some Farms were turned into joint-stock companies

Svetlana Dagileva with her one-year-old daughter Elvira, and two other children, Camp 11 along Korechan River valley, Tomponski Region, Verkhoyansk Range, Yakutia, Siberia. *(Photograph by Subhankar Banerjee, November 2007.)*

(*astsionernoe obschestvo*). Often the herders received the reindeer, but the equipment went to the Farms' Russian specialists who took it out of the area altogether, leaving the herders without technical support. The starving and cashless communities were approached by outside traders who offered groceries in exchange for meat, and laced their offers with lorry loads of vodka. While an unsympathetic local government looked on, the herders succumbed to four-legged and two-legged wolves. By 2000, the Chukchi had become the most destitute reindeer herders in the world. At the 2002 spring festival in the village of Omolon, where the 30,000 reindeer—more than have ever existed in Sebyan—had been reduced to a mere 6,000, the younger people danced away the night in a disco, while the older herders sat and wept. Omolon was dying from a sickness far more hopeless than the despair of Sebyan. The brigade nearest the village, which suffered most from the outside traders' blandishments, sold or drank their inheritance down to the last reindeer.

The massive herds that the old people were lamenting, and which to them already seemed "traditional," were in fact a modern industrial development of the previous small-scale relationship between hunters and their *uchakhs*. The decline in herd size is consistent with a wider de-industrialization of the Russian North, as the high tide of the Soviet empire retreats after the shock of perestroika, like blood being withdrawn from the outer limbs of an organism to the vital organs at the core.

While business culture flourishes at the centre of the new Russia, the industrial towns that spearheaded the "mastery of the North" at the Arctic edge are dying. The only thriving industry in the North is the extraction of oil and gas for export. Towns like the coal-mining settlement of Sangar, loading point for the barges of the Lena River Fleet, or the Arctic Ocean ports of Chersky and Tiksi, which serve the caravans of icebreakers escorting merchant ships from Murmansk to Vladivostók or Yokohama during the few weeks of thin summer sea-ice, are becoming ghost towns where one can buy an apartment in a half-empty block for the price of a one-way ticket to Moscow. The project of the homogenization of space has been defeated by that space's own vastness. In the great Soviet vision, distance itself was the North's greatest resource; now, it has become the region's greatest burden.

When Pushkin wrote that his high art would reach even the "wild Tungus," he was echoing a poem written in Latin 2,000 years earlier by Horace, court poet to the first Roman emperor Augustus, who consolidated the modern idea of empire as control over a far-flung territory of diverse peoples who

feed consumption at the centre in exchange for civilization, their own lives bent to an agenda they can barely comprehend.

"I have wrought a monument more lasting than bronze" (*exegi monumentum aere perennius*), proclaimed Horace as he opened the final poem in his major collection, a fanfare which Pushkin adapted as "I have raised myself a miraculous monument" (*Ya pamyatnik sebe vozdvig ne rukotvorny*). Where Pushkin expected to be cited by Tungus peoples such as the Eveny, Horace looked for his primitive peoples at the southern tip of Italy. "I shall be quoted [*dicar*]," he claimed,

> qua violens obstrepit Aufidus
> et qua pauper aquae Daunus agrestium
> regnavit populorum
>
> Where the torrential River Aufidus growls
> And where the water-starved Daunus
> Once ruled over wild tribes

Poems can indeed last longer than bronze, and certainly longer than empires. The Roman empire vanished 433 years after Horace published these lines; in the twentieth century a Soviet empire, which Pushkin could not even have imagined less than a century earlier, lasted for only seventy-four years.

Daunus was a legendary king. Perhaps his tribes had disappeared by Horace's time, perhaps they had been civilized by the emperor: we are not told. But Pushkin's Tungus were "still" (*nyne*) wild, and remained so until Soviet educators civilized them. The Soviet Union was not only the most psychologically intrusive empire the world has ever seen, but also the shortest lived. Having subverted what people had of their own, it just as suddenly disappeared.

What kind of people will the northern reindeer-herding natives become as the empire abandons them?

The villages established in Soviet times were designed to occupy a specialized niche in a complex political ecosystem, drawing the nomadic tribes into the State's program of development as suppliers of meat to industrial settlements. Native communities were made logistically and psychologically dependent on veterinary and medical services, schools and hospitals, all integrated through aeroplanes and helicopters into a tight network of control and fulfillment. Suddenly all these facilities, the goals and satisfactions, have been withdrawn. Sebyan can go for a whole summer without a doctor or any

physical contact with the outside world, and sell no meat in the autumn. With the Farms bankrupt and their urban customers emigrating, can such settlements continue to exist? Many native villages were closed as uneconomic in the 1960s and amalgamated with others. Why not the remaining ones?

"Sebyan is slowly dying of alcohol poisoning," Lidia told me over one of our many pots of tea. "But they won't close it as long as there's still reindeer herding. The market will encourage us to form kin-based associations [*rodovaya obschina*], without the State Farm."

Many visions of renaissance since the late 1980s have been based on a return to modernized versions of pre-Soviet forms, based necessarily on reduced dependence and greater self-sufficiency. The more organized visions have created these self-help associations, collectives that struggle in some regions and occasionally flourish (though several attempts to establish them in Sebyan have failed). But then, combining a contradictory scenario in the same flow of thought, Lidia raised a more anarchic possibility which I have also heard from others.

"If there's is a big crisis," she said, "people will flee to the taiga, not to the city."

So the Eveny may take to the mountains again like their ancestors, feral humans riding on *uchakhs* to hunt feral reindeer, the descendants of their own abandoned herds. The Communist Revolution and the might of the Soviet Union; the State Farm and the wonder of free helicopter taxis on demand; the twentieth century, bringer of civilization, war, and large-scale betrayal: all these will have come and gone, over a large swathe of the earth's surface they will leave nothing but occasional ruins of wooden poles on an uninhabited landscape that changes so slowly that it will take centuries for the Arctic vegetation to roll over them.

"But there are lots of young people who can't survive in the taiga," I objected. One had only to remember Lidia's own daughters on Hotorchon Pass during a brief summer snowstorm.

"Yes," she conceded, "some will go to the city—the ones with education." She thought for a moment, then insisted, "But the rest of us could live in the taiga without the village."

I do not believe that the Age of Reindeer is coming to an end, but that the people who live with reindeer are moving to a new global awareness that opens up possibilities for new kinds of action, even turning deficiencies into opportunities. As the air transport of heavy reindeer carcasses becomes prohibitively expensive, herders seek to increase the value of every available flight. In the far west, within reach of Scandinavia, they try to sell the meat

abroad as an exotic delicacy; in other areas, they load the aircraft instead with velvet antlers for the Korean market.

Talk in Russia of total collapse, which became so prominent in the 1990s, is itself a kind of rhetoric that can also serve as a "cover" (*krysha*) for people's own purposeful activities of *vyzhivanie* (surviving, or making do) and entrepreneurship, which crosscut and belie the appearance of dependency. Even while their Farm's inadequacy closes off transport links and makes the marketing of their meat impossible, reindeer peoples continue to reach outward in attempts to form new connections, associations, and pressure groups.

In May 2002 I visited Johan Mathis Turi, the Sami president of the Association of World Reindeer Herders at his home in the far north of Norway. We had just been taking part in an international conference in Kautokeino on reindeer herders' legal rights, held to mark the publication of a comprehensive survey of the current state of reindeer herding throughout the world.

"I went on a trip to Topolinoye in 1990," he told me as we sat in his upstairs living room, gazing at a fast, shallow river that ran away down the valley just in front of the window, seeming by an optical illusion to flow straight out of the house. Topolinoye was the showcase Eveny village, 5,000 miles east of the Sami, that I had sidestepped in favour of Sebyan during my first visit in 1988. "I was amazed," he continued, "I still thought we Sami were the only reindeer people in the world."

Though they live in liberal democracies, the migration of their reindeer still brings the Sami of Norway, Sweden, and Finland into conflict with their governments over rights to land, culture, and language, and their professional and political associations are well developed. The journey to Siberia made such an impression on Johan Mathis that in 1993 he persuaded the Sami to invite the reindeer herders of Russia to a World Reindeer Peoples' Festival in Troms, which was attended by representatives from twenty-four different peoples. Inspired by this, the herders of Russia formed their own association, a more specific pressure group than the Association of Northern Peoples whose inaugural meetings in Moscow and Chersky I had attended in 1990. At the banquet in Yakutsk to celebrate the establishment of the regional branch of the Association of Reindeer Herders of the Russian Federation in 1995, I drank vodka and Crimean champagne with friends from many communities around the Sakha Republic and danced with elegantly dressed women whom I had last seen in floral frocks or baggy tracksuits boiling meat in a tent. In 1997 the Association of World Reindeer Herders was established at a congress in Nadym and Johan Mathis was elected president.

The functioning of reindeer-herding communities is often undermined by the extraction of oil, gas, and other minerals, and their associations must work in an uneasy blend of opposition and cooperation with their governments, also drawing on international support to stimulate official interest at national and local levels. The meeting that brought me to Johan Mathis's home was attended by high-level representatives from the Norwegian and Russian governments, as well as by Nenets leaders, the director of the only reindeer Farm in Russia that made a profit (selling meat to the military bases on the Kola Peninsula), and the Chukchi Vladimir Etylin, dedicated Member of Parliament (Duma) in Moscow for the region of Chukotka, who had just promoted a law that would protect communal reindeer pasture from being sold off to private owners.

In the late winter of 2001, Tolya and I brought the last practicing Tungus shaman in all of Siberia to Sebyan. The spirits of the village had agreed to allow this old Evenki man, who lived as a recluse in a forest hundreds of miles away, to perform a séance.

The village hall was packed. Row after row of serious faces filled the darkened seats, while more people stood in the aisle and along the side walls. The audience wore fur coats, fur gloves, fur muffs, fur hats: reindeer, fox, wolf, mountain sheep, marmot, wolverine, otter, squirrel, muskrat, ermine. In any other setting, this would have been a glorious fashion display. But in this hall at minus 30 degrees Fahrenheit, their dinner of meat and fat and their covering of the outer skins of mammals were all that kept these destitute humans alive.

The backdrop of the stage was a stylized reindeer prancing beside a *chum*, a tepee in the old conical Eveny style which few living people have seen. In the dust at the front of the stage lay the sphere that projects coloured rays of light at discos and song-and-dance cabarets. The audience looked up over this sphere onto the platform, where the light of a single electric bulb showed the shaman's young woman assistant lighting a fire of larch shavings and herbs to fumigate and purify his costume and drum. The hidden art of an authentic shaman had come out of the forest and onto the stage, a setting that for eighty years throughout Siberia had carried the exaggerated manic convulsions of actors performing hostile propaganda. Eleven years ago in this very space, its walls heavy with the accumulated reprimands of leaden voices telling the villagers what to do, think, and feel, I had watched the downfall of a theatrical shaman, naively played by a schoolchild who could have understood little of what he was enacting.

The shaman sat on a rectangular mat made from the brown head-fur of two wild male reindeer, the slits of the eye-holes and antler-holes sealed with the white fur of a male domestic reindeer. Patches of wolverine, bear, and lynx were sewn around the border with thread of wild reindeer sinew. His robe was made from tanned elk hide, processed with a dye obtained from the inner bark of an alder tree, and embroidered with a brass sun as well as iron representations of the shaman's own skeleton and of his animal and bird spirits. Every item was laden with meaning. From the shaman's waist hung tassel embroidered with tufts of fur gathered from a reindeer's throat, the seat of its soul, in such a way that not a single hair was scattered or lost. His headdress was made of two crossed strips of decorated cloth, representing the four corners of the universe, from which a fringe of fur tassel covered his eyes to conceal the ordinary world as he made his voyage of insight into another reality.

The four struts of the cross-piece on the inside of his flat drum likewise represented the four directions. The shaman himself stood at the centre of the universe, which for the duration of this ritual would be located in the village hall of Sebyan. The inside of the drum was ornamented with iron models of his helping spirits: an eider-duck and a bear. A pair of bear's ears would enable him to hear the speech of spirits, and twelve pine cones represented each of the levels of the cosmos to which he was qualified to fly.

The shaman was already singing into the interior of the drum in an unbroken chant and beating the drum with a flat, paddle-shaped drumstick in a steady 1—1—1—1 rhythm, the bells inside the drum and round his costume jingling with a slight delay after each beat. His eyes were half open, but he was already in another state of consciousness. On the biplane to the village, the shaman had been just a frail old man, blinking shyly as many people do here, avoiding eye contact even more than most. Now, an entire community was transfixed, watching every flicker of his half-hidden face. The tone changed as he moved from invocation to full trance, and both chant and beat acquired a sudden extra force as his body stood up and his soul took off. The fur tassels hanging from his waist swirled, while the iron animals and the brass sun and bells jingled with the swaying of his torso.

The ritual was not to locate wild animals, but to heal. Tolya had selected two women for treatment, one of them his own sister Anna, who suffered from crippling arthritis in her hands.

The shaman's tassels swirled as he bent down to his first patient. His spirits continued to sing through him, but the throbbing beat stopped for a moment as he put his hands on her head. He drew out her illness, which now

appeared as a smear of blood and gore on the inside of the drumskin which his assistant held out to the audience. Until now they had been silent, but there was a hubbub as the people sitting in the first few rows and standing around the walls surged forward, adults and children together, their various fur coats pressing together like a herd of mixed animals. His assistant wiped away the blood and the shaman resumed his drumming while she whispered to the patient and helped her down from the platform.

Now the shaman was bending down in front of Anna, while his assistant talked to her gently and helped her to her feet. The beat stopped again while he crouched in front of her and brushed her over and over again with his drumstick, repeating the movement with his bare hands, drawing her arthritis down from the wrist and out through the tips of her fingers. Anna blinked, dazed, as he passed his drum right around her body, doing his best to gather up her illness into its concave interior. Tolya turned the drum toward the audience, shining my head-torch onto another splash of blood, and they surged forward again.

The spirits had declared that Anna's illness was the working out of a curse which had also manifested itself through the recent death of her boy, who had been victimized by gangs when he went to study in the city and had mysteriously fallen down a stairwell in a student hostel. She was suffering for an ancestor who had killed a sacred piebald reindeer; her arthritis was a punishment for the sin of his hands that had committed the deed. There would be no easy cure. Anna's eyes were brimmed with tears and the assistant comforted her in a low murmur as she stepped down from the stage and joined her surviving son.

The ritual was coming toward the end. The assistant wiped the shaman's face, which was drenched in sweat. She removed his headdress, then his drum. He sank exhausted onto his mat of wild reindeer fur, his soul beginning to return from the twelfth level of the sky. His chanting began to slow down as she wiped his face repeatedly and fed him sips of water.

Instructed by Tolya, others donned the robe and picked up the drum, to draw the spiritual arousal away from the shaman and bring his soul safely down to earth. Kesha was the first to imitate his drumbeat and twirling dance. The pace was the same as before, but the intensity was diminishing as the robe and drum passed from one person to the next. The shaman lay huddled on his mat like a baby, still singing softly in rhythm to the beat. He put on a woollen skullcap and started to wipe his own face, gradually falling silent as he lay under a coat, smoking a cigarette. At length, all drumming ceased.

Tolya had waited years for an opportunity to show the people of his community what they had lost from the heart of their own culture. While his aim

was to raise cultural awareness, I believe that Native leaders and activists like Tolya and Vladimir Etylin have taken on a core role of the old shamans, that of protecting their people by cultivating a specialist knowledge of other worlds. They sense, in a way that the old shaman cannot, how the hidden reality behind the surface of daily appearances has changed. Instead of the spirits of animals, land, and sky, modern Native leaders must understand regional and federal government agencies and international organizations. Like the upper and lower worlds of shamanic cosmology, the purposes of these bureaucratic worlds are inscrutable to ordinary people, yet they have the power to nurture or destroy them. A drilling license granted over a community's head to a multinational company can sever the reindeers' migration routes and smother their pasture under devastating oil spills; a nature reserve created with the uncomprehending encouragement of an international wildlife organization can destroy a community and starve the families who are forbidden to catch food in their own home; a nomads' territory mistakenly marked as uninhabited and unused on the plan of a project that does not consult the people, can be lost forever.

This is the capriciousness of Bayanay carried into new realms. Where shamans would traditionally "fly" on reindeer or drums made from their skins to locate wild animals for harvesting and to fend off hostile spirits, these new Native leaders fly in aeroplanes between ministries, parliaments, and expert committees, petitioning and bargaining for their communities, making sure a Native voice is heard, harvesting new laws about land rights and natural resource management, and remaining ever vigilant for new kinds of threat. Like shamans, they cannot work alone with their own limited strength but need helper spirits, who include sympathetic scholars, lawyers, and activists in Russian cities and abroad.

In an attempt to help the destitute Chukchi camp at Omolon, Vladimir Etylin has flown around the local aviation authorities, the office of a new, sympathetic governor in Anádyr, and the Sakha Ministry of Agriculture in Yakutsk. By teaming up with Tolya, he has come up with an extraordinary plan: to restock this camp by buying 1,000 reindeer from the Eveny of Sebyan and Topolinoye and transporting them to Chukotka to reconstitute an entire herd.

Small groups of reindeer were moved between districts in Soviet times, usually stud males to improve the stock. Even on this scale, there were problems of integration and adaptation: breeds had to be chosen to suit the forest or taiga environment, and incoming animals had to fight with local reindeer for supremacy. When Sebyan bought some Tofalar males from the original area of reindeer domestication in south Siberia, they died of the northern cold; when they sold their own reindeer to a Farm 250 miles away in Zhigansk, the animals ran home.

The reindeers' homing instinct can be thwarted by airlifting them. The operation envisaged in Chukotka will be unprecedented. Rather than a few males to tone up existing stock, an entire herd of breeding males, females, *uchakhs*, and calves will be delivered to a brigade that has lost every one of its previous animals. Chukchi herders will fly in advance to the Eveny villages to work alongside local herders and become acquainted with the animals, and the Eveny will return with them to Chukotka to settle the reindeer into their new pasture.

The Sakha-Chukotka airlift is planned on a scale that has never before been conceived, even under the technical might of the Soviet empire. A gigantic Mi-26 military helicopter will collect 150 animals at a time right from where they graze and carry them on a 1,200-mile swoop over the massive peaks of the Chersky and Kolyma Rages, decanting them directly into their new pasture.

Will the reindeer try to circle anticlockwise inside the cavernous body of the helicopter, as they do in a pen or when contained by a ring of gesticulating women and children? Lacking room to throw their lassos, how will the herders tie them down to distribute their weight evenly and safely over the interior? Will the reindeer grunt in the eco-chamber of the aircraft, or will they endure in silence, like Zinovy's four reindeer which half filled our little Mi-8 helicopter, soothed by the vibrations of the engine and the calming presence of their own herders? I hope I shall be there to find out.

This assistance from the Eveny to the Chukchi will be the biggest airborne herd of reindeer in history, a huge modern manifestation of the flying reindeer that have helped humans for millennia. Specific manifestations of belief can change. When the Old Man, Granny, Yura, Dmitri Konstantinovich, and Tolya's mother died, they were not buried on platforms high up in trees as they would have been 200 years ago, or under stones carved with reindeer sprouting huge winged antlers, like people in western Mongolia two millennia earlier; when Ivan, Kesha, and Tolya strip to the waist to chop wood on a hot day, they are not revealed as tattooed with reindeer on their shoulders, like the mummified people of Pazyryk.

Yet the journeys made beyond the grave on a sacrificed *uchakh* show that neither Christianity nor Communism has succeeded in completely wiping out the association between reindeer, flight, and human salvation. The discovery of how to ride a reindeer must have been a literal fulfillment of a long-held fantasy, allowing the ancestors of today's Siberian peoples to partake in the speed with which reindeer run for huge distances over plains, mountains, ice, water, bog, and scree, with an ease of movement that had otherwise been available only to the shaman in trance.

In taking off from the earth, the reindeer at the old midsummer festival did not merely support the Eveny physically on a saddle: they also carried their

Matvey Nikolayev on his *uchakh* (transport raindeer), leaving camp to attend to the raindeer heard, Camp 11 along Korechan River valley, Tomponski Region, Verkhoyansk Range, Yakutia, Siberia. *(Photograph by Subhankar Banerjee, November 2007.)*

souls. Since Tolya's early conversations about the festival with Eveny Elders, in a language with 1,500 specialized words for expressing human relations with reindeer, almost every one of those old people has ridden their *uchakh* on to the next world. If I had understood those firelight conversations at the time, I might have pressed Tolya to ask them what they "really" believed, what they "really" felt at the moment when they were said to be flying. But that would have been giving in to my own newcomer's impatience. My quest to enter the inner world of the Eveny could not be fulfilled by such direct, crude questions, but only by sharing their daily work, witnessing their life stories, and reflecting on their experiences of spirits and dreams. The life of another people is a mystery one can never plumb to the full; but my reward for living with the Eveny has been some wonderful friendships, and a glimpse into the enduring relationship between a community of humans and a species put on earth to nourish them with its flesh, insulate them with its fur, and exalt them with its soul.

> I have come home from afar,
> I have not beheld you for so long.
> With all my heart I love you,
> My homeland!
>
> How fine you are in spring,
> Sebyan, Sebyan,
> Your lake surrounded by peaks,
> Your pure water, Sebyan!
>
> The autumn leaves fall,
> My voice echoes far.
> My song is about you, my homeland,
> Birthplace of my ancestors!
>
> If the reindeer do not come,
> If the herd turns away,
> If the reindeer do not come,
> There will be no more Eveny!
>
> —song by Motya the Music Woman,
> daughter of old Sofron in camp 1

ACKNOWLEDGMENTS

NO WORDS can adequately express my gratitude to everyone who helped me over the past decade to learn about and engage with the Arctic. I won't be able to mention all those names, but here are a few people without whom this volume would not have been possible.

Several contributors generously agreed to participate when I sent out an e-mail in August 2010. Since then, other writers and artists also agreed to take time out of their busy schedules to lend their voice for this anthology. At times, I'd send e-mails to them that included "The deadline was yesterday, sorry!" and they responded with humor. Thank you!

My publisher-editor Dan Simon always reminded me, "You're the editor of the book, but I'm your editor." I'm lucky that this was the case. Without Dan's critical but supportive guidance, we wouldn't have *this* book. Each time I'd send in a manuscript, he would express a mixture of satisfaction and disappointment, and give suggestions for improvement. But, after approving the final manuscript, he wrote, "This is the book we both wanted. It's emotionally filled to overflowing, a truly generous gift for the readers." Thank you!

And thank you to the most talented team at Seven Stories Press—Elizabeth DeLong for managing the project with such care, Gabe Espinal, Phoebe Hwang, Jon Gilbert, Veronica Liu, Anna Lui, Jamie Quirk, Anne Rumberger, Indre Telksnyte, and Ruth Weiner for helping to spread the word.

Editor of my first book Christine Clifton-Thornton also provided crucial editorial help with several essays in this volume. Thank you!

In July 2010, I proposed the idea to do this book to my friend Anthony Arnove, co-editor with Howard Zinn of the anthology *Voices of a People's History of the United States.* He responded, "No worries, I will find you a good publisher." He did. Thank you!

And financial support for contributor fees and the color plates? I called up Cindy Shogan of Alaska Wilderness League. She said, "Sure, AWL will provide the financial support for the book." Thank you!

And time? Peter Goddard, director of the Institute for Advanced Study in Princeton and Yve-Alain Bois, professor of art history; John P. Harrington, dean of faculty, and Jo Anna Isaak, chair of art history and music, Fordham University, provided successive appointments with ample time so that I could focus and complete this volume. Thank you!

And research? Pamela A. Miller of Northern Alaska Environmental Center, and Leah Donahey and Gwen Dobbs of Alaska Wilderness League provided much needed research help for this volume. Also I'm grateful to my friends Fran Mauer, Luci Beach, Robert Thompson, and Sarah James for always helping me with information about all things Arctic.

For financial support over the years I'm grateful to the Lannan Foundation, in particular my friends Patrick Lannan, Laurie Betlach, and Christie M. Davis; Blue Earth Alliance and its co-founder, Natalie Fobes; Tom Campion; and Ann and Ron Holz.

Thank you—to Peter Matthiessen and Helen Cherullo for your friendship and support; and to Gerald McMaster and Catherine de Zegher, co-artistic directors of the 18th Biennale of Sydney for sharing my Arctic photographs in Australia, so many miles and seas away.

Many thanks to my friends Sanjeeban and Madushree Chatterjee; Virendra and Roshila Chaudhary; Srikant, Sumita and Soumen Ghosh; Lorene Mills, Chris and Victoria Sloan Jordan; Ashish and Ushree Kirtania; and my parents, siblings, and their families—Debdas and Nina Banerjee, Sudakshina and Abhijit Sen, Dipankar and Suktara Banerjee, Titli, Monty, Dinky, and Riya—for your love and support.

The final choices—as well as any omissions or errors that remain—are mine.

CONTRIBUTORS

ROSEMARY AHTUANGARUAK is an Iñupiaq mother, grandmother, and cultural activist. She is a graduate of the University of Washington Medex Northwest Physician Assistant Program. She has fought tirelessly for the health and protection of her people and of the Arctic's unparalleled wilderness that has sustained her culture for thousands of years. Rosemary is a former mayor of Nuiqsut and served many years on the board of the Iñupiat Community of the Arctic Slope, the regional tribal government for the North Slope, and is an executive council member of the Alaska Inter-Tribal Council. She received the 2009 Voice of the Wild Award from the Alaska Wilderness League. She is a founding board member of REDOIL (Resisting Environmental Destruction on Indigenous Lands).

DACHO ALEXANDER is a member of the small community of Fort Yukon, Alaska, where he works as an airplane mechanic and serves as a magistrate. A former first chief on the Gwichyaa Zhee Gwich'in Tribal Council, Dacho has been a prominent critic of a proposed land exchange between the US Fish and Wildlife Service and Doyon, a regional Native corporation based in Fairbanks. The land swap would open parts of the Yukon Flats National Wildlife Refuge to oil and gas development, a move that an overwhelming majority of tribal governments and community members oppose. He serves on the Board of Directors of Indian Law Resource Center: Justice for Indigenous Peoples.

GEORGE ARCHIBALD is the co-founder of the International Crane Foundation. He was the President of ICF from 1973 to 2000 and continues to work there as a Senior Conservationist. He received a doctorate from Cornell University. His doctoral thesis concerned the evolution of cranes as revealed by their Unison Calls. He has earned four honorary doctorates and won the

Gold Medal from the World Wildlife Fund. He is also a MacArthur Fellow. George travels frequently to crane conservation sites in North America, Europe, Asia, and Africa. Currently he is helping a major crane conservation program in North Korea. George and his wife, Kyoko, live in the countryside near Baraboo, Wisconsin, where they enjoy aviculture and gardening, and visits with family in Canada and Japan.

SUBHANKAR BANERJEE is an Indian-born American photographer, writer, and activist. Over the past decade he has worked tirelessly for the conservation of ecoculturally significant areas of the Arctic, and to raise awareness about indigenous human rights and climate change. His first book, *Arctic National Wildlife Refuge: Seasons of Life and Land,* has become an influential conservation document. Subhankar has lectured widely, and his photographs have been published across the globe and exhibited in more than fifty museums in the US, Europe, and Mexico, and will be shown at the 18th Biennale of Sydney. In 2010, he founded ClimateStoryTellers.org. His academic appointments have included visiting scholar at the University of Utah, artist-in-rresidence at Dartmouth College, distinguished visiting professor at Fordham University, and director's visitor at the Institute for Advanced Study in Princeton. In 2011, he was named a Distinguished Alumni by New Mexico State University. For his conservation efforts, Subhankar received a Cultural Freedom Fellowship from Lannan Foundation, a Greenleaf Artist Award from the UN Environment Programme, national conservation awards from the Sierra Club and National Wildlife Federation, and was named an Arctic Hero by Alaska Wilderness League.

As Manomet Center for Conservation Science's director of shorebird science, STEPHEN BROWN works to protect this imperiled group of birds. Brown conducts an active research program to determine potential impacts of oil development on nesting shorebirds in the Arctic National Wildlife Refuge and the Teshekpuk Lake Special Area of the National Petroleum Reserve–Alaska. He co-founded the Shorebird Research Group of the Americas, which aims to determine the underlying causes of shorebird population declines throughout the Western Hemisphere, and as lead author of the US Shorebird Conservation Plan he brought together wildlife managers and policy makers from all fifty states to develop a coordinated strategy for restoring the declining populations of shorebirds. Brown received his doctorate from Cornell University, has published dozens of peer-reviewed articles on shorebirds and wetland management, and edited *Arctic Wings: Birds of the Arctic National Wildlife Refuge.*

CAROLINE CANNON is an Iñupiaq tribal leader. She been a council member of the Native village of Point Hope for many years and has served as its president since 2008. She also served as the mayor of the City of Point Hope from 1996 to 2000, and also worked for the North Slope Borough. Her work and testimonies have been instrumental in saving the Chukchi Sea from offshore oil and gas development. She lives in Point Hope, Alaska.

MARLA CONE is editor-in-chief of *Environmental Health Sciences*. She reported for newspapers for thirty years, including eighteen at the *Los Angeles Times* as senior environmental writer. In 1999, she was awarded a Pew Fellowship in Marine Conservation to explore contaminants that are spreading to the Arctic and endangering the people and animals of the far north. Her book, *Silent Snow: The Slow Poisoning of the Arctic*, published in 2005, was a finalist for the National Academies' Communication Award. She has twice won the Scripps Howard Meeman Award for environmental reporting and served on the board of the Society of Environmental Journalists for nine years. She lives in Long Beach, California, with her husband and son.

Arctic pilgrim, freelance author, and wildlife biologist JEFF FAIR has studied loons and endeavored to conserve them since 1978, beginning in New Hampshire. He moved to Alaska in 1995, and now divides his field work between Maine and the Alaskan and Canadian Arctic. His writing has received awards from the National Wildlife Federation and the National Press Club, and appears frequently in *Audubon* and *Alaska* magazines and in *Appalachia*, where he is a contributing editor.

MATTHEW GILBERT lives in Arctic Village, Alaska, where he was raised by his grandparents, Reverend Trimble and Mary Gilbert. He received his BA in English from the University of Alaska–Anchorage and a master's in rural development from the University of Alaska–Fairbanks. He did his thesis on transcribing ancient Gwich'in stories with his grandfather. He has documented Gwich'in climate change impacts and adaptation methods through a fellowship from the National Wildlife Federation and a grant from the Arctic Borderlands Ecological Knowledge Network. Gilbert has published articles in *The Nation, Winds of Change*, and *First Alaskans* magazines, and was featured on NPR's *All Things Considered.*

REVEREND TRIMBLE GILBERT is a Gwich'in Athabascan. He and his wife, Mary, live in Arctic Village, Alaska. They have been married for more than fifty years. He is the traditional chief of Arctic Village, an Episcopal priest,

and Second Traditional Chief for the Tanana Chiefs region in Interior Alaska. He is also a renowned Athabascan fiddler whose recordings include Neets'aii Gwich'in Fiddlers. He was Elder adviser to the Smithsonian's book, *Living Our Cultures, Sharing Our Heritage: The First Peoples of Alaska*, and the associated exhibit at the Anchorage Museum. He has traveled to Washington, DC many times to meet with lawmakers to urge protection of the Arctic National Wildlife Refuge from oil development.

KARSTEN HEUER has spent the better part of the last decade studying and, in some cases, actually following wide-ranging and threatened wildlife on foot. He has worked as a wildlife biologist and park warden in the Madikwe Game Reserve in South Africa; in Canada's Yukon Territory; and in Banff and Jasper national parks in the Canadian Rockies. Accompanied by his wife, Leanne Allison, and his border collie, he walked twenty-two hundred miles from Yellowstone to the Yukon in 1998 and 1999, and another one thousand to Alaska's Arctic National Wildlife Refuge with the 123,000-member Porcupine caribou herd in 2003. He is the author of *Walking the Big Wild: From Yellowstone to the Yukon on the Grizzly Bear's Trail* and *Being Caribou*. In 2003, he received the Conservation Leadership Award from the Wilburforce Foundation.

SARAH JAMES is an internationally known Gwich'in Elder and activist. She is a founding board member of the Gwich'in Steering Committee and has fought tirelessly for the protection of the coastal plain of the Arctic National Wildlife Refuge. James shared the Goldman Prize with fellow Gwich'in activists Jonathon Solomon and Norma Kassi. She also received a Leadership for a Changing World Award from the Ford Foundation, and was inducted in the Alaska Women's Hall of Fame, which recognizes the contribution of fifty women throughout the history of Alaska. She lives in Arctic Village, Alaska.

NICK JANS is one of Alaska's most recognized and prolific writers. A contributing editor to *Alaska* magazine and a member of *USA Today*'s board of editorial contributors, he has written nine books and hundreds of magazine articles, and contributed to many anthologies. His range includes poetry, short fiction, literary essays, natural history, outdoor adventure, fishing, and political commentary. In addition, Jans is a professional nature photographer, specializing in wildlife and landscapes in remote locations. He has been the recipient of numerous writing awards, most recently the co-winner of two Ben Franklin Medals (2007 and 2008), a Rasmuson Foundation artist grant (2009), and an IPBA silver medal for his latest

essay collection, *The Glacier Wolf.* He currently lives in Juneau with his wife, Sherrie, and travels widely in Alaska. He returns each year to Ambler, the Arctic Iñupiat Eskimo village in which he lived for twenty years, and the place he still calls "home."

SETH KANTNER was born and raised in the Arctic. He is the author of *Shopping for Porcupine* and the best-selling novel *Ordinary Wolves.* He lives with his wife and daughter in northwest Alaska.

EARL KINGIK is a prominent Iñupiaq Elder, hunter, and activist. His work and testimonies have been instrumental in saving the Chukchi Sea from offshore oil and gas development. Earl Kingik lives in Point Hope, Alaska.

JOE LIEBEZEIT has worked as an Associate Conservation Biologist for the Wildlife Conservation Society Arctic Program since 2001. He develops and implements collaborative research projects investigating how energy development and climate change are impacting wildlife on the Arctic Coastal Plain of Alaska, focusing on nesting birds. Joe has spent ten summers leading field studies in both human-impacted areas near Prudhoe Bay and in remote places within the Teshekpuk Lake region. He received his BA from the University of New Hampshire and his MS from Humboldt State University.

BARRY LOPEZ is best known as the author of *Arctic Dreams*, for which he received the National Book Award. Among his other nonfiction books are *About This Life* and *Of Wolves and Men*, which was a National Book Award finalist. He is also author of several works of fiction, including *Field Notes*, *Winter Count*, and *Resistance*—a book of interrelated stories—Lopez's eloquent response to the recent ideological changes in the American society. He lives in rural Western Oregon.

NANCY LORD, Alaska's writer laureate 2008–10, holds a liberal arts degree from Hampshire College and an MFA in creative writing from Vermont College. She is the author of three short fiction collections and five books of literary nonfiction, including most recently *Early Warming: Crisis and Response in the Climate-Changed North*. Her awards include fellowships from the Alaska State Council on the Arts and the Rasmuson Foundation, a Pushcart Prize, and artist residencies. She teaches part-time for the University of Alaska–Anchorage and volunteers with conservation organizations.

ANDRI SNÆR MAGNASON is an Icelandic writer born in Reykjavík in 1973. Andri has written novels, poetry, plays, short stories, and essays. He studied Icelandic literature at the University of Iceland. His novel, *LoveStar*, was chosen as Novel of the Year in Iceland in 2002. *The Story of the Blue Planet* was the first children's book to receive the Icelandic Literary Award and has been published or performed in twenty-two countries. Andri has been active in the fight against the destruction of the Icelandic Highlands. His book *Dreamland: A Self-Help Manual for a Frightened Nation* takes on these issues and has sold more than twenty thousand copies in Iceland. Andri codirected *Dreamland*, a feature-length documentary film based on the book. Footage from *Dreamland* and an interview with Andri can be seen in the Oscar Award–winning documentary *Inside Job*, by Charles Ferguson.

PETER MATTHIESSEN is a two-time National Book Award–winning writer and environmental activist. His novels include *Far Tortuga*, *At Play in the Fields of the Lord* (nominated for the National Book Award), and *Shadow Country* (won the National Book Award); his numerous works of nonfiction include *Birds of Heaven: Travel with Cranes*, *The Tree Where Man Was Born* (nominated for the National Book Award), *The Snow Leopard* (won the National Book Award), and *The Spirit of Crazy Horse*, in which he made a detailed study of the Leonard Peltier case and American Indian issues. He has received numerous awards including the 2010 Spiros Vergos Prize for Freedom of Expression, and lifetime achievement awards from Lannan Foundation and Heinz Foundation.

JOHN MCPHEE has written nearly thirty books, including *Oranges*, *Coming into the Country*, *The Control of Nature*, *The Founding Fish*, *Uncommon Carriers*, and most recently *Silk Parachute*. *Encounters with the Archdruid* and *The Curve of Binding Energy* were nominated for National Book Awards. In 1999, he was awarded the Pulitzer Prize for *Annals of the Former World*.

Fairbanks author DEBBIE S. MILLER has explored the wilderness of Alaska for thirty-five years. She is the author of the classic *Midnight Wilderness: Journeys in Alaska's Arctic National Wildlife Refuge* (Braided River, 2011), based on thirteen years of expeditions in the Arctic Refuge. Debbie is also the author of many award-winning nature books for children, including *Survival at 40 Below* (Walker, 2010) and *Arctic Lights, Arctic Nights* (Walker, 2003). She is currently working on a new adult book about the wilderness and extraordinary

wildlife of the National Petroleum Reserve–Alaska, the single largest block of public land in America. Debbie enjoys sharing the world of Alaska with all ages, and she is an advocate for protecting the wild places that she has grown to cherish. She is a founding board member of the Alaska Wilderness League. To learn more about her work, visit www.debbiemilleralaska.com.

PAMELA A. MILLER, conservationist, is currently Arctic Program Director of the Northern Alaska Environmental Center in Fairbanks, Alaska. She began three decades of Arctic conservation work as a wildlife biologist for the US Fish and Wildlife Service, studying bird habitats at the Arctic National Wildlife Refuge and evaluating North Slope oil development impacts. She chaired the nationwide Alaska Coalition while serving The Wilderness Society in Washington, DC. For ten years she ran a small business focused on Arctic policy and oil impacts, and did Arctic wilderness guiding for *Science Times*, Fox News, CBS Sunday Morning, *Chicago Tribune, Washington Times*, the BBC, and others. In 2009, she received the prestigious Wilburforce Conservation Leadership Award. Her BS is from The Evergreen State College and her MS is from the University of Oregon. Miller grew up in Cleveland, Ohio.

FARLEY MOWAT is a conservationist and one of Canada's most widely read authors. He has written nearly forty books, including *People of the Deer, The Desperate People, Never Cry Wolf, The Boat Who Wouldn't Float, And No Birds Sang, Woman in the Mists: The Story of Diane Fossey*, and *No Man's River*.

In 1924, **MARGARET E. MURIE** became the first woman to graduate from the University of Alaska, and in the same year she married wildlife biologist Olaus Murie and began a lifetime of travel, scientific research, and involvement in conservation activities. She played a key role in the passage of the Alaska National Interest Lands Conservation Act and fought tirelessly for the preservation of the Arctic National Wildlife Refuge. In 1998, she received the Presidential Medal of Freedom. In 2003, she passed away at the age of 101 on the Murie Ranch.

DAN O'NEILL was born and raised in San Francisco, graduated from the University of California at Berkeley, and worked after college as an environmental planner. He moved to Alaska at the age of twenty-five, and, among other things, hunted, fished, trapped, ran dogs, built log cabins, and did graduate work in poetry. For a decade or so he was research associate at the

oral history program at the University of Alaska—Fairbanks, where he wrote and produced radio and television programs for public broadcasting dealing with Alaska history and science. For four years, he was a political columnist for the Fairbanks daily newspaper. He is the author of three books of literary nonfiction: *The Firecracker Boys* (for which he was named Alaska Historian of the Year), *The Last Giant of Beringia*, and *A Land Gone Lonesome*. He has lived in the Fairbanks area for thirty-six years.

RIKI OTT, PhD, was an eye-witness and participant in the *Exxon Valdez* oil spill—and became an "accidental activist" in its wake. A trained marine toxicologist and former commercial fisherma'am, Ott has written two books on oil spill impacts to ecosystems, people, and communities (*Sound Truth and Corporate Myths*; *Not One Drop*) and starred in *Black Wave*, an award-winning feature film. In 2010, Ott brought her expertise to the Gulf of Mexico, volunteering for one year to expose a public health crisis of chemical illness and to help with community organizing. *The Huffington Post* named Ott a 2010 Game Changer. In 2011, she co-hosted a national webcast teach-in, *Changing the Endgame*, to expose the high costs of America's fossil fuel dependency—and explore how communities are reducing their carbon footprint. Ott co-founded Ultimate Civics, a project of Earth Island Institute, and is a member of the national grassroots coalition MoveToAmend.org. She advocates ending corporate rule and creating sustainable communities.

CHIE SAKAKIBARA is an assistant professor of geography at Appalachian State University, Boone, North Carolina. Previous to this appointment, Dr. Sakakibara was a fellow at the Earth Institute at Columbia University. Broadly defined, her research focuses on indigenous studies, cultural geography, and environmental sustainability. Dr. Sakakibara has published widely on cultural response to climate change among the Iñupiat of the North Slope of Alaska. Her book, *On Thin Ice: Iñupiaq Whaling, Climate Change, and Cultural Resilience in Arctic Alaska*, is under contract with the University of Arizona Press, to be published in Fall 2012. She is an adopted member of whaling crews in Barrow, and her Iñupiaq names are Siqiñiq and Kuniŋa.

MARILYN SAVAGE is a Gwich'in Elder and writer. She lives in Fort Yukon and Fairbanks, Alaska.

GEORGE B. SCHALLER is a mammalogist, naturalist, conservationist, and

author. He is recognized by many as the world's preeminent field biologist. His many books include *The Last Panda, Tibet's Hidden Wilderness,* and *The Serengeti Lion,* which won a National Book Award. Schaller accompanied Olaus and Mardy Murie in the 1956 expedition to the Sheenjek River Valley that later helped found the Arctic Wildlife Range in 1960, which was later renamed the Arctic National Wildlife Refuge. He has received numerous awards, including the International Cosmos Prize, the Tyler Prize for Environmental Achievement, the Lifetime Achievement Award from National Geographic, and most recently the Indianapolis Prize. Dr. Schaller is a senior conservationist at the Wildlife Conservation Society and vice president of Panthera.

CHRISTINE SHEARER is a postdoctoral scholar in science and technology studies at the University of California, Santa Barbara, and a researcher for CoalSwarm. She is managing editor of Conducive and author of *Kivalina: A Climate Change Story* (Haymarket Books, 2011).

In November 1998, Alaska Wilderness League hired former Southern Utah Wilderness Alliance (SUWA) Legislative Director CINDY SHOGAN as its executive director. Under her leadership, Alaska Wilderness League's membership has grown from two hundred to ten thousand members nationwide, and the staff has grown to twenty-one full-time staff positions with offices across the country and Alaska. In 2002, Alaska Wilderness League was one of seven organizations to receive the inaugural Leadership Award from the Natural Resources Council of America for the environmental community's campaign to protect the Arctic National Wildlife Refuge. To honor her exceptional leadership in the conservation movement, Cindy received the Wilburforce Foundation's Conservation Leadership Award in August 2003. Cindy has previously worked for Defenders of Wildlife, the Izaak Walton League, and the Sierra Club.

JONATHON SOLOMON, 1932–2006, Gwich'in Native leader and Traditional Chief from Fort Yukon, was instrumental in preserving the Porcupine caribou herd and the Arctic Refuge. He helped organize the 1988 Gwich'in Niintsyaa gathering in Arctic Village that concluded with the first resolution of the Gwich'in Nation, calling for permanent protection of the caribou calving and nursery grounds as wilderness, and formation of the Gwich'in Steering Committee on which he served from that time. He and two other Gwich'in leaders received the Goldman Environmental Prize in 2002. During the 1960s,

he led Gwich'in efforts to block construction of the Rampart Canyon Dam on the Yukon River that would have flooded ten Gwich'in villages and what is now the Yukon Flats National Wildlife Refuge. He began work to protect the Arctic Refuge in 1978 during debate over the Alaska National Interest Lands Conservation Act. Solomon led efforts to negotiate the US–Canada Agreement to Protect the Porcupine Caribou Herd and Its Habitat, signed July 1987, and later served on the US negotiating team for the US–Canada amendments to the Migratory Bird Treaty. He worked on the Alaska Native Claims Settlement Act and was on the first Doyon Ltd. Board, and also served on the boards of RuralCap, Denakkanaaga' Elders Conference, and the Alaska Federation of Natives, which honored him as Citizen of the Year in 2002.

EMILIE KARRICK SURRUSCO began her career as a newspaper journalist in California and New Mexico. After spending five years as a reporter and editor, Surrusco moved back to her hometown of Washington, DC to dedicate herself to progressive politics. She worked as a communications strategist in the women's movement, the labor movement, and the anti-war movement before coming to Alaska Wilderness League. She also is an accomplished writer, with her work published in both national and local publications. Surrusco graduated with honors from Pitzer College in Claremont, California, and earned her MFA in creative nonfiction from Goucher College in Baltimore, Maryland.

ROBERT THOMPSON is an Iñupiaq hunter and conservationist, and founding member of Resisting Environmental Destruction on Indigenous Lands (REDOIL). He has traveled to Washington, DC and around the world to educate government officials and the public about climate change and the threat of oil and gas development in the Arctic National Wildlife Refuge and the Arctic Ocean. His op-eds have appeared in the *Anchorage Daily News* and the *Arctic Sounder*. He is also an adventure guide and runs trips in the Arctic through Kaktovik Arctic Adventures, which he founded and owns. He is an excellent cook and storyteller, and his local knowledge of the rivers, land, plants, and animals is sought out by photographers, journalists, and scientists from across the planet. Robert is a husband, father, grandfather, and great-grandfather.

PIERS VITEBSKY has been head of Anthropology and Russian Northern Studies at the Scott Polar Research Institute at the University of Cambridge since 1986. He has carried out long-term fieldwork among shamans and shifting cultivators in tribal India since 1975, and among nomadic reindeer herders

in the Siberian Arctic since 1988. His books include *Reindeer People: Living with Animals and Spirits in Siberia*, *Dialogues with the Dead: The Discussion of Morality Among the Sora of Eastern India*, and *The Shaman: Voyages of the Soul from the Arctic to the Amazon*.

VELMA WALLIS grew up in a subsistence-based lifestyle in the Gwich'in country of Yukon Flats. Her debut novel, *Two Old Women: An Alaska Legend of Betrayal, Courage, and Survival*, has sold more than 1.5 million copies internationally and has been translated into seventeen languages. She is also author of the novel *Bird Girl and the Man Who Followed the Sun*, and a memoir, *Raising Ourselves: A Gwich'in Coming-of-Age Story from the Yukon River*, which won the American Book Award. Velma Wallis lives in Fairbanks and Fort Yukon, Alaska.

MARIA SHAA TLÁA WILLIAMS is associate professor of Music and Native American Studies at the University of New Mexico in Albuquerque. She is Tlingit and is of the Decitaan clan and enrolled in the Carcross/Tagish First Nations and Tlingit/Haida, a federally recognized tribe. Her research is on Alaska indigenous cultural practices. She is editor of *The Alaska Native Reader: History, Culture, Politics*.

STEVE ZACK is a conservation scientist with the Wildlife Conservation Society–North America Program. He joined WCS in 1997 and is in charge of studies of wildlife and conservation in Arctic Alaska, a program that began in 2001. In Alaska, Steve has engaged in studies of the oil "footprint" effect on wildlife, long-term evaluations of wildlife and the changing climate, and explorations of remote areas in Arctic Alaska in advance of development so as to help create protection for wildlife of key places, including the Teshekpuk Lake region. He earned his BS from Oregon State University and his PhD from the University of New Mexico. He was on the Biology faculty at Yale University prior to joining WCS. He has also done extensive studies of birds in Kenya, Venezuela, Madagascar, and in the western United States. He lives in Portland, Oregon, and migrates with the birds to his various projects.

CREDITS AND PERMISSIONS

"A Brief History of Native Solidarity," in *The Alaska Native Reader* by Maria Shaa Tláa Williams, Ed., p. 202–216. Copyright © 2009 by Duke University Press. Reprinted by permission of the publisher.

"Lancaster Sound: Monodon monoceros" from *Arctic Dreams* by Barry Lopez. Copyright © 2001 by Barry Holstun Lopez. Reprinted by permission of SLL/ Sterling Lord Literistic, Inc.

INDEX

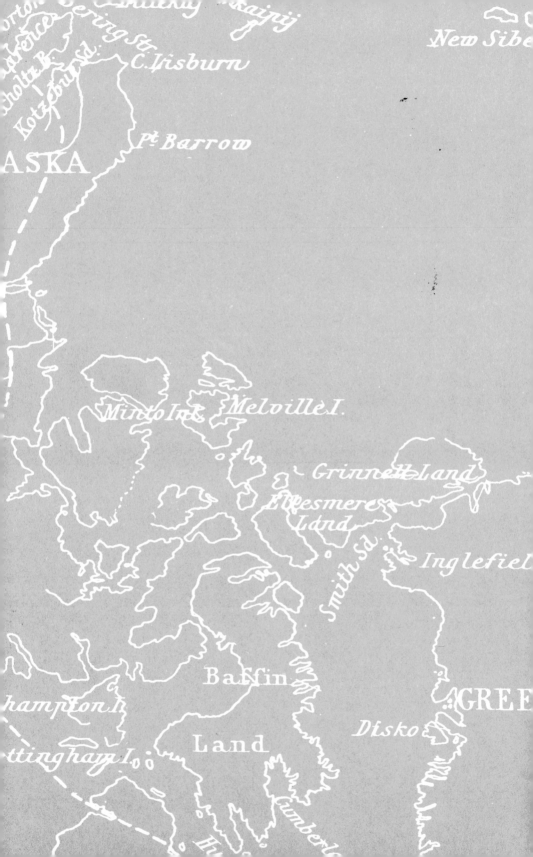